Art of Tibet

Expanded Edition

Art of Tibet

A Catalogue of the Los Angeles County Museum of Art Collection

by Pratapaditya Pal

with an Appendix on Inscriptions
by *H. E. Richardson*

and Additional Entries on Textiles
by *Dale Carolyn Gluckman*

Los Angeles County Museum of Art

Published by the
Los Angeles County Museum of Art
5905 Wilshire Boulevard
Los Angeles, California 90036

in association with
Mapin Publishing Pvt. Ltd.
Chidambaram
Ahmedabad 380 013 India

by arrangement with
Grantha Corporation
80 Cliffedgeway
Middletown, New Jersey 07701

Distributed worldwide except in Asia by
Harry N. Abrams, Incorporated, New York,
A Times Mirror Company
100 Fifth Avenue
New York, New York 10011

Library of Congress Cataloging–in–Publication Data

Los Angeles County Museum of Art.
 Art of Tibet: a catalogue of the Los Angeles County Museum of Art
collection / by Pratapaditya Pal; with an appendix on inscriptions
by H. E. Richardson; and additional entries on textiles by Dale
Carolyn Gluckman.—Expanded ed.
 p. cm.
 Includes bibliographical references and index.
 ISBN: 0-944142-58-3 (Mapin)—ISBN 0-8109-1899-4 (Abrams)
 1. Art, Tibetan—Catalogs. 2. Art, Tibetan—Influence—
Catalogs.
3. Art—California—Los Angeles—Catalogs. 4. Los Angeles County
Museum of Art—Catalogs. I. Pal, Pratapaditya. II. Richardson,
Hugh Edward, 1905– . III. Gluckman, Dale Carolyn. IV. Title.
N7346.T5L6 1990
709'.51'507479494—dc20 90-8401
 CIP

In dimensions, height precedes width; if only one dimension is given it
is that of height unless otherwise noted.

Edited by Phil Freshman and Dorothy J. Schuler; addenda by
Chris Keledjian
Designed in Los Angeles by Gregory Thomas; addenda by
Amy McFarland
Photography by Lawrence S. Reynolds, Peter Brenner, and Jack Ross;
additional photography by Steve Oliver

Type set in Garamond by RS Typographics, North Hollywood,
California, and Continental Typographics, Inc., Chatsworth, California
Printed by Nissha Printing Co., Ltd., Kyoto, Japan

The first edition of this catalogue was supported by a grant from the
National Endowment for the Arts. The expanded edition was made
possible in part by the Andrew W. Mellon Foundation.

Cover: *Power of Faith,* detail of folio from a *Prajnaparamita* manuscript,
eleventh century, cat. no. M1 d.

Contents

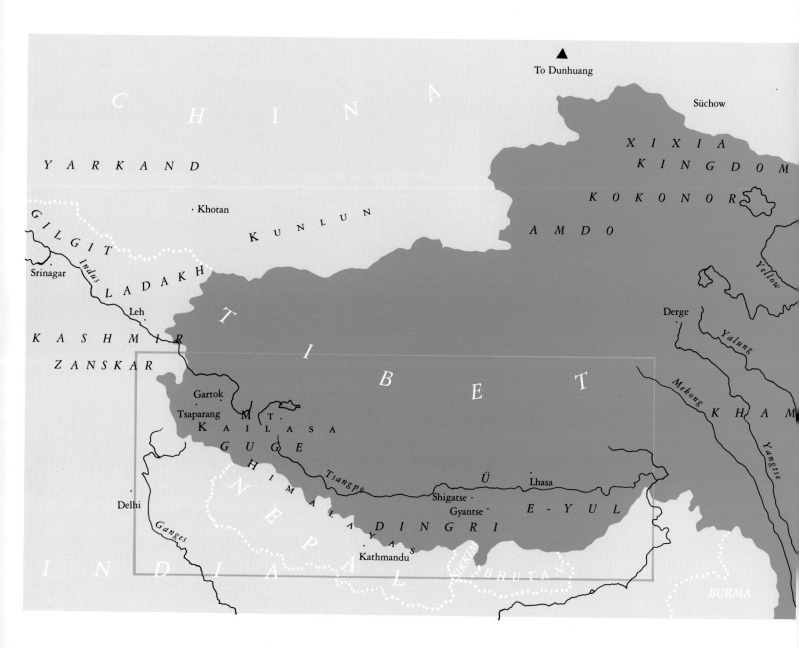

To Dunhuang

Süchow

C H I N A

XIXIA KINGDOM

KOKONOR

AMDO

YARKAND

· Khotan

KUNLUN

GILGIT

Indus

Srinagar

LADAKH

Yellow

KASHMIR

Leh ·

Derge ·

Yalung

ZANSKAR

T

I

B

E

T

Mekong

KHAM

Gartok ·

Yangtse

Tsaparang ·

MT. KAILASA

GUGE

Tsangpo

Ü ·

· Lhasa

Delhi ·

HIMALAYAS

Shigatse ·

E - Y U L

NEPAL

Gyantse ·

Ganges

DINGRI

I N D I A

Kathmandu ·

SIKKIM

BHUTAN

BURMA

N

1. Iwang
 (*early Kadampa monastery*)

2. Narthang
 (*monastery*)

3. Ngor
 (*Sakyapa monastery*)

4. Reting
 (*Gelukpa monastery*)

5. Sakya
 (*monastery; headquarters of Sakyapas*)

6. Samye
 (*earliest Tibetan monastery*)

7. Sera
 (*Gelukpa monastery*)

8. Shalu
 (*Sakyapa monastery*)

9. Tashilumpo
 (*Gelukpa monastery; seat of Panchen Lamas*)

10. Toling
 (*monastery founded by Yeshe Ö and Rinchen Sangpo*)

11. Tshurphu
 (*monastery; headquarters of Karmapas*)

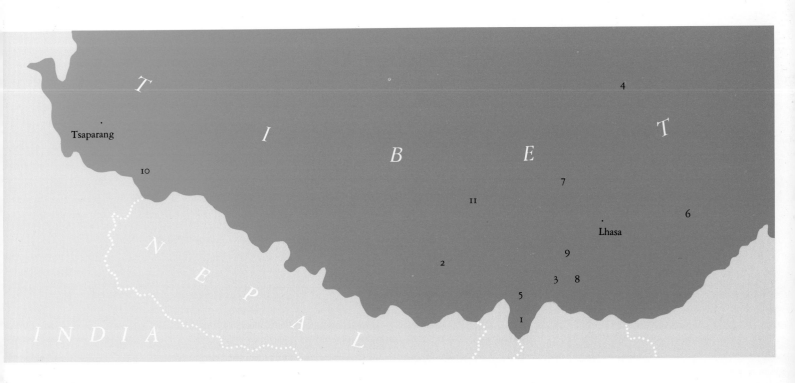

Foreword

With this volume, the Los Angeles County Museum of Art begins publication of its series of catalogues raisonnés on its extensive holdings of the art of the Indian subcontinent and Tibet.

The development of these holdings was given its basis with the acquisition of the highly important Nasli and Alice Heeramaneck Collection of Indian, Nepalese, and Tibetan Art, which began in 1969. Under the guidance of Dr. Pratapaditya Pal, Senior Curator of Indian and Southeast Asian Art, the commitment was made to cultivate collections of exceptional quality in these areas. In recent years, as this commitment has reached significant realization, Dr. Pal and the Museum's Board of Trustees have accorded priority to the publication of this series.

In the area of Tibetan art, the Museum's collection is unmatched outside Tibet itself. Contained here, for example, is a more comprehensive group of twelfth- to nineteenth-century paintings and illustrated manuscript pages than can be found anywhere in the United States. The collections of sculptures and ritual objects are likewise wide-ranging and impressive.

Because a great many of these pieces have remained unpublished until now, it is with particular pride that we make the scholarship on them and the rest of the Tibetan collection available in *Art of Tibet*. In this regard, we are deeply grateful to the National Endowment for the Arts for providing a grant that greatly facilitated the publication of this volume.

We look forward eagerly to the subsequent catalogues in this series.

Earl A. Powell III
Director
Los Angeles County Museum of Art

Preface to the Expanded Edition

It is always gratifying to an author when a book is reprinted, thereby indicating that it has been generally well received. This edition includes changes and corrects errors in the basic information and adds further comments where necessary. Forty-seven new entries have been added, reflecting the continued growth of the collection between 1983 and 1988. Dale Carolyn Gluckman, Associate Curator of Costumes and Textiles, has written five of the new entries (T1–5). Moreover, the bibliography has been brought up to date.

It is a great pleasure for me to thank Dr. Heather Karmay, the noted Tibetologist, for her help in reading the names of the principal monks in P15; Dr. Stephen Markel, Assistant Curator of Indian and Southeast Asian Art, for checking all the basic catalogue information; Mary Katherine Aldin for preparing the manuscripts; Ethel Heyer, the department's diligent volunteer, for her clerical assistance; Steve Oliver for supervising photography; and Chris Keledjian for editing. Thanks are also due to Joseph Newland, editor, for his enthusiastic support of the project.

Pratapaditya Pal
Senior Curator
Indian and Southeast Asian Art
September 1989

Dale Carolyn Gluckman wishes to thank Dr. Pal for his encouragement and, for their generous sharing of time and information, the following individuals: John Vollmer, director of the Design Center, Toronto; Jean Mailey of the Metropolitan Museum of Art, New York; Valrae Reynolds of the Newark Museum; Dr. Janice Leoshko of the Los Angeles County Museum of Art; Tamara Wasserman Hill in San Francisco; Jacqueline Simcox in London; and Steven McGuiness in Hong Kong.

Preface to the First Edition

The Museum's Tibetan holdings make up one of the most significant and comprehensive collections of Tibetan art outside that country. The core of the collection was acquired from the Nasli and Alice Heeramaneck Collection beginning in 1969. Since then the collection has been substantially augmented with purchases and gifts from many generous donors, to whom we are most grateful.

The Museum is especially fortunate in having a great many fine Tibetan paintings. While other institutions possess interesting collections of thankas, none is so comprehensive as the Museum's for the study of early painting. The history of Tibetan painting stretches from the eleventh through the nineteenth century, and a glance through this catalogue will demonstrate how well represented the earlier centuries are in the collection. Indeed, the group of manuscript illuminations and book covers is perhaps without parallel. This eminence is in no small measure due to the efforts of Professor Giuseppe Tucci, the greatest Tibetologist of modern times, who was responsible for recovering (in the 1930s) some of the priceless early thankas and manuscript pages that the Heeramanecks later acquired. Paintings, however, are not the only strength of the collection; the bronzes and ritual objects are equally varied and rich.

The study of Tibetan art history is beset with unusual problems. Most objects have emerged, and continue to do so, from the numerous monasteries, which are, generally speaking, inaccessible to us. Most of the art was created primarily for use in these monasteries, but no proper inventory of the material *in situ* nor a systematic, art-historical study of these works has been made to date. Perhaps the task is impossible given the present political circumstances. While Professor Tucci's *Indo-Tibetica,* long out of print, is of fundamental importance, and while attention has been given in recent years to the monuments of Ladakh and the western Himalayas, the present insufficient state of our knowledge prevents any accurate determination of the various styles and periods of Tibetan art. The attempt made here—despite the limitations of a single collection—to suggest a basic framework for the study of styles, both of painting and sculpture, must therefore be regarded as tentative and is meant to provide preliminary guidelines for future scholars.

Another problem encountered in writing a catalogue of this nature is that frequently one must use both Sanskrit and Tibetan words, a potential source of confusion. Because Sanskrit names and terms are by and large more familiar than Tibetan ones, I have employed Sanskrit wherever possible. I have done so because this catalogue is the first in a projected series—other volumes planned will concern the arts of Nepal and India—and so cross-referencing between volumes will be easier if thematic terms and names appear, consistently, in one language. Moreover, in order to make

this book easier to read, diacritical marks for Sanskrit words have been omitted in the text. All appropriate diacritical marks, however, are provided in the glossary of Sanskrit terms at the back of the book. The system for transliteration of Tibetan into English produces spellings that at times bear a remote relationship to correct Tibetan pronunciation. For that reason, Tibetan words appear phonetically spelled in the text, while a pronunciation key has been added, at the back of the book, that joins the phonetic spellings of frequently used words with their correct transliterations.

Since some readers may be unfamiliar with the terminology and personalities discussed in this catalogue, a glossary of selected Sanskrit terms (just mentioned) and a glossary of Tibetan terms have been included. Terms mentioned only once in the text and accompanied there by an explanation have generally been excluded from the glossaries. Chinese names and terms appearing in the text are given according to the *pinyin* system of romanization; those that are most commonly known by their former Wade-Giles romanized spellings appear parenthetically following the *pinyin*.

Catalogue entries in this volume are keyed to a letter-number system, with the letters *M, P, S,* and *R* representing, respectively, Manuscript Illuminations and Book Covers; Paintings and Appliqué Hangings; Sculptures; and Ritual Objects. The catalogue numbers of those entries illustrated by color plates appear in boldface type throughout the text (e.g., S36). All bibliographic references in the text and catalogue-entry sections are presented in abbreviated form, consisting simply of author, publication date (if more than one publication by a given author has been included in the bibliography), and, where applicable, page numbers. These are keyed to a full listing of citations to be found in the bibliography at the back of the catalogue. Publications referred to only once are fully cited in the text.

Many people have helped in the preparation of this catalogue, and I am greatly indebted to them all. Most of all, however, I must thank Mr. H. E. Richardson, a great Tibetologist and a fine gentleman, who has honored us by being associated with this enterprise. He has read most of the inscriptions to be found on many of the manuscripts, paintings, and sculptures in the collection and has provided us with an appendix in which selected inscriptions have been transliterated, translated, and commented upon. In all, he has cooperated most cheerfully in sharing his vast knowledge of Tibetan civilization.

The success of a catalogue depends largely upon the quality of photography in it. It is my great pleasure to thank the Museum's Photography Department, headed from 1966 until 1980 by Edward Cornachio and now by Larry Reynolds, for its excellent work. Of the various other Museum staff members who have been directly involved, and have provided ungrudging cooperation, mention must be made of the following: Eleanor Hartman, the Museum's librarian, and her staff; Assistant Director Myrna Smoot; the editors of the Publications and Graphic Design Department; Dr. Robert Brown, Dr. Sheila Canby, and Sheila Sklar in the Department of Indian and Southeast Asian Art; the staff of the Museum's Conservation Center; and the many diligent volunteers of the Museum Service Council. A special word of appreciation is due to paper conservator Victoria Blyth-Hill and objects conservator Billie Milam of the Conservation Center and to Yasuhiro Iguchi of Boston's Museum of Fine Arts for their patient efforts in the cleaning, restoring, and mounting of the paintings and sculptures in the collection. We are also grateful to Mr. Suresh K. Neotia for permission to use the photograph of text figure 2 and to Mr. Robert Skelton for supplying the photograph.

The publication of this catalogue would have been unduly costly without the financial support it received from several important sources. In addition to the National Endowment for the Arts, we are grateful to the late Christian Humann for establishing a publications fund in the Museum, which will subsidize this and subsequent volumes in this series.

P. P.
September 1982

General Introduction

Since art consists of body, speech and mind, in truth it must be understood as the harmonious coalescence of all learning.

Lama Sumpa Khenpo (1702–1775)

Mountains and Men

This centre of heaven,
This core of the earth,
This heart of the world,
Fenced round by snow,
The headland of all rivers,
Where the mountains are high and
the land is pure.[1]

The above extract from the Dunhuang documents, which form the earliest surviving examples of Tibetan literature (eighth or ninth century), may sound hyperbolic, but it merely anticipates some of the equally romantic expressions, such as "land of snow" and "rooftop of the world," that gained currency in the last century to describe the little-known and mysterious country called Tibet. The land is indeed fenced by snow, for in the north, south, and west, Tibet is surrounded by some of the most awesome mountains in the world. In the northwest are the lofty Karakoram; in the north the formidable Kunlun; and in the south the extensive and majestic Himalayas, which act as a natural border with India. Although Tibet is not the "headland of all rivers," certainly two of the greatest rivers of India, the Indus and the Brahmaputra (known as the Tsangpo in Tibet), rise in the western mountains, while the Salween, the Mekong, and the mighty Yangtse of China rise in the eastern part of the country. Undeniably, too, as the extract tells us, both the land and the air were once pure; perhaps, in much of the country, they still are.

Although Tibet today forms a semiautonomous region or state within the People's Republic of China, during the period (1000 through 1940) when the works discussed in this catalogue were created, Tibet was an independent country. Two of its most powerful neighbors then were China and India. Both these ancient civilizations played a pivotal role in molding Tibetan culture. Equally important was the contribution of Nepal, a less formidable southern neighbor. As will be apparent in this catalogue, the history of Tibet's relationships with her neighbors is obstensibly reflected in her artistic traditions and styles.

It would be wrong to presume, however, that Tibet has always remained at the receiving end. Tibetan cultural influence extended far beyond her political boundaries. Both Bhutan and Sikkim (now part of India) may well be regarded as cultural satellites of Tibet. Large areas of Nepal, especially the northern and northwestern parts of the country, are inhabited by peoples who are ethnically and culturally a part of Tibetan civilization. Even in the central Kathmandu Valley (the cradle of Nepali culture) the principal architects of that culture, the Newars, have remained closely associated with Tibet. The Newars played a fundamental role in the story of Tibetan art and were themselves influenced by Tibetan culture. Much of Ladakh, Zanskar, Lahoul, Spiti, and other neighboring regions of the northwestern Indian Himalayas are today part of India, but culturally they are far more Tibetan than Indian. In fact, most of these regions once owed political allegiance to Tibet and were at times integral parts of her empire.

Tibet occupied much of Chinese Turkestan and irritated the Tang dynasty (618–907) for almost two centuries (c. 632–822), and her influence was also felt in the southwestern states of China where there were several Tibeto-Burman tribes. In

the north the Xixia (Hsi-Hsia) kingdom (1032–1226), which was comprised of part of northwest China, was a strongly Tibetanized state, while the religion in Mongolia drew its spiritual nourishment from Tibet, just as Tibet once did from India. From the thirteenth through the nineteenth century Tibetan monks were a constant presence at the imperial Chinese court and, acting as royal preceptors, exerted considerable influence upon the Chinese emperors.

The area of Tibet is about one and a half million square miles, but the country has a population of only about four million. Because of the extensive Chang Tang desert in the north, as well as the intimidating mountain ranges, the actual habitable land area is only a fraction of the total available space. Despite its awesome mountains and fifteen-thousand-foot-high passes, its vast deserts and virgin forests, Tibet is neither so isolated nor so inhospitable as one may have been led to believe in recent times; and certainly, the habitable areas are not so snowbound as the expression "land of snow" indicates. As a matter of fact, but for the mountain peaks, snow is rarely a familiar feature in the lives of most Tibetans, certainly far less so than in the lives of most North Americans or Russians. However, the climate is harsh, especially at high elevations, and the mountains, the passes, the forests, and the rivers made a journey in the old days an extremely hazardous and grueling experience. There is no doubt that all these features contributed to the molding of Tibetan civilization.

This natural harshness is mirrored in the architecture of Tibet (P20, P27),* consisting primarily of majestic, fortresslike structures which not only reflect the severe austerity and the imperturbable solidity of the mountains around them, but which once served as impregnable forts against the onslaught of both man and nature. The buildings were designed to keep out the cold winds. Because of the scarcity of both rain and snow, their roofs were made flat. Hailstorms, on the other hand, are frequent and disastrous for crops; the religion, consequently, has many rituals to prevent this variety of natural calamity.

Nature has always remained extremely important in the spiritual life of the Tibetan. All the mountains are sacred, as they are believed to be inhabited by gods and spirits who must constantly be appeased. These deities of the mountains and passes were given places in the pantheon and hence in the world of visual images. Similarly, the rivers and lakes (the most celebrated being Lake Mipham, or Manasarowar, in the west) are also sacred entities and contain spirits that are different from those inhabiting the mountains, but are equally prominent in religion, mythology, and the arts. The preeminence of wrathful deities, demonology, and oracles in the daily life of Tibetans may have been brought about by the generally hostile environment in which they live.

Who the original inhabitants of Tibet were remains a mystery. Legend claims that they descended from a forest monkey and a rock demoness. Later, when Buddhism became dominant, the monkey was identified with Avalokitesvara and the demoness with Tara. The first king and his two wives were also regarded as incarnations of these same two deities (S41). The myth may disguise the memory of the early symbiosis between the nomadic, non-Chinese Chang tribes (thought to be among the earliest settlers in Tibet), represented by the rock ogress, and the agricultural tribes of the southern valleys, symbolized by the monkey.

The vast region from Amdo in the northeast to Ladakh in the west is inhabited by a diversity of peoples who have over the centuries either coexisted or coalesced to create the ethnic mosaic that has come to be known as Tibet. These range from the "savage" tribes of the Amdo forest, the Golok nomads of the north,

*The catalogue numbers of those entries illustrated by color plates appear in boldface type throughout the text.

16

and the dwarfish people of Chala (a district in Kham), to the Dards and Baltis of Ladakh who may have been the original settlers in that region. The Tibetans call themselves Bodpas (pronounced Pöpa) and their country Bod. (The Indian name for the country is Bhota, while in Chinese it is called Tufan.) Besides Tibetans there are other peoples, such as the Horpas and the Mon, but what seems clear is that the predominant ethnic strain in the population is Mongoloid. The major language, with several regional dialects, which binds the various tribes and races together is Tibetan; it belongs to a group known among linguists as the Tibeto-Burman. A monosyllabic language, it is written in a script that was derived from India, specifically from Kashmir, in the seventh century.

Broadly, Tibetan society consists of three classes of people: the commoners, the nobility, and the clergy. The common people are farmers, pastoral nomads, craftsmen, and traders, with the two former groups predominating. Thus, the basic economy of Tibet is derived from animal husbandry and cereal agriculture. The pastoral nomads provide the meat, milk products, and the wool used by the society, while the sedentary farmers grow the staple foodstuffs, consisting largely of barley, maize, and buckwheat. As the Tibetologist R. A. Stein has so succinctly written, "The habitat, by its very nature, gives Tibetan life a dualistic form. Sometimes this governs one and the same group in a seasonal rhythm (summer and winter), and sometimes two groups live in symbiosis."[2]

Although the Chinese claim that in early times the Tibetans were essentially a pastoral and nomadic people may have been colored by a romantic view of their past, the nomads are still an important component of Tibetan life. By tending their sheep and yaks (as distinctive an animal of the Tibetan plateau as the llama is in Peru and the kangaroo is in Australia), the nomads provide Tibetans with food and clothing and also with one of the country's most important cash crops, wool. Another export provided by the nomads is the yak tail, which, as the *camara* (fly whisk) was a royal symbol par excellence in much of Asia and in India is still an essential implement in Hindu temple ritual.[3]

The influence of nomads in Tibetan life is evidenced by the widespread use of tents, even among royalty and the nobility. Their mansions and castles were once used mostly during the winter; much of the summer was spent in beautiful tents pitched in verdant parks. While traveling, the rich and powerful used tents and, like the Moghul emperors in sixteenth-century India, exalted monks traveled with a virtual "city of tents" as they made their long and arduous journeys to China, Mongolia, or across their own country.[4] It is hardly surprising, therefore, that Mahakala (**P10**, **P11**), the Indian god who protected the monastery, when transported to Tibet became the protector of the tent (*gur gyi mgon po*) as well. In the mysterious *chö* rite the tent and its peg play an important role, and the peg may well have been the prototype of the most distinctive of all Tibetan ritual implements, the *phurpa* (**R6**, **R7**), frequently referred to as the "magic dagger."

The less popular Bon religion, with its gods of the mountains and the lakes—many of whom were later incorporated into the Buddhist pantheon—very likely reflects the religious needs of the nomads. Similarly, the shamanistic rites and many of the oracles that have survived in the religious life of Tibet may well have been inherited from the earlier cultures of the nomads.[5] The yak, the mythical *khyung* bird (later identified with the Indian *garuda*), and the *lu*, the malevolent serpents that inhabit the lakes, all familiar creatures in Tibetan iconography, are among the many contributions of the nomadic component of Tibetan society.

The dedicatory inscriptions on paintings and sculptures make it abundantly clear that the common people of Tibet, however devout, were not directly responsible for commissioning any of the objects. That privilege was reserved largely for the wealthy nobility and the clergy. Nonetheless, the wealth was generated by the common people whose labor with their flocks and in their fields not only fed and clothed the rich but also created the surplus that could be expended for religious purposes. It was also the faith and piety of the common people that formed the solid foundation of the Buddhist religion for which much of the art in Tibet was created. Except for foreign artists and some monks, the majority of artists, craftsmen, and artisans were commoners who were neither rich nor very literate. And yet their skill and devotion produced works of art which, universally admired today, inspired countless Tibetans, both lay and religious, in their quest for spiritual bliss.

It is neither necessary nor possible here to provide a detailed account of the structure and morphology of Tibetan society, but a few additional remarks are pertinent in order to understand some of its religious and iconographical features. A major element of the religious structure of Tibet is the great emphasis placed on the twin principles of absolute authority and stringent hierarchy in the various monastic lineages. As R. A. Stein very clearly states:

> Twin principles exemplified in the family are found again when we turn to consider the structure of authority: cohesion and the strength of the group, on the one hand; the hereditary authority of one person and a keen sense of hierarchy, on the other. Time and again one has the feeling that the second of these principles has won the day, but that the first continues to counterbalance it.[6]

While this authoritarianism may partly be explained by the predominance of the concept of guru or preceptor, which is fundamentally important in tantric Buddhism, it does not give the whole picture. Tantric Buddhism flourished in India as well as in other Asian countries, including Nepal, China, Japan, Java, and Cambodia, and while the arts of some of those regions also portrayed their monks and teachers, nowhere is the emphasis on authority and hierarchy so pervasive and paramount as in Tibet. One is less surprised, therefore, by the cohesion and pervasive influence of monastic organizations and the authoritarian arrangement of the monks within each religious order. Transplanted into Tibet, the Indian concept of the guru found a fertile soil and his Tibetan counterpart, the lama, ultimately came to enjoy both spiritual and temporal power and authority. The twin principles of cohesion and hierarchy not only underlie the structure of the monastic orders but also of the divine pantheon itself, particularly in the organizations of the numerous gods and demons, monks and mystics who populate Tibetan paintings.

As Stein has further stressed, the hierarchic structure is strongly evident in the language itself.

> The latter [the language] is altogether different when talking to a superior, an equal, or an inferior; and that is true in all spheres of human intercourse—government, the family, or spiritual relations. The whole vocabulary is affected; not only by joining the honorific words, as in the polite speech of China and elsewhere, but by different sets of nouns and verbs, as in Japan.[7]

Religion has often been characterized as the handmaiden of commerce; in no other country have the two flourished in such harmony as in Tibet. If religion is considered to be the heart of a Tibetan, trade must be regarded as his lungs. As has often been observed, every Tibetan is a natural trader. The nomads come down from

the mountains and plateaus to trade; the farmers supplement their income by trading; at least one member of every landowning family is a merchant, just as another is a monk; and even the monks and monasteries engage in vigorous commerce. A monk from Zanskar may go all the way to Amdo to trade his goods for the horses for which that region is famous. Indeed, Tibetan traders used to go all the way down to the agricultural fairs in northern Bihar to sell horses and yak tails. They went down to Nepal to sell wool and turquoises; they went to Kashmir and the markets of the northwestern part of the Himalayas to sell yak tails and woolen goods. Across the forbidding Karakoram passes (in places over nineteen thousand feet high) they went to Yarkand and Kashgar, and merchants from those regions visited Leh, the capital of Ladakh. The famous metalwork of Derge in the northeast was sought all across Tibet, Mongolia, and deep into China. (Tibet still provides a large market for Chinese brick tea, by far the most popular national beverage.)

Indeed, commerce had something to do with that much-discussed Tibetan social institution known as fraternal polyandry. Although polyandry was practiced principally to encourage familial cohesion by keeping property and land within one family, its success depended largely upon the fact that brothers rarely shared a wife at the same time. One brother usually stayed at home to look after the property while the others were away in military or ecclesiastical service, or off on a commercial journey.

More pertinent here is the influence trade exerted upon the arts. Most traders visited the monasteries and temples on their journeys; thus a commercial journey was also a pilgrimage. They carried with them their portable shrines, or *gau* (R15), as well as thankas. They purchased thankas, bronzes, and *tsha tsha* (votive plaques) (R16) in the places they visited much as the modern tourist buys souvenirs. This is one way large quantities of Indian bronzes found their way into Tibet; why thankas painted in an eastern Tibetan style now hang in a monastery in Zanskar; and why the same style may be seen in western Tibetan temples as in paintings recovered from Kharakhoto in China. The piety of the traders and the pilgrims was just as responsible for the wide dispersion of styles and iconography as was the mobility of the artists.

As can be seen, religion has exerted a major influence on the Tibetan mind and civilization. Although religion has remained a predominant trait of Indian civilization as well, neither its political nor its intellectual life has been so profoundly dominated by religion as has Tibet's. This is partly due to Tibet's environmental and self-imposed isolation and also to its hostile climate. As Charles Bell has so perceptively observed:

> The wide, open spaces of the earth, deserts and semi-deserts, are the homes of religion. . . . Buddhism, of the type that has been formed in Tibet and Mongolia, flourishes characteristically in their great expanses, which though not absolute desert, came near to being so. The dry, cold, pure air stimulates his intellect, but isolation from the cities of men and from other nations deprives the Tibetan of subjects on which to feed his brain. So his mind turns inwards and spends itself on religious contemplation, held still further by the monotony of his life and the awe-inspiring scale on which Nature works around him. . . . There is all the difference in the world between the devout, religious outlook of Tibet and the philosophic materialism of agricultural China."[8]

Because of the predominance of religion in Tibetan life, monastic orders and organizations were the most prominent force in the civilization, and, ultimately, must bear some of the responsibility for the country's loss of independence to China in 1951. Ever since the thirteenth century, the monasteries had repeatedly invited

the Chinese to interfere in their internal rivalries, which assured a strong Chinese presence on Tibetan soil and ultimately led to the mid-century subjugation of the country by the People's Republic. Tibet's history has at times been compared with that of Medieval Europe, where life was also governed principally by the ecclesiastical and feudal classes. But the influence of religion remained much more pervasive in Tibet and the power of the monasteries that sprang up after the revival of Buddhism in the eleventh century was far more extensive and led finally to the complete fusion of church and state in the peculiarly Tibetan institution of the Dalai Lama.

Although the castles of the feudal lords and princes are of imposing proportions, it is the monastic complex that dominates the Tibetan landscape. The large monasteries are virtually self-contained cities, and even in pictures the majesty of the Potala, the official residence of the Dalai Lama in Lhasa, is awesome. The number of monks far exceeded the number of nobles, by at least three to one if not more, and often the important monks were scions of princely and influential families. Every family, rich or poor, was expected to provide at least one son for the monastery. From the tenth century on, both political and economic power were increasingly shared by the nobility and the monasteries; but it would be wrong to presume that they always made compatible bedfellows. On the contrary, the history of Tibet—from the fall of the Yarlung dynasty in the ninth century until the concentration of both spiritual and temporal authority in the institution of the Dalai Lama in the sixteenth—is a turbulent saga. It is a story of the struggle for power between the nobility and the ecclesiastical establishments and among the various religious orders themselves, aided and abetted by the princes and the landed aristocracy, as well as by the Mongols and the Chinese whose interest in the political affairs of Tibet had, as we have just suggested, a long history.

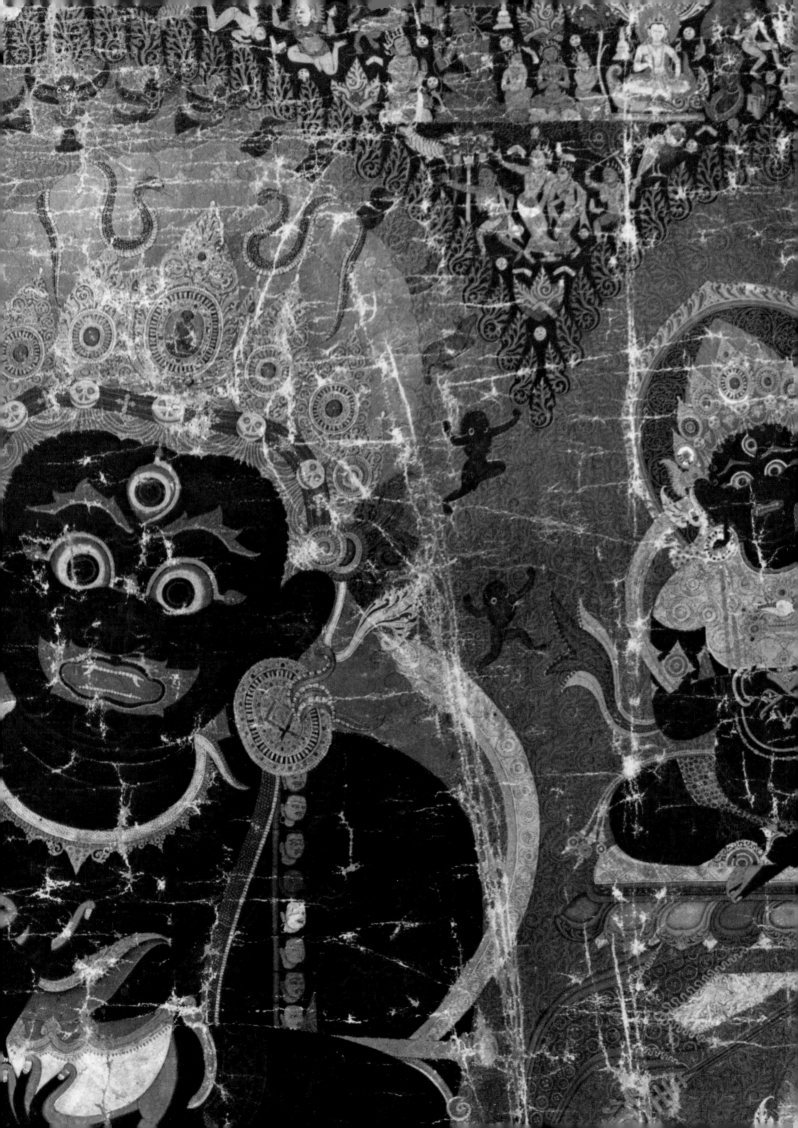

Monks and Monarchs

When the curtain lifts once more and a few gleams of light fall
on the scene, Tibetan civilization is definitely taking on the
aspect it has retained till modern times. History is no longer
concerned with kings but with monasteries and religious orders.
The princes or heads of noble houses are now no more than
benefactors and partisans of one ecclesiastical establishment or
another. It is the eleventh century.

R. A. Stein[9]

The earliest works of art in the Museum's collection are from the eleventh century, which was one of the most remarkable periods in the history of Tibet. It witnessed both the revival of Buddhism and the foundation of most of the important monasteries and religious orders with which the works of art were directly associated.

Just as Tibetan art is mostly religious, so also is its history, and since Buddhism is the predominant religion in the country, all chronicles are woven around the history of this faith. Political events are recorded only if they are relevant to the spread of Buddhism. Lives of monks are hagiographies rather than biographies, emphasizing spiritual progress and the mystical rather than the historical life. Events are, therefore, always spiritualized and sublimated, just as the portraits are idealized. In writing the religious histories and hagiographies of the monks, Tibetans appear to have made a compromise between the Indian love of mythology and fantasy and the Chinese sense of history and pragmatism.

Buddhism was introduced into Tibet during the reign of King Songtsen Gampo (r.c. 609–49), whose rare portrait is included in the collection (S41). Two of his queens were from China and Nepal, and both were said to have been ardent followers of Buddhism. The Chinese princess brought with her an image of Buddha Sakyamuni which was housed in a temple in Lhasa. During the next two hundred years, most of Songtsen Gampo's successors espoused the cause of the imported religion, and one of the most fervent adherents was King Thisong Detsen (b. 742). With the help of two Indians, the monk Santarakshita and the mystic Padmasambhava, the king established the first great monastery at Samye around the year 779.

Santarakshita was an erudite teacher but apparently no match for the occult powers of the followers of the pre-Buddhist religious beliefs in the country, which were mostly animistic and shamanistic. Thus, Padmasambhava, a celebrated mystic, was invited from Uddiyana (identified with the Swat region in modern Pakistan) to control the indigenous spirits and demons, which he did, probably by incorporating many of the local cults into the Buddhist fold. It appears that during this early period both Indian and Chinese monks (known as *hoshang*) were present in Tibet, and friction arose between the two groups as to whose system of Buddhism was the superior. This was settled by a debate at Samye in 792, sponsored by King Thisong Detsen.[10] Apparently, the Indian side was victorious, and, thereafter, Tibet maintained closer relations with India in religious matters, until the disappearance of Buddhism from the subcontinent around 1300. Consequently also, Indian Buddhist art exerted a greater influence on Tibetan art than did that of China.

The dynasty of Songtsen Gampo, which ruled much of Tibet from about the mid-seventh until the mid-ninth century, is known as the Yarlung dynasty since the

family originated in the Yarlung Valley, southeast of Lhasa. Although his successors continued to patronize the imported Buddhist religion—and despite Padmasambhava's efforts and those of other Indian monks and mystics who visited Tibet at the invitation of the royal family—Buddhism continued to encounter opposition both from practitioners of indigenous religious traditions and from the nobility. The political power of the feudal lords of Tibet had been controlled by Songtsen Gampo but not obliterated. They remained a constant source of irritation to the dynasty and were hostile to Buddhism. Around the middle of the ninth century, the disgruntled nobles found an ally in King Langdarma (803–842?), who was virulently anti-Buddhist. Regarded as the "apostate king" by Buddhists, he is remembered by later historians as a relentless persecutor of the faith. He was assassinated by a pious Buddhist, probably in 842 (there is disagreement as to the exact date, some scholars placing the event later), and thus ended the rule of the only centralized political authority Tibet was to know until the seventeenth century, the period during which the authority of the Dalai Lama was consolidated.

Little is known of the political or religious history of Tibet from the fall of the Yarlung dynasty until the beginning of the eleventh century, when, in Stein's words, "the curtain lifts once more," though it lifted in western rather than in central Tibet. This largely unrecorded period was probably the time during which the more ancient beliefs and religious practices were coalesced, though with considerable Buddhist influence, into the only other Tibetan religion, known as Bon. According to Buddhist historians, their own religion during the ninth and tenth centuries became highly contaminated by unsavory cultic practices which were both native and imported. Buddhism appears to have been almost nonexistent in the central region of the country and flickered dimly in outlying areas both in the east and west. It was in the west that the lamp was made to burn brighter once again in the eleventh century due to the zeal and piety of yet another royal family and of monks, both Indian and Tibetan.

One of Langdarma's sons had moved west and, subsequently, his descendants carved out three kingdoms, one of which came to be known as Guge. Members of the Guge royal family were devout Buddhists. One of them, known as Yeshe Ö (lived c. 1000), abdicated the throne, along with his two sons, to devote himself entirely to rejuvenating the religion in the country. Disturbed by the moribund and degenerate state of the religion, Yeshe Ö sent monks to India, built temples and monasteries in Guge, and invited Indian teachers to alter the situation. Among the monks he sent to India was Rinchen Sangpo (958–1055); but the most celebrated Indian teacher to visit Tibet was Atisa (982–1054), who came from the Vikramasila monastery to western Tibet in 1042. It was due largely to the efforts of these two, with the enthusiastic support of the Guge royal family, that Buddhism not only revived in Tibet, but ultimately became the predominant aspect of Tibetan civilization.

A great scholar and translator, Rinchen Sangpo was one of several young Tibetans handpicked by Yeshe Ö and sent to Kashmir to continue their studies. Upon his return, Rinchen Sangpo proved to be a zealous champion of the religion and, apart from translating numerous Buddhist texts from Sanskrit into Tibetan, founded several temples and monasteries. Thus, Buddhism was already flourishing in western Tibet when Atisa arrived. After three years in the west, Atisa moved to central Tibet where he died in 1054 after reestablishing Buddhism in the heart of the country. He was assisted by his three disciples, Khutön, Ngoktön, and Dromtön, who were from Kham in the east—the other region where the lamp of Buddhism was kept flickering by small groups of monks and wandering teachers, such as Smriti of Nepal. In 1056–57 Dromtön founded the famous Reting monastery north of Lhasa and the religious order that came to be known as the Kadam and its adherents as Kadampas.

While Atisa was the inspiring force behind the revival, it was Dromtön's organizational ability that was responsible for the rapid spread of the religion.

Atisa was only one—though the most eminent—of the many monk-teachers from India who contributed to the rapid expansion of Buddhism in Tibet. Between the tenth and the thirteenth century, when Buddhism was for all intents and purposes destroyed in India, scores of monks and mystics from Kashmir, Orissa, Bihar, Bengal, and also from Nepal undertook the difficult journey to Tibet. While the Indians have forgotten these enterprising teachers, they are remembered with affection and reverence in the Tibetan religious tradition. Along with their Tibetan colleagues, most of the Indian monks spent much of their time translating religious texts from Sanskrit into Tibetan, as had been done once before, in the ninth century. Most of these translated texts are now included in the two monumental compilations of Tibetan Buddhist canonical literature known as the *Tanjur* (original treatises) and *Kanjur* (commentaries). Translating and organizing the religious literature and founding monasteries and religious orders seem to have been the principal occupations of the Tibetans from the tenth to the thirteenth century. Thus, this phase of Tibetan religious history may be characterized as the "age of the *lotsawas*" (translators).

Most major monasteries and religious orders of Tibet were founded in the eleventh and twelfth centuries. Apart from Reting, Shalu was founded in 1040, Sakya in 1073, Thel in 1158, Drigung in 1167, Tshel in 1175, and Tshurphu in 1189. Some of the more ancient groups had combined to form what came to be known as the Nyingmapas (or the ancient order), while the Kadampas, as mentioned, were the followers of Dromtön. The influential order of the Kagyupas was founded by Marpa, about whom we will have something to say later. The three principal suborders that stemmed from the Kagyupas were the Drigungpas, the Phagmotrupas, and the Karmapas. The Kagyupas and their derivatives were more mystically oriented than most of the other orders.

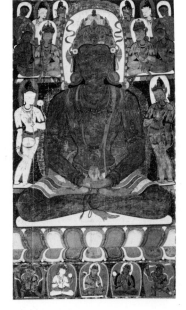

Although the reasons are not clear, Buddhism was more successful this time around in gaining the support of the local principalities and the nobility. The Sakya monastery was founded by the powerful Khön family, the Che founded Shalu, and the Phagmotru family was responsible for establishing the order derived from that name. The lords of Gyantse, an important commercial and religious center in central Tibet, became the supporters of the principal religious establishments there. As will be apparent in the catalogue section, many of the paintings in the collection were associated with the monasteries of the various orders mentioned above. The eleventh-century manuscript pages (**M1**) were recovered from the monastery at Toling in the kingdom of Guge. Founded by Yeshe Ö, Toling was intimately connected with both Rinchen Sangpo and Atisa. Two of the most important thankas in the collection (**P1, P2**) were very likely rendered for Kadampa monasteries in south-central Tibet, while an impressive group (**P10–P13**) were associated with Sakyapa monasteries. At least one thanka (**P11**) may have been executed by the same artists who were responsible for painting murals in one of the major shrines at Gyantse in the fifteenth century.

It has already been mentioned that the royal house of Guge not only supported the monasteries, but that many of its rulers and their sons became monks, too. Members of other noble families in western Tibet as well as Ladakh, such as the Drö clan, also gave up their purple mantles to don the monastic robes. This was true of noble families in other parts of Tibet as well. In some instances, as was the case with the Sakyapas, when two brothers joined the monastery, one was allowed to marry so that the abbotship could pass from the uncle to the nephew. Such arrangements ensured close ties between the nobility and the religious establishments and also increased the wealth of the monasteries, which in turn enhanced their political power and ambition.

P1

Apart from the encouragement of the ruling families, Buddhism could not have spread as rapidly as it did without the support of the general populace; it received this support, in large part, due to several vital economic factors. Beginning in the eleventh century, monasteries began to own land and to become one of the principal sources of employment. Enormous supplies of labor and materials were necessary to build the gargantuan monastic establishments and their furnishings, and to supply their religious images and ritual necessities. Trade, too, flourished because of the monasteries, which as a result became the chief economic power in the areas surrounding them. Need we wonder why the traders, the peasants, the craftsmen, and the artists met this faith with greater zeal than they did the Bon or other primitive religions?

While the interests of the monks and the monarchs sometimes merged, at other times they did not. Because of their wealth and power, the monasteries were not only frequently drawn into feudal politics, but were often mired in bloody wars, with each other and with the monarchs, often over trivial, temporal matters. And the more they quarreled among themselves, the more they openly encouraged the Mongols and the Chinese to interfere in their internal affairs—a policy, as we have noted, that ultimately led to the annexation of Tibet by the People's Republic of China. The history of Tibet from the thirteenth century until the punitive expedition sent into the country by the Chinese emperor Kangxi (K'ang-hsi) (r. 1662–1722) in 1720 is a dreary tale of the sanguine and internecine struggle for political hegemony among the Sakyapas, Karmapas, Phagmotrupas, and the Gelukpas.

The Gelukpa order was founded by the principal disciples of Tsongkhapa (1357–1419), the great reformer of Tibetan Buddhism. Tsongkhapa's reformation did not really involve any fundamental innovation either in doctrine or ritual. As Stein writes:

> No more than Atiśa, whose teachings he followed, did he neglect the Tantras with all the rituals and meditations that go with them which he had studied with the Karma-pas and Sakya-pas. But, like Atiśa and his Kadam-pa order, he insisted once more on the need for monastic discipline and the gradual path (morality, etc.), for the generality of men and even as preliminary to total liberation.[11]

The rise of the Gelukpas in the fourteenth century was meteoric, perhaps because the Tibetan people were tired of the constant feuds among the older orders and of the frequent interference and raids by foreigners. They probably expected the Gelukpas to help the country to return to sanity. If this indeed was their expectation they were to be disappointed, for the Gelukpas played an equally questionable role in the struggle for hegemony, and certainly encouraged foreign intervention with no less zeal than had the older monastic orders.

Like the eleventh and twelfth centuries, the fifteenth century witnessed the foundation of a number of great monasteries, several of which were established by the Gelukpas. Ganden, where the Gelukpa order originated, was founded in 1409, Drepung seven years later, and Sera in 1419; all were located in Ü in central Tibet, where the Gelukpas had consolidated their power. (The Tsang region was then under the influence of the Sakyapas, while the Karmapas were predominant in Kham.) The rapidity of the Gelukpa rise can be seen in the fact that within four decades of the foundation of Ganden, they had won important footholds by establishing the Chamdo monastery between 1436 and 1444 in Kham and the Tashilumpo monastery in Tsang in 1447. Until the country's loss of independence to the People's Republic of China, the Gelukpas were the most important religious order in Tibet.

In the following century the institution of the Dalai Lama was created. From that time until 1956, when the present incumbent fled the country—he now lives in exile in India—the Dalai Lama was the figure in whom all temporal and spiritual authority over the country was invested. The first to receive the title (*Ta le,* or "ocean," in Tibetan) was a Gelukpa abbot, Sonam Gyatso (1543–1588), from the Drepung monastery; it was bestowed upon him by the Mongol ruler Altan Khan.

Assessing post-eleventh-century Tibetan history, Giuseppe Tucci has written that the "great religious communities arose out of a symbiosis of sacred and secular power."[12] This symbiosis had certain predictable results. Nineteenth-century British historian Lord Acton's famous dictum, "Power corrupts, and absolute power corrupts absolutely," fittingly characterizes the story of the monasteries in this time, despite the zealousness and genuine commitment of some reformers and despite the saintliness and wisdom of some monks. In this regard, the following passage from the *Gesar,* the most popular Tibetan epic, though written in a sarcastic vein, is highly illuminating:

> The lama, the godlike, is learned in sermons; possessions are impermanent, bubbles on the water's surface, says he; life is impermanent, a play of lightning, says he. But his acts are different from his words. Is he pleased? That depends on the amount of the offerings. Does he find fault with someone? That depends on whether they are handsome or ugly. Wealth, he considers, is for his control. His hand clasps it in the knot of avarice.[13]

Other literary sources tend to confirm such monastic excesses. In his biography, the sixteenth-century Drukpa saint Künlek is quoted as remarking, after a visit to Druk:

> I have visited the monasteries of Druk. In those in Upper Druk there were internal quarrels about landed property.... As for me, the yogin, I refrain: I should be afraid of stirring up strife between cousin brothers...[14]

Künlek was one of a type of yogi, often considered the "mad" or inspired type, who were especially revered by rural Tibetans and who contributed immensely toward popularizing Buddhism in the countryside; the monasteries concentrated their efforts in the urban centers. These mystics, many of whom came to be regarded as saints, were mostly wandering poets who communicated their simple messages through songs and through personal example. They owned no personal property, re-jected all material comforts, and laid greater emphasis on love and compassion than on performing rites and rituals. Indeed, these singing yogis of Tibet continued a tradition that had prevailed in India from very ancient times. Known as mahasiddhas in India, they were totally emancipated beings who were not concerned with either formal religions or with social norms. Since they played an important role in Tibetan art, more will be said about the mahasiddhas in a later chapter. The phenomenal success of such simple but inspired mystics in Tibet may in a large measure have been due to the ordinary Tibetan's disenchantment with the excesses and avarice of orga-nized religion. The singing saints, on the other hand, made no demands, and often were both amusing and easy to follow.

The most famous of these saints lived in the eleventh century. One was Dampa Sangye (d. 1117), who was an Indian mystic though he lived most of his life in Dingri near the border with Nepal. He did not sing but was a folk hero all the same. He organized no order or sect, but had a large number of followers who spread his doctrine and teachings in many different parts of the country. He mingled with the people, mystified and awed them by performing mystical rites (*see* introduction, Ritual Objects), and helped them directly in their search for salvation.

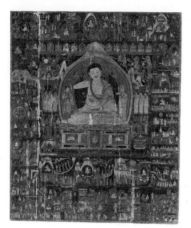

P14

Another such saint was Marpa (1012–1096), who was a remarkable personality. Although he did not belong to any organized religion, he is regarded as the founder of the Kagyupa order. Like many others, he did not live like yogis but was a married householder. Highly neurotic, he was a man of violent temper and difficult to approach, as is clear from passages in the biography of his most famous disciple, Milarepa (1040–1123). Marpa is best remembered, however, for introducing "a new kind of Tibetan poetry, often religious and didactic on the Indian model, but also expressive of their personal feelings and observations."[15] His successors in the Kagyupa order continued to preach through poetry, which appealed greatly to the masses precisely because the poems expressed personal feelings and observations.

The greatest of Tibet's mystics and singing poets was Milarepa. The collection contains a splendid painting representing the mystical life of this extraordinary figure (P14). Unlike his guru, Marpa, Milarepa was a strict ascetic who truly renounced the mundane world. Although a mixture of fantasy and history, his biography, which is available in an English translation, makes fascinating reading, as does his poetry. Because of their sincerity, poignancy, and simple elegance, his poems and songs have remained extremely popular among all classes of Tibetans. How direct and effective his instruction was may best be gauged from the following verse:

> Hearken, my sons! If you want
> To climb the mountain peak
> To enjoy the view,
> You should hold the Self-mind's light,
> Tie {it} with a great "Knot,"
> And catch it with a firm "Hook."
> If you practice thus
> You can climb the mountain peak
> To enjoy the view.[16]

Apart from the mystics, monks, and monarchs of Tibet, there were other kings and emperors—all of them foreigners, either Mongol or Chinese—who made significant contributions to the religious and political history of the country. A brief knowledge of both the Mongol and the Chinese connections is essential in order to appreciate the extent to which Chinese art contributed toward the formation of the Tibetan aesthetic.

During the Yarlung dynasty period, in spite of that ruling group's occasional raids into Nepal and northern India, Tibet was preoccupied with fighting the Tang in Chinese Turkestan, no doubt in an effort to capture the lucrative trade along the Silk Route. The Tibetans occupied Dunhuang and other Central Asian sites from about 670 to 822, cutting off trade between China and Western Asia. On one occasion they sacked the then Chinese capital of Xian (Ch'ang-an). It is, therefore, both ironic and amusing to read that when a Tibetan envoy asked for some Chinese classics, a court minister recommended to the emperor that the request be denied on the grounds that the Tibetans, who "were steadfast in purpose, intelligent and industrious, intent on learning undistractedly"[17] would gain too much knowledge about arms and warfare.

Although little information is available about the extent of Chinese influence on Tibetan religious or cultural life during this period, we can assume that it was not inconsiderable. Apart from the fact that the prolonged presence of the Tibetans in Chinese Turkestan must have exposed them to the strong influences of Chinese culture, several of the Tibetan monarchs married Chinese princesses. The religious debate at Samye, already mentioned, indicates that the influence of Chinese Buddhism at the time was significant. There was some impact by Chinese architecture as well, as

is evident from the tradition that one of the floors of the Samye monastery was decorated in the Chinese manner. Among the lasting contributions of Chinese civilization to Tibet during the period of the Yarlung dynasty were paper and ink, silks and tea. And, although due to Songtsen Gampo's influence some sons of the nobility were given a Chinese education, by and large, from the ninth century, "Chinese studies were never fostered in Tibet, and the Tibetans have remained to this day as ignorant of Chinese literature and philosophy as of Chinese historical records."[18] While this contention may be true, less acceptable is the statement that "Chinese cultural influence in Tibet has been so slight compared with what it might have been, and is virtually limited to a few artifacts."[19] This is certainly not borne out by the evidence of the visual arts.

Little is known of Tibet's political relations with the various Chinese dynasties between the fall of the Tang in 906 and the rise of the Yuan in the thirteenth century. There was no central authority in Tibet, and, as we have seen, the Tibetans appear to have been preoccupied with their own internal affairs. The Chinese, too, had become rather introspective and chauvinistic under the Song dynasty (960–1279), after the glorious and cosmopolitan age of the Tang, and showed little interest in Tibetan affairs. Buddhism no longer enjoyed the same status in China as it had during the Tang dynasty. However, it continued to flourish in the north under the Khitan Liao (907–1125) and the Jurchen Jin (1115–1234) dynasties, both of which maintained religious ties with Tibet.

More important was the close connection between Tibet and the Xixia kingdom, which dominated the Kokonor and parts of northwest China, including Gansu. Consisting of a mixed population of Tibetans, Turko-Mongols, Sumpas, Chiangs, and Chinese, Xixia was highly Tibetanized culturally. Both the Drigungpas and the Tshelpas were influential in the Xixia kingdom, and because of such associations, a strongly Tibetan style of painting prevailed at this time in Dunhuang and Kharakhoto. The Russian historical expedition of 1908–09 discovered a large number of paintings and illustrated Buddhist texts at Kharakhoto that definitely indicate the presence of Tibetan artists in Xixia.

The Xixia kingdom was devastated by Genghis Khan (1162–1227), the Mongol emperor, but Tibet was spared as it readily submitted to the Mongols. After Genghis' death, Tibet became the heritage of the conqueror's second son, Godan. It was at Godan's invitation that the abbot of the Sakya monastery, along with his nephew, went to the Mongol court and was made the regent of Tibet. After the uncle's death the nephew, Phakpa (1235–1280), became a friend of Kublai Khan (1216–1294), the founder of the Mongol dynasty, who was now the emperor of China. Kublai invested Phakpa with the title of *Ti shih* which made the Sakya abbot the virtual ruler of Tibet. From this time, as Snellgrove and Richardson have written, "dates that peculiar relationship between Tibet and China, known as *Yon-mchod,* 'Patron and Priest,' by which the ruler of Tibet in the person of the predominant grand lama was regarded as the religious adviser and priest of the Emperor, who in return acted as patron and protector."[20]

The close relationship between the Mongol emperors and the Tibetan lamas had significant political effects in Tibet, but more important for us are the cultural exhanges which were mutually beneficial. The Mongol emperors were generous in presenting the Sakyapas with lavish gifts, both in cash and kind. There were constant exchanges of images and other religious objects between the monks and the monarchs. While it is more difficult to find Chinese statues and paintings of this period in Tibetan monasteries, there is much more evidence, both artistic and literary, to indicate the strong influence exerted by the Tibetans on Chinese Buddhist art. Tibetan

colors and gilding are frequently mentioned in Chinese texts, and several monuments survive northwest of Beijing and in Hangzhou in southeast China that were designed by Tibetan monks and were very likely built and carved by both Tibetan and Chinese artists.[21] It is especially significant that Tibetan influence is perceptible in Feilai Feng, the ancient capital of the Southern Song. For as we shall see in the introduction to the paintings portion of the catalogue, the arhat paintings of the Southern Song period may have provided some of the models for Tibetan paintings of the same theme.

Mongol rule in China ended in 1368 with the establishment of the native Chinese Ming dynasty (1368–1644), which was subsequently overthrown by the Manchus, who established the Qing (Ch'ing) dynasty (1644–1912). Nevertheless, emperors of both dynasties continued to patronize Tibetan lamas, though the Sakyapa hegemony had ended with the fall of the Mongols. Unlike the Mongols, the Ming emperors supported various Tibetan religious orders, especially the Karmapas and the Gelukpas. But like the Mongols, they too were generous in sending gifts to the Tibetan monasteries, and Chinese art exerted the strongest influence on the art of Tibet during this period.

The Karmapa Dehzin Shegpa (1384–1415), the head of his order, had the same kind of priest and patron relationship with the Ming emperor Yongle as the Mongol emperors had had with the Sakyapa monks. On a visit to Nanjing in 1406, the Karmapa was lodged in the palace and among other presents received one hundred ounces of gold, 1000 of silver and silks. Since such gifts were bestowed frequently, one can well imagine how the resources of the monasteries swelled as a result of their close association with the Chinese emperors. Statues and paintings were exchanged, too. As Heather Karmay has pointed out, between 1406 and 1417 images were sent from Tibet to China at least seven times, while between 1408 and 1419 Chinese images were taken to Tibet at least six times.

Even more interesting was the exchange of gifts between Tsongkhapa and the Chinese emperor, recorded in a letter of 1408, in which the monk declined the emperor's invitation to visit China. Chinese silks and ritual objects figure prominently among the gifts sent by the emperor. Among the silks were three rolls that were unpatterned, two that had fine flower and cloud patterns, seven rolls of natural colors, and "silk for thangka curtains."[22] These are the silks that the Tibetans used to mount their thankas and to provide curtains or coverings for them. The tradition may have been older, but certainly it may be dated from the early fifteenth century. Among the ritual objects were one crystal rosary, one set of bell and thunderbolt, two porcelain bowls, two altar cloths, and three aprons with mandala designs. Indeed, the magnificent set of ritual weapons of crystal and gilt metal in the collection (R9) may well have been sent by a Chinese emperor to a grand lama in Tibet. Among the objects sent as presents by Tsongkhapa were several gilt-bronze images, relics of both Buddha and Atisa, and a statue of Avalokitesvara which was brought from Li-yul, generally identified with Khotan in Central Asia. Because of this we know that Khotanese bronzes were familiar in Tibet, but none has been identified so far. Such exchanges of artworks aside—objects which must have served as models in both countries—it is also well known that artists were invited from China to paint murals at Shalu and Gyantse.

Although the Mongol dynasty in China fell in 1368, the Mongols were still, in the fifteenth century, a strong presence in that part of Asia known today as Inner and Outer Mongolia. Both the Ming and Qing emperors realized the political advantage of patronizing and humoring the lamas of Tibet, for this was the easiest way to keep both the Mongols and the Tibetans, as well as their cousins in Yunnan and Sichuan,

under imperial control. Thinking also that Tibetan Buddhism might have a salutary effect in containing the aggression and militancy of the Mongols, the Chinese emperors encouraged the lamas to associate closely with the Mongols. This association resulted in a momentous meeting in 1578 between Sonam Gyatso, the head of the Gelukpas, and Altan Khan, the chief of the Tumed branch of the Mongols. As noted, it was Altan Khan who bestowed the title of *Ta le* on Sonam Gyatso, thus originating the institution of the Dalai Lama. When Sonam Gyatso died in 1588, the Gelukpas were smart enough to declare the grandson of Altan Khan as the next emanation and Dalai Lama, which further cemented the bond between the Mongols and the Gelukpas. This relationship was strengthened further still when the Fifth Dalai Lama (1617–1679) became the preceptor of Gushri Khan.

Known as the "Great Fifth," the Fifth Dalai Lama was the man who first combined both spiritual and temporal authority in the office of the Dalai Lama. An able administrator, he also ushered in an age of grandeur for the Gelukpas, symbolized best by his erecting of the majestic Potala, the palace of the Dalai Lamas which overlooks Lhasa with such commanding presence. He visited China, but also revived the glories of Tibet's past by receiving visits from some of her southern neighbors. Unfortunately, his successor was a libertine and a romantic poet, and was unfit to be either a spiritual or a temporal leader. The Mongols interfered once again, but now the Chinese were intent upon counterbalancing the growing Mongol influence. So the emperor Kangxi took matters into his own hands, sending imperial representatives to Lhasa in 1721. Thus the monarch, even though a foreigner, finally triumphed over the monk in Tibet.

◆

Tradition claims that the great monastery of Samye was built in the eighth century on the model of Odantapuri in India, but each of its three floors was designed according to Indian, Nepali, and Chinese modes. This amalgamation symbolizes the fact that these three countries were the ones principally responsible for the molding of Tibet's religious life and her arts. The impact of India and Nepal was felt primarily through their monks, artists, and their artistic creations. Indian influence was strongest between the seventh and the thirteenth century—during which time Buddhism disintegrated as a religious force in India—and it stemmed mostly from Kashmir and eastern India. The Newars of Nepal were, beginning in the seventh century, another constant presence, and contributed greatly to Tibet's trade and to her arts.[23] But no monarchs, from either India or Nepal, played any role in Tibet's history.

The only strong and unifying secular authority in Tibet's history was the Yarlung dynasty, which introduced and ardently supported Buddhism. With the fall of the dynasty in the ninth century, however, the religion suffered a setback, and it was not until the eleventh century that the torch was picked up, once again by a royal family, but this time, as noted, in western Tibet. With the revival of Buddhism and the foundation of the monasteries between the eleventh and the thirteenth century, the power of the monks increased continually, and there evolved what Tucci has described as a "symbiotic" relationship between the religious and secular powers in Tibet.

Although some monarchs of the Yarlung dynasty married Chinese princesses, the relationship between China and Tibet during the early period was primarily hostile; the cultural impact of China in Tibet at the time was limited. After the fall of the Tang in the ninth century and until the establishment of the Yuan in the thirteenth, very little is known of the Sino-Tibetan relationship. Thereafter, a very special kind of religious bond developed between the Tibetan lamas and the Chinese emperors. Although these religious ties were strongest under the Yuan, they did not slacken under the Ming or the Qing. A similar relationship also evolved with the Mongols

of Mongolia, starting in the sixteenth century. While this prolonged religious and political intercourse between the Tibetan monks and the monarchs of China and Mongolia proved in the long run to be unhealthy for Tibet's freedom, it did have beneficial consequences for the history of Tibetan art.

The Way and the Goal

Master, pupil, instruction, these three,
Effort, fortitude, faith, these three,
Wisdom, Compassion, Absolute, these three,
All these are constant knowers of the way.
 Milarepa[24]

Here there is no beginning,
 no middle, no end,
Neither samsara nor nirvana.
In this state of highest bliss
There is neither self nor other.
 Saraha[25]

These two songs by Milarepa (**P14**, S40), the greatest of Tibet's singing yogis, and by Saraha, a celebrated Buddhist teacher who lived in India sometime in the seventh or eighth century, describe with brevity and lucidity the way and the goal of Vajrayana Buddhism. It was this form of Buddhism, also known as Tantrayana, that was introduced into Tibet from India in the seventh century. Although Vajrayana is also practiced in Nepal, Japan, China, and Korea, nowhere has it flourished with such zeal and mystique as in Tibet. The word *yana* means path, way, or vehicle; *vajra* means thunderbolt (R4) or diamond; and *tantra* is a blanket term for a wide body of religious traditions, both Hindu and Buddhist, that includes many esoteric rituals and cults. *Vajra,* connoting diamond, was chosen as the name of the tantric Buddhist tradition because of the diamond's indestructibility as well as because of its physical ability to cut through all substances. Systematized in India around the fifth century A.D., Vajrayana constitutes the last major stage in the development of Buddhism, which originated in the sixth century B.C. with Sakyamuni, the Enlightened One or the Buddha.

Early Buddhism stressed that the goal of each individual was to seek freedom from the chain of rebirth and thus from all suffering and death. The word used to describe this goal was nirvana. Although there were many different philosophical schools, the religion centered around the institution of the monastery, with its ordained monks and a lay congregation that supported the monastery. No image was used, rituals were simple and minimal, and meditation and introspection were encouraged. Each individual sought his own nirvana, which, however, was easier for a monk to achieve than for a layman. Sometime around the birth of Christ there was a profound doctrinal change; some dissenters, asserting that it was "selfish" for an individual to seek his own nirvana, created the revolutionary concept of the bodhisattva (the being of enlightenment), which formed the basis of Buddhist "theism" and consequently of its "pantheon." The function of the bodhisattva was to postpone his own final leap into nirvana and "to remain in the Round as long as a single blade of grass shall remain undelivered from suffering.[26] This form of Buddhism came to be known as Mahayana (the Great Way), or Bodhisattvayana. It is necessary to discuss Mahayana briefly, as it formed the basis for the later development of Vajrayana.

While the goal of Mahayana remained the same, the method of attaining it was altered. From a communal religion that was largely moralistic, intellectual, and contemplative, Buddhism changed through Mahayana into an individualistic, faith-oriented system in which, in addition to meditative practices, devotion to a bodhisattva—and, by extension, to a deity—was regarded as an equally valid way to reach nirvana. The goal was now characterized as the state of *sunyata,* which is translated variously as void, emptiness, nonduality, or nothingness. It still involved

freedom from the chain of rebirth, but was more accessible to the layman because faith, rather than intellect, was stressed. Mahayana broadened the base of Buddhism further by introducing the concept of *dharani* (literally, support), which involved the belief in the efficacy of charms and mantras (syllable incantations) against various misfortunes. One of the most popular and early *dharanis* was Mahamayuri, which was seen as both a prophylactic against and a cure for snakebite—as common, but far deadlier, for the traveler in those days than a flat tire on the highway is today. A religion that had been cerebral, rationalistic, and agnostic, Buddhism became, with Mahayana, emotional, devotional, and to some extent, theistic.

Vajrayana Buddhism accepts all assumptions of Mahayana but expands and elaborates them further, adding a few of its own. The goal now is characterized as *bodhicitta* (the mind of enlightenment), but the concept of bodhisattva is given even greater emphasis. Every sentient being is a potential Buddha, but he or she is unaware of it because of the dense fog of ignorance that clouds the mind. This fog is said to be discursive thought, which discriminates and polarizes all concepts. Once it is removed, *bodhicitta* will emerge like a clear light. This state of reality is achieved by combining *prajna* (knowledge, wisdom, or insight) with *upaya* (means or fitness of action, which is the same as *karuna,* or compassion). Thus, both literally and figuratively, Vajrayana is the belief in the twin principles of insight and compassion and in their coemergence *(sahaja),* which leads one to the state of *mahasukha* (great bliss), nothingness, or Clear Light.

Going one step further, Vajrayana asserts that a person can become a complete Buddha in a single existence by following the direct path. In a brilliant essay, Marco Pallis compares the passage along the path to climbing a mountain.[27] There are those, Pallis writes, who follow the gradual and winding way with a modest incline; others take the steeper and much more arduous shortcut. The easier way is for the ordinary man, who performs his daily rituals routinely, worships his family deity, circumambulates the *chöten* (R1), turns the invocation wheel as he mutters his mantra, and adds another stone to the pile as he safely negotiates a pass. The shorter and more direct path is for lamas, mystics, and saints, whose concentration on the goal is so unwavering that no obstacle can deter their arrival. Pallis very appropriately compares the Vajrayana shortcut to the Christian symbol of the "narrow way" leading into the Kingdom of Heaven. The bodhisattvas, arhats, mahasiddhas, and other eminent religious persons, such as Padmasambhava (S37), Atisa, Dampa Sangye (S31), and Tsongkhapa, are examples of those who successfully followed the shortcut.

A glance at the illustrations in this catalogue will make it clear that images of divinities are a crucial element of Tibetan art. Although the texts frequently tell us that "Of the different gods and goddesses generated by him and his family, neither the gods nor goddesses exist,"[28] in point of fact, for the ordinary believer they do exist and must be propitiated. On a more metaphysical level, the divine images are simply symbols of the body of the Buddha, just as the mantras are symbols of his speech and the *chöten* and the *vajra* are symbols of his mind. They are not themselves real but help to define reality, and are dispensed with by the enlightened mind and by the true yogi.

Yoga is common to both Hinduism and Buddhism but has a slightly different connotation in the two religions. Older than Buddha Sakyamuni himself, yoga is a spiritual system emphasizing rigorous physical and mental discipline that is practiced in order to attain knowledge of the self *(atma)* and to achieve union *(yoga)* of the self with Universal Consciousness. Buddhism, however, stresses that the idea of the self itself is a false notion, to obliterate which yoga is necessary. Just as the

Hindu yogi believes his body to be a microcosm of the universe, the Buddhist regards his body to be a mandala, a microcosmic diagram of the macrocosm. The word mandala means that which contains (*la* being container) the *manda* or the essence, which of course is perfectly consistent with the other Vajrayana idea that every individual has the potentiality of Buddhahood within him. The body is considered to have three vertical channels within it, the central being the vertebrae column, called the *meru-danda* in Sanskrit. The mythical Mount Meru is the *axis mundi* in Indian cosmology, and *danda* means staff. Hence, by calling the vertebrae the *meru*-staff, the body is clearly regarded as a microcosm. As we will see in the next section, such ideas contributed profoundly to the formulation of Buddhist images.

Buddhist tantras are divided into four categories: *kriya* (action), *carya* (performance and praxis), yoga, and *anuttara yoga* (that which is beyond yoga, or the highest yoga). Tsongkhapa refers to these as the four doors of entry to the *Vajrayana* and, quoting the *Vajrapanjara*, tells us who should follow which tantra.[29] Thus, the action tantra is for the inferior; performance or praxis tantra is for those above them; yoga is for superior persons; and the highest yoga is for the truly enlightened. Some tantras use the more graphic and picturesque metaphor of the sexual act to describe the four states.

> *The four aspects of laughing, looking*
> *Holding hands and the two embracing,*
> *Reside as the four tantras*
> *In the manner of insects.*[30]

Commenting on this verse from the *Samputa Tantra,* Tsongkhapa wrote, "The sets of tantras are also called tantras of looking [Action], laughing [Performance], holding hands or embracing [Yoga], and union of the two [Highest Yoga]."[31]

It is at the first two stages that images and mandalas are needed as "supports" for the practice of spiritual discipline. At the third stage all external acts and symbols are suspended altogether and the adept assimilates and realizes the truth through internal yoga only. Even internal yoga is not necessary in the final stage of the pilgrim's progress. In any event, what is clear is that Vajrayana is a very pragmatic form of religion in which everyone has an opportunity to see the Clear Light by slowly removing the fog of ignorance in four distinct stages. It is also during the first two stages that one needs the guru, who acts as guide throughout the spiritual journey. While in early Buddhism one followed the path alone, in Vajrayana one cannot do so without a guru.

In theory, the Tibetan tradition remained extraordinarily faithful to the religion as it was imported from India. Indian texts, both religious and non-religious, were assiduously translated and copious commentaries were compiled and systematized in the *Tanjur* and the *Kanjur.* A glance at any of these commentaries, such as those by Tsongkhapa or his disciple Khedubje (1385–1438), will demonstrate how faithful Tibetans were to the Indian masters and commentators. However, it would be wrong to assume that they did not add to or modify the imported tradition according to their own perceptions and needs, although perhaps they did less of this than Buddhists in other countries. Among Tibetan Buddhism's significant departures from Indian traditions, of course, was the overpowering role played by the monasteries in Tibetan life. As we have also noted, the concept of guru, which originated in India and was transplanted into Tibet, became influenced by the sense of hierarchy that is fundamental to Tibetan social morphology, and, in the institution of the lama, achieved an unprecedented preeminence. The emphasis on lineage, as

well as on emanation in the form of the *tulku*, is likewise characteristically Tibetan, though these concepts are not unknown in India.

A *tulku* is generally regarded as a "reincarnated lama" or "a living Buddha." It is believed that when an enlightened teacher or religious personage passes away, he is reborn in another body. The Dalai Lama is perhaps the best-known example of a *tulku*. When a Dalai Lama dies, a special search is conducted to find his successor; invariably, he is a young boy but is said to be the dead Dalai Lama's reincarnation. Inasmuch as Buddhism does not believe in the existence of the soul, there is an inherent contradiction in the use of the words reincarnation or rebirth; that is why the expression "emanation" is perhaps more suitable.[32] In any event, because of the particular emphasis given to the concept of *tulku*, especially after the sixteenth century, every important religious figure in every monastery traced his lineage through spiritual forebears, to mahasiddhas, and ultimately to various divinities. Thus, the Dalai Lama is an emanation not only of various earlier saints or teachers but also of Bodhisattva Avalokitesvara.

Very little is known of the religious traditions and practices of pre-Buddhist Tibet. Some have survived in the religion known as Bon, which now flourishes mostly in the eastern province of Kham and the Dolpo region of Nepal. Bon was systematized only after Buddhism became an established religion and is heavily colored by Buddhist ideas. Nevertheless, one can sort out elements in Tibetan Buddhism, both in practice and theory, that are of pre-Buddhist origin. Certainly the very elaborate practices of the Kagyupa cult of Tara, described at length by Beyer, has many ritualistic features that are unknown in India.[33] And, in fact, Indian tradition claims that some of the forms and rituals of Tara were introduced from Tibet. The form of sonorous chanting, for example, and the use of a certain type of musical instrument, so familiar in Tibetan monasteries, are also characteristically Tibetan. The distinctive ritual implement known as the *phurpa* may be a combination of the Indian *vajra* with a shaman's peg. There are many other aspects of the Tibetan ritual with a distinct local flavor (*see* Ritual Objects). If nothing else, the colorful monastic habit, including the variety of hats that distinguished different orders and liturgical functions, is clearly of local origin. Other notable differences and innovations are apparent in the iconography, and are discussed in the next section.

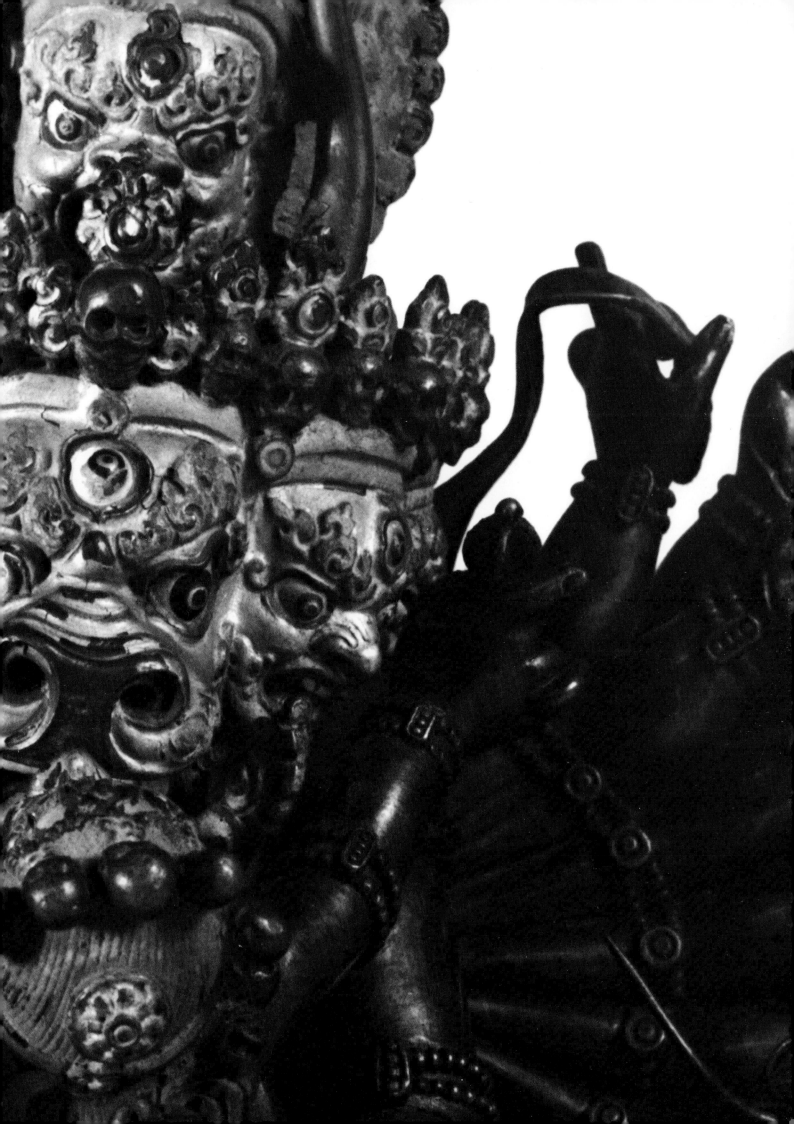

Images and Symbols

The Tibetan Buddhist pantheon is infinitely varied and complex. In addition to the myriad deities imported from India, countless other local creations have swelled the pantheon to a bewildering mass that defies any attempt at classification. The Vajrayana deities from India are usually divided into five basic families, each headed by a tathagata (a synonym for a Buddha). These five tathagatas—Amitabha, Akshobhya, Ratnasambhava, Amoghasiddhi, and Vairocana—symbolize the four cardinal directions plus the center, and are emanations of the supreme Buddha essence. Most Vajrayana deities belong to these five families, a fact often indicated by the placing of the titular head of the family on the crown or headdress of a lesser divinity. Thus, Amitabha will be shown on the head of Avalokitesvara (S13), thereby demonstrating the lineage. Each of the five tathagatas is portrayed exactly like Sakyamuni but includes his own distinguishing emblems. Both historical and transcendental Buddhas are generally represented as idealized, but essentially human, monks with supranormal characteristics, such as a cranial bump, elongated earlobes, or an auspicious *urna* (dot) in the middle of the forehead. The deities belonging to these families, however, have multiple limbs and heads and may appear either as male or female, and benign or angry.

Individual deities are identified in this catalogue's entries, but it must be remembered that the interrelationships among them are extremely complex. In a sense they may all be identified with one another and share each others' attributes and have the same functions, since they are all part of the Buddha essence. Firstly, all divinities and Buddhas symbolize the cosmic principle or consciousness and the addition of multiple limbs to their human-form images signifies their universality. The heads and arms are multiplied not because the deities need them to look on all sides or destroy all demons at once—they are, after all, omniscient and omnipotent—but because such multiplication was a convenient conceptual formula for materializing the pervasiveness of the deity. This was an ancient tradition in India, where it was common to both Hinduism and Buddhism.[35]

Yoga is the second principle playing an important role in both the Buddhist and Hindu iconographies. It is preeminent in the iconographic tradition as well as in the religious traditions. The posture of meditation which is the most common attribute of all divinities, monks, arhats, and mahasiddhas is derived from yoga. Many of the deities with matted hair are modeled after yogis, although they may also be bejeweled and diademed. This may seem contradictory, but it must be remembered that bodhisattvas are not attached to the phenomenal world and that ornaments merely symbolize their universal sovereignty, which is spiritual, not mundane. (Christianity is similar in that it, too, emphasizes the spiritual kingship of Christ, and in that the Pope is often referred to as the Prince of the Church.) In tantric Buddhism, as Tsongkhapa pointed out, the deities of "the vajra element are explained as having

features that accord with kings and their retinue,"[36] features that are necessary for trainees of Yogatantra. The *mudra*, or gestures, that the figures make with their hands also derive from yogic ritual, as well as from the dancer's repertoire. The bulging and staring eyes, often given to saints and monks (S31, S34), symbolize the fervor or energy intrinsic to the yogi.

All Buddhist deities are symbols either of insight or of compassion which together lead to *bodhicitta* and are, therefore, like the proton and neutron that constitute an atom. Thus, the goddess Tara, as a manifestation of Prajnaparamita, embodies *prajna*, or insight, and at the same time is the savior who protects her devotees from all natural and supernatural perils. Similarly, Vajrabhairava (**P12, S28**)—the terrifying emanation of Manjusri, the embodiment of insight—is really a symbol of compassion, no matter how awesome and hair-raising his external form. Since he is the protector of the faithful, how can he not be compassionate? It must be emphasized that although these terrifying deities of Buddhism may appear demonic, they are not "demons" in the Western sense. Nor are they personifications of evil or demonic forces. Rather, their fierce forms symbolize the violence that is a fundamental reality of the cosmos and the cosmic process in the universe in general, and of the human mind in particular. The purpose of all gods is to destroy the passions of the mind and to eradicate the supreme form of ignorance inherent in the concept of ego, a function that the angry deities perform, too. They also symbolize the universal force or power conceived as the cosmic devourer in both Hindu and Buddhist mythology. Science now states that the cosmos was born in violence; perhaps the ancient visionaries realized this universal truth when they envisioned the divine principle in terms of a *mysterium tremendum*.

Notwithstanding the fact that the Buddha essence is nonpolar, Buddhist iconographers use sexual polarity to symbolize the twin concepts of insight and compassion. All goddesses are symbols of insight and the gods represent compassion. The union of compassion and insight symbolizes the nonpolarized state of *bodhicitta*, or the mind of enlightenment, which is represented visually by showing two deities engaged in sexual union. Tibetans characterize such images as *yab-yum*, which literally means father-mother; in Sanskrit the expression is *yuganaddha* (pair-united). This sexual metaphor is also used to denote the highest stage of yoga in which there is no polarity, no discrimination, and in which the truth is indivisible as is the *vajra* itself. It may be added parenthetically that while such images, whether statues or paintings, are today much sought after by collectors and boldly displayed in museums, in Tibet they were always meant to be seen only by the initiated. The rites associated with these images were also arcane and not for public consumption.

Although such representations are described in Indian Vajrayana texts, only a few examples have come to light in India. In Japan, for example, very explicit sexual imagery is avoided; and in Java, few images representing the deities in actual physical embrace have been found. In Indian images the female is generally shown seated on the lap of the god rather than in an embrace. When embracing deities were portrayed in India, the image was placed inside a metal lotus which could be opened or closed as necessary, or perhaps was painted on fabric which could be kept rolled up. Significantly, in neither India nor Nepal have stone images of any antiquity been found that depict embracing deities. Thus, although the symbol originated in India, it appears to have been employed more frequently and with greater expressiveness in the art and ritual of Tibetan Buddhism.

As needs arose, local Tibetan deities were often adopted into the Buddhist pantheon, and legitimatized either by making them manifestations of existing divinities or by incorporating them into one of the five divine lineages. All native gods

and spirits already inhabiting the local mountains, the forests, the lakes and rivers, the sky, and the underworld were adopted into the pantheon and made protectors of the Buddhist religion. Thus, while Mahakala was imported from India, many of his Tibetan manifestations are completely local and totally unknown in India. Similarly, his consort Lhamo (P10), although conceptually related to the Hindu goddess Kali/ Camunda, was probably a powerful indigenous goddess. Pehar is another example of a native (or perhaps a Mongolian) deity who was admitted into the Buddhist pantheon.

Other deities were intellectual creations, the most prominent examples being Guhyasamaja, Prajnaparamita, Hevajra, Kalacakra, and the Dharani goddesses. The first four share their names with texts that are of fundamental importance to Vajrayana Buddhism. The texts are themselves sacred, for they symbolize the "speech" of the Buddha just as the images symbolize the "body." Moreover, the seeds of such deification are contained in the texts themselves. Thus, although the *Prajnaparamita* is essentially a philosophical work, the abstract concept of *prajna,* or insight, is frequently characterized in the opus as "the mother of all the Buddhas." Inevitably, therefore, Prajnaparamita became a goddess and the Buddhist *magna mater* with whom all other goddesses, whether created intellectually or adopted locally, were promptly homologized. Similarly, a *dharani,* consisting of a mantra and a charm, was originally simply recited; but here, too, the iconic propensity of the Indians and Tibetans prevailed, and the charm became a deity.

Among the most popular figures represented in Tibetan art are the protective deities. How important the concept of protection was is made clear by Tsongkhapa's explanation of the word mantra:

> Minds arising dependent
> On a sense and an object
> Are said to be *man,*
> *Tra* means protection.[37]

Thus, mantra is that which protects the mind, and the basic function of all deities in Tibet is to provide a protection from demons that are both internal and external. Even religion itself is in need of protection, and so there are gods *(chökyong)* who protect the religion, while there are others *(yidam)* who protect the individual. The *chökyong (dharmapala* in Sanskrit) are numerous, but eight of them are considered the most important, including Mahakala, Lhamo, and Yama, the three who are prominently represented in the Museum's collection. Although some of them, especially Mahakala, were protectors of religion in India as well, this specific group of eight seems to be peculiarly Tibetan, as is evident from the inclusion of Lhamo and Begtse, who are not of Indian origin. Mahakala is unquestionably the most important dharmapala; every Tibetan monastery, no matter what the order, has a shrine devoted to this deity. Indeed, his preeminence may also be gauged by the fact that he is regarded as the protector of the tent.

The religion was in constant need of protection, which is why the great tantric master Padmasambhava was imported from India to defeat the local deities and spirits. Using his superior magic, he changed them into eternal protectors of religion in Tibet. This process is very old in the history of Buddhism, and there is even a well-known story of how the Buddha himself converted the child-devouring ogress Hariti into the protectress of both children and the monastery. Rinchen Sangpo, too, had to convert the four Dzalamati sisters, who were water sprites *(sman)* in his own village, and appoint them guardians of various temples before he could build his own shrine.[38] Thus, even in the eleventh century the old native spirits and divinities were retaining their power and influence.

The *yidam* (*ishtadevata* in Sanskrit) is a tutelary deity and may be regarded as a kind of guardian angel. Each individual, family, and monastery has a *yidam*. For instance, Atisa's *yidam* was the goddess Tara, who constantly appeared to him in dreams and visions and gave him guidance. It was Tara who persuaded him in a vision to accept the invitation to visit Tibet. The fierce god Vajrabhairava (S28) is the *yidam* of the Gelukpas, and Hevajra serves that function for the Sakyapas. *Yidams* are divine guides who help the adept to find the way and also to reach the goal, a function that is performed on earth by the aspirant's mortal guru or lama. An individual's *yidam* is usually determined by his lama and given to him at the time of initiation. For the rest of his life the individual often carries an image of his *yidam* in a *gau* (a portable shrine) (R15) or in a thanka.

Dakinis, a class of demigoddesses who play an important role in Buddhist iconography and mythology, are the female versions of the male *dakas.* In Tibetan, the word *daka (dpa' bo)* means hero or wise man and *dakini* is the female counterpart.[39] The Tibetan expression for *dakini (mkh'a 'gro ma)* literally means "sky-walking woman" and hence the common belief that a *dakini* can fly. The expression is also used, however, as a synonym for *prajna;* therefore, as the embodiment of wisdom, every goddess may be regarded as a *dakini.* Both *dakas* and *dakinis* occur frequently in Tibetan literature, though the latter predominate. In the lives of the mahasiddhas, *dakinis* play a very important role, and both mortal and celestial varieties are encountered. They usually act as spiritual guides to the mahasiddhas and in at least one thanka in the collection (P28) a *dakini* plays this role. There is also a "realm of the dakas" where all the mahasiddhas go at the end of their lives, but nothing is known about this paradise. The expression *dakini* is further used to designate the female partner in the tantric initiation, and thus she can be both human and superhuman.

P5

Perhaps the most admired and discussed symbol of Tibetan religion and art is the mandala (**P5**), a word which, like guru and yoga, has become part of the English language. Eminent psychologists, Carl Jung perhaps most conspicuously, have written extensively on the subject, as have such illustrious Tibetologists as Giuseppe Tucci. However, it is necessary to make a few brief comments here, as the collection contains several important and unusual mandalas.

A mandala serves various functions and has several meanings. The word is derived, as we have already mentioned, from *manda,* which means essence, to which the suffix *la,* meaning container, has been added. Thus, one obvious connotation of mandala is that it is a container of essence, and in that sense it is like a *chöten,* also a container of religious essence *(dharmadhatu).* As an image, a mandala may symbolize both the mind and the body of the Buddha. When the mandala is devoid of images and is filled with a mantra, it may be regarded as a symbol of the third characteristic of the Buddha—speech. It is, therefore, an all-inclusive symbol. While the mandala is primarily a support for meditation in Vajrayana praxis, it is also considered a source for more mundane benefits as well. For example, in Rinchen Sangpo's biography we read that the great translator had seven Amitayus mandalas painted "in order to avert an illness of his mother and to prolong her years."[40] This act extended his mother's life by eighteen years.

The mandala has been variously characterized as a cosmogram, as a microcosmic symbol of the universe and of the collective consciousness, and as an "inner forum" for the psychic drama of man's reintegration with the cosmos. All such symbolic interpretations are valid; the mandala remains one of the most graphic symbols ever invented to denote the order and harmony of an enlightened mind. Since the terms of reference for all concepts and symbols are essentially those of the world man lives in, the mandala is conceived pictorially as a palace. As a Buddhist text states:

> One should contemplate as below, a spot of earth made of diamond; across, a diamond enclosure; above, a tent (or a canopy); in the middle, a dreadful burning ground. . . . In the midst of that, one sees a palace with a single courtyard and made entirely of jewels—with four corners, four gates, decorated with four arches, having four altars, and radiant with nets and so on. . . .[41]

The text further states that "the palace is knowledge *(jnana)*" as well as "an edifice of consciousness."[42]

The burning ground or the flames that surround the perimeter of a mandala represent the phenomenal world, or *samsara,* which the aspirant leaves as he enters the palace and moves toward the center (the *axis mundi,* the top of the mountain, or the goal) where the reintegration takes place. Once again, however, such external supports are for the elementary stage of praxis; for the enlightened, the body itself is the sublime mandala and the drama of integration is enacted in the mind.

Even though one mandala may ultimately look different from another, the basic configuration consists of various combinations of the square and the circle. Both peaceful and angry deities may reside in a mandala. In mandalas of angry deities the outer circle, which symbolizes the phenomenal world, is divided into eight segments, each of which represents a cemetery. In esoteric Buddhist cosmology the phenomenal world is symbolized by eight cemeteries. A stock iconographic formula was used to depict these cemeteries. Invariably each consists of a presiding guardian deity and his spouse, a mahasiddha, corpses, skeletons and severed limbs, scavenging animals, trees, and a stupa, among other symbols. It may further be pointed out that these eight cemeteries also surround many of the important angry Vajrayana deities, such as Mahakala (**P11**), Vajrabhairava (**P12**), and others, even when they are not represented in mandalas.

Divinities and nature spirits, demons and mythological creatures are not the only figures populating the Tibetan pantheon. In addition to all such creations of the mind, the iconography is further enriched by the inclusion of three other categories of apotheosized mortals: the arhats, the mahasiddhas, and the lamas. In this respect, the Tibetan Buddhist pantheon is even more populous than those of India and Nepal.

The word *arhat* literally means worthy, and is a common designation in early Buddhist literature for all venerable persons, as well as being applied to those who have attained nirvana. A group of such enlightened beings was singled out and sent back to earth by the Buddha to tide things over, so to speak, until the appearance of the future Buddha, Maitreya. Thus, the arhat became a sort of bodhisattva who helped others reach their goal, and those chosen to be arhats were sent all over the world to show the way to the less fortunate. In the beginning there were very likely only four arhats, symbolizing the four directions; later the number was increased to sixteen.[43] This happened by the seventh century, when the Chinese pilgrim Xuanzang (Hsuan-tsang) transported the concept of sixteen arhats from India to China. The cult of arhats, however, does not appear to have been popular in India. Not a single Indian portrayal of a specific arhat has yet come to light; for that matter, the cult is unknown in Sri Lanka and in Buddhist countries of Southeast Asia. It was, however, extremely popular in both Central Asia and China and is an important component of Buddhism in Japan. By the Song period, the Chinese had developed one concept of eighteen arhats (known as *lohan* in China and Japan) and another, of five hundred, as well. Obviously the idea of these mortal teachers appealed strongly to the pragmatic and humanistic Chinese.

Tibetan literature makes reference to three distinct traditions of arhats: the Indian, Central Asian, and Chinese. However, Tibetans do not seem to have been influenced by the idea of five hundred *lohans;* generally in Tibetan art, groups of sixteen, seventeen, or eighteen arhats are portrayed. It may be pointed out that the two additional members (beyond the sixteen) of the Tibetan group have different names than the Chinese, though the other sixteen are the same. According to Tucci, of the two additions, Hva Shang may be the Chinese monk who was defeated at the Samye debate in the eighth century. (In Chinese *hoshang* means teacher.) Later he was represented as the potbellied, laughing Buddha of Ming China. Regarding the eighteenth arhat, who is called Dharmatala in Tibetan, Tucci may be correct in asserting that he was introduced from Central Asia. No one, however, has given a satisfactory explanation of why the number became eighteen. In fact, numbers sixteen and seventeen have not been explained cogently, either.

As Tucci has suggested, the original number four probably symbolized the four directions; and, sixteen being a multiple of four, spatial significance may be implied as well. Space, however, is usually indicated by eight or by ten, with the addition of the zenith and the nadir. It would seem more reasonable therefore to assume that the number sixteen is connected with the idea of the sixteen-spoked wheel. Since the arhats were concerned principally with preaching rather than succouring, they turned the Wheel of Law, which symbolizes the Buddha's first sermon. The number was extended by one, perhaps, to include the nave which symbolizes the center of the wheel as well as of the universe. The number eighteen may represent something quite different. It may signify the concept of the eighteen special *dharmas,* or duties, of a Buddha as enumerated in the Mahayana Buddhist text *Prajnaparamita-satasahasrika.*[44] Moreover, the *Pratimoksha (The Doctrine of Salvation)* is divided into eighteen schools and it is fitting therefore that the arhats who are temporarily in charge of salvation should be eighteen in number.

No matter where it originated—and China, including Central Asia, is the most likely source—the cult of the arhats was popular in Tibet. Shrines dedicated to arhats exist in most monasteries and, whatever their function or symbolism, they too came to be worshiped by Tibetans for health, wealth, and welfare (P46).

The cult of the mahasiddhas, unlike that of the arhats, appears to be almost exclusively Tibetan. The word *maha* signifies greatness and *siddha* denotes a perfected being. In its broader implication, a mahasiddha is a perfected being, while in the narrower sense, he or she is the possessor of certain occult powers. Both Hindu and Buddhist tantras assert that by practicing certain rites, a person can gain control *(siddhi)* over forces of nature as well as acquire special abilities, such as the ability to fly or to generate a storm. For instance, Virupa (S34) is said to have stopped the movement of the sun when he was refused a drink; Milarepa, though not one of the Indian mahasiddhas, used to bring down hailstorms at will. In addition to possessing such supernatural powers, however, a mahasiddha is also one who has seen the Clear Light.

The Tibetan tradition recognizes a group of eighty-five mahasiddhas; all of them were Indians. Many of them were historical figures, and with the exception of three, all were male. They came from all walks of life: some were royalty, others brahmins, and still others professionals. Many came from among the "untouchable" classes. Many of these mahasiddhas are also claimed by certain Saiva sects as their saints. The mahasiddhas were unconventional teachers, always yogis, and mostly homeless wandering mystics who dispensed with ordinary social norms and believed in transmitting their messages orally and often in songs and verses. Some did not believe in any form of religious ritual, while others wrote learned treatises. Naropa, another mahasiddha, was a historical person who lived in the tenth or eleventh cen-

tury and taught Marpa, the teacher of Milarepa. Although Milarepa is not considered a mahasiddha, his life, which is recorded in detail, is perhaps the best example of who or what a mahasiddha was. Another personality, also excluded from the list, but who would qualify as a mahasiddha, was Dampa Sangye; his expressive portrait in the collection (**S31**) is one of the finest representations of these perfected beings.

◆

We must finally include a few words about the lineages of monks or lamas, a subject that has frequently been mentioned in these pages. The collection contains several paintings and sculptures portraying lamas of various Tibetan orders and lineages, although images of the Sakyapas predominate. But for inscriptions, it is impossible to identify them, and the representations generally follow stereotyped formulas. The Gelukpa lamas are distinguished generally by their yellow hats, while the Karmapas wear black hats (**P25**). All other orders wear red hats, although the shapes vary according to function. Some of the monks carry attributes of their personal *yidams,* but these are of little help in determining their identity. It should be mentioned, however, that monks of one order may be included in representations of another, even though they are not recognized as belonging to the lineage.

Although beginning in the thirteenth century the monasteries carried on a prolonged struggle for political hegemony, it must be stressed that in spiritual matters the lamas were generally tolerant. The various orders may be compared to various airplanes: it was of little consequence whether one traveled in a Boeing 747 or a DC 10, as long as one reached the same goal. Obviously there were instances of individual jealousies. On one occasion, for example, an envious *geshe* (doctor of divinity) tried to poison Milarepa. On the other hand, when the Chinese emperor Yongle suggested to Karmapa Dezhin Shegpa (**P25**) that he would like to send cavalry into Tibet in order to subjugate the different sects under the Karmapa, the latter gently replied:

> One sect cannot bring order to the lives of all types of people. It is not beneficial to think of converting all sects into one. Each individual sect is especially constituted so as to accomplish a particular aspect of good activity.[45]

Likewise each deity and each lama was seen as an aspect of the ultimate reality. The artists' task, expressing that reality in various forms and media, is the subject of the following section.

The Patron and the Artist

You would think that the painters have by some wizardry conjured up living forces and driven them into their work, and that these could float out of the walls, force their way into your soul and take possession of it by a magic spell.

Giuseppe Tucci

Several of the paintings and bronzes in the Museum's collection have inscriptions (*see* Appendix) which provide information of some art historical interest. Usually the dedicatory inscription occurs at the bottom of a thanka or along the base of a bronze. Some thankas have inscriptions on the back, generally consisting of the mantras of the deity and/or the stock Buddhist formula, written in a stylized Indian script, that begins with the expression *ye dharma* and means:

> *Of all the things springing from a cause*
> *The cause has been shown by him "Thus-came"*
> *And their cessation too*
> *The Great Pilgrim has deciphered.*

Whatever the specific purpose for having an image made, each commission had three broad aims: the image is a support or aid for meditation; the act accrues merit for the donor; and the act brings merit generally to all sentient beings. Thus, a sentence such as "By its merit may all creatures attain Buddhahood" is frequently included in the inscription, which emphasizes that every donor is a potential bodhisattva.

Statues and paintings were commissioned for a number of purposes. The great twelfth-century thanka (**P1**) was made to celebrate the life-attainment ceremony and therefore is a commemorative image, although it may have been used in the ceremony itself. In dedicating the early mandala (**P5**), the donor hoped that, by seeing it as a support, the lama would attain fulfillment. The lineage thanka which has Sonam Tsemo as its central figure (P18) appears to have been consecrated as a simple act of reverence, while another (**P20**) was specifically commissioned so that the donor and his relatives might be "purged of the two sins." The beautiful bronze portrayal of Dampa Sangye (S31) was dedicated to his memory by his devout followers. Finally, the magnificent hanging (P45) given in 1940 to the Norbulinga monastery was not created for any specific purpose except, simply, to spread the doctrine and to help all creatures attain enlightenment. As is also evident from some inscriptions, artworks were commissioned both individually and collectively. The statue of Dampa Sangye and the Norbulinga hanging are examples of collective efforts; in the latter instance, the inscription states not only how the money was collected from all the monks in the monastery but also how much the object cost.

Thus, a variety of motives impelled donors to dedicate images. Some of the dedications were made for such mundane purposes as good health and prosperity. For instance, even though the fine embroidered thanka (P46) does not possess an inscription, the presence of the bats at the top and the *yakshas* bearing gems, as the catalogue entry makes clear, leaves no doubt as to the wishes of the donor. Images of the Buddha of Healing (P8) were commissioned for obvious reasons. Similarly,

it may be assumed that most representations of Amitayus must have been consecrated by those who performed the ceremonies of long life. It may likewise be assumed, as catalogue entry P39 explains, that the Newars in Nepal, when performing the *Bhimaratha* rite of longevity, commissioned the thanka of Ushnishavijaya. Some thankas (**P26**, **P28**) probably had didactic functions and were perhaps displayed during narrations of the biographies of the personages portrayed.

It is not surprising that most of the artworks were commissioned by monks or their relatives. Only one thanka in the collection seems certainly associated with royalty (**P17**); the ruler of Ladakh may have dedicated this thanka for his personal use or for use by a monastery. Since it too is a representation of Amitayus, it was very likely used during the life-attainment ceremony performed by the king. In addition to the members of nobility who supported art in the monasteries, monks from wealthy families frequently used their own resources to commission images and to undertake major restorations (**P20**). Monks were also intimately associated with works of art in other ways, including being artists themselves. They both selected the subject of the image, and often also organized the iconographic program down to the last detail. The enormous complexity of the iconography could only have been culled from books on liturgy. Moreover, the ability to both read and memorize the texts would have been beyond the capacity of an ordinary lay artist.

There is documentary evidence to prove the extensive involvement of lamas in both the building of monasteries and in the execution of works of art. The most classic instance is the lama Butön rinpoche, whose portrait is in the collection (**M4**). He was responsible for extensive building and renovation at the Shalu monastery, as well as for working out the entire iconographic program of the murals and images in some of its chapels. Indeed, his biography states that in addition to Shalu, he was responsible for outlining the plan of the temple and determining the iconographic principles for the great *kumbum* (a *chöten* with chapels) at Gyantse, although it was built after his death.[46] He once constructed a mandala that measured thirty-six cubits (forearm lengths). The length of the forearm of the donor was often the basic unit for the measurement of an image, both in India and in Tibet. Another rare biographical thanka in the collection (**P20**) not only shows the Sakyapa lama Kunga Tashi repairing the monastery and consecrating it, but it depicts him inspecting a bronze he had commissioned. The final way in which monks were associated with an image was in the ceremony of consecration, an elaborate religious ritual that could only be performed by those who were ordained. One of the Museum's thankas (**P21**) was consecrated by the abbot of the well-known Ngor monastery, and even though such facts are not recorded in every instance, it can be assumed that most images were consecrated or blessed by lamas. Sometimes a lama's handprints were added to the back of the thanka to increase its potency.

Although anonymity was the rule, the names of many artists have survived in texts (as in the chronicles of the Fifth Dalai Lama), on the walls of monasteries, and on some individual thankas or bronzes. However, it was rare for an artist to sign a work, and only one inscription in this collection contains the name of an artist. The inscription on this fourteenth-century mandala (**P5**) states that it was painted by a group of craftsmen headed by Gyalpo Palseng. He was very likely a lay artist and the master of an atelier, and although the painting is rendered in a strong Nepali style, his name indicates that he was a Tibetan. One must also assume that Butön had to have been an accomplished artist, as was the seventeenth-century polymath Taranath. Another well-known monk who was deeply interested in art was Situ Panchen (1700–1774), whose autobiography, like the chronicles of the Fifth Dalai Lama and the history of Sumpa Khenpo (1702–1775), contains fascinating art historical information. Tucci has discussed many of the references to artists that

occur in various Tibetan texts; therefore, in the present text only the information contained in the biographies of the famous Karmapas, several of whom were accomplished artists, is discussed.[47]

The great Karma Pakshi (1206–1283) was probably an artist himself, although his biography does not say so explicitly. Once, after a visit with the Mongol emperor Kublai Khan, he returned to the Tshurphu monastery, the principal seat of the Karmapas, and decided to create a large statue of Sakyamuni. Fifty-five feet tall, the cast-brass statue contained relics of Sakyamuni and his disciples. Upon completion, it appeared to tilt to one side. "Seeing this, Karma Pakshi entered into meditation, tilting his body in the same way. As he straightened up, the statue righted itself."[48] This statue subsequently fell into disrepair and was restored by Karmapa Chödrag Gyatsho (1454–1506); in referring to the event, his biographer said that it was "fashioned" by Karma Pakshi. Whether or not Karma Pakshi himself was the sculptor, the story is important as it reveals the technical skill of Tibetan craftsmen; a fifty-five foot brass statue is not easy to cast. Thus, it seems curious that when Kublai Khan requested some artists from the Sakyapas, the latter recruited them from Nepal rather than from Tibet. Of course, the Sakyapas appear to have always patronized Newari artists.

Karmapa Rölpe Dorje (1343–1383) had a disciple, the princess of Minyak, who once dreamed of an enormous thanka of Sakyamuni which was eleven arm spans wide. On learning of this dream the Karmapa drew the plan of the thanka on the ground by riding his horse in an appropriate pattern.

> Then the image was transferred to a huge piece of silk. In all it took five hundred people thirteen months to complete the *thangka,* which also represented Manjusri and Maitreya on either side of Sakyamuni. On completion the *thangka* was blessed by Rölpe Dorje. During the ceremony auspicious events occurred. Afterwards Princess Prenyodhari gave the *thangka* to her guru.[49]

Virtually the entire process of a monk's involvement with a work of art is encapsulated in this story, which, of course, is somewhat embroidered by the pious biographer.

One artist whose greatness is certain was the celebrated Karmapa Mikyö Dorje (1507–1554). As his biography states, "The eighth Karmapa also ventured into the fields of poetry, painting and sculpture, where he met with considerable success."[50] What is even more interesting is that while visiting the region of Mar Kham, he carved a self-portrait out of stone, not a popular medium for sculpture in Tibet. In any event, when the sculpture was ready, so the story goes, the Karmapa asked the statue, "Are you a good likeness of me?" "Yes, I am," replied the statue. This statue is reputed to be the one preserved in the Rumtek monastery in Sikkim. The biography further states that Mikyö Dorje also "inspired the Karma gadri movement in art through his work in this field."[51]

The names of many lay artists are preserved in the Tibetan tradition and the presence of artists from India, Nepal, Central Asia (specifically Khotan), and China in the tradition is frequent. Generally, as noted, the artist remained anonymous. Two reasons may be given to explain why most Tibetan artists, like their counterparts in India or in Europe in the Middle Ages, did not sign their works. First, every act of creation was considered to be divine; the artist was simply serving as a mortal instrument, and so his own identity was inconsequential.[52] Also, attaching one's name to a work was considered an egotistical act, and it was the duty of the artist, like all pious Buddhists, to destroy the ego. Thus, except for the Newari artists who worked in Tibet, virtually nothing is known about Tibetan artists or their

social background. Whether the profession was hereditary, which it may well have been, is also not known. What is known, from the chronicles of the Fifth Dalai Lama, is that artists were organized into guilds; so the inscription on the mandala **P5** may imply either a guild or a workshop. Since artists were the creators of objects that illuminated the way that led to the goal, it is not surprising to find them mentioned, and also praised, in a number of Tibetan chronicles.

The evidence for the presence of Kashmiri artists in Tibet, especially in the eleventh century at the height of Rinchen Sangpo's career, has already been discussed. Although no artists are known who came to Tibet from eastern India, it is interesting to note that artists from Nalanda may have visited China. Thus, their presence in Tibet is very probable. There is much evidence indicating that Chinese artists were often invited to work in Tibetan monasteries. The eastern provinces of Tibet have always been readily susceptible to Chinese influence, but even in the central region the presence of Chinese artists is attested to by artistic evidence as well as by literary tradition. Apart from Butön rinpoche, who brought artists from China, the Tshalpa abbot Gade also built a temple with the help of Chinese craftsmen.[53]

Of all foreign artists working in Tibet, the most sought after were the Newars, who were among the most ancient settlers in the Kathmandu Valley in Nepal. Newari artists were especially popular with the Sakyapas in southern Tibet, and inscriptions in the Ngor monastery relate how the founder imported artists from Nepal to paint the murals.[54] Indeed, the fifteenth-century Ngor style may well be regarded as simply an extension of the Nepalese tradition of painting. A class of Newars, resulting from intermarriage between Newars and Tibetans, was known as the Uray; this group provided many of the artists in the country, especially in such metropolitan centers as Lhasa, Shigatse, and Gyantse. The Uray Newar was "often honoured and courted by great lamas as much for his talents as a craftsman as for his sometimes not inconsiderable wealth."[55] The observation that "the influence of Newar painters in Tibet from the mid-16th century onwards seems to have been slight" is, however, unacceptable, as is evident from a look at the seventeenth-century sketchbook made by a Newar in Lhasa (fig. 1, p. 61). In any event, the Newars continued to contribute to Tibetan metalwork as late as the nineteenth century. This is made clear from the following enthusiastic comments by Father Huc, a visiting Christian missionary:

> The *Pebouns* [Newars] are the only workers in metals in Lha-sa...You find, among the *Pebouns,* artists very distinguished in metallurgy. They manufacture all sorts of vases in gold and silver for the use of lamaseries and jewelry of every description that certainly would reflect no discredit on European artists. It is they who construct for the Buddhist temples those fine roofs of gilt plates which resist all the inclemencies of the seasons and always retain a marvelous freshness and glitter. They are so skillful at this class of work that they are sent to the very interior of Tartary to decorate the great lamaseries.[56]

Although knowledge of the artists themselves is limited, it is known that they moved about a good deal. For instance, Rinchen Sangpo was responsible for building several monasteries and temples in Guge, Purang, Ladakh, and Zanskar. There is no doubt that his Kashmiri painters went with him from one place to another, for the murals in the various monasteries reflect the same Kashmiri style. Similarly, artists in the retinue of Atisa must have moved with him from western to central Tibet, and the same style, though with local variations, is clearly perceptible in thankas (**P1–P3**) and murals in an extensive area of Tibet. The style is also evident at Dunhuang and Kharakhoto, in murals produced at a time when these regions of Chinese Turkestan were under the domination of the Xixia kingdom.

More specifically, fourteenth-century artists who are mentioned on the walls of the Narthang monastery are also included in the lists of those responsible for the Shalu and Gyantse murals. A comparison of the murals in these two monuments leaves no doubt that Butön's iconographic scheme is not the only element they have in common; their styles are remarkably similar as well.

The mobility of the objects themselves must also be kept in mind. Thankas, bronzes, *tsha tsha,* and illuminated manuscripts are all easily portable. Thus, the discovery of an object in a particular monastery need not indicate that it originated there. A glance at the pictures of monastic altars published by Tucci will convince the most determined skeptic of this.[57] Indian bronzes in Tibetan monasteries even include Jain figures, while Kashmiri-style bronzes and palm leaf manuscripts are among the precious possessions of most ancient Tibetan monasteries. Rinchen Sangpo himself commissioned a bronze in Kashmir in the likeness of his father and, because it was large, had to buy a cart to convey it to his homeland.[58] Although few Chinese paintings have actually been found in Tibet, the biography of Dezhin Shegpa, whose portrait is in the collection (**P25**), states that during one of his visits to the Chinese capital, where the Karmapa performed many miracles:

> Emperor Yung Lo decided that the apparently miraculous events which he witnessed due to his devotion, should be recorded for posterity. He commissioned talented artists to represent them in paintings on large rolls of silk, one of which was kept at Tsurphu.[59]

There is plenty of evidence, as has been pointed out, of exchanges of statues and paintings between Tibetan monks and Chinese emperors. The objects brought back to Tibet must have served as models for the artists, much as their own creations were influential in synthesizing a recognizable "Lamaist" tradition of art in China. This constant exposure to new styles and forms, which Tibetan artists assimilated with remarkable self-confidence to create their own aesthetic, was one reason why the Tibetan artistic tradition remained so vital for so long.

◆

The image created by the artist was used for ritual purposes as well as for yogic contemplation, but the artistic process itself was a form of yoga and the artist, by extension, was a yogi himself. This is clear from the fact that so many erudite and spiritually inspired lamas were so deeply interested in art. It was also expected, however, that the lay artist would be a man of character and spiritual inclination. As one Buddhist text states:

> The painter must be a good man, no sluggard, not given to anger, holy, learned, who is a master of his senses, pious, and benevolent, free from avarice, such should be his character. . . . He must draw in a secluded place, he may paint when besides him another *Sadhaka* [adept] is present, but not when someone else, a lay man is there. The painting should not be shown to a stranger, nor should it be unrolled before one.[60]

This undoubtedly describes the ideal. But as the inspired works of art in this catalogue illustrate, the artistic process was as spiritual an experience for the artist as the completed image was for the donor and the beholder.

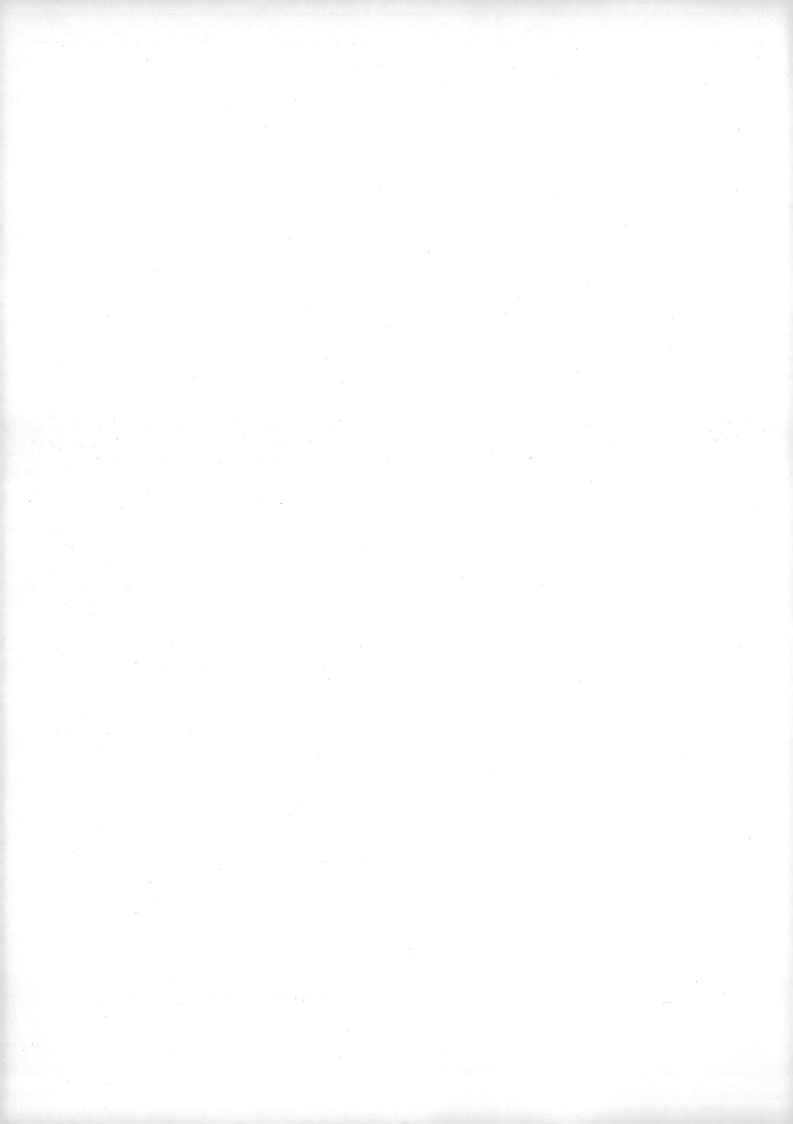

Form and Fantasy

In the space of the dharmadhatu of my mind
Are spread myriads of stars of various experiences...
In the realm of the inanimate world
Appear the stars of animate beings.
Chökyi Wangchuk[61]

Tibetan artists worked primarily within the framework of the Indian aesthetic tradition, but the influence of Chinese aesthetics was, as we have shown, not inconsiderable. It is, however, most difficult to determine the extent of the Central Asian or Khotanese influences often alluded to in Tibetan texts. It must be remembered that one cannot really speak of a Central Asian aesthetic per se, for that area was the setting for the interplay of three major artistic traditions: Indian, Iranian, and Chinese. By the time the earliest works in this catalogue were rendered, in the eleventh century, Central Asian influences had by and large been completely absorbed. That is why, except for iconographic motifs, it is extremely difficult to discern stylistic elements in these works. Only one painting in the collection (**P14**) probably retains memories of the Central Asian tradition.

The artists had to learn the very precise theories of proportion which were contained in iconographic manuals, translated from Sanskrit, which became a part of the Tibetan canonical literature. Some of these have been translated and studied. Although the size of the image may have been determined by the length of the donor's forearm, the relationships of the parts of a figure to the whole were governed by elaborate theories of proportion. Such theories and instructions were codified in Indian texts known as *silpasastra,* several of which are contained in the *Tanjur.*[62] Proportions were of fundamental importance, and if incorrect, the image was regarded as both an aesthetic and a spiritual anomaly. These texts contain precise measurements for the images of the tathagatas and divinities which had to be implicitly followed. With reference to the image of a tathagata, one such text states that the image must be well-proportioned like the banyan tree *(nyagrodhaparimandala).* "It should amount to 108 digits according to the measurements of his own finger; in no case is the digital measurement of others applicable to him."[63]

The comparison with the banyan tree is literal in that its branches are well proportioned, but the tree also symbolizes the *axis mundi* in Indian cosmological tradition and hence is an appropriate simile. Such similes are always drawn from nature, especially plant life. In this sense, the essence of nature was being transubstantiated into the divine image, even as individual similes served the immediate purpose of providing a conceptual schema for the artist. Thus, in the following passage from an iconographic manual it can easily be seen how both the shape and character of a natural object form a model for the artist. In instructing the artist how to paint eyes, the manual states:

> In the case of Yogis, their eyes, bespeaking of equanimity, should be made to resemble a bow made of bamboo. In the case of women and lovers should be made eyes that resemble the belly of a fish.... It is laid down that to express fright and crying, eyes resembling the petal of a padma (lotus) should be used. The eyes of those troubled by anger and grief should be painted resembling a cowrie shell...[64]

55

Needless to say, some of these instructions must have been difficult for a Tibetan artist to follow, for he was neither familiar with a banyan tree nor always with the lotus. Indeed, a glance at the paintings will demonstrate how conceptual and varied are the representations of the lotus. Nevertheless, with some modifications and adjustments, the shapes of the eyes do follow the various instructions.

Apart from such technical treatises, the artist worked from both verbal and visual models. Verbal models were the descriptive invocations of a deity, known in Sanskrit as a *dhyana* or *sadhana*. These *dhyanas* are remarkably precise and detailed, as can be gleaned from the following example invoking a particular form of Mahakala (**P10**, **P11**, **S27**):

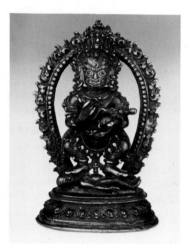

P10

S27

> To the south of Bodhgaya is situated the great cemetery *bSil ba'i tshal.* At this supreme place, one can hear the mighty voices of the *gshin rje,* the magically powerful howling of the *ma mo,* the splashing of the sea of blood, the sputtering of the lamps fed with human fat, there is visible the coiling smoke rising from the evil burnt offering, there sounds the thudding of the male *bdud* who are dancing a drum dance, the blaring of the thigh bone trumpets, the roar of wild animals; there is visible the quick flaring zip of the great scorching lightnings, is audible the fierce rolling of thunder and the crashing of great yellow meteors, the horrible laughter of the multitude of *bdud* and *yakṣas* causes the earth-foundations to quake. At such a supreme place resides he, who has one face and two hands and possesses a terrifying body. His mouth is open and he clicks his tongue. His three eyes blaze like the fire at the end of a *kalpa.* He is of a violently desirous nature, his body radiates and his limbs are strong. He roars like a dragon the horrible syllable *hum.* The colour of his body is a brilliant sky-blue, like the hue of the world-mountain *Sumeru.* In his right hand he holds the chopper with which he cuts out the hearts of enemies—and he drinks blood from a skull-cup, which he holds with his left hand. The trampling of his feet causes the three realms to quake and in the countless worlds he reduces all kinds of evil powers to dust.[65]

Parts of another equally expressive and bizarre *dhyana* evoking the goddess Lhamo are quoted elsewhere in this catalogue (**P34**).

These two examples make it clear that the verbal models were not only highly imaginative and meticulously detailed, but were often far more fantastic than anything the artist ever produced. Certainly the gruesome description of the cemetery in the above *dhyana* is far more vivid than the painted versions (**P11**, **P21**). Those evocations which describe specifically Indian deities were obviously composed by Indian mystics and theologians, whereas those which describe Tibetan divinities were no doubt the creations of Tibetan lamas and saints. Nonetheless, all of them followed Indian models. Such graphic and elaborate evocations, together with instructions given in the iconographic manuals, formed the basic conceptual schema for the artist.

Even in terms of colors he had no freedom to deviate from the prescribed instructions except to vary the shades and treatment of the accessories, such as the throne, the lotus, the ornaments, or the garments. A quick glance at the paintings, however, will reveal how diversely some of these elements, especially the lotus seat and the attire, are depicted; obviously the creative urge of the artist found expression in such details. Styles, too, differed in fundamental, ostensible ways, notwithstanding the rigid, rigorous stylistic and aesthetic framework within which the artist had to work. No one need be told, for example, that the style of the eleventh-century manuscript illumination (**M1**) is radically different from that of the Pala-Tibetan-style thankas (**P1**–**P3**); or that the Guge thankas of the fifteenth century

(P6–P8) have very little in common with the contemporary Ngor style (P10, P12). These profound differences are not merely iconographic.

What all these thankas, and some bronzes as well, have in common, apart from iconographic similarities if the subject is the same, are certain basic aesthetic principles that were immutable. Symmetry, order, and harmony are essential features of all the paintings, whether the subject is benign or terrifying. The emphasis is always on the human figure, whether divine or mortal. And except in specifically "landscape" paintings, everything else, whether trees or flowers, thrones or cushions, animals or birds, serves a purely symbolic function, amplifying the greater glory of the figures themselves. The composition is rigidly schematic, following basic geometrical configurations—either the rectangle or the circle—and little attempt is made within the picture plane to break up this pattern. Within a given composition, the center stage is invariably occupied by the principal personage, while all acolytes and attendants are greatly reduced in size to further emphasize the majesty and enormity of the central figure. Although attempts are occasionally made to model the figures by perfunctory shading or graduating colors, volume is generally suggested by contrasting colors in bold juxtapositions. Chiaroscuro does not play any role; the entire surface of the thanka is uniformly lighted, and no attempt is made to represent the third dimension or depth. Thus, André Grabar's expression "geometric-chromatic," used to characterize the Byzantine aesthetic, is perfectly appropriate for the religious paintings of Tibet, and for those of Nepal, India, and other Buddhist countries as well.[66] Because it was not the artist's function or intention to recreate a world of illusion, but to delineate a picture that was a symbol of Clear Light, chiaroscuro and perspective had no particular relevance. The purity of both line and color was a desideratum; hence, the drawing, always sure, articulate, and precise, defines the form with certitude and verity in contrast to the flux of samsara. The colors, generally bright and dense but lucid, are evenly applied so that the entire surface is both suffused and saturated.

Allowing for fundamental differences in the medium, some of these observations are true of sculpture as well. Most sculptures were brightly painted, and often their backs were left unfinished as they were meant to be seen only from the front. Hieratic frontality and schematic compositions emphasizing symmetry and order are also the *sine qua non* of most sculptural representations, except in some images strongly influenced by Chinese aesthetics (S36). Generally, in their postures and gestures, the sculptured figures are no different from their painted counterparts.

A few remarks must be made here about portraiture, one of the principal subjects of Tibetan art. Typically, the representations of arhats and mahasiddhas are imaginary, even though some of them appear to have very individual faces. It is possible that in such instances the artist had a specific model in mind or was influenced subconsciously by a striking yogi or mystic with whom he was familiar. The norm, however, dictated that portraits were to be as idealized as possible, even those of such historical persons as the lamas. Here, it is important to know that most portraits were done posthumously, and that the artist may never have seen his model.

The principal reason idealized portraiture was preferred was that individualization implied egotism; as we have emphasized, the very purpose of the religion was to destroy the ego. Moreover, it was more important to express the subject's spiritual qualities than to emphasize his physical characteristics. Nevertheless, on occasion, one does come across remarkably realistic portraits, especially in sculpture, which provide some idea of the character and personality of the person. A good example of such a portrait in the collection is the fine bronze depicting the lama Karma Dudtsi (S32).

Apart from some architectural embellishments and iconographic forms and symbols, such as the dragon, the phoenix, the mountain and water motifs, and the animals of the zodiac (P32), the influence of the Chinese aesthetic was felt primarily in two areas: in representations of arhats and in the use of landscape elements. Tibetan literature recognizes the influence of both the Indian and the Chinese arhat traditions; the former is said to have arrived with Atisa and the latter with Lume, who is said to have gone to China around the tenth century.[67] Unfortunately, no reproductions of arhats in India or in Nepal have survived; thus, we do not know what Atisa's tradition was, in visual terms, in those countries. But in both Central Asia and China the cult of the arhat was important and popular, and whether or not Lume went to China, the artistic evidence certainly indicates that the Tibetans were very much aware of the major Chinese styles, or traditions, of arhat representation. Most monasteries in Tibet have shrines dedicated to the arhats, as did those in China, and like the Chinese, the Tibetans preferred depicting their arhats in clay images. The expressive gilt-bronze representation of Arhat Kalika (S36) gives a fine idea of how a terracotta image made in a predominantly Chinese style would look.

Perhaps the most profound influence exerted by Chinese aesthetics upon the Tibetan pictorial tradition was the instilling of an interest in landscape elements. However, the Tibetans, unlike the Chinese, were not interested in landscape paintings as a genre, but instead used landscape motifs for illustrative and narrative purposes. Less concerned with landscapes as an exercise in formalism, Tibetans were more intrigued by the evocative powers of nature. Although they developed a complex and varied tradition of fantastic rather than realistic landscapes, nature remained, by and large, either subordinate to the human figure or symbolically echoed the forms and thereby enhanced the spiritual qualities of the central personage (P25, P27). Tibetan visual imagery invariably reflects literary images and metaphors and rarely imitates nature. Perspective and other optical laws of nature were ignored by the artist, and no effort was made to capture the subtle nuances of light, to record the changes of seasons, or to portray the natural environment in which he lived. Rather, by borrowing motifs and forms from the various Chinese-style pictures which were at his disposal, and by modifying and embellishing them further with his own flights of fancy and imagination, he created a uniformly lighted design that is as distinct from the Chinese tradition as it is delightful in its quaint archaisms, bold electicism, and visionary qualities.

◆

Much has been written about the iconography of Tibetan painting, and some attempts have been made, however tentative, to classify the styles, but no one has seriously studied the "landscape" thankas of Tibet. Preoccupied with the literati tradition, Chinese scholars tend to ignore Buddhist paintings of precisely those periods, the Yuan and the Ming, which are the most interesting in relation to the history of Tibetan painting. This, of course, makes it particularly difficult to establish relationships and to articulate differences, if not innovations. Fascinating as the subject is, it is beyond the scope of this catalogue to enter into an extensive discussion of it. Therefore, only a few comments will be made, in order to help the reader appreciate the creative impulse of the Tibetan artist, and to offer some guidelines for future scholarship in the field.

Landscape elements are used mostly in portraits of arhats, monks, and mahasiddhas for biographical and narrative paintings, but rarely and sparingly in purely iconic thankas. The beautiful image of the goddess Sarasvati in the collection (P23) is an exception rather than the rule. It is also evident that landscape in Tibetan paintings derives from fantasy rather than from fact. To understand this we must turn to the images of nature in Tibetan literature.

Whenever nature is described in Tibetan poetry, there is an element of fantasy and evocation that borders on the supernatural. Nevertheless, the Tibetan poet is always aware of his surroundings—mountains and lakes, rivers and valleys, trees and flowers—even though his descriptions are highly fanciful, at times psychedelic, and often charged with symbolism, magic, and mystery. Describing the arrival of the first Tibetan king, an unknown poet wrote:

He came to the Holy Mountain Gyang-bo,
And the great messy mountain bowed low, bowed low.
The trees came together, came together
And the springs rippled with their blue waters
And the rocky boulders and the like bid him honour.
And the cranes made him salutation.[68]

Clearly nature plays a humble role before the mighty king. Natural forms in such descriptions are always used as metaphors: "The fair Mount Chimbu is like a lion, blue as turquoise"; "The Red Crag is like a lion of coral, soaring into the sky;" and, as Milarepa wrote, "This place where I dwell alone is the Red Rock Agate Mansion Fortress of Garudas."[69] Tibetans' innate fascination with the color blue, whether lapis lazuli or turquoise, is also evident in their poetry. Not only are mountains, lakes, and the sky compared with turquoise, but the color is used almost ubiquitously as a simile. Thus, when Milarepa dreams of a lion, he is "fully displaying his thick turquoise mane"; and when Rinchenpal, the Kagyupa saint, hears the roll of thunder it is like that of a turquoise dragon.[70] Is it surprising, then, that the blue-green mountains of Chinese paintings should have held such fascination for the Tibetans?

The literary tradition is unequivocal about the Chinese style of arhat painting, as is apparent from the following extract:

Wishing to represent them after the Chinese manner, the models are taken from the T'ang period; their clothes are of a sombre hue, like those of the Chinese scholars; they wear ample silken robes. Their main symbols are those of their birth-stories, the others may vary: for instance a staff made of a bananastalk or of osier, a vase for perfume, porcelain cups, etc. They sit on jewelled thrones, surrounded by cliffs, animals, dragons, people of noble race, dressed in silk, Chinese scholars, men of various races carrying fans and different objects as offerings; around them are seen pleasure-grounds, fields with palaces ornamented with lattice-work and caves surrounded with grass and trees.[71]

This conceptualization is also evident in the paintings, even though there are notable stylistic differences. For example, in the earliest arhat painting in the collection (**P3**), which has become a landmark in the history of thankas, conceptual landscape elements are used at the top, the bottom, and in the kneeling figure's garments as vignettes. They are subordinated to the central figure, who dominates the composition. Similarly, in later paintings (**P25–P27**), even though nature is given greater prominence, the principal personage is not obscured. These are not natural landscapes but are fascinating arrangements of shapes and colors that are both enchanting and visually exciting. No one style or tradition of Chinese landscape painting predominates, and even though the Tibetan pictures are replete with archaisms, they are never self-conscious or purely imitative. One is always impressed by the artist's resourcefulness.

It has been said that art is born of art and not of nature. The art of Tibet is no exception. In addition to verbal models, Tibetan artists used various visual

models to create their own eclectic mannerisms. We have repeatedly stressed here that Tibetan monasteries were rich repositories of Indian images, but they also possessed a good deal of art from Central Asia and China. In the *Monks and Monarchs* section of this Introduction, it is noted that Chinese emperors sent images as gifts to Tibetan monasteries. One such gift was a scroll the Ming emperor Yongle had painted, recording Karmapa Dehzin Shegpa's visit to China. In 1949 H. E. Richardson had the opportunity to examine this scroll in the Tshurphu monastery where it was kept. Such objects must therefore have provided artists with visual models for their own representations.

Until recently very little was known of the artistic process itself, but now a number of pattern books and sketches have come to light that indicate how styles were transmitted. The collection contains two small sketches (P19 a, b) representing mahasiddhas which, since the figures are drawn on both sides, must have formed patterns for larger thankas. A comparison of these drawings with a pattern book dated 1653 (fig. 1), rendered by a Newari artist, leaves no doubt that the Tibetan sketches were executed at about the same time. Tibetan inscriptions on the mahasiddha drawings also make it clear that they were intended for use by a Tibetan artist. The colophon of the folding pattern book, which contains designs and motifs seen only in Tibetan thankas and rarely used in Nepal, gives the interesting information that it was written in Lhasa by a Newari Buddhist *vajracarya* (priest).[72] He was very likely the artist, too, and obviously made the sketches to take back to Nepal so he could paint thankas for his Tibetan patrons. A similar but earlier pattern book, made by a fifteenth-century Newari artist named Jivarama on a visit to Gyantse, contains an enormous number of iconographic patterns and designs, of which a section containing the representations of the arhats is reproduced here (fig. 2).

Some of the iconographic implications of this book have been discussed elsewhere.[73] The style in which these sketches are rendered is the same as that employed in the chapels of the *kumbum* at Gyantse, a monument that was painted in the early part of the fifteenth century by both Newari and Chinese artists. One of the Newars may have been Jivarama, who put together the pattern book. Moreover, the section reproduced here clearly shows how the artist intended to use rocks and animals for the arhat paintings. Sketchy as they are, these landscape elements, which have often been regarded as later inventions, clearly demonstrate that they were already familiar to Tibetan and Newari painters as early as the fifteenth century. A further implication of these sketchbooks is that Newari artists not only painted in their own style, but were very self-assured in painting what are regarded as purely Tibetan-style landscape thankas. While this demonstrates how complex the artistic milieu in Tibet was, it also indicates how, through such pattern books, Tibetan aesthetics may have influenced the styles in Nepal.

◆

While it may be true that a Tibetan did not respond to a work of art in the same ways people do today, it would be wrong to say that he or she was unresponsive to the beauty of the object. The norms by which he or she judged a work of art were different—no distinction was made between beauty and truth. Radical departure from the norms was not deemed a virtue, nor was conformity considered stifling or debilitating. The fact that the Tibetan atist was so open and receptive to various styles and traditions clearly reflects his spirit of aesthetic adventure and his innovative impulse. Art was not an end in itself, as the following statement, drawn from an iconographic manual, makes evident: "When one has painted the eyes of the Gods, which are pleasing with the lustre of their colour appearing in soft tones, the well being of the Kings and of all beings shall increase."[74] Elsewhere the manual states that the face should be articulately delineated and should be "beautifully full and endowed with brilliant pleasing marks." Such remarks are hardly indicative of the absence of aesthetic response.

Perhaps the most graphic example of the excitement generated by the creation of an object of art is provided by the following eyewitness account, written in 1604, of the casting of a bronze by Newari artists in the presence of the First Panchen Lama:

As soon as the alloy of molten copper and bell-metal *(li)* was poured, crackling and sputtering noises filled our ears. Molten copper boiled out of the mouth of the mould, completely spattering the whole workshop. Because it seemed that it had not gone into the mould at all, the Newars *(Bal-po)* scowled blackly and muttered something in their language about the casting being a failure. The others were in a complete quandary what to do. Everyone fell into silence. I also was mystified as to what had happened, but I called out urging them: 'Break the mould and see!' Without giving it time to cool (by itself) they chilled it by splashing a good deal of cold water over it. When they cracked the mould, a splendid image of the Jetsun emerged. All were in a state of awe and astonishment: becoming mad with sheer joy, we all cried out: 'A la la!'[75]

A Michaelangelo, a Bernini, or a Rodin would have empathized with the unknown Newari masters, who, like artists everywhere, must have experienced the anguish and the ecstasy that are present in every creative process.

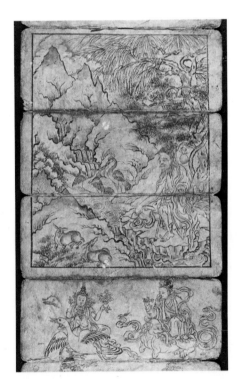

Fig. 1
Vajracarya Srimantadeva
(Newari, 17th century)
Ascetic in Landscape from artist's pattern book
Nepal or Tibet, 1653
Ink on paper
Each folio: 3¼ x 7¾ in. (8.2 x 19.6 cm.)
Indian Art Special Purposes Fund
M.81.56

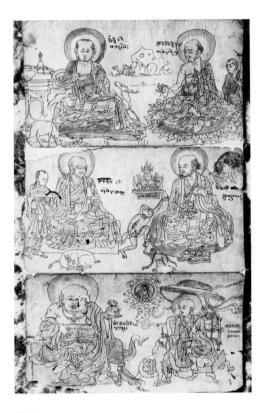

Fig. 2
Jivarama (Newari, 15th century)
Representation of Arhats from artist's
pattern book
Tibet, 1435
Ink on paper
Each folio (average): 5⅛ x 9½ in.
(13 x 23.2 cm.)
Mr. Suresh K. Neotia Collection, Calcutta

Notes

1. Snellgrove and Richardson, p. 24.

2. Stein, 1972, from which the passage is quoted, is perhaps the most brilliant general introduction to Tibetan civilization to date. It may be supplemented by Snellgrove and Richardson.

3. For the Chinese interest in yak tails, see Schafer, p. 74.

4. For instance, we learn from a Chinese source (672 A.D.): "The (Tibetan) king moves about each spring and summer at the dictates of grass and water: only in autumn and winter does he live in the fortified city, but even then, he pitches his tent and does not live beneath a roof." (Stein, 1972, p. 118). This ancient custom continued with the later Tibetans as well, and in the biography of the Karmapas (Thinley, p. 86) we are told: "In contrast to his own personal austerity Karmapa's monastic camp was richly endowed and beautifully decorated. The shrine tent had a golden roof and was decorated with his most precious relics, above which hung thirteen ornate umbrellas."

5. See Eliade, 1964: Hoffmann; and Stein, 1972.

6. Stein, 1972, p. 125.

7. Ibid.

8. Bell, pp. 5–6.

9. Stein, 1972, p. 70.

10. For a recent discussion of the subject, see Pachow.

11. Stein, 1972, p. 80.

12. Tucci, 1980, p. 27.

13. Stein, 1972, p. 155.

14. Ibid., p. 154.

15. Snellgrove and Richardson, p. 132.

16. Chang 2, pp. 572–73.

17. Snellgrove and Richardson, p. 31.

18. Ibid., p. 64.

19. Ibid.

20. Ibid., p. 148.

21. See Karmay, 1975, for an extensive discussion of Sino-Tibetan relations under the Yuan and the Ming dynasties. Much of the discussion that follows is based on Karmay's book.

22. Karmay, 1975, pp. 80–81.

23. For a general discussion of the topic, see Macdonald and Stahl.

24. Conze, p. 263.

25. Ibid., p. 154.

26. Pallis, 1960, p. 186.

27. Ibid., p. 19.

28. Wayman, 1977, p. 11.

29. Tsong-ka-pa, p. 151.

30. Ibid., p. 157.

31. Ibid.

32. See Pallis, 1960, pp. 160–76 for further development of this idea and for more on the institution of the Dalai Lama. Pallis very correctly questions the use of the words "reincarnation" or "rebirth" to describe the concept of *tulku*, as found in most books. See, for instance, Zwalf, p. 65f, where an entire section is entitled "Incarnation."

33. Beyer.

34. Trungpa, p. 167.

35. See Pal, 1982 A for an extensive discussion of the concept.

5. Tsong-ka-pa, p. 156. The idea of the Buddha being a spiritual king is very old and, according to the manuals in iconography, his form is to be modeled after that of the Universal King (*Cakravarti*); see Laufer's translation of *Citralakshana* as translated by Goswamy and Dahmen-Dallapiccola.

7. Tsong-ka-pa, p. 106 and pp. 47–48.

8. Snellgrove and Skorupski, 1980, p. 93.

9. Robinson, p. 394; Trungpa, p. 345. The origin of the word *daka* is obscure and I don't know why Robinson opines that it probably comes from a Sanskrit root meaning "to fly." P. C. Bagchi was of the opinion that the word *daka,* meaning a wise man, was borrowed by Sanskrit from the Tibetan; this is refuted by Banerjea (J. N. Banerjea, *Pauranic and Tantric Religion,* Calcutta, 1966, pp. 127–29) on the grounds that the word *dakini* occurs in the Gangdhar inscription of 423–24 A.D.

0. Snellgrove and Skorupski, 1980, p. 91. He also had seven mandalas painted for the benefit of his father.

1. Wayman, 1973, pp. 82–83.

2. Ibid. For an interesting interpretation of the mandala, see Ellingson-Waugh, 1974.

3. Tucci, 1949, pp. 566ff.

4. Conze, p. 145.

5. Thinley, p. 74

6. Ruegg, p. 18.

7. For Situ Panchen, see Macdonald and Stahl, pp. 32–33 and references cited therein. For an extensive discussion about Tibetan artists in general, see Tucci, 1949, pp. 271ff. The following information about the Karmapas is taken from Thinley.

8. Thinley, p. 52

49. Ibid., p. 67.

50. Ibid., p. 91.

51. Ibid., pp. 92, 131–32.

52. In one of the inscriptions at Alchi (Snellgrove and Skorupski, 1980, p. 148) we are told: "This great temple and vihara has been built with a wealthy patron supplying the means and skillful craftsmen acting as agents."

53. Ruegg, p. 17, n. 14. See also Tucci, 1949.

54. Tucci, 1949, p. 157.

55. As quoted in Macdonald and Stahl, p. 33. This book also discusses the role of the Newari artists in Tibet at considerable length.

56. As quoted in Macdonald and Stahl, p. 33.

57. Tucci, 1973, figs. 157–64, 170–76.

58. Snellgrove and Skorupski, 1980, p. 92.

59. Thinley, p. 74.

60. Goswamy and Dahmen-Dallapiccola, p. 24, n. 36.

61. Trungpa, p. 56.

62. These works are discussed in Laufer. Also Goswamy and Dahmen-Dallapiccola, pp. 9ff; and Tucci, 1949, pp. 291ff.

63. Ibid., pp. 81–82.

64. Ibid., p. 84.

65. Nebesky-Wojkowitz, p. 41.

66. *Byzantine Painting* (Geneva: Rizzoli, 1979), p. 40.

67. Tucci, 1949, p. 83.

68. Snellgrove and Richardson, p. 24.

69. Trungpa, p. 201.

70. Ibid., p. 244.

71. Tucci, 1949, p. 562.

72. According to the colophon, the pattern book was completed in the Newari year 773 (1653 A.D.) by Vajracarya Srimantadeva in Lhasa. The manuscript bears the accession number M.81.56 and will be discussed at length in a forthcoming article and in the catalogue of the Museum's Nepali collections to be published in 1985.

73. Lowry, 1977.

74. Goswamy and Dahmen-Dallapiccola, p. 82.

75. As quoted by Macdonald and Stahl, p. 32.

Plate 1
Perfection of Insight,
an illuminated folio from a *Prajnaparamita* manuscript
(M1 c)

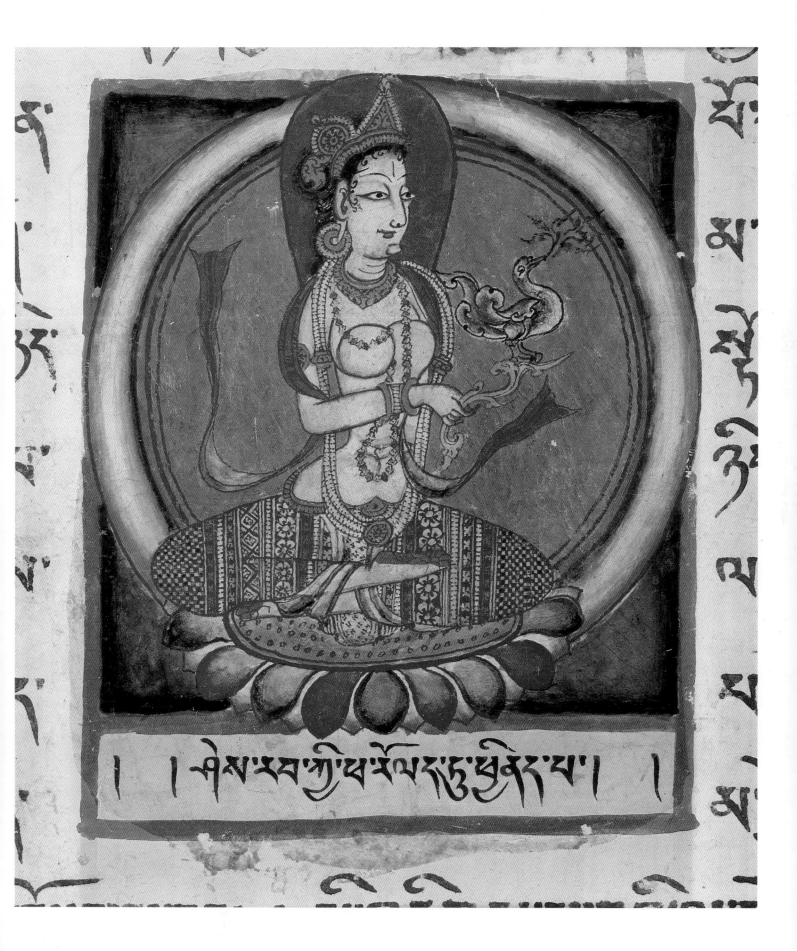

Plate 2
Power of Faith,
an illuminated folio from a *Prajnaparamita* manuscript
(M1 d)

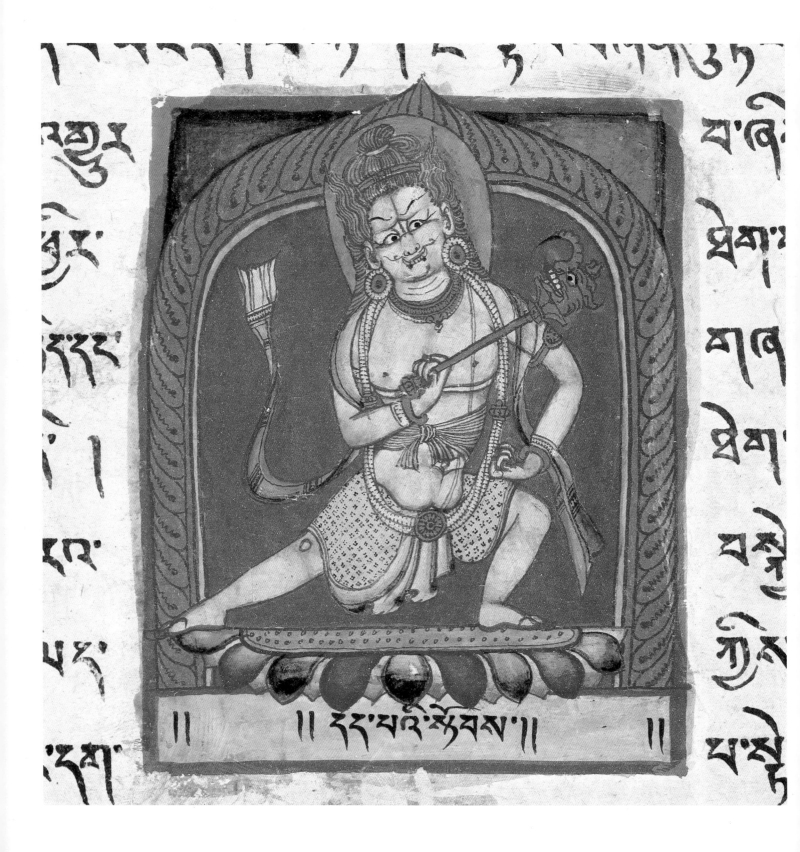

Plate 3
Cover of a Prajnaparamita *Manuscript*
(M2, detail)

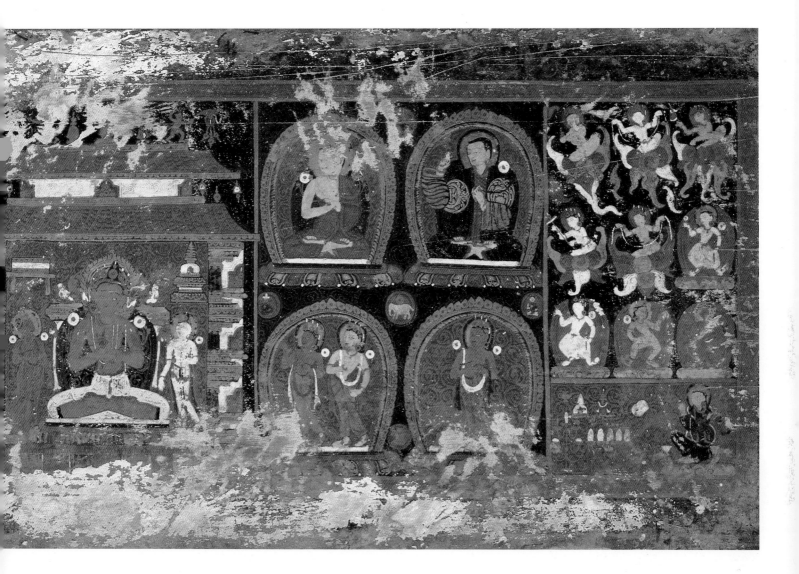

Plate 4
Cover of a Prajnaparamita *Manuscript*
(M3, detail)

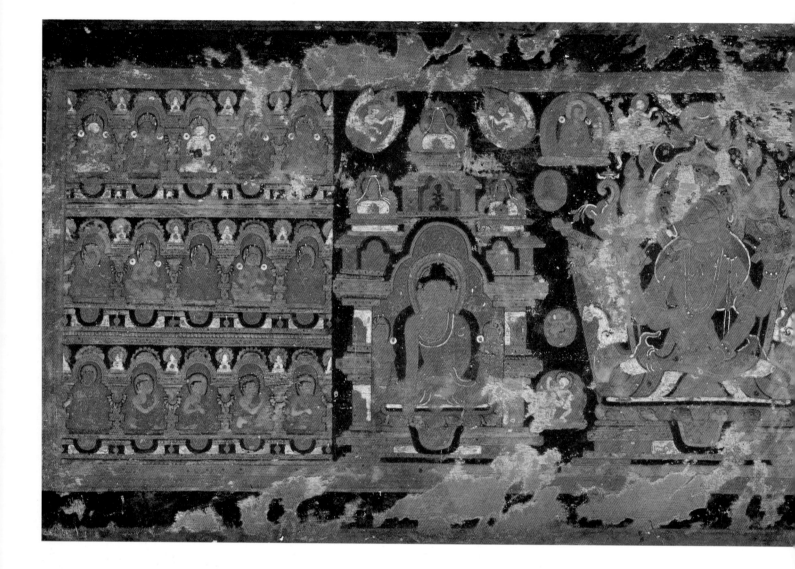

Plate 5
Illuminated Page from a Dharani *Manuscript*
(M4 a, detail)

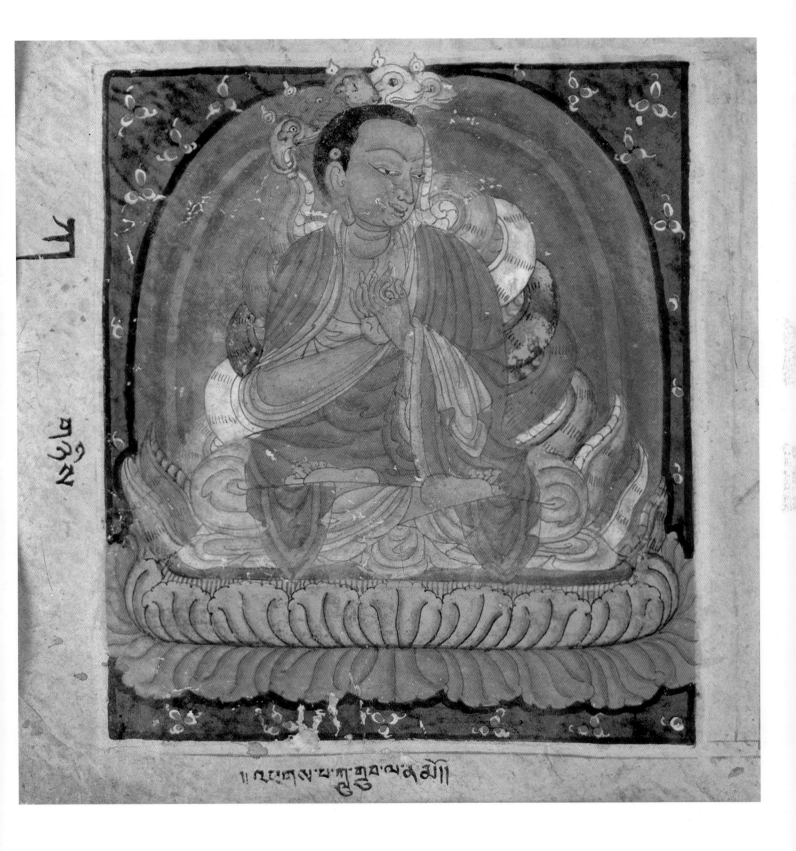

Plate 6
Page from an Ashtasahasrika Prajnaparamita *Manuscript*
(M6 b, detail)

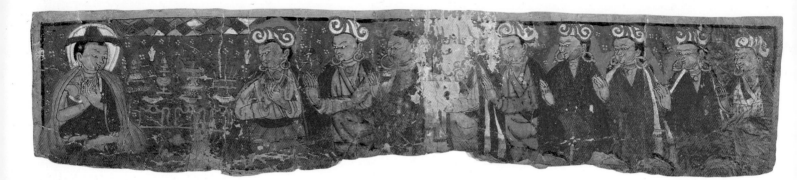

Plate 7
Tathagata Amitayus and Acolytes
(P1)

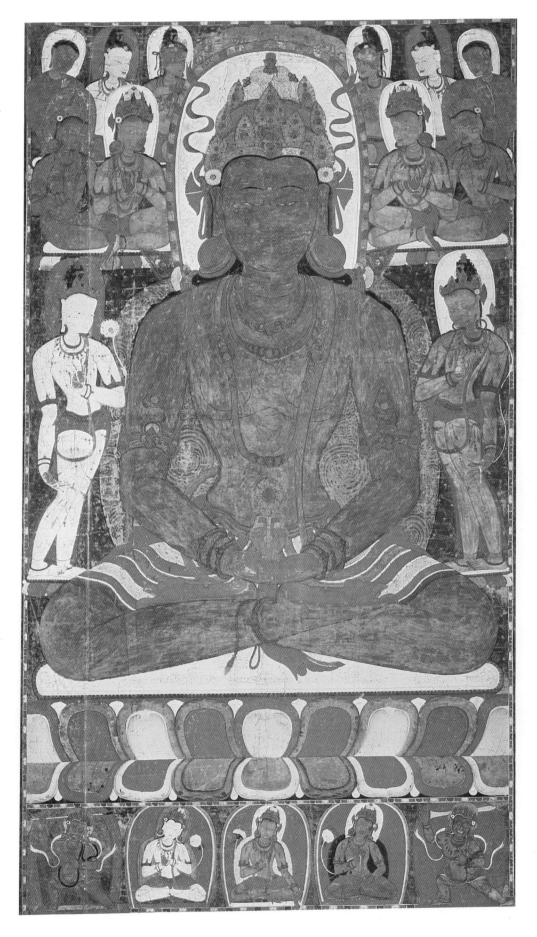

Plate 8
Tathagata Ratnasambhava
(P2)

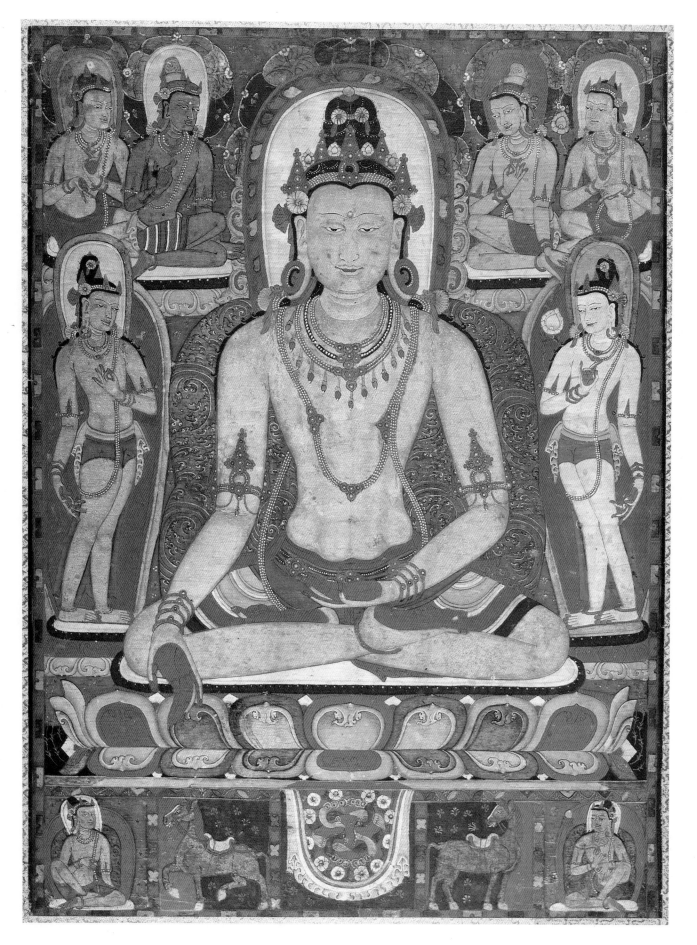

Plate 9
An Abbot and His Lineage
(P3)

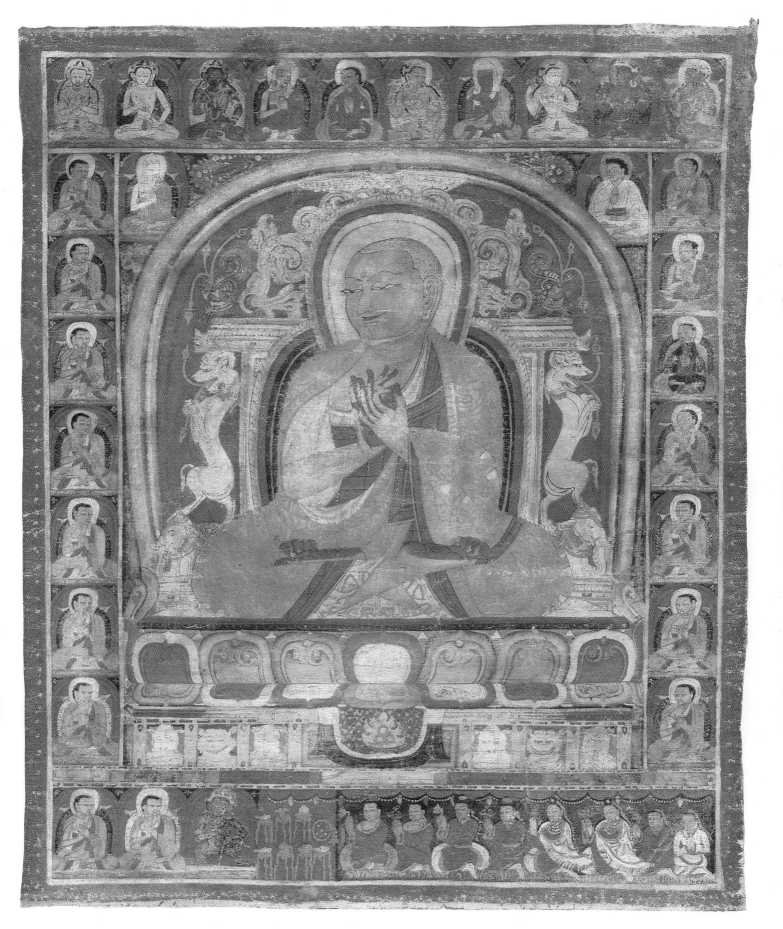

Plate 10
An Arhat with Attendants
(P4)

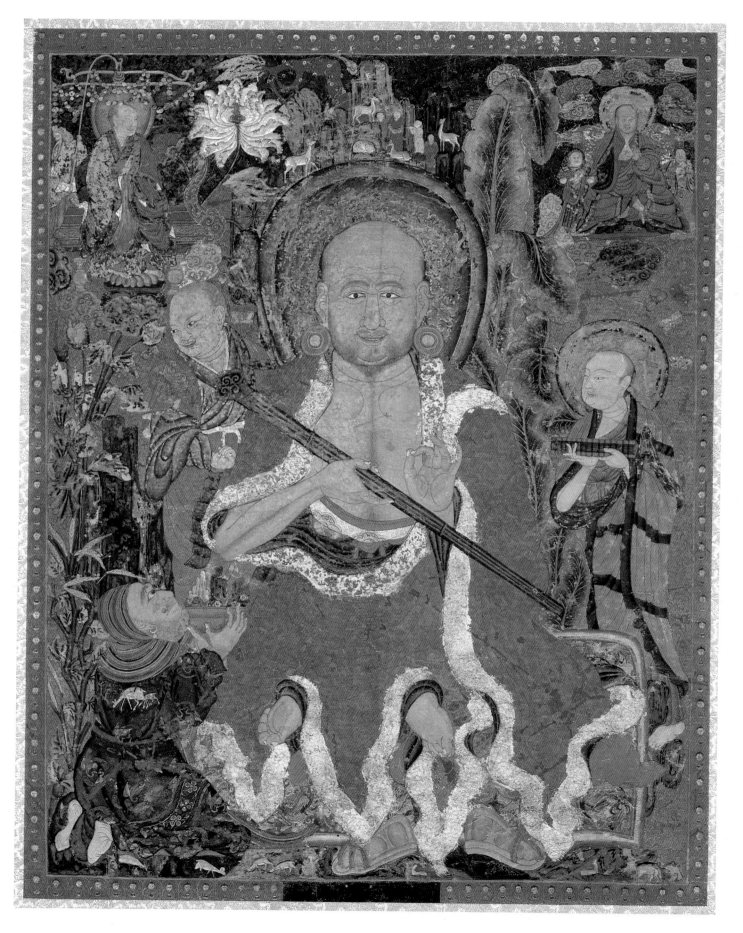

Plate 11
Mandalas of Hevajra and Other Deities
(P5)

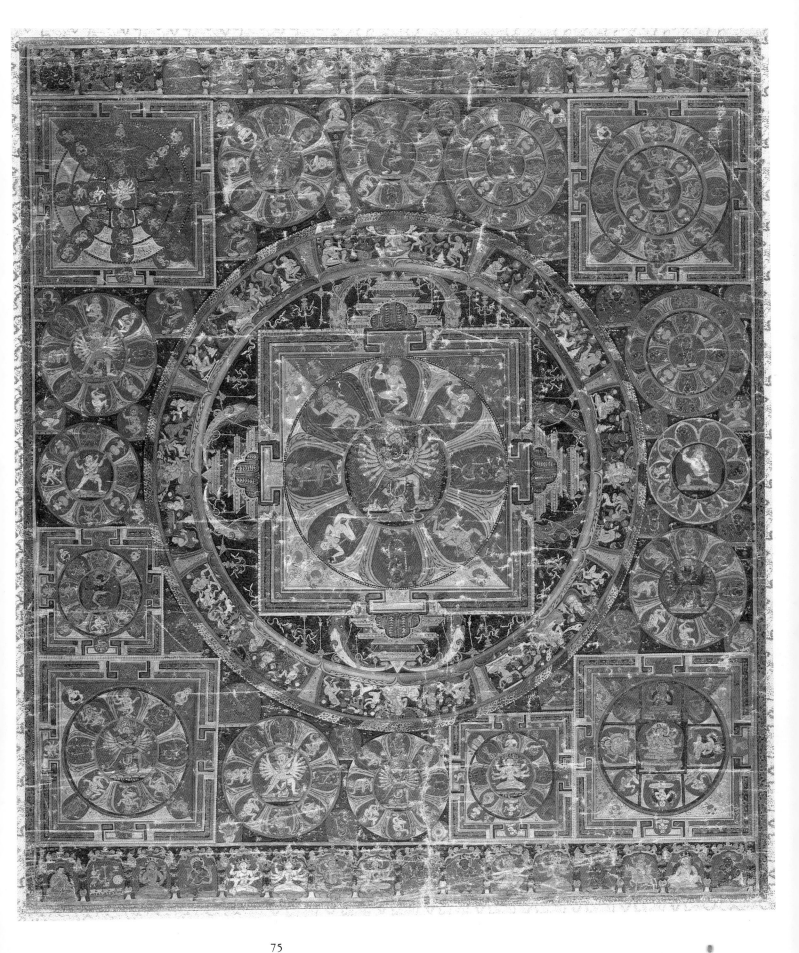

Plate 12
Amithabha in His Paradise
(P7)

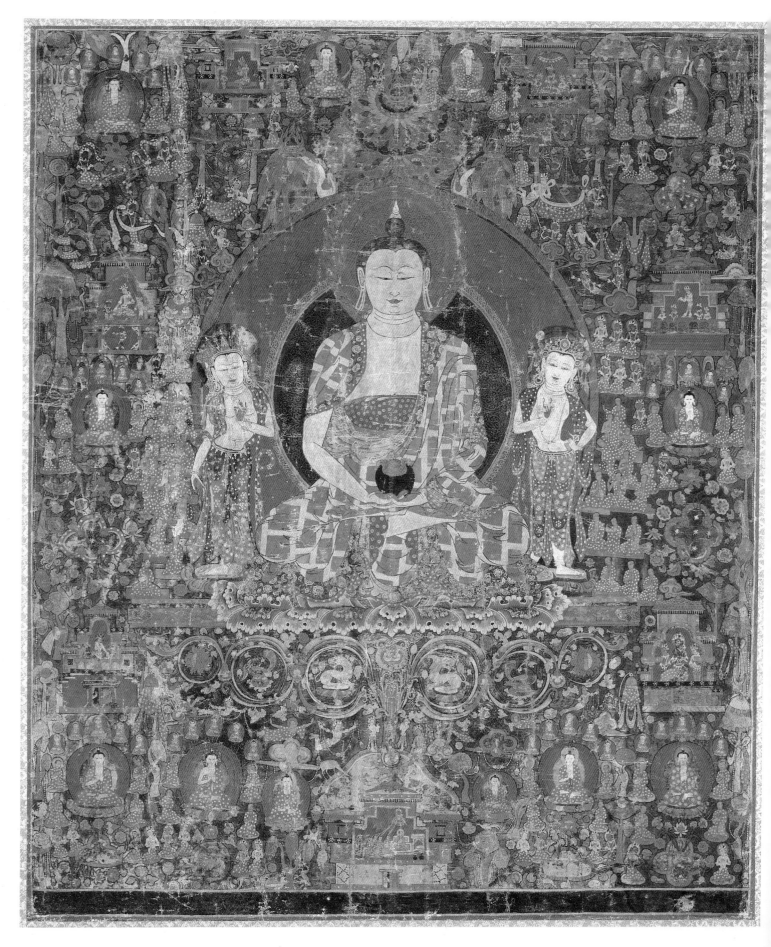

Plate 13
The Healing Buddha and His Celestial Assembly
(P8)

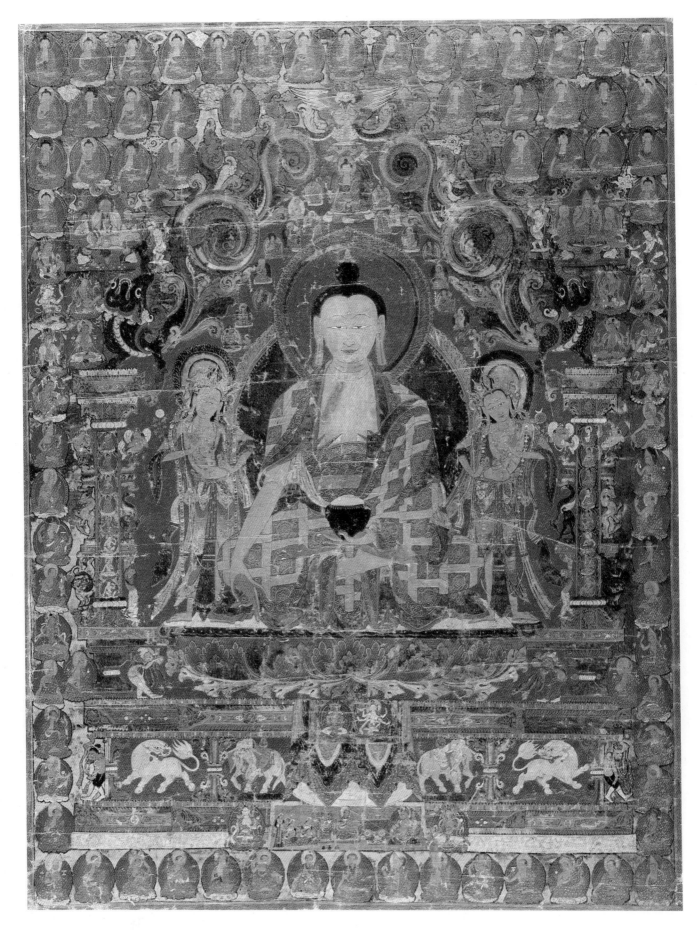

Plate 14
Arhat Kanakavatsa
(P9)

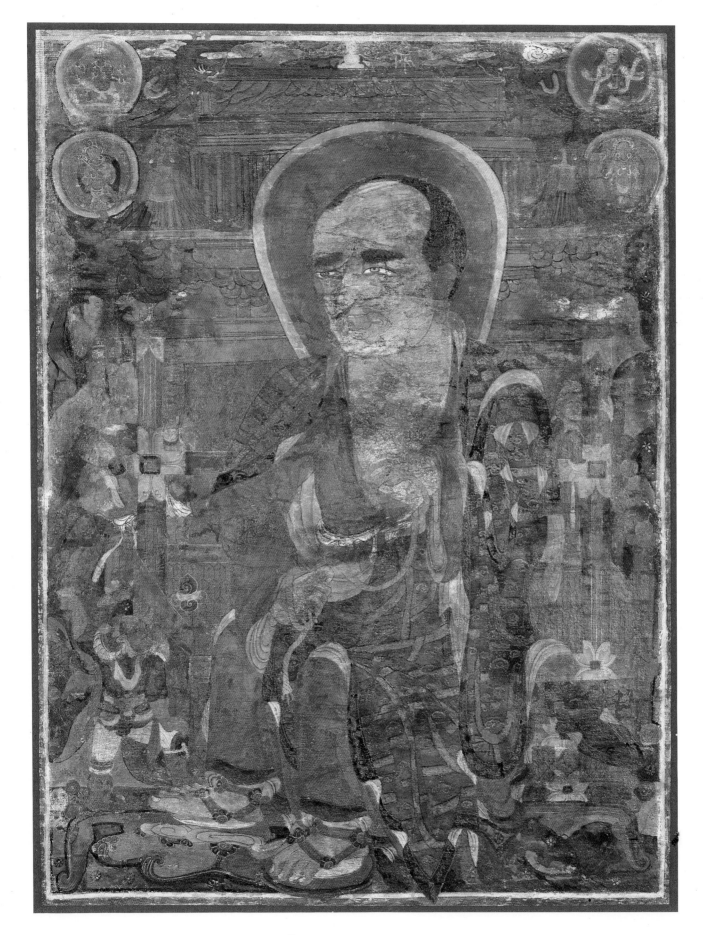

Plate 15
Mahakala with Companions
(P10)

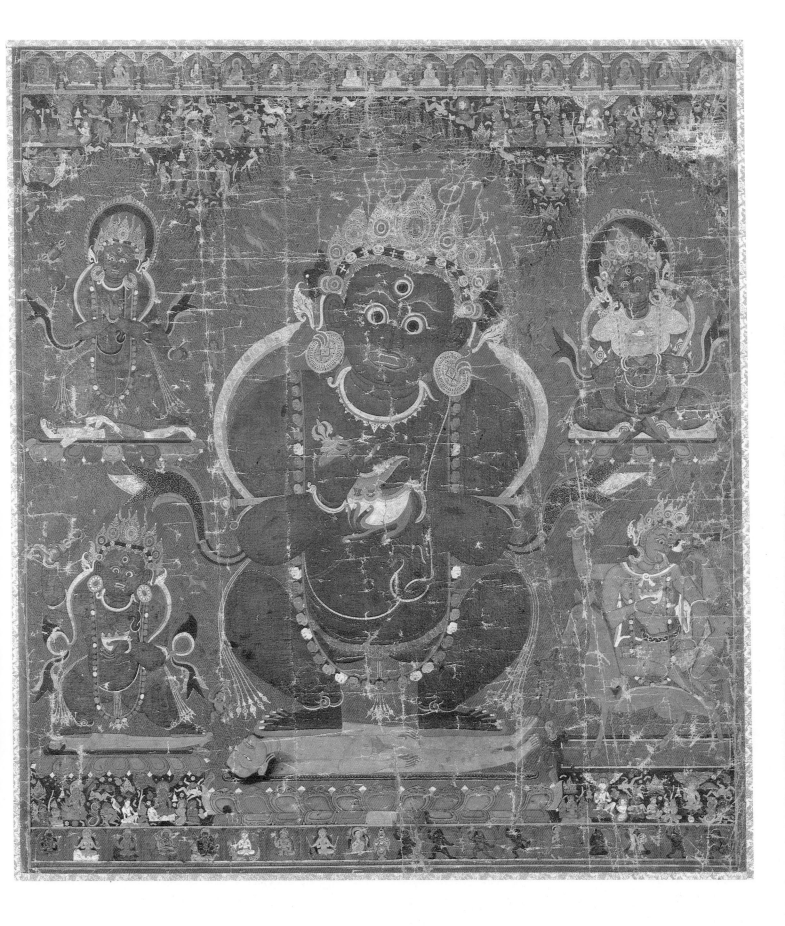

Plate 16
Mahakala and Companions
(P11)

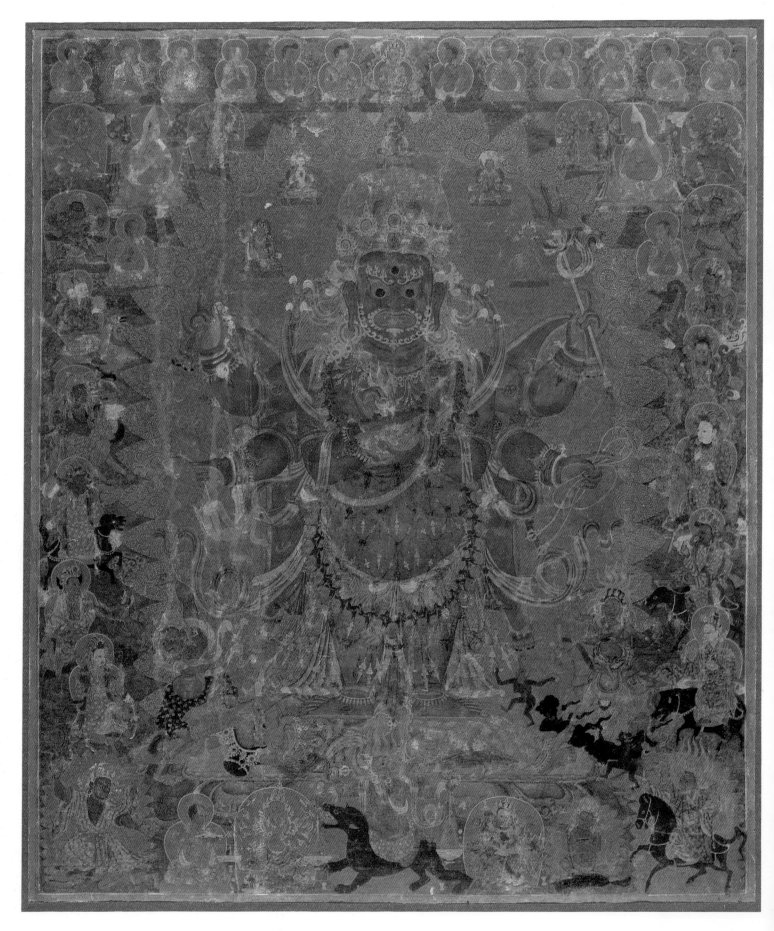

Plate 17
Vajrabhairava
(P12)

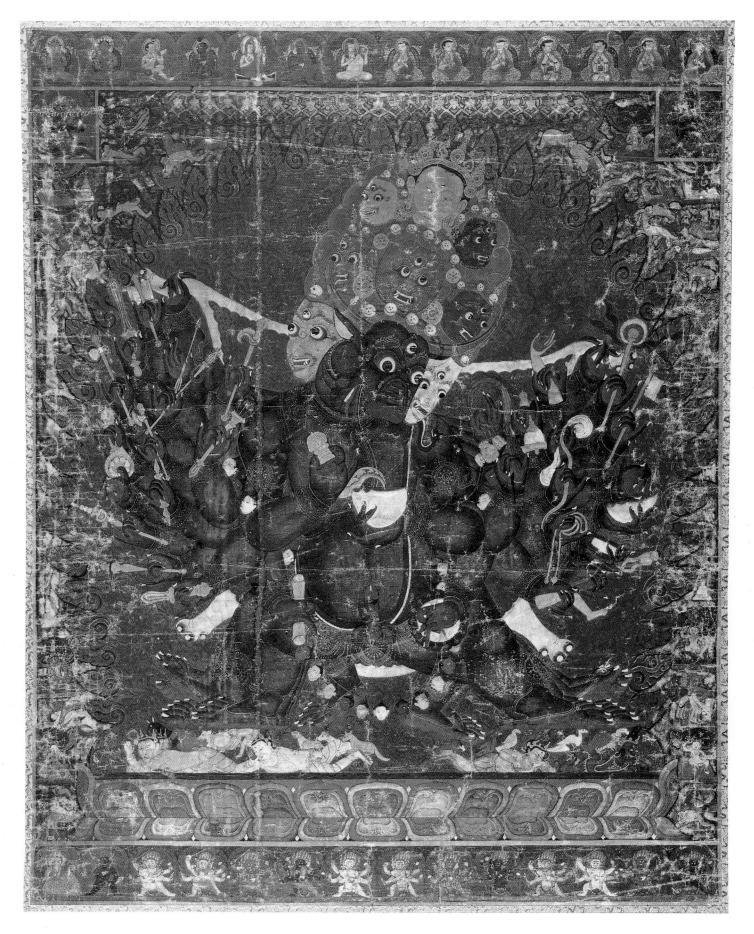

Plate 18
Sakyapa Lineage
(P13)

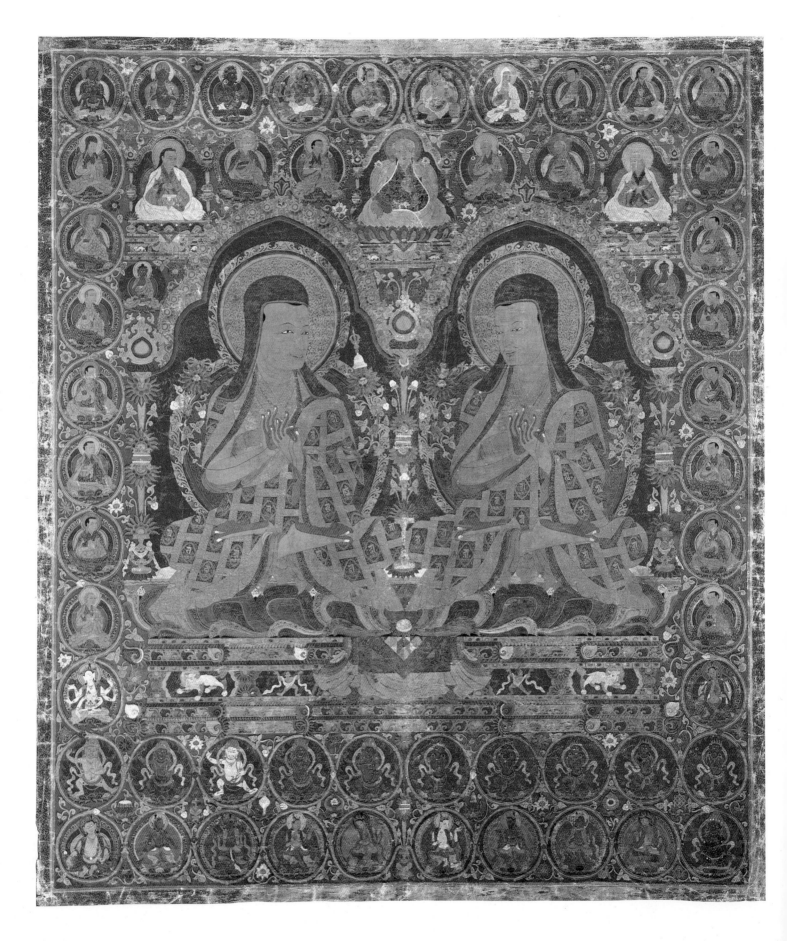

Plate 19
The Life of Milarepa
(P14, detail)

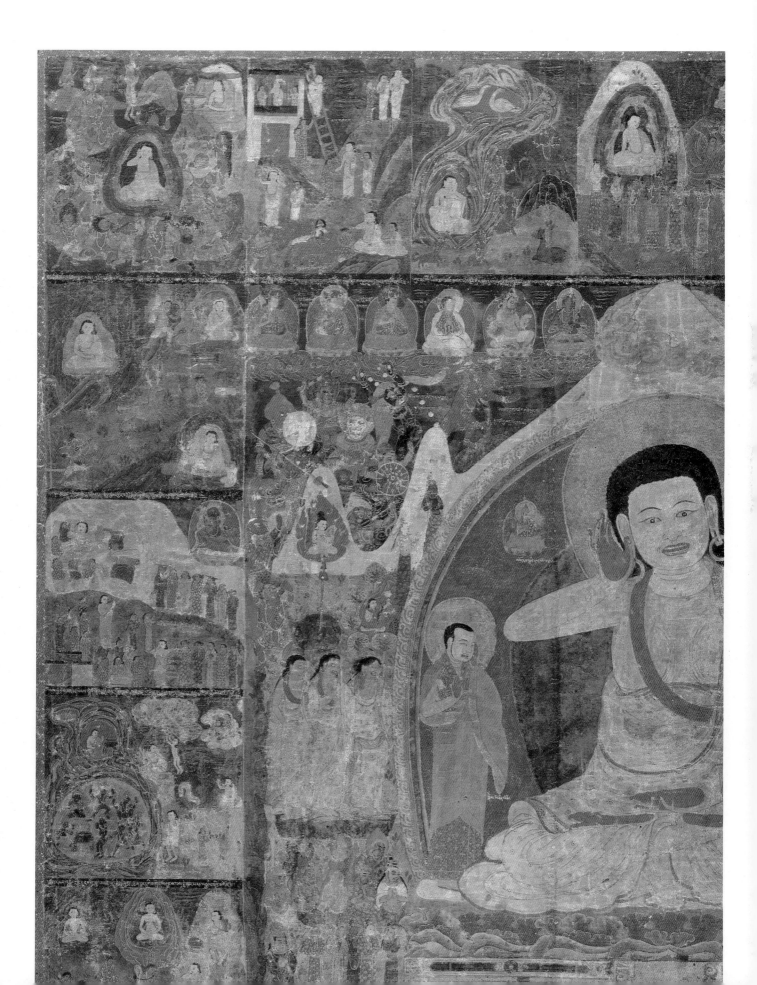

Plate 20
Sakyapa Monks
(P15)

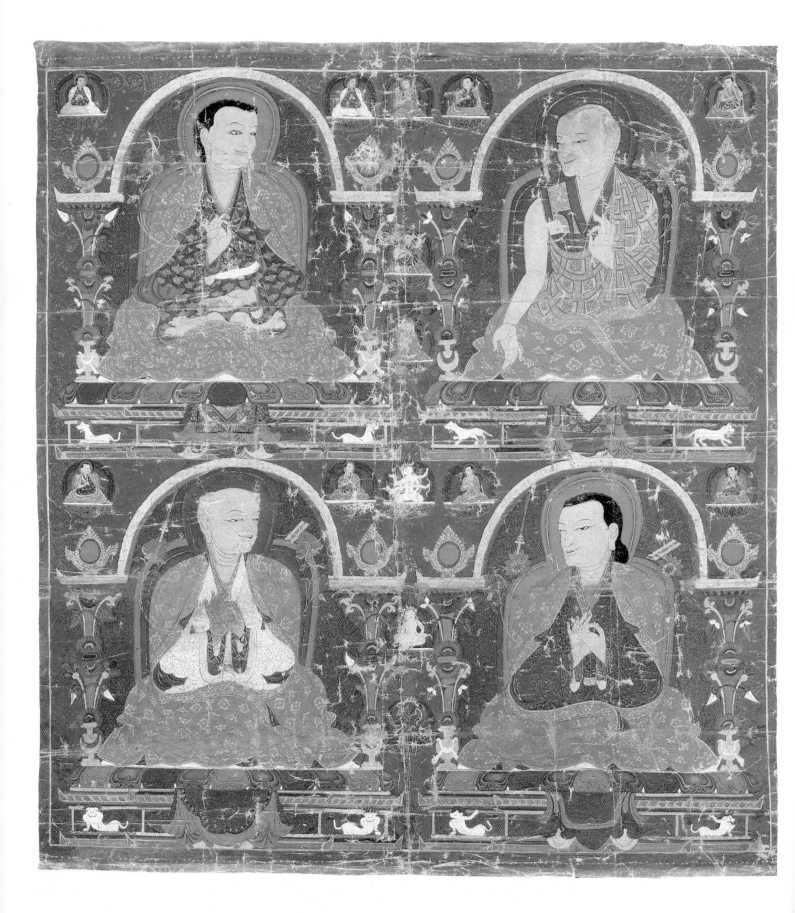

Plate 21
Three Mandalas
(P16, detail)

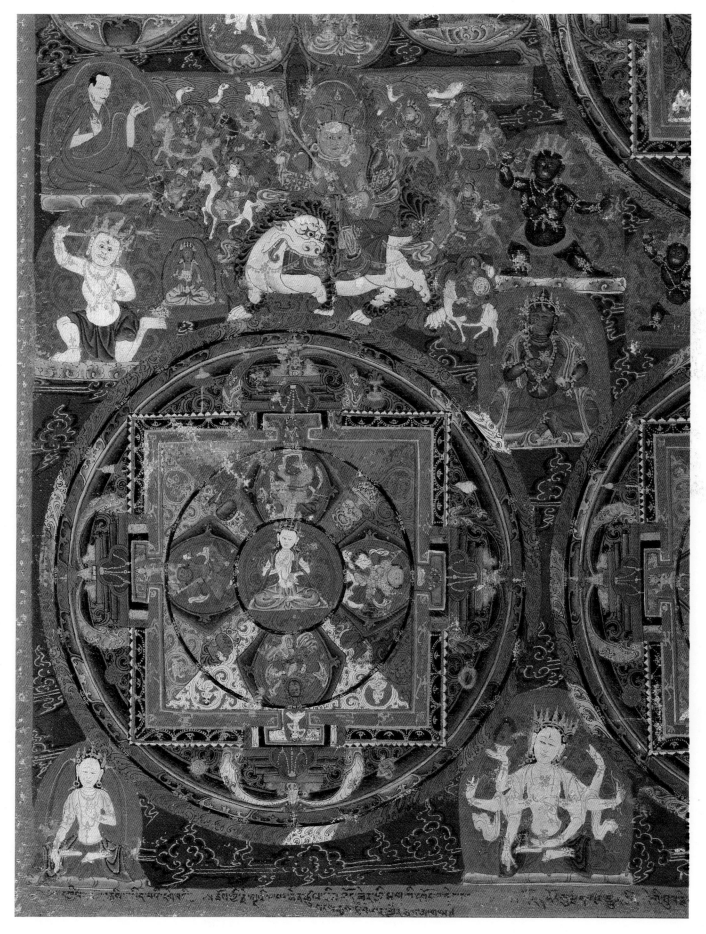

Plate 22
The Buddha of Endless Life (Amitayus)
(P17)

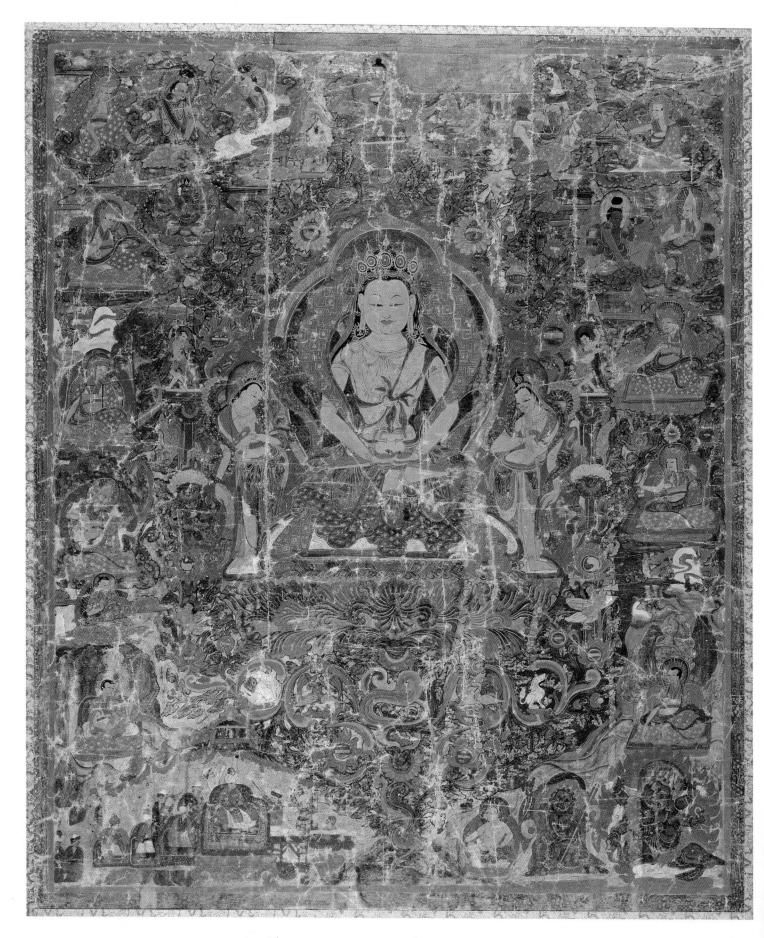

Plate 23
Kunga Tashi and Incidents from His Life
(P20, detail)

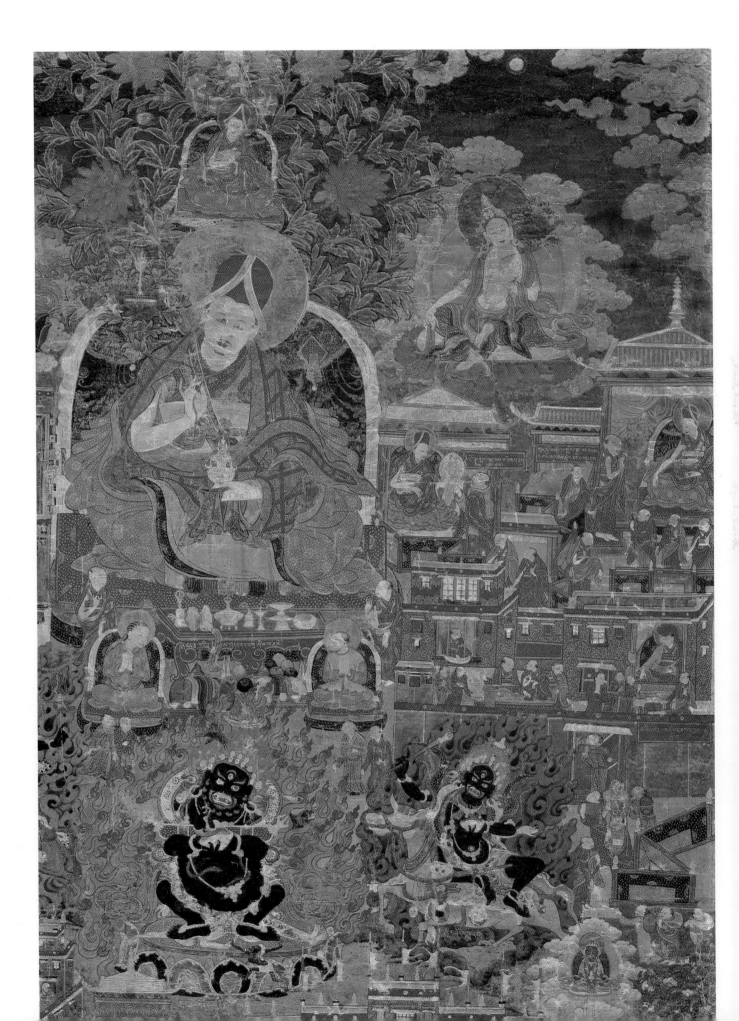

Plate 24
Mahakala and Companions
(P21)

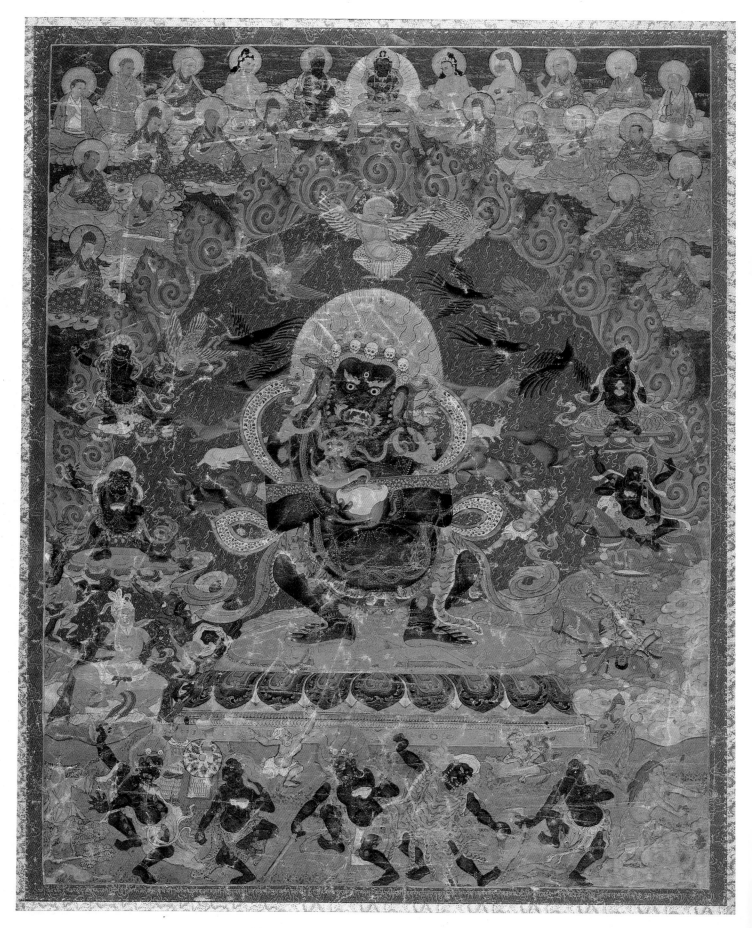

Plate 25
Sakyasri and the Lotsawa of Trophu
(P22)

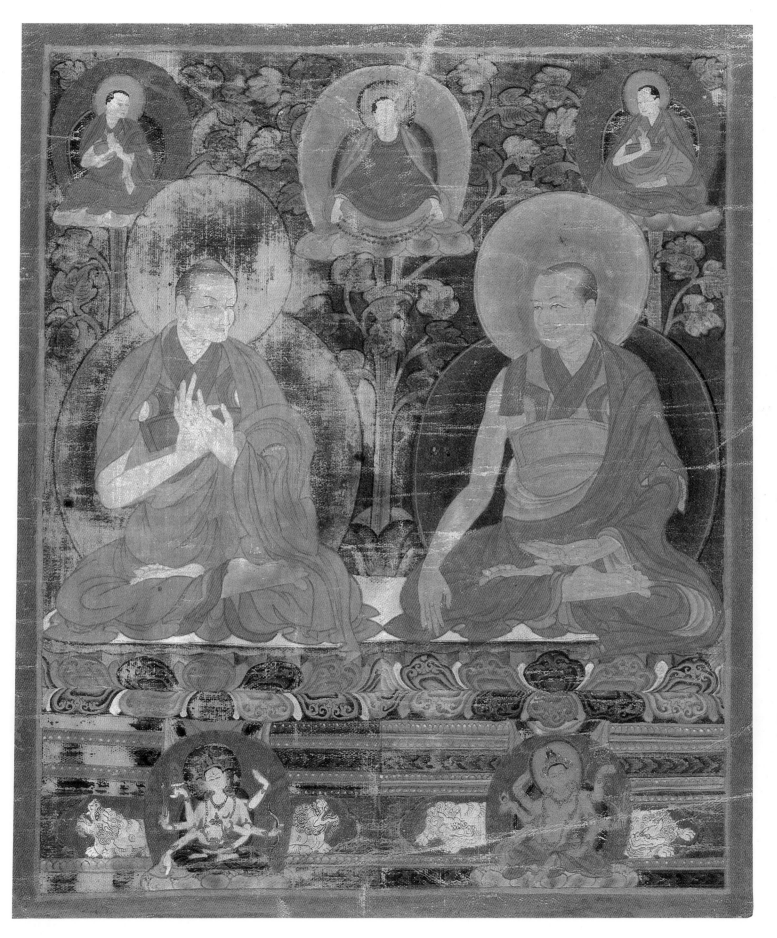

Plate 26
The Goddess Sarasvati
(P23)

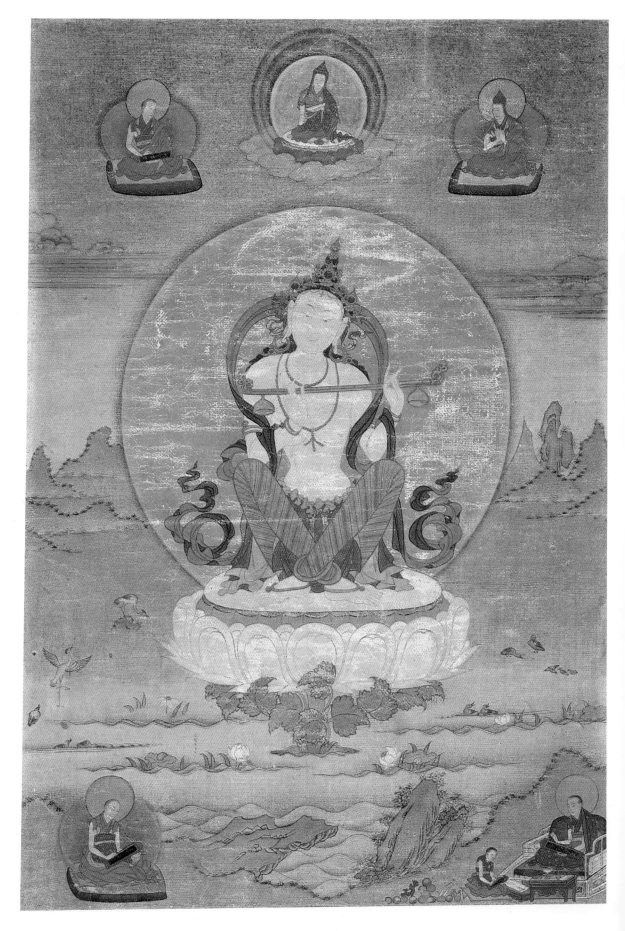

Plate 27
Sakyamuni and the Eighteen Arhats
(P24)

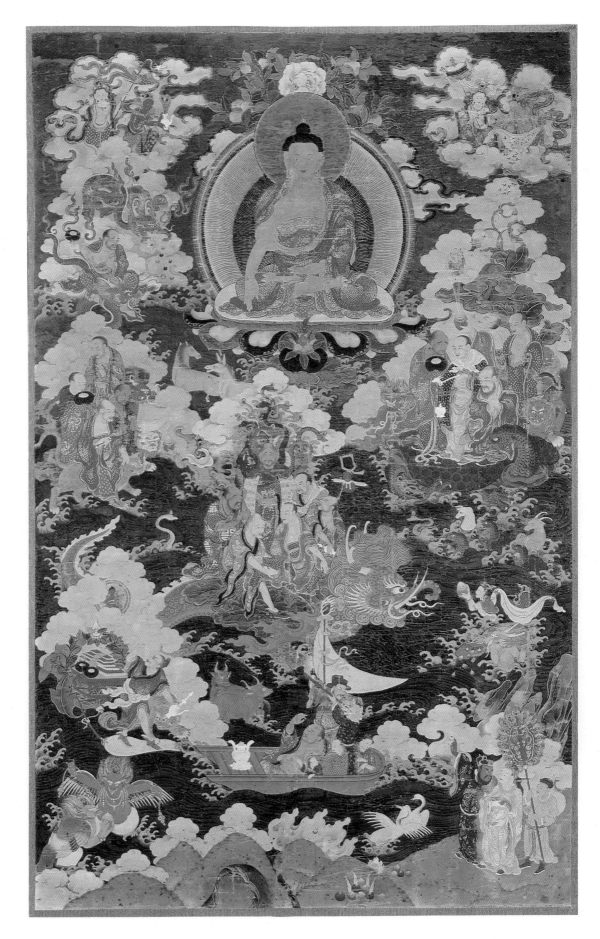

Plate 28
Portrait of the Fifth Karmapa
(P25)

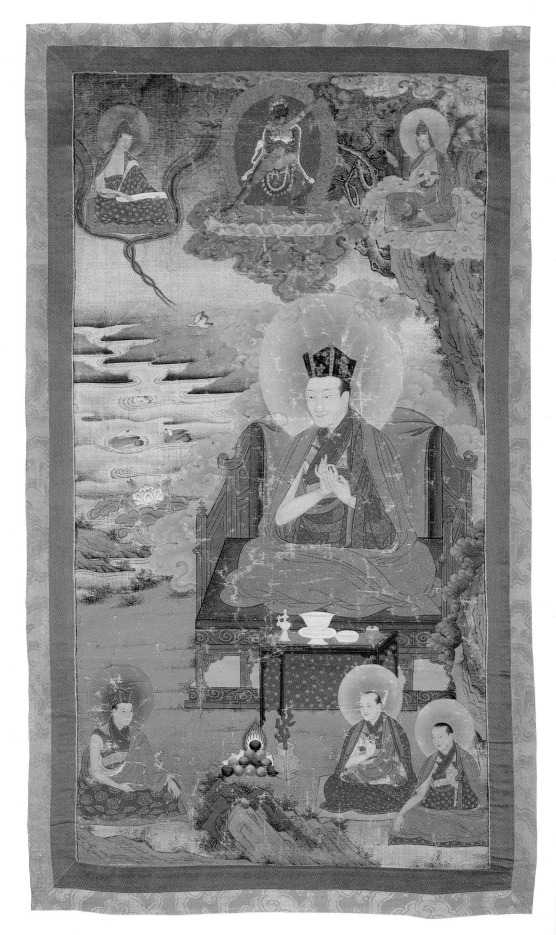

Plate 29
Buddha Sakyamuni and Narrative Scenes
(P26)

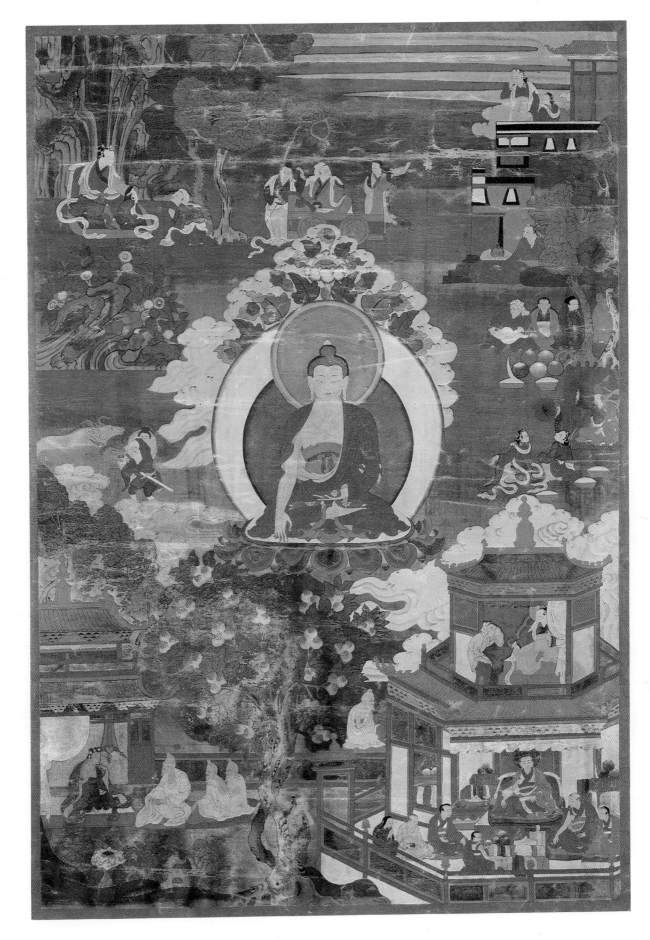

Plate 30
A Mahasiddha and Talungpa Lamas
(P27)

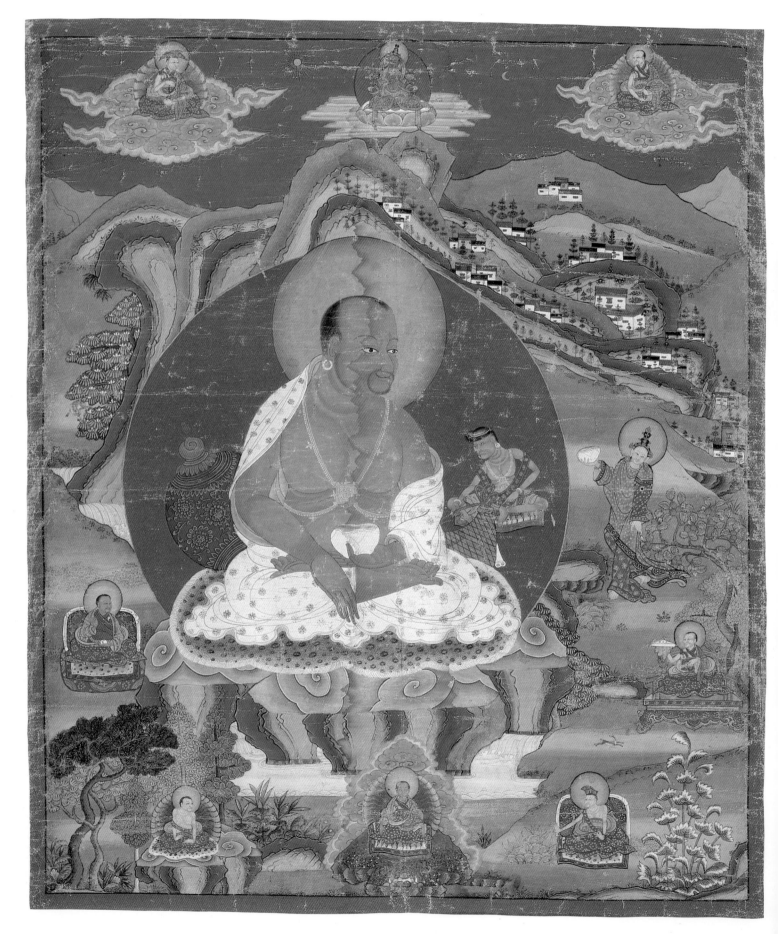

Plate 31
A Biographical Painting
(P28)

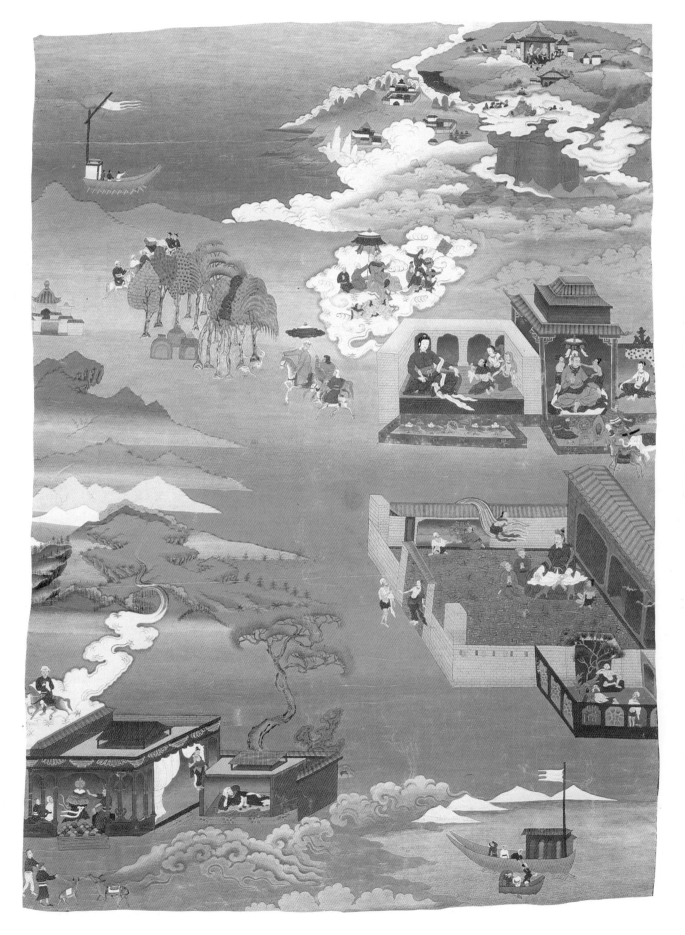

Plate 32
Symbolic Offerings
(P30)

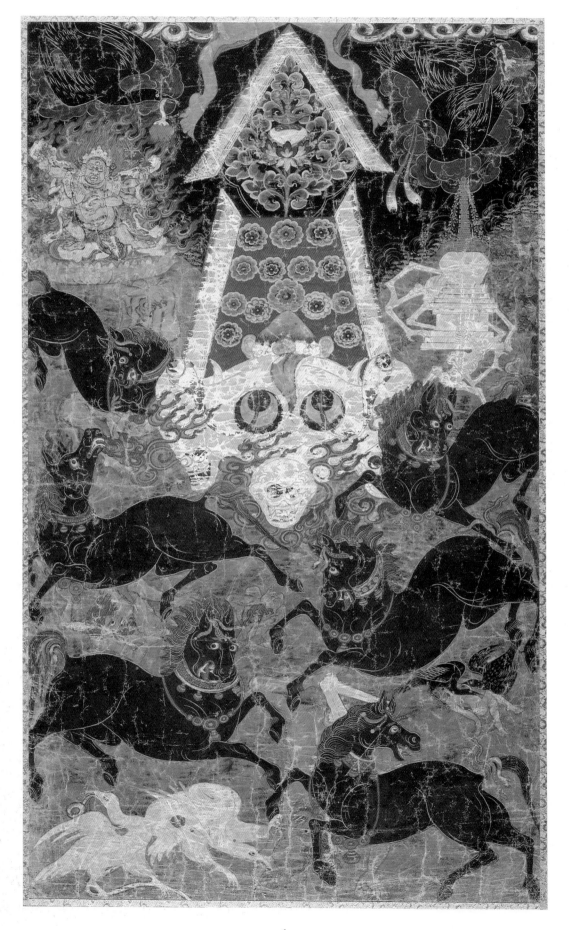

Plate 33
Palden Remati and Her Retinue
(P34)

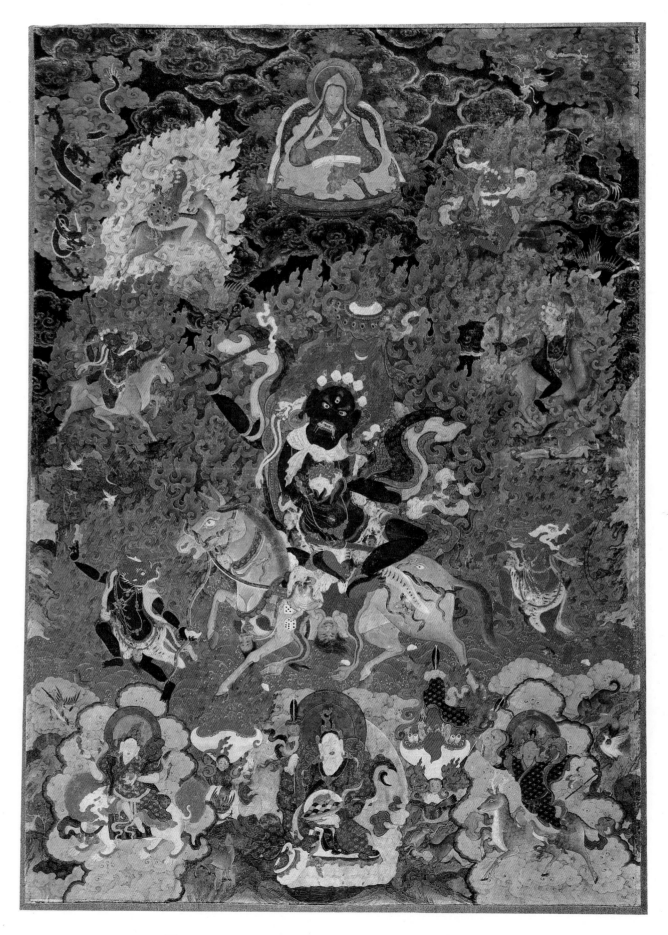

Plate 34
Temple Hanging
(P44, detail)

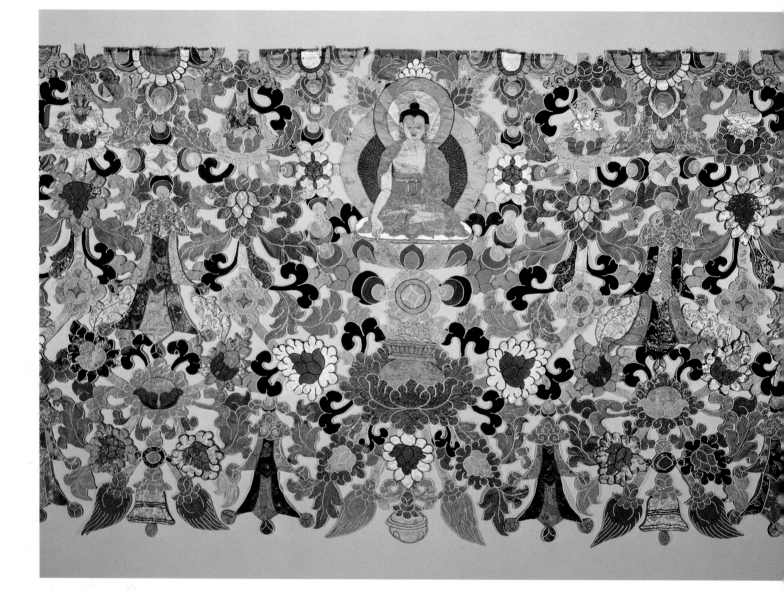

Plate 35
Bodhisattva Avalokitesvara
(S2)

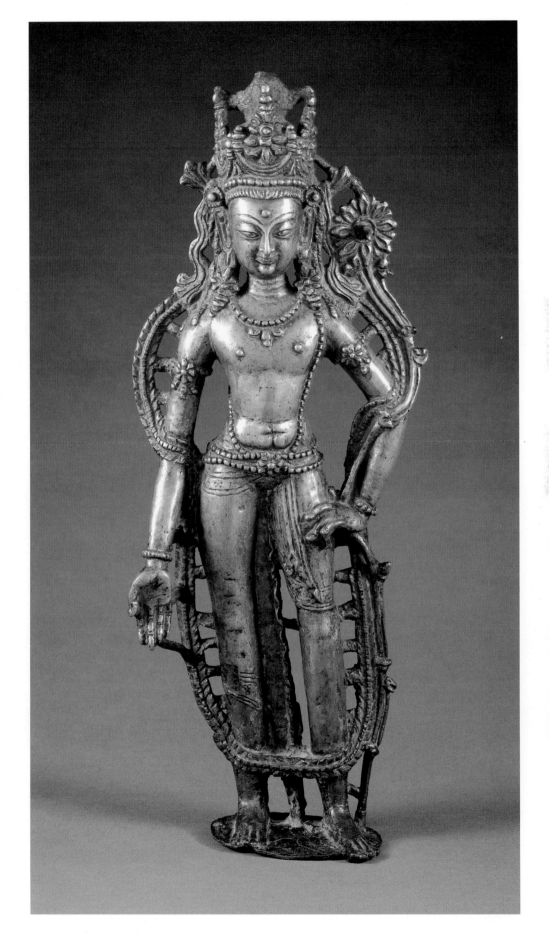

Plate 36
Eleven-Headed Avalokitesvara
(S3)

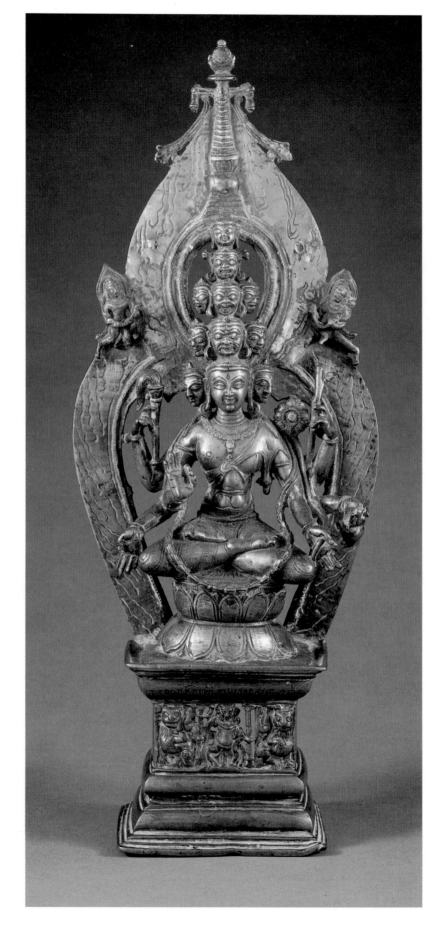

Plate 37
Bodhisattva Manjusri
(S9)

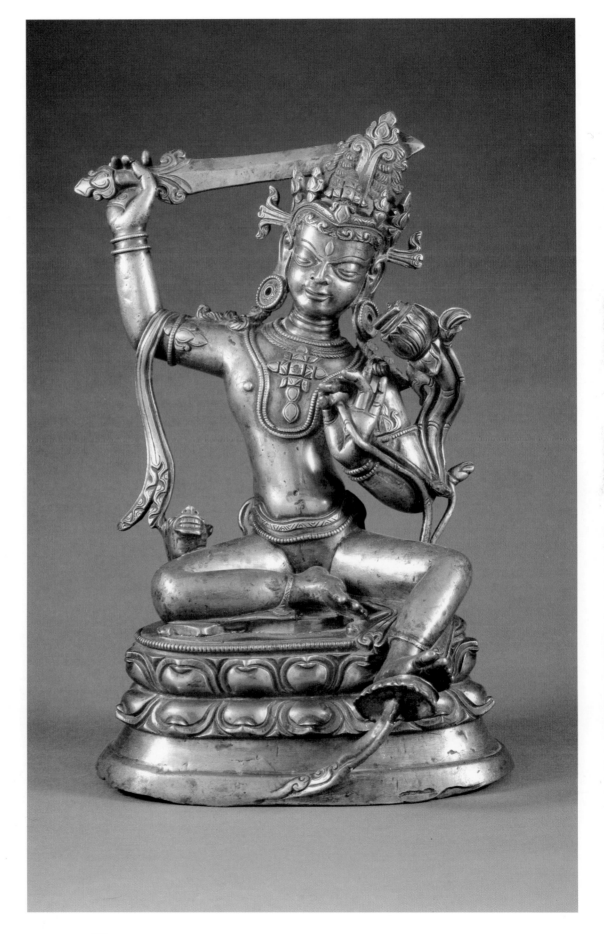

Plate 38
Vajrapani in Yab-Yum
(S23)

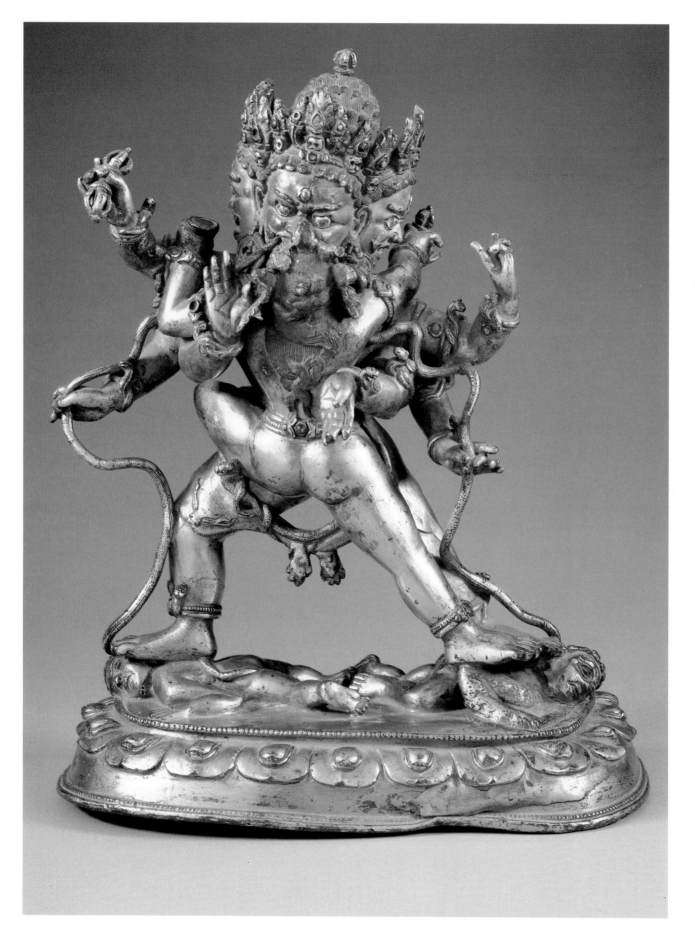

Plate 39
An Unusual Form of Mahakala (?)
(S24)

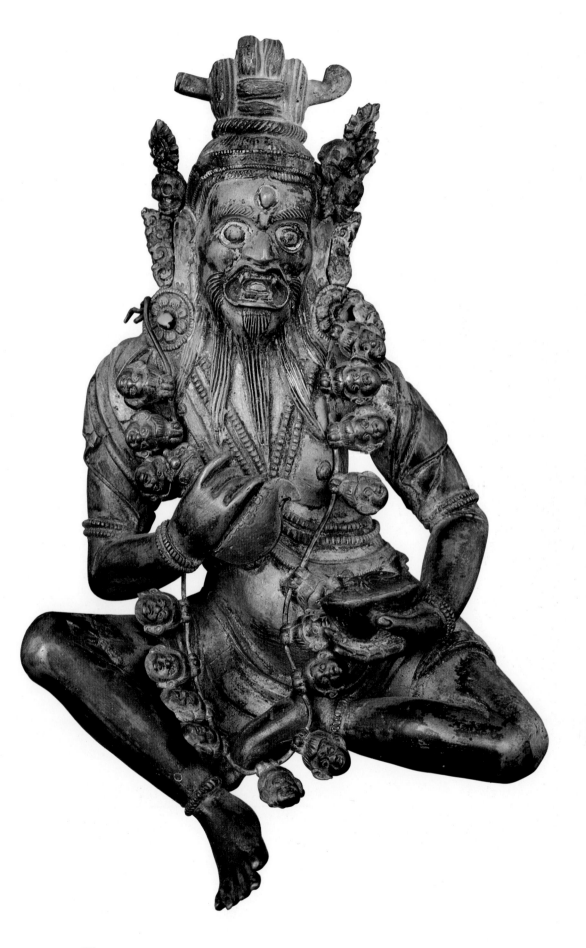

Plate 40
Goddess Nairatmya
(S25)

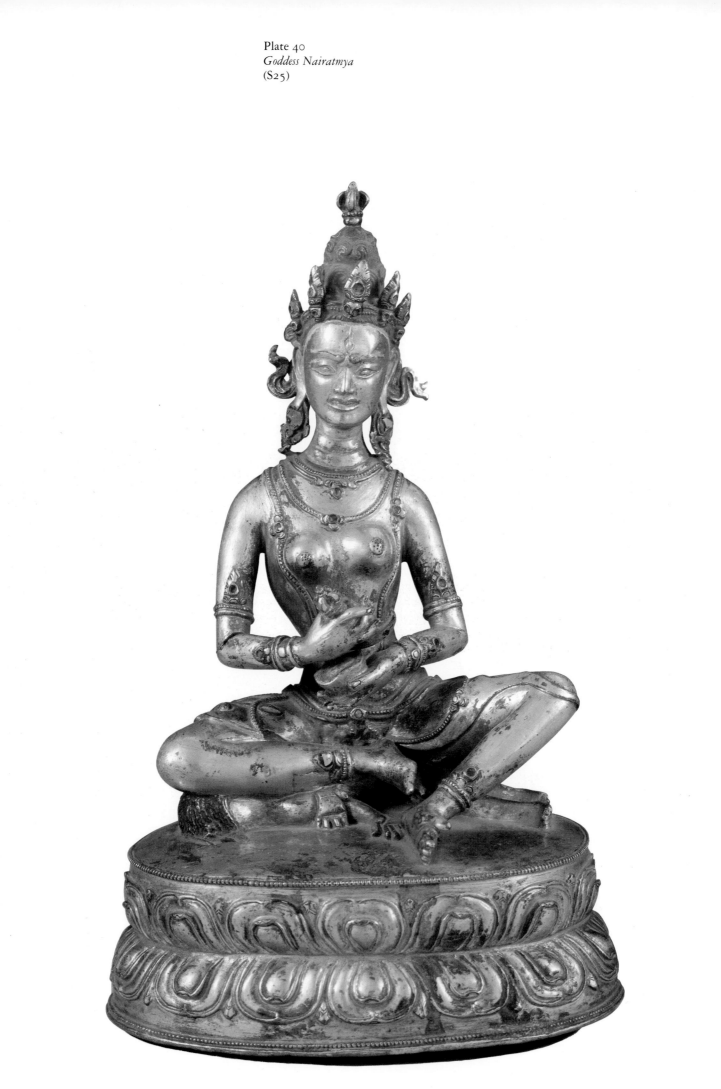

Plate 41
Vajrabhairava in Yab-Yum
(S28)

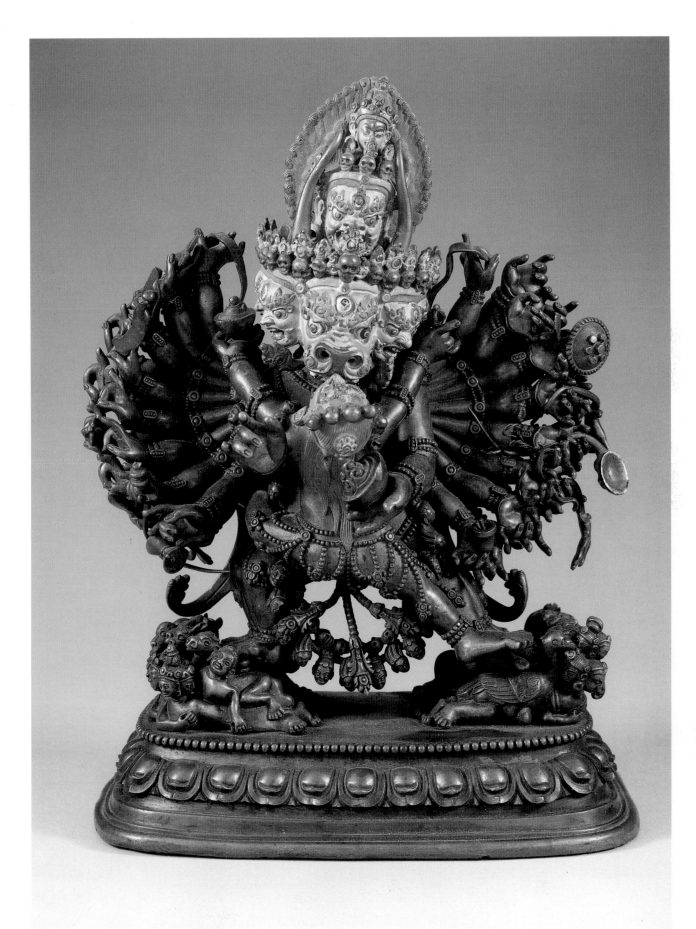

Plate 42
Dampa Sangye
(S31)

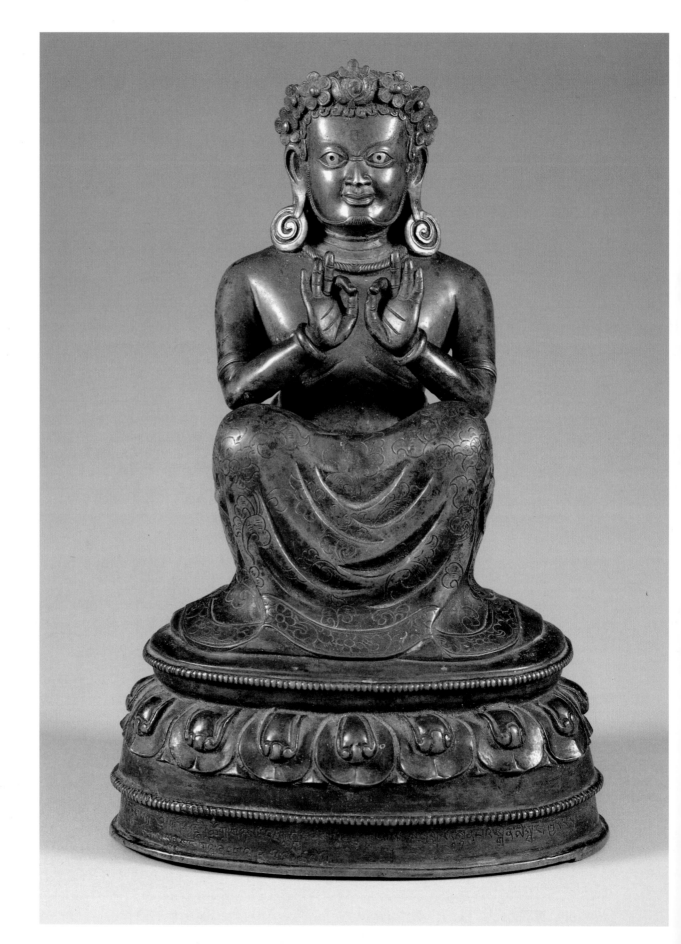

Plate 43
A Mahasiddha
(S33)

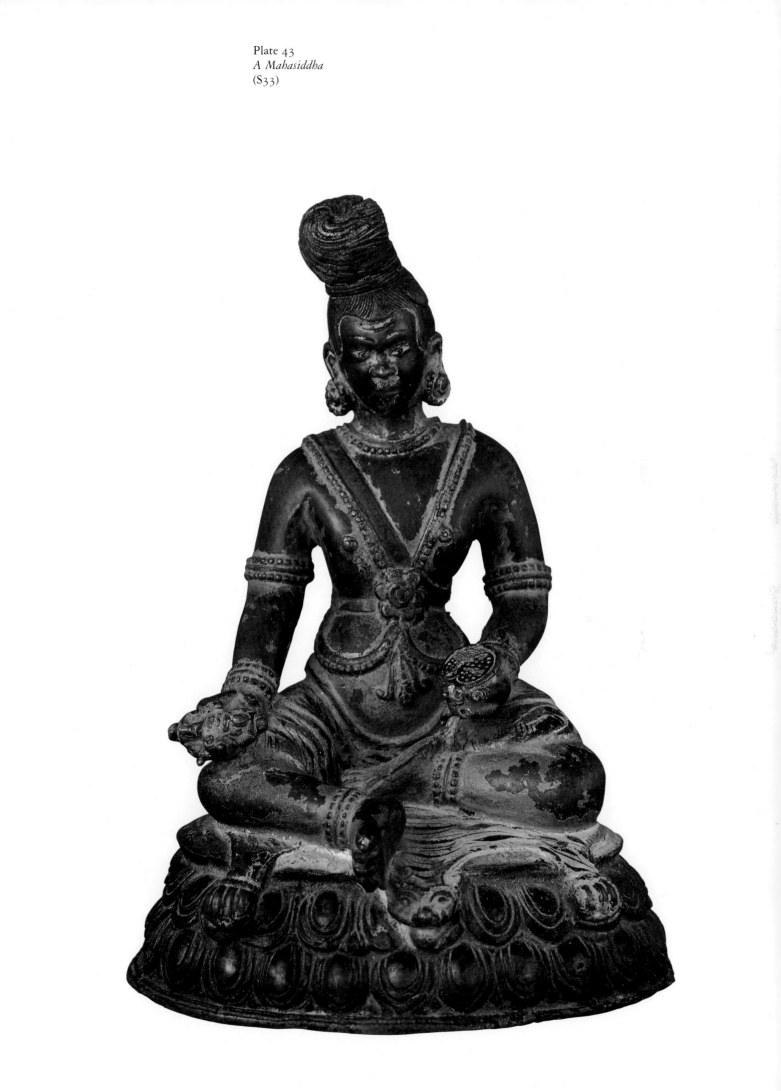

Plate 44
Arhat Kalika
(S36)

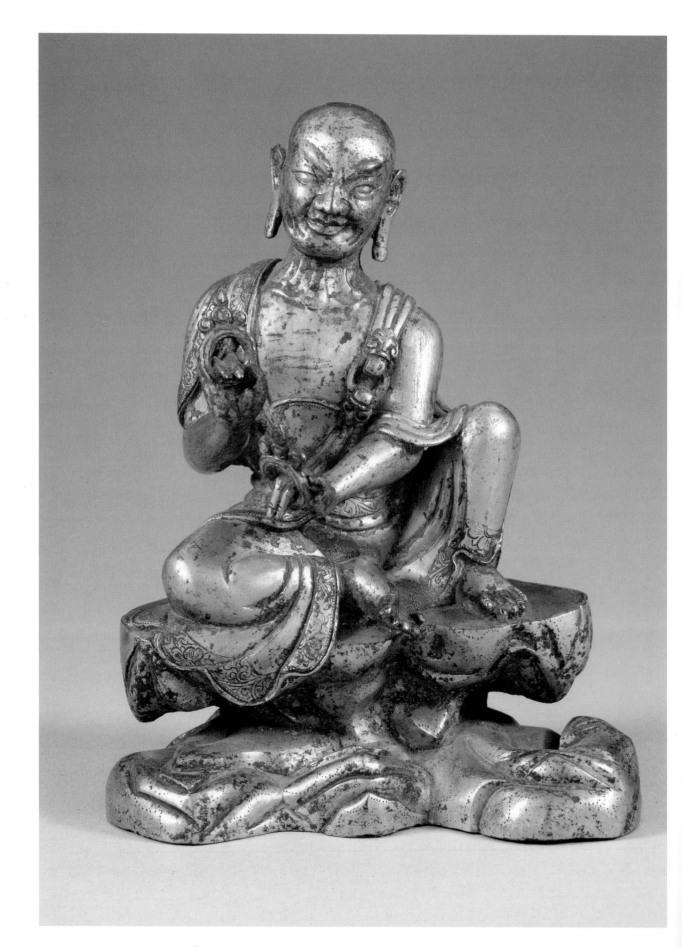

Plate 45
Ritual Dagger (Phurpa)
(R7)

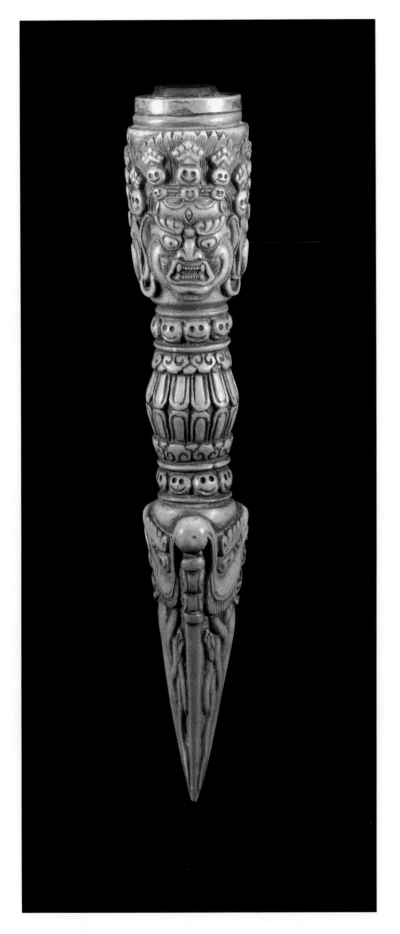

Plate 46
Sword
(R10)

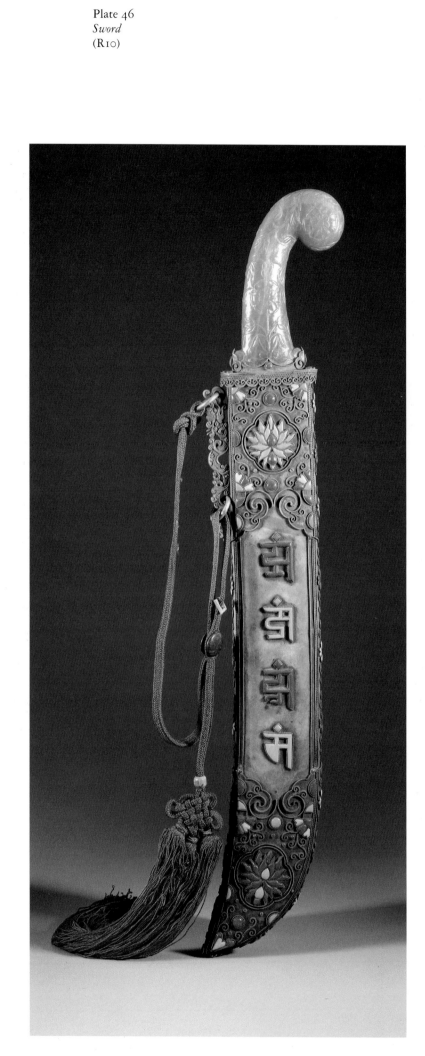

Plate 47
Conch Shell
(RII)

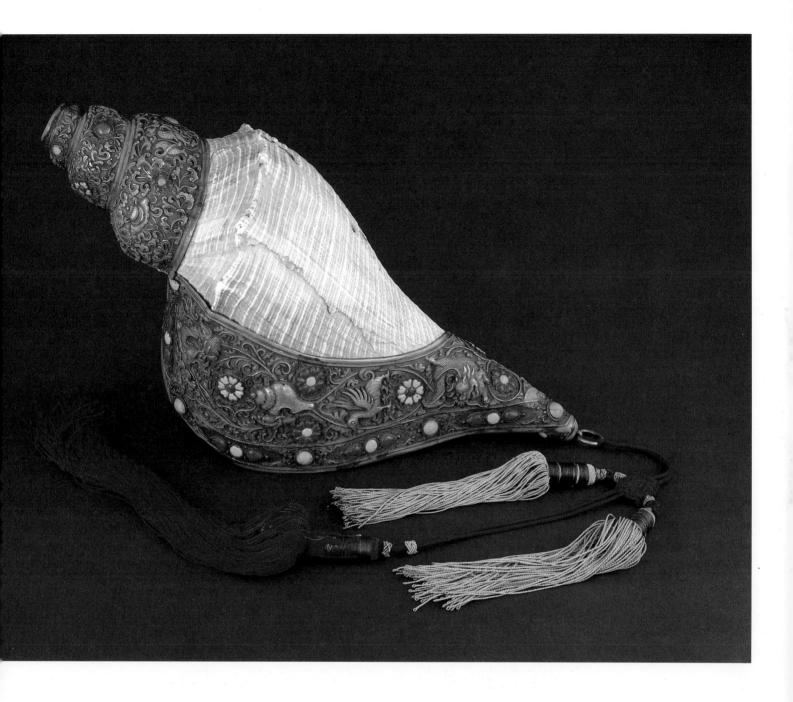

Plate 48
Pair of Butter Lamps
(R14)

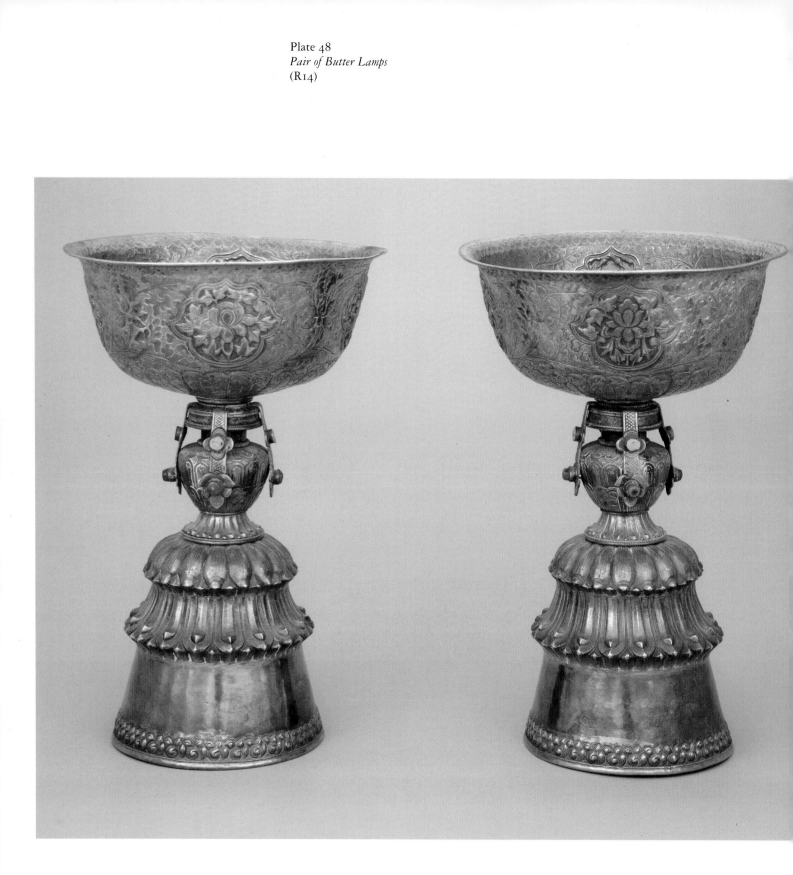

Catalogue

A look at a map of Tibet makes it clear that the southern half of the country is its most densely populated region, and it is from this area that much of Tibet's art comes. For purposes of attribution, the country has been divided here into three broad regions, as is commonly done in works on Tibetan geography (*see* Wylie 1962). These are: western Tibet, comprising the wide region known as Ngari Khorsum; central Tibet, including the provinces of Tsang and Ü; and eastern Tibet, consisting of Kham and Amdo. Ladakh and Zanskar, which are parts of India, are here regarded as two separate but related cultural regions. Subsequent research may help in fixing more precise provenances. Until it is conducted, however, we can only attribute artworks to the broad regions defined above.

Except where otherwise noted, height precedes width in the entries on the objects in this catalogue. For most of the sculptures, height is the only dimension indicated. Where necessary, the following letters have been used to key dimensions: *h* (height); *w* (width); and *l* (length).

Unless otherwise indicated, the thankas included in this volume were painted in opaque watercolors on cotton supports. Those who wish to learn more about the materials and techniques employed in thankas or illuminated manuscripts may read Austen; Roerich 1925; Tucci 1949; and Anyetsang.

Painting

Just as Sumeru is the foremost among mountains,
just as Ganga is the foremost among rivers,
just as the Sun is the foremost among the heavenly bodies,
just as Garuda is the king of the birds,
just as Indra is the foremost among the gods,
so is Painting the foremost among skills.
 Citralakshana[1]

Of the three types of Tibetan painting—thankas, illustrations for manuscripts and their covers, and murals—only the first two are included in the Museum's collection. A thanka (written in Tibetan as *t'an ka, t'an sku,* or *sku t'an;* in English as tanka, thanka, or thangka) is a religious painting usually on cotton (*pata* in Sanskrit) that can be rolled up. Of rectangular shape, it has a thin border of red and yellow silk strips and is mounted either on plain blue silk or on Chinese brocades which, as has been noted, were often sent by Chinese emperors as gifts to the larger monasteries. The bottom of the mount, usually wider than the other three sides, may have a smaller, rectangular patch that serves as a "door" through which one may pass into the consecrated realm. Often the thanka is provided with a cover of gossamer silk and two red bands. When the thanka hangs on an altar the cover is gathered up to the top and acts as a curtain while the bands hang down across the surface of the thanka. Two narrow sticks are attached to the top and the bottom so that the thanka can be easily rolled up for storage or for a journey. Unlike the Chinese, Tibetans rarely, if ever, painted on silk. The medium was either cotton or linen; this is another instance of Indian influence. It must be mentioned, however, that no prototype of the thanka in India has survived, though similar paintings in Nepal (*paubha* in the Newari language), are dated as early as the Tibetan examples. Although there are no murals in the collection, the thankas (as well as the early manuscript illuminations) provide us with a good idea of what the wall paintings in Tibetan monasteries look like, for in terms of both style and composition they are remarkably alike.

It has already been mentioned that the Tibetans were among the most indefatigable translators of sacred texts the world has ever known. The books themselves are regarded as sacred, for just as the image symbolizes the body of the Buddha, the book represents his speech. Reading the sacred books, whether or not the contents are understood, is an essential part of a monk's daily routine. Unlike Indian and Nepali manuscripts of the early period (tenth–twelfth century), which were written on birch bark or palm leaves, Tibetan books were all written on local, handmade paper, which was introduced from China. However, the shape of the books followed the Indian format of birch bark or palm leaf manuscripts, even though, because of the greater flexibility of paper, the Tibetan pages are of a considerably larger size. Also, as in Indian manuscripts, the illuminations are placed either in the center (**M1**) or at the ends of a page (**M4**), and the wooden covers are carved on the outside and painted on the inside. Both on the page and the cover the representations are usually of divine figures, which may or may not relate to the text. As was the case in India, these images were not simply illustrative; rather, it was believed that they would protect the manuscripts from harm. And since the images are symbolic of the body of the Buddha, their presence further increased the potency of the text.

The group of manuscript illuminations and covers in the Museum probably forms the world's richest collection besides those found in some Tibetan monasteries. Although there are examples of manuscript illuminations in other collections, the dozen pages of the *Prajnaparamita* manuscript (**M1**) are not only the oldest but also the only surviving examples of western Tibetan paintings outside of those in the monasteries themselves. They reveal a direct stylistic kinship with the tenth-to-eleventh-century murals at such sites as Toling, Tabo, Mannang, Sumda, and Alchi[2] in western Tibet. Strikingly similar to the murals in the Dukhang and the Sumtsek temples at Alchi, which were built in the mid-eleventh century,[3] the *Prajnaparamita* paintings (with the exception of three illustrations) reflect the same brilliance and lustrous coloring, and the same attraction for elegant, sumptuously clad, swaying figures with pinched waists and full bosoms, that are hallmarks of the Kashmiri figurative tradition. Indeed, along with the western Tibetan murals, these manuscript illuminations are as important for the early history of Kashmiri painting as they are for the early history of Tibetan painting. They also demonstrate that the Kashmiri artistic tradition was already strong in the tenth and eleventh centuries in western Tibet, when Rinchen Sangpo returned from Kashmir with thirty-two artists. Unfortunately, but for one or two manuscript covers found at Gilgit, no examples of Kashmiri painting are known to have survived. However, because of the close relationship between sculptures preserved in western Tibetan monasteries and those that remain in situ in Kashmir, we can easily surmise that a similar kinship existed with paintings. Thus, undoubtedly, the Tibetan tradition is correct when it states that one of the stylistic sources for Tibetan art was Kashmir.[4] Be that as it may, the style in which the early *Prajnaparamita* illuminations were done may appropriately be designated as the Tibeto-Kashmiri style.

We are more fortunate in documenting influences from eastern India, for both Nepali and Tibetan monasteries have preserved a vast quantity of manuscripts that were written and illustrated in various monasteries of Bihar and Bengal. During the tenth and eleventh centuries much of eastern India, including Bihar and Bengal, was ruled by the Pala dynasty. Many of the Pala monarchs were generous patrons of Buddhism and strongly supported the major monasteries in the region. The style of art that flourished at the time in Bihar and Bengal is generally referred to as the Pala style.

According to Tibetan tradition, the Pala school of art strongly influenced the art of Tibet.[5] Unfortunately, we know little about the physical presence of artists from eastern India in Tibet, but it is likely that some traveled in the retinue of Atisa and other Indian monks in the eleventh and twelfth centuries. Apart from the surviving illuminated manuscripts, evidence for the existence of a vigorous Pala style of painting is provided, unexpectedly, from a Chinese source. A Chinese text informs us that a technique of coloring had been developed at Nalanda, one of the principal centers of Buddhist art during the Pala period, which was unknown in China.[6] In any case, a recognizable style of painting developed in Tibet in the eleventh century that may justly be called the Pala-Tibetan style.

There were two distinct versions of the Pala-Tibetan style which appear to have been connected chiefly with the Kadampa monasteries between the eleventh and the fourteenth century. One style developed in the central region and the other in western Tibet. Vestiges of the style may be seen in the murals of such early Kadampa monasteries as Nethang (where Atisa died), Nesar, Dranang, and Iwang—the latter being the most important. The few pictures of the Iwang murals published by Tucci leave no doubt that their style is extremely close to that of the two thankas (**P1, P2**) reflecting the Pala-Tibetan manner.[7] With regard to the Iwang temple Tucci writes: "The Iwang temple, hidden in a dale left of the mountain road

midway between Samada and Kangmar on the map, was the oldest of all. In the small cell, standing Bodhisattva images surround the Buddha in the middle."[8] This is the basic subject matter of both of the Museum's thankas just referred to, as it is of most other examples in this style from early Kadampa monasteries. The cult of the Eight Bodhisattvas appears to have been especially popular with the Kadampas and must once have been more familiar in Nalanda than the present evidence indicates.[9]

The larger of the two paintings in the collection (P1) is by far the more art historically interesting, because of its inscription, although the smaller (P2) is much better preserved and is perhaps the more beautiful. The inscription on P1 states that the painting was dedicated in Ba-yul, which is in E-yul and was a relatively obscure retreat for monks. On the other hand, both Phan-yul and Bya-yul were actively associated with the Kadampa orders; one wonders if Ba is an orthographical error for Phan or Bya.

In any event, this Pala-Tibetan style, with its distinctive coloring (which was noted by the Chinese), its slim, willowy figures wearing peculiar jewelry and pointed diadems, and its strong emphasis on linearism, was very likely developed in those central Tibetan monasteries which were associated with the Kadampas. During the period of Tibet's close relationship with the Xixia kingdom, the style traveled as far into China as Kharakhoto,[10] which was destroyed by the Mongols in 1227. Shortly thereafter, however, artists from central Tibet must again have been employed to paint various caves at Dunhuang, which they rendered in the Pala-Tibetan style.[11]

The western Tibetan version of the same style, more cursive and freely drawn and revealing neither the sophisticated coloring nor the elegance of the central Tibetan manner, may be seen in one painting in the collection (P3). Other thankas in this style were recovered from the Mount Kailasa region; and one of the temples at Alchi in Ladakh is painted entirely in this manner.[12] Although not so refined as the Pala-Tibetan style, the western Tibetan idiom has a rustic vigor and expressiveness that make it seem closer to the Kharakhoto thankas than to the central Tibetan mode. I have written elsewhere that the Alchi murals in this style may have been rendered for the Drigungpas, a subsect of the Kagyupas, around the year 1215.[13] It is interesting to note that Heather Karmay has suggested that the same order may have had something to do with the Kharakhoto thankas.[14] Further evidence for ascribing the Museum's thanka to western Tibet is the costume of the figures at the bottom.

The remaining thankas from western Tibet reflect three manners which, though distinct, share certain stylistic features. Of these, the Guge style is well-known (P6–P8);[15] the style in which the Milarepa (P14) was painted is difficult to localize; and the thanka representing Amitayus (P17) must now be considered to be a fine example of the manner that flourished in sixteenth- and seventeenth-century Ladakh.

The three Guge thankas are clearly recognizable examples of that style. Guge was the kingdom in western Tibet to which King Yeshe Ö belonged. As noted, at least two major styles of painting can be discerned as having appeared in that region between the tenth and the fourteenth century: the Tibeto-Kashmiri style and the Pala-Tibetan style. By the fifteenth century, however, when the three paradise thankas in the collection (P6–P8) were painted, a notably different style, which we now distinguish as Guge, was prevalent.

Perhaps the most striking difference between the early Tibeto-Kashmiri style (**M1**) and these three thankas in the Guge style is in the application of colors. The colors are subdued and of muted tonality, no longer ravishingly lustrous and vibrant, more like Nepali paintings of the time. No attempt has been made to model the figures by graduating the colors, and the pigments are derived in a different manner and from different sources. The figures show a continuation of the earlier type in the rendering of the principal personages, who have round, bloated faces vaguely reminiscent of the Kashmiri-style physiognomies. The intrusion of a new form that bears a direct resemblance to figures in the narrative panels of fourteenth- and fifteenth-century Nepali paintings is also evident. However, in the figures of the principal bodhisattvas flanking the seated Buddhas in the Guge-style thankas, we encounter a mannered elegance and a preoccupation with scarves and accessories that one observes in the early fifteenth-century *kumbum* at Gyantse.[16] The lotuses on which the Buddhas sit with their stylized and curly petals are quite different from Kashmiri-style lotuses of the artichoke variety, and again are more common in the Gyantse murals and in the fifteenth-century sketchbook of the Newari painter Jivarama.[17] In general, the crowded compositions, the architectural details, some of the figurative types, and the coloring (with its preponderance of red) make this fifteenth-century Guge style a fascinating amalgam of the earlier Tibeto-Kashmiri manner and the Sakyapa style of central Tibet, especially of Gyantse. What must be emphasized is that there are no perceptible traces of any Central Asian features in this style, although one painting in the collection, which will be discussed presently, may show vestiges of the Central Asian tradition.

Perhaps the most fascinating, and stylistically enigmatic, western Tibetan thanka in the collection is the one depicting Milarepa and scenes from his spiritual experiences (**P14**). Its kinship with the fifteenth-century Guge thankas is evident from the similar treatment of the throne and the lotus on which the saint sits, while some of the demons attacking him have the same expressiveness as the *yakshas* (gnomes) and lions supporting Bhaishajyaguru's throne (**P8**). The surface is crowded, but, in contrast to the sprawling composition of the two paradises (**P6**, **P7**), this thanka's various scenes are depicted in separate mini-compositions around its central figure in a manner much loved by the Nepalis, but also occurring in earlier Central Asian paintings.[18] The coloring is quite different from that used in the Guge thankas, revealing both a richer palette and brighter tonalities; this feature is also reminiscent of Central Asian works. The most curious features of this thanka are its landscape elements, which include variegated colors and snowy peaks that are quite unlike the mountains in Sino-Tibetan-style paintings or in contemporary Nepali *paubhas*. This indicates a strong influence of the Central Asian painting style, in which mountainous landscapes are represented as a series of undulating and alternating peaks and valleys. A similar conceptualization is also apparent in an arhat thanka in the collection (**P9**). These landscape elements may have been extrapolated from earlier Central Asian-style paintings that were available to Tibetan artists.[19] It may be further noted that the group of figures standing immediately above the tent below Milarepa's throne includes several that are clearly derived from Central Asian pictures, as does the group of attacking demons in the upper-right corner. However, the variegated colors of the rocks are dictated by the Tibetans' own inclination to describe mountains in terms of diversely colored gems. Milarepa's poetry also uses this imagery, and the unknown master responsible for this beautiful thanka may have been inspired by the rich metaphors in the saint's poems.

An important thanka in the collection (**P17**), previously considered to be of the Guge school, was very likely commissioned by the Ladakhi royal family in the early part of the seventeenth century. The style of this painting can be definitely

related to the murals which have survived in the palace temples at Basgo, the Ladakhi capital. Although derived from the fifteenth-century Guge style, many features of this thanka reflect departures that are very likely the result of central Tibetan influences. What is perhaps of greater interest is the fact that the painting contains portraits of some members of the ruling family. Idealized portraits also appear in other paintings (M7, P14), and these representations are of great importance for the study of costumes, especially in western Tibet.

One of the strengths of the Museum's collection lies in the several magnificent paintings it contains that were commissioned by the Sakyapa monasteries of south-central Tibet, primarily in the province of Tsang, the traditional enclave of this powerful order. As noted in the General Introduction, the Sakyapas rose to power in the thirteenth century due to their close association with the Yuan dynasty in China. Much of the wealth that consequently filled the coffers of the Sakyapa monasteries was expended in religious benefactions and artistic commissions. Between the thirteenth and the seventeeth century, Sakyapa monasteries, such as those at Shalu, Ngor, and Gyantse, became active centers of artistic productivity.

Some Sakyapa prelates appear to have been especially fond of foreign artists and patronized both the Chinese and the Newars of Nepal. Newari artists were particularly associated with the Ngor monastery, whose founder imported artists from the Kathmandu Valley in 1422 to decorate his temple. They also worked alongside their Chinese colleagues in the Shalu monastery in the fourteenth century and later in the *kumbum* (its principal temple) of Gyantse. One thanka in the collection may have been painted in Gyantse (P11), while several others were very likely executed in the Ngor monastery. The early Hevajra mandala (P5) could have been painted in the Narthang monastery toward the end of the fourteenth century; it is one of the earliest extant Tibetan mandalas. Unusual among the fifteenth-century Sakyapa thankas, the impressive lineage painting (P13) may have been rendered in the Ngor monastery or in Thubten Namgyal, the monastery founded in 1478 by one of the principal personages in the thanka. Its style, however, differs little from that of the Ngor and Gyantse murals. All these thankas reflect strong influences of the contemporary Nepali style, especially in their emphasis on red, which is intense and has a slightly maroon tinge; in their careful draftsmanship, with every detail drawn very carefully and patiently; in their penchant for fine scrollwork which could compete with the most delicate lacework; and in their figurative forms that combine the Tibetan love for expressiveness and power with the Nepali predilection for gentle contours and subtle features.

◆

The extent of Chinese influence on Tibetan paintings has yet to be resolved. Considering the Tibetans' lengthy occupation of Central Asia during the period of the Yarlung dynasty, we can assume that Chinese paintings of the Tang period were known in Tibet, but none has surfaced. On the other hand, there is clear evidence of the presence of Tibetan artists in Central Asia as early as the ninth century.[20] Eastern Tibet was always susceptible to Chinese influence, but in the central region of the country the impact is less obviously discernible.

What does seem clear is that the Chinese aesthetic did have a profound effect on the Tibetan artistic tradition, especially in the representations of the arhats and in landscapes in general. It has already been mentioned that one of the traditions of painting the arhats was brought from China in the tenth century by the monk Lume. As has also been noted, vigorous exchange of works of art went on between the Tibetan monks and the Chinese emperors of both the Yuan and the Ming dynasties. During the fourteenth and fifteenth centuries, Tibetan religious establishments at Shalu and Gyantse invited Chinese painters to paint murals. Thus, the

Tibetans were very likely aware of several Chinese styles from which they borrowed whatever elements they admired to create their own distinctive manners. This is evident in a remarkable representation of an arhat (**P4**), which remains one of the earliest thankas reflecting Chinese influences.

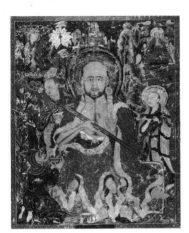

P4

No Chinese painting of the arhats is so densely packed with figures and vegetation as this thanka is. Clearly, we are witnessing in this work the sort of *horror vacuii* that only a Tibetan artist would inherit from the Indo-Nepali tradition. There are no open spaces here, and natural forms, although sensitively rendered, remain subordinate to the human or divine figures. But perhaps the most significant difference may be seen in the expression given to the arhat's eyes and to those of the kneeling foreigner. The eyes are particularly intense, and in the case of the devotee, they seem to jump out of their sockets. This characteristic is frequently employed in Tibetan art (S32, S35) to express the luminous, inner effulgence of a great yogi who has achieved his goal. (In Southern Song China the cult of the arhats was particularly popular with the Chan Buddhists; the arhats are often portrayed there as contemplative figures whose faces reflect their inner calm.)

The artist responsible for this beautiful thanka was a great eclectic who was familiar with the various Chinese styles of arhat painting prevalent in the Song and early Yuan periods but who was not a slavish imitator. He followed none of the styles explicitly, but extrapolated elements from several to create his own distinctive manner. It also seems evident that the artist was a Tibetan rather than a Chinese.

Like tigers who cannot do without human blood once they have tasted it, Tibetans became totally engrossed with the pictorial possibilities of landscapes once they discovered their charm and potential—especially after the thirteenth century. Mahasiddhas and lamas, as well as arhats, were placed in evocative landscapes that borrowed elements from the Chinese styles, but the Tibetans used them in more imaginative and colorful ways. Less concerned with their surroundings, the Tibetans did not explore the relationship between light and shadow, as the Chinese did; nor were they interested in depicting the changing seasons or in communicating with nature. But they did use some of the Chinese motifs and forms: the blue-green rocks of Yuan and early Ming paintings; cascading streams and gentle waterfalls; limpid pools with lotuses and ducks; vast blue skies with floating, stylized clouds; lively and natural animals and birds; and flowering as well as gnarled trees. They combined all these elements in endless varieties, sometimes with extraordinary visual effects. This newly founded pictorial vocabulary was used over a wide area, from Gyantse in central Tibet to Kham in the east. Styles differed from one region to another, however, depending on the skill and aesthetic sensibility of the artist.

It is not difficult to isolate specific Chinese motifs and pictorial devices in Tibetan landscape thankas, yet the overall expression is essentially Tibetan. Because Tibetan artists were constantly exposed to so many different traditions, often at the same time—in the Shalu and Gyantse monasteries, for instance, artists from Nepal and China worked alongside their Tibetan colleagues—they had, of necessity, to be great synthesizers. How well they succeeded in creating their own distinctive style may be seen by considering a particularly colorful thanka of about 1500 in the collection (**P15**). Though elements of the Nepali tradition are visible here, along with several Chinese-derived details (such as the robe folds and pink flesh), the fact of overriding importance is that the style—in its figurative forms, in the boldness of its dense, glowing colors, and in its overall aesthetic vision—is decisively Tibetan. The organization of the composition, with the monks placed in golden-arched niches, is remarkably like similar arrangements of fifteenth-century portrait sculptures in the monastery of Ladong.[21]

Because it is located in the east, the province of Kham has always been in close touch with Sichuan, Yunnan, and the northwestern provinces of China. Although knowledge of the early artistic traditions of Kham is almost nonexistent, one style of Tibetan painting that probably originated in that region is called, in Tibetan, Karma-gadri. Most known examples of this style (**P26, P28**) belong to the seventeenth century or later and, as already suggested, the style was inspired, if not invented, by the famous Karmapa Mikyö Dorje. The style is very likely called Karma-gadri because of its association with the Karmapas, who have always exerted strong influence in eastern Tibet.

The models for this style, however, are probably Chinese paintings of a much earlier period. The emphasis in Karma-gadri paintings on open spaces with small figures grouped together in clusters, as well as these works' sparse use of landscape elements, also reduced in scale, makes them seem to echo the arhat paintings of such Yuan masters as Zhao Mengfu (Chao Meng-fu) (1254–1322), Lu Xinchong (Lu Hsin-ch'ung) (thirteenth century), and others. Indeed, a set of arhat paintings, two examples of which are now in the Museum of Fine Arts, Boston, may well have served as the distant forebears of the Karma-gadri style.[22] Paintings such as the thirteenth-century arhats at Boston may have inspired the "open" landscape style in Tibet, especially the grouping of figures in receding planes surrounded by empty spaces, as if to emphasize the emptiness of both samsara and nirvana.

How complex the study of Tibet's pictorial tradition is can best be illustrated by the two sections of two pattern books illustrated as figures 1 and 2 and briefly discussed in the General Introduction. Figure 2 shows arhats seated in rudimentary landscapes. The Newari colophon informs us that it was rendered by the Newari painter Jivarama in Tibet (probably at Gyantse) in 1435. Jivarama was apparently aided by a Tibetan colleague.[23] The book is filled with drawings and patterns that are employed only in Tibetan paintings and relate closely to fifteenth-century murals in the *kumbum* of Gyantse. Not only does this pattern book throw light upon the antiquity of arhat paintings in Tibet, but it raises the possibility that some Tibetan paintings may actually have been painted by Newari artists in Nepal rather than in Tibet. Why else would a Newari artist prepare a pattern book in Tibet and bring it back with him to Nepal?

The other pattern book (fig. 1) is even more fascinating. It was sketched by Vajracarya Srimantadeva in Lhasa in 1653. The section illustrated here is a graphic composition reflecting a style of arhat thanka that was extremely popular in Tibet and that is generally considered to have originated in the eighteenth century. The places associated with the style are the great monasteries of Tashilumpo and Narthang. And yet, we encounter in this book the style well formulated in Lhasa in the mid-seventeenth century. Moreover, once again a Newari artist, who was also a *vajracarya* or priest, took the book back home with him, no doubt to have it serve as an aid in the painting of thankas for the Tibetan market. Indeed, if the document did not contain Newari writing, few scholars would have hesitated to suggest a Tibetan provenance for it, based purely on style. In this connection, it may be pointed out that the collection contains two rare sketches of mahasiddhas (P19 a,b) that are stylistically related to these 1653 drawings. The inscriptions on them, however, are in Tibetan. The facts that they are sketched on both sides and are small clearly indicate that they were meant to serve as models. But were they done by a Tibetan or a Newari artist?

One can draw another conclusion from the existence of such pattern books —that they exerted some influence on the Nepali painting tradition, playing a role, at least, in the introduction of landscape elements. Certainly by the seventeenth

century, Tashilumpo had become an important center of pilgrimage for Buddhist Newars. At least one painting in the collection (P39) was produced at Tashilumpo for a Newari patron and brought back to Nepal. There are many other examples, several of which are inscribed, of similar paintings created specifically for Newari merchants visiting Tashilumpo both for business and pilgrimage.[24] Finally, Tibetan art may also be said to have exerted some influence on Chinese Buddhist art after the thirteenth century. However fascinating such topics are, they are beyond the scope of this catalogue.

◆

The Museum's collection of Tibetan paintings is one of the most comprehensive outside Tibet. Most major styles and expressions, from the eleventh through the nineteenth century, are represented by outstanding examples that are fascinating both for their iconographic complexity and for their aesthetic characteristics. Between the eleventh and the thirteenth century, the strongest influences were exerted by the Indian schools of Kashmir and Bihar. The influence of Nepal was pervasive throughout the period, especially in southern and central Tibet, where the monasteries frequently employed professional artists from that country. While no early painting in the collection reflects either Chinese or Central Asian influences, at least one thanka (P3) clearly shows that Chinese pictorial elements were introduced by the fourteenth century; another (P14) may echo a few Central Asian elements. The influence of the Chinese aesthetic is evident in specific features of landscape thankas, but the landscapes of fantasy created by the Tibetans generally reflect the richness of their own imaginations. Whether Tibetans borrowed from India, Nepal, or China, they were always creative enough to adapt the foreign elements to suit their own aesthetic and religious needs.

No matter what the style, rich and varied color is the most striking feature of Tibetan painting. This penchant for color also affects many other areas of the country's artistic expression. Even though the external walls of Tibetan buildings are austere and colorless, the gilded and brilliant tiled roofs, the interior pillars and walls, the richly woven carpets and brightly painted furniture—as well as the thankas and hangings—all reflect this innate affinity. From the earliest times, the tents of the wealthy have been embellished with bright and cheerful designs. Their personal ornaments and ritual articles have always displayed the Tibetans' inordinate fondness for rich and densely colored stones—turquoise, carnelians, rubies, and agates—rather than diamonds. This liking for bright surfaces is evident in both their sculpture and their paintings, in which the presentation of forms often seems to be an excuse for displaying bold and vivacious colors. Here, Tibetans seem to be closer to the Indian aesthetic, in which color usually overwhelms both draftsmanship and composition, than to the Chinese concern with clarity of line and subtle brushwork. As we shall see, even when the Tibetans borrowed landscape elements from the Chinese tradition, they suffused their visionary landscapes with brilliant hues.

1. A slightly rearranged version of the passage may be found in Goswamy and Dahmen-Dallapiccola, p. 9.

2. See discussion in M1 and references cited therein.

3. See Snellgrove and Skorupski, 1977, for a discussion and illustrations of the Alchi murals. Also, Pal, 1982 B.

4. "In Kashmir, later, spread a school of painting and sculpture of a certain Hasuraja, which is known as the school of 'Kashmir.'" From the *dPag bsam ljon bzang* by the lama Lumpa Khenpo (1702–1775); Goswamy and Dahmen-Dallapiccola, p. 114.

5. Ibid. These artists apparently lived during the reigns of the Pala kings Devapala and Dharmapala in the ninth century. It is interesting that the passage referring to Pala kings precedes that relating to Kashmir quoted in the previous note. In that statement, by inserting the expression "later" Sumpa Khenpo seems to imply that the Kashmiri style was invented later than the Pala style.

6. See Giles, p. 135.

7. Tucci, 1973, fig. 124; Tucci, 1956, plate facing p. 158 for a mural from Dranang, which seems to be an admixture of the Kashmiri and the Pala styles; Tucci, 1949, I, fig. 78; and Liu I-se, figs. 17, 19, 23. All three paintings are said to be in the Ladong (its name in Chinese) monastery. Liu I-se dates fig. 17 to 1039 and the others to the twelfth century. The first date is unlikely, as it would make it a work rendered prior to the arrival of Atisa in central Tibet in 1044. However, a twelfth-century dating is consistent with the date suggested for the Museum's thanka. See also Hatt; and Karmay, 1975, for further discussion about the style.

8. Tucci, 1956, p. 36.

9. For the many references to the representations of the *Ashtabodhisattva-mandala* in Tibet, see Tucci, 1956. For the familiarity of this cult in Nalanda, see Pal, 1972–73.

10. For the Kharakhoto thankas, see d'Oldenburg; Karmay, 1975; and *Dieux et démons*, where several thankas are reproduced.

11. Pelliot, pls. CCCXLVII–CCCLI.

12. Olschak and Wangyal, pp. 50–51; Snellgrove and Skorupski, 1977, figs. 56–64.

13. Pal, 1982 B.

14. Karmay, 1975, pp. 41–42.

15. For a discussion of the Guge style, see Huntington, 1972.

16. Karmay, 1975, figs. 51, 55, 57; and Tucci, 1932–41, vol. IV., pts. 1–3, *The Gyantse Temples*.

17. Lowry, 1977, pp. 107–09.

18. Hambis, fig. 146.

19. Ibid., figs. 116, 134; and pp. 185–87.

20. Karmay, 1975, pp. 7–14.

21. Liu I-se, figs. 67–71. It is not entirely clear whether the name of the monastery, as given in this Chinese publication, is Ladong or Lithang. The former seems more probable.

22. Pal and Tseng, figs. 24 a, b.

23. For a detailed discussion, see Lowry, 1977.

24. Pal, 1978, pp. 153–55.

M1

Twelve Illuminated Folios from a
Prajnaparamita *Manuscript*
Western Tibet or Ladakh,
11th–17th century
Ink, watercolors, and gold on paper
Each page: 7½ x 26⅛ in. (19 x 66.3 cm.)
From the Nasli and Alice Heeramaneck
Collection
Purchased with Funds from the Jane and
Justin Dart Foundation
M.81.90.6-17

Literature: Tucci, 1949, pp. 273–74 and
pls. C, D; Pal. 1969 A, pp. 113, 156;
Huntington, 1972, p. 113; *Dieux et
démons*, pp. 15, 74.

These twelve richly illuminated manuscript pages were recovered from Toling by Tucci, who found them "in ruins of upper Toling, among a heap of canonical works, indiscriminately flung into a store-room." Toling was an important cultural center of the ancient kingdom of Guge, and its temple was founded by the pious Yeshe Ö and Rinchen Sangpo in the tenth century.

The text on all twelve pages belongs to the most celebrated Mahayana Buddhist work, known as the *Ashtasahasrika Prajnaparamita*. Attributed to the famous Indian philosopher Nagarjuna (*see* **M4 a**), the *Prajnaparamita* is a lucid exposition of the basic philosophy of Mahayana Buddhism. Therefore, it was frequently copied by pious Buddhists. These twelve folios are among the earliest from Tibet that have survived. With the possible exception of one page (*l*), they all appear to have belonged to the same manuscript, for the style of writing is identical.

Some of the figures, which are identified by inscriptions (*see* Appendix), are deified representations of abstract philosophical concepts discussed in the text. For example, the inscription below *b* reads *stong pa nyid stong pa nyid*. Translated into Sanskrit, this means *sunyata sunyata*—in English, "nothingness of nothingness." This is one of the eighteen categories of *sunyata,* a concept of fundamental importance to Mahayana Buddhism. Two more of these categories are represented among the pictures: on folio *f* it is *asamskrita sunyata*, or "unpurified nothingness"; and on folio *h* it is *paramartha sunyata*, or "absolute nothingness." Insight (*c*) and charity (*e*) are two of the twelve perfections expounded in the *Prajnaparamita* text; it was not uncommon to represent these as goddesses. The label below *e* identifies the ferocious figure as *dad pa'i stobs,* which is Tibetan for the Sanskrit *sraddha bala* (literally, power of faith). No deity of this name is known, but *bala,* or power, is an important concept in Mahayana Buddhism. The *Prajnaparamita* enumerates five such powers of a bodhisattva. They are: faith, vigor, mindfulness, concentration, and wisdom.

Thus, unlike the Indo-Nepali tradition of *Prajnaparamita* illuminations, the pictures in this Tibetan manuscript relate directly to the text. Moreover, they introduce us to images of abstract ideas that are not common in Buddhist iconography.

MI a *Prajnaparamita with Devotees*
11th century
4⅞ x 10¾ in. (12.4 x 27.3 cm.)
M.81.90.6

b *Nothingness of Nothingness*
11th century
3 x 3 in. (7.6 x 7.6 cm.)
M.81.90.7

c *Perfection of Insight*
11th century
3⁹⁄₁₆ x 3 in. (9.1 x 7.6 cm.)
M.81.90.8
See plate 1

d *Power of Faith*
11th century
3½ x 3⅛ in. (8.9 x 7.7 cm.)
M.81.90.9
See plate 2

e *Perfection of Charity*
11th century
3¾ x 3¹⁄₁₆ in. (9.5 x 7.8 cm.)
M.81.90.10

f *Unpurified Nothingness*
11th century
3⅝ x 3 in. (9.2 x 7.6 cm.)
M.81.90.11

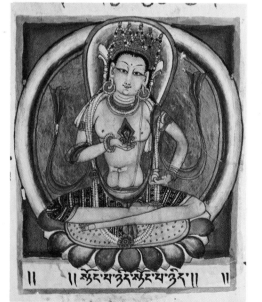

detail

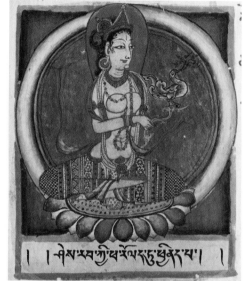

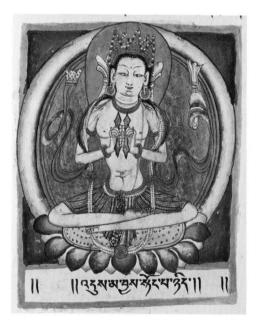

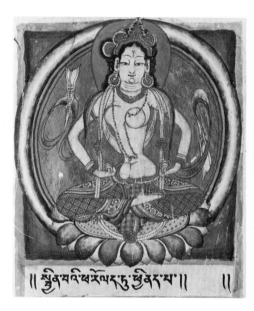

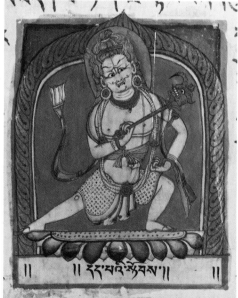

g *Buddha Vairocana*
 11th century
 3⅞ x 3½ in. (9.8 x 8.9 cm.)
 M.81.90.13

h *Absolute Nothingness*
 11th century
 3⅝ x 3 in. (9.2 x 7.6 cm.)
 M.81.90.14

i *Buddha Ratnasambhava*
 11th century
 3⅝ x 3 in. (9.2 x 7.6 cm.)
 M.81.90.16

j *A Buddha in a Shrine*
 11th–13th century (?)
 4 x 3⅛ in. (10.1 x 8 cm.)
 M.81.90.12

k *A Bodhisattva in a Shrine*
 13th–14th century (?)
 2⁹⁄₁₆ x 2⁷⁄₁₆ in. (6.5 x 6.2 in.)
 M.81.90.15

l *A Goddess*
 16th–17th century (?)
 4⅛ x 3⅛ in. (10.5 x 8 cm.)
 M.81.90.17

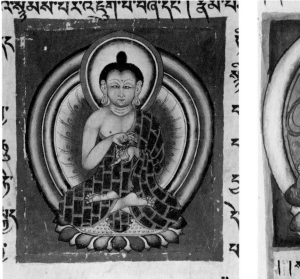

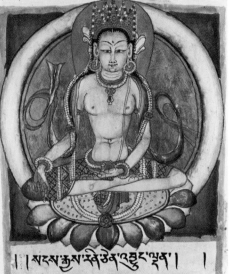

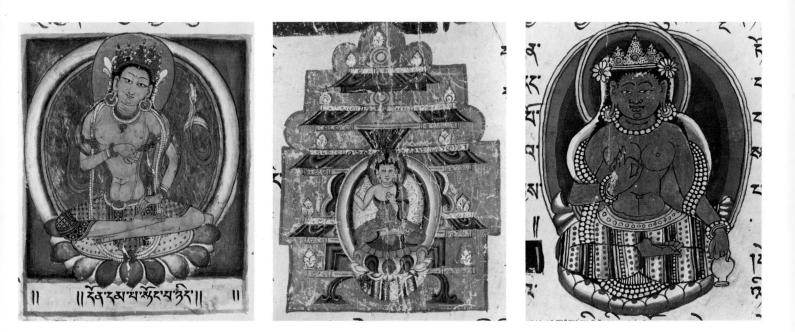

Nine of the twelve illuminations (a–i) reflect a homogeneous style and, if not made by the same hand, are very likely the products of the same school and period. They are characterized by bright colors, including a rich blue and a deep magenta red; gold is used as the background for several of the aureoles. The figures are finely drawn and the artist has made a conscious attempt at suggesting volume by strongly shading areas of the exposed bodies. Except for Vairocana, the figures are richly ornamented and attired with sumptuously printed garments and swirling, brightly colored scarves that considerably enhance their liveliness. Tall and slender and with pinched waistlines, most of the figures are shown frontally, with the exception of c, whose body is elegantly turned toward a goose with which she appears to be playing. Especially spirited is the figure of the angry male deity (d) who strides to the left, holding a handsome elephant-goad in his right hand. The details in these nine paintings are rendered with such great care that every design is precisely articulated.

The most elaborate of the compositions is that portraying Prajnaparamita (a). Unlike the other figures on this folio, whose torsos are bare, she wears a blouse. Moreover, while the others have only two arms each, she is given six. Two of the hands form the gesture of preaching, one is stretched in the gesture of munificence, and the other three hold a thunderbolt, a manuscript, and a blue lotus. Of great interest here are the figures of the monk and the kneeling devotees. All four hold flowers in their hands in a manner similar to Chinese donor figures in Central Asian paintings. In front of the goddess and between the devotees are a black plate of offerings (frontal position) and six tripods supporting bowls with heaps of grain, flowers, a candle, and two conch shells. The devotee next to the monk is dressed in the typical costume worn by western Tibetans. Similarly dressed figures are encountered in murals at Alchi in Ladakh, as well as at Tabo. Indeed, the murals of Tabo (*see* Karmay 1977) also contain figures attired, like the two devotees on the right, in coats with wide lapels and large sombrerolike hats; the two figures here have taken off their hats, evidently as a sign of respect for the deity.

When he first wrote about these manuscript pages, Tucci (1949) emphasized their importance in the history of Kashmiri painting, and correctly suggested that they are closely related to murals in Toling, Tabo, Mannang, Alchi, and other sites in the western Himalayas. He also rightly attributed them to the period in the eleventh century when Buddhism regained supremacy under the enlightened patronage of the kings of Guge. Huntington argues that stylistically the illuminations are closely related to the Tabo murals and assigns them to the late tenth century.

Two of the remaining illustrations (j and k) are not so sumptuous or accomplished as the early group of nine, but are still stylistically related to them. In both, architectural elements predominate the figures. Both illustrations also display an architectural style employing wood, though the designs of each are different. The shrine in j containing the Buddha image, with its tiered stages and pent roofs, seems to suggest a Himalayan wooden temple, whereas the shrine in k has no projecting eaves and suggests structures encountered in some Pala miniatures from Bihar. The figures, on the other hand, are of the same basic style as the group of nine, though the outline in k is thicker than in the others. An attempt has been made to convey a rudimentary sense of plasticity by using light shading, but the drawing is less accomplished and quite perfunctory. The colors

in k are similar to those in the group of nine, but the red in j is less intense. While it is difficult to be certain of their date, it seems possible that these two pictures are the work of artists who were experimenting with various styles and who were not quite so accomplished as the person responsible for the others.

The last picture (l), portraying a goddess holding a pot, is painted in an altogether different manner and is of rather inferior quality; neither in its proportions nor in its coloration and drawing does it bear any resemblance to the other illuminations. While I am suggesting a much later date for this illustration, it must be pointed out that the workmanship is of poor quality regardless of when it was produced. Seemingly, an indifferent artist came across a blank space while going through the manuscript and decided to fill it with a figure.

M2

Cover of a Prajnaparamita *Manuscript*
Central or western Tibet, 15th century
Carved and painted wood
9¾ x 27 in. (24.8 x 68.6 cm.)
From the Nasli and Alice Heeramaneck
Collection
Museum Associates Purchase
M.82.42.5
See plate 3 (detail)

This and the following cover (**M3**) very likely form a pair that once belonged to the same manuscript; not only are they of identical size, but the paintings are rendered in the same style. The outside of this cover is carved with a lotus design, and the central section is painted with large letters in gold on a red ground. On the inside is an elaborate composition showing various deities, monks, and donors. The colors on this cover are better preserved than those on the other one; they are brighter and appear fresher.

In the center of the composition is an elaborate Nepali shrine with the enthroned figure of an orange Manjusri. His hands make the gesture of preaching while holding two lotus stalks. He is flanked by two goddesses, one orange and one white, each also holding lotuses. Both sides of Manjusri's head are flanked by a manuscript on a stand and a stupa. The two inner panels on either side of the shrine have two rows of figures. In the lower row six goddesses stand on four lotuses. Of the four figures in the upper row, the two seated on inner lotuses are a bodhisattva and a monk; the outer two figures wear similar costumes—though only one has a turban on his head—and are probably lay personages. The decorative scheme of the two outer panels is identical, with iconographic variations introduced in the lower tier only. In the upper section of each panel are four dancing goddesses and five celestial beings who fly in their stylized cloud chariots to take offerings to Manjusri. In the bottom row the deities Mahakala, Lhamo, and Vaisravana are on the left and a worshiper with offerings is on the right. The offerings include a lamp, a *chöten,* a vase, and *tormas.*

The style of both covers suggests that they were painted by a Nepali artist. The designs of the central shrines in both covers and the peculiar shapes of the clouds carrying the celestials, as well as the row of pillared niches with crowning foliage and stupas in **M3**, are characteristic of early Nepali paintings

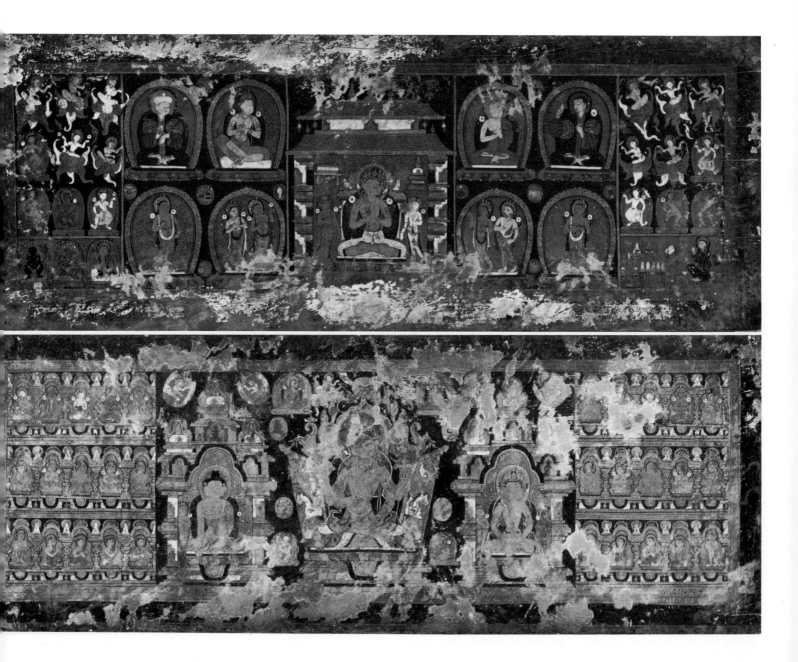

(Pal 1978, figs. 60, 70, 79). The penchant for various shades of red—the primary color used in these crowded compositions—adds to the conviction that the artist was Nepali. Greens, grays, and purples have been sparingly employed, while blue is the background color.

M3

Cover of a Prajnaparamita *Manuscript*
Central or western Tibet, 15th century
Carved and painted wood
9¾ x 27 in. (24.8 x 68.6 cm.)
From the Nasli and Alice Heeramaneck
Collection
Museum Associates Purchase
M.71.1.48
See plate 4 (detail)

On the outside of this cover a richly carved lotus which follows the rectangular shape of the object encloses a wide band of deeply carved Devanagari letters in the stylized script known as Lantsa. The letters, some of which are broken, form the conventional Buddhist expression beginning *ye dharma.*

The inside of the cover is filled with painted images of bodhisattvas, various deities, and monks. In the center, the enthroned image of the goddess Prajnaparamita, who holds a book with her upper left hand, makes it clear that the manuscript must have been a *Prajnaparamita* text. The goddess' upper right hand holds the *vajra* (thunderbolt), thereby emphasizing her relevance to Vajrayana Buddhism. She is flanked by two shrines, containing images of the Buddha Sakyamuni on her right and Amitayus on her left. Both are accompanied by various other

Two Illuminated Pages from a Dharani *Manuscript*
See plate 5 (M4 a, detail)

a

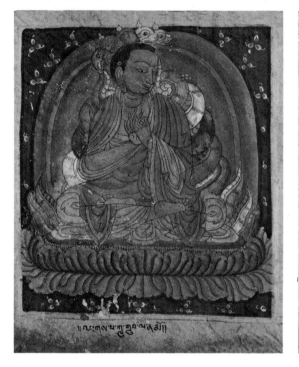

detail

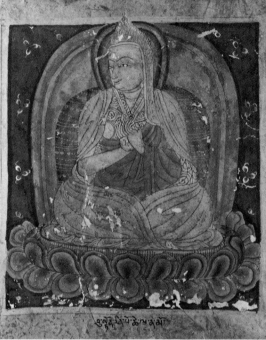

detail

deities. Little vignettes of other deities surround Prajnaparamita, while flying angels offer wreaths from stylized cloud cartouches above the shrines and the throne of the central goddess. At the top, on either side of the throne, are two seated Sakyapa monks wearing red hats; thus we can be certain that the manuscript was written for a Sakyapa monastery. On each side of this central panel of shrines are three rows of monks and deities. The deities in the uppermost row sit frontally, but the others are oriented toward the three central shrines and are represented in adoring attitudes. Each figure is seated in a niche framed with lotus pillars capped with little white stupas. In the bottom row all the figures, except the two goddesses at the far ends, are monks.

M4

Two Illuminated Pages from a Dharani
Manuscript
Central Tibet (Shalu monastery?), early
15th century
Opaque watercolors on paper
6 x 25 in. (15.2 x 63.5 cm.)
Each illustration approx. 3 x 2½ in.
(7.6 x 6.4 cm.)
Purchased with Funds from The Lewis

and Erma Zalk Foundation
M.81.9.1,2
See plate 5 (M4 a, detail)

Because there is no colophon, the exact title of this text is difficult to determine. However, the page numbered two begins with invocations to various deities, such as Narasimha, Mahesvara, Ananda, and Mahakala, thereby indicating that it is part of a *dharani* (charms) manuscript. The recto of each page contains an illustration at both ends, while the verso has only text.

The seated monks on the first page (M4 a) are identified by inscriptions as Nagarjuna (on the left) and Butön rinpoche (on the right) (*see* Appendix). Nagarjuna is distinguished by the multiple-serpent hood that forms a canopy above his head; apart from this feature, he is portrayed as an idealized monk engaged in teaching. A great Indian philosopher, he is said to have lived in the first–second century A.D. and to have founded the Madhyamika school of Buddhist philosophy. So far no portrait of him has been found in India, but in both Nepal and Tibet, Nagarjuna was frequently represented as a monk protected by the snake-hood canopy. This iconographic feature was very

b

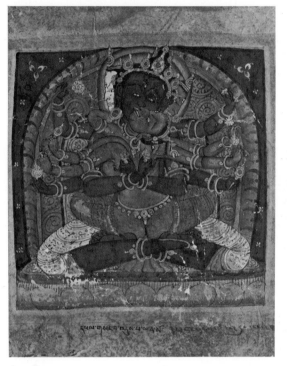

detail detail

likely inspired by the word *naga,* meaning snake, which forms part of his name.

An eminent polymath, Butön (1290–1364) is one of the most celebrated figures in the history of Tibetan Buddhism. The founder of the Shalupa school (although the Shalu monastery was established by the Sakyapas in the eleventh century), his greatest achievement was the organization of the *Tanjur* and the *Kanjur* compendia of all sacred Tibetan texts. Although this portrait was probably rendered within a few decades of his death, it is, nevertheless, decidedly idealized. But for the inscription one would be hard pressed to recognize him.

The two deities in the other folio (M4 b) are shown in *yab-yum.* The seated figures, Guhyasamaja and his prajna, each has six arms and three heads. Their complexions are two different shades of blue; he is dark and she is light. His principal hands are crossed in the *vajrahumkara* gesture and they hold the bell and the thunderbolt. As his name suggests, Guhyasamaja is the deification of the *Guhyasamajatantra,* one of the oldest and most fundamental texts of Vajrayana Buddhism. The other painting depicts one of the terrifying emanations of the Bodhisattva Manjusri, known as Raktayamari, or the red enemy of Yama,

the Hindu god of death. Both he and his prajna are therefore painted red. They engage in sexual union as they stand militantly on a flattened buffalo. A dead human lies between the feet of the couple. Both deities are naked, terrifying in appearance, and wear diadems and garlands of skulls. Raktayamari brandishes the cot's leg and holds a skullcap, which is also one of his partner's attributes.

The style of these illuminations closely corresponds to that found in Nepali paintings of the fifteenth century. We know that Nepali artists were very active at that time in several Tibetan monasteries, such as those at Gyantse, Shalu, and Ngor. The inclusion of the figure of Butön indicates that the manuscript was very likely written and illustrated in the Shalu monastery. Because of the pictures' small size, the artist was less constrained by stringent demands of iconometry than would be necessary with thankas; hence, the drawing is freer and more spontaneous. The coloring, too, follows the Nepali tradition of using maroon red as the principal hue, with deep blue as the background color. The lotus on which the two teachers sit has an upper row of blue petals and a lower row of red ones, an unusual combination that may reflect an idiosyncrasy of this particular artist.

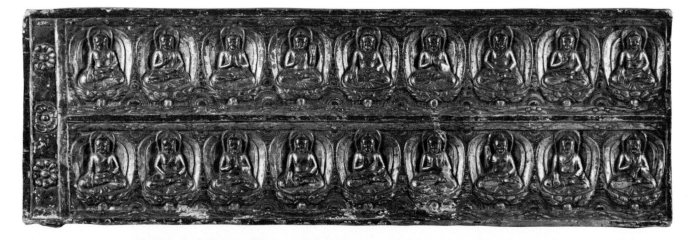

outside

inside

M5

Manuscript Cover
Central Tibet, 15th century
Gilded and painted wood
8⅛ x 25½ in. (20.6 x 64.8 cm.)
Gift of Mrs. Beverly Coburn
M.78.101.1

The outside of this cover is decorated more elaborately than the inside. Eighteen deeply carved Buddhas are seated on lotuses in two rows across the outside surface. The narrow borders on either side of the two rows of Buddhas are decorated with half a floral motif and heavily gilded. The spaces between the Buddhas are painted with geometrical designs in red, black, and gold. Three carved and gilded flowers—a lotus and two rosettes—are on the left end of the cover, the edge of which includes a meandering lotus stem.

The painted designs on the inside of the cover are considerably effaced. A wide border of lotus petals outlined in black on a faint green ground frames a rectangular panel with narrow red borders. Similar red borders enclose a diamond in the center

and the triangle at each end of the panel. Within the diamond is a double *vajra (visvavajra)* motif surrounded by stylized flames. The same motif, sliced in half, adorns the triangular sections.

Except for their hand gestures, the Buddhas on the outside of the cover are identical. Seven gestures are common to the eighteen Buddhas. If the second cover, which is missing, contained seventeen more images of the Buddha, the group would represent the Thirty-five Buddhas of Confession. The cult of the Thirty-five Buddhas of Confession is also known in China and Japan, and Tsongkhapa himself wrote a treatise about them. Perhaps the covers contained a manuscript of this text. Whatever the exact identification of the Buddhas, the quality of the carving is better than that of the painting. Nevertheless, the designs on the inside are drawn with a free hand and appear lively and spontaneous.

M6

Two Pages from an Ashtasahasrika
Prajnaparamita *Manuscript*
Central Tibet, 15th century
Ink, color, and gold on paper

Two Pages from an Ashtasahsrika
Prajnaparamita *Manuscript*
See plate 6 (detail)

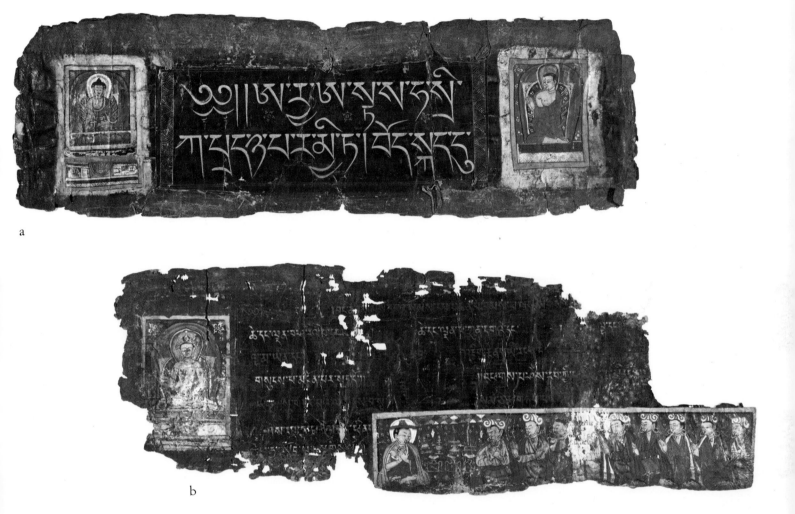

a

b

a) Page: 25 x 8 in. (63.5 x 20.3 cm.)
Ill. on left: 4⅞ x 3 in. (12.5 x 7.6 cm.)
Ill. on right: 4½ x 3⅛ (11.5 x 8 cm.)
Gift of Dr. and Mrs. P. Pal
M.82.60

b) Page: 22¼ x 7¾ in. (56.5 x 19.6 cm.)
Ill. on left: 4½ x 3 in. (11.4 x 7.6 cm.)
Ill. on right: 2⅞ x 13 in. (7.3 x
33 cm.)
Gift of Mr. and Mrs. Ramesh Kapoor
M.82.61
See plate 6 (detail)

Both pages are frayed along the edges, *b* being more
damaged than *a*, but there is no doubt that they belong to-
gether. The lettering is larger and bolder on *a*, the title page of
the manuscript. In addition, the page contains the expression
Bod skad du, which was probably followed on the next page by
bsgyur bcug; both phrases together mean "translated into Ti-
betan." Unlike *a, b* has writing on both sides. The illumina-
tions are painted on separate pieces of paper; they are sewn to *a*
and glued to page *b*. The long panel of donors has been pasted
over the writing on page *b*. Except for the reverse of *b*, which is

buff colored, both pages are made of black paper. Pale yellow
and gold letters, with red accents on the title page, are em-
ployed on the black pages, while black ink has been used on the
buff page.

(*a*) In the illumination on the left, red-robed Sakyamuni is
seated on a mauve lotus placed upon a lion throne. The two
lions flank a carpet marked with a thunderbolt, which, to-
gether with the gesture of Sakyamuni's right hand, indicate
that the image symbolizes the moment of enlightenment at
Vajrasana. In the other illumination an Indian monk, also
wearing a red robe, is seen adoring Sakyamuni. The exact
identification of this figure is uncertain, but he may repre-
sent Nagarjuna (even though he has no snake-hood canopy)
to whom the *Prajnaparamita* was miraculously revealed
(*see* **M4 a**).

(*b*) The illumination on the left depicts a crowned bodhisattva
with a yellow complexion. His left hand rests on his lap,
and the right hand forms the gesture of teaching. His
throne was decorated with two geese, only one of which re-
mains. The bodhisattva is very likely Manjusri. The other
illumination depicts a monk wearing a red hat, a yellow

robe, and red garments, who is engaged in conversation with a turbaned figure, who is followed by seven turbaned male figures and one turbanless female. All the men wear the same white turban with red swirls, and though they are in other ways similarly dressed, the colors of their garments differ from one to the other. The second figure holds a flower, but all the others display the gesture of adoration. These figures obviously represent the donor and members of his family. Between them and the monk are various ritual implements which are graphically represented.

Without inscriptions the exact identification of these donor figures cannot be determined. It is likely, however, that they represent royalty; kings and princes in western Tibet are consistently portrayed wearing turbans, although the turbans here are more stylized than and are in other ways quite different from those worn by other monarchs (*see* **P17**). It is possible that this turban was copied from ones in older paintings, a conclusion suggested by the monk's peculiar hat. Similar hats are worn by monks in the Alchi murals, which cannot be dated later than the thirteenth century (Pal 1982 B). Seemingly, then, this panel is a copy of an early composition, one which may go back to the eleventh century. In that case the group may represent the famous translator Richen Sangpo with King Yeshe Ö and members of his family. Responsible for translating *Ashtasahasrika Prajnaparamita,* Rinchen Sangpo is seen here in conversation with the pious monarch of Guge.

These illuminations were probably executed in the fifteenth century, and are predominantly Nepali in style. The divine figures closely resemble the paintings in **M2** and **M3**, but the donor figures were probably modeled on an earlier representation from a western Tibetan monastery. The drawing here is less careful and the colors of red, blue, green, yellow, black, and white have been more perfunctorily applied than is usual in early illuminations.

M7

Manuscript Cover
Zanskar (?), 16th century
Carved and painted wood
4⅝ x 14⅝ in. (11.7 x 37.1 cm.)
Indian Art Special Purposes Fund
M.75.45

The outside of the cover is richly carved with a sinuous floral and vegetable design; its central panel is surrounded by a row of beads and a border of broad, meandering plant motifs. The panel is further decorated with exuberant vegetable motifs that enclose a rearing griffin in the center. One end of the cover contains a simplified version of the border motif, while the other has a carving of the four auspicious symbols: a lotus, a knot, a pot, and an animal head (?).

On the inside, framed by a border of geometric designs, are five figures. All five wear purple undergarments—two with short sleeves—and yellow robes. Four of them look to the left and are distinguished by blue cushions behind their backs, red aureoles, and halos behind their heads. The hands of two of the figures form the gesture of turning the Wheel of Law; one displays the preaching gesture with his right hand, while the left hand rests on his lap. The arms of the second figure from the left are disposed in a most unusual fashion: although both hands

form the teaching gesture, the arms are spread out and raised to shoulder level. Because of their halos, it is clear that all four are apotheosized monks engaged in teaching. It is unusual to find Tibetan monks wearing yellow robes, for they generally wear red; however, monks in many of the monasteries in Zanskar wear yellow robes (Francke, pp. 23–24), and so it is possible that this cover was painted for a monastery in that region.

The remaining figure, in the fifth panel on the right, though dressed exactly like the monks, appears to be a less exalted figure—he lacks a nimbus. He looks at the four monks as he sits, his hands forming the gesture of adoration, and evidently he is the solitary listener. However, the canopy above his head and the black disc or shield near his right shoulder may mean he is a royal personage.

Because they have no headdresses, it is difficult to determine the monks' sectarian affiliations, but they very likely belong to the Sakyapa order. Although seated frontally, their heads are shown in three-quarter profile. The cover's muted colors do not obscure these figures' stylistic relationship to the monks in a central Tibetan thanka in the collection (**P15**). The faces of the monks in both works seem to have been drawn in a similar fashion, but the execution on the cover is more carefree. Noteworthy in both the cover and the thanka representations is the enormous size of the hands. The principal colors employed are blue, red, purple, green, and yellow, with the last predominating.

P1

Tathagata Amitayus and Acolytes
Central Tibet (Kadampa monastery),
late 12th century
102 x 69 in. (259.1 x 175.3 cm.)
The Nasli and Alice Heeramaneck
Collection
L.69.24.281
Literature: Pal, 1966, pp. 108–09; Pal,
1969 A, pp. 36, 131; *A Decade of Collect-
ing,* pp. 35, 153; *Dieux et démons,* p. 74;
Hatt, fig. 10, pp. 199–200.

There are several inscriptions on this painting which are in differing stages of preservation. The principal dedicatory inscription (*see* Appendix) occurs on the tiny lotus petals immediately below the large lotus bearing the imposing central figure. It states that the thanka was consecrated at a place in Ba-yul by Lama Chökyi Gyaltsen on the occasion of his life-attainment ceremony. Neither the name of the monastery nor its locality can be definitely identified. However, Richardson suggests that Ba-yul may be the mountainous region not very far from E-yul, south of the river Sangpo and west of Tsa-ri. This would make Ba-yul part of Tsang in south-central Tibet.

From the size and quality of the painting, one can assume that Chökyi Gyaltsen was an important personage. *The Blue Annals* (Roerich 1979, p. 276) mentions a Chökyi Gyaltsen who lived from 1121 until 1189. Apparently, he founded two monasteries, but again neither is named in the inscription. Also, the places connected with his religious life are in 'Phan-yul (northeast of Lhasa), and one wonders if Ba is an orthographical error for 'Phan. However, the place of Chökyi Gyaltsen's birth —Grayal—Richardson tells us, is not very far from where he tentatively locates Ba-yul. Thus, it is not improbable that the lama mentioned in the dedicatory inscription is the same teacher named in *The Blue Annals.*

If this identification is acceptable, we then have a fairly certain date for the thanka. Since Chökyi Gyaltsen apparently died in 1189, it would not be unreasonable to assume that he performed the life-attainment ceremony, for which the thanka was commissioned, shortly before his death. A late-twelfth-century date is not inconsistent with dates of other examples of this style of painting, which probably originated with the Kadampas in the eleventh century. Paintings in this style have been found as far east as Kharakhoto in China, and these were executed before the Mongol invasion in 1227. Several monastic establishments in central Tibet, primarily Iwang, contain murals rendered in this style (*see* pp. 115–16).

The major portion of this enormous painting is composed of a crowned and bejeweled figure with a green complexion. He is seated in *paryankasana* on a lotus, and his hands, placed on his lap, support a flowering vase. Two bodhisattvas stand on either side, like swaying stalks, on lotuses connected to the large, central lotus. The white figure carrying a white lotus is Bodhisattva Avalokitesvara; the brown figure holds a gray-green flower which cannot be identified with certainty. It appears that some of the colors on this painting are not in their original state; neither the brown nor the green coloring of the central figure follows canonical prescriptions. The brown was very likely originally yellow (*see* P2); hence, the figure is Maitreya, the future Buddha.

But for his complexion, the central figure could be identified as Amitayus. He is not fundamentally different from Amitabha, the lord of the Western Paradise, the only significant iconographic distinction between the two being that Amitayus additionally holds the vase of immortality. Further evidence that the figure may indeed represent Amitayus is seen in the fact that Chökyi Gyaltsen dedicated this thanka while performing the life-attainment ceremony; Amitayus is the tathagata of endless life. However, if the complexion of the figure was originally green, this image may instead represent a Buddha of healing. Amitabha or Amitayus is generally portrayed with a red or golden complexion, and an error in coloration would have been unlikely in the twelfth century.

On each side of the tathagata's head are four bodhisattvas and a Buddha or an apotheosized monk; the latter identification seems the more probable since the Tibetan names for the two figures are not names of Buddhas. One of the figures is identified as 'Ga ba; if this is a mistake for Ka ba, he may be the lama who was a contemporary of Atisa and was responsible for dividing the ashes after the Indian master's cremation (Roerich 1979, p. 262). Of the five figures at the bottom, the three placid bodhisattvas are Avalokitesvara, Manjusri, and Vajrapani. The angry figure on the left with a horse's head, curiously covered with a red hat, is Hayagriva. The blue figure on the right is identified as Mi gya ba, who is none other than Acala, another protector of Vajrayana Buddhism.

The dedicatory inscription remarks on the size of the thanka indicate that even at the time of its creation its proportions were regarded as unusual. Certainly it is the largest Tibetan thanka outside Tibet, and, if our suggested date is correct, it is also one of the earliest. Its imposing size is matched by its excellent craftsmanship, and even if the colors are not well preserved after almost eight centuries, the flawless composition and the sure draftsmanship leave no doubt that Chökyi Gyaltsen employed a master for his pious dedication.

P2

Tathagata Ratnasambhava
Central Tibet (Kadampa monastery),
13th century
36¼ x 26⅞ in. (92.1 x 68.3 cm.)
From the Nasli and Alice Heeramaneck
Collection
Museum Associates Purchase
M.78.9.2
Literature: Tucci, 1949, II, p. 331 and
pl. E; B. Rowland, *The Evolution of the
Buddha Image* (New York: Asia House,
1963), cover and pp. 68, 134; Pal, 1966,
pp. 108, 110; Pal. 1972–73, p. 71 and
fig. 4; Snellgrove, 1978, p. 342, fig. 266.
See plate 8

In this painting the yellow-complexioned central figure is the tathagata Ratnasambhava. One of the five transcendental Buddhas of the Vajrayana pantheon, his name literally means "jewel-born." Seated in *paryankasana* on a multicolored lotus, he is bedecked with jewelry and tiaras. His right hand is stretched in the gesture of charity and the left rests on his lap. His symbol, the horse, is represented twice on the pedestal of his throne;

Tathagata Amitayus and Acolytes
See plate 7

Tathagata Ratnasambhava
See plate 8

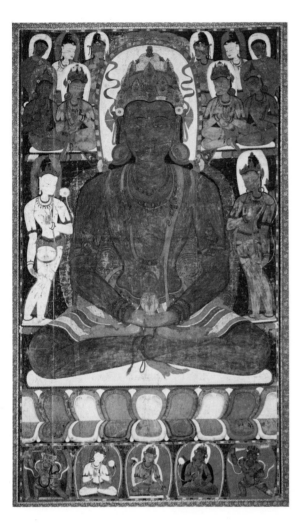

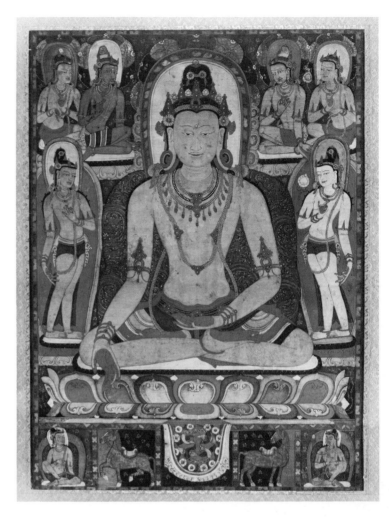

part of a mantle or carpet, decorated with four birds, overhangs the pedestal. The birds may symbolize the south, which is the direction of Ratnasambhava, and may have been borrowed from Chinese cosmology. Altogether, eight bodhisattvas surround Ratnasambhava. The white bodhisattva on his left holding a white lotus may be identified with Avalokitesvara. The yellow bodhisattva on the other side appears to hold a stupa in his right hand; if so, he can be identified as Maitreya. Canopies formed of clusters of stylized leaves are behind the nimbus of the principal figure and the four seated bodhisattvas on top. Multicolored lotus petals form a border for the entire painting and enclose the nimbus of Ratnasambhava as well.

It would appear that the thanka represents a mandala of the Eight Bodhisattvas. The cult of the Mandala of the Eight Bodhisattvas originated in India during the early days of Mahayana Buddhism and was particularly popular in Central Asia and Tibet. One of the earliest texts to describe the rituals and iconography of this cult is the *Ashtamandalakasutra*, translated into Chinese by Amoghavajra. The Eight Bodhisattvas, representing the eight directions, were worshiped in a mandala largely for mundane favors and for protection from disease, famine, and war. Apart from thankas, the mandalas of the Eight Bodhisattvas are found painted on walls in several Tibetan

monasteries, such as Iwang, Samding, Dölma, and Lakhang (Tucci 1956, pp. 64, 70, 117), thus attesting to the cult's wide popularity. The only Indian region where the cult was strong, however, was Bihar, during the Pala period (Pal 1972–73). As is suggested in the introduction to this section, the style of this painting, as well as of the murals at Iwang, is directly derived from the Pala style.

But for minor differences in the physiognomies of the figures and the designs of the ornaments, this thanka is closely related to **P1**. Although the figurative style in both thankas derives ultimately from the Pala style, the exaggerated sway as well as the slim and effete proportions of the standing figures in both paintings are quite different from those encountered in Pala manuscript illuminations. Also, the tonality of the colors of these two paintings differs considerably from both Pala and Nepali paintings. The warm, mellow tones are neither as intense and deep as in Nepali paintings nor as bright and vibrant as in Pala miniatures. Unique features of this thanka are the mica flakes which sparkle on its surface and its excellent state of preservation. To my knowledge, no other Tibetan painting shows such a generous use of mica flakes.

An Abbot and His Lineage
Western Tibet, 14th century or earlier
17¾ x 15⅛ in. (45.1 x 38.4 cm.)
Purchased with Funds from the Julian C.
Wright Bequest
M.80.188
See plate 9

The center of this painting is occupied by the figure of an abbot engaged in teaching while seated on an elaborate lotus throne. His pleasant, smiling face indicates his serenity. His advanced age is reflected by a beard, a goatee below the lower lip, and a moustache—each of which has a mixture of black and white hair. The hair on his head is cropped down almost to the scalp. Both his palms and the soles of his feet are colored a bright red, as is customary with divine images; in life, however, these men were probably not painted. His apotheosis is further emphasized by the white nimbus behind his head.

Almost identical figures (without the facial outgrowth and with black instead of white hair) who represent other members of the lineage are depicted in a row on each side of the thanka. One of these figures wears a black inner garment, but all the others are clad, in contrast to the sumptuously clothed older abbot, in a simple combination of orange, red, and yellow robes. Like him, they make the gesture of teaching and have white halos. In the upper corners of the central rectangle are two other teachers, one of whom has a white complexion and wears only a yellow robe and a yellow pundit's hat; the other, with a crown of luxurious black hair, wears white garments. Of the three teachers included in the top border row, two wear yellow pundit's hats. Most of the religious personages, including the central figure, may represent Indian monks, as they are dressed in the red robes more typical of that group. The principal figure may in fact depict the celebrated eighth-century teacher Santarakshita, who is venerated by the Kagyupas.

The remaining figures in the upper register are Vajrayana deities, Vajradhara and Vajrasattva being the first two on the left. Along the bottom, from left to right, are two orange-robed teachers, a black figure of Jambhala (a wrathful guardian deity), ritual implements and offerings, two worshiping monks, and the three males and three females of the donor's family. All of them hold flowers and sit in identical postures that are quite different from those of the teachers. Of the donors, the first four figures are the same size, while the last couple is slightly smaller and therefore less important.

A half-dozen thankas in this particular style are known to exist, and this example forms a pair with one in a private collection (Pal 1975, pp. 47, 78). Because the central figures in that thanka are Vajrasattva and his spouse, it was very likely the frontispiece for a set of thankas portraying important teachers of a particular order, the exact affiliation of which is not easy to determine. The other paintings in this style, though not belonging to the same set, have been assigned to the Sakyapa order. Although it is tempting to attribute the Museum's thanka to the Sakyapas, especially because of the white-robed abbot (Sakyapa abbots who are permitted to marry generally wear white robes to distinguish them from celibate monks; *see* P18), it may have belonged to a Kagyupa monastery. Vajradhara, who leads the figures along the top row, is the tutelary deity of the Kagyupa order. (The Sakyapas' tutelary deity is Manjusri.)

Of the other paintings in this style, two have been assigned to southern Tibet (Lauf 1969, p. 68, pls. XIII, XIV), but no reasons are given for the attribution. Four others were recovered from "a sunken cave-monastery in the valley of the Sib-chu river, to the west of the holy Mt. Kailasa" (Olschak-Wangyal, pp. 50–52), which would make their provenance western Tibet. While the discovery of a particular thanka in a given monastery is no indication that it was painted locally, a western Tibetan provenance seems likely. As noted in the introduction to this section, in the early part of the thirteenth century the Drigungpas, a sub-sect of the Kagyupas, established themselves in western Tibet, especially around the Mt. Kailasa region. The iconography of the Museum's thanka also seems to indicate its association with a Kagyupa monastery. The dress of the donors generally conforms to western Tibetan fashions as seen in murals in Tabo and other sites.

The thanka is a fine example of what may be defined as the western Tibetan version of the Pala-Tibetan style. Although not so suave as the central Tibetan version of the style seen in **P1** and **P2**, the style of this thanka is closely related to the thirteenth-century murals in the Alchi monastery in Ladakh as well as to the Kharakhoto paintings rendered before 1227. Thus, a fourteenth-century date is cautiously suggested for this thanka; it may well be somewhat earlier. The divine figures in the uppermost row are stylistically similar to early Nepali and Pala manuscript illustrations of the twelfth century.

An Arhat with Attendants
Central Tibet, 14th century
25½ x 21¼ in. (64.8 x 54 cm.)
From the Nasli and Alice Heeramaneck
Collection
Museum Associates Purchase
M.77.19.9
Literature: Pal, 1966, p. 114; M. W.
Meister, "The Arts of India and Nepal,"
Oriental Art, n.s. XIV, 2 (1968), pp. 104,
109; Pal, 1969 A, frontispiece and p. 132;
Pal, 1969 B, p. 48; *A Decade of Collecting,*
pp. 36, 153; *Dieux et démons,* pp. 112, 116.
See plate 10

The busy composition of this thanka is dominated by the stern and splendidly robed figure of an arhat. Seated on a carpet enriched with animated bird-of-paradise, the arhat's legs are crossed, his feet emerge from his robe, and his sandals lie in front. His balding head is set off by a blue nimbus, and he has bushy eyebrows, a substantial beard, and a hairy chest. He wears large circular earrings, undergarments, and a sumptuous red robe with a wide gold border. His right hand holds a staff, which seems to consist of several thin lengths of bamboo held together by strings; the left hand makes the gesture of teaching. On either side stand two monks. The one on his right wears orange, blue, and red robes and has no halo; the other wears orange and purple robes and is nimbused. The plump monk on the arhat's right looks down at the figure kneeling before the arhat; the other offers a manuscript.

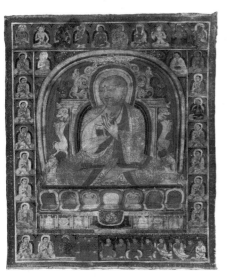

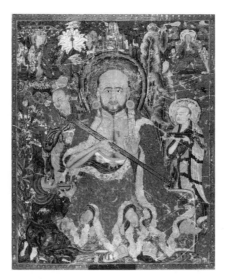

Two other monks sit surrounded by clouds at the two upper corners of the thanka. The one in the left-hand corner, attired in red-blue robes, sits on a dais with his feet resting on a purple lotus; an attendant holds a parasol above his head. The other, dressed in more somber robes, sits in the yogic posture on a carpet and holds a bottle with his right hand, while the left displays the teaching gesture. He is attended by two figures: it is not clear what the one on the right holds, but plainly, the one on the left is tenderly petting a small animal. Both are smiling and seem to be happy.

The kneeling devotee at the bottom of the thanka has bushy eyebrows, a curling moustache, and a red beard. His physiognomy is quite different from that of the others and his head and neck are wrapped in a shawl of red, blue, and yellow stripes. Wearing a long blue coat, richly embroidred with grazing deer, birds of paradise, and flowers, he offers the arhat a bowl filled with blue and yellow rocks, which symbolize precious stones. Beside him rise stalks of plants and stylized rock formations.

Plants are also added on both sides of the central figure's nimbus. On his right is a prominent white peony and on his left, the rather distinct, broad leaves of the banana palm. Immediately above the arhat's head is a charming rocky landscape populated by several figures dressed in red or yellow robes and by grazing deer. The trunk of a tree rises abruptly from behind the rocks and bends, impossibly, at a right angle to avoid the border of the thanka. More deer are seen grazing below the central figure, and butterflies hover around the heads of the two standing personages. The thanka's red border is filled with tiny golden images of the Buddha, each wearing the red garment and holding the monk's bowl.

An exact identification of the central figure is difficult, but it seems unquestionable that he is an arhat. It has been suggested (Pal 1969 A, p. 132; *Dieux et démons*, p. 112) that the representation is of Vajriputra, but this seems in no way certain. The iconography differs significantly from the standardized rep-

resentations of that particular arhat in the Tibetan, or for that matter the Chinese, tradition. The early arhat paintings, however, both in Central Asia and China, did not adhere to any specific iconographic tradition. Indeed, the representation could well be of the arhat Kanakavatsa, following the early Chinese tradition. For instance, in an arhat series probably painted in the Song period, following a famous series by the earlier Chan master Guan Xiu (Kuan-hsiu, 832–912), Kanakavatsa grasps his straight bamboo staff with both hands while his "indexes are stretched forward" (de Visser, p. 113). In another eleventh-century description of an arhat series by an unknown Song master we find the following iconography of Kanakavatsa: "Kanakavatsa is worshiped by the King of Kashmir who sits on the right hand side. The arhat makes a mudra. Before him a Vaidurya flower bowl is placed. A kw'un-lun slave offers him a sutra box" (de Visser, p. 124). It is evident that these two descriptions together could have served as the model for the arhat in this thanka. Kanakavatsa appears to have had a different iconography in Tang and Song paintings than the more familiar attributes of later representations (P9). The kneeling figure in this thanka, wearing the rich, figured silk and offering the lapis lazuli flower, may be the "barbarian" king of Kashmir who is said to have visited Kanakavatsa, whereas the sutra-bearing slave has here become an apotheosized monk. Indeed, a sutra is placed before the arhat in the first Song-period description as well. Yet a third description of the arhats in praise of an embroidered image written in 1115 informs us that Kanakavatsa holds a special staff known as a *khakhara* and that a barbarian king kneels before him (de Visser, p. 125).

Identifying the figures in the two upper corners is even more difficult than determining the identity of the arhat. It is possible, though, that because of their normal features they may represent deified monks rather than arhats.

The broader stylistic aspects of this thanka and its importance in the history of Tibetan painting have been discussed in this section's introduction. It is a unique painting, as is the

Milarepa (**P14**), and, so far, no other thanka in this particular style has been discovered. Nor is the style seen here reflected in any known murals or sculptures of arhats in Tibetan monasteries. In *Dieux et démons* (p. 112), it is suggested that the thanka is a fifteenth-century copy of a Chinese original of the Yuan dynasty (1280–1368). The catalogue further states that the composition resembles paintings of arhats executed in China in the fifteenth century which copied earlier models. Unfortunately, however, no such examples are cited. In view of the strong relation between the Sakyapas and the Yuan emperors, there seems no reason why this thanka could not be an original executed during the Yuan period.

Several elements in this thanka can be traced back directly to late Southern Song (1127–1279) or Yuan paintings. The rather bloated faces are unlike typical Tibetan faces and seem closer to those prominent in late Song and Yuan-period art (cf. Wai-kam Ho, et. al., p. 65; Lee and Ho, nos. 3–5, 194, 207). The arhat's beard, as well as the manner in which the outline is drawn, have close parallels in Yuan art (Lee and Ho, nos. 198, 209). The forms of the peony and the banana palms around the arhat's nimbus seem to derive directly from Chinese paintings of the late thirteenth century (cf. Wai-kam Ho, et. al., pp. 65, 93–94, 113). Another detail that indicates a fourteenth-century date is the little bottle held by the figure in the upper left-hand corner of the thanka. Its muted color, faint, delicate design, and fluted neck relate it to Chingpai ware of the Yuan dynasty rather than to the later Ming porcelain. A date earlier than the fifteenth century is also suggested by the peculiar shape of the lotus petals below the feet of the deified monk in the opposite corner. This particular type of lotus is often seen in western Tibetan art and stems ultimately from Kashmiri bronzes. Specific parallels may be cited in manuscript illuminations (**M1**) which cannot be dated later than the thirteenth century.

There are other features that make this thanka unique. Not only are the colors different from post-fifteenth-century arhat paintings, but they also have an unusually rich tonality. The principal figure's robe is as sumptuous as the expression on his face is intense. The border of the robe is rendered in a peculiar fashion; while much of it is painted with red floral vines on a gold ground, the section that forms a loop around the neck is embellished with a gold floral pattern in high relief that looks like gesso work. This technique has been employed on one other thanka (Tucci 1949, pl. 4, p. 333), also on the border of a monk's robe; Tucci suggested a fifteenth-century date for this thanka, but it may well be earlier. Finally, the unusual row of Buddhas along the narrow red border both places the composition within the "Buddha-field," so to speak, and symbolizes the idea of the thousand Buddhas who pervade all space.

It may be concluded, then, that the thanka was painted by a Tibetan master well acquainted with the various Chinese styles of arhat painting in the Song and Yuan periods. The most likely model may have been the popular style of the Song painter Zhang Sigong (Chang Ssu-Kung), whose works may have been familiar to the Tibetan artist, and who may have been a Sakyapa monk. The Sakyapas maintained a close relationship with the Yuan dynasty until its fall in 1368. A date in the first half of the fourteenth century for this thanka seems both stylistically and historically consistent, although a still-earlier date—the end of the previous century—is not improbable.

P5

Gyalpo Palseng, early 15th century
Mandalas of Hevajra and Other Deities
Central Tibet (Sakyapa monastery), c. 1400
29 x 26⅛ in. (73.6 x 66.2 cm.)
From the Nasli and Alice Heeramaneck
Collection
Museum Associates Purchase
M.77.19.6
Literature: Pal, 1966, pp. 112–13; Fisher,
pp. 18, 38.
See plate 11

According to the dedicatory inscription (*see* Appendix), this thanka was dedicated as an inner spiritual support for the lama Jamyang by the monk Gyeltsen. Although the inscription is illegible in parts, it appears that Jamyang was expected to attain complete fulfillment by seeing this thanka, and thus it can be assumed that it was painted during his lifetime.

The Jamyang mentioned in the inscription is difficult to identify, but he may be the same person who is mentioned as the translator in an inscription in the *kumbum* of the Narthang monastery. He was responsible for composing that inscription (Tucci 1949, I, pp. 188; II, pp. 674–76), which records the circumstances of the building and painting the monument. Tucci has established that the abbot in whose memory the edifice was raised died in 1376. Presumably, therefore, the *kumbum* was built a few years thereafter. Thus, the Jamyang of the Narthang inscription could well be the same one named in this thanka. The inscription on the Museum's thanka also tells us that it was painted by a group of artists led by Gyalpo Palseng. Curiously, one of the artists named in the Narthang inscription is Gyalpo Dar (of Gro bo long), and he may well have been related to Gyalpo Palseng. These considerations, as well as the thanka's style, have led us to suggest a date around 1400. The style is consistent with that characterizing Nepali paintings of the period and is very close to a Vasudhara mandala painted in 1367 (Pal 1975, p. 59).

Altogether, seventeen different mandalas of the Hevajra cycle form the principal subject matter of this thanka. Sixteen smaller mandalas surround the central mandala of Hevajra, one of the most important deities of esoteric Buddhism. In the pericarp of the lotus, Hevajra dances in ecstasy while embracing his prajna, known as Nairatmya. He has eight heads, sixteen arms, and four legs. As Hevajra himself says in the *Hevajra-tantra* (Snellgrove 1959, p. 110):

> The circle is the same as described before, square and with four portals, and adorned with garlands and chains and *vajra*-threads. There at its centre am I, O Fair One, together with you. The Joy innate I am in essence, and impassioned with great passion. I have eight faces, four legs, and sixteen arms, and trample the four Maras under foot. Fearful am I to fear itself, with my necklace made of a string of heads, and dancing furiously on a solar disk. Black am I and terrible with a crossed *vajra* on my head, my body smeared with ashes, and my mouth sending forth the sound HUM. But my inner nature is tranquil, and holding Nairatmya in loving embrace, I am possessed of tranquil bliss.

Mandalas of Hevajra and Other Deities
See plate 11

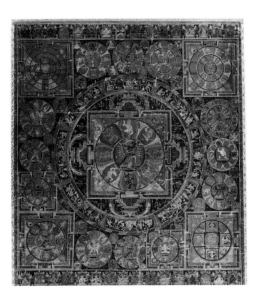

On the eight petals of the central lotus are dancing figures of the goddesses who emerge from the union of the principal pair. They are Gauri, Cauri, Vetali, Ghasmari, Pukkasi, Savari, Candali, and Dombini. The four maras whom Hevajra tramples under his feet are the Hindu gods Brahma, Vishnu, Siva, and Indra. Each of Hevajra's sixteen hands holds a skullcup; each skullcup contains one of the following objects: (on the right) elephant, horse, ass, ox, camel, man, lion, and cat; (on the left) earth, water, air, fire, moon, sun, Yama, and Vaisravana. The mandala is circumscribed, as is usual, by the eight cremation grounds, each well separated and reflecting the conventional iconography (*see* pp. 44–45). Thus, there is no doubt that Hevajra is a cosmic god like the eleven-headed Avalokitesvara; his entire iconography reflects his universal form. The god himself is given eight heads and sixteen arms. His own mandala is surrounded by sixteen others; sixteen, like eight, is a cosmic number.

Apart from its iconographic richness, the thanka is of great art historical significance because its inscription contains the artist's name. Without the name, which presumably indicates that the artist was a Tibetan, this could easily have been mistaken for a Nepali painting. Thus, here we have an instance of a Tibetan artist who was well trained in the Nepali tradition.

P6

Akshobhya in His Abhirati Heaven
Western Tibet (Guge), 15th century
59½ x 49¼ in. (151.1 x 125.1 cm.)
From the Nasli and Alice Heeramaneck Collection
Purchased with Funds Provided by the Jane and Justin Dart Foundation
M.81.90.3
Literature: Tucci, 1935, pl. XLVIII; Tucci, 1949, II, pp. 347–48, pls. 14–22; Pal, 1969 A, pp. 56, 134; Huntington, 1972, pp. 108–11 and pl. LVIa.

This heaven belongs to Akshobhya, one of the transcendental Buddhas of the Vajrayana pentad. Called Abhirati (meaning pleasure) in Sanskrit, Akshobhya's heaven is not so well known as the more famous Sukhavati heaven (**P7**, **P8**). No separate text, like the *Sukhavativyuha*, is devoted to the Abhirati. However, a brief description occurs in another important Mahayana Buddhist text known as *Vimalakirtinirdesa*, and Tucci has drawn our attention to this passage, which is the closest verbal model for this rarely portrayed subject. While displaying the heaven to the community, Vimalakirti declares:

> I will show this Abhirati heaven, with several hundreds of thousands of Bodhisattvas and gods and Nāgas and Yakṣas and Gandharvas and Asuras, surrounded by the mountain which encircles it (Cakravāla); and waterfalls, ponds, sources, lakes, oceans, Sumeru, mountains, hills and knolls, and the moon, the sun and the constellations . . . and villages, cities, countries, and regions, and kingdoms and monks and women; Bodhisattvas, listeners, and the Tathāgata Akṣobhya's bodhi tree, and the Tathāgata Akṣobhya explaining the Law, seated amid an assembly vast as the ocean; and lotuses [scattered] in the ten points of space, [seated on which he shows] the actions

proper to a Buddha, and a threefold ladder, wrought with gems, going from the Jambudvīpa up to Trayastriṃśa's heaven, and on that noble ladder the Trayastriṃśa's gods descend into the Jambudvīpa to see the Tathāgata Akṣobhya and to do him homage and worship him to hear the Law.

Although Huntington does not find Tucci convincing, there seems little doubt that Tucci was perfectly justified in making his suggestion. That the central figure is Akshobhya is certain because of the gesture of his right hand (*bhumisparsamudra*) and the *vajra* (thunderbolt) placed on his left hand. Both are appropriate symbols of Akshobhya.

While the general description of the paradise is not different from that of the Sukhavati, one detail, pointed out by Tucci, not only distinguishes this painting but also relates it to the text cited above. Unlike the Sukhavati paintings, here the Trayastrimsa heaven of the gods is connected with the Abhirati by means of two ladders on either side of Akshobhya's head. Furthermore, as is described in the passage, there is two-way traffic up and down the ladder. Thus, we can go a step further than Tucci and identify the upper register of the painting as the heaven of the gods. That Akshobhya is also engaged in preaching is evident from the congregation of monks and bodhisattvas, seated on either side of the throne, listening to the discourse. And indeed, lotuses scattered over the entire surface of the painting represent the "ten points of space."

This spatial symbolism adds a cosmic significance to the vision of the paradise, a significance further reinforced by the presence of the ladders. The ladder is employed elsewhere in Buddhist mythology and art, as, for instance, when the historical Buddha Sakyamuni himself ascended to the same heaven to preach to his parents. It is well known that in other mythologies, too, the ladder is a cosmic symbol (Jacob's ladder in the Old Testament). Another feature in the thanka bearing a similar cosmic significance is the lotus below Akshobhya's throne; in this instance, the flower symbolizes the universe, which floats in the cosmic ocean, while the stalk represents the *axis mundi*.

A curious feature of Akshobhya's Abhirati heaven is that it is situated at a lower level than the heaven of the gods. In fact, it is specifically stated that the heaven is in Jambudvipa, which is one of the terrestrial continents (of which India is a part) of Indian cosmology. It would appear, therefore, that Akshobhya's paradise of pleasure is terrestrial rather than celestial.

Whatever its verbal model, there is no doubt that visually there is very little conceptual or compositional difference between this thanka and its contemporary Sukhavati paintings (**P7**). Indeed, the stylistic similarities between the two thankas are so overwhelming that it could safely be concluded that they are the work of the same atelier, if not the same master.

P7

Amitabha in His Paradise
Western Tibet (Guge), 15th century
41½ x 34 in. (105.4 x 86.4 cm.)
From the Nasli and Alice Heeramaneck Collection
Museum Associates Purchase
M.77.19.12
Literature: Tucci, 1949, II, pp. 348–51 and pls. 23 and H; Huntington, 1972, pl. LIX and pp. 114–15; cf. *Dieux et démons*, p. 98.
See plate 12

As is usually the case in such paintings, the central figure of Amitabha and his companion bodhisattvas, Avalokitesvara and Mahasthamaprapta, are separated from the rest of the thanka by a red aureole. Dressed in a monk's robes, Amitabha is seated in meditation on a lotus throne with a begging bowl in his hands, which make the gesture of meditation. On either side of him are monks and bodhisattvas seated in rapt attention, listening to the discourse. The lotus supporting Amitabha springs from the cosmic ocean. Vines or shoots from the central stem curl into medallions which contain lions and peacocks, this bird being the symbol of Amitabha. The rest of the painting's surface is occupied by various gatherings of monks and celestial inhabitants of the paradise. There are limpid pools with lotuses, bejeweled trees and banners, light and airy pavilions, and flowers all over the place. There seems to be no doubt that the painting is modeled on the descriptions of the celebrated Western Paradise as given in the *Sukhavativyuha*.

The paradise, called Sukhavati, is described in ecstatic language as a delightful place, "with its groves, resplendent with gold...adorned with the sons of Sugata...full of many jewels and treasures" (Müller, p. 42). The country has no mountains but is level on all sides. The trees are made with precious stones and the lotuses with gems and gold. Seated cross-legged on the lotuses are those who are filled with faith. According to another text (H. Kern, tr. *Saddharmapundarika*, New York, 1963, p. 417), which contains a brief description of this paradise, the figures sitting in the "undefiled cups of lotuses" are the sons of Jina. We are further told that "the Chief Amitabha himself is seated on a throne in the pure and nice cup of a lotus, and shines as the Sala-king."

Elsewhere in the *Sukhavativyuha* the paradise is said to contain beautiful palaces and pavilions. "And in these delightful palaces they dwell, play, sport, walk about being honoured, and surrounded by seven times seven thousands of Apsarases." Apsarases are divine courtesans, and it is rather surprising that they should be the entertainers in Sukhavati, for the *Saddharmapundarika* categorically excludes women from the land of bliss. "There no women are to be found; there sexual intercourse is absolutely unknown..." Indeed, if we look carefully at the thanka, we will be hard pressed to find a single woman in this composition, which teems with masses of celestial beings. It also appears that while the lotuses are occupied entirely by Buddhas, the pavilions are reserved for bodhisattvas who are richly adorned.

As Tucci writes, there are no known Indian prototypes, at least insofar as paintings are concerned, for such paradise representations. It would be a mistake, however, to rule out the

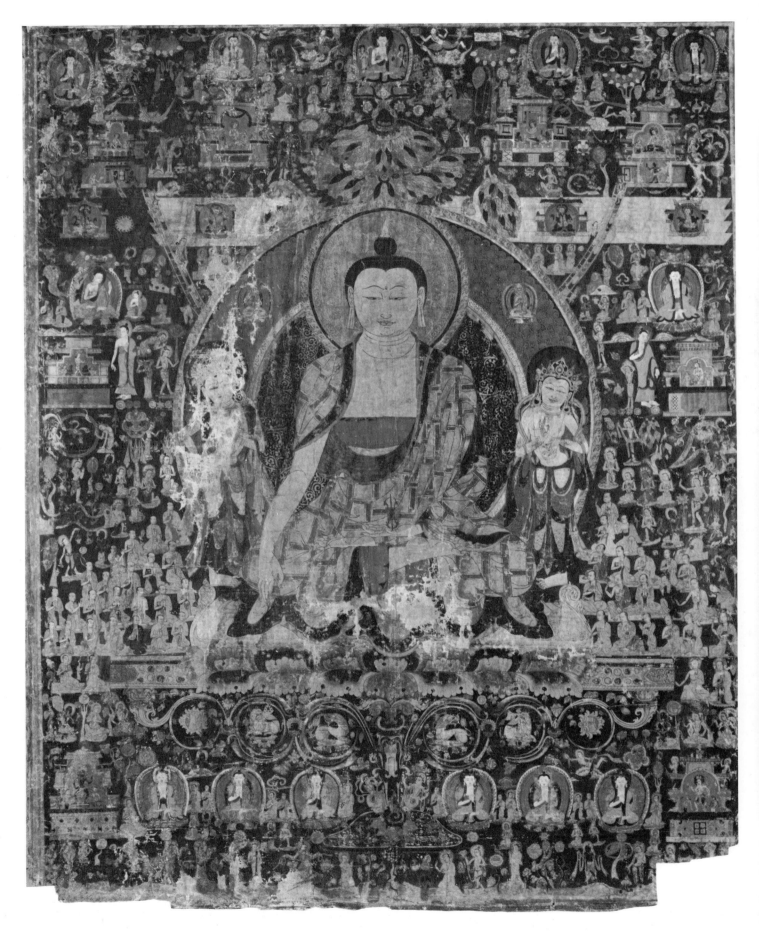

possibility altogether. Some of the rock-cut reliefs in western Indian caves, particularly at Kanheri and Aurangabad, as well as those on steles in Gandhara, may represent similar paradise themes, albeit in a more summary fashion. Tucci also suggests that the immediate forebears of thankas such as this one are the Central Asian representations of Amitabha's paradise. However, the differences between the two seem to be more pronounced than the similarities. For instance, most Central Asian Sukhavati paintings include the stories of kings Bimbisara and Ajatasatru, which are not included in this thanka. The Central Asian paintings are less specific in following the detailed textual descriptions, and often include a scene with celestial dancers, not part of the Tibetan iconography. On the other hand, the paradise in this thanka bears a conceptual similarity to the so-called theophany reliefs in Gandhara, where there is also a central Buddha seated on a lotus, surrounded by other Buddhas on lotuses and princely figures in pavilions.

P8

The Healing Buddha and His Celestial Assembly
Western Tibet (Guge), 15th century
31¾ x 24¼ in. (80.6 x 61.6 cm.)
From the Nasli and Alice Heeramaneck Collection
Museum Associates Purchase
M.77.19.13
Literature: Tucci, 1949, II, pp. 380–81 and pls. 30, 31; *Dieux et démons*, pp. 94, 99; Birnbaum, pl. 6. (Birnbaum's book is the most comprehensive work on the subject.)
See plate 13

The center of this painting is dominated by the enthroned figure of a golden Buddha. His right hand holds a myrobalan, a dried astringent fruit used mainly in tanning and inks, but also employed—as indicated here—medicinally. The left hand holds a bowl. These symbols help identify the figure as Bhaishajyaguru, or the Healing Buddha. The two attendant bodhisattvas on either side, therefore, are Suryavairocana and Candravairocana. The concept of the Buddha as both a physical and spiritual healer goes back to early Buddhism, but artistic remains suggest that the cult was most popular outside India (*see* Birnbaum reference above). Indeed, the cult of the Healing Buddha was so popular in Japan that an entire temple complex, that of Yakushiji, was constructed in 730 in Nara to symbolize his spiritual realm on earth.

Although Tucci suggests that the painting represents the heaven of Bhaishajyaguru, it must be pointed out that this thanka differs considerably from the two other paradises already discussed (P6, **P7**). Rather than the sprawling compositions—filled with rich vignettes of various activities and interesting architectural motifs—of the other paradise scenes, in this painting the various teachers and divinities are organized in formal registers and columns around the Healing Buddha, as is the case with thankas depicting monastic lineages (**P3**, P18). It is also curious that while the texts strongly emphasize that both the Buddha's own body and his realm are constituted with pure lapis lazuli, blue is the weakest color in this thanka.

Tucci discusses the iconography of this particular painting at length and Birnbaum covers the concept and cult of the Healing Buddha in general. The following comments are, therefore, offered as supplemental information. The *Bhaishajyaguru-sutra* (written before the sixth century) makes this Buddha far more than a healer of either the body or the spirit. He is conceived, rather, as a supreme and cosmic figure who illuminates the entire world and possesses infinite knowledge. It is also interesting to note that the sutra places considerable importance on the worship of the Healing Buddha's image. The worshiper should "bathe, and with a pure mind try to be friendly to all beings. After this he is to circumambulate the image with music..." (Dutt, p. 56) The Chinese translation further states that "if one makes an image of this buddha, or if one recites the text of the sutra, he will escape from the nine ways of death" (ibid., p. 53).

The painting includes a number of interesting iconographic features. Immediately above the Healing Buddha's head is an image of Sakyamuni, and surrounding the nimbus are the figures of the eighteen arhats. Eight Buddhas, also of healing, and eight bodhisattvas are represented on two pillars flanking the central figure. These are very likely the eight bodhisattvas, seven of whom are named in the Chinese text (Manjusri, Avalokitesvara, Mahasthamaprapta, Akshayamati, Pao-t'an-houa, Bhaishajyaraja, and Bhaishajyasamudgata), who are said to attend the deceased and conduct him to the place of delight if he should dream of the Healing Buddha at the time of death. Along the top of the thanka are thirty-five identical figures representing the Thirty-five Buddhas of the Confession of Sins. Immediately below the central figure, represented against the overhanging carpet, are Amitayus and the goddess Ushnishavijaya, both of whom are worshiped to prolong life.

Below the carpet is a cartouche containing representations of the donors watching the enactment of rituals. As is frequently the case, the god being worshiped is Jambhala, also called Kubera, the dispenser of wealth. Three monks are engaged in offering worship, and behind them are three female donors. The first lady has a young boy in her lap, while the lady behind her is suckling an infant. This cartouche is flanked by two images of Tara, one white and the other green.

Particularly curious are the ink sketches, without any color washes, depicting scenes from the life of Sakyamuni—ending with his cremation—found along the lowermost, narrow register of the throne. Stylistically, the painting forms a group with the two paradise thankas (P6, **P7**). All three are fine examples of the distinctive style developed in Guge in the fifteenth century. The forms of the demons and lions supporting the throne are probably derived from Chinese paintings.

P9

Arhat Kanakavatsa
Central or Eastern Tibet, late 15th century
29 x 21½ in. (73.7 x 54.6 cm.)
The Nasli and Alice Heeramaneck Collection
L.69.24.325
Literature: Pal, 1969 A, pp. 53, 133; *Dieux et démons*, pp. 113, 116 (no. 86), and no. 85 for another from the series.
See plate 14

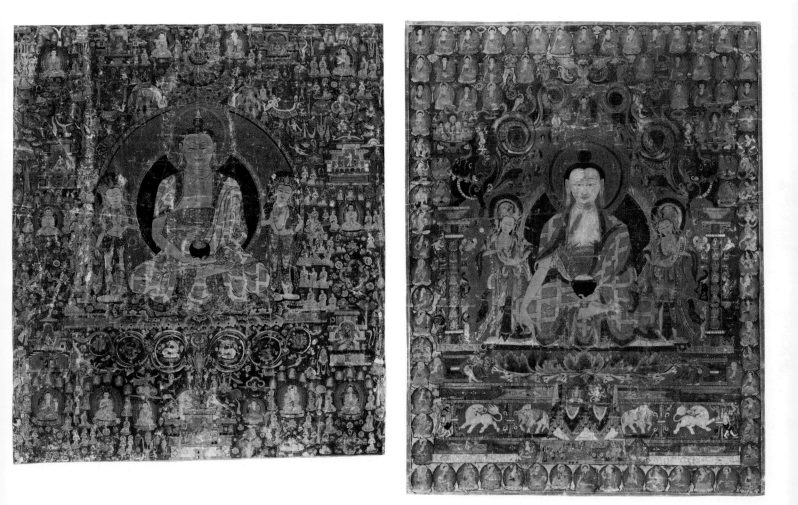

Kanakavatsa is said to reside on the saffron hill in Kashmir where he preaches that form of religion which helps to develop intuition and uplift the heart. It is also said that at the very moment he was born—to a middle-class family in Magadha (Bihbar)—a she-elephant gave birth to a golden-colored calf (*kanakavatsa*); hence, the future arhat was named Kanakavatsa. He was sent to preach the doctrine in the world of serpents (*nagas*), who presented him with a jeweled string to show their gratitude. This string or rope, clearly depicted in this thanka, became his distinctive attribute.

The large figure of Kanakavatsa, looking to the right, dominates the composition; it is necessary to look carefully to recognize the undulating forms on either side that represent the saffron hill of Kashmir. Perhaps because he resides in Kashmir, he has been given bright blue eyes, which are the most arresting feature of his expressive face. (In Chinese paintings, blue eyes are often given to people from the western lands, including Kashmir.) His balding head is surrounded by a nimbus and he is clothed in voluminous robes. A most curious feature of this painting is the manner in which the figure has been foreshortened so that he appears disproportionate and somewhat stunted.

The arhat is confronted by a dark, ominous figure, heavily robed in a colorful Mongolian costume. His right leg firmly planted near Kanakavatsa's right foot, the figure raises a bowl with his left hand. A monk holding a mirror and a vase looks down at the Mongolian warrior. Above him another monk stands holding a fly whisk. On the left of Kanakavatsa an attendant wearing a turban peers from behind a pillar, as if afraid to emerge. Rather curious is the fact that although Kanakavatsa wears sandals, a pair of shoes with curled toes is placed before his feet. On either side of the tiered roofs of the shrine are four deities, each enclosed in a roundel. Three of them are goddesses, and one is an angry, black god.

A comparison with an earlier arhat painting (P4), that may also represent Kanakavatsa, shows both iconographic and stylistic differences. Exactly when the rope or string became Kanakavatsa's distinctive attribute is not clear, but it was probably before the early fifteenth century. The figure dressed in the Mongolian garb near the arhat's right foot may be the "barbarian" king of Kashmir (*see* P4), although he is supposed to kneel rather than stand. Another unusual trait is the row of thunderbolts decorating the lower part of the back of the throne.

Even a cursory glance makes it clear that the painting is based on a Chinese prototype. The elaborate throne or chair on which the arhat sits and the rich folds and overlapping draperies have parallels in the paintings of the Ming period (1368–1644) (de Visser, pl. X, fig. 22) as well as in the Gyantse murals of the early fifteenth century. The very expressive face of the arhat, with its strong well-defined nose, bushy eyebrows, bright blue eyes, and slightly open snarling mouth, seems to carry memories of a much earlier tradition. The blue and green sloping hills on either side of the throne are quite different from the typical formula of jagged shapes and forms that are derived from Ming paintings and dominate later Tibetan landscape pictures. Here they have the gentle undulation that we encounter in fifteenth-century Tibetan paintings, which was derived from Buddhist pictures of Central Asia. Thus, it would seem that this series of arhats (three other examples of the series are in private collections) was painted sometime in the fifteenth century and predates the period when Tibetan artists consciously began copying landscape elements from Ming paintings. This date is

also substantiated by the forms of the three goddesses, who are stylistically akin to figures in pictures rendered in China in the third quarter of the fifteenth century (cf. Pal 1969 A, p. 57; *Dieux et démons,* p. 114, nos. 80–81).

Despite the curious foreshortening, the arhat is an impressive figure. The expressive face is sensitively rendered and seems lifelike. The swirling and cascading folds of the garment and the undulating hills make the representation lively and compensate for the rather limited palette of blue, green, and red. Browns, yellows, and whites are used sparingly, and the coloring is not so subtle or luminous as in the earlier arhat painting (P4). However, the composition is not so densely packed as that of the other thanka, and the arhat predominates. Like the other, this thanka offers no clue as to the place where it was painted.

P10

Mahakala with Companions
Central Tibet (Sakyapa monastery),
1450 or earlier
34¾ x 31⅝ in. (88.3 x 80.3 cm.)
The Nasli and Alice Heeramaneck
Collection
L.69.24.265
Literature: Pal, 1966, p. 113; Pal, 1977,
97–102; Pal, 1978, fig. 208 and pp.
150–52.
See plate 15

Mahakala, one of the dharmapalas, is a major figure in the Tibetan pantheon and is represented by a variety of images. In this painting he is portrayed in an especially popular form known in Tibetan as Gur gyi mGon po. (*See* S27 for an explanation of his iconography.) He is accompanied by two male deities on his right and two goddesses on his left. The deity with the four arms is Bhutadamara Vajrapani, while the two-armed figure is Legden Nagpo, an emanation of Mahakala; both gods are militant. The two-armed female wearing a blouse is Ekajati and the other is Lhamo (*see* P20). Except for Lhamo, who is blue, all the figures are black and are portrayed against a striking fiery red background. Mahakala's elaborate yellow hair is surrounded by a circle of scavenging animals, birds of prey, snakes, and prancing demons, with the *khyung* at the apex. The *khyung* is a *garuda*-like mythical bird that serves as Mahakala's messenger. Below and above this fiery realm, the conventional cremation grounds are depicted in typical crowded compositions. Two other interesting iconographic details must be pointed out. In the central lobe of Mahakala's crown is an image of Tathagata Akshobhya, and immediately above his hair, at either end, are several figures who appear to be Mara and his retinue. Thus, Mahakala is being attacked by demons of the senses.

Along the top of the thanka monks of the Sakyapa lineage are led by Vajradhara, Mahakala, the mahasiddha Indrabhuti, and another mahasiddha who cannot be definitely identified. Along the bottom, from left to right, are the Eight Guardians of the Directions, a seated monk holding the bell and the thunderbolt, four dancing *dakinis,* a walking Buddha or monk, and four more figures, three of whom appear to be angry deities.

There seems little doubt that stylistically this thanka is closely related to the Vajrabhairava (P12); both must have been

Arhat Kanakavatsa
See plate 14

Mahakala with Companions
See plate 15

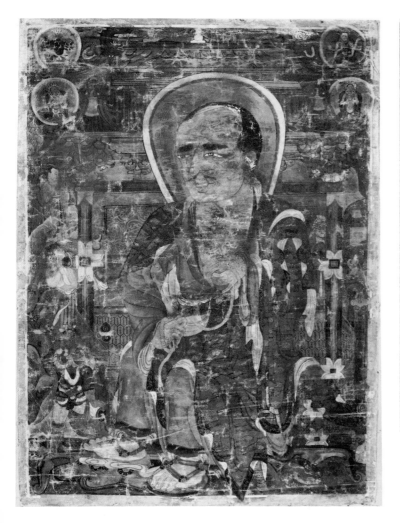

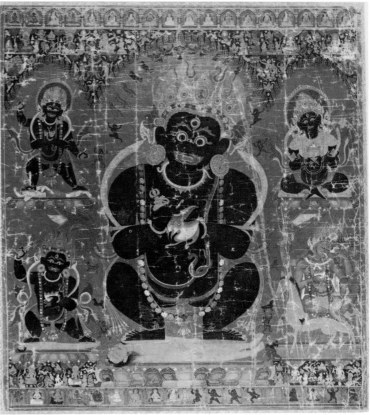

executed in the same atelier. Not only are the details rendered in a similar fashion, but both reflect the same manner of drawing and an identical palette. The minor differences, however, are noteworthy. Whereas the form of Vajrabhairava in the other thanka is made more expressive by the use of gray patches on his body to highlight the modeling, Mahakala and his companions are uniformly black. The drawing in the Mahakala painting seems to be more refined, and the details, especially of the garments, crowns, and jewelery, are rendered with greater finesse. The brush has been used more sweepingly in the Vajrabhairava than in the Mahakala, as is apparent from a comparison of the flame motif in the two paintings. The slightly earlier date is suggested for the Mahakala because of its closer stylistic kinship to Nepali paintings of the mid-fifteenth century (cf. Pal 1979, figs. 90–91).

P11

Mahakala and Companions
Central Tibet (Gyantse?), 1450–1500
39½ x 34 in. (100.3 x 86.3 cm.)
From the Nasli and Alice Heeramaneck
Collection
Purchased with Funds Provided by the
Jane and Justin Dart Foundation

M.81.90.4
Literature: Tucci, 1949, II, pp. 584–87,
pl. 195; *Dieux et démons,* pp. 127, 134.
See plate 16

Because Tucci explains the iconography of this monumental thanka at length, this discussion will simply summarize his observations, concentrating more on the style; for, as will be made clear, this is a rare and historically important painting.

As in **P10**, the principal figure here is Mahakala, but his iconography is different. He stands erect on the prostrate figure of Ganesa, the elephant-headed god regarded by Hindus as the remover of obstacles. The Buddhists' ambivalent attitude toward this god is evident from the fact that in the lower left-hand corner of the thanka a monk is seen worshiping another image of Ganesa, even while Mahakala tramples him above. In this instance Ganesa represents an *obstacle,* a threat to the faith of which Mahakala is the defender. Two of Mahakala's six arms hold the chopper and the skullcup (**P10, S28**); the other four hold a rosary of skulls, a kettledrum, a noose, and a trident. In addition, with his two upper arms, he stretches the hide of an elephant.

He is surrounded by various other deities forming his troupe, or family; the five principal companions are shown at the head and feet of the recumbent Ganesa and in the middle and extremities of the lowermost row of the thanka. The two figures above Mahakala's head, represented along the axis of the thanka, are emanations of Vajradhara. Monks, mahasiddhas, and other deities, both benign and wrathful, complete the mandala. Only two of the monks wear the peaked yellow hats of the pundit. Above the bottom of the thanka are several deities, including Ganesa and Kubera (the god of wealth), and a monk engaged in worship. An interesting group of deities are the Ten Guardians of the Directions, each riding his mount, represented in a vertical row on either side of Mahakala. The tantric tradition adheres to the theory of ten directions, which encompasses the nadir and the zenith.

Tucci states that this painting was procured in Guge and is stylistically related to murals at Tsaparang. He also suggests that it may be dated between the sixteenth and the seventeenth century. In *Dieux et démons* the authors observe that the thanka reflects the style of the main temple at Gyantse, which was founded in 1423. Hence, the authors cautiously suggest a "fifteenth-century or more recent" date.

A connection with the style of Gyantse murals and a fifteenth-century date for this thanka may be confirmed by a close comparison. The central figure of Mahakala is so similar—down to the minute details of the peculiar curls of his golden beard—to a representation of Vajrapani in one of the Gyantse chapels that both must be attributed to the same workshop. Furthermore, the distinctive flying hairstyle of the two figures riding animals at the bottom of the Museum's thanka occurs frequently in the Gyantse murals, as do mahasiddhas similar to those depicted in this thanka. Thus, Gyantse seems to be a likely place of origin, even though the thanka was found in western Tibet.

It has already been mentioned that the thanka presents interesting iconographic features, especially in the rare form of Mahakala and the inclusion of the ten gods of directions. Stylistically, too, it is a thanka of unusual importance, for no other known example can be so closely associated with the style of Gyantse, which was one of the major centers of Tibetan art and religion.

P12

Vajrabhairava
Central Tibet (Sakyapa monastery), 1500 or earlier
38⅜ x 31½ in. (97.5 x 80 cm.)
From the Nasli and Alice Heeramaneck Collection
Museum Associates Purchase
M.77.19.8
Literature: Pal, 1969 A, pp. 60, 135; Fisher, pp. 15, 35; *Dieux et démons,* pp. 27, 127.
See plate 17

An ominous belligerent figure with multiple limbs occupies the center of this thanka. His dark form is prominently set off by a fiery red aureole fringed with stylized tongues of flame. The ithyphallic god has eight demonic heads, the principal one being that of a buffalo, and the ninth, at the summit, that of a benign bodhisattva. His multiple arms spread out in all directions and hold a variety of emblems, mostly weapons. His primary hands hold the chopper and the skullcup. He has several pairs of legs, some of which trample gods, animals, and birds, while others appear to be dancing. Surrounding the aureole of fire are stereotypical scenes of cremation grounds. Along the top of the thanka is a row of seated figures, including the bodhisattva Manjusri, the mahasiddhas, and Sakyapa monks. Immediately below this row and in the two corners are the images of two protector deities; twelve more ferocious gods are represented along the bottom of the thanka. In the left-hand corner a Sakyapa monk adores an image of Jambhala.

The principal figure is Vajrabhairava, an angry manifestation of Manjusri, the gentle bodhisattva of wisdom, whose golden head tops all the others. Conceptually, Vajrabhairava is no different from Yamantaka, another angry form of Manjusri, though their forms differ slightly. The *bhairava* in his name and his iconography demonstrate that Vajrabhairava is an adaptation into the Buddhist pantheon of Mahabhairava, the fierce form of the Hindu god Siva. In fact, just as Mahabhairava is the cosmic form of Siva, so also is Vajrabhairava that of Manjusri. His eight heads represent the eight directions, while the ninth symbolizes the center of the universe. His arms and legs pervade the entire universe, symbolized by the cremation grounds; like Siva, his legs simultaneously trample upon the various creatures of the world as he dances the cosmic dance of destruction. (*See* also S28 for Tsongkhapa's explanation of Vajrabhairava's form in terms of Vajrayana theology.)

The inclusion of the Sakyapa monks makes the sectarian affiliation of the thanka clear, and its stylistic features make it a likely production of the Ngor monastery. However, murals in this style are found in other monasteries as well and attribution, therefore, must remain tentative. What is certain is that this thanka, along with its contemporary Mahakala (P10), strongly reflect fifteenth-century Nepali style and may have been painted by a Nepali master.

No matter where it was executed, there can be little doubt that it is one of the finest and most expressive paintings done in this style. Although the details of the cemeteries and the small figures along the top and bottom are rendered with great skill and finesse, it is clear that the artist intended to overpower the viewer with the commanding and compelling image of Vajrabhairava. In terms of its scale and expressive power, this is indeed a cosmic image, one that admirably portrays the powers and fury of the god. Especially intriguing is the manner in which the artist has represented the multiple legs, anticipating techniques that would be used in still photography.

P13

Sakyapa Lineage
Central Tibet (Ngor monastery?), 1475–1500
53 x 46 in. (134.6 x 116.8 cm.)
From the Nasli and Alice Heeramaneck Collection
Purchased with Funds Provided by the Jane and Justin Dart Foundation
M.81.90.1
Literature: Fisher, pp. 17, 37; *Dieux et démons,* pp. 128, 136–37.
See plate 18

P11

Mahakala and Companions
See plate 16

P12

Vajrabhairava
See plate 17

147

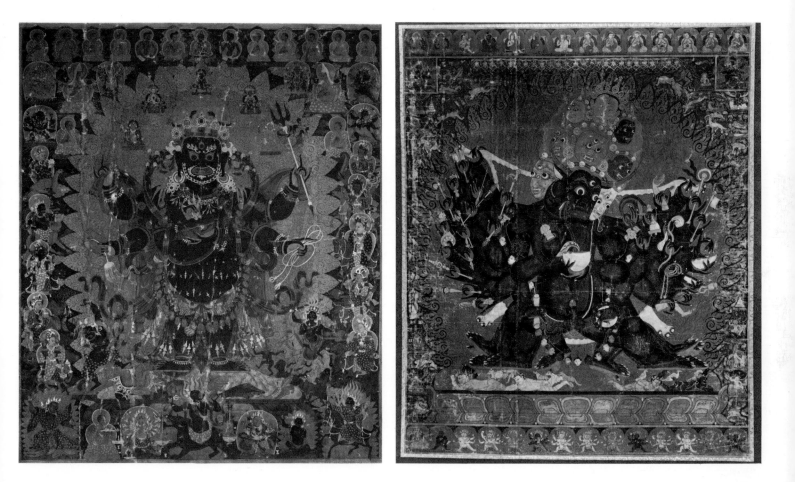

This is one of the finest and largest of a type of thanka portraying the lineage of Sakyapa monks that was especially popular with monasteries of that sect. In such thankas one or two important personages of the lineage are usually represented as large figures in the center, surrounded by smaller images. The deities of the Vajrayana pantheon and several of the mahasiddhas are added in this painting to complete the hierarchy.

The two central figures here are identified by faint inscriptions (see Appendix) on the petals of the lotuses on which they sit. The figure on the left is Kunga Wangchuk, a disciple of Kunga Sangpo. The figure on the right is Sonam Senge. Among the others, the best known are Phakpa and Sonam Tsemo. Although not much information is available about Kunga Wangchuk, his guru, Kunga Sangpo (1382–1444), was the celebrated founder of the Ngor monastery. Sonam Senge was the founder of another well-known Tibetan monastery, Thubten Namgyal, established in 1478.

There is very little to distinguish these two monks, who are dressed in identical attire of red and orange robes and the red hats typical of Sakyapa monks. Characteristic of such idealized portraiture are the gestures of exposition made by both, and the stringlike lotus stem held by each. Open flowers at shoulder level support different attributes. One monk has the thunderbolt and the bell, while the other has the sword and the manuscript. Neither the emblems nor the gestures, however, are necessarily characteristic of either figure, but are ubiquitously displayed by monks and teachers. Thus, but for the inscriptions, it would be impossible to identify such figures.

The most noteworthy feature of such lineage thankas is that the figures in them are often connected with each other, and with the central personages, by means of intertwining vines which conveniently form roundels that also serve as aureoles. This further emphasizes the divine nature of the monks (indicated also by the halos behind their heads) who are in any case emanations of one another, as well as of the mahasiddhas and the various gods. Interestingly, with the exception of one or two divine figures at the top, most of the deities are represented in two rows along the bottom. Two goddesses, Ushnishavijaya and Tara, are depicted on either side of the elaborate base of the throne. Most of the monks are bareheaded, make different gestures, and display considerable variety in their attire; those wearing white robes represent Sakyapa hierarchs who were allowed to marry. Some of the monks are older than others, but in general the portraits conform to stereotypes.

It would not be farfetched to assume that this painting was made soon after the demise of the two principal monks as a sort of memorial. There are close correspondences with the Nepali artist Jivarama's sketches done in 1435 (Lowry 1977). The style lingered in Ngor for a considerable time, as is evident from this thanka which could not have been painted earlier than 1478, the year Sonam Senge founded his monastery. That is why the thanka is dated toward the end of the fifteenth century. The date may be corroborated by other stylistic comparisons as well. A comparison with other Sakyapa thankas (P10, P12) also indicates a date close to the year 1500. The predominant colors are red, green, and blue—hues typical of Ngor paintings of that time, as well as of those from Gyantse.

Its size and superb condition make this thanka an unusual example of Tibetan hieratic portraiture. The pleasing overall design emphasizes the continuity of the religious family.

It was not important whether the portraits were realistic; the artist's intent was to capture the serenity of the other shore where the monks presumably went after death. In this he was eminently successful. The abundance of vegetative forms imbues the surface with an organic rhythm that adds to the liveliness of the otherwise hieratic composition.

P14

The Life of Milarepa
Western Tibet (Kagyupa monastery),
c. 1500
51½ x 41½ in. (130.8 x 105.4 cm.)
From the Nasli and Alice Heeramaneck
Collection
Purchased with Funds Provided by the
Jane and Justin Dart Foundation
M.81.90.2
Literature: Pal, 1969 A, pp. 61, 135;
Dieux et démons, pp. 22, 95.
See plate 19 (detail)

This thanka is a rich and detailed illustration of the mystical life of Milarepa, the central figure depicted here. (For a discussion of his personality and iconography, see S40.) Around him are represented scenes from his life, identified with inscriptions that are very difficult to read. The episodes illustrated do not always follow the accounts given in the various known biographies of Milarepa, although some can be identified from these texts. It is likely therefore that the events shown are drawn from a biography that was adhered to in the region where this thanka was painted.

The scenes from Milarepa's life are too numerous to identify at length here, but one or two will be discussed below. It may be noted that most of the incidents occur in the mountains, and that the cave is the dominant feature of the landscape. However, some of the scenes are laid in villages and towns which are indicated perfunctorily by small pavilions or houses. Milarepa eschewed urban settlements, preferring to wander around the countryside like a true ascetic, often seeking shelter in caves, as yogis still do in the remote regions of the Himalayas.

The golden figure of the great yogi is seated on a lotus throne within a golden cave. Milarepa wears golden robes and a red sash, and cups his right ear with his right hand, a pose characteristically his own. A blue and red aureole deftly integrates the golden cave with the rest of the thanka. Within this cave two other monks, one wearing a hat and golden robes and the other orange and red robes but no hat, flank Milarepa like sentinels. Two smaller figures of monks, probably wearing yellow hats, are on either side of the yogi's head.

Outside the aureole, two groups of three monks stand columnlike on either side; below them are groups of listeners consisting of demons and lay personages. The carpet overhanging the base of the throne is adorned with the image of Sarasvati holding a lyre (P23). At the lower-right corner of the throne a tent with several figures representing the donors is positioned; on the left side a pavilion with *nagas* floats on a lake. This lake is the source of a river which flows along the front of the throne. In the upper corners of the central section various demons attack the yogi. Above the demons, in a row, are the seated figures of gods, mahasiddhas, Marpa (Milarepa's guru), and several monks wearing hats typical of the Drukpas, a subsect of the Kagyupas.

P13

Sakyapa Lineage
See plate 18

P14

The Life of Milarepa
See plate 19 (detail)

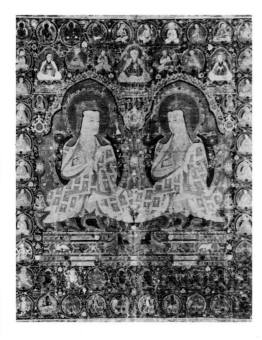

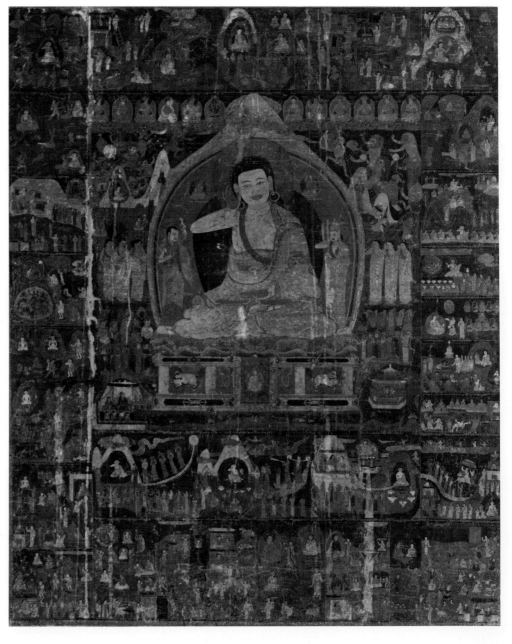

This central section encapsulates two important themes of the *Mila Grubum,* Milarepa's biography: his victory over the demons and his teaching—of the demons as well as of his disciples and others. The entire first part is dedicated to the consistent harassment of the yogi by demons and *dakinis.* In the second part are stories of the conversion of human teachers and his discourses to them. The attack of the demons probably helped to establish a homology between the Tibetan mystic and the concept of the Buddha Sakyamuni, whose *bodhi* (enlightenment) is symbolized by his victory over Mara and his demons at Bodhgaya.

In the very first composition in the upper left-hand corner—the incidents move from left to right—Milarepa is assaulted by Indian demons while he is living in the Eagle Castle of Red Rock Jewel Valley. The next segment depicts Milarepa's brief halt at Dreloon Joomoo on his way to the Lashi Snow Mountain. Here he enjoyed the hospitality of a rich young girl named Shindormo before continuing on his journey. In the third scene the solitary Milarepa is meditating in a cave within a strikingly painted rock formation, where he is once again attacked by demons, this time from Nepal. The two birds within the nest are probably the vultures that appeared to him in his dreams as he was receiving initiation from his guru, Marpa. Interpreting the dreams, Marpa is supposed to have said: "The vulture's nest, clinging to the rock shows that his life shall endure as the rocks" (Lauf 1976 B, p. 199). Another composition (*see* detail) illustrates the story of the deer and the hunter. When Milarepa was living on a secluded mountain near the border between Nepal and Tibet, the serenity of the hermitage was disturbed one day by the barking of a bitch. On emerging from his cave, the yogi noticed a panting deer and out of compassion sang a song. While the deer sat at his side, the bitch arrived and she too became docile on hearing the master's sermon. Finally, the hunter followed with his bow and arrow and attempted to kill Milarepa, but the arrow missed him. Milarepa then preached to him as well, and the converted hunter became known as Cirarepa.

This painting is both historically important and one of the most colorful in the collection. Dominated by blue, green, and gold, the combination of colors is most unusual and does not stem from any known school of Tibetan painting. It is, therefore, extremely difficult to relate this thanka to a particular style, but it almost certainly comes from western Tibet and shows Central Asian influences. Although the headdresses of the donor figures are not recognizable, their regal postures as well as their halos must indicate that the donors are royal personages. In that case, this thanka is the result of yet another royal commission. The large figure wearing a blue dress and holding a rosary probably represents the king. The figures below him may be his sons, but the one behind him has neither a halo nor headgear. Rather, his hair seems to fly behind him, and this particular hairstyle may also be seen on one of the donors in a thanka of the Drukpa order which Tucci acquired in Namgyal near the Indian border (Tucci 1949, pl. 42).

Stylistically, the thanka is related to another painting of the Drukpas (ibid., pls. 40, 41) as well as to three fragmentary murals recovered from southern Tibet, now preserved in Rome (Tucci 1967, pl. 1). These mural fragments are usually dated to the sixteenth century, but the Milarepa is probably earlier. The closest stylistic parallel for the figurative types may be seen

in a thanka in the Victoria and Albert Museum believed to be from western Tibet and dated to the fourteenth century (Lowry 1973 A, cover and p. 63).

P15

Sakyapa Monks
Central Tibet (Sakyapa monastery),
c. 1500
28½ x 27 in. (72.4 x 68.6 cm.)
Purchased with Funds from The
Ahmanson Foundation
M.81.26
See plate 20

Four Sakyapa monks wearing different kinds of robes, but seated on almost identical thrones, dominate this richly colored thanka. The thrones differ only in the designs of the overhanging carpets and the dispositions of the white lions with green manes. The principal monks are surrounded by small figures of other monks of the lineage but only three deities. Notwithstanding the idealized nature of the portraits, each principal figure has a recognizably different face and varying attributes. Each pair consists of a younger, black-haired monk and an older, balding, white-haired monk. All four wear the customary orange robe, but both the color and design of the inner garments are different.

The younger monk in the upper row wears a garment of red and gold with green sleeves and a white sash. His left hand is placed on his lap and the right hand, which holds a lotus stalk, forms the gesture of exposition. His companion wears a short, sleeveless inner jacket of red and orange; a shawl embroidered with red and orange rectangles is wrapped around his left shoulder, leaving the right arm free. His right hand forms the gesture of charity and his left holds a blue lotus. The older monk on the lower left wears an inner garment of white with gold patterns and red sleeves. The inner garment of his younger companion is blue-black with gold designs. Both display the same gesture of turning the Wheel of Law; both also hold thin, golden, stringlike stems of two different kinds of lotus flowers. The same attributes, a sword and a book, are placed on each pair of flowers. Despite these specific iconographic features, it is not possible to identify the individuals except to say that they are important members of the Sakyapa hierarchy.

Two other thankas of this series are known (*see* Pal 1969 A, pp. 44, 133–34; Lauf 1969, pp. 67–68 and color pl. A.); in each instance the composition is identical. In one of them there are two mahasiddhas and two Sakyapa monks, and in the other there are four monks, one of whom wears a yellow hat. In addition, at least four other smaller figures in that thanka wear yellow hats. Since yellow hats are worn by the Gelukpas, it seems that the series portrays monks of both the Sakyapa and Gelukpa lineages, and was probably painted for a Sakyapa monastery after it was taken over by the Gelukpas. Since several monasteries in Tsang were taken over, the thanka is attributed to that region, but it is not possible to be more precise about the identification of the monastery.

The rich, resonant tonality of colors in this series is striking and unlike those of any other paintings of the Sakyapa

Sakyapa Monks
See plate 20

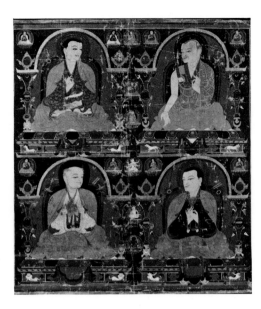

school or the Nepali tradition. Because the composition is not so crowded as in other such lineage thankas (**P13**), the deep and intense indigo blue of the background is unusually prominent. The other colors employed are orange, red, green, dark blue, and black; the flesh of the figures is pink. Gold has been applied lightly on the costumes but is thicker where it is used as trimming, especially in the arches of the thrones. All these colors, although seen in other paintings of the Sakyapa tradition, are far more intense and vibrant in this series and create a dazzling visual effect.

In an earlier publication (Pal 1969 A, p. 55) I suggested a date of around 1400 for another of the series, but at that time I was not aware of the example showing Gelukpa monks. In Lauf's *Tibetische Kunst* no attempt is made to date the thanka and it is suggested that the style is predominantly Nepali. While certain elements in the series do reflect Nepali influence, such as the design of the thrones and the three divine figures, neither the composition nor the strong bright colors are encountered in other Sakyapa or Nepali paintings. However, the specific Nepali elements are seen in mid-fifteenth-century paintings rendered in that country (cf. Pal 1978, figs. 83–89), while among Tibetan works, a thanka in the Victoria and Albert Museum (Lowry 1973 A, pp. 60–61) offers a close parallel. Lowry dates the Victoria and Albert painting to the first half of the fifteenth century, and thus a date toward the end of that same century for this thanka is probable.

P16

Three Mandalas
Tibet (Ngor monastery), 16th century
16⅛ x 12½ in. (41.3 x 31.8 cm.)
From the Nasli and Alice Heeramaneck
Collection
Museum Associates Purchase
M.77.19.15
Literature: Tucci, 1949, pl. Z and p. 600;
Pal, 1966, pp. 119–20.
See plate 21 (detail)

The inscription at the bottom of this thanka states that it was part of a series of twelve mandalas and was dedicated by Gyaltsen Özer for the removal of his sins, those of his parents, and of all creatures. It also prays that the learned Lama Tshulgyi Özer may attain fulfillment of his wishes (*see* Appendix; also Tucci reference above). It would seem that the donor and the lama were related; they may have been nephew and uncle. The lama is otherwise unknown and, as Tucci suggests, he may have been an abbot of the Ngor monastery where the thanka was acquired.

Of the three mandalas, the upper one belongs to Amitayus (*see* **P1**, **P17**), while the principal deity in the others is Vajrasattva. Tucci identifies the mandalas as well as the other figures, who include Buddhas, bodhisattvas, dharmapalas, and *yidams,* along with monks belonging to various liturgical cycles having no apparent relationship to each other. While most of the divine figures are represented in a hieratic manner, each seated or striding against a red aureole, a slight variation is introduced in the depiction of Kubera/Vaisravana and his troupe consisting of eight figures (center-left). All are dressed in Mongolian costumes and ride horses. Kubera rides his lion. The

Three Mandalas
See plate 21 (detail)

The Buddha of Endless Life (Amitayus)
See plate 22

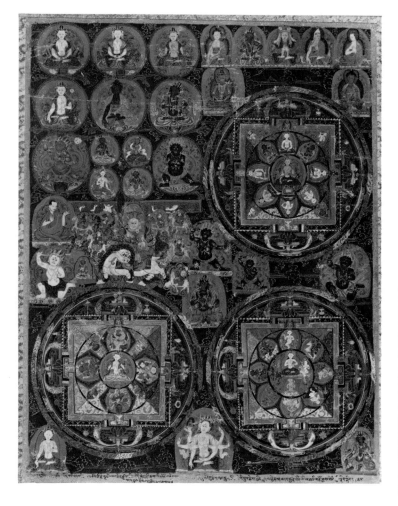

detail

entire group appears to move toward a seated monk, as if he has conjured up these forms. This may well be true, since the figures are enveloped with swirling clouds which indicate that they are riding through the air. Generally, such scenes of invocation are included at the bottom of a thanka and depicted far less elaborately. The monk may well be Tshulgyi Özer. And possibly this is the last of the series of thankas, since it contains the dedicatory inscription.

Apart from the unusual placement of the visionary invocation scene with Kubera, the general configuration of the composition is somewhat curious. The three mandalas are placed asymmetrically; normally, thankas with mandalas follow strict symmetrical designs. There is also no focal point in this composition and the center is occupied not by the principal figure of a mandala but by three protective deities of lesser importance. Whether such striking deviations reflect the whimsy of the artist or are parts of an overall design involving other thankas in the series is difficult to determine. In any event, the asymmetrical disposition of the mandalas, as well as the variant placement of the invocation scenes, enhance rather than detract from the visual appeal of this thanka. Noteworthy also is the diamond shape of the lotus petals within each mandala.

Although the mandalas with their decorative elements and the swirling forms behind the figures are reminiscent of the more familiar Nepali style at Ngor, the facial features as well as the treatment of the garments appear more Chinese. Certainly in the delineation of the garments and their folds, which reveals a sense of volume, and of the stylized white cloud patterns interspersed between the figures, the artist displays his familiarity with Chinese mannerisms.

P17

The Buddha of Endless Life (Amitayus)
Ladakh (Basgo citadel), early 17th century
30¾ x 25¾ in. (78.1 x 65.4 cm.)
From the Nasli and Alice Heeramaneck
Collection
Museum Associates Purchase
M.77.19.14
Literature: Tucci, 1949, II, pp. 363–64,
pls. 37, 38; Pal, 1966, pp. 118–19;
Dieux et démons, p. 23, no. 60.
See plate 22

The golden figure of Amitayus sits on a lotus throne and holds a vase containing a plant. As is usually the case with this tathagata, he is bedecked in ornaments; this contrasts with his hypostasis, Amitabha, who is represented as a humble monk at the top of the painting. In addition, in this depiction, Amitayus has a sash tied across his body and various scarves and ribbons billow around him. Both of his attending bodhisattvas also have golden complexions, and, but for their facial features, are almost identical. A lotus rises from the bottom of the painting with a great flourish—its stems carry peacocks, lions, and other symbols. The swaying, flowering stems surround the three figures and continue to the top of the thanka.

The roots of the lotus spring from a small mound with larger hills on either side. On the right are three tantric divinities, including the god of wealth. On the left is a court scene. There is a column of monks, most of whom are of the Kagyupa sect—with some early Gelukpas included as well—on each side of the painting. The Indian yogis along the top edge, with their characteristic ascetic hair arrangements, are iconographically interesting. The esoteric deity Guhyasamaja is seen in a little vignette in the upper left-hand corner near the second monk from the top.

Art historically, this scene, in which a turbaned king sits on a throne accompanied by his sons, is the most important section of the thanka (see detail). Tucci suggests that the principal figure, the donor, is very likely King Senge Namgyal (c. 1570–1642) of Ladakh. This suggestion may be confirmed by royal portraits painted on the wall of the Maitreya temple in the citadel of Basgo in Ladakh (see Snellgrove and Skorupsky 1977, fig. 75). In fact, Tucci obtained this thanka at Basgo, a residence of the kings of Ladakh, and it was probably painted by a lama or an artist attached to that monastery. The presence of the king's portrait makes it possible to date the painting with relative certainty. This thanka is one of the few known and datable paintings from Ladakh, and is of great historical significance. Since it was a royal commission, it is not unreasonable to imagine that the finest available artist of the period was employed to paint it.

Senge Namgyal, the donor of this thanka, was responsible for building the Serzang temple where the murals, unfortunately, are now much too indistinct to be photographed. As Snellgrove and Skorupski remark, however, they are similar to those in the upper Maitreya temple erected by Tshewang Namgyal (Snellgrove and Skorupski 1977, pp. 95–97). A comparison of this thanka with a published mural from the Maitreya temple (ibid., fig. 87) seems to confirm this suggestion.

In previous publications this thanka has been attributed to the Guge school. While it may reflect some Guge characteristics, it certainly is notably different from the earlier Guge style (P6–P8). The composition is more open, and landscape elements, however perfunctory, are now introduced to enrich the design. The drawing is not so careful or fine as that in earlier thankas but is more spontaneous. There is a general exuberance of style manifested in the excessive use of flying draperies, undulating plants, and in the exaggerated stances—particularly of the two bodhisattvas. The garment designs and the form of the lotuses are now more stylized than in fifteenth-century Guge paintings and the flower looks more like a peony than a lotus. The facial features are distinctly Mongoloid, which, together with the swirling forms below Amitayus' throne, the use of

landscape elements, and the peonylike lotuses, indicate that the artist responsible for this thanka was familiar with contemporary central-Tibetan painting styles. In contrast to the more mellow colors of the earlier Guge style, much brighter shades, especially a glowing blue that dominates most of the surface, are applied here.

P18

Sonam Tsemo and His Lineage
Central Tibet (Ngor monastery),
early 17th century
31 x 26½ in. (78.7 x 67.3 cm.)
Gift of Paul E. Manheim, by Exchange
M.70.57
Literature: Fisher, pp. 22, 41.

The central figure in this thanka depicting the Sakyapa hierarchy is identified twice—once on the back and again in the dedicatory inscription at the bottom (see Appendix). He is Sonam Tsemo, the eminent Sakyapa scholar who lived from 1142 to 1182. The collection also contains a bronze portrait of this lama (S38), who is appropriately characterized in the inscription here as a man who "achieves immeasurable virtue, and extends knowledge and wisdom, and is an excellent friend to all creatures."

As is usual in such portraits, the other hierarchs of the order are depicted around the central figure in neat, orderly rows. The most significant difference between this portrait and the version in bronze is that here Sonam Tsemo holds the thunderbolt and the bell, the symbols of Vajradhara/Vajrasattva, against his chest, whereas in the bronze, his hands form the gesture of teaching the Law. His attire is somewhat unusual in this thanka. He wears a richly embroidered blue jacket, and the garment wrapped around his legs is plain and yellow, rather than the patterned orange more customary in Sakyapa hieratical representations.

It may also be pointed out that the collection contains yet another representation of Sonam Tsemo. He is included in the earlier Sakyapa lineage thanka (P13) (cf. fig. 12 in P13, Appendix). There he is shown wearing a white robe over a gray jacket, but holding the thunderbolt and the bell, as in this painting. Interestingly, the facial features differ in all three representations, which confirms the suggestion that Tibetan portraiture is more idealistic than realistic.

This thanka is one of a series now dispersed in various public and private collections (see Pal 1971, pl. 78; Fisher, p. 42; Lauf 1976 A, pp. 92–93; *Dieux et démons*, pp. 128–29, 138–39). But for the central figures wearing different costumes and displaying various emblems and gestures, the composition in all the examples is identical. The workmanship is careful and flawless and the details have been rendered with great finesse. The faces of the figures, drawn with fine pale lines, reflect the influence of the refined Chinese manner of draftsmanship. The coloring, however, follows the Sakyapa penchant for bright, deep tones. The predominant color is red, but in some of the other paintings in the series the background is an indigo blue of the same intensity and tonality as the blue in an earlier Sakyapa portrait in the collection (P15).

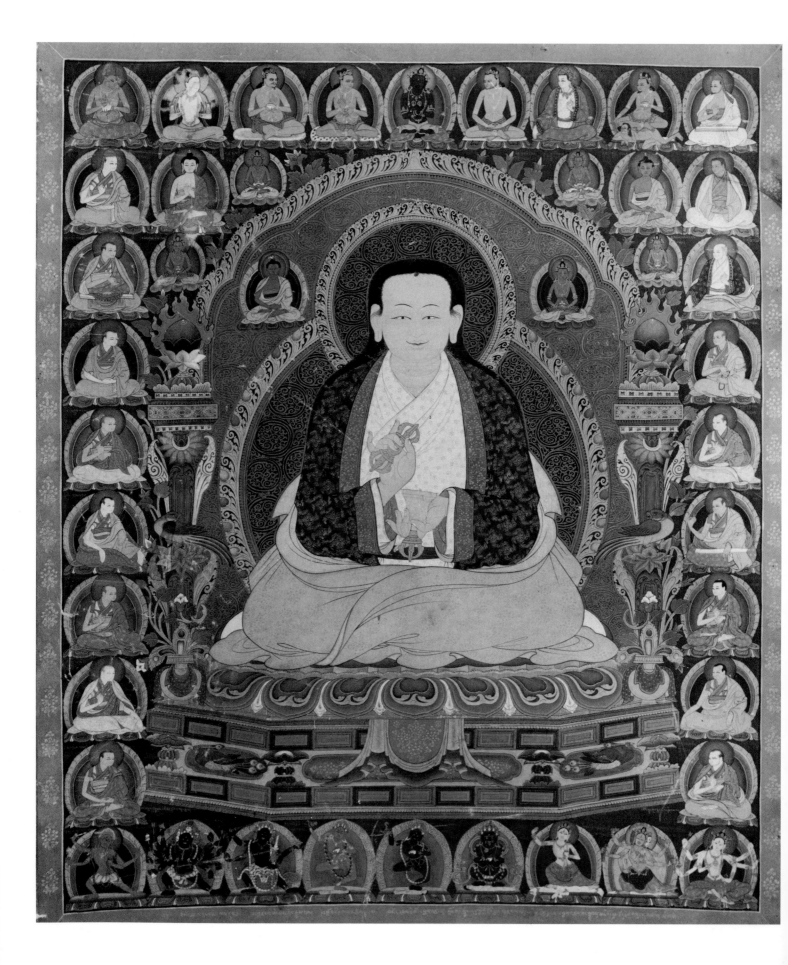

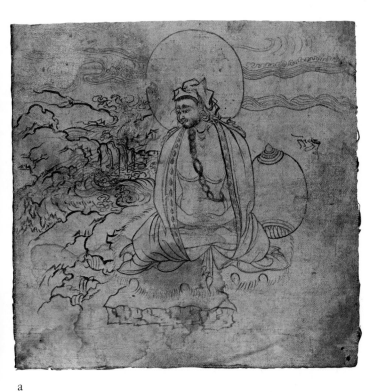

a

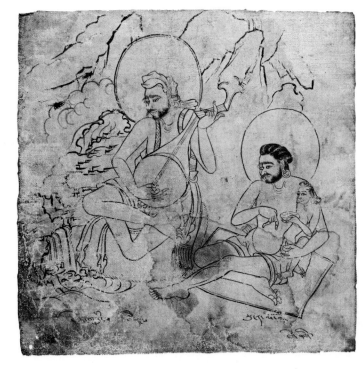

b

P19

Mahasiddhas in Landscape
Central Tibet, 17th century
Ink on cloth
7⅞ x 8 in. (20 x 20.3 cm.)
Gift of Dr. and Mrs. P. Pal in Honor of
A. Quincy Jones
M.80.155.2

Figures of mahasiddhas in perfunctory landscapes are sketched on both sides of this cloth. On one side (a), supported by a cushion, a solitary mahasiddha is seated in meditation on a rock beside a lake (with a waterfall?). The inscription identifies him as Sengepa. On the other (b) are two mahasiddhas: one plays a stringed instrument; the other supports his female partner—who holds a skullcup in her left hand—on his lap. The musician is identified by the inscription as Bainapa, which is a variation of Vinapa. The inscription for the other mahasiddha is difficult to read and so his identification is uncertain.

Within the Tibetan tradition there are various lists of mahasiddhas which do not always agree. The iconography is not consistent, either, which increases the difficulty of identifying the second figure in (b). Vinapa, however, is a familiar figure and is known from the Indian scholar Abhayadatta's biographies of the mahasiddhas (*see* Robinson, pp. 57–59). He was called Vinapa because he played the stringed instrument known as the vina. Born into a royal family of the country of Gahuri, Vinapa was a musical prodigy who refused to give up music—even for

the throne. Ultimately he was initiated by another mahasiddha known as Buddhapa and achieved *siddhi* (enlightenment) through his music.

Sengepa is not known in the Indian tradition and is obviously a Tibetan figure. It has been suggested, however, that he may be the same as Samudra of the Indian list (Schmid 1958, p. 98), but if so, the representation here follows a completely different iconographic tradition. Since Samudra is said to have brought forth riches from the ocean, he is generally shown in a boat or floating on a skin in the ocean. Here, however, he is simply a meditating yogi.

Few sketches from Tibet have survived. These probably formed part of an artist's pattern book. The same brush appears to have been used to sketch the compositions and write the inscriptions. Thus, although certain elements of the style are derived from the Chinese pictorial tradition, the artist was very likely a Tibetan. He was also an assured draftsman, for the outlines are drawn with clarity and firmness. Because of the Indian, rather than the Chinese, types of figures, the sketches are assigned to central rather than to eastern Tibet. Two other examples from the same set of sketches are in private collections.

Kunga Tashi and Incidents from His Life
See plate 23 (detail)

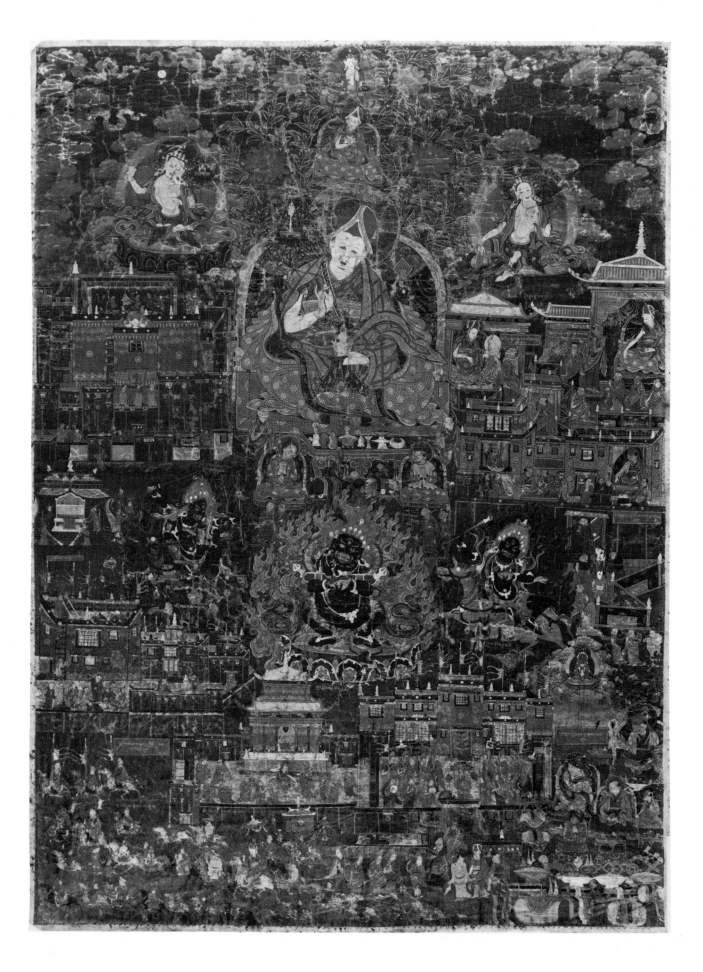

Kunga Tashi and Incidents from His Life
Central Tibet (Sakyapa monastery),
1675–1700
37 x 27¼ in. (94 x 69.2 cm.)
The Nasli and Alice Heeramaneck
Collection
L.69.24.322
Literature: Tucci, 1949, II, pp. 372–73,
pls. 54–58.
See plate 23 (detail)

The subject of this thanka is of unusual interest, for it combines hieratical portraiture with narrative panels depicting incidents from the life of the principal personage portrayed. It differs from the Milarepa thanka (P14) in that the events represented are more biographical than hagiographical. The various episodes are identified by copious inscriptions, transcribed by Richardson in this catalogue's Appendix and discussed adequately by Tucci (*see* literature above).

The principal personage depicted, in the center of the thanka, is Kunga Tashi (1349–1425). Wearing the typical red hat of the Sakyapas, he holds a flowering vase of immortality with his left hand. In his right is a flower topped by a sword and a manuscript, the emblems of Manjusri who is seated near his right shoulder. On the other side is the goddess Tara. Immediately above Kunga Tashi is a small image of a monk displaying the gesture of the god Vajradhara who is at the summit. Immediately below the throne are the portraits of the monk's two disciples, who were the principal donors of the thanka. Below them is an image of Mahakala, the protecting deity of the Sakyapa order, who is identified in the inscription as Gur gyi mGon po. He is accompanied by two different forms of Lhamo. The two monk donors of this thanka were apparently supported by a lay donor from eastern Tibet, who is portrayed as a high official (wearing a fur cap) with his bureaucratic retinue in the lower right-hand corner.

Various activities which must have been the highlights of Kunga Tashi's religious life are depicted elsewhere in the thanka. Since Tucci has described all these, only two are mentioned here.

On the left, immediately below the image of Manjusri, is the scene of the restoration of the great temple Lhakhang Chemo, one of the important monasteries of Sakya. The upper terrace is actually being repaired by workmen under the supervision of a monk wearing an enormous headgear who must represent the foreman or manager. At the other end of the monastery monks in ceremonial dress are engaged in consecrating the building by performing appropriate rites. It would be interesting to determine the accuracy of the representation by comparing it with the existing structures of the monastery. A particularly intriguing scene is depicted on the other side of Kunga Tashi, immediately below the image of Tara. In it, a man is offering a golden statue to the monk. The inscription states that the lama had ordered his treasurer to have the golden image made, and the scene here shows its presentation to Kunga Tashi for his inspection and approval.

There is some disagreement about the identification of Kunga Tashi, although it is agreed that he was a Sakyapa.

According to Tucci, he was a contemporary of the Fifth Dalai Lama. This Kunga Tashi was confirmed in 1668 and both he and the Fifth Dalai Lama shared the same guru (Dargay, p. 189). However, Richardson identifies Kunga Tashi as the thirty-second abbot of Sakya (*see* Appendix). And since the incidents from his life recorded in the painting do not mention his death, Richardson is of the opinion that the thanka could have been painted while he was still alive.

This conclusion is difficult to accept, however, in view of the style of the thanka. The fifteenth-century Sakyapa style is well documented by several examples in this collection (P10–P13, P15). The style of this thanka not only differs notably from that of the earlier examples but is closely related to the style of several dated paintings of the second half of the seventeenth century (*see* Pal 1978, figs. 214–15).

For instance, the forms of Mahakala and his acolytes are very similar to those seen in another Sakyapa thanka painted around 1700 (P21). The figures of the lamas in the various structures, too, are closer to those seen in thankas of this period than to those in thankas of the fifteenth century. The cursory modeling of some of the faces (particularly Kunga Tashi's), of the other important monks, and of the deities above is more typical of the seventeenth century than of earlier periods. The forms of the trees and the clouds are seen more commonly in later paintings, while the lay donor figure in the lower right-hand corner wearing a hat is very similar to representations of some noblemen of Kham portrayed in another thanka published by Tucci (1949, pl. O), a thanka which is unlikely to be earlier than the seventeenth century.

Thus, if the central figure in this thanka is indeed the fifteenth-century Sakyapa abbot, it must be concluded that this is a seventeenth-century copy of the original. Such copies were not unknown, especially if the original was damaged and if the thanka was as historically important as this one. It is also possible that the donor was a dignitary from Kham who was a devotee of Kunga Tashi and that, on a visit to Sakya, he had a copy made of the original. Apparently, there is an inscribed portrait of Kunga Tashi in the *kumbum* of Gyantse (Karmay 1975, p. 80); so until one can compare the two portraits, a definite identification is not possible.

No matter who the person portrayed is, the thanka remains one of the most significant examples of Tibetan biographical painting. It is of particular interest to students of Tibetan architecture, since it both illustrates recognizable buildings and demonstrates how some were constructed. Indeed, the significance of this thanka for the cultural history of Tibet in general far exceeds its aesthetic importance.

P21

Mahakala and Companions
Central Tibet (Ngor monastery), c. 1700
26¼ x 21¾ in. (66.7 x 55.2 cm.)
From the Nasli and Alice Heeramaneck
Collection
Museum Associates Purchase
M.77.19.11
Literature: Pal, 1966, p. 117; *Dieux et démons*, pp. 128, 135; Pal, 1977, p. 100.
See plate 24

Mahakala in this thanka is not different iconographically from other representations in the collection (**P10**, S27). The number of his immediate companions, however, has increased. There are now two forms of Lhamo, one black and the other blue, both riding their mules through a sea of blood, which, according to one text, issues from the vagina of Ekajati (Nebesky-Wojkowitz, p. 50). The black Lhamo has four arms and the blue Lhamo only two, but both images are equally gruesome. There are three figures on the other side of Mahakala: Bhutadamara Vajrapani, Legden Nagpo, and the figure of an Indian ascetic, presumably a mahasiddha (Heruka?), seated on a corpse and carrying a skullcup. This mahasiddha is not often included with representations of Mahakala. In front of the throne, five black *dakinis* on the warpath are being chastised by an armored guardian, a monk, and other attendants of Mahakala. According to one Tibetan tradition, these five may represent the five classes of *dakinis* (*mkha' gro sde lnga*), while the Indian text identifies them as the five Mother Goddesses: Kali, Karali, Varali, Kankali, and Mahakali.

A long dedicatory inscription (*see* Appendix) at the bottom of this painting provides us with interesting information, though it is of little help in dating the thanka. Most of the Sakyapa lamas depicted above Mahakala are also identified by the inscriptions, but except for a few early and famous names in the lineage, the majority remain unknown. In a few instances, the names read by Richardson differ from the readings given in *Dieux et démons* (*see* reference above).

The inscription identifies the central figure as Gur mGon (a form of Mahakala), but more importantly, it indicates that the thanka was consecrated in the monastery of Evam, another name for Ngor. Presumably it was painted by an artist attached to this monastery, since the monks are all of the Sakyapa order; however, one cannot rule out the possibility that it was executed somewhere else and brought to Ngor for consecration. The thanka was commissioned by mDo khams Ga zi ba, about whom nothing is known. It is also not clear whether he dedicated the thanka to the monastery or took it home with him. The reason for the commission seems to have been to purge "the two sins and attain fulfillment in the two spheres" [meaning not clear] of the father and grandfather of On po mkhyen rab, whose kinship with the donor is not explained.

The style of this thanka is notably different from examples of the fifteenth-century Ngor style (**P10**). Although there is a basic similarity in the composition, the figures are now less regimented and seem to have more elbowroom. The brushwork is unquestionably bolder and reveals greater spontaneity—the figures seem considerably more freely drawn. The scene with the dancing *dakinis* is especially lively and vigorous, and the animals and birds appear to be drawn from life. One can recognize the Tibetan mastiff in the dogs, and the birds fly with much greater ease and naturalism than they do in the earlier painting. The crowded cemetery scenes are dispensed with, and the billowing scarves, swirling pools of water, the flying birds, and the bold, leaping tongues of flame make this a lively and dramatic composition. And yet, a sense of calm prevails in the upper section as the deified lamas and others watch the vigorous antics of both gods and demons with serene and impassive detachment.

P22

Sakyasri and the Lotsawa of Trophu
Central Tibet, c. 1700
11½ x 9¹¹/₁₆ in. (29.2 x 24.3 cm.)
From the Nasli and Alice Heeramaneck
Collection
Museum Associates Purchase
M.77.19.10
Literature: Pal, 1966, p. 115; Fisher, pp. 23, 43.
See plate 25

Five monks and two deities constitute the subject matter of this thanka. Two of the five monks are the central figures; they are seated on lion thrones. They both have distinct physiognomies and display different gestures with their hands. The monk on the left exhibits the gesture of teaching the Law while the other has his right arm extended, the left resting on his lap. Each monk has an image of a deity portrayed at the base of his throne. The white deity on the left is Ushnishavijaya, the goddess of long life, and the one on the right is the golden Vasudhara, the goddess of wealth. Of the three monks along the top, each of whom is seated on a lotus, two are shown teaching, while the figure in the middle holds a rosary with both hands.

An exact identification of the principal figures is difficult, but they may represent Sakyasri (on the left) and the *lotsawa* (translator) of the Trophu monastery (on the right). Sakyasri (b. 1145), the great teacher from Kashmir, came to Tibet in 1204 at the invitation of the *lotsawa*. He vigorously spread the doctrine in the country and was probably the last great Indian scholar to have played an eminent role in the history of Tibetan Buddhism. Trophu is a monastery associated with the Kagyupas; it played an important role in the life of Butön rinpoche in the fourteenth century.

The figure on the left is the more important of the two, for he is teaching; presumably, the other is listening. Adding to his status is the bump on his head that represents the *ushnisha*, symbol of wisdom. Moreover, it may be noted that the lions below his throne are shown roaring while those below the other are quiet. The roaring lion is a well-known metaphor for a great teacher—the Buddha Sakyamuni is often said to roar like a lion. Thus, the identification of the figure on the left with Sakyasri and the other with the Trophu *lotsawa* seems appropriate. It is not known whether the portrayals are realistic, but the faces of both personalities are expressive and sensitively drawn. While the *lotsawa* is distinguished by his slight smile, the other figure has very distinctive features, especially the aquiline nose, the high cheekbones, and the rather square jaws. Thus, his face is definitely related to a much earlier portrait of Sakyasri, probably painted soon after his death (Pal 1969 A, p. 52, no. 5).

Although this painting may have been rendered for a Sakyapa monastery, a comparison with the earlier Sakyapa portrait (**P13**) reveals how significantly different the style of this work is. The crowded compositions of earlier renderings are replaced here by an almost stark simplicity. Nothing is allowed to distract our attention from the figures which seem to have more elbowroom in the unencumbered background. The colors, too, lack the intensity of the earlier styles, and their soft tonality and subtle shades relate this thanka to the contemporary style preferred in some schools of central Tibet.

Mahakala and Companions
See plate 24

Sakyasri and the Lotsawa of Trophu
See plate 25

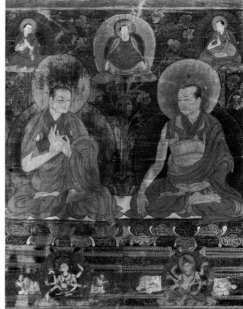

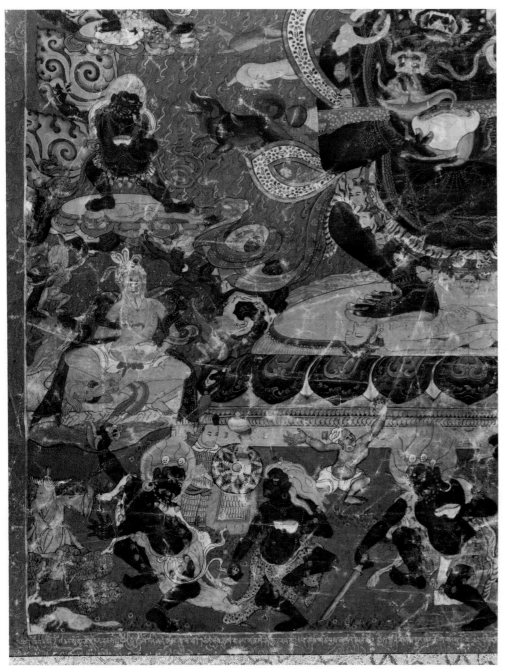

detail

The Goddess Sarasvati
Eastern Tibet (Kham), 18th century
14³/₁₆ x 9⅝ in. (36.1 x 24.4 cm.)
The Nasli and Alice Heeramaneck
Collection
L.69.24.282
Literature: Tucci, 1949, pl. R and p. 570.
See plate 26

On a white lotus rising from a lake is seated Sarasvati, or Changchanma, as she is called in Tibet. The goddess of wisdom and music, Sarasvati was a creation of the Vedic Aryans (1500–1000 B.C.) and is one of the oldest Indian female deities. She has remained equally popular with the Hindus, Buddhists, and Jains. Although the Vajrayana Buddhists had other deities of wisdom, such as Manjusri and Prajnaparamita, Sarasvati, because she was considered the dispenser of intellect and eloquent speech, remained especially popular with teachers and masters among Tibetan Buddhists. Her popularity with exorcists and tantrics is due to the fact that she presides over most mantras and charms, called *dharani* or *vidya.*

In this painting the slight and delicate goddess, with her white complexion, is elegantly clad in a light silk material of brown, red, and mauve. A green scarf and an orange aureole accentuate her graceful form, and she holds a vina in her supple hands. Three Sakyapa monks are seated in the sky while two others, engaged in reading manuscripts, sit beside the lake at the bottom.

The iconography of the painting agrees in essentials with the description of the goddess given in the *Sgrub thabs kun btus* (Wayman 1977, p. 249):

> Surrounded by delectable herbs of a Mt. Meru grove, within a white and pure ocean of milk she is seated on a white lotus with large petals. She has a white body, one face, two arms, her face calm, smiling and lovely with charming youth of sixteen years, breasts firm and high, narrow waist, in squatting posture; with her hands holding an instrument of many strings of lapis lazuli...The upper part of her body is covered with white silk, and the lower part wound in variegated fashion like a rainbow.

This is precisely how the artist has rendered her image in this painting.

One of the finest thankas of the Kham tradition, this is evidently the work of a master. The fluent and elegant outlines are firmly drawn in a controlled manner. The open and spacious landscape, though reminiscent of the Chinese pictorial tradition, is rendered with great economy of form and a penchant for gentle shapes that distinguish this style from the more dominant landscape style of the period (**P25**, **P27**). Except for the orange and red of the aureoles and the robes, the colors are soft and muted and impart a feeling of serenity to the overall composition. It may well have been rendered by the same master responsible for another delicate thanka now in a private collection (Tucci 1949, pl. N).

Sakyamuni and the Eighteen Arhats
Eastern Tibet (Kham), 18th century
28¾ x 18½ in. (73 x 47 cm.)
The Nasli and Alice Heeramaneck
Collection
L.69.24.324
See plate 27

This delicately painted thanka presents an unusual subject: a vivid portrayal of a Tibetan legend about Hva Shang, the seventeenth arhat in the Tibetan pantheon (P36). As briefly recounted by Tucci (1949, II, p. 557), Hva Shang was a monk who lived under the Ming dynasty. One day he offended the emperor, and fled the country to avoid punishment. Years after, when he returned in a boat, the arhats came out of the sea to protect Hva Shang from the emperor's wrath. In the painting, seventeen arhats are seen emerging from the ocean on various fabulous aquatic creatures. Hva Shang sails in a small boat in the foreground. At the lower right, a dark courtier stands beside the emperor and points to the miraculous appearance of the arhats, while an attendant holds a beautiful peacock-tail parasol behind the emperor's head. From the heavens an impassive Sakyamuni appears to watch the scene, although he is not part of the legend.

Indeed the thanka is so richly detailed that unless one looks carefully, many interesting features may be missed. At the upper right a celestial being empties a cloth filled with flowers to symbolize the auspiciousness of the occasion, while one of the arhats in the group below appears to conjure up several monks from a gem he is holding. An amusing detail shows one of Hva Shang's fellow sailors looking up at the arhats through a long telescope, as if he is looking for land.

Apart from the principal personages, the thanka is enlivened with whorling clouds, dancing waves, and various birds and animals—both natural and mythological. However, despite all the activity, the composition reflects an ethereal and serene atmosphere achieved by the controlled use of the brush and soft hues. The fine calligraphic lines, the stylized though exuberant waves, and the expressive faces of the arhats reveal the continued influence of the Chinese pictorial tradition. Especially deft and imaginative are the renderings of animals, particularly of the buffalo and horses, which are convincing in their fidelity. The fantastic creatures, such as the dragons and giant tortoises, reveal the richness of the artist's imagination. Departing from the Tibetan penchant for strong, primary colors, the artist has used a wide variety of mellow hues, such as muted grays, mauves, pinks, lavenders, and a gentle green, that create a pleasant contrast with the deep blue of the sea. The arhats' robes, however, are painted in bright reds and oranges.

It is difficult to be precise about the provenance of this thanka. The style was prevalent in central as well as eastern Tibet. The strong influence of the Chinese tradition here, however, leads to the suggestion that it may have been painted somewhere in the province of Kham. It is interesting to note that this same subject is painted in a Chinese temple, as is evident from the following passage:

P23

The Goddess Sarasvati
See plate 26

P24

Sakyamuni and the Eighteen Arhats
See plate 27

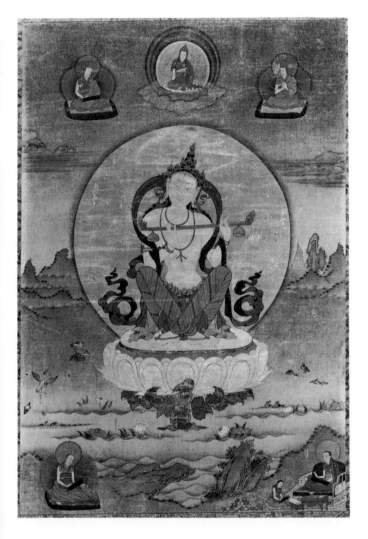

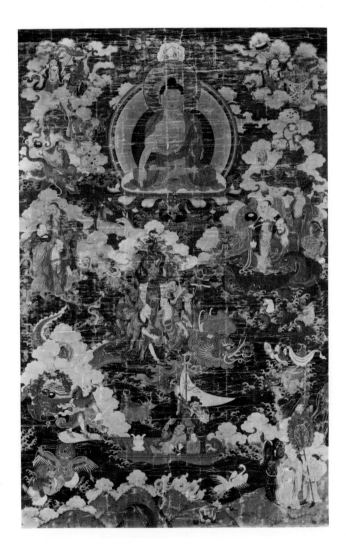

In a small temple called *Hung-fah-t'ang,* just beyond one of the two large monasteries on *P'u-to-shan,* is an interesting representation of the *eighteen Arhats crossing the sea.* They are seated on various sea animals (de Visser, p. 138).

It is obvious that the picture in the Chinese temple represents the legend depicted in this thanka and may have served as the model for the Tibetan representation.

P25

Portrait of the Fifth Karmapa
Eastern Tibet (Kham), 18th century
31 x 17 in. (78.8 x 43.2 cm.)
Gift of Christian Humann
M.71.98.2
See plate 28

This finely preserved and colorful thanka, probably from a set, portrays the fifth Karmapa, Dezhin Shegpa (1384–1415). The names of the other figures are also known from inscriptions (*see* Appendix), but most of them cannot be identified. Above the fifth Karmapa is the figure of Hevajra in *yab-yum* with his partner; flanking this divine tableau are two monks who wear red hats. Among the three figures below, the one in the red hat is Chospal Yeshe (1406–1452), who was a disciple of the fifth Karmapa and the third member of the Shamar lineage. The Shamarpas are distinguished from the Karma-Kagyupas by their red hats which, however, are different from the red hats of the Sakyapas.

A contemporary of Tsongkhapa, the founder of the Gelukpa sect, the fifth Karmapa was a remarkable man who traveled widely during his brief earthly existence. In 1407 he went to China at the invitation of Emperor Yongle (r. 1403–24), who bestowed many honors upon the Karmapa. Perhaps the most significant gift was a potent black hat which became the distinctive ceremonial hat of all later Karmapas and is still worn by the present leader on special occasions. Twice Dezhin Shegpa saved his country from a Chinese invasion, a service which was only possible because of his sincere and intimate relationship with the emperor. Although Tsongkhapa never met Dezhin Shegpa, he sent the Karmapa a letter that said, in part: "You are like a second Buddha. I would like to see you, but I am in a three year retreat. So I am sending you a statue of Maitreya which belonged to Atisa" (Thinley, p. 75).

Clad in orange and red robes, the Karmapa is represented as a teacher, wearing his black hat and seated on an elaborate Chinese chair beside a river. Offerings are placed before him on a table and on the ground as well. The predominant colors of the landscape are various shades of blue, green, gray, and brown, and the rocks and chair are outlined in gold. Although both the facial features and the expression are individualistic, it is difficult to determine if this is a true likeness. Indeed, if one were to compare it with another Kham portrait of the same Karmapa (Thinley, p. 70), one would believe they were of different persons. Apparently, there were various iconographic traditions for representing the fifth Karmapa.

Although this thanka is rendered in a style typical of the eighteenth century, the strong Chinese influence seen here suggests that the thanka was rendered in Kham, which has remained a stronghold of the Karmapa tradition.

P26

Buddha Sakyamuni and Narrative Scenes
Eastern Tibet (Kham), 18th century
34½ x 24⅛ in. (87.6 x 61.1 cm.)
Indian Art Special Purposes Fund
M.75.23
See plate 29

As there are no inscriptions, exact identifications of the narrative compositions in this beautiful thanka are difficult. As is usual in such thankas, the figure of Buddha Sakyamuni is in the center; the scenes unfolding around him may represent traditional stories of his previous lives (called *jatakas* or *avadanas*) or episodes in his historic life. However, none of the scenes recalls any episode from his life, nor can we relate them to any of the earlier birth stories.

In the upper left-hand corner of the painting a princely figure, seated below a formation of colorful rocks, is engaged in conversation with a kneeling man. As we move clockwise we encounter what may be the same prince in a chariot with an attendant holding a parasol above his head. The chariot seems to be approaching a house where two persons stand on the terrace and watch, while a third is seated on a veranda. Curiously, beside the seated personage, the head of the Buddha emerges from a pile of cloth. Below this building a group of people is seated beneath a tree with offerings piled before them, while a lama and companion point upward as a third figure turns and looks at them. Behind them are three heaping bowls of grain. Immediately below is a two-storied pavilion, the upper story of which is surrounded by clouds. An important figure, perhaps the same prince as in the upper left-hand corner, is receiving a messenger in the second story of the upper pavilion. On the lower story a divine monk with a rosary and a book is preaching to a congregation. A bearded ascetic and a man beneath a tree outside the fence appear to be listening to the sermon. On the other side of the tree a princely figure is conversing with three ascetics, and in the clouds above the tree a shepherd leads two cows.

Because of the presence of the monks, it is possible that the scenes are related not to myths concerning the Buddha Sakyamuni but to the hagiography of some Tibetan religious luminary or of an ancient king. The emergence of the image of the Buddha from the ground reminds us of the stories about the most famous statue in the Jokhang temple in Lhasa. Apparently this image of the Buddha, brought to Tibet by Songtsen Gampo's Chinese wife, was frequently hidden and rediscovered, once by King Thisong Detsen (b.742).

Whatever the exact identification, the thanka is a fine example of the Karma-gadri style. Although somewhat busier than seventeenth-century thankas in that style, the painting conveys a sense of openness and reflects the harmony and serenity of nature. As is usual for Karma-gadri paintings, the drawing is refined and delicate and the colors are applied with far greater restraint than in the Tashilumpo and Narthang styles. The formulas for landscape elements do not differ basically, but nature in this painting is less overpowering. Indeed, the scale of the rocks and trees is in keeping with the miniature scale of the figures. The predominant, characteristically Karma-gadri colors are green, blue, and red, but various other shades are employed with a subtle yet sensuous effect.

Portrait of the Fifth Karmapa
See plate 28

Buddha Sakyamuni and Narrative Scenes
See plate 29

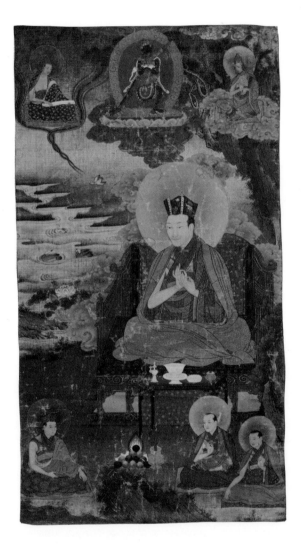

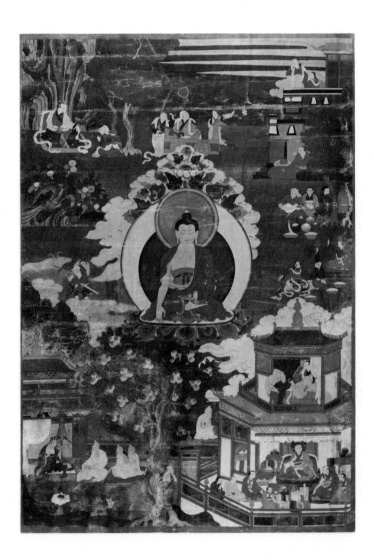

P27

A Mahasiddha and Talungpa Lamas
Central Tibet (Talung monastery),
late 18th century
24 x 21¾ in. (61 x 55.2 cm.)
Gift of Dr. and Mrs. Robert Coles
M.81.206.2
See plate 30

The center of this painting is occupied by an elderly
mahasiddha wearing a printed white robe with yellow lining.
Seated on a leopard skin, his legs are crossed and he holds a
skullcup with his left hand, while his right hand makes the ges-
ture of touching the earth *(bhumisparsamudra).* On his right is a
blue cushion and beneath the leopard skin are rocks painted in
light and dark blue, with two green patches and swirling purple
designs. The mahasiddha wears the crossbelts and earrings typi-
cal of this class of ascetic; his aureole is red, his nimbus purple.
On his left the other ascetic is identified by a tiny golden in-
scription as Nger nas. Further left, a lady approaches the
mahasiddha with a skullcup in her right hand. The rocky hills
in the background are blue and green and on the right are
dotted with a number of buildings.

Below the mahasiddha are five other red-robed monks,
identified by golden inscriptions. Four of them sit on tiger and
leopard skins, but the one on the right is seated on an elaborate
chair. Above the mahasiddha the bodhisattva Manjusri at the
center is flanked by two more lamas, identified as Lama Nang
and Lama Gyalpa khung cheng pa.

Three other paintings from the same set have been pub-
lished (*Dieux et démons,* pp. 232, 236, and nos. 273–75) and
have been attributed to eastern Tibet. That attribution is based
primarily on the costumes worn by some of the lay figures in
the frontispiece of the set—depicting Vajradhara—which are
similar to those worn in the Mi-nyag district of eastern Tibet.
In another publication (Lauf 1976 A, pp. 116–17), one of the
set portraying abbots has been attributed to the Talung monas-
tery, north of the capital. According to this author, the series of
thankas depicts the various teachers and abbots of the Talungpa
sect, a branch of the Kagyupas. The monastery of Talung was
founded by Tashipal in 1180, and the hats worn there are quite
different from those worn by other red-hat sects.

The only figure not identified by an inscription is the
principal mahasiddha. He is very likely Luipa, the teacher of
Naropa, who, along with his Tibetan disciple, is especially
associated with the Kagyupa lineage. This would explain the
presence of the skullcup-bearing female, who must represent a
dakini who plays an important role in Luipa's mystical life. More-
over, in the Tibeto-Mongol pantheon (Olschak and Wangyal,
p. 117, no. 12) Luipa is given the same attributes. The other
figures, though identified, remain merely names, but each figure
is given a distinct physiognomy. However, it is not possible
to determine whether these are actual portraits, or simply the
work of a perceptive artist who did not care to make all his
characters look alike. Indeed, the representation of Luipa with
his distinctive features and rather flabby body seems quite
realistic; the artist may have used a model.

Although the Talung monastery is in central Tibet, the
series could have been painted for a donor from Mi-nyag who
was a follower of the Talungpa order. This particular landscape
style was widely popular from Tashilumpo to Kham during the
eighteenth and nineteenth centuries, although its expression
varied from region to region and artist to artist. For instance,
similar landscape motifs are used in other thankas of the period
(P25, P29), and even a quick glance makes clear the differences
in composition and emphasis. In most of the Talung portraits,
the artist has not only struck a balance between the figures and
the landscape elements but has also made extensive use of archi-
tecture. The composition seems less constrained by hieraticism
and more concerned with purely visual effects. Fantasy still pre-
dominates, as in the other landscape styles, but the presence of
architectural elements (depicting historic buildings) appears to
have kept the artist's imagination more earthbound.

P28

A Biographical Painting
Eastern Tibet (Kham), 18th century
31 x 23 in. (78.7 x 58.4 cm.)
Gift of The Louis and Erma Zalk
Foundation
M.82.9
See plate 31

The mate to this thanka is in a private collection and
depicts scenes from the life of the Buddha Sakyamuni. Here, the
principal figure appears to be royal, and thus the thanka may
represent the legendary life of one of the early kings of Tibet.

The narrative begins in the upper right-hand corner with
the representation of a paradise in which two figures are seen
conversing in a pavilion. The figure on the right with a bare
body and white turban is seen again amid the clouds, riding a
blue elephant, accompanied by soldiers and attendants. Although
he now wears golden garments, the turban identifies him as
one of the figures in the pavilion. Apparently he has been dis-
patched to earth, as Sakyamuni himself was, or as the future
Buddha Maitreya would be. The journey to earth continues
further down, in the next scene, in which the regal figure on his
elephant is being entertained by musicians. Next, in an open
pavilion beside a lotus pond, a child is presented by three ladies
to an imposing figure dressed in blue. This is undoubtedly our
divine hero, who is next shown in a roofed pavilion enthroned
as a universal monarch with the seven symbols of such a king
placed before him. To the left, the white-turbaned prince rides
with two companions toward a grove sheltering three thatched
huts. Such isolated huts were—and may still be—used as re-
treats, and are frequently mentioned in Tibetan texts as places of
meditation for kings as well as lamas.

In the architectural composition below the scene of en-
thronement, the hero of our tale—now dressed in a red jacket
and a white dhoti—is seated in a blue-tiled courtyard. Against
the wall to his right a vendor appears to offer a golden, or
perhaps bronze, head to an ascetic turbaned figure who seems to
be refusing the offer. Behind the vendor, a lady—the same one
who is seated next to the king in the enthronement scene—
glides on a rainbow toward the king. She also appears at the
gate, apparently greeting the same turbaned figure who is seen
inside. The vendor, as well as the two figures kneeling before
the king, wear gray Scythian caps, while the person on the
monarch's left wears a garland of leaves and matted hair which
indicates his forest origin. In a small enclosure with a red door
connecting it to the larger courtyard, we see a man decapitating

A Mahasiddha and Talungpa Lamas
See plate 30

A Biographical Painting
See plate 31

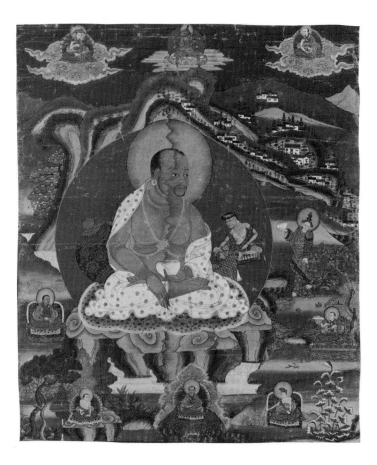

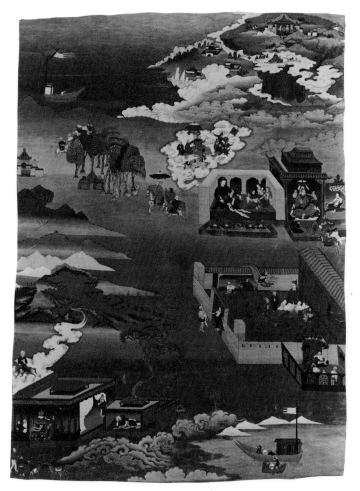

himself. As his lifeless body falls to the ground, another figure
—perhaps the same fellow who stands at the entrance—has
picked up the head.

Below the courtyard, on a lake or ocean, are figures in a
large boat and in a dinghy who appear to be transferring an
object from one vessel to the other. Swirls of clouds rise from the
water and move toward two pavilions at the left. In the smaller
one a man lies on a bed while the lady we have encountered
before watches from the larger pavilion. In another part of the
pavilion a man, clad in an orange robe, is adoring the *Triratna*
(Three Jewels of Buddhism) placed above a banner and a pile of
multicolored gems. Outside, two men lead two animals while
above the pavilion a man holds a blue gem as he rides through a
sea of clouds.

There seems no doubt that the viewer is witnessing
scenes from the mystical life of someone who may be a Tibetan
king or a mahasiddha born into a royal family. Showing him
descending to earth on an elephant appears to be an attempt to
homologize his life with that of the Buddha Sakyamuni, who
entered his mother's womb as a white elephant. The presence of
a goddess or a *dakini* who is always near the hero like a guardian
angel is also a common feature of the legendary lives of great

teachers and mahasiddhas.

This fine example of the Karma-gadri style was probably
painted in eastern Tibet. Although stylistically related to the
two preceding examples, the delineation here is even more sub-
tle and evocative than in those works. The delicate forms and
the soft hues, the gentle, misty mountains, and the fluffy clouds
imbue the painting with a sense of real elegance and enchanting
simplicity.

P29

Arhat Ajita in a Landscape
Eastern Tibet (Kham), c. 1800
24½ x 17⅜ in. (62.2 x 44.2 cm.)
Gift of Dr. and Mrs. P. Pal
M.71.107

In a mountainous landscape a man with a mauve com-
plexion and an ugly distorted face is seated on a rock while
clasping his right leg. He is clad in sumptuous silks, the lower
garment being blue while the upper robe is a yellow Chinese
brocade enlivened with multihued cloud patterns, a blue dragon,

and a red border. The dragon and clouds are well-known Chinese symbols that appear frequently on imperial robes. Before him is a low table with a basket of fruit, a blue bowl of rice, and a pair of cymbals. An attendant standing beside a tree offers a fruit, perhaps a peach, to the master who seemingly snarls at him. Miraculously suspended in midair, the enthroned golden Amitayus appears to be watching the scene. The elaborate rock formations, with waterfalls and green knolls lined with trees, form a canopy over the seated figure. In the foreground a solitary rock projects from the ground like a missile in an otherwise tranquil landscape, which features a blue lake where some deer have come to drink.

Although the principal figure has neither attributes nor a nimbus, he very likely represents an arhat. According to one Tibetan tradition, the arhats must wear silken robes and be surrounded by cliffs, animals, and pleasure-grounds, but nothing is said about their physiognomies. Such grotesque arhats as this one were an invention of the celebrated Chan master Guan Xiu (Kuan Hsiu) (832–912); one of his famous portrayals was seen and admired by the Qing emperor Qianlong (Chien-lung) (r. 1736–95) in 1757. Stonecuts of these arhats were made and, among other copies, at least one set of paintings is in the Takahashi collection in Japan (de Visser, pp. 111–14). In that series the arhat Ajita is portrayed seated on a rock, like the others, "clasping his hands round his right knee; with an open mouth he cries out his sorrow."

There can be little doubt, therefore, that this is the arhat Ajita and that his snarling open mouth depicts his cry of anguish or sorrow. Like the arhats in the series in the Takahashi collection, this one does not have a halo. Thus, although this thanka was executed in eastern Tibet about 1800, it is probably based on an earlier copy of Guan Xiu's famous work. Except for the arhat's figure, the rest of the composition probably differs considerably from the Chinese model.

The landscape is a design of pure fantasy, and the unknown artist's attempt to suggest a sense of volume, by highlighting the structure of the blue rock formations with patches of green and brown with gold accents, is a purely mechanical exercise. This is also evident from the fact that, defying all laws of gravity, bushes and trees of miniscule size hang upside down from the edges of the rock. The striking analogy between the contorted shapes of the mountains and the arhat's face and body is remarkable. Not only the misshapen lumps on his head, but his shoulders, knees, and firmly clasped hands also seem to echo the formal structure of the rocks around him. Perhaps the artist's intent was to express the consubstantiality of the arhat and nature by emphasizing such formal relationships. Even nature seems to echo the arhat's cry of anguish.

P30

Symbolic Offerings
Central or eastern Tibet, early 18th
century
36⅝ x 22⅛ in. (93 x 56.2 cm.)
From the Nasli and Alice Heeramaneck
Collection
Museum Associates Purchase
M.81.8.5
Literature: Pal, 1969 A, pp. 115–16;
Dieux et démons, p. 170.
See plate 32

This remarkably expressive thanka appears to be incomplete and may be a fragment of a large offering thanka, or *rgyan tshogs* (sets of ornaments), such as the more elaborate example in entry P31. Its predominant features are a bannerlike construction and six ferocious dark horses. The unique design of the banner is almost like that of a shrine, with an eaved superstructure shielding a chopper and a skullcup placed on a stylized lotus. Below, a piece of printed silk rises from a skullcup supported by three skulls. A tongue overhangs the rim of the cup (decorated with two large eyes) and it is surrounded by tongues of flame. This banner is very likely a *zor*, an important element in the Yama-offering thankas that is used to chase away evil spirits (*see* Wayman 1973, pp. 71–81).

A flayed skin forms a canopy over the banner, and on either side are black ravens—one on the left and two on the right—with human organs in their beaks. Immediately below the bird on the left is Vajrapani; a *chöten* is below the other ravens. Two skeletons seem to dance as they circumambulate the *chöten*. They may represent Citipati, a pair of skeletal figures said to perform the Tsan dance on the cremation ground. Indeed, Yama's realm is indicated by various other corpses being trampled by the horses and gouged by predatory birds in the lower section.

The artist has successfully created a compelling atmosphere of the bizarre and the occult for a thanka that was obviously used in esoteric ceremonies. Unquestionably the most arresting figures in the thanka are the black horses, which, seeming to be engaged in a *danse macabre*, express a sense of apocalyptic vision. With swift lines and deft brushstrokes, an unknown master has created a group of animals that convey both unnatural energy and hellish terror.

P31

A Symbolic Banquet
Eastern Tibet (Kham), c. 1785
Opaque watercolors on cotton
47⅞ x 93½ in. (121.6 x 237.5 cm.)
Gift of Mr. George C. Zachary
M.81.211

Peculiar to the Lamaist world, this type of painting is known either as *rgyan tshogs* (sets of ornaments) or as *Bskang rdsas* (material for the banquet). In contrast to ephemeral offerings, such as rice, barley, flowers, and incense, these paintings served as symbolic though permanent offerings to the deity. In some, the center is occupied by the mythical Mt. Meru, the center of the cosmos; in other examples such as this, the form of the deity is suggested by his symbols. The god represented here is probably Mahakala. Around his symbolic representation is a great variety of gifts (*lha rdsas*), which may be grouped in three broad categories:

> i) *Mchod rdsas* or oblations, such as the eight offerings, the five gratifications of the senses, the seven and eight precious things, the eight precious objects, the secret offerings, etc.; ii) *spyan rdsas*, gifts to gratify the eyes of the god, such as various kinds of animals; iii) *dam rdsas* or "holy objects," such as the bell, the thunderbolt, and other ritual objects (Lessing, pp. 100ff.).

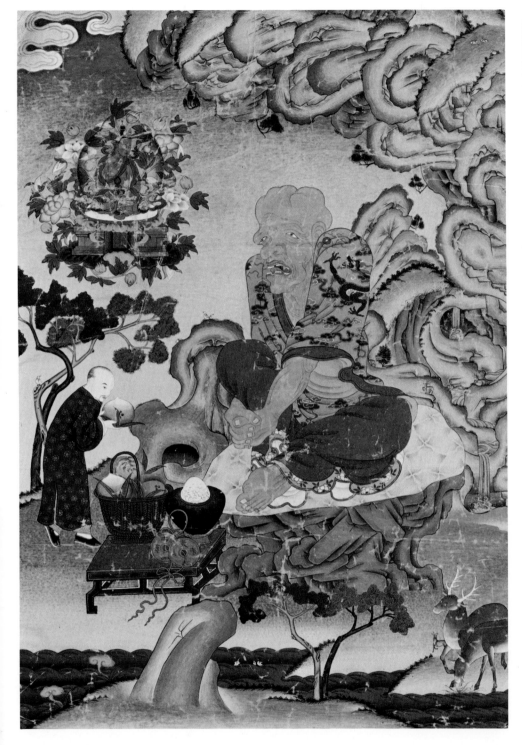

A Symbolic Banquet

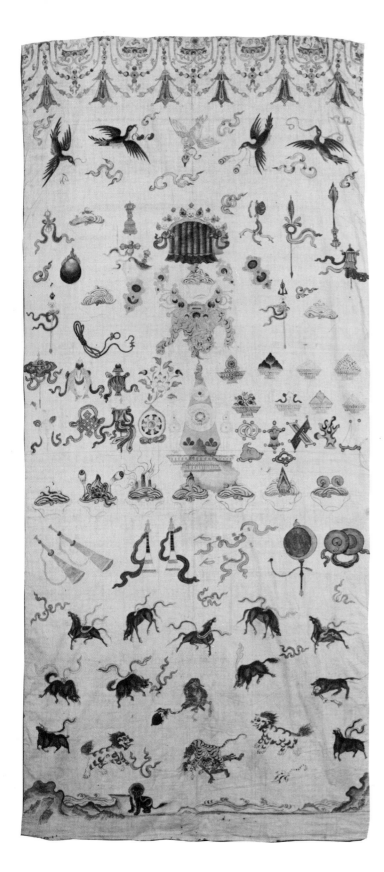

Many of the ritual implements—the bell, the thunderbolt, swords, a chopper, a trident, a thunderbolt-and-skull-crowned staff, a noose, and banners—are included in the painting. There are auspicious symbols, such as the conch, the pot, the parasol, and the wheel, while various organs of the body are offered in skullcups filled with blood. Other organs, such as eyes, kidneys, and the heart, are carried by the birds in the upper region. In the lower half, below the row of musical instruments, are various animals, among which the horse, the yak, the tiger, the lion, and the boar are easily recognizable.

According to the inscription on the back of the thanka (*see* Appendix), this painting was given as an act of faith by Lobsang Samten in the "female wood-snake year." At the time of dedication, Lobsang was the retired monk who led prayers in the assembly of a monastery whose name is not clear. The female wood-snake year could be either 1725 or 1785. A comparison with another painting of a similar subject (**P30**) leads to the suggestion that the most likely date for this painting is 1785.

P32

A Scroll with Astrological Themes
Eastern Tibet, 18th century
22¼ x 101¼ in. (56.5 x 257.2 cm.)
Purchased with Funds from Christian
Humann
M.72.75.1

This scroll consists of astrological and divination charts and tables used to make horoscopes and foretell the future. Apart from its usefulness for scholars of Tibetan astrology, the scroll is of considerable interest to the student of Tibetan culture in general. It is a rich source for the shapes and forms of various symbols and utensils, for weapons and costumes, and for animals and plants. The animals that symbolize the Tibetan calendar—the mouse, elephant, tiger, hare, dragon, snake, horse, ram, monkey, raven, doe, and boar—are repeated often, as they are of fundamental importance for astrological calculations. The style of writing, although cursive, is particularly fine and legible. The bodhisattva Manjusri, who is represented above the trellislike structure connecting four very tall trees, may be the presiding deity of the divination texts.

Drawn with freedom and spontaneity, both the humans and animals here are lively and entertaining. Especially captivating are the studies of animals in the lower middle of the scroll, where various pairs seem to confront one another in a snarling match. The mandalalike configuration on the left, with a conceptually rendered but convincingly ferocious tortoise in the center surrounded by rows of animals, forms a visually attractive design. By and large, the artist has confined himself to the primary colors, which are lightly applied.

P33

Yama and Yami
Central or eastern Tibet, c. 1800
97½ x 61 in. (247.6 x 155 cm.)
Gift of Jack and Muriel Zimmerman
M.71.78

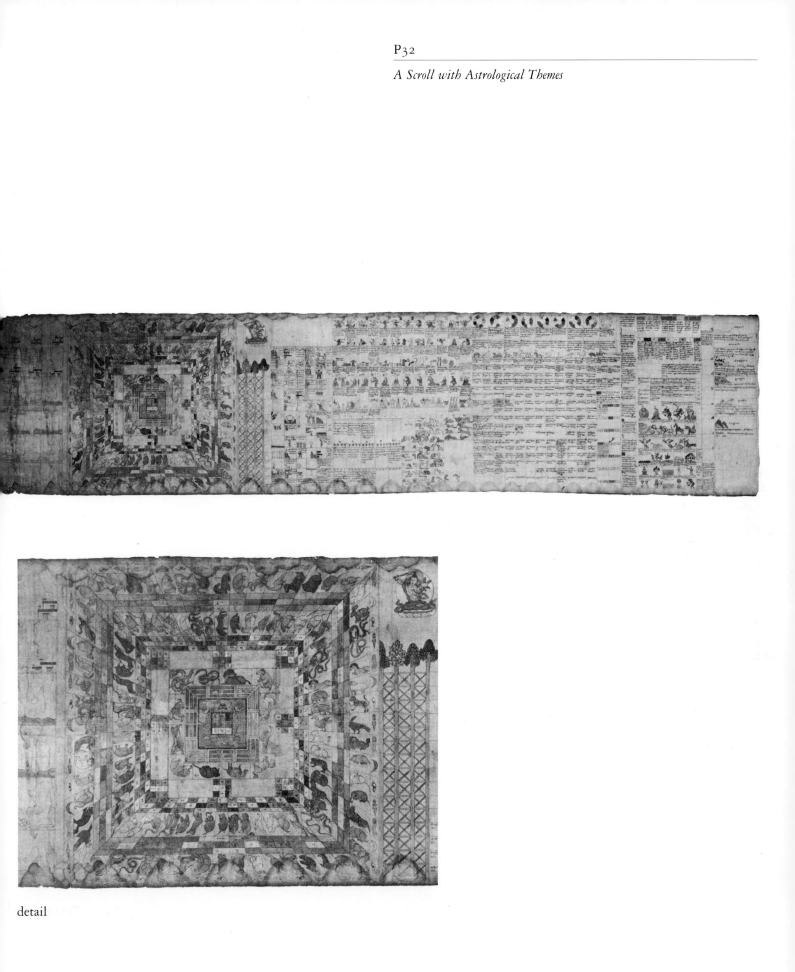

detail

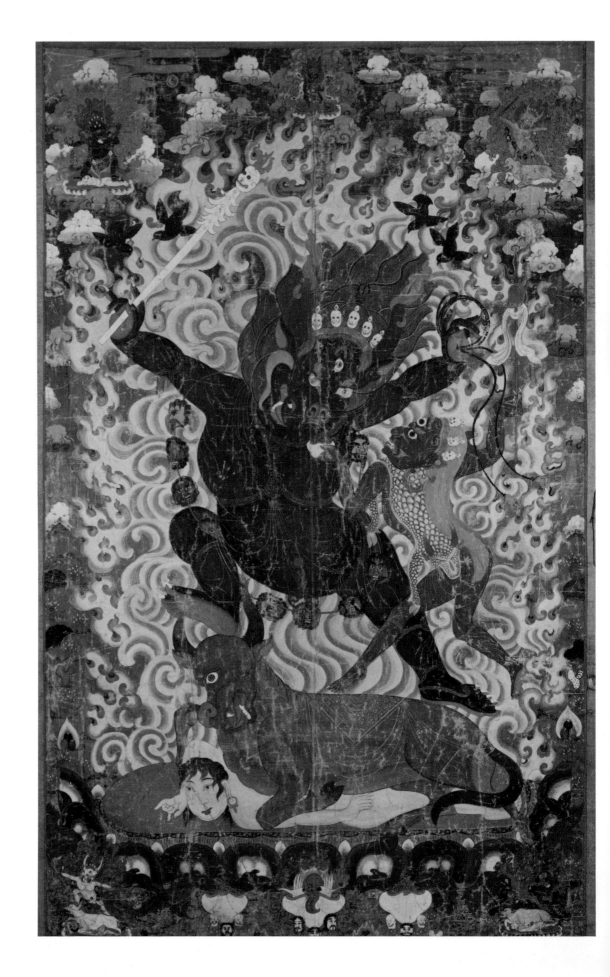

This unusually large and expressive thanka portrays Yama and his sister, Yami, along with several other manifestations of the god. An ancient Hindu god of death, Yama plays a more expanded role in the Tibetan pantheon and has a different iconography. Apart from being the Lord of the Dead (*gShsin rje*), he is also the King of Religion (*Cos gyal*). Furthermore, Yama is one of the eight dharmapalas in Tibetan Buddhism; hence, he is always shown in a terrifying posture. The Hindu Yama simply rides a buffalo, but his Buddhist counterpart has the head of a buffalo and rides a blue bull. In fact, the iconography of the Buddhist Yama is far more macabre than that of his Hindu counterpart, who is generally portrayed as a placid, regal figure. When accompanied by his sister, as in this thanka, Yama is known as Minister of the Exterior (*Phyi sgrub*).

Naked, he is adorned with garlands of severed heads, a diadem of skulls, and various other ornaments. With hair rising like flames and an erect penis, his is a menacing figure; he throws his arms out and glowers at his sister. With his right hand he brandishes his chastising staff and with his left he holds the noose. The bull is as aggressive as his master and appears to be crushing a pink-complexioned human figure. Although Yami appears to be no less terrifying or aggressive, she does not have an animal's head. In contrast to her brother, she is slender and athletic and seems to be dancing as she steps onto the bull to offer Yama a cup of blood. With her other hand she holds a trident with streamers. An animal skin drapes her back and her long, orange hair partially covers her nakedness. Her complexion, like that of the bull, is blue-gray.

Five smaller images of Yama, in different colors, are in the four corners and at the apex of the painting. The entire tableau is presented against a background of leaping and dancing red and orange flames. At the bottom of the painting are various offerings, including multicolored gems and three skullcups filled with blood, a red tongue, and eyes. The strip of green pastures and hills along the bottom and the sides supply the only relief in a composition dominated by fiery and bizarre forms and violent action. Notwithstanding its enormous size, the quality of the drawing is excellent and the brushwork, especially of the bold flames, is vigorous and expressive.

P34

Palden Remati and Her Retinue
Central Tibet (Gelukpa monastery),
1800–1850
28½ x 21¼ in. (72.4 x 54 cm.)
The Nasli and Alice Heeramaneck
Collection
L.69.24.323
Literature: Pal, 1980, pp. 40, 89.
See plate 33

The figure dominating the center of the painting is Palden Remati, a form of the better-known Palden Lhamo, or Lhamo for short. Lhamo is the most eminent goddess of the Tibetan pantheon and is the protector deity of both the Gelukpa order and of Lhasa, the capital of Tibet. One of the most important liturgical texts followed by the Gelukpa sect is named after her and has been discussed at length by Tucci (1949, II, pp. 590–94) and by Nebesky-Wojkowitz (pp. 24–31). She has

P34

Palden Remati and Her Retinue
See plate 33

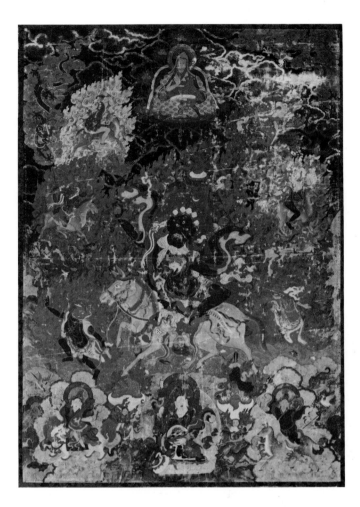

an enormous retinue of followers, which appears to be drastically reduced in this thanka. A comparison with the more popular form of the goddess, as she accompanies her spouse, Mahakala (**P10**, **P21**), reveals differences from this particular manifestation.

Palden Remati's description in the Gelukpa text is worth quoting extensively for two reasons: the form agrees verbatim with the text, and the passage provides a graphic verbal model which the artist had to follow.

> In the middle of a vast wild sea of blood and fat, in the centre of a black storm rides on a kyang with a white spot on the forehead, which has a belt of rākṣasa heads and a rākṣasa skin as cover, with a crupper, bridle, and reins consisting of poisonous snakes, the dPal ldan dmag zor gyi rgyal mo Remati, who comes forth from the syllable bhyo. She is of a dark-blue colour, has one face and two hands. Her right hand wields a club adorned with a thunderbolt, which she lifts above the heads of oathbreakers, the left hand holds in front of her breast the skull of a child born out of an incestuous union (nal thod) full of substance possessing magic virtues, and blood. Her mouth gapes widely open and she bares her four sharp teeth; she chews a corpse and laughs thunderously [Nebesky-Wojkowitz, pp. 25–26].

The description continues on in this vein, painting a gruesome image of the goddess which the artist of the thanka has followed in explicit detail. Indeed, as the text states, "on the crown of her head shines the disc of the moon and on the navel the disc of the sun," which is exactly what we see in the thanka. Her large retinue is reduced in this painting to only nine figures. She is flanked by two animal-headed deities who dance threateningly as they brandish their weapons. Above Remati's head are the four goddesses of the seasons, each riding her characteristic animal and appearing belligerent. The forms of the three goddesses below are less gruesome, though not entirely benign. Between them are two large skulls filled with blood and plucked eyes, obviously of disbelievers and demons, which form her offerings as they do with other angry deities (**P30**). In the upper corners two menacing dragons add to the macabre imagery of this remarkably expressive composition, one which simply bristles with swirling cloud patterns, dancing multiple-hued flames, sprawling oceans of blood, and gyrating deities who seem to revel in their bizarre orgy. In total contrast, a monk of the Gelukpa sect sits at the top of the painting with a book in his hand, completely unconcerned with the frenetic activity below.

An identification of this lama would help in the precise dating of the picture. There are, however, several figures in the Gelukpa hierarchy with this identical iconography. The earliest are Gyeltsabje and Khedubje, two famous disciples of Tsongkhapa, while the latest is the Fourth Panchen Lama (1781–1852). If the portrait is of the Panchen Lama, it may have been painted in the first half of the nineteenth century. It could, in fact, have been commissioned by him and rendered in the Tashilumpo monastery, the seat of the Panchen Lamas. This date is consistent with the style of the painting, which may be said to have evolved in central Tibet around 1750; it continued to enjoy popularity until at least 1850. If, on the other hand, the figure represents one of the early lamas, the thanka could be dated to the second half of the eighteenth century. The painting is related stylistically to a portrait of the Seventh Dalai Lama (1708–1757) which may have been made soon after his death

(Olschak and Wangyal, p. 90). Whatever its exact date, the thanka is of superb workmanship and must have been executed by a master artist—strengthening the suggestion of a commission by the Fourth Panchen Lama himself.

P35

Myriad Buddhas
Eastern Tibet (Kham), c. 1800
31 x 22¾ in. (78.7 x 57.8 cm.)
Gift of Mr. and Mrs. Michael Blankfort
M.80.221.2

Ninety identical blue-complexioned Buddhas surround a central Buddha who has a golden complexion, which is the only feature distinguishing him from the others. The right hand of each Buddha is stretched in the gesture of touching the earth and the left holds a thunderbolt. These two attributes, together with the blue complexion, help identify this Buddha as Akshobhya. The central figure, too, despite his golden complexion, must thus be identified as Akshobhya (**P6**). The concept of the Thousand Buddhas of the Auspicious Age (*bhadrakalpa*) was particularly popular in the northern Buddhist countries. Whether the number is ninety-one, as in this instance, or a thousand, it is symbolic of infinity, and the multitude of figures here, therefore, symbolize the pervasive nature of the transcendental Buddha.

All the figures wear red garments and are represented against two aureoles: the smaller is either green or indigo blue and the larger is orange. The nimbus behind each Buddha's head is green, as is the background. The central Buddha is seated on a lotus with alternating blue and orange petals. The arrangement of the figures in such paintings is strictly symmetrical and regimental, but the overall visual effect is often attractive.

P36

Hva Shang and Guardians
Central Tibet, 19th century
25½ x 18 in. (64.8 x 45.7 cm.)
Gift of the de Anda-Fast Family
M.77.155.3

The inscription at the top indicates this thanka's place in a series of arhat paintings. Its subject is Hva Shang and two of the Eight Guardians of the Directions. Hva Shang is portrayed in the familiar manner as a dark, obese, and jovial fellow surrounded by children whom he loves and protects. He holds a lemon (a fertility symbol) with his left hand, a rosary in his right, and seems to be amused by the boys' antics. While the arhat sits on a tiger skin in a stylized landscape, the two guardians below are surrounded by swirling clouds and dancing flames. The figure holding the sword is Virudhaka, the regent of the south; the one playing the lute is Dhritarashtra, the regent of the east. They are dressed in attire typical of Mongolian warriors. Floating in the sky above is the figure of Amitayus.

Tucci discusses the problem of Hva Shang at length (1949, II, p. 555). As he shows, although Hva Shang's iconography is modeled after "Maitreya of the big belly," or the laughing Buddha of China, he is not included in the Chinese

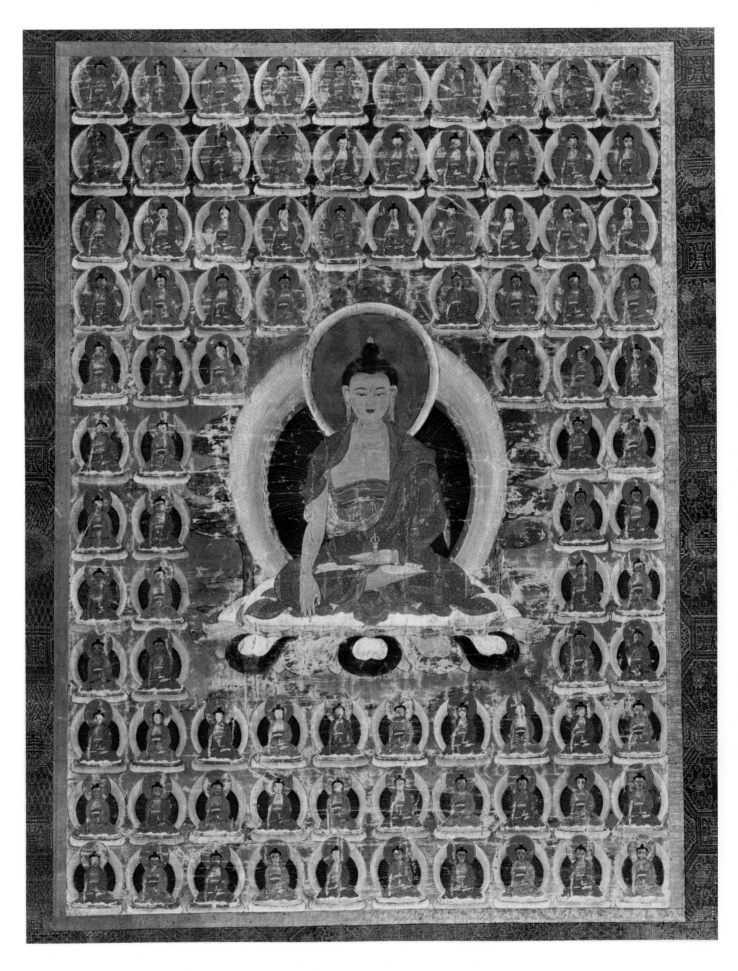

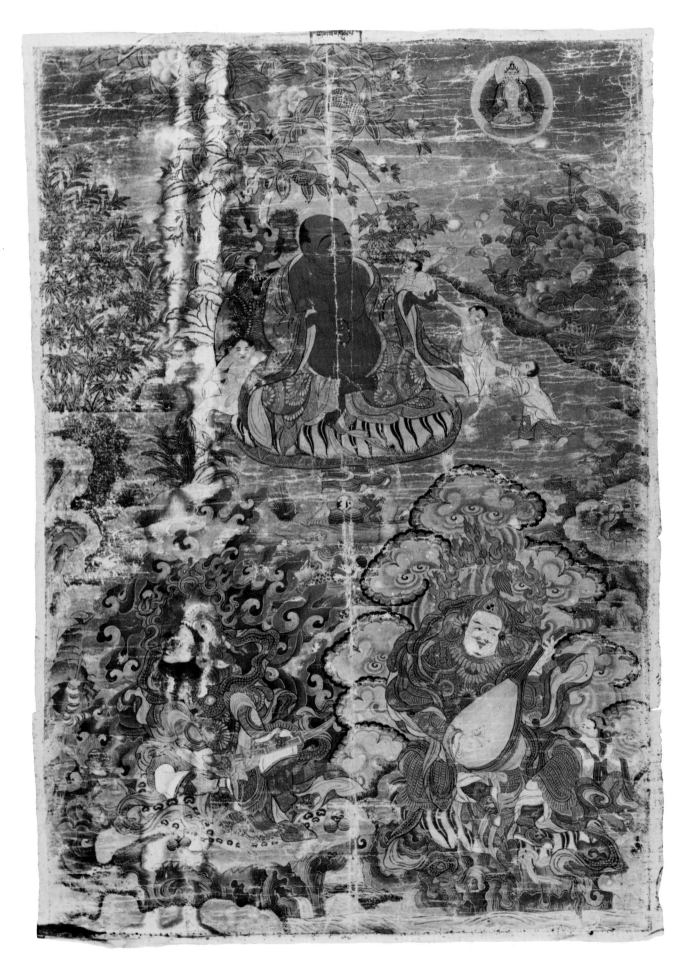

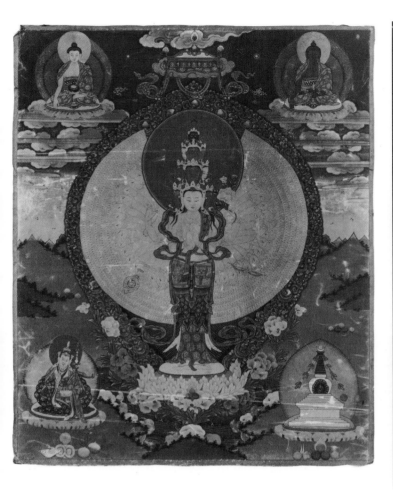

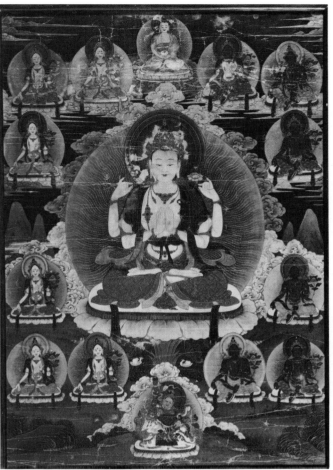

tradition of arhats or *lohans*. On the other hand, Tucci's belief that Hva Shang was unknown in the Tibetan tradition prior to the eighteenth century appears to be mistaken. He is definitely included, along with Dharmatala, in the 1435 sketchbook of Tibetan deities made by Jivarama. Thus, the literary tradition (*see* **P24**) as discussed by Tucci, which claims that Hva Shang was introduced during the Ming dynasty, is essentially correct.

The style of this painting is related to the Narthang woodcuts of the mid-eighteenth century, discussed extensively by Tucci. A remarkably close parallel of this painting is in a private collection (Lauf 1976 A, pp. 62–63). Although there are some differences in detail, both may have been based on a master composition cut in wood (**P47**). The subsequent prints were modified by individual artists and filled in with colors. For a complete set of arhats in the same style, though earlier than the present example, see Olschak and Wangyal (pp. 66–67).

P37

Cosmic Form of Avalokitesvara
Eastern Tibet (Kham), 19th century
21 x 17½ in. (53.3 x 44.4 cm.)
Gift of Christian Humann
M.71.98.3

The central figure here is that of the bodhisattva Avalokitesvara in his cosmic form (S19). In the clouds above are two transcendental Buddhas, one golden and carrying a pot (Sakyamuni), the other blue and holding a thunderbolt (Akshobhya). On the earth below are Padmasambhava on one side and a *chöten* on the other.

The cosmic bodhisattva stands on a lotus rising from a lake; above his head is a parasol touching the clouds. Thus, he is shown as the cosmic pillar connecting the heavens, the atmosphere, and the earth. He is given eleven heads, eight of which represent the cardinal directions and their intermediate points, and the other three of which signify the zenith, the center, and the nadir. Nine of the heads have benign faces and are depicted in three rows; the tenth has an angry face, while the head at the top is Avalokitesvara's parental tathagata, Amitabha. In addition, he is given a thousand arms which form a mandala around his body and symbolize his pervasiveness. The palm of each hand is marked with an eye, for the cosmic god is said to have a thousand eyes (*sahasraksha*) as well so that he can see on all sides. (For a further discussion of the symbolism, *see* Pal 1982 A.)

With its gentle landscape and muted colors, this thanka is related stylistically to another thanka from Kham (**P23**).

Commemoration Thanka for Bhimaratha Rite

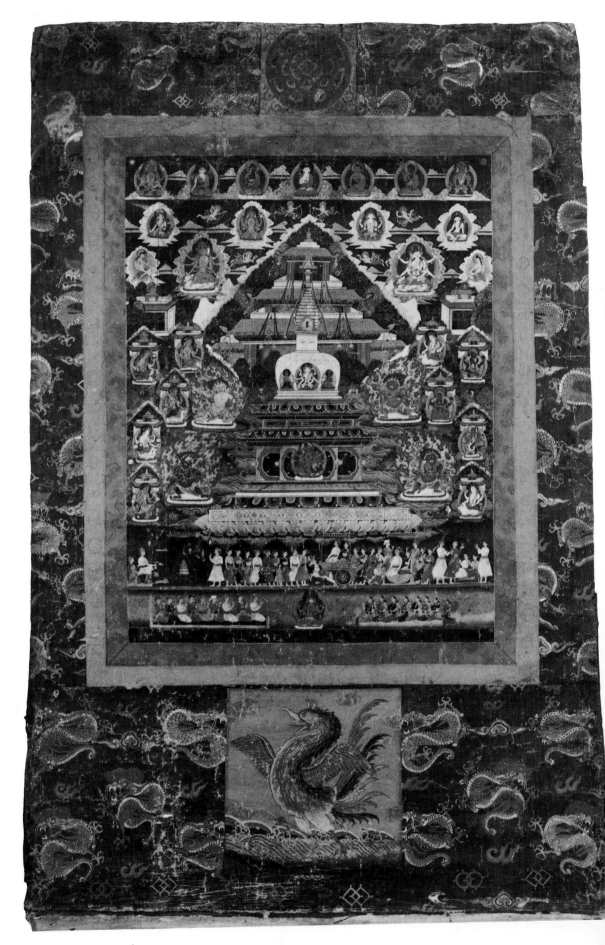

Shadakshari Lokesvara and Twelve Taras
Eastern Tibet, 19th century
28½ x 20½ in. (72.4 x 52 cm.)
Gift of Mr. and Mrs. Michael Blankfort
M.80.221.2

Shadakshari Lokesvara, the large central figure in this thanka, is an important manifestation of the bodhisattva Avalokitesvara (S10, S19), who is of special significance to Tibetans; the Dalai Lamas are said to be incarnations of this form of the bodhisattva.

Seated on a lotus with mauve petals in the classic posture of a yogi, he is clad in red and green garments, is elaborately bejeweled, and wears an elegant, intricate crown. His smooth, white complexion is set off against a light blue aureole with radiating golden rays. In his upper right hand he holds a rosary and in the corresponding left hand a lotus. The second pair of hands rests against the chest in the offering gesture. At the apex of the painting is a golden Buddha with a pot in his hand, and at the bottom, Kubera, the god of wealth, rides his lion. Lokesvara is surrounded by twelve Taras; the six on his right are white and those on his left are green. Each of these deities is portrayed against radiating aureoles, and some are surrounded by swirls of clouds tinted green, blue, and purple. The upper half of the background, representing the sky, is painted blue. Rocks, peaks, and knolls in different shades of green constitute the earth's landscape.

The central figure of Lokesvara is given a satin-smooth finish reminiscent of a ceramic figurine. His face and garments seem more Chinese than Tibetan, and it is possible that the artist modeled his figure on a Chinese porcelain prototype. In any event, the painting was very likely rendered somewhere in eastern Tibet, close to the Chinese border.

Commemoration Thanka for Bhimaratha Rite
Central Tibet (Tashilumpo monastery),
19th century
28¼ x 22 in. (71.8 x 55.9 cm.)
Gift of Christian Humann
M.71.98.1
Literature: Pal, 1977, p. 1974, fig. 2.

This thanka was painted in the Tashilumpo monastery for a Newari patron from Nepal. It became a common practice, apparently from the seventeenth century on, for Newari merchants trading with Tibet to visit this famous monastery and commission paintings which they took back home. Thus, while the style of such works closely follows the contemporary Tibetan formula—notable both in the figures and in the landscape and architectural elements—the donors at the bottom and the scenes of consecration follow the Nepali tradition. Many of these export-style thankas are inscribed and all of them mention Tashilumpo as the place where they were painted (*see* Pal 1978, pp. 153–55). In addition, the mount in this example is painted with designs imitating imperial Chinese brocade which was often used to mount Tibetan thankas executed for such important monasteries as Tashilumpo. Since the brocades were for the use of monasteries only, they were not available for the Newari merchants; hence, the close imitation.

Amitabha and Eight Bodhisattvas

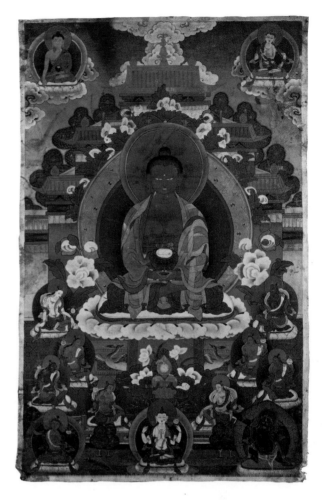

The thanka was commissioned to commemorate a performance of the *Bhimaratha* rite which was particularly popular among the Buddhist Newars. It was performed by an individual or by a married couple when either partner reached the age of seventy years, seven months, and seven days. This is obviously a senility rite, for it is believed that by performing it one is absolved of all moral responsibility for one's actions from that moment until death. The persons in whose honor the ceremony is performed are usually portrayed at the bottom of the painting riding in a chariot in a procession of much mirth and fanfare. The subject matter of such paintings usually consists of a large stupa in the middle with the goddess Ushnishavijaya in the dome surrounded by various gods and goddesses, both awesome and benign. (*See* the Pal reference above for a further discussion of the subject and such export-style thankas.) Ushnishavijaya is the predominant deity in such paintings because, along with Amitabha and the White Tara, she is one of the three divinities of long life.

Amitabha and Eight Bodhisattvas
Central Tibet, late 19th century
26¾ x 17¼ in. (68 x 43.8 cm.)
Gift of the de Anda-Fast Family
M.77.155.2

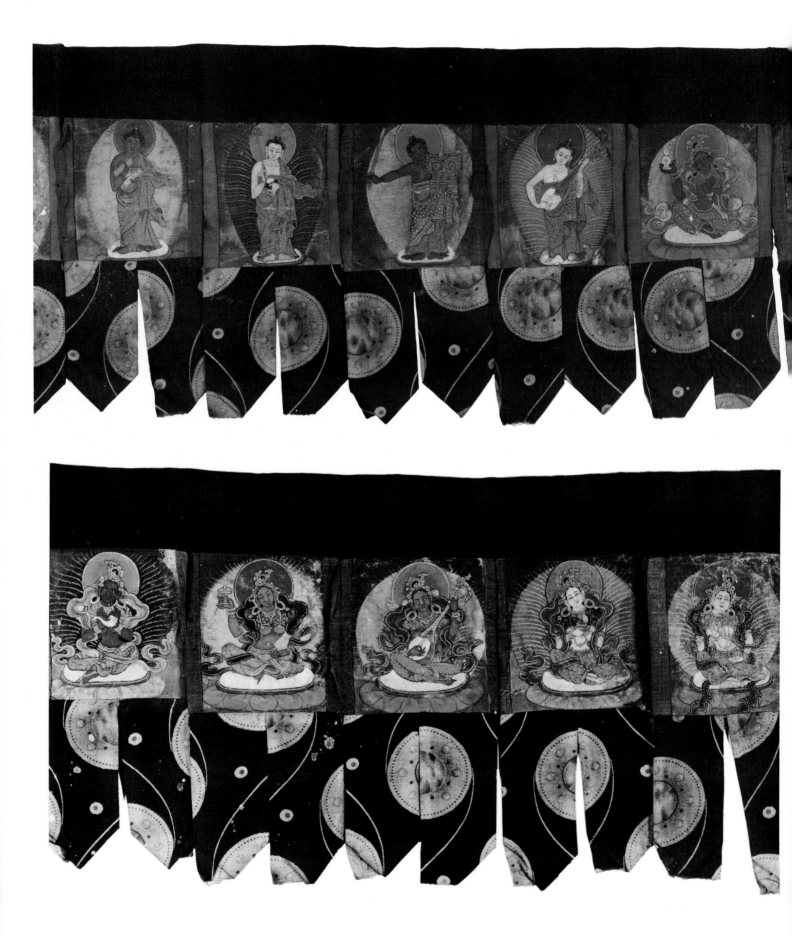

The central figure of Buddha Amitabha is seated on a
lotus, against the background of a shrine with green roofs
trimmed with bright orange. The lotus rises from a lake and
two peacocks, the symbol of Amitabha, are represented on the
throne on either side of an overhanging carpet of orange, green,
and gold. Above the shrine in the clouds, a golden Buddha is
depicted on the left, and the bodhisattva Vajrasattva is seen on
the right. Around the lotus of Amitabha are eight seated
figures, constituting the mandala of the Eight Bodhisattvas.
Each has a different color and a different attribute (P2). The cult
of the Eight Bodhisattvas was popular in both Central Asia and
Tibet. (See Granoff, and Pal 1972–73, for further discussions on
the cult.) Along the bottom of the painting are the figures of
Manjusri, Shadakshari Lokesvara, and the angry Vajrapani.

Stylistically the painting is related to the *Bhimaratha*
thanka (P39) and may be regarded as a typical example of the
Tashilumpo style of the nineteenth century. As is usual with
such thankas, the colors are bold and bright; gold has been used
for the jewelry of the various deities and for the radiating au-
reoles. The freshness of the colors leads to the suggestion of a
date toward the end of the nineteenth century.

P41

Set of Twenty Banners
Central Tibet, 19th century
Each banner: 10⅜ x 3⅜ in. (26.4 x
8.6 cm.)
Gift of Mr. and Mrs. Jack Zimmerman
M.72.109

Each of these banners contains an image of a deity
mounted on blue cloth, the upper section being plain, and the
lower—cut along the middle to form two flaps—decorated
with circular designs. The twenty deities may be divided into
three groups: eight angry deities, six Buddhas, and six peaceful
goddesses. The eight angry divinities include two goddesses and
six manifestations of Garuda Vajrapani. The six Buddhas are
members of a pantheon of the Thirty-five Buddhas of Confession
(M5). The remaining six goddesses hold various objects, such as
a conch shell, an incense burner, or a lute. Strung together, the
twenty small banners may once have belonged to a larger set.

The artistic quality of the banners is indifferent; they are
of greater cultural than art historical significance. Although the
figures are rendered with correct iconography, the drawing is
cursive and colors are crudely applied. It is possible that these
miniature paintings represent a type of picture known in the
Tibetan religious tradition as *tsa ka li* (*see* Wayman 1973,
pp. 56–57). Such pictures were used by masters in the initiation
ceremonies of adepts.

P42

A Terrifying Deity in Yab-Yum
Northwestern Nepal or Tibet,
19th century
7 x 5¾ in. (17.8 x 14.6 cm.)
Gift of Dr. Ronald M. Lawrence
M.74.139.8

A dark, terrifying deity is seen here in *yab-yum* with his
red prajna. He tramples upon two nude figures as he strikes a

P42

A Terrifying Deity in Yab-Yum

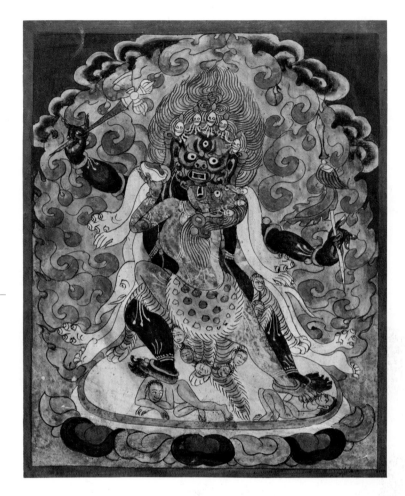

Eleven-Headed Avalokitesvara

Temple Hanging
See plate 34 (detail)

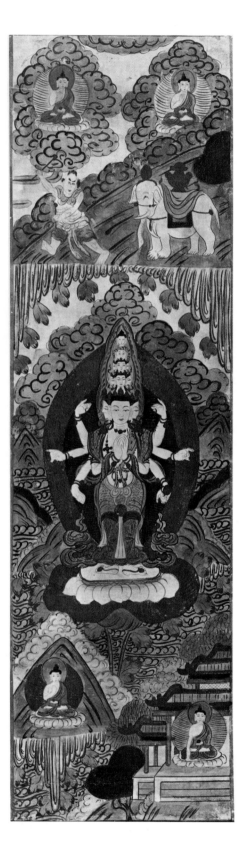

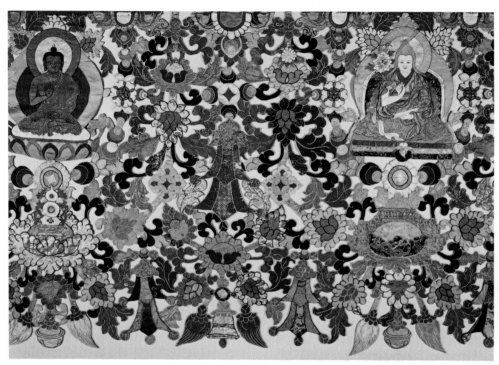

detail

militant posture (*pratyalidha*) on a lotus. He is clad in a tiger skin and an elephant-skin cape. His right hand brandishes a battle-axe, and his left holds a spear. His spouse throws her left leg around his waist and holds a skullcup with her left hand. The figures, surrounded by a sea of orange and yellow flames, are difficult to identify, but the male may represent a form of Mahakala.

The painting, acquired by the donor in a village in northwestern Nepal, was probably rendered locally by either a monk or a professional artist, but its style is related to nineteenth-century paintings from Tibet.

P43

Eleven-Headed Avalokitesvara
Eastern Tibet or Sichuan, China,
late 19th century
34 x 10 in. (86.3 x 25.4 cm.)
Gift of Mr. and Mrs. Jack Zimmerman
M.81.212.2

In the center of this painting is the bodhisattva Avalokitesvara in his eleven-headed form (S3). Below him are two Buddha images, one seated within a cave and the other in a shrine. The upper section shows a demonic figure leading a white elephant with a jewel on his head and the vase of immortality on his back. Two identical Buddhas are seated above in cloud cartouches. All four surrounding Buddhas hold pots in their left hands; the right hands of three are raised to the chest. The enshrined Buddha at the lower right forms the gesture of touching the earth with his right hand.

The provenance of such paintings is extremely difficult to suggest. In a previous publication (Pal and Tseng, pp. 40–41, fig. 21), another painting in this identical style is assigned to the Sichuan province of China, based primarily on the similarity of such works with Nakhi (or Nashi) paintings. The Nakhis are a tribal people, related to the Tibetan family, who live in Sichuan. Although these paintings are somewhat crudely and perfunctorily executed, they are often characterized by primitive vitality and spontaneous liveliness. The drawing here is free but cursive, and the artist appears not to have been very constrained by sophisticated iconographic standards. The palette, too, with its muted browns, grays, and oranges, is distinct and differs from that used in most Tibetan paintings. Thick, black brush strokes prominently emphasize forms and shapes such as clouds and mountains, which reflect an elementary conceptualization; the artist seems to have been totally unaware of either Chinese or eastern Tibetan landscape paintings.

P44

Temple Hanging
Central Tibet, mid-19th century (?)
Appliqué with cut silks, brocade, and
embroidery
50 x 648 in. (1.77 x 18.9 m.)
Gift of Mr. and Mrs. Robert D. Mathey
M.81.332
See plate 34 (detail)

Unlike the other appliqué in the collection (P45), this example does not have an inscription on its back. Although it is larger, it lacks the border along the top and the figures are smaller in size. These include the five tathagatas, the deities Vajrasattva and Hayagriva, and three Gelukpa lamas. Vajrasattva and Hayagriva are both represented in *yab-yum* and are placed at the two ends of the hanging. Of the three lamas, one can certainly be identified as Tsongkhapa, the founder of the Gelukpa order. The others are very likely the Seventh Dalai Lama and the Fourth Panchen Lama. The Seventh Dalai Lama was a great scholar who lived between 1708 and 1757; the Fourth Panchen Lama's dates are 1781–1852. Thus, if the identification is correct, this hanging was very likely made around the mid-nineteenth century.

Before each figure is an altar consisting of a stylized lotus bearing various objects, such as a butter lamp, a wheel, a jade bowl, and *tormas*, or offerings. The greater part of the hanging is comprised of flowers—mostly lotuses—foliage, banners, bells, wheels, thunderbolts, skullcups filled with blood, choppers, fly whisks, and tiny figures of guardians. All are intertwined in an elaborate tableau of bewildering and dazzling shapes and colors. It may be pointed out, however, that because this hanging is older than the later example its colors have acquired a softer and more muted tonality.

It is not known how ancient is the tradition of such appliquéd and embroidered temple hangings, but they appear to have been very popular among the Tibetans. Most Tibetan monasteries have their halls and shrines decorated with similar hangings that make the rooms colorful and festive. The inscription on P45 makes it clear that the commission and dedication of such hangings was a significant religious act. Like the other hanging, this one must have been created for an important Gelukpa monastery.

P45

Temple Hanging
Central Tibet (Norbulinga), 1940
Appliqué with cut silk, brocade, and
pearls
48 x 516 in. (1.42 x 13.2 m.)
Gift of Mr. and Mrs. James Coburn
M.78.74

The dedicatory inscription for this hanging, included in this catalogue's Appendix, informs us that this "beautifully made network hanging" was offered to the Norbulinga monastery, the summer palace of the Dalai Lama, by Geshe Lobsang Bangphyug and his pupils in the year 1940. The geshe may still be alive in India. The present Dalai Lama was five years old at the time the hanging was executed. It was paid for by contributions collected from the whole Vinaya College, and, as can be seen from the amount of silver and semiprecious stones listed in the inscription, it was not cheap.

Except for the smaller figures of Tsongkhapa and the First Panchen Lama (who holds a string of pearls) which flank the central Buddha, the dominant figures are seven Buddhas, all of whom are seated. Presumably they are the five Buddhas of the past, the Buddha Sakyamuni of the present era, and the future Buddha, Maitreya. Their images are interspersed with impressive grinning *kirttimukhas* (faces of glory) or *kala*, symbolizing time. To each head is attached a pair of hands, with which the monster appears to pull strings of gems from his mouth; these

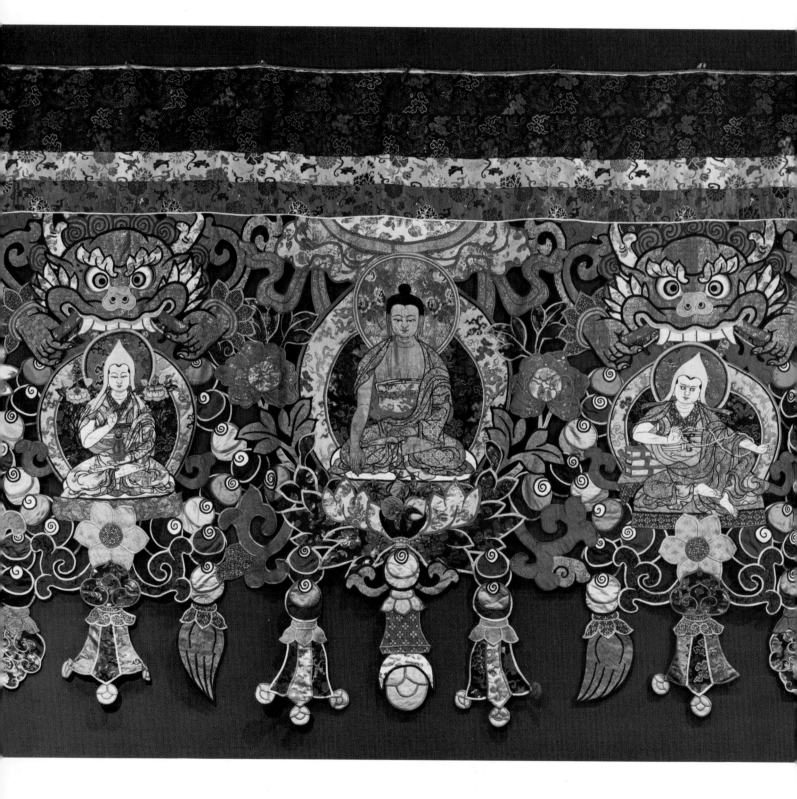

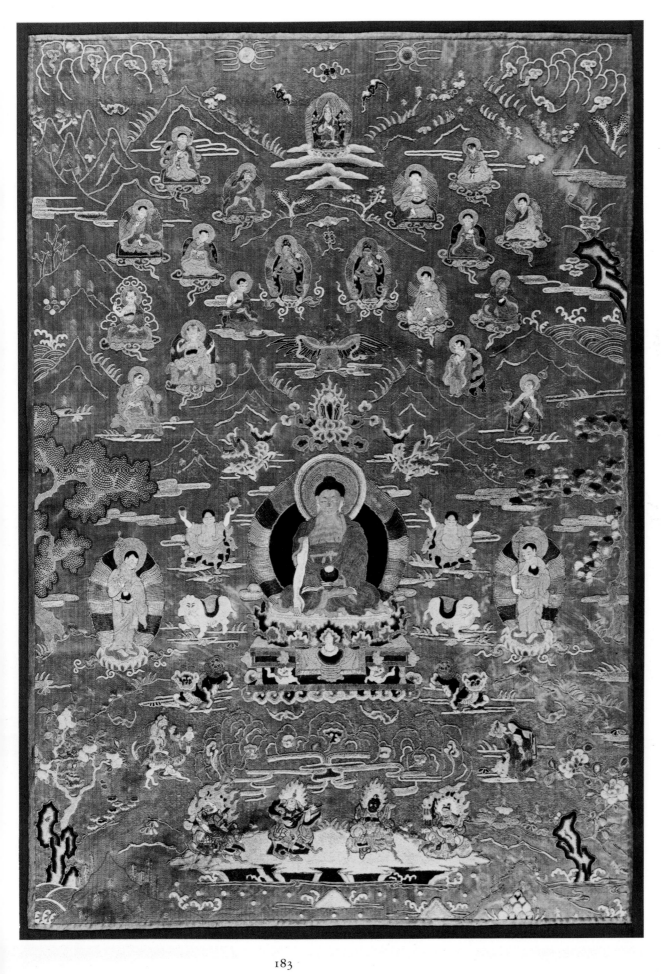

cascade down toward the Buddhas. The rest of the hanging's surface is filled with lotuses, foliage, banners, bells, tassels, swirling stalks, and cloud patterns in both silk and brocade. Because the hanging is of more recent origin than the earlier example (**P44**), the colors of the fabrics are much better preserved. Altogether, the effect is that of a sumptuous visual feast. All the material used was imported from China and some of it, with dragons and cloud patterns, was probably imperial silk.

P46

Sakyamuni and the Eighteen Arhats
Eastern Tibet, 19th century
Embroidered satin
41½ x 29½ in. (105.4 x 75 cm.)
Gift of the de Anda-Fast Family
M.77.155.1

In the center of this thanka is Buddha Sakyamuni, seated with his legs crossed atop a stylized lotus placed on a lion throne. Two elephants and two *yakshas* (gnomes) holding gems flank his multicolored aureole. Beyond them are the figures of Sakyamuni's two chief disciples, Sariputra and Mahamaudgalyayana, standing on lotuses holding a mendicant's staff and bowl. Sakyamuni's right hand makes the gesture of touching the earth, and his left holds the begging bowl. Above his head are the *Triratna* (three flaming jewels) flanked by two *makaras*. Above the *Triratna* symbol, a *khyung* or *garuda* spreads its wings to form a canopy; immediately above this creature are two standing bodhisattvas. Directly above them in the clouds is the seated figure of Tsongkhapa. Surrounding the bodhisattva figures, the sixteen arhats, each seated on a chair or a cushion, are spread out in a semicircle. Above Tsongkhapa's head are three flying bats and the symbols of the sun and the moon. Below Sakyamuni two lions seem to be leaping on either side of the throne, it would appear, at the two remaining arhats. The plump arhat, surrounded by a group of frolicking boys, is obviously Hva Shang (**P36**), while the other is Dharmatala, who sees a vision of Sakyamuni. The four guardians of the cardinal directions float on a stylized rock that emerges from the water. Offerings consisting of a pile of gems are placed on the right along the bottom of the thanka. The entire background is filled with undulating hills and peaks, leafy and blossoming trees, rocks of lapis lazuli of various shapes, and water at the bottom and clouds at the top.

This thanka is rich in symbols, and there is no doubt that the artist intended to represent the entire universe in it. It is divided into three zones: water at the bottom, earth in the middle, and the heavens with the clouds and planetary symbols at the top. Below the four divine guardians, who further symbolize the spatial directions, is a small peak emerging from the waters. This is a well-known Chinese motif, which was used on the border of the imperial robes to signify the emperor's role as a mediator with heaven on behalf of his people; the mountain symbolizes the *axis mundi*, which rises from the middle of the "swirling Sea of Possibilities" (Pallis 1960, p. 25). Another interesting Chinese symbol, rarely encountered in Tibetan thankas, is the flying bat above Tsongkhapa's head. The bat *(pien fu)* symbolizes both happiness and longevity, and although only three are included here, "the design of the Five Bats is a pictorial rebus standing for the Five Blessings"—old age, wealth, health, love of virtue, and natural death (Williams, pp. 34–35). That the blessing of wealth was of special concern to the donor is evident from the inclusion of the *yakshas* bearing gems to Sakyamuni.

P47

Vajradhara and Spouse

The embroidery is of very fine quality in the "forbidden stitch," which was a special stitch that was so hard on the eyes that it was forbidden in China in the early years of this century. The colors have now faded because of water damage, but what remains shows the embroiderer's very subtle use of muted hues. The background is a silver gray satin; hence, the entire surface has a shimmering quality. The faces of the arhats are remarkably varied and expressive; not even the tiniest detail has escaped the careful attention of this deft embroiderer. The inclusion of the bat, apart from the general stylistic features, clinches the Sino-Tibetan attribution.

P47

Vajradhara and Spouse
Eastern Tibet (Kham), 20th century
Woodblock print on paper
21¾ x 16 in. (55.2 x 40.6 cm.)
Gift of Mr. and Mrs. Edward Cornacchio
M.71.92

Vajradhara, holding the *vajra* and the bell with his two crossed hands, is seated cross-legged on a lotus and embraces the goddess who is the symbol of insight *(prajna)*. She holds a skullcap filled with blood in her left hand; her right hand clasps his neck and carries a chopper. He is the primordial Buddha *(Adibuddha)* of the Vajrayana pantheon. This modern print was made from a nineteenth-century woodblock. Such woodblock prints were often used as transfers for the outlines of thankas.

Sculpture

With the exception of a few works created from wood or bone (**R7**), most sculptures in the collection are made of metal. One piece in unfired clay (**S1**) is included here, although its Tibetan attribution is uncertain. From the earliest period, both clay and stucco were popular sculptural media in Tibet, and large statues made from these materials adorn many of the monasteries. Wood, too, was a favorite material, though used more often for entrances to temples and architectural embellishments than for statues. Elaborately carved entrances, some as old as the tenth and eleventh centuries or earlier, are often the only ornate features of the exteriors of otherwise austere though dignified buildings. Some idea of the intricacy and finesse of such entrances can be formed by looking at the book covers (**M5**) and the two sections of a diadem (**R3**) in the collection. Although not so monumental as an entrance, these pieces were very likely made by the craftsmen who also carved entrances, brackets, and beams. Woodcarving is very popular throughout the Himalayan area, and the Tibetans share this love.

More typically Tibetan, the solitary bone sculpture in the collection (**S29**) exhibits the same rather awkward though lively manner in which images are carved on rocks all over the country. Invariably in shallow relief, the figures are often crude but impressive. Although the Tibetans have always used stone for their majestic buildings, this material has not been popular with sculptors. In this respect, they appear to have followed neither the Indians nor the Nepalis, nor for that matter the Chinese. During their occupation of Chinese Turkestan, they must have become familiar with the great sculptures that are carved from live rock at Dunhuang, but their own attempts at rock sculpture proved to be less accomplished. They seem to have preferred to work in clay and stucco—which were popular media in other Central Asian locales, as well as in Buddhist monasteries in Kashmir and its neighboring regions—and in bronze.

Like their fellow Buddhists in other countries, Tibetans have always delighted in gilding and painting their sculptures. Stucco and clay obviously lend themselves to polychromy, but both wood and bone were also painted in bright colors and even gilded. Traces of gilding may still be discerned in the segments of the diadem and the book covers mentioned above, while vestiges of pigment continue to adhere to the bone and the clay figures. Considerable amounts of paint also linger on **S14**, the wooden bodhisattva.

When a sculpture is polychromed, the skin of the figure is painted in the liturgically prescribed colors. Thus, Amitabha will always have a red complexion and Akshobhya will always have a blue one. Gold, however, is the favored color, and any image may be gilded; only the faces may be brushed with cold gold and the eyes, hair, and mouth painted in appropriate colors. Hair is invariably rendered in

blue or black, except for angry deities, on whose hair red or orange is used. Red appears to symbolize passion and violence universally; for us in the West, of course, the "wrath" of the redhead is proverbial. Whenever the original polychromy faded or peeled off, a fresh coat was applied, as has recently happened to a small gilt bronze in the collection (S20). In this instance, the body has been painted in silver and the face in gold.

The practice of painting statues, particularly faces, with gold paint appears to be exclusively Tibetan. If, therefore, a sculpture looks as if it has been given a face-lift with gold paint, it is likely to have emerged from Tibet, no matter where it was made. Gold paint is applied even to gilded bronzes, and reapplied from time to time as the paint peels off. With this method, known in Tibetan as *trang ser,* which means "gold coated," a mixture of gold powder and gelatin is applied with a fine brush. Although the practice of painting statues with gold satisfies the Tibetans' religious needs, it is aesthetically less pleasing, for the thick heavy paint tends to obscure the contours of the features. Gilding *(tsa ser),* by comparison, is a much more complex process, one that requires skill and precision. A mixture of gold and mercury is applied to the surface and heated over a smokeless fire; the mercury evaporates and the gold adheres to the surface, which is then polished with a smooth stone resembling a cat's eye.

The word "bronze" is used loosely to describe Tibetan metal sculptures; that term is used here for the sake of convenience. However, a wide variety of alloys have been utilized in casting statues, not all of which are bronze. (Tibetans themselves use the general term *li* for the metals they employ.) A glance at the bronzes in the collection will reveal the remarkable variation in surface color. Such distinctions are achieved not only by artificial patination but by varying the proportions of the metals in a given alloy. Thus, bronzes containing a significant amount of copper tend to have a reddish surface, while those with a good deal of brass bear a yellowish hue.

Although some texts by Tibetans attempt to distinguish styles of bronzes by their colors, such efforts are not very helpful.[1] One modern scholar has also divided Tibetan bronzes into two "schools," one gilt and the other non-gilt,[2] but this, too, is unsatisfactory because gilding was not confined to any particular school, atelier, or period. More to the point is the fact that Tibetans have a love for gold that stretches back to ancient times. This love is reflected in their workmanship in gold, which was praised as long ago as the Tang period in Chinese chronicles and which, therefore, may have been as intrinsic to them as it was to the Scythians in Central Asia.

Newari sculptors have continued until today to cast their bronzes in an alloy that has a high copper content. Copper is a fairly soft metal, and so Nepali-style bronzes have smoother surfaces than bronzes produced with alloys containing more zinc or tin. In Kashmir and the western Himalayas of India, on the other hand, the preference was for brass which, with its dull yellow sheen, approximates the color of gold. Kashmiri sculptors also added to the expressiveness of the faces of their bronzes by inlaying eyes with silver and mouths with copper. This practice was adopted in Tibet (S2, S4), though not so widely nor with so much finesse as in Kashmir.

What is distinctive about Tibetan bronzes is the delight taken in encrusting their surfaces with semiprecious stones, such as turquoise, opal, agate, crystal, and carnelian. Such encrustations add texture and enhance the sumptuousness of the gilded surface. With ritual implements, this is carried to such an extreme that the entire object appears as a rich mosaic of glittering stones (*see* **R10**–**R12**). Anyone

who looks at a picture of a Tibetan woman can see Tibetans' strong love for inlaid jewelry. Although turquoise is now the most popular stone, the original favorite was lapis lazuli. As E. H. Schafer summarizes the available evidence:

> The Chinese were not alone among the Far Eastern peoples in their admiration for the blue mineral. The Tibetans valued it above all others, even ahead of gold, and those highlanders saw in it the image of the azure sky, and said that the hair of their goddesses had its color. Both men and women there wore it on their heads.[3]

Neither lapis lazuli nor turquoise is a local stone; they come from further west. The kingdom of Khotan in Central Asia, an ever-important stop along the Silk Route, was also, during Tang times, the leading market for gems. The Chinese knew the lapis lazuli as the "stone of Khotan." Turquoise came from Iran but passed into Tibet and China through Khotan. Tibet occupied Khotan in the seventh and eighth centuries. It was at Khotan that the Tibetans must have first been enchanted by the rarity and magical luster of lapis lazuli and later by turquoise.

Most bronzes were cast using the *cire perdue*, or lost-wax, process. Although some solid-cast bronzes were made, hollow casting was the preferred method, since it enabled the images to hold the relics and charms that increased their potency. The practice of inserting relics and charms (consisting of bits of paper with mantras, pieces of cloth, and grains) inside bronzes was more common in Tibet than in India or Nepal. The thin plate, attached at the bottom to seal the contents, was frequently embossed or incised with a double-thunderbolt symbol, a distinguishing trait of Tibetan bronzes. If a plate was attached to the base of an Indian or Nepali bronze, it was not adorned with the double-thunderbolt.

After the bronze was cast, it was chased, gilded, and inlaid—often with a jeweler's precision. Indeed, adorning the surface of a bronze, particularly with the attire in portrait sculptures (S31, S35, S38), appears to have been a specialty of the Tibetan tradition. Most small bronzes are cast in two major pieces: the base and the figure. Such appurtenances as the aureole or the scarf, however, were also often cast separately and later attached to the back. In some instances, especially when the images are in *yab-yum* (S28), the bronze is cast in several pieces and skillfully assembled. Both the repoussé and beaten-metal techniques were prevalent (S16–S18). Such methods were often employed to encase images of clay or wood. Repoussé is a favorite mode in Nepal, and most fine Tibetan objects using this technique were probably made by Newari craftsmen working in Tibet. Sometimes small bronzes were cast from matrices (S12), presumably when the demand was great and where there was a brisk trade in religious souvenirs. This is why one often encounters identical bronzes which have minor differences and rather perfunctory finishes. Most bronzes, however, were cast using the *cire perdue* process, and, therefore, each is one of a kind.

The major centers for metalwork in Tibet were, and may still be, Derge, Chamdo, and Reo-Chi—all in the eastern province of Kham. Because of its proximity to China, one tends to find a close relationship between the aesthetic traditions of Kham and China. The expressive portrait of Arhat Kalika (S36) should be characterized as Sino-Tibetan, for it may have been made either in Kham or in China proper. Some of the excellent ritual objects were certainly made in Derge, which was widely noted for its metalwork. Two well-known centers in the province of Tsang were at Tsedong and Tanag. The sculptors in these places traced their charter to Sakya times, at least back to the thirteenth century. Gyantse was another important religious and commercial center where colonies of Newari or Banre craftsmen settled. In western Tibet, the most celebrated center was Luk in the ancient king-

dom of Guge. And at the foot of the hill in Lhasa on which rests the great Potala palace lived (and perhaps still does) a colony of hereditary sculptors who were organized into a guild by the Fifth Dalai Lama in the seventeenth century.

All this, however, is of purely academic interest, for there is no way to distinguish a bronze made in Luk from one manufactured in Tsedong. Neither can one determine whether a bronze was cast by a Newari or a Tibetan, or by a monk or a layman. Because of existing murals found in the monasteries, it is possible to pinpoint a painting style with some precision, but to localize the various styles of bronzes is a much more difficult task. Being easily portable, bronzes have traveled far and wide, and published pictures of Tibetan monasteries reveal how remarkably varied a single monastery's collection can be. What does seem significant, however, is that one sees very few Chinese or Central Asian bronzes in these pictures. Most are from Kashmir, Nepal, or eastern India, and one even clearly recognizes Jain bronzes from western India.

As with paintings, the three major traditions which influenced Tibetan sculpture were those of India, Nepal, and China. From the seventh century until Buddhism disappeared in India around 1200, Indian influences stemmed largely from two sources: Kashmir and the adjoining regions of Swat and Gilgit in the west, and the regions of Bihar and Bengal in the east. Kashmiri influence was felt more strongly in the western parts of the country, although Kashmiri bronzes adorn the altars of temples in central Tibet as well. Both Kashmiri artists and bronzes were imported into Tibet, and Kashmir's influence probably prevailed at least until the fourteenth century, when that region succumbed to Islam. Influences from eastern India were less pronounced in western Tibet but were more predominant, until the thirteenth century, in the central and southern parts of the country.

It was only natural that India's impact should have been strongest until the thirteenth century. As long as India remained the spiritual source, Indian bronzes must have been repeatedly copied. Once India ceased to be such a source its influences began to diminish, and, while the ancient sacrosanct bronzes were piously displayed on altars, Tibetan artists began to exert their own personality in developing a more Tibetan style. However, it is not possible yet to define exactly what that style is.

Even when Tibetan bronzes are inscribed, the inscriptions throw little light on either style or date. When relevant information is present it creates more problems than it solves. Two examples will suffice to illuminate this situation. A magnificent bronze Buddha almost three feet tall (now in the Cleveland Museum of Art) bears a Tibetan inscription noting that it was the personal image of Lhatsun Nagaraja.[4] Lhatsun was a royal title used in eastern Tibet, and we do know of a prince by that name who lived in Guge in the tenth century. The bronze, however, is considered by scholars to be a Kashmiri sculpture. In fact, if the bronze were not inscribed, no one would have connected it with Tibet. There may be two major ways to reconcile the inscription and the style. The bronze may have been made in Kashmir and brought to Tibet, as Rinchen Sangpo did at about the same time, or it may have been cast in Guge by one of the Kashmiri artists brought back by Rinchen Sangpo. If the latter is true, is the bronze Tibetan or Kashmiri?

A Tibetan inscription on a much smaller and less important bronze indicates that its sculptor, Aphajyoti, was from Nepal but that the bronze was cast in Tibet, though we are not told exactly where.[5] What is even more perplexing is that, contrary to what one might expect from a Nepali sculptor, the bronze is clearly rendered in the Pala rather than the Nepali style. It is possible that the patron, in

this instance, may have wanted a copy of a famous Pala icon and that the Nepali sculptor obliged.

These two examples underscore the difficulties both of attempting to sort out the various stylistic influences and of distinguishing the many different styles of sculpture that flourished in Tibet between the eleventh and the nineteenth century. Tibetan artists were always cognizant of the three major traditions—Indian, Nepali, and Chinese—and these traditions' influences on local artists and ateliers naturally varied according to the talents and tastes of individual artists.

For these reasons, then, the attribution of bronzes in this catalogue either to Tibet in general or to specific regions must remain tentative. Although reasons for such attributions are given in the individual entries that follow, one can only determine whether a bronze is Nepali or Tibetan through experience and constant handling. Certain broad indications, however, may be helpful.

S31

The greatest difficulty one encounters in distinguishing a Tibetan bronze precisely occurs when the subject matter is a benign deity. This is especially true of the early stages of Tibetan art (prior to the fourteenth century), when the sacrosanct, imported models were faithfully copied. Thereafter, however, the faces of the figures begin to reflect stronger ethnic features, with higher cheekbones, slanting eyes, less prominent noses, and thinner lips. The modeling of the figure becomes less naturalistic than in either Kashmiri or Pala figures. Some bronzes, especially those created in western Tibet, have a distinct "provincial" quality, marked by rather clumsy proportions and unfinished backs. Others can be recognized from the color of the bronze or from surface decorations. By and large, Tibetans have had a more distinct predilection for enriching the surfaces of their bronzes with semiprecious stones than their Indian and Nepali counterparts.

The easiest to recognize are portraits of mahasiddhas, mystics, and religious hierarchs who were Tibetan. No mahasiddha is known to have been portrayed in Indian art. In fact, even Tibet, which has preserved so many Indian and Nepali bronzes, has not yielded a single mahasiddha of Indian or Nepali origin. Mystics such as Padmasambhava (S37) and Dampa Sangye (S31) were revered only in Tibet, as were Yuthok Yönten Gonpo (S39) or Songtsen Gampo (S41). Such figures, as well as all portraits of religious hierarchs of the various orders, are clearly of Tibetan origin both in iconography and style.

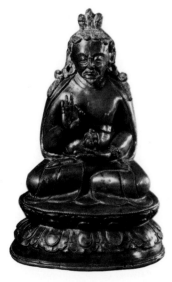

S39

One cannot help but suggest a comparison with the portrayals of historic figures in Japanese Buddhist art. The commanding images of their monks, patriarchs, and *lohans* (arhats) have an expressive power and originality that are admirable and exciting. Japanese portraits of monks and priests reveal a curious but compelling fusion of realism and hieratic grandeur. Similarly, Tibetan sculptures of lamas and *lotsawas,* mahasiddhas and arhats, notwithstanding their stronger idealization, are among the most imaginative and spiritually satisfying religious portraits created anywhere.

Invariably, the figures in the Tibetan portraits are seated in a variety of yogic postures (S31, S32), sometimes in a relaxed manner (S33, S36). Often only their faces emerge from the subtle folds of their robes, which are enlivened with delicate etchings. These sensitively rendered details, as well as the expressive faces with eyes that seem to bulge from their sockets, exhibit an inner energy that makes them astonishingly animated figures (S31, S34). The representations of the arhats and the mahasiddhas are totally idealized, but once again, the sculptor's imaginative power and his capacity to express the essence of the personality are impressive. The

extraordinary realization of Dampa Sangye (S31), whose arresting stare leaves no doubt as to his supranormal powers, is a good example of this. In another portrait of a lama (S32), made soon after its subject's death, the artist has given us an imposing representation that combines the required idealization with a sensitively modeled face that must be a true likeness. Generally, however, Tibetans did not indulge in realistic portraiture, as the Japanese did. In this regard, they adhered closely to the message of Vajrayana Buddhism, in which expressions such as "reality" and "realism" are meaningless and form is thought to be an illusion.

Statues of dharmapalas, *yidams*, and other terrifying deities, some of whom were created by the Tibetans themselves, are also, like the idealized portraits, more easily recognizable as Tibetan. Tibetans appear to have been especially adept and imaginative in creating expressive images of terrifying deities, much more so than their fellow artists in other Buddhist countries. A Tibetan bronze of a terrifying deity, with its multiple limbs and heads, its violent postures and gestures, appears as a coherent, organic mass—a composition that is forceful and alive with expressive power. Although they may at first shake Western sensibilities, these dynamic bronzes are informed with surging energy and rhythmic elegance, whether the figures dance (S26) or are seated (S24, S25). No matter how bellicose the figure, the sense of movement is always restrained and the multiple limbs are invariably arranged with clarity and logic. One is constantly surprised and fascinated by the extent of the artist's fantasy and awed by his technical dexterity. It is immaterial whether the artists involved were Newars or Tibetans; the exciting forms they created reflect an aesthetic vision and psychological insight that are essentially Tibetan.

Notes

1. Tucci, 1959.
2. von Schroeder, pp. 395ff.
3. Schafer, p. 232
4. Pal, 1975, pp. 100–101.
5. von Schroeder, p. 478, no. 133B.

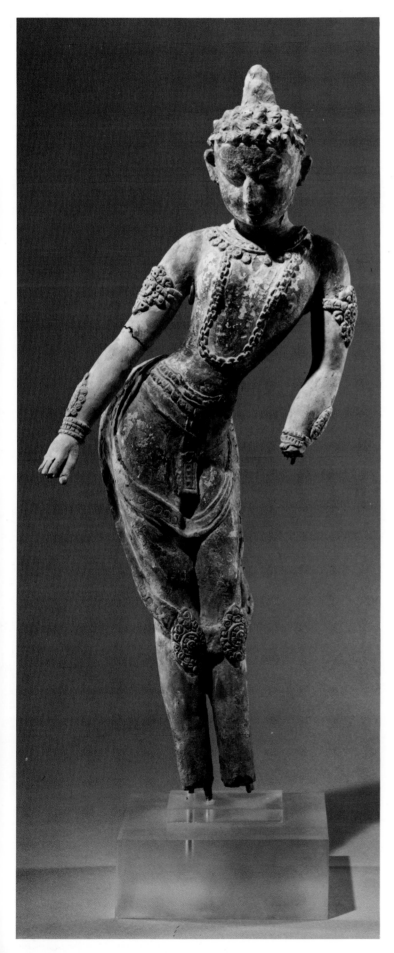

A Buddhist Deity
Tibet (?), 11th–12th century
Unfired clay with polychrome
24 in. (61 cm.)
From the Nasli and Alice Heeramaneck
Collection
Museum Associates Purchase
M.73.4.9
Literature: Rosenfield, et. al., p. 39.

This enigmatic sculpture, considerably restored, presents many problems. When first published it was identified as a Buddhist deity made during the eighth century in the region of the Indo-Iranian border. Because the original arms are missing, its identification cannot be certain, but the rendition of the hair suggests a Buddhist affiliation. While the hairstyle is more like that of a Buddha, the ornamented body, the posture, and the face imply an attendant bodhisattva. The thin paper that has been glued to the head, the protruding lump atop the head, and parts of the arms and legs are rather crude attempts at restoration.

Although the sculpture does share its slim elegance with the well-known figures from Fundukistan in Afghanistan, an atribution to the Indo-Iranian border region and an eighth-century date seem highly unlikely. Polychromed and unbaked-clay sculptures are quite common in Tibet, as is the strong *dehanche-ment* of the posture which results in an almost awkward body position (cf. Tucci 1973, figs. 151–52, 166, 172, 201). The face too reflects Mongolian features, and the gentle expression—even though more characteristic of Nepal—is also encountered in Tibetan sculptures of the eleventh and twelfth centuries. A Tibetan attribution for this puzzling sculpture seems more likely than an Indo-Iranian one.

Bodhisattva Avalokitesvara
See plate 35

Eleven-Headed Avalokitesvara
See plate 36

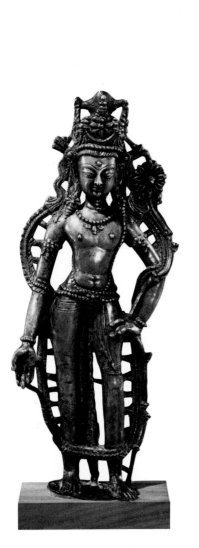

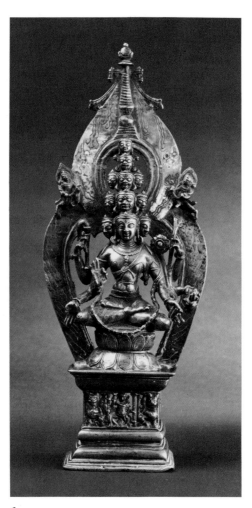

front

back

Bodhisattva Avalokitesvara
Western Tibet or Kashmir, 11th century
Brass with inlaid-silver eyes and inlaid-
copper lips
14½ in. (36.8 cm.)
From the Nasli and Alice Heeramaneck
Collection
Museum Associates Purchase
M.75.4.1
Literature: Pal, 1966, p. 69, no. 58;
Beguin, 1974, p. 335, fig. 5; *Dieux et
démons,* p. 89, no. 41; von Schroeder,
p. 130, no. 22B.
See plate 35

Swaying slightly to his right, Bodhisattva Avalokitesvara stands on a thin plate, which was once attached to a lotus base. He wears a dhoti and a crown and is bedecked with jewelry and a garland. His left hand holds a lotus in full bloom and his right is outstretched in the gesture of charity. Spruces, used as channels in casting the metal, remain attached between the body and the garland.

In previous publications, this bronze has been variously dated between the tenth and the twelfth century. There is also a difference of opinion about its provenance: some art historians consider it to be from Kashmir, and others vacillate between Kashmir and western Tibet. Precise origins of such bronzes are very difficult to determine. Tucci, while publishing a similar bronze which he saw in the Samada temple, considered it Nepalese (Tucci 1941, pp. 103–05, fig. 23), but later concluded that the sculptor was from Kulu (Tucci 1973, fig. 20). The same bronze is given a western Tibetan attribution in a recent publication (von Schroeder, p. 130, no. 22A).

An inscription in the Samada temple tells us that the bronze was made by an Indian brahmin whose name was Mati and who came from "Pan-tso-ra." Although one cannot identify the place (could it be Pir Panjal, a mountain range in Kashmir?), it is likely that he was from Kashmir or the Chamba region, which had a long-standing tradition of bronze casting. It is clear that not all Kashmiri-style bronzes were simply imported into Tibet, but that some were made locally by Indian artists. Thus, like the Samada bronze and many others which are in situ in monasteries (mostly in western Tibet), this bronze may have been made in Tibet. Many of these bronzes have unfinished backs, which is not the case with those works firmly attributable to Kashmir. Moreover, the details in this example have been rendered more summarily than in other bronzes in this style. The garment is plain, without any incised designs, and the garland is fashioned in a crude manner. Nevertheless, the figure is strongly modeled and has a commanding presence.

Eleven-Headed Avalokitesvara
Ladakh, 11th century
Brass
15½ in. (39.4 cm.)
Gift of Mr. and Mrs. Harry Kahn
M.78.40
Literature: Pal, 1982 A, pp. 16–18.
See plate 36

Framed by an aureole and a nimbus, the eleven-headed, six-armed deity is seated on a lotus in the classic posture of meditation. The lotus rests atop a pedestal supported by a *yaksha* (gnome) and two lions, with the bodhisattva's knees extending well beyond the open lotus. Both the aureole and nimbus are decorated with an etched design of flames and a row of beads along the inner rim. Two nimbused celestial beings with garland offerings are attached to the place where the aureole and nimbus overlap. The apex of the nimbus is adorned with a *chöten* decorated with festoons and crowned with the solar and lunar symbols.

The bodhisattva wears a dhoti marked with incised patterns; an antelope's skin is tied diagonally across his chest, the animal's head hanging from the left shoulder. In addition to the usual ornaments, the deity wears a large garland that overhangs the lotus on which he sits. Curiously, the tiara on each head is so insignificantly rendered as to be scarcely noticeable. The pyramid of heads is topped with that of a tathagata. Among the others, only the three on the lower tier are given placid faces while all the remaining seven are terrifying. The three left hands hold the stem of a lotus, a pot, and a staff; one right hand holds what appears to be a fly whisk while the other two form the gestures of charity and exposition.

An inscription along the upper molding of the base (*see* Appendix) is not very helpful. It says that the bronze was commissioned by an unnamed person in fulfillment of a vow. However, the name of the deity, presumably Nyag Chang Lha, is unfamiliar. It is certainly not a known epithet of the eleven-headed Avalokitesvara whose image this must be, despite the inscription and the minor iconographic variations. Normally, in this popular manifestation of the bodhisattva, only one head is shown as terrifying (P43), but in Tibet there are several instances (the most famous being the now-destroyed image in the Jokhang in Lhasa) in which the deity is represented with multiple awesome heads. (*See* Pal reference above.) Also unusual for representations of this manifestation is the number of arms; generally there are eight, but here there are only six. It is more common to encounter six-armed, eleven-headed figures in Central Asian representations. Another uncommon feature is the inclusion of the fly whisk as an attribute.

The symbolism of this figure is complex and has been discussed at length elsewhere (Pal 1982 A). It is commonly believed that once, while pondering the miseries of this world, Avalokitesvara's head split into ten fragments. Out of compassion they were reassembled as ten heads by his spiritual father, Amitabha, who added his own as the eleventh. Fascinating as this myth is, it probably disguises an earlier myth of cosmic creation in which a primal being created the universe by disintegrating his own person.

Although strongly Kashmiri in style, the bronze was very likely executed in Ladakh. Stylistically similar figures may be seen in the murals of Alchi as well as in the eleventh-century manuscript illuminations in this collection (M1). The modeling of the figure, especially the manner in which the pectoral muscles are delineated, is akin to that seen in the painted images at Alchi. Among Kashmiri bronzes the closest parallel is the image of Sugatisandarsana Lokesvara dedicated during the reign of Queen Didda (980–1003).

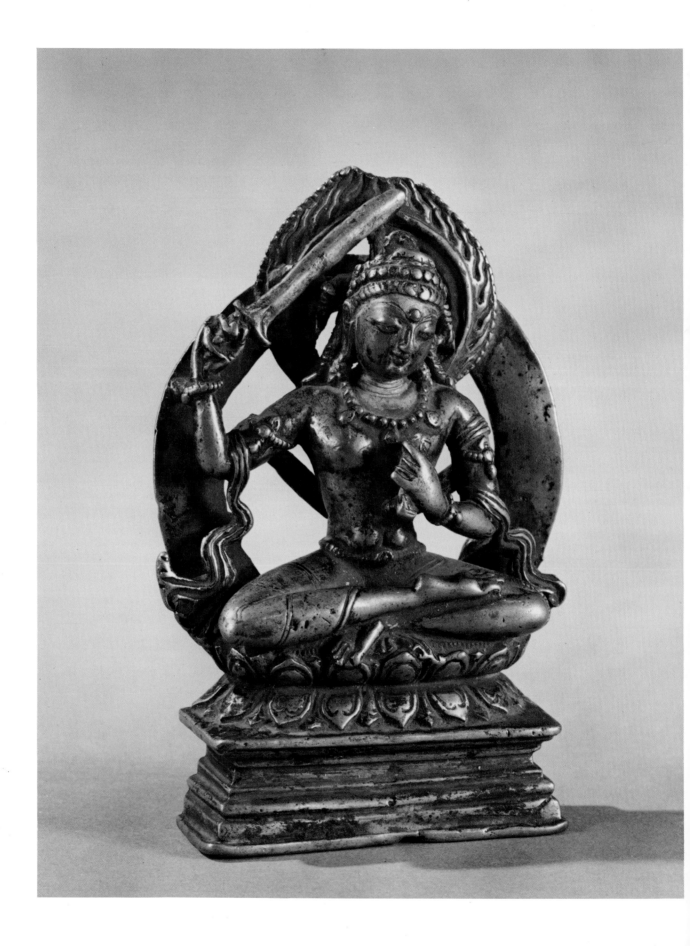

Bodhisattva Manjusri
Lakakh or western Tibet, 11th century
Brass with inlaid silver and traces of
gilding
5⅛ in. (13 cm.)
From the Nasli and Alice Heeramaneck
Collection
Museum Associates Purchase
M.75.4.6
Literature: *The Art of India,* no. 54; Pal,
1966, p. 70, no. 60; Pal, 1974, pp. 152–
53, no. 54.

The bodhisattva Manjusri is seated in the lotus posture
on an open lotus atop a molded base. He wears a plain dhoti
and a scarf is thrown across his back, its ends fluttering on
either side in the front, and is adorned with two sets of arm or-
naments and a pearl necklace with three pendants. His hair is
distinctly rendered; matted above the head, and tied with a
strand of pearls, five braids fall down onto his shoulders. This is
in keeping with Manjusri's epithet, *pancasikha,* which means
"five-crested." The figure's right hand brandishes the sword
which dispels ignorance and the left holds the book, symboliz-
ing wisdom, against his chest. His head is set off by a flame
nimbus, but the aureole is plain. In this form the bodhisattva is
known as Arapacana Manjusri.

In previous publications this bronze was hesitantly attrib-
uted to Kashmir. Without a doubt, it is closely related to Kash-
miri bronzes of the late tenth and eleventh centuries. However,
the face of this figure is not quite so bloated as typical Kashmiri
faces. Rather, it reveals strong Mongolian features, and as in the
Avalokitesvara (S2) the details do not appear to have been ren-
dered with the kind of finesse one finds in Kashmiri bronzes.
For instance, the lotus, the scarf, and the hands are treated in a
more cursive manner. Moreover, the figure may be compared
with representations of this deity on terracotta plaques recovered
from Ladakh (Kak, pp. 82–83). It would seem, therefore, that
the bronze was made either in Ladakh or in western Tibet
following a Kashmiri model.

Whatever its exact provenance and however crude some
of its details, the artist has succeeded eminently in capturing
the benign essence of this compassionate bodhisattva. Despite
the sword in his right hand, he is hardly a menacing figure.
With his head set at an angle, with downcast eyes and a gentle
expression on his face, he seems to be looking compassionately
at the devotee.

S5

A Buddha
Western Tibet or Ladakh, 11th century
Brass with paint
3¾ in. (9.5 cm.)
Indian Art Special Purposes Fund
M.76.79

Fully clothed in monastic robes, this Buddha is seated in
the cross-legged posture on the pericarp of a single-petaled lotus.
His right hand is extended in the gesture of charity and his left
holds a bowl with something indistinguishable in it. The curls

of his hair are painted black, as are his eyebrows and the circle
of dots that decorate his robe and lower garment. That he is a
Buddha is certain, but whether he represents the Buddha
Sakyamuni, the tathagata Ratnasambhava, or the Healing
Buddha, Bhaishajyaguru, is more difficult to determine.

The style of the bronze is as enigmatic as its identification.
Although it relates to bronzes from Kashmir and Swat, there
are notable differences. The garments are much more summarily
treated, with the folds indicated by widely separated double
lines. In no Kashmiri or Swat bronze, discovered to date,
does one see such clusters of dots on Buddha's garments. The
treatment of the upper part of the robe as a V-shaped collar
appears contrived and flat in this bronze, while the additional
band (of flesh?) around the neck makes it seem as if the head
is grafted onto the body. Unusual also are the painted curls
on the head and the plain topknot, both of which are more
likely to be Tibetan characteristics. It is not uncommon in Tibet
to indicate the hair with paint (*see* S30, S32) rather than with
sculptured volume or incisions. On the whole the workmanship
is quite crude, especially in the execution of the right hand and
the lotus base.

It seems probable, therefore, that the bronze was cast
somewhere in Ladakh or western Tibet by a relatively unskilled
artist who was trying to imitate a Kashmiri bronze, but who
added several touches of his own.

S6

Bodhisattva Avalokitesvara
Western Tibet or Ladakh, 12th century
Dark bronze
7½ in. (19.1 cm.)
From the Nasli and Alice Heeramaneck
Collection
Museum Associates Purchase
M.75.4.7
Literature: Pal, 1966, p. 70, no. 59.

The bodhisattva Avalokitesvara stands gracefully in
slight contrapposto on a rectangular pedestal with moldings at
the top and at the base. The recessed portion of the pedestal in
the front is incised with a thunderbolt and a light floral design.
An aureole etched with a cursive flame design rises from the
pedestal on either side and is joined at the top to a nimbus, un-
fortunately broken. The bodhisattva wears a dhoti held together
at the waist by a clasped belt and a sacred cord. He is sparsely
ornamented with a simple strand of pearls, earrings, and a tiara.
A plain garland hangs down to his calves and his left hand
grasps the stalk of a lotus which rises from the base. The right
hand is broken, but originally it very likely displayed the ges-
ture of reassurance.

Elegantly proportioned, this bronze is less detailed than
the Kashmiri bronzes after which it was modeled. The modeling
here is more abstract and the sculpture is informed with a
greater linear quality than is usual in Kashmiri figures. The
dhoti, however, with its horizontal folds, reflects greater fidelity
to its prototype. In a previous publication (*see* reference above) it
was attributed to Kashmir, but on reconsideration, it seems
more likely to have been rendered in Ladakh or western Tibet.

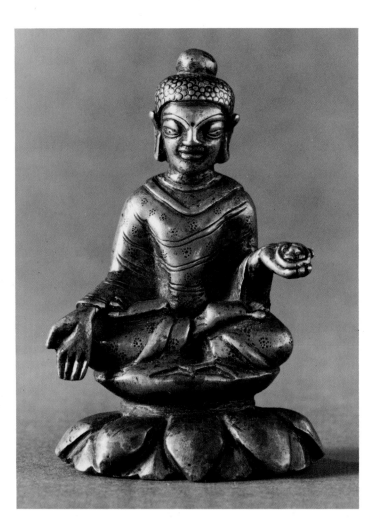

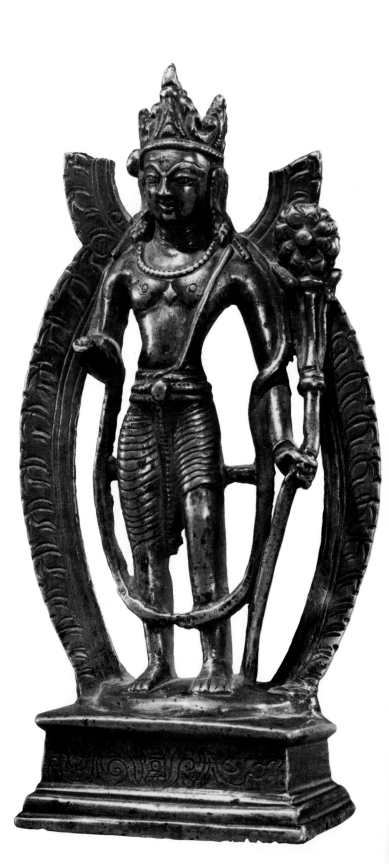

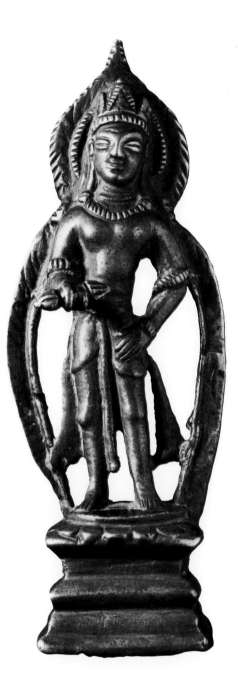

S7

Bodhisattva Vajrapani
Western Tibet, 12th–13th century
Brass
5⅞ in. (15 cm.)
Gift of Mr. and Mrs. Michael Phillips
M.81.276.4

One of the oldest bodhisattvas in the Buddist pantheon, Vajrapani, or the thunderbolt-bearer, makes his first appearance in India in the art of the Kushan period (2nd century A.D.). Later, in the Vajrayana pantheon, he became one of the four principal bodhisattvas, and although portrayed in Indian Buddhist art, his cult was more popular in Tibet and Nepal. In the Vajrayana pantheon he is the master of the Vajra family of deities, and is frequently portrayed in Tibetan art in both his benign and angry forms (S22).

In this bronze, Vajrapani is benign. He stands in contrapposto on a summarily rendered lotus that rests on a tall molded base. His aureole and nimbus are cursively delineated, as are the ornaments he wears. His right hand is stretched out and horizontally holds the lotus; the left hand simply rests against the left thigh. Although Vajrapani's legs seem somewhat elongated, the artist has made some effort to model the body naturalistically, following the Kashmiri manner. The design of the crown, with its three pointed lobes, is similar to those seen in eleventh-to-twelfth-century western Tibetan paintings, such as the figures in the manuscript illuminations (M1). As is also typical of western Tibetan bronzes, the back is crudely finished, and the perfunctory workmanship in the front indicates that the bronze was probably cast in a provincial workshop following a Kashmiri original.

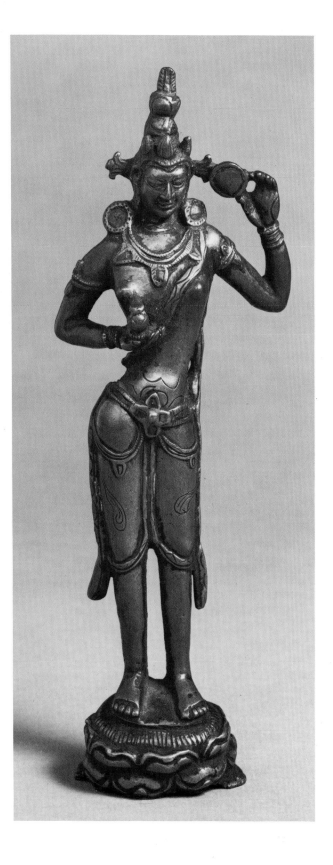

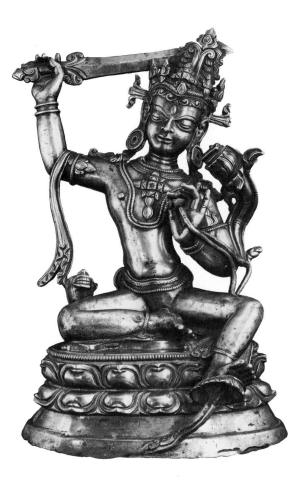

A Divine Figure
Western Tibet (?), 12th–14th century
Brass
7¾ in. (19.7 cm.)
Julian Wright Bequest
M.79.152.179

This divine figure stands in an awkward posture on a crudely rendered lotus base, which was cast separately from the figure. Wearing a dhoti, he is adorned with various ornaments and a tiara. His right hand holds a pot or a vase and the left, raised to the level of his ear, holds a disc. The disc may represent either the sun, the moon, or a mirror. That it represents a wheel is unlikely because there are no spokes. If the disc does symbolize either the sun or the moon, the figure may depict Bodhisattva Suryagarbha or Bodhisattva Candragarbha, respectively. Both these bodhisattvas are companions of the Healing Buddha (**P8**). If, on the other hand, the disc represents a mirror, the figure portrayed may be a Bonpo deity.

Neither the exact provenance nor the date of this bronze can be determined with any certainty. From time to time, such bronzes, usually representing triads and always small in size (made small as if intended for domestic or traveling shrines), appear on the market. Some of them have been assigned, broadly, to western Tibet (von Schroeder, pp. 172–76), but without any evidence. All that may be said for certain is that the group possesses unique characteristics and was very likely manufactured in a particular atelier by artists who were not very skillful.

As is the case with this bronze, the figures are generally disproportionate (although not without charm), their postures are stiff and without grace, their modeling is summary and reflects anatomical distortions, and their details are crudely and cursorily rendered. Von Schroeder assumes that they were often made with matrices and generally regards them as the earliest western Tibetan creations by unskilled artists who were attempting to copy Indian or Nepali models. He therefore dates them all to the eleventh and twelfth centuries. That they are crude attempts to copy Indian models—here the model may have been an eleventh- or twelfth-century Pala bronze—is in no doubt. But in view of the visible remains in western Tibetan monasteries that are from the same period and of excellent quality, it is difficult to accept his theory that these are the earliest tentative attempts by faltering artists of the region. It is more probable that such bronzes were made in or near a small monastery that had neither the material nor the creative resources of the more important artistic centers. In other words, they are the products of a provincial atelier in some remote region of western Tibet or Nepal that cannot yet be identified.

Bodhisattva Manjusri
Western or central Tibet, 13th century
Brass
11 in. (27.9 cm.)
Gift of Doris and Ed Wiener
M.78.136
See plate 37

The bodhisattva Manjusri is seated gracefully on the pericarp of a lotus in full bloom, and his body seems to sway like the sinuous stem of the lotus he holds. The extended left foot rests on a smaller lotus attached by a stem to the base of the large flower. Although he wears a plain dhoti, the bodhisattva is adorned with a profusion of jewelry. His matted hair is set off by a tiara tied with strings whose ends project prominently above both his ears. An oval beauty mark adorns his forehead like a third eye. A sash, broken on the left, goes around his back and overhangs his raised right arm in which he brandishes a sword. His left hand holds the stems of a lotus which supports a manuscript. (*See* S4 for the explanation of these attributes.) From behind his right thigh, a whimsical stylized lion, Manjusri's mount, looks up with a grin at his divine master.

A comparison with the early Pala-Tibetan paintings (**P1–P3**) reveals the stylistic affiliation of this bronze. Although such bronzes have indiscriminately been given a western Tibetan attribution, they could have been made for monasteries in central Tibet as well, as indeed two of the paintings were. It is clear that these bronzes reflect a style derived from Pala rather than from Kashmir. Although given a distinctive, local expression, and more attenuated than Pala figures, the exaggerated sway of the postures, the sinuous modeling of the body, and the strong emphasis on asymmetry, with a pronounced inclination of the head, are features ultimately derived from the late Pala (11th–12th century) styles. Rather than growing organically from the body, the legs appear to be grafted on as separate appendages. The forms and shapes of the ornaments are also different from those on Pala bronzes and are more akin to those seen in the Pala-Tibetan paintings. The shape of the sword is more Tibetan than Indian, and the elegant, distinctive design of its handle is especially noteworthy. The content, as well as the soft, pale yellow color of this bronze, also distinguish it from its Pala models.

Shadakshari Lokesvara
Western Tibet, early 16th century
Brass with semiprecious stones and paint
10½ in. (26.7 cm.)
Julian Wright Bequest
M.79.152.106

In this form Bodhisattva Avalokitesvara is known as Shadakshari, or the Six-Syllabled Lokesvara (P38). The six syllables are *om mani padme hum* and constitute the famous mantra of the bodhisattva that is constantly chanted by devout Tibetans. The mantra is considered so efficacious that it has been carved on numerous rock faces throughout the country. Although bejeweled and crowned, the bodhisattva is represented as a perfectly poised yogi seated in the lotus posture on a lotus base. His half-shut eyes look down at the tip of his nose and his hair is arranged in an ascetic's tall chignon. The fillet that holds the tiara in place flutters rhythmically behind his ears. The principal hands are raised to the chest with the palms enjoined in *namaskaramudra,* the gesture of prayer or greeting. The upper right hand displays the rosary, while the corresponding left hand holds the lotus, the distinctive emblem of this bodhisattva.

A beautifully proportioned figure, its outline is defined with clarity and its facial features, as well as the fingers, are delicately rendered. The crisp and finely chased ornaments still

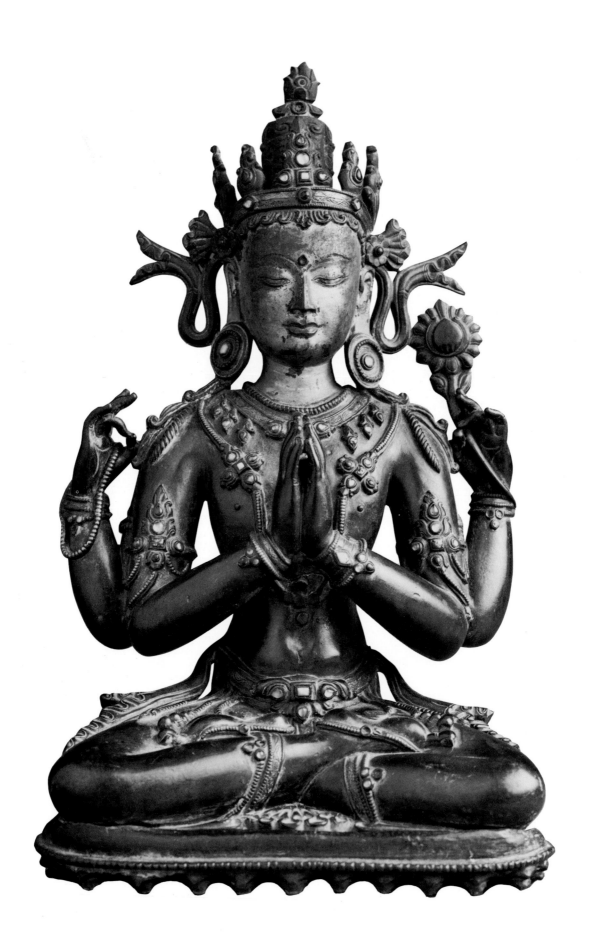

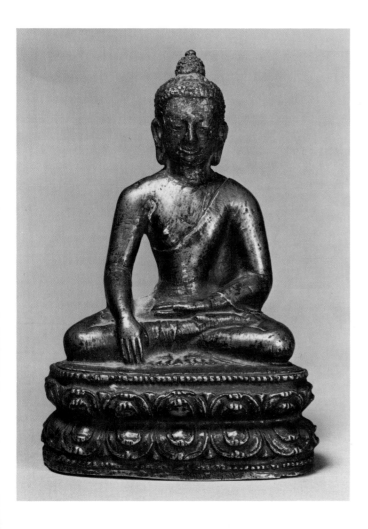

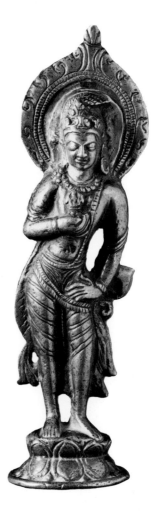

retain some of the semiprecious stones that enliven the surface of this handsome figure. The face and neck are painted in cold gold.

S11

Buddha Sakyamuni
Nepal or Tibet, 11th–12th century
Light bronze with paint
5½ in. (14 cm.)
Gift of Dr. and Mrs. P. Pal in Memory of
Christian Humann
M.81.208

The extremely poor orthography of the brief Tibetan inscription on the back of this bronze makes it difficult to read, but two words seem clear enough. These are *mchog sakya,* which means "the excellent Sakya"; there is no doubt that the figure represents Buddha Sakyamuni. He is seated on a lotus base, the petals of the flower only being indicated on the front and the sides. Sakyamuni's right hand makes the gesture of touching the earth, symbolizing his enlightenment at Bodhgaya. His hair was painted in indigo blue, traces of which still remain; the face was certainly painted in cold gold.

The bronze is strongly Nepali in style and therefore may

have been made in Nepal and taken to Tibet by a pilgrim. In fact, it may even have been made from a matrix for export, with the inscription being incised by a Nepali artist whose knowledge of Tibetan was poor. However, both the inscription and the application of paint clearly indicate that it was used by a Tibetan, though we cannot be certain whether in a monastery in Tibet or in northern Nepal. The style of the bronze is closely related to Nepali images of the eleventh century (cf. Pal 1974, figs. 184, 205).

S12

Bodhisattva Vajrapani
Provenance unknown, 11th–12th century
Copper with traces of paint
6⁹⁄₁₆ in. (17.8 cm.)
Gift of Mr. and Mrs. Michael Phillips
M.81.276.6

Iconographically, this Vajrapani is very similar to another in the collection (S7), but stylistically the two are poles apart. Here, as in S7, Vajrapani holds the thunderbolt against his chest and his left hand rests against his left thigh. Otherwise, the treatment of the garment, the designs of the jewelry and the hairstyle, and, more fundamentally, the modeling of the two figures are ostensibly different.

Several bronzes in this style are now known, and, in fact, two others are stylistically so close (von Schroeder, p. 173, nos. 30D, 30E) that they must be regarded as belonging to the same workshop. In first publishing a similar bronze, I tentatively suggested a western Tibetan origin and wrote that it "may represent rather early Tibetan workmanship, which is not yet mature in technical proficiency but which displays a certain naive and spontaneous charm" (Pal 1969 A, p. 144). Von Schroeder accepts these views and the suggested date and further opines that such bronzes were made with "the simplified method of plaster casting employing reusable matrices" (p. 166). It is more difficult, however, to accept that such bronzes "were quite evidently modeled after early Kashmiri prototypes." Even a cursory comparison with bronzes in this collection which reflect strong Kashmiri styles (S2, S3) reveals that this Vajrapani is quite different. The only element which may have been borrowed from Kashmir is the manner in which the thunderbolt is held against the chest; otherwise, the bronze is much more akin to early Nepali bronzes than to those from Kashmir. For instance, the most distinctive feature of this Vajrapani is his hair, which cascades down the left side of the head in a stylized version of what in an early Nepali bronze is a more graceful swirl of the locks. In fact, there are other similarities as well, such as the placement of the right hand against the chest, the delineation of the design of the dhoti, and the slim, elegant modeling of the figure. Moreover, as is usual with Nepali bronzes, the metal is copper rather than brass. It seems much more cogent, therefore, to consider this a sculpture modeled after a Nepali prototype and cast in a workshop that may have been located in western Nepal, western Tibet, or even southern Tibet.

S13

Bodhisattva Avalokitesvara
Central Tibet (?), 12th–13th century
Gilded bronze
4½ in. (11.4 cm.)
From the Nasli and Alice Heeramaneck
Collection
Museum Associates Purchase
M.72.1.9
Literature: *The Art of India*, no. 52; Pal,
1966, p. 87, fig. 96; von Schroeder,
p. 423, no. 109D.

Balancing himself with his left arm, which would have rested on the now-missing lotus base, Bodhisattva Avalokitesvara is seated in the cross-legged posture. He wears a dhoti printed with a design of squares containing dots and has a matching shawl or scarf that covers his body diagonally across the left shoulder. The dhoti is held by a belt with a plain metal clasp. His other ornaments include bangles, armlets, anklets, a necklace, ear ornaments, and a diadem with three pointed lobes. The ends of the fillet that secures the diadem around his head are spread out fanlike behind both ears. His hair is gathered in a tall chignon and a tiny image of Tathagata Amitabha is included in the central lobe of the crown. With his right hand, Avalokitesvara holds a round object which may represent the fruit *amalaka* (myrobalan), a symbol of knowledge.

This work sheds light on the difficulties encountered in the study of Tibetan sculpture. Whether the bronze was cast in Nepal or made by a Newari artist in Tibet will probably remain unresolved. In a recent publication the bronze was attributed to Tibet with a date of between 1050 and 1150, while a stylistically identical bronze now in the Musée Guimet, Paris, was assigned to Nepal with a tenth-century date. Indeed, these two bronzes are excellent examples of the eclectic character of Tibetan art, for while the figures are rendered in a Nepali style, the throne back in the Guimet example copies a Pala model. This figure of Avalokitesvara may once have had such a throne. Moreover, the designs of the textile and the necklace are encountered in Kashmiri-style bronzes. Such a mixture of styles was more likely in southern Tibet than in Nepal, which already had a strong artistic tradition and appears to have been little influenced by Pala or Kashmiri sculptures. The abstract modeling of the bodhisattva's body and the soft and gentle expression of the face are clearly Nepali traits. But the pinched waist on his right contrasting with the almost rigid contour on his left, as well as the narrow eyes and slightly puffed face, which reflect a more Mongoloid ethnic type, are features that indicate a Tibetan origin. As I wrote in 1966, "Probably cast in western Tibet, this piece shows the intermingling of many influences." I would now suggest changing the word western to central; but, considering the minor Kashmiri traits, a western Tibetan attribution cannot be altogether ruled out.

S14

A Bodhisattva
Central Tibet, 13th–14th century
Wood, gold, and paint
13 in. (33 cm.)
Museum Associates Purchase
M.75.67

This bodhisattva stands in slight contrapposto on a simple wooden base. His broad shoulders rest on a rather slim torso with a narrow waist, but his arms and legs are somewhat thickset. The dhoti he wears is held by a clasped belt and its folds cascade between his legs. The only other adornments are a pair of substantial ear ornaments and a tall, impressive crown with the image of a tathagata in the central panel. The bodhisattva's matted hair bulges out on either side of the crown in an unusual arrangement. The figure's arm is outstretched along the body, the hand forming the gesture of charity; the left hand rests against the thigh.

Normally there would be no hesitation about identifying the figure as the bodhisattva Avalokitesvara; but there is no indication of the lotus, his ubiquitous symbol. Also, the Buddha in his crown is not Avalokitesvara's spiritual father, Amitabha, who is generally shown seated with his hands in the *dhyanamudra*. Here, the Buddha is standing and the gesture of the right hand implies that he is Tathagata Ratnasambhava. Thus, although an exact identification cannot be made, the fact that he represents a bodhisattva is certain.

The body, crown, and face have been painted in gold, the face perhaps more recently than the rest of the sculpture. The eyes and eyebrows are realistically painted, while the hair has been indifferently colored in black. In fact, where the black pigment has peeled off one can see the rather finely carved lines of hair. At least two other wood sculptures and an ivory in this style are known (Kramrisch 1964, p. 143; *Oriental Art,* n.s. xx [1974], p. 457). The ivory is remarkably similar to the present example, and the entire group reflects a strongly Nepali style, though there are differences. While the stylish delineation of the sash across the thighs is almost a hallmark of Nepali representations of bodhisattvas, neither the distinctive hairstyle nor

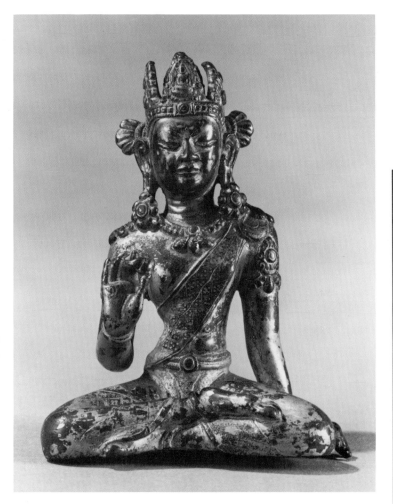

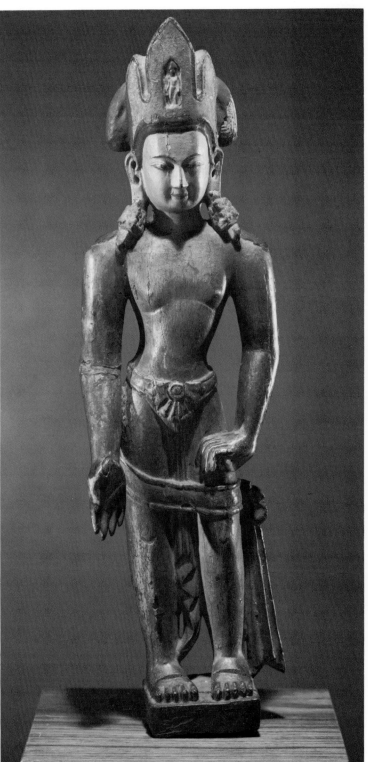

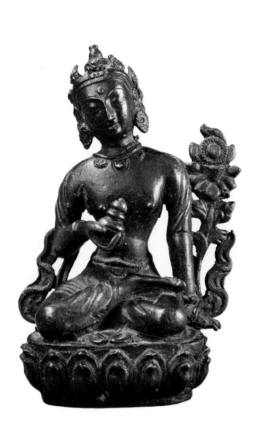

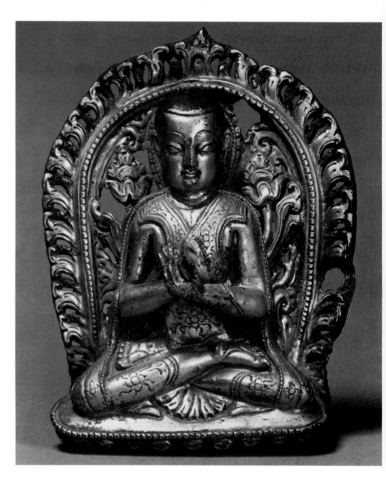

the design of the crown is encountered in the numerous stone and bronze images known to be from Nepal.

S15

A Bodhisattva
Central Tibet, 16th century
Dark bronze
3⅝ in. (9.2 cm.)
From the Nasli and Alice Heeramaneck
Collection
Museum Associates Purchase
M.75.4.12
Literature: Pal, 1966, p. 77, no. 75.

Although seated in a yogic posture, this bodhisattva seems relaxed. He balances himself with his left hand on a seat formed of a single lotus with two rows of petals, both of which point upward. The hair is matted on top of his head and his tiara is modest. Large earrings, a simple necklace, and plain bangles constitute his other ornaments. He wears a plain dhoti and a scarf hangs loosely around the arms. A fillet is tied around the head, its undulating ends almost hidden behind his ears, and in the middle of his forehead is a raised dot marking the *urna*. The attribute in his right hand cannot be identified, but with

his left he holds the stalk of a lotus on which is a circular object. On the assumption that this may represent a wheel, the figure was tentatively identified as Bodhisattva Samatabahadra in a previous publication (*see* reference above). The object may well be a flower, however, in which case the figure depicts some other bodhisattva.

The style of the figure is as enigmatic as its iconography. The body is curiously modeled, with the chest thrust forward and stomach pulled in. The flying ends of the scarf, as well as the stalk of the lotus and its leaves, are rendered in a perfunctory manner. The face, however, is nicely executed, its gentle expression enhanced by the slight trace of a smile.

S16

A Sakyapa Abbot
Central Tibet (Sakyapa monastery),
16th century
Gilt-bronze repoussé with paint
5½ in. (14 cm.)
Gift of Dr. and Mrs. P. Pal in Memory of
Christian Humann
M.81.183.2

Two Flanges from a Shrine or Throne

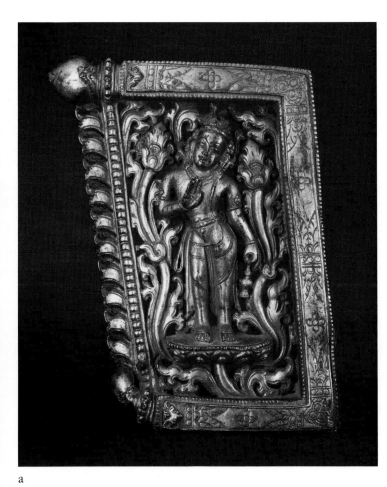

a

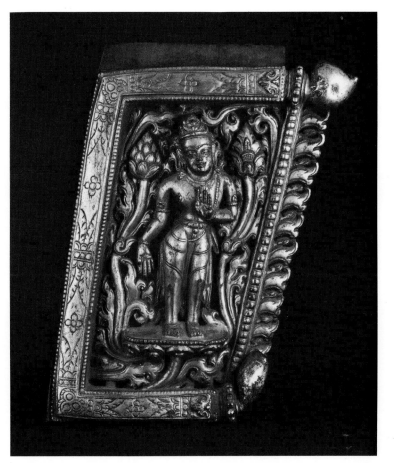

b

A Sakyapa abbot with his hair painted black is seated in the cross-legged posture on a lotus. Both his undervest and his robe are decorated with incised floral designs. His hands form the gesture of turning the Wheel of Law. The figure is set off by an aureole adorned with two pierced lotuses, foliage on the inside, and the flame motif on the outside.

The small but handsome repoussé plaque may have encased a terracotta image of a Sakyapa abbot. Shrines and altars containing portraits of the important teachers are common in most Tibetan monasteries, and such statues were often made from clay and covered with gilt-bronze repoussé plaques such as this. Although gilded, the plaque was originally painted, for traces of red pigment are still attached to the crevices.

S17

Two Flanges from a Shrine or Throne
Central Tibet, 16th–17th century
Gilt-copper repoussé
Each: 8 x 6 in. (20.3 x 15.2 cm.)
Gift of Dr. and Mrs. P. Pal
M.78.106.2–3

These two flanges probably formed parts of a small shrine or a throne back. Each flange shows a bodhisattva standing,

with a slight thrust of the hip, on a lotus. One hand of each is raised to the chest in the gesture of reassurance. With the other hand, one holds the ascetic's *kundika* (water pot) and the other displays the gesture of charity. Thus, the pot-holding figure is Maitreya and the other is Avalokitesvara. Both bodhisattvas are surrounded by flowering stems and rich foliage that rise from the lotus on which they stand. The frames around them have a bead-and-flame border on one side and a band incised with floral and geometrical patterns on the other three sides.

A comparison with the throne back (S18) as well as the Sakyapa abbot portrait (S16) makes it clear that these flanges reflect the same stylistic tradition and may even have originated in the same workshop. Similar thrones with images are common in Sakyapa monasteries of central Tibet, as may be seen from photographs of altars in various publications.

S18

Throne Back
Central Tibet, 17th–18th century
Gilt-copper repoussé with paint
12 x 9½ in. (30.5 x 24.1 cm.)
Gift of Professor and Mrs. Thomas
Ballinger
M.80.97.2

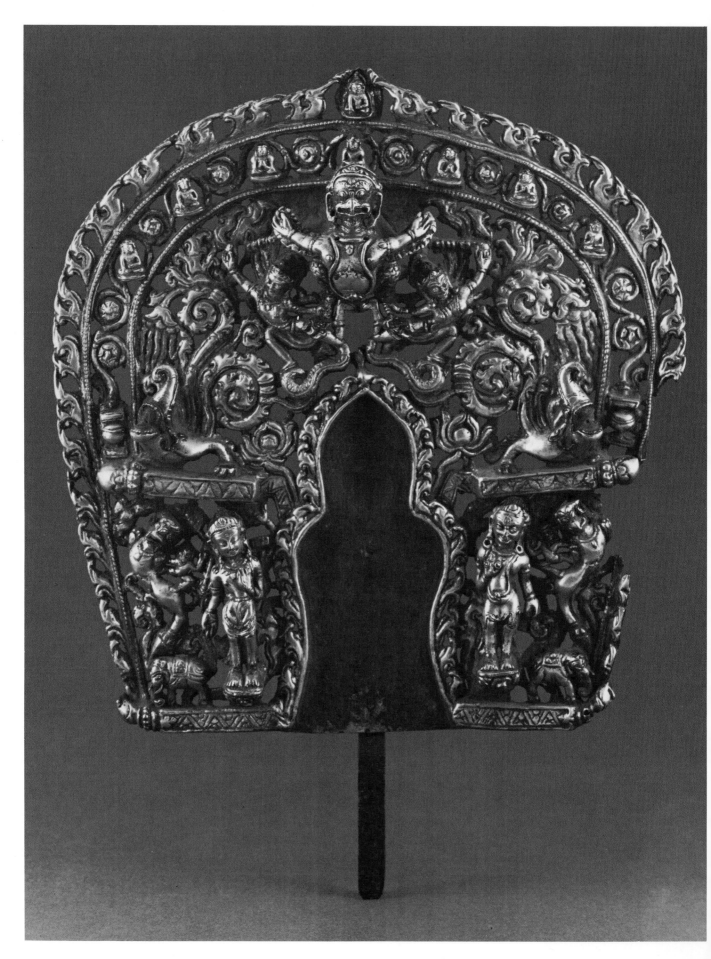

This richly gilded repoussé plaque very likely once served as a throne back for an image of a bodhisattva. The figure was probably standing, as indicated by the shape of the aureole with a flame border. On either side two bodhisattvas stand awkwardly —each on a lotus. That on the right of the empty aureole is Manjusri, who holds a lotus bearing a sword; on the other side Vajrapani holds the thunderbolt against his chest with his right hand. Each bodhisattva is flanked by the traditional *gajasimha* motif, in which a lion or a griffin triumphs over an elephant. At the base of the arch on either side are two *makaras,* and above the arch is the combined motif of a *garuda* triumphing over two serpents and two jewel-carrying flying figures. The remaining space of the arch is occupied by the foliate, meandering tails of the *makaras.* A narrow border around the arch shows a flowering vine rising at both ends from two auspicious vases. Tiny images of the five tathagatas and of two Tibetan monks are attached to the vine. The outside border is decorated with flames symbolizing the fire of knowledge, and at the summit is a tiny figure of a Buddha, perhaps Sakyamuni himself. The five tathagatas on the inside border appear to be crowned; thus, the image probably was used for a Yogatantra ritual.

Such pierced and repoussé metalwork is a specialty of the Newari artists of Nepal, but that this piece was meant for a Tibetan patron is evident from the two lamas, probably of the Sakyapa sect, included in the inner border of the arch. The piece was very likely made by a Newari or Uray craftsman in the Gyantse region for a Sakyapa monastery. The exuberance of the design has been made less powerful by cutting away the spaces around the decorative motifs. As a result, the motifs are not only better articulated, but the whole object also appears light and lively.

S19

Cosmic Form of Avalokitesvara
Western Nepal, 19th century
Silver, cast, and repoussé
6¾ in. (17.1 cm.)
Gift of Dr. Ronald M. Lawrence
M.74.139.11

Avalokitesvara is represented here in his cosmic manifestation, with eleven heads and one thousand arms. The basic image is of the eleven-headed and eight-armed form (*see* P43); this is evident from the fact that eight of the arms are given greater prominence while the remaining ones are distributed on either side to form a mandala. These arms are sometimes marked with eyes, but generally they hold no attributes. The eleventh head at the summit is that of his parent tathagata, Amitabha. While the tenth head is terrifying, all the others are placid and benign as is usual in such images. The principal pair of hands is held against the chest in the gesture of adoration while the two uppermost hands hold the rosary and the lotus. These four hands thus represent the aspect of the bodhisattva known as Shadakshari (S20). The other four hands display the jewel and the gesture of charity on the right and the pot and the bow and arrow on the left. His dress and long flowing scarf are rendered in the Chinese manner. That part of the plaque's surface not occupied by the figure is etched with a flowering plant motif.

Although acquired in a Lamaist monastery in northwestern Nepal near the Tibetan border, this sculpture is very likely of Tibetan origin. Certainly the style of the figure, especially of the dress and the exuberant scarfs, is more akin to nineteenth-

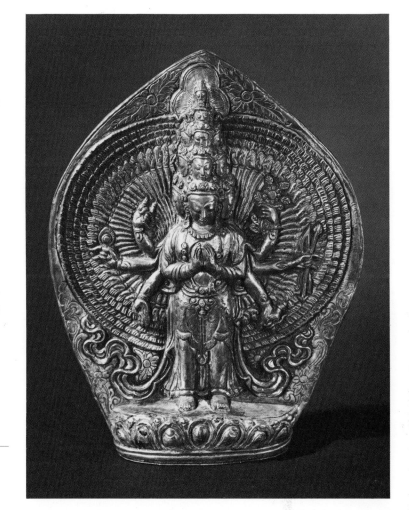

S19

Cosmic Form of Avalokitesvara

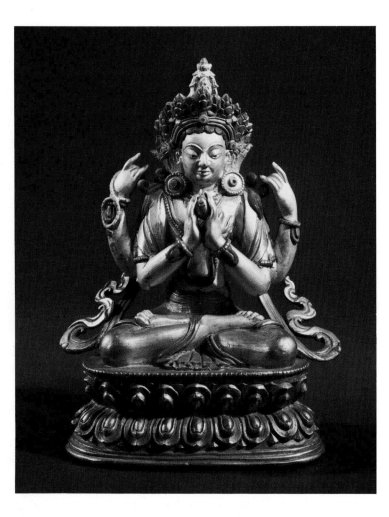

century bronzes from central and eastern Tibet than to those from the contemporary Kathmandu Valley. The plaque was probably meant for a traveling shrine.

Shadakshari Lokesvara
Eastern Tibet, 19th century
Bronze with polychrome
6¾ in. (17.1 cm.)
Gift of Mr. and Mrs. Harry Lenart
M.76.70

Iconographically, this bronze is similar to the earlier example from western Tibet (S10) with only minor differences. The lotus, originally held by the upper left hand, is now missing. The principal hands hold a round object and form the gesture of adoration (*namaskaramudra* or *kritanjalimudra*). This object may well symbolize the fruit *amalaka,* regarded as a symbol of knowledge. The design of the crown, the swirling scarf, and the subtle, naturalistic modeling of the legs indicate an eastern Tibetan origin for the bronze, although the model may have been a Nepali figure. The bronze is heavily painted with silver and other colors, and although not very distinguished, it shows how brightly such bronzes were once painted.

S21

Dorje Phurpa
Western Tibet (Nyingmapa monastery),
12th century
Brass with traces of paint
13⅜ in. (33.5 cm.)
From the Nasli and Alice Heeramaneck
Collection
Museum Associates Purchase
M.70.1.6
Literature: *Dieux et démons,* pp. 183–84,
no. 198.

Dorje Phurpa is literally the deification of the ritual dagger, or *phurpa* (R6, **R7**), and appears to be a creation of Tibetan Buddhism. He is usually represented as a combination of an anthropomorphic multiheaded figure and the blade of the *phurpa,* but he also has a special form in which the lower part of the body does not consist of the blade. Instead, as in this sculpture, he tramples the two Rudras (forms of Siva) with his four legs. His cult is most prevalent among the Nyingmapas, but he is also worshiped by other sects.

According to the Nyingmapa tradition, Dorje Phurpa is a supramundane deity of karma, or function, and is also known as Vajrakumara, or the "diamond youth." With his two principal hands he rolls the *phurpa* between his palms—an ancient Tibetan method of casting a curse upon an enemy. That this was very likely a pre-Buddhist practice is indicated by the following mantra, used by the Kagyupas in some of their religious ceremonies:

> *Accept this with a willing mind and avert,*
> *turn back the strength of the magicians*
> *who roll the magic dagger between their palms,*
> *who fling white mustard seed as magic,*
> *who cast their magic weapons, who prepare*
> *for destructive magic* [Beyer].

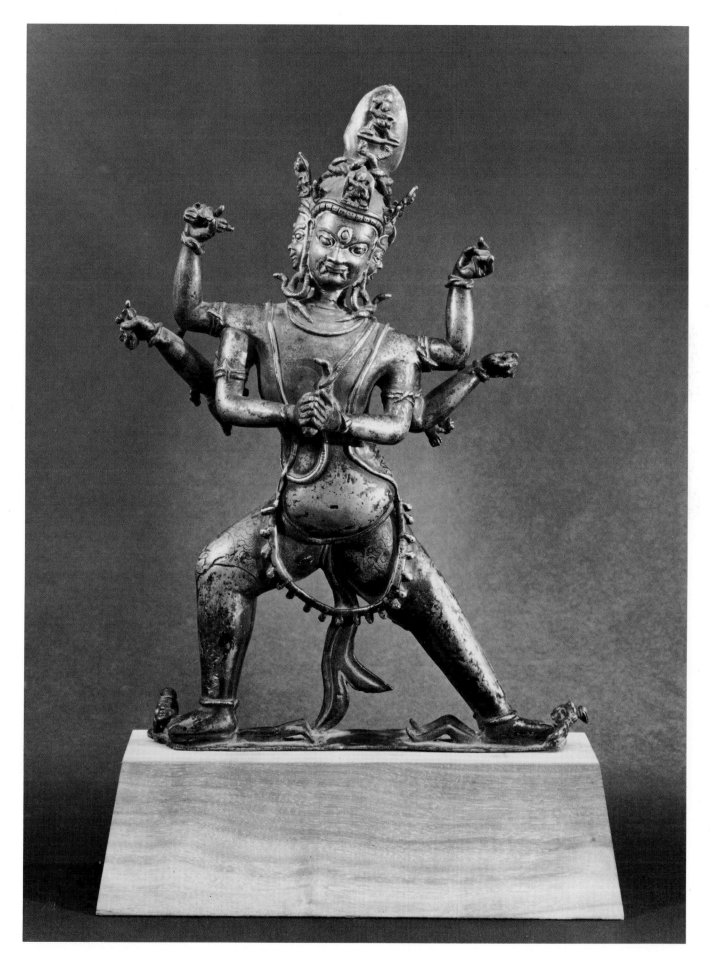

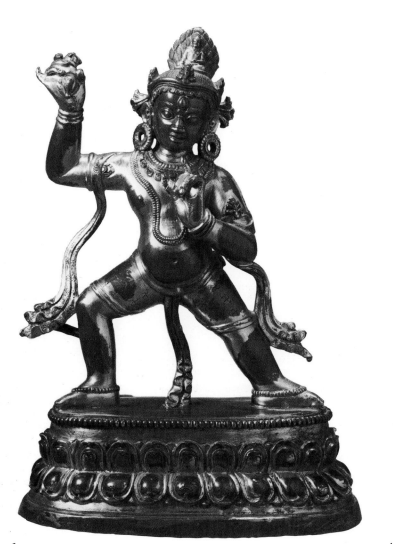

front

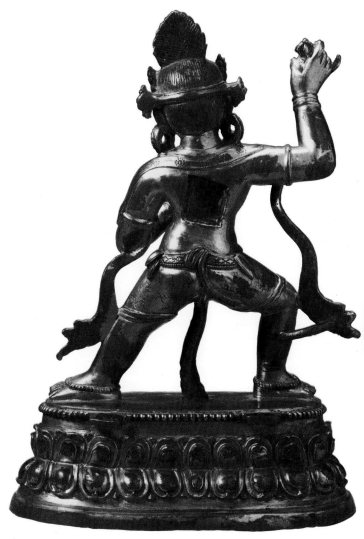

back

The upper one of his two other right hands holds the nine-pronged thunderbolt, while the lower holds the five-pronged thunderbolt. The objects held by the analogous left hands are now missing. Two holes on two of the arms at the back indicate that wings, characteristic of Dorje Phurpa, were once separately attached.

An animal skin, probably of a tiger, serves as Dorje Phurpa's loincloth in this piece, while another, perhaps that of an elephant, once served as his cloak. But for a garland of skulls, all his ornaments are formed with snakes, which indeed are his most prominent attribute. Each of his four faces is embellished with rows of skulls above the forehead and, although all the faces are terrifying, only the one in front is given fangs. The third eye on this face is also more clearly delineated than those in the others, and two tridents project like horns from the front head only. Five other small, squat, militant figures, brandishing different weapons are added on the four sides of the head and on the chignon that projects like a crown from the center of the cranium.

As frequently occurs in western Tibetan bronzes, the back of this sculpture has been crudely rendered. The back also appears to have been damaged at some time. Both the propor-

tions of the figure and the modeling are quite distinctive and represent a figurative type seen neither in Indian nor Nepali sculptures. The contrived way the arms have been grafted to the shoulders and to each other is also unusual. Generally, arms are disposed in a more naturalistic manner, but here they appear like mechanical appendages. This type of treatment of the arms is occasionally encountered in other bronzes and very likely reflects the peculiarity of a particular atelier.

S22

Bodhisattva Vajrapani
Central Tibet, 13th century
Gilt bronze
10 in. (25.4 cm.)
Gift of Marilyn Walter Grounds
M.81.272.1
Literature: P. Pal, "Indian Art from the Paul Walter Collection," *Allen Memorial Art Museum Bulletin,* vol. XXVIII, no. 2 (1971), pp. 100–101; Pal, 1975, pp. 44, 77; *Dieux et démons,* pp. 120–21, no. 93.

Bodhisattva Vajrapani (S7, S12) is shown here in one of his several angry manifestations. In such forms he is represented in the *vajravidarana* body, the body which shatters all impediments. The *Vajravidāraṇa-nāma-dhāraṇī* states that the four divine guardians once complained to the Buddha that wickedness in the world was triumphing over good. The Buddha requested Vajrapani to devise a means to protect the pure-minded, and it was then that Vajrapani assumed his impediment-shattering body.

Appropriately, then, the bodhisattva of this bronze stands on a lotus with his legs set widely, belligerently, apart. He is plump, his belly overhanging a short dhoti marked with swastikas. His scarf, which complements the center folds of his dhoti, sways in a serpentine manner on either side of him, enhancing the sense of action. He is given various ornaments, and his chignon spreads like a fan above his head to form an aureole for Tathagata Akshobhya, to whose family he belongs. Vajrapani is given a third eye, and, except for the wrinkled eyebrows, his expression is not so mendacious as those usually given to other angry deities. With his left hand he forms the gesture of admonition *(tarjanimudra)*, as if warning the wicked that he will indeed hurl the thunderbolt, held by his right hand, unless the mischief is stopped.

This handsome sculpture is a good example with which to demonstrate the difficulty of suggesting an exact provenance for such bronzes. It could have been made in Nepal or in Tibet. The back of the bronze has a square hole into which some relics were inserted at the time it was created. Since this practice was more customary in Tibet than in Nepal, this can be considered a Tibetan bronze. The dark brown color of the solidly cast bronze underneath the gilding also points to a Tibetan origin.

S23

Vajrapani in Yab-Yum
Central Tibet, 15th century
Gilt bronze with paint
11 in. (27.9 cm.)
From the Nasli and Alice Heeramaneck
Collection
Museum Associates Purchase
M.82.42.6
Literature: Pal, 1969 A, pp. 99, 150.
See plate 38

The male represents the angry form of Bodhisattva Vajrapani, who is shown here in *yab-yum* with his prajna. He stands militantly with his legs apart, trampling two figures symbolizing evil. An animal skin is wrapped around his waist, but his partner is naked. Her right leg is stretched parallel to his left, and her other leg encircles his waist. He has three heads and six arms, while she has one head and two arms; the faces of both, however, are fierce, have the third eye, and are made more expressive with cold gold paint and colors. Two of his hands hold snakes, which attack the prostrate figures below, and a third holds the thunderbolt. The remaining hands display the gestures of reassurance, admonition, and charity. The tiara on each of his four heads is adorned with skulls, and the hair, painted red, is formed into a common chignon crowned with the thunderbolt.

Although the oval lotus base is not completed at the back, the figures are modeled in the round. Both figures convey a robust sense of volume with thick, solid limbs revealing subtle

S23

Vajrapani in Yab-Yum
See plate 38

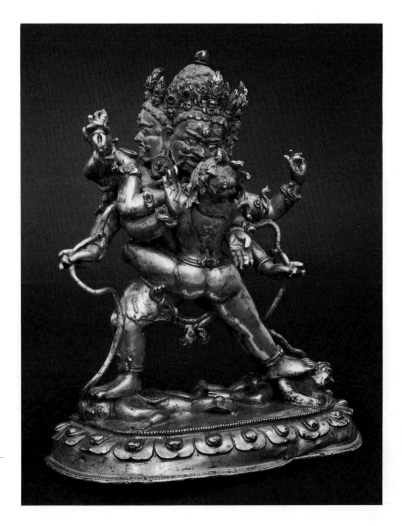

An Unusual Form of Mahakala (?)
See plate 39

Goddess Nairatmya
See plate 40

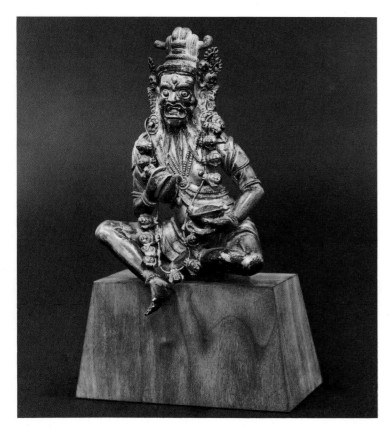

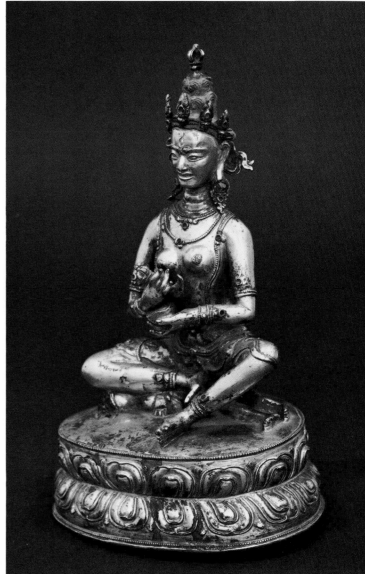

transitions from one area of the body to another. While the sculptor's principal emphasis was on expressing a sense of essential massiveness that stands resolutely in space, he was equally interested in delineating details. The fingers of the hands are delicately rendered, while the expressive faces exhibit features that are precisely articulated and modeled with sensitivity.

S24

An Unusual Form of Mahakala (?)
Central Tibet (Sakyapa monastery),
16th century
Silver with turquoises and paint
6¼ in. (15.9 cm.)
From the Nasli and Alice Heeramaneck
Collection
Purchased with Funds Provided by the
Jane and Justin Dart Foundation
M.81.90.19
Literature: *Dieux et démons,* pp. 50, 183.
See plate 39

Wearing a loincloth and a shawl across his shoulders, an angry ascetic figure is seated with a chopper in his right hand and a blood-filled skullcup in his left hand. He is adorned with bangles and anklets of beads, earrings set with turquoises, a garland of severed heads, and the crossed belts typical of ascetics and mahasiddhas. A band with four skulls is tied above his head and his hair is matted around a human bone. The inside of his wide-open mouth, displaying his tongue and teeth, is painted red. Large rolling eyes and long strands of beard enhance his terrifying appearance.

In a previous publication (*see* reference above) it was suggested that the figure represents a particular form of Mahakala known as *Gur kyang rNgog lugs.* The worship of this form was introduced by the monk-translator Ngok Lotsawa, who appears to have envisioned the god in a human guise. As Nebesky-Wojkowitz (p. 52) writes:

> His angry face has three eyes. Blood drips from his open mouth, in which the bare fangs are visible. His attributes are a chopper and a skullcup. He stands on a corpse and wears the usual adornments of the wrathful *dharmapalas.*

Although a number of the above features are present in this figure, there are noteworthy differences as well. He is not shown standing, does not wear the usual adornments of a wrathful dharmapala, and his hairstyle is that of an ascetic. However, the third eye makes this figure a god rather than a human teacher and thus, despite the differences, the identification with Mahakala must for the present be accepted.

Born in 1059, Ngok Lotsawa was associated with the Sangphu monastery, founded in 1073, which became one of the principal Kadampa centers for the study of the *Prajnaparamita.* It was common for important lamas and mystics to envision particular forms of deities or to see them in dreams, and, subsequently, such images became part of the pantheon. This particular example may have been commissioned by a lama who considered himself an emanation of the *lotsawa.*

It is difficult to determine the exact age and provenance of this remarkably powerful and expressive image. The face seems alive, the painted mouth so realistically rendered that one gets the impression that he has just taken a swig of blood from his skullcup. The slim, taut body is modeled with subtle naturalism and the details, of both the face and the ornaments, are delineated with great precision. The back appears to have been damaged or broken open, perhaps in search of relics, but the repair seems to be old. The closest stylistic parallels for this sculpture may be seen in the frescoes of the main temple at Gyantse; hence, the central Tibetan attribution. Apart from the fact that in terms of both style and iconography this is an unusual statue, it is also one of the finest examples of Tibetan metal sculpture.

S25

Goddess Nairatmya
Central Tibet, 16th century
Gilt copper inlaid with turquoise; paint
9¼ in. (23.5 cm.)
From the Nasli and Alice Heeramaneck
Collection
Museum Associates Purchase
M.70.1.4
Literature: Pal, 1969 A, no. 61 and p. 149;
Pal, 1974, p. 38, fig. 15; *Dieux et démons,*
pp. 149–51, no. 147; von Schroeder,
p. 446, no. 121F.
See plate 40

The goddess is seated on the back of a corpse set on a fully open lotus. Her right leg is folded parallel to the body, but the other is slightly raised and placed forward. She wears an animal skin and is profusely ornamented with several tiers of necklaces, anklets, armlets, bracelets, earrings, and a tiara. All this jewelry was once encrusted with stones which now, except for a few remaining turquoises, are missing. Her forehead is marked with a third eye and her hair, painted red, is matted in a pyramidal fashion and crowned with a thunderbolt. Her right hand holds a chopper, her left a skullcup filled with blood.

These attributes, her scowling face, and the third eye lead to identification as Nairatmya, or Nairatma (No-Soul), who is the prajna, or partner, of Hevajra, the presiding deity of the *Hevajratantra,* one of the most important texts of Vajrayana Buddhism. However, the same attributes may be held by other goddesses. Moreover, Nairatmya is usually shown embracing her partner, or when alone, as a dancing figure like the Vajravarahi in the collection (S26). Thus, if this indeed is a representation of the goddess, it remains a unique example.

Aesthetically, as well, the bronze is unusual and one of the finest in the collection. But for her face she is an attractive and elegant figure. Her long legs, slim torso, and long face make her proportions unique. The full, firm breasts are well formed, and curiously, instead of the nipple, the artist has delineated a perforated circle reminiscent of the heart or pericarp of a lotus. The lotus is not an uncommon metaphor in the Indo-Tibetan literary tradition for various parts of the female anatomy. Although she sits in a relaxed posture—note how naturalistically the left foot rests on the side and how she seems to be wiggling the big toe—hers is a stately and graceful figure with a majestic presence.

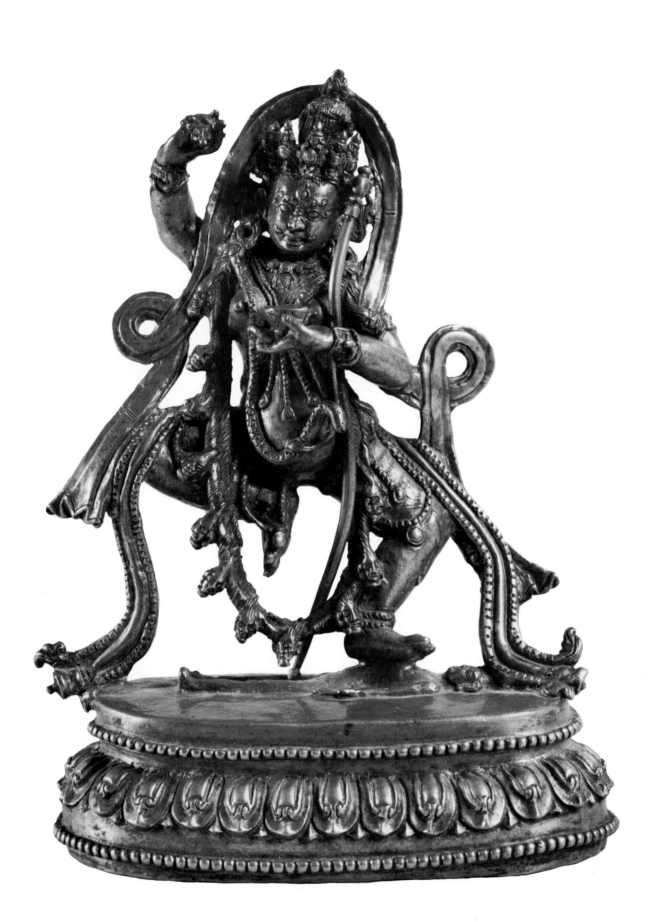

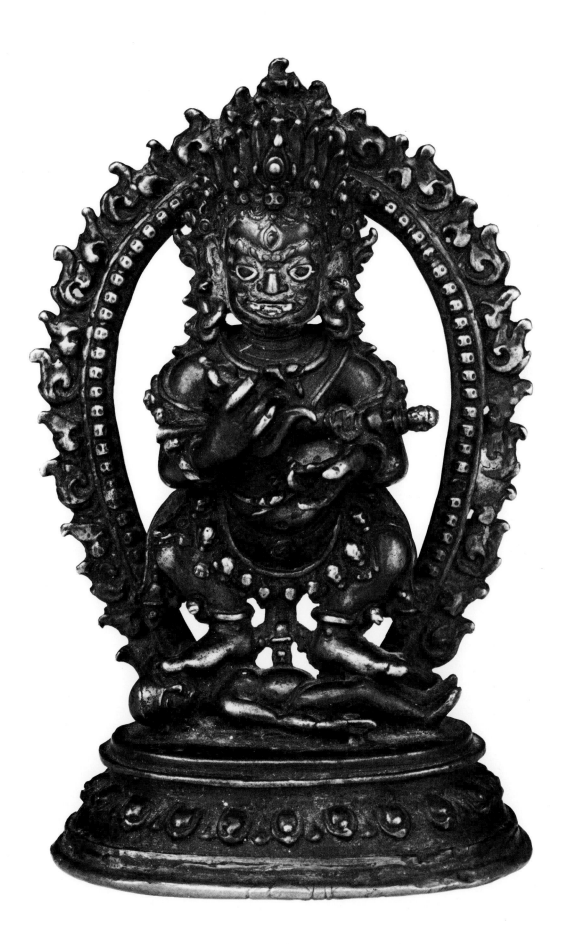

Goddess Vajravarahi
Central Tibet, 17th century
Bronze with traces of gilding
6½ in. (16.5 cm.)
Gift of Paul F. Walter
M.74.106.1

Vajravarahi, or the Adamantine Sow, is the consort of
Cakrasamvara, the presiding deity of the *Samvaratantra*. Except
for the sow's head projecting as an excrescence above her right
ear, she is no different from the goddess Nairatmya, Hevajra's
spouse (S25). Vajravarahi is the tutelary goddess of the nunnery
of Semding, where every abbess is considered to be her ema-
nation. She is also a very important goddess for the Drukpas,
a subsect of the Kagyupas, who perform a special ritual for her
every year on the twentieth day of the sixth month.

Her left foot set on the stomach of a prostrate male,
Vajravarahi dances with her right leg raised. Although an animal
skin wraps her hips and thighs, she appears naked. Apart from
various jewelry and a tiara, she wears a garland of severed hu-
man heads; a snake encircles her body and rears its head against
her ample belly. Two chains, one with a bell and the other, pos-
sibly with an animal head, come down her thighs like two ser-
pents. Even livelier is the delineation of the scarf which swirls
on either side of her body and forms a sort of halo around her
head. With her right hand she brandishes a chopper and with
her left a skullcup. A *khatvanga* (skull-crowned magic staff),
also sinewy like her other appendages, is held against her body
by her left arm.

Mahakala
Central Tibet (Sakyapa monastery),
17th century
Copper with traces of gilt and paint
4⅛ in. (10.5 cm.)
Gift of Dale Crawford
M.79.184

Mahakala, framed by a ring of fire representing the
cremation ground, as well as the phenomenal world that is his
habitat, stands, knees bent, on a *preta* (ghost) stretched on a
lotus base. Plump and dwarfish, he has a terrifying, masklike
face—dominated by his third eye—and a crown of flying hair.
He wears an animal skin and his ornaments include a garland of
skulls and several snakes. With his principal hands, he holds the
chopper and the skullcup; he cuts up all disbelievers with the
chopper, then drinks their blood from the skullcup. Across his
arms rests a staff crowned with a severed head, a representation
particular to Tibet.

The patron deity of the Sakyapas, Mahakala is the Bud-
dhist version of the Hindus' Bhairava, the angry form of Siva. In
this manifestation, he is known in Tibet as Gur gyi mGon po,
or Lord of the Tent. Apart from the staff, the only other pecu-
liarity of Tibetan representation is that the deity is always de-
picted with his knees bent, as if about to rise. This posture is
described in the *Sadhanamala*; Mahakala is said to be rising
from the body of the ghost (*pretasanastham utthitham*) on which
he was apparently seated in yogic meditation. Evidently, only
Tibetan artists followed this prescription literally, for in Nepal
and India he is always shown fully erect.

Vajrabhairava in Yab-Yum
Central Tibet (Gelukpa monastery),
17th century
Dark brown bronze with paint
9½ in. (24.1 cm.)
Gift of Christian Humann
M.76.143
Literature: Fisher, pp. 24, 43; Pal, 1982
A, p. 37.
See plate 41

One of the most powerful *yidams* (protective deities),
especially of the Gelukpa order, Vajrabhairava (*see* **P12**) is shown
here in physical union with his prajna. While he has multiple
arms and heads (one of the latter of which is that of a buffalo),
she is depicted with only one head and two arms. Both, how-
ever, stand belligerently, their legs (only one of hers) trampling
upon gods, humans, animals, and birds. Of his nine heads,
seven of which are shown in a circle, only the one at the summit
is placid; this is Manjusri, whose angry emanation Vajrabhairava
represents. Grinning skulls form the tiara of his demonic heads.
His thirty-four arms, spread on either side in a circle, hold a
wide range of weapons and attributes. Holding the chopper and
a skullcup, his prajna flings her arms on either side of his faces
as she looks up at him with passionate intensity.

The symbolism of the various limbs and attributes of
Vajrabhairava is lucidly explained by Tsongkhapa:

> His nine faces point to the ninefold classification of the
> scriptures; his two horns to the two truths (conventional
> and ultimate); his thirty-four arms together with his
> spirituality, communication and embodiment in tangible
> form to the thirty-seven facts of enlightenment; his six-
> teen legs to the sixteen kinds of no-thing-ness . . . etc.
> [Tsong-ka-pa]

Apart from such doctrinaire symbolism, it may be stressed that
Vajrabhairava also represents the cosmic as well as the angry
forms of Manjusri (S9).

Although a god of Indian origin, Vajrabhairava has ac-
quired a special Tibetan flavor. During the New Year festivals
the god is evoked and propitiated according to the Sakyapa
method in special ceremonies performed jointly by both the
Sakyapas and Nyingmapas. Such festivities are a curious admix-
ture of pre-Buddhist military ceremonies, shamanistic dances of
exorcism, and Buddhist rituals.

This is a fine example of the complexity of such sculp-
tural forms and of the exceptional dexterity of Tibetan sculptors.
Cast in several pieces, the bronze was skillfully assembled to
form a coherent and rhythmic composition. The faces of the
figures, too, are adroitly painted to enhance the desired effect.

A Terrifying Deity
Central Tibet (?), 18th century
Elephant bone
6 in. (15.2 cm.)
Indian Art Special Purposes Fund
M.77.6.2

Vajrabhairava in Yab-Yum
See plate 41

A Terrifying Deity

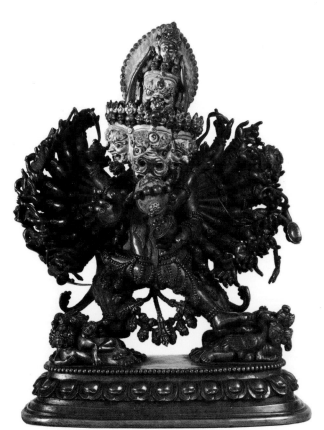

front

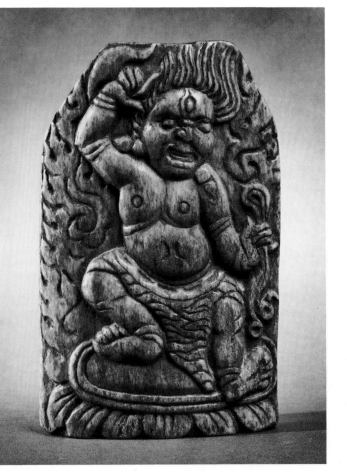

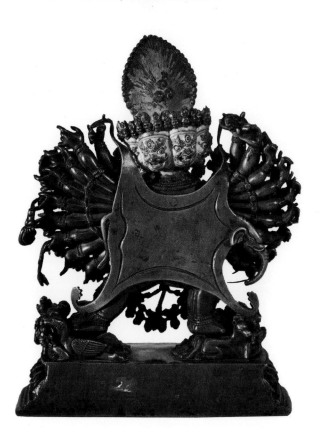

back

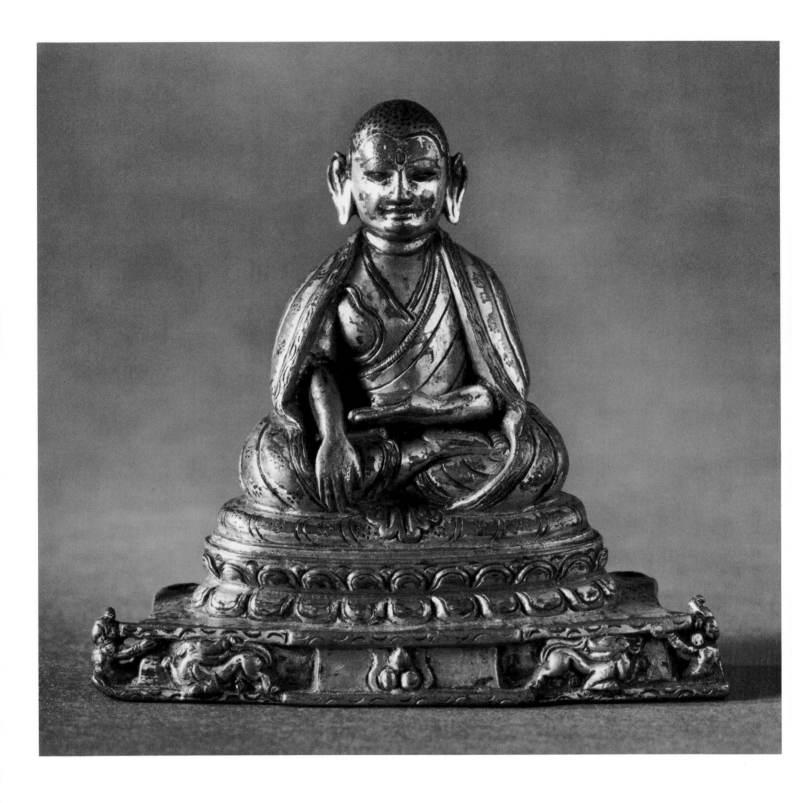

A terrifying deity awkwardly dances on a lotus against a sea of flames. His scowling face is made more menacing by his third eye and flying hair. Clad in a tiger skin and sparsely ornamented, he is plump and heavyset and has disproportionately large feet. With his right hand he brandishes a chopper and with his left he holds a noose. He is one of a host of such terrifying deities populating the Tibetan pantheon; it is not possible to be certain of his identification.

Rather freely rendered and not of great quality, the image is nonetheless a forceful example of a bone carving of impressive proportions. Tibetan bone sculptures are generally much smaller. Despite its somewhat crude workmanship, it provides an idea of the appearance of sculptures on live rock, often seen in Tibet, but rarely encountered outside the country.

S30

Portrait of a Monk
Central Tibet (Sakyapa monastery),
14th century
Gilt bronze with paint
3¼ in. (8.2 cm.)
Gift of Mr. and Mrs. Frank Neustatter
M.76.93.1
Literature: von Schroeder, p. 425, no.
110C.

A monk with a pleasant face, betraying a trace of a smile, is seated in a yogic posture on a lotus atop an unusual base. Its shape, and especially its decoration, are distinctive: in the middle are three gems seen more often as offerings in a thanka than in a bronze; next are two lively lions with their heads turned inward; finally, each of the front corners is supported by a *naga* with a human body who spreads out his arms as if swimming or flying. The monk's body is fully covered by his robes, and his hair is indicated by dots of black paint, as if the roots on his shaven head are about to sprout again. His ears are disproportionately large. A circular mark on the forehead may symbolize his divine status. While his left hand rests on his lap, the other touches the cushion on which he sits. Without an inscription it is impossible to identify the figure, but he very likely belonged to the Sakyapa order.

Although diminutive, the bronze is of considerable interest. The unusual facade of the base, with its lively creatures, is just as fascinating as the distinctive and smiling visage of the monk. The high copper content, as well as the color of the metal below the gilding, are reminiscent of early Nepali bronzes, as is the feeling of gentle elegance the monk imparts. With their outstretched arms, the *nagas* at the corners are very much like the *garudas* that carry Vishnu in tenth- to thirteenth-century Nepali sculptures. Thus, a fourteenth-century date for this charming little bronze is not improbable.

S31

Dampa Sangye
See plate 42

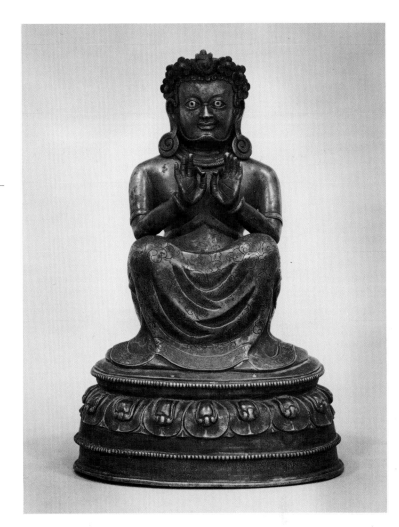

Dampa Sangye
Central Tibet, 1350–1400
Bronze with inlaid copper and silver
8¾ in. (22.2 cm.)
From the Nasli and Alice Heeramaneck
Collection
Museum Associates Purchase
M.70.1.5
Literature: Pal, 1969 A, pp. 110, 154;
Dieux et démons, pp. 155, 156.
See plate 42

According to the inscription around the base (*see* Appendix), this is a portrait of Dampa Sangye, whom the inscription exalts as "Fully accomplished in the two spheres miraculously perfected in two bodies." It was commissioned as a memorial by a lady, perhaps an aunt (also a nun?) of a lama named Palden. As Richardson suggests, Palden may be the Palden Sengge who lived in the fourteenth century.

Although he is known by his Tibetan name, Dampa Sangye (also called Phadampa) was an Indian mystic who came to Tibet shortly after the death of Atisa in the second half of the eleventh century. *The Blue Annals* contains brief accounts of both his legendary and historical lives, and a recently published article (*see* Aziz, pp. 19–37) provides us with the various legends preserved about him in Langkor, where he is a folk hero. Apparently, he settled in the valley of Dingri during the period of his religious activity in Tibet, although he did travel elsewhere in the country and to China. He was a contemporary of Milarepa (S40) and the two are said to have had a magical exchange near the sacred hill of Langkor. He is believed to have introduced the doctrine of Shiche and the practice of the *chö* technique (*see* introduction, *Ritual Objects*). The former emphasizes the essence of the path of Prajnaparamita, while the latter is a meditative technique that leads to "spontaneous detachment from ego."

In this unusual portrait, the eminent teacher is seated on his haunches, his legs completely covered by a lower garment adorned with lightly etched floral designs. His torso is bare, but he wears simple ornaments, except for the prominently rendered spiral earrings with a spiral design. His tiara of floral wreaths is also unique, and his hair, beautifully groomed at the back, rolls down his neck and spreads out in neat curls. The back of the bronze is modeled and chased as elegantly as the front. His hands are raised to chest level and display the gesture of exposition. The silver inlay of his large, staring eyes and his beard give his visage an intensity that is characteristic, like the large earrings, of portraits of great yogis.

It would appear from this idealized portrayal that Dampa Sangye was remembered as a mahasiddha. The depiction is closely related to such early representations of the mahasiddhas as the fifteenth-century murals of Gyantse. Because of its similarity to those murals, I once suggested a fifteenth-century date for this bronze. However, if the person in whose memory this bronze was dedicated is indeed the Palden Sengge of the Sakyapas, the bronze must be dated soon after 1342, the year he died. This date is not inconsistent with the iconography, style, or quality of the bronze. The iconography follows a different tradition than that seen in the later images of Dampa Sangye, while the workmanship seems quite typical of fourteenth- to fifteenth-century bronzes made in central Tibet for Sakyapa monasteries.

Portrait of Karma Dudtsi
Eastern Tibet (Karmapa monastery?),
16th century or earlier
Gilt bronze with paint
11¼ in. (28.6 cm.)
Gift of Christian Humann
M.77.152
Literature: *A Decade of Collecting,* pp. 37, 153–54.

The inscription on the back (*see* Appendix) states that this is the portrait of Karma Dudtsi, and that it was made by his devotees posthumously. He is styled as a *rinpoche,* an honorific title for "reincarnated" high lamas. According to the inscription, the hollow bronze once contained relics of wood, but these have disappeared. The identification of the lama remains uncertain, but his name suggests that he may have belonged to the Karmapa lineage. According to Richardson, he may be the disciple of the eighth Zwa Nagpa Lama who lived in the sixteenth century. However, this seems unlikely since the bronze appears to be stylistically earlier than that.

The lama sits firm and erect in the meditating posture on a base consisting of two cushions covered with a rug. His heavy robes are articulated with opulent folds. His outstretched right hand rests on his right knee, and his left is placed in his lap in the gesture of meditation (*dhyanamudra*).

Although the portrait is hieratic and idealized, the face appears to be realistically rendered; the artist may well have known his subject personally. The features, including the flaring nose, sensitive mouth, and kindly eyes, are expressive of the lama's personality and character. The naturalistic treatment of the robes imparts a sense of impressive grandeur to the figure and makes it gently animated. His hair is indicated with paint. A similar bronze portrait—with a realistic face but otherwise hieratically presented—of the first Karmapa (1110–1193), containing his funerary relics, is preserved in the Rumtek monastery in Sikkim.

It would be unwise to suggest a specific date for this bronze until the figure can be positively identified. In general, however, it seems to relate to fourteenth-fifteenth-century Tibetan representations, such as the Sakyapa portraits (**P13, P15**), rather than to works of the seventeenth century or later. No matter when it was made, it remains one of the most impressive hieratic portraits created in Tibet.

Portrait of Karma Dudtsi

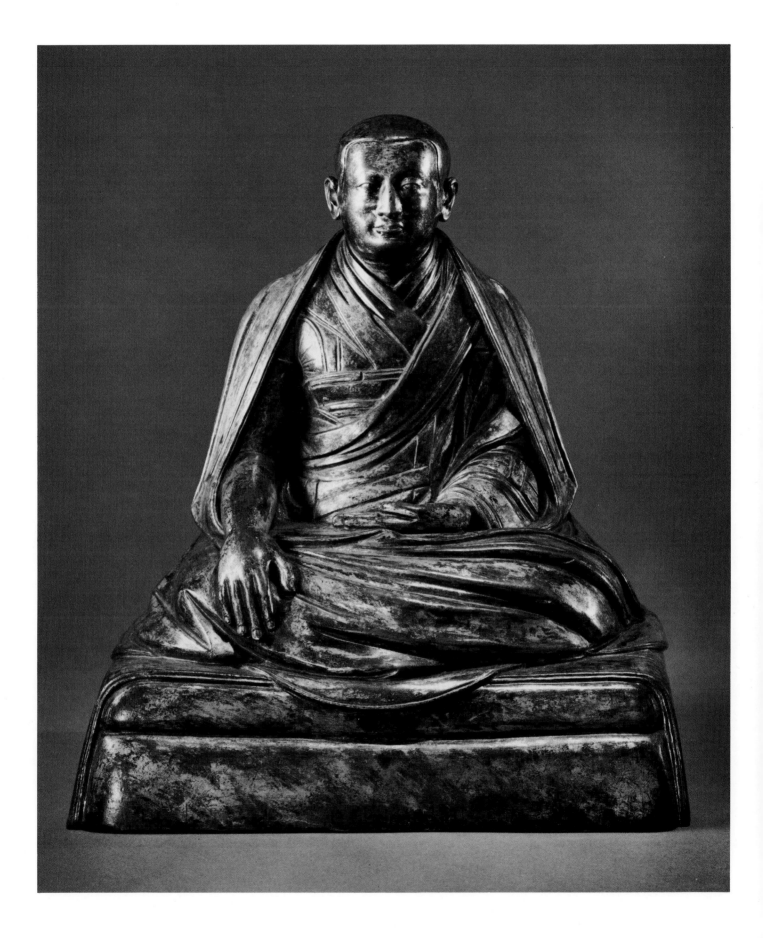

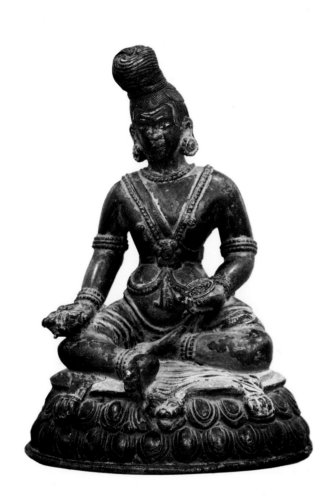

S33

A *Mahasiddha*
Central Tibet, 15th century
Bronze with polychrome
7 in. (17.8 cm.)
From the Nasli and Alice Heeramaneck
Collection
Museum Associates Purchase
M.73.4.14
Literature: Pal, 1969 A, pp. 104, 154.
See plate 43

The mahasiddha is seated on a realistically painted tiger skin spread atop a lotus base. His belly overhangs a short loincloth and his bare torso is adorned with a crossbelt with a floral clasp and a yogic band *(yogapatta)*. All his ornaments simulate berries or beads. His hair is piled high in an ascetic's chignon *(jata)*, of a kind that is still frequently seen on the heads of wandering yogis in India. His right hand holds a thunderbolt, and a skullcup is placed in his left hand.

In a previous publication I suggested that the figure represents the mahasiddha Heruka, also known as Dombi-Heruka or Dombipa. The suggestion was based upon similar images painted on the wall of the Gyantse *kumbum* and identified by an inscription as Heruka. In later Tibetan paintings, however, Heruka is usually shown with a female companion and riding a tiger. This does not negate the identification of this figure as Mahasiddha Heruka, for there appears to be a distinct difference between the early representations of the mahasiddhas and the later pictorial traditions. Most early representations, whether at Gyantse or in thankas, portray the mahasiddhas as Indian yogis, with few distinguishing attributes.

Stylistically, as well, this bronze relates closely to the Gyantse murals which were painted in the fifteenth century. It may also be pointed out that the design of the lotus base is unusual; generally, the flower is shown with a single row of petals, or when with two, one is up and the other down. Here, both rows point down, a feature not usually encountered in bronzes but found in a fragmentary Tibetan mural now in Rome. This mural is said to be from a southern Tibetan monastery and is dated to the fifteenth century.

Whatever the identification or date of the bronze, it is an excellent example of a Tibetan polychromed sculpture. The artist was obviously a keen observer, for he has not only painted the tiger skin realistically but has given the mahasiddha a life-like, expressive face. The snub nose, the trimmed moustache and goatee, the wrinkled forehead, and the pointed eyes impart an individual character to the face—as if it were modeled after a living yogi.

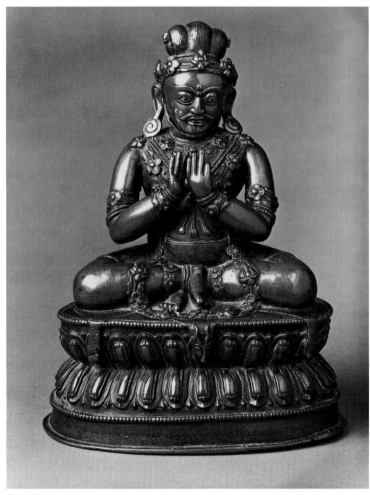

front

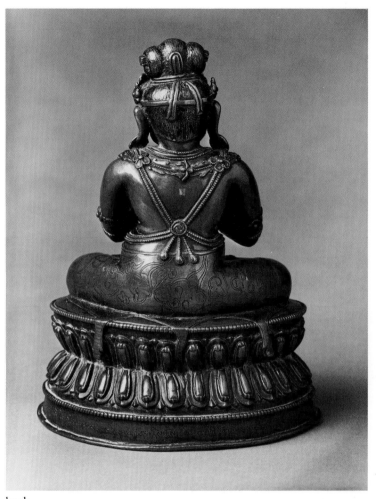

back

S34

Mahasiddha Virupa
Central Tibet, 15th century
Bronze with inlaid silver
8⅞ in. (22.5 cm.)
Gift of Anna C. Walter
M.80.230

The long dedicatory inscription (*see* Appendix) on the base of the bronze provides the usual pious wishes but only the name of one of the two donors, Lama Namkha Shenyen. The other donor, the lama's uncle, is not named. Nothing is known about this lama. He may have belonged to the Sakyapa order because the mahasiddha Virupa is regarded as their human guru. Thus, it is likely that his image would be consecrated by a lama of the Sakyapa order.

Virupa was born in Tripura in eastern India, but his main work went on in a monastery called Somapuri in southern India. A man of unorthodox habits, Virupa was a great devotee of Vajravarahi, whose cult was more prevalent in the east than in the south. He is noted for his supernatural powers and is said to have stopped the sun once when he was displeased with a bar-

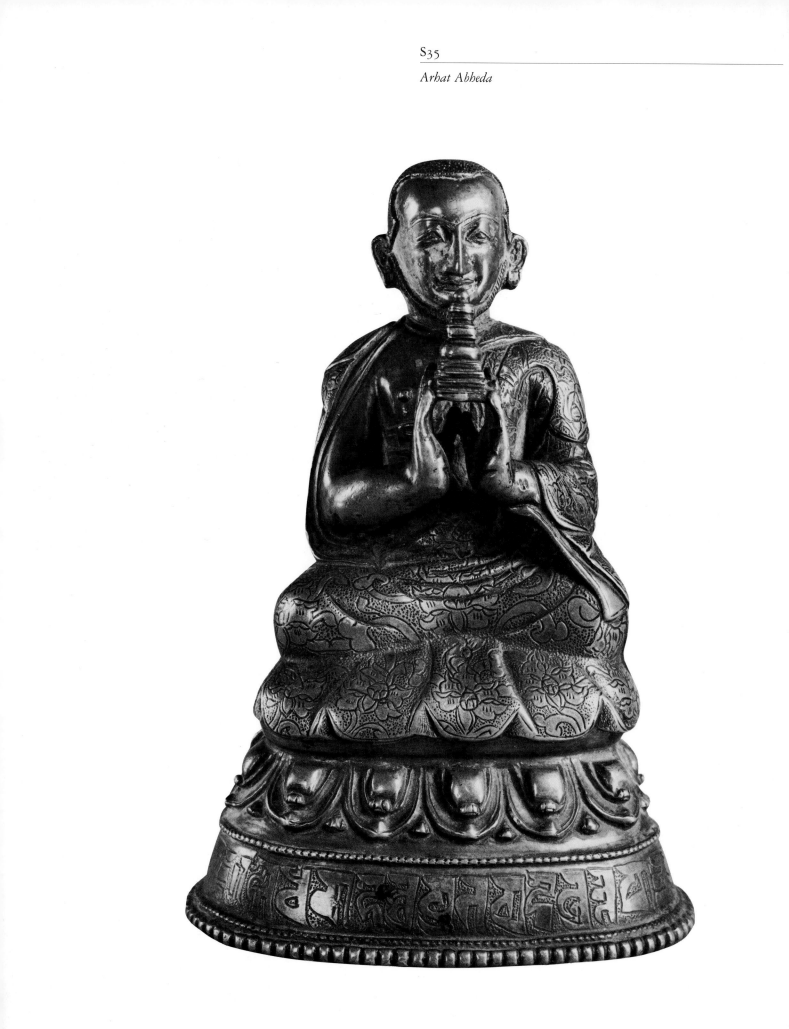

maid in a tavern. Another story tells how he split a statue of Siva and converted the Sivaites to Buddhism. It is noteworthy that *virupa,* meaning the "ugly eyed," is one of the epithets of Siva.

In this bronze Virupa is shown as a plump yogi, seated on the typical lotus seat, engaged in teaching. Characteristic of the mahasiddhas, he wears a crossbelt and various floral ornaments. His diadem is made of flowers as is that of Dampa Sangye (S31). He has a narrow, rolled beard like Abheda (S35) and a goatee and moustache. His hair is matted around a human bone, as is Mahakala's (S24), and his open mouth displays teeth inlaid with silver. His large bulging eyes are emphasized with inlaid silver in order to express the intensity of the yogi's spiritual powers and extraordinary luster *(tapas).* As is typical of other Sakyapa bronzes of this period, the details of the garment and the deerskin on which he sits are delicately chased.

S35

Arhat Abheda
Central Tibet, 15th–16th century
Bronze with paint
6½ in. (16.5 cm.)
Indian Art Special Purposes Fund
M.76.67

The bottom of the lotus base on which this arhat sits consists of a band with an inscription in bold, stylized letters in the *siddha* script. The text of the inscription is the typical Buddhist formula beginning with the expression *ye dharma.* Wearing a robe embroidered with floral patterns, Abheda is seated with his legs completely covered. His closely cropped hair hugs his head like a shallow cap and he has a narrow, rolled beard. He holds a small stupa against his chest. The stupa, the only distinctive attribute of this arhat, is said to have been given to him by Sakyamuni himself so that its magic properties would appease the *yakshas* of the northern countries where Abheda was sent to preach.

Stylistically, the bronze is closely related to the portrait of the Indian tantric master Dampa Sangye (S31). The floral design in the other bronze, however, is executed with greater finesse, and the folds of the garment are more naturalistic. In this bronze the floral patterns appear to be more freely etched and have a bolder and livelier quality. Curiously, the sculptor has filled in the intervening spaces around the flowers with tiny dots which make the surface rather busy. The folds and lower edge of the garment are rendered more perfunctorily and with a greater degree of stylization. The face of the arhat, however, has an individual personality and appears modeled from life.

S36

Arhat Kalika
Eastern Tibet or China, 2nd half of the
15th century
Gilt bronze
6½ in. (16.5 cm.)
From the Nasli and Alice Heeramaneck
Collection
Purchased with Funds Provided by the
Jane and Justin Dart Foundation
M.81.90.18
Literature: Pal, 1969 A, p. 55, no. 87;

S36

Arhat Kalika
See plate 44

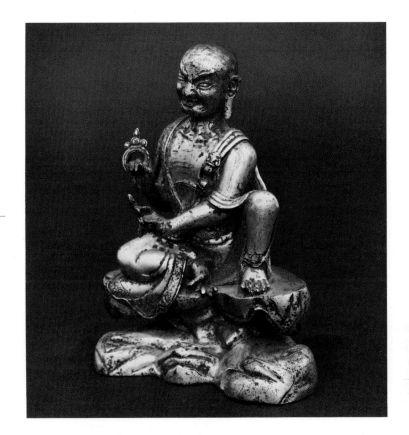

Pal, 1975, p. 35, fig. 8; *Dieux et démons,*
pp. 107–08, no. 70; von Schroeder,
p. 596, no. 155G.
See plate 44

Arhat Kalika is posed on a rocky seat, his right leg folded horizontally and his left leg raised. He wears garments with a wide border incised with a floral design; a sash with a clasp near his left shoulder encircles his body diagonally. The lower garment is pleated just below his bare chest. He has a shaven head, elongated earlobes, and a scowling face. The two metal bangles he holds help identify him as Arhat Kalika.

Kalika was the son of a rich brahmin in India. Early in his life he was found by the Buddha in a cremation ground and admitted into the Buddhist order. The Buddha dispatched him to preach to the divine populace of Kamadhatu, the Realm of Desire, where children gave him various ornaments, such as the two bangles, to show their appreciation. Tradition also states that he resides in the mythical land of Zangling along with eleven hundred other arhats.

Although this bronze may have come from Tibet, it was very likely made by a Chinese sculptor. The conceptualization of the rock formation, typically Chinese, is rarely encountered in Tibetan bronzes. The modeling of the body, the delineation of the ribs around the neck, and the remarkably expressive face are other features that give credence to a Chinese origin. Noteworthy is the very naturalistic manner in which the arhat sits. The body's tilt to the right both breaks the monotony of symmetry

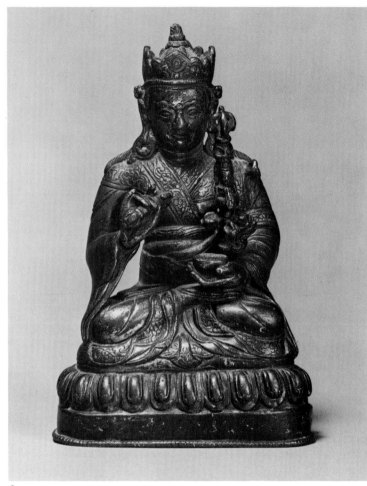

front

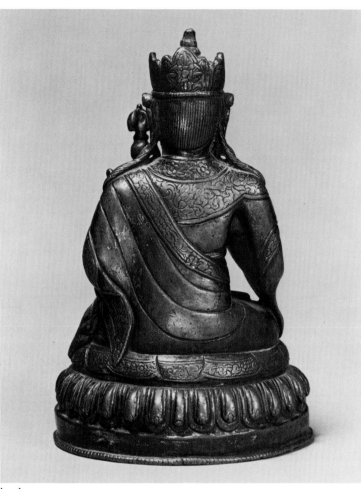

back

and makes the figure particularly animated. The sculpture continues the tradition of lively, naturalistic delineations encountered in the earlier arhat painting in this collection (P4) and in the Yuan and early Ming representations of the ascetic Sakyamuni. Stylistically, it is close to bronzes dedicated during the reign of the Ming emperor Chenghua (Ch'eng-hua) (r. 1465–87).

S37

Padmasambhava
Central or eastern Tibet, 16th century
Copper with traces of gilt
5¾ in. (14.6 cm.)
Gift of Dr. and Mrs. P. Pal in Memory of
Christian Humann
M.81.183.1

Although a voluminous literature has evolved around the legendary life of Padmasambhava, as a historical personage he remains a shadowy figure. All that can be said with certainty is that he was an inhabitant of Uddiyana (identified with the present-day Swat Valley in Pakistan) and was invited to Tibet by King Thisong Detsen (r. 756–97?). Apparently, Padmasambhava was renowned as a tantric exorcist and was invited specifically to tame the demons, presumably of pre-Buddhist religions, who were obstructing the path of Buddhism. Evidently,

he accomplished this task and returned to India, but there is no agreement either about the duration of his sojourn in Tibet or about his other accomplishments. Nevertheless, he has remained the most colorful figure among the apotheosized saints of the country and is universally venerated as *guru rinpoche*. He is the patron saint of the Nyingmapas, regarded by them as the "second Buddha."

Characteristic of the tantric yogi, Padmasambhava sits on a lotus with his legs crossed, holding a thunderbolt in his right hand and a scullcup in his left. Three of his attributes are typical of exorcists: the magic staff, known as the *khatvanga,* which rests in the crook of his right arm; the crown; and the lotus cloak which is oriented to the four directions, thereby emphasizing his pervasive power. This type of idealized portrait of Padmasambhava, therefore, stresses his role as a great tantric master and destroyer of demons.

Although the statue is hollow cast, it is unusually heavy and is probably filled with relics. The original plate at the bottom is still attached and does not appear to have been tampered with. The high copper content, as well as the workmanship—especially of the floral motif on the borders of the garments—indicate that the sculpture may have been made by a Newari craftsman. The *khatvanga* is very well rendered and the head of

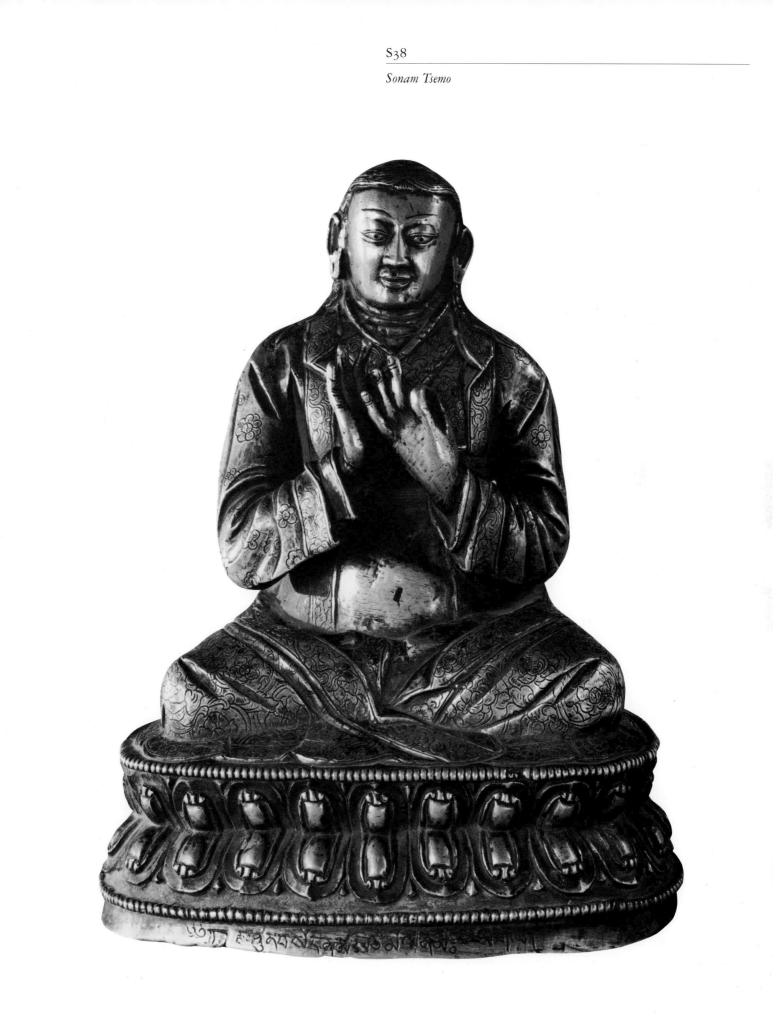

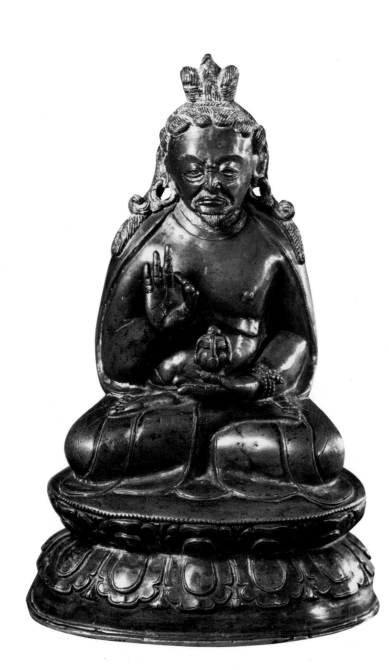

the bodhisattva above the vase of immortality in the middle of the implement reflects the fine, sensitive features of a Nepali figure.

S38

Sonam Tsemo
Central Tibet (Sakyapa monastery),
16th century
Copper alloy with paint
7¼ in. (18.4 cm.)
Gift of Doris and Ed Wiener
M.72.108.3
Literature: Fisher, pp. 21, 40.

The inscription along the base of this work identifies the figure as Sonam Tsemo (1142–1182), who was the great Sakyapa scholar and exegete responsible for organizing the vast body of tantric literature. A forerunner of the more famous Phakpa, Sonam Tsemo wrote several works including the *rGyd sde spyii rnam par bzag,* a general analysis of the tantra, and *Chos la hjug pai sgo* (Door to enter into law).

The hierarch is seated on a lotus in the characteristic posture, and his hands form the gesture of turning the Wheel of Law—most appropriate for this great teacher. As in other such portraits, his elaborate robes are decorated with incised floral patterns. It is interesting to compare his bronze portrait with two painted representations in the collection (**P13, P18**). The faces differ considerably, as do certain other details; however, it is noteworthy that in all three representations the scholar is given long black hair that falls down over his shoulders. This seems to be a characteristic feature of Sonam Tsemo, for most other bareheaded Sakyapa monks have closely cropped hair. The hair in this bronze is painted black and details of the garments are carefully delineated and chased.

S39

Yuthok Yönten Gonpo
Central Tibet, 16th century
Reddish brown bronze with paint
10⅛ in. (25.7 cm.)
Gift of Paul F. Walter
M.80.231.1

The name of the figure is incised on the back of the lotus base. Yuthok Yönten Gonpo was one of the most eminent physicians of Tibet and continues to be worshiped as a divine figure. Although Yuthok's biography does not identify the monarch he served, it has been generally believed that he lived in the eighth century and was the court physician to King Thisong Detsen. Dargay, however, has shown from other textual sources that Yuthok was a contemporary of the famous Sakya Pandita (1182–1251) and is said to have spread the teachings contained in the medical treatise *rGyud bzi.* The biography also states that the physician went to India several times in search of medical knowledge.

His portrait follows an idealized norm; Yuthok is depicted as an Indian yogi or a *siddha* rather than as a Tibetan doctor. He is seated in the familiar yogic posture on an open lotus wearing an ascetic's garments. His bare body displays a generous paunch and the roll of flesh characteristic of an elderly person. His advanced age is also indicated by the streaks of white paint added to his goatee, moustache, and matted hair, as well as by

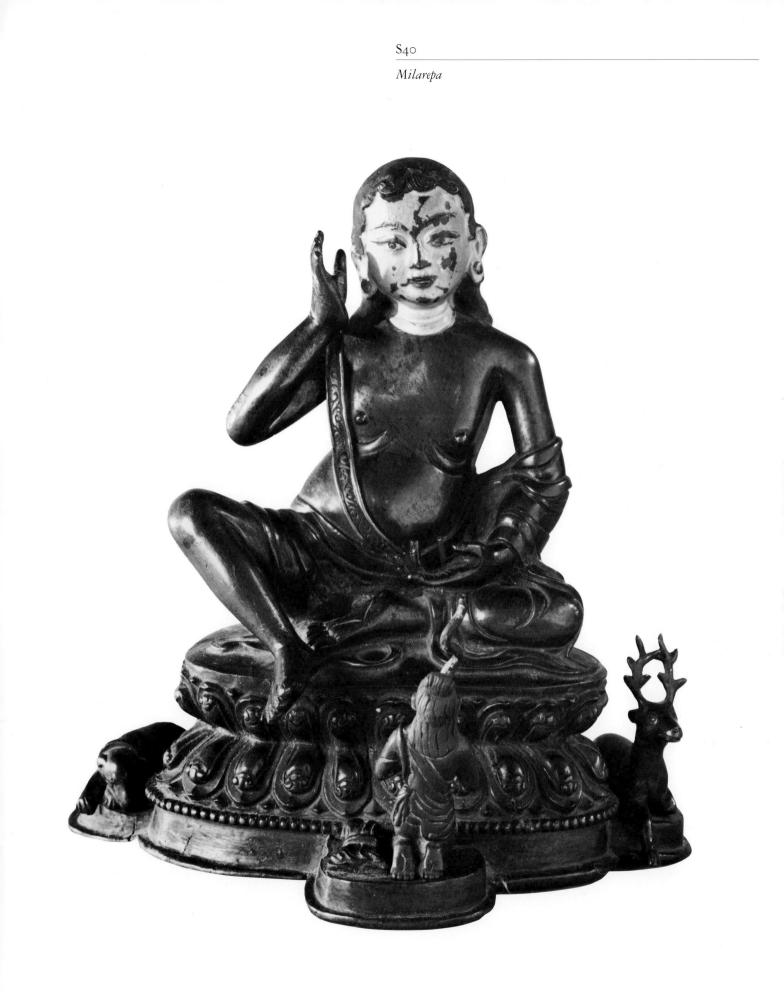

the rings below his eyes. Indeed, notwithstanding the idealization, the face appears to be rendered realistically; it is possible that a likeness of the physician was taken during his life and served as a model for subsequent renderings. His earrings are the same type as those given to eminent yogis like Milarepa (P14).

In keeping with his role, he holds the vase of immortality in his left hand. The right hand holds a small ball which must represent the dried astringent fruit *amalaka* (myrobalan), which is the distinctive emblem of the Healing Buddha (P8). Around his left wrist is tied a rosary, a detail not normally seen in portraits of other ascetic figures, that may well have been one of the physician's personal belongings.

S40

Milarepa
Central Tibet, 17th century
Dark brown bronze with polychrome
7 in. (17.8 cm.)
Gift of Ed and Doris Wiener
M.72.108.1

Milarepa is seated on a lotus in a relaxed posture, with his body swinging asymmetrically to the left. In contrast to the painted representation of him in this collection (P14), Milarepa is clad here in the single piece of cotton (*ras*) that gave him the sobriquet *Mi la Ras pa,* the cotton-clad Mila. His slender, well-formed arms and legs and his boyish face are incongruously juxtaposed with the flaccid flesh below his breasts and his rotund belly. Usually his right hand cups his ear, but here it is simply raised near the ear; the left is placed naturalistically in his lap. A yogic band encircles the right side of his torso. His face is painted in cold gold and his hair in black, with the eyes painted more sensitively.

This bronze is not simply a hieratic portrait of the most famous saint of Tibet—it has a narrative intent. It encapsulates the episode of the yogi's encounter with and conversion of the hunter that is described elsewhere (P14). The three other characters of the drama—the stag, the dog, and the hunter—are added to the base. The hunter with his bow kneels in front of Milarepa, his back turned toward the viewer. The dog and the stag sit peacefully, reassured, in the presence of the gentle saint.

The most intriguing inconographic feature in the portrayals of Milarepa, the feature which indeed is his hallmark, is the gesture made by his right hand. In a general way the gesture is appropriate for a Buddhist adept who is a *sravaka,* or listener. More specifically, Milarepa was a master of the esoteric teachings of the tantra which were orally transmitted from guru to disciple. The gesture, therefore, may symbolize Milarepa's capacity to retain those teachings and doctrines in his ear. As he himself said, "Unless the Secret Teachings be retained within one's ear, what gain is it to suffer sorrow?" It is well known that classical singers in India often cup one of their ears while they perform in order to hear the subtle notes better. Perhaps the gesture indicates that Milarepa is singing his sermons, as history says he did.

S41

King Songtsen Gampo
Central Tibet, 17th century
Gilt bronze
6⅛ in. (15.5 cm.)
Gift of Mr. and Mrs. Werner Scharff
M.80.229
Literature: Pal, 1981, pp. 25–29,
fig. 19.

Songtsen Gampo (d. 649) is generally regarded as the founder of the first royal dynasty in Tibet. A powerful monarch and conqueror, he forged central Tibet into a strong political entity, and extended the newly founded kingdom's influence far beyond the geographical boundaries of the country. He is said to have been converted to Buddhism by his two wives, who were princesses from Nepal and China. Apparently, these two wives brought the first Buddhist images into Tibet and founded its first temples. Tibetans not only remember Songtsen Gampo with pride, but have deified him, adding his image to the Buddhist pantheon. Although other important lay personages have been apotheosized, none has enjoyed so much veneration as this first monarch of the country.

This gilt-bronze sculpture is modeled after the more famous portraits of Songtsen Gampo, the prized possessions of the Jokhang in Lhasa. The images in the Jokhang are thought to have been made soon after the monarch's death. Whether lifelike or not, representations of him are certainly idealized and follow the general pattern of portraiture of religious figures. The attire the king wears here appears to reflect the period during which he lived; this is especially true of the peculiar, distinctively tied turban. Indeed, Chinese paintings of the Tang dynasty depict Tibetans dressed in this manner.

The monarch is seated like a yogi on an animal skin thrown across a cushion. His long robe is held together by a waistband. He has a scowling face, and his hair flows down both shoulders in strands and curls. His right hand rests against his leg and forms the gesture of teaching—although the palm is turned toward the body. The left hand rests on his lap in the gesture of meditation. From the crest of his turban emerges the head of Amitabha, thereby establishing the king's identification with the bodhisattva Avalokitesvara. This homology is further emphasized by the fact that Songtsen Gampo's two wives are traditionally identified with two emanations of the goddess Tara, the spiritual consort of Avalokitesvara. The most significant way in which this portrayal differs from those in the Jokhang is the scowling facial expression—a characteristic occasionally given to images of Padmasambhava.

S42

Mahakala
Central Tibet, 16th century
Terracotta with polychrome
5¼ in. (13.3 cm.)
Indian Art Special Purposes Fund
M.83.22

The guardian deity Mahakala is represented in this terracotta sculpture in his six-handed form. He stands militantly upon the prostrate figure of the elephant-headed Hindu god, Ganesa, who is

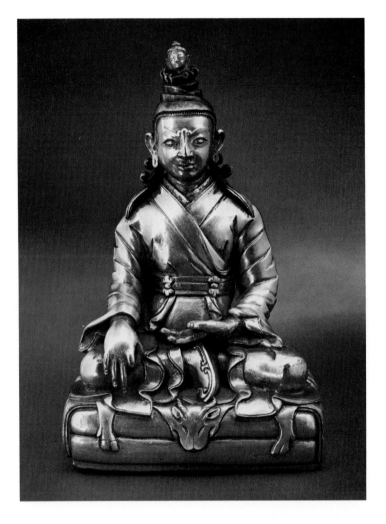

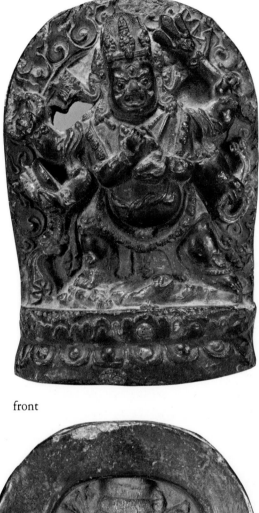

front

back

stretched out on a lotus. The nimbus behind him is adorned with leaping flames which are painted red. With his principal hands, Mahakala holds the chopper and the skullcup in his characteristic fashion. The four other hands hold (on his right) the drum and the rosary; and (on his left) the rope and the trident. Against his hair is represented a seated Buddha in meditation.

This form of Mahakala was popular both with the Sakyapas and the Kagyupas, but especially with the latter. Stylistically, the representation reflects the strongly Nepali style that was favored by central Tibetan Sakyapas in the fifteenth and sixteenth centuries. However, there is no way to determine exactly where this handsome and well-executed sculpture was made, for, as noted in the introduction to this chapter, clay was a popular medium in Tibet.

Ritual Objects

Rites and rituals are an essential part of Tibetan religion and reflect its practical side.[1] Not restricted to temples alone, they are performed in a variety of places and circumstances for a myriad of purposes. Daily ceremonies are conducted in temples, although they are perhaps not so elaborate as those that take place in Hindu temples in India and Nepal. Throughout the year, too, special rituals are performed to propitiate deities, to precipitate rain, to avert hailstorms, diseases, and death, to ensure good harvests, to exorcise demons and evil spirits, and, of course, to destroy the passions of the mind and, ultimately, the ego. All these practices—whether occult, magical, or shamanistic—require various implements which are as important as the images of the deities in whose service they are employed. Because the objects are for sacred rather than profane purposes, they are often rendered in precious metals, such as gold or silver, and are sumptuously encrusted or inlaid with turquoise, carnelians, crystals, and agates (R10–R12). In addition, each object is pregnant with symbolic meaning and is frequently imbued with magical power and potency.

How some of the implements and offerings are used in a ritual can best be grasped by looking at two paintings in the collection, M1a and M7b, and from the following description of a rite of consecration involving a mandala from a Vajrayana Buddhist text written by Anangavajra, a tantric master:

> Then the worthy vajra-guru, filled with sympathy and intent on good, makes manifest his compassion and calls the pupil into the mandala. It is strewn with the five kinds of delectable things resplendent with a canopy spread above [see M7b]; it resounds with bells and cymbals, and is pleasant with flowers and incense and garlands and heavenly perfumes; it is the most wondrous resort of Vajrasattva and other divine beings and is prepared for union with the yogini. Then joining with the yogini the most worthy master places the Thought of Enlightenment in the lotus-vessel, which is the abode of the Buddhas. Next he consecrates the pupil, now joined with the yogini, with chowries and umbrellas held high and with propitious songs and verses. Having thus bestowed upon him the consecration, that excellent gem, he should give him the fivefold sacrament, delightful, divine, essentially pure. It consists of the precious jewel, with camphor, red sandal-wood and vajra-water, and as fifth component the empowering mantra. "This is your sacrament, Beloved, prescribed by former Buddhas. Do thou protect it always, and harken now to the vow you must keep. Never must you take life, and never abandon the Three Jewels, and never abandon your master. This is the vow you transgress at your peril."[2]

Rituals are performed both communally and individually in the temple, the home, or in a solitary place such as the cremation ground. The performances of the Kalacakra initiation in recent years by both the Dalai Lama and the Karmapa in

India and in the United States, respectively, are instances of communal spiritual practice which, according to the present Dalai Lama, is the greatest pleasure and "ultimate in nature."[3] Whatever the merit of such mass empowerments or initiations, Vajrayana generally advocates the "direct path" for the individual, which leads to enlightenment in this life. This objective can only be achieved by the individual with the help of a guru. The importance of the guru, the rituals to be performed, and the use of certain implements are exemplified by two accounts of individualized rituals, one written in the fourteenth century (though not by an eyewitness) and the other by a twentieth-century observer. The earlier one, found in *The Blue Annals*,[4] is an example of how bizarre a tantric rite can be. Dampa Sangye, a mystic who was especially important for Lamaism and whose portrait is in the collection (S31), participated in this rite.

The account given in *The Blue Annals* goes as follows. A great female ascetic known as Macig (Ma gcig) was born in the year 1062; all the auspicious signs of divinity surrounded her birth. She was married at the age of fourteen, but, being spiritually inclined and failing to persuade her husband to adopt a religious life, she abandoned her home and became a disciple of the celebrated guru Ma Lotsawa. She learned many tantras and practices from him, went into seclusion for four years, and, after performing further rites, obtained the four miraculous powers *(siddhi)*. When Macig was twenty-eight years old, Ma Lotsawa was poisoned; she returned from her wanderings to perform his funeral rites. Beginning in her thirty-first year and for three successive years she was struck by seven calamities, some of which were physical and others spiritual. Since all attempts to cure herself failed, she decided to visit Dingri, where the well-known Dampa Sangye was then residing.

Dampa Sangye, of course, knew of her afflictions and told her that she was suffering because she had transgressed her vow in respect to her principal teacher. Macig protested, but Dampa enumerated her transgressions, which were seven in number. She had, Dampa said, acted as a tantric assistant of other adepts without her guru's permission; partaken of food in the company of persons who had defiled their vows; become filled with the other tantric assistants' envy of the guru; broken her undertaking; sat on her guru's mat; not offered the guru remuneration for her initiation; and had not partaken of the sacrificial foods.

A distraught Macig asked how she could be cured, and Dampa told her to fetch seven objects: an egg laid by a black hen, a right front leg of a lamb, a skull-cup filled with wine, seven young girls who had attained puberty, a relic of the tathagata, a royal mat, and a piece of cloth bearing the footprint of her teacher. When these were brought the following remedy was suggested: to offer the mat to Dampa, to act as a tantric assistant equal in position to the teacher (presumably Dampa himself), to wash herself and circumambulate the relic (perhaps a *chöten; see* R1), to offer the seven girls to the teacher, to worship the mutton and the wine, and to insert the egg in her vagina. The meat and wine were served to ten teachers and their retinue, and thereafter—apparently under hypnosis—Macig confessed her transgressions. Having thus cleansed her, Dampa instructed her to look after the descendants of her original guru, make offerings to him, whitewash the *chöten* containing his relics, and to light lamps. He also asked her to remove the egg. The egg had turned black, and Dampa asked Macig to break it. When it was broken, Dampa told her how her misfortunes were due to the malevolence of a black magician but that now she had been cured through the rite she performed with the master.

The purpose of the rite was to indicate the superiority of Buddhism. The black magician Dampa referred to was a Bonpo whose occult powers, which had induced Macig's misfortunes, were no match for the superior efficacy of Buddhist

233

rites, although these, too, were magical in nature. In any event, Macig lived happily thereafter, became a great saint, and died at the age of eighty-eight in the year 1150. She was a contemporary of Milarepa and shared with him as a disciple the famous Phagmotrupa.

The second, more recent account is about the little-understood and mysterious *chö* rite, which was introduced by Dampa Sangye and has remained popular among the mystics of Tibet. This is a psychic drama enacted by an individual, preferably in a cemetery, and probably carries memories of a shamanistic rite from pre-Buddhist days. The purpose of the rite is to destroy the demon of ego that lurks within each human and prevents recognition of the ultimate truth—*sunyata,* or nothingingess. As Tucci writes, the practical side of *chö* "is intended to cut off the discursive process at the root and so directly help bring about the insight that in reality nothing exists."[5] In addition to Tucci's serious discussion of this rite, there is a colorful description of a lama's performance of it by an eyewitness, Alexandra David-Neel, who visited Tibet earlier in this century.

> It follows that, during the performance of *chod,* which I have compared to a drama enacted by a single actor, the latter may happen to see himself suddenly surrounded by players of the occult worlds who begin to play unexpected roles. . . . Like any other actor, the man who wants to perform *chod* must first learn his role by heart. Then he must practice the ritual dance, his steps forming geometrical figures, and also turning on one foot, stamping and leaping while keeping time with the liturgical recitation. Finally, he must learn to handle, according to rule, the bell, the *dorjee,* and the magic dagger *(phurba),* to beat rhythmically a kind of small drum *(damaru)* and to blow a trumpet made of a human femur *(kangling).* . . .[6]

David-Neel goes on to observe that in a secluded spot in the middle of the night the performer summoned the demons by blowing his bone trumpet. He imagined that a goddess, or *dakini,* personifying his own will, had emerged from his cranium and with one stroke had cut off his head. Ghouls then appeared and devoured him bit by bit until the last drop of blood was lapped up and the last bone thoroughly chewed. And while this macabre and imaginary feast was taking place, the performer chanted the following verse:

> For ages, in the course of renewed births I have borrowed from countless living beings—at the cost of their welfare and life—food, clothing, all kinds of services to sustain my body, to keep it joyful in comfort and to defend it against death. Today, I pay my debt, offering for destruction this body which I have held so dear.[7]

However, David-Neel's vivid account of the performance by a young lama is more relevant for our topic.

> The *kangling* in his left hand, the *damaru* lifted high in the right and beating an aggressive staccato, the man stood in a challenging attitude, as if defying some invisible enemy. . . . Then he began the ritual dance, turning successively towards the four quarters, reciting "I trample down the demon of pride, the demon of anger, the demon of lust, the demon of stupidity. . . ." He rearranged his toga, which trailed on the ground, and having put aside his *damaru* and the bone trumpet, he spread the tent, seized a peg in one hand, a stone in the other one, and drove home the pegs while chanting the liturgy.[8]

The *chö* was very likely a pre-Buddhist rite of shamanistic import that was adopted by Dampa Sangye for Buddhist usage. The use of a tent and pegs implies that it was a ceremony associated with the nomads. It was also practiced near a

corpse or in a cemetery. Tibetans normally dispose of their dead by chopping up the body so that it cannot be repossessed by spirits or demons—another practice antedating Buddhism. Significantly, when an epidemic disease breaks out, the *chö* adepts are summoned to transport corpses to the cemetery and to chop up the bodies and crush the bones. They also perform a ceremony, *me zhags,* to avert an epidemic and another, *gshed dur,* to exorcise the demon who obstructs a dead person's path to paradise.[9]

This ritual is an excellent example for demonstrating how Tibetan Buddhism evolved by accepting earlier religious theories and practices and elevating some of the rites by giving them a lofty and philosophically acceptable interpretation. In the *chö,* an external rite of shamanistic exorcism and occult magic was internalized and given a yogic gloss, and became a ritual to eliminate the ego. The *chö* rite, perhaps unconsciously echoing more primitive ideas, also symbolizes the sacrifice of the self whereby one attains a homology with the primal sacrifice of the creator.

David-Neel's observations further help us to understand the origin of one of the most important ritual implements of Tibetan Buddhism—the *phurpa* or *phurbu* (R6, **R7**). The word *phurpa* and its Sanskrit equivalent, *kila,* literally mean "peg," and a glance at either illustrated example will reveal that its blade is really not a dagger but a peg, precisely the kind of peg used to secure tents. To this basic form of the peg, the Tibetan Buddhists may have added the *dorje* (thunderbolt) not only to symbolize the religion but also to make it a more potent weapon because of the indestructible nature of the symbol. The motif of skulls which is sometimes attached to the *phurpa* may have survived from earlier times.

It is significant that although the words *kila* and *vajrakila* occur in Sanskrit Buddhist texts, not a single implement remotely similar to the *phurpa* has been discovered in India or even in Nepal.[10] Quantities of *vajras* and bells have been discovered in Java, but not a single *phurpa* has been found. Similarly, in Japan, where tantric Buddhism is a living tradition, most other implements of Tibetan Buddhist ritual are familiar, but not the *phurpa.* And in China, in the numerous Buddhist paintings discovered in Dunhuang and other Central Asian sites, the *vajra* and the chopper (R8) are predominant ritual weapons, but the *phurpa* does not appear. Only later on, during the Yuan dynasty, after Tibetans came to dominate the Chinese religious scene, do we find the *phurpa* used in temples. It seems evident, therefore, that while in tantric Buddhism the *vajra* is generally the most important ritual weapon, in Tibet it was replaced, if not superseded, by the native *phurpa.*

The importance of the *phurpa* in Tibetan ritual is demonstrated by the special immovable *phurpa* found in many Chinese as well as Tibetan monasteries. It is often of gigantic size (four to five feet high), made of iron, and believed to be the source of potency for all smaller *phurpas* used in actual ceremonies. One of the most famous examples of such a powerful *phurpa* is that preserved in the Sera monastery.[11] The claim that it arrived from India like a missile probably reflects a pious wish, but it may disguise archaic shamanistic ritual involving the imaginary flight of the shaman's arrow.[12] Touching the object is considered a protection against evil spirits, and once a year, after the Dalai Lama has done so, the public is allowed to touch it. Indeed, so important and potent is this implement in Tibetan ritual that, ultimately, the *phurpa* itself was personified as a deity (S21).

The *dorje,* the chopper, the cot's leg *(khatvanga),* and the sword are also important weapons, employed in various rituals and exorcism ceremonies and frequently carried by the deities as well. All these instruments are considered means of removing ignorance which, in Buddhist parlance, is "discriminating thought."

But every image and every object has several levels of meaning, and while the *phurpa* may literally be used to exorcise demons, both internal and external, Mahakala (S24, S27) uses his chopper to cut up nonbelievers and Manjusri's sword (S9) is the sword of knowledge (*jnanakhadga*) which symbolically cuts through the fog of ignorance. Each is a weapon of destruction but also an instrument of salvation, and each may further embody the *axis mundi* symbolism.

The drum and the human bone trumpet are essential elements of the *chö* rite, and both probably reflect an ancient shamanistic tradition. The drum was, and may still be, the instrument par excellence of shamanistic ritual involving both "magical music" and the "music of noise."[13] The former is the music that signifies, in the case of the shamans, a celestial journey through an ecstatic experience; the latter is the music that drives away evil spirits. Music in one form or another accompanies all rituals, whether Hindu or Buddhist, and Tibetan religious ceremonies are not exceptions. Music is considered to be similar to a mantra, and whether vocal —such as chants and recitations of the proper liturgy—or instrumental—such as that provided by drums, trumpets, the bell, or the conch shell (R11)—sound is of fundamental significance in the performance of all ritual. The muttering of the mantra *om mani padme hum* is considered the surest and quickest way to achieve one's spiritual goal; the syllable *om* is the primal sound symbolizing the Absolute, or Universal Consciousness, in Indian thought. Seed (*vija*) mantras, such as *hrim, hum,* and *lam,* are syllables or elemental sounds that constitute the basis of all Hindu and Vajrayana Buddhist liturgy.

Various instruments have different levels of usage and meaning. The most common and indispensable musical instrument in tantric Buddhist ritual is the bell. Gods and apotheosized lamas alike hold this popular symbol, along with the thunderbolt, in their hands. During a ritual the priest or lama grasps the thunderbolt with his right hand and the bell with his left; the two together symbolize the *bodhicitta,* or mind of enlightenment. The thunderbolt signifies the means (*upaya*) or fitness of action, while the bell symbolizes wisdom; the former is polarized as male and the latter as female. Their union is expressed in the gesture of two hands, holding the attributes, crossed against the chest (P5). The bell has an elemental function and its sound, like those made by the trumpet and the drum, is regarded as auspicious; it is said to drive away evil spirits. Like the church bell, the Buddhist hand bell sends the message to the evil spirits that they must stay away from the consecrated area where the ritual is being performed.

The conch shell is another instrument with multiple meanings and uses. In India it is used more frequently than the bell to mark all auspicious occasions, whether sacred or secular. How old the custom is and whence it originated are not known, but it probably started near the seacoast, where the shell is found. Transplanted to Tibet with Buddhist rituals, it is used multifariously. Eleanor Olson summarizes those uses admirably in the following passage:

> The conch is but one of many trumpets which play a part in Tibet's unique temple music. As a natural trumpet which comes from watery regions, the conch is believed to have magical power over rain. Thus, its flange is often decorated with dragons and clouds. To stop the hail which is a frequent menace to Tibetan crops, the monks stand on the temple roofs and blow the conch in all directions, taking turns at breathing so that the sound is prolonged in a succession of great heaving waves. The conch also serves as an offering vessel. Filled with curds, it is one of the Offerings of the Five Senses, the others being a stringed musical instrument (hearing), flowers (smell), mirror (sight), and cloth (touch).[14]

Water plays an essential role in Tibet's spiritual life in general and in ritual in particular. Every lake in Tibet is regarded as sacred and is the habitat of spirits known as *lu*. Aquatic creatures and plants, such as the lotus, are generally present in both Hindu and Buddhist iconography, and water is an indispensable ingredient in most religious rituals. It is essential for initiation *(abhisheka)*, which is as basic to esoteric Buddhism as baptism is to Christianity. A full vase is an auspicious emblem for all occasions in India, and is regarded there as a symbol of the womb as well as of the universe. In Tibet, vessels or pots *(kalasa)* are also fit receptacles for the deities themselves, and most offerings are made to the vessel rather than to the deity directly. Various kinds of water containers are used by the lamas for their own ablutions, for purifying virtually anything and everything, and for initiation. Made of silver or gold and encrusted with semiprecious stones (R12) whenever the lamas or monasteries are wealthy enough, such water containers are always present on altars.

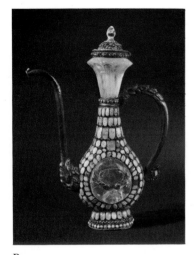

R12

Once such vase is the *tshe bum* which is held by Amitayus, the tathagata of eternal life (**P1**). It is used for all life-prolonging ceremonies *(tshe wang)* and is associated with the goddesses Tara and Ushnishavijaya. In the ceremony, the consecrated water becomes transformed into an elixir or nectar. The vase held by Amitayus is connected by a cord to the heart of the officiating priest or monk; through this cord the life power passes from the divine source to the mortal body. In other instances a vase may be held over the recipient's head. The chanted liturgy describes the process of transfer:

> All these dissolve into the flask in his hands, and from their dissolving it overflows with wavelets of white nectar, which enters into me through the hole of Brahma in the top of my head; it in turn dissolves into the wheel in my heart, with its seed and garland of the mantra; from this there falls a stream of nectar which fills up the entire inside of my body and washes its entire outside, so that it cleanses and makes pure all the sins, obscurations, diseases, and impediments to life which I have accumulated from beginningless time; it restores my life and merit and renews the vows and pledges I have broken, and I gain the magical attainment of deathless life.[15]

Apart from water, both beer and blood are appropriate libations for the gods as well as for the participants in a ritual. While blood is offered and imbibed in esoteric rituals, it is more common to use either water or beer as a substitute. The liquid is usually offered in a real skullcup made of the cranium of a human, or in a simulated one (R5) which may once have been lined with a genuine skull.

Human bones play an extremely important role in Tibetan ritual. We have already mentioned the *kangling* (a trumpet made from a femur) and the skull. An apron made of human bones is worn by terrifying deities (S29) and by tantric priests during the performance of certain esoteric rites. Sometimes the bones of a dead lama are gathered and inserted in a *chöten* or an image. In certain rituals bones may also be crushed to powder and eaten as a sacrament. Among other human organs used ritually are the eyes, the tongue, and the heart, all of which are shown as symbolic offerings in two paintings in the collection (**P30, P31**). The use of bones and other organs is not unknown in Indian tantric rituals, but the use of human bone seems to be more pervasive and intense in the Tibetan religious experience.

Tibetans also sacrifice flesh, real and symbolic, to their deities. It may be recalled that among the objects Macig had to bring to Dampa were a leg of lamb and wine. The five kinds of flesh offered to the deities are that of cattle, dog, horse, elephant, and man. In Indian tantric rites the dog and the elephant are excluded. However, in most Tibetan ceremonies such flesh is offered symbolically, either as a

permanent offering in painted banners (**P30**, **P31**) or in the form of *torma (gtor ma)*. A *torma* is an effigy, modeled or molded of flour and/or yak's butter, that is offered as a substitute, since an actual sacrifice would necessitate killing. Colorfully painted, such *tormas* may be faithful copies of natural creatures or may take abstract, imaginative forms. The mold from which the dough substitutes are made is called a *zan par* (**R17**) and is usually of wood; the figures are varied, charming, and lively.[16]

The highest sacrifice one can make, however, is of one's own body. The imaginary sacrifice of the body, which can symbolize both a personal act of compassion (by feeding hungry beings) and the reenactment of the cosmic drama of primal sacrifice, as performed in the *chö* rite, is not an isolated occult act. It embodies an idea that is far more ancient. The entire bodhisattva concept is based on the idea of self-sacrifice as a supreme act of altruism, and it was out of despair at the misery of the world that the bodhisattva Avalokitesvara's head was split asunder (**S3**).[17] This self-sacrifice forms the central theme in the ancient cycle of birth stories of the Buddha known as the *jataka*.

Most ritual objects in the collection, with the exception of the butter lamps (**R14**), were and are used in temples by initiated lamas who alone have the right and duty to perform the various rituals. In this and in many other ways the customs are not different from those of Judaism and Christianity, in which the rabbi or priest performs most acts of worship. The Tibetan layman's participation in the religious experience is limited to visiting temples, contributing funds for the performance of the rites, praying, repeating the formula *om mani padme hum* and rotating the wheel as he circumambulates a *chöten*, lighting butter lamps, and witnessing the public ceremonies performed by the lamas during special religious festivals. On such occasions masked ceremonial dances are done to conquer the evil spirits, and large embroidered or appliquéd thankas are hung from the walls of the monasteries to be worshiped and admired.

A layman, especially a traveler, may worship the mountain and nature spirits at every pass and crossroad by planting a banner, placing another stone on an existing heap, or by burning juniper or other aromatic herbs or woods. The devout traveler always carries a portable shrine (**R15**), known as a *gau*, containing the image of his tutelary deity *(yidam)* and will, of course, visit every monastery, temple, or *chöten* in his path. Thus, just as the modern Western businessman may mix business with pleasure, Tibetan merchants mixed, and presumably still do, business with religion—and sometimes with pleasure as well.

Almost every Tibetan house has a chapel or at least an altar in a corner where the householder worships his personal deities. Even the humble tent of the nomad is not without such an altar. Thankas may hang behind the altar, which is furnished with images of bronze, wood, or silver. Butter lamps and little lidded cups are invariably placed in front of these images. Every morning the head of the household or its most senior member fills the cups with water *(yon chab)*. Lamps are lighted continually, and incense is burned early in the morning. The latter is perhaps the most important domestic ritual act performed by a layman and is known as *sang (bsangs)*.[18] Burning aromatic herbs for the purpose of ritual fumigation clears the air of evil spirits, and is not an indulgence in psychedelic fantasy. The *sang* is accompanied by prayers and invocations.

Another act closely associated with the *sang* is the *ngan (brngan)*, an offering to the nebulous powers that lurk in space, such as "the powers of the ground and the earth on which the maker of offerings lives...and also the various *lha* the deity of the house, of the herd, of the stove, room...etc.[19] Here, indeed, the gods

and goddesses are no longer illusions, regardless of what the texts and the mystics may say. These domestic rituals are both elemental and instinctive, and no matter how disguised by any cloak of sophisticated symbolism or religious profundity, they constitute the substance of religious practice.

Tibetan ritual objects were crafted from a wide variety of materials and reveal diverse and visually exciting shapes and forms. Since such objects were used for the service of the gods, they were often made as sumptuous as possible with rich encrustations of gems and semiprecious stones. As already mentioned, Tibetans were inordinately fond of enriching the surfaces of their metal objects with gilding and with stone inlay; these ritual implements provided them with the opportunity to indulge their taste in a lavish manner. Gilt bronze, silver, crystals, and turquoises figure prominently among the broad array of ritual objects in the Museum's collection. Aesthetically appealing and visually resplendent as these objects are, it is not always easy to determine their provenance and exact dates; thus, the attributions made in this catalogue must be regarded as tentative. Nevertheless, the implements are fascinating as much for their exquisite craftsmanship as for their rich forms and symbolism.

Notes

1. For a brief and general review of Tibetan rituals, see E. Olson's essay in Pal, 1969 A; for a more elaborate account of some of the important rituals and oracles in Tibetan Buddhism, see Nebesky-Wojkowitz, Part II; for a detailed description of the cult and ritual of the goddess Tara as practiced by the Kagyupas, see Beyer.

2. Conze, p. 245.

3. As quoted by Olson (Pal, 1969 A, p. 40) from *My Land and My People* by the Dalai Lama (New York: McGraw-Hill, 1962).

4. See Roerich, 1979, pp. 220–26, for the entire account.

5. Tucci, 1980, p. 87. On this and the following pages Tucci succinctly explains this particular rite and its symbolic importance.

6. David-Neel, 1971, pp. 149–50. For an amusing story regarding the performance of *chö,* see Beyer, p. 282.

7. David-Neel, 1971, pp. 150–51.

8. Ibid., p. 158.

9. Tucci, 1980, p. 92

10. For instance, *vajrakila* is mentioned in the *Guhyasamajatantra* (B. Bhat-

tacharyya, ed., *Guhyasamājatantra,* Baroda, India, 1967, pp. 67, 68, 91–92, 165) as an implement used mainly in destructive magic *(abhicara).* Although it is not described, it appears to have been made of human bone and was a few inches in size *(mānushāsthimayaṁ kīlaṁ ashṭāṅgulapramāṇataḥ).* The *kila* used by Nepali tantrics *(see* Huntington, 1975, pp. 48–56) may have been influenced by the *phurpa* and probably does not follow an Indian prototype.

11. Ferrari, pp. 42, 100–101.

12. Meredith, pp. 238–39.

13. See Eliade, pp. 168ff.

14. Olson in Pal, 1969 A, p. 43.

15. Beyer, p. 381.

16. See Tucci, 1980 and Beyer for elaborate discussions of the use of *torma* in Tibetan ritual.

17. See Pal, 1982 A, for a discussion of the symbolism behind this fascinating iconography.

18. See Tucci, 1980, pp. 199ff, for a detailed explanation of this domestic ritual act.

19. Ibid., p. 200.

R1

Chöten

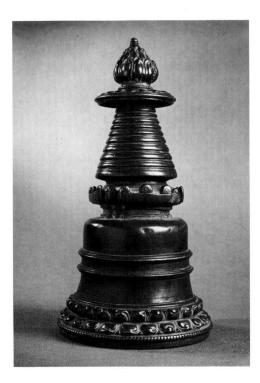

R1

Chöten
Central Tibet, 12th century
Dark brown bronze
h: 6½ in. (16.5 cm.)
Indian Art Special Purposes Fund
M.76.130

The *chöten* (the word is Tibetan for stupa, literally meaning heap or mound), is the most prominent and ubiquitous symbol of Buddhism. It can have many different shapes and various symbolic meanings. In Tibetan Buddhism it usually symbolizes the mind of the Buddha. Small *chötens* such as this one generally served as reliquaries for important personages, both lay and monk, and often the hollow interior was stuffed with relics and charms. This one has yielded rolls of cotton, sand, some grains, and bits of paper with faint drawings of scarcely recognizable figures. A recent article convincingly demonstrates that *chötens* of this shape and material were probably made for the use of monks of the Kadampa order (*see* Hatt).

The base of this *chöten* has an open lotus form, from which rises a squarish drum with two simple moldings encircling it in the middle. Above the drum is a square section with moldings and lintels that appear to represent gateways facing each of the cardinal directions. This square section is known in Sanskrit as the *harmika.* Above it rises a pyramidal arrangement of ten or thirteen rings known as *chatravali* (each ring being called a *chatra,* or parasol), which symbolize the stages (*bhumi*) of enlightenment, usually ten or thirteen in number. This spire of *chatras* is shaded by a wider parasol with lotus leaves on the out-

side; the crowning element is a closed lotus. All these elements make the stupa or *chöten* an object of simple but elegant design and a potent cosmic symbol as well.

R2

Two Plaques from a Ritual Diadem
Western or central Tibet, 13th–14th
century
Wood with traces of gilding and lacquer
h. of each: 12½ in. (31.7 cm.)
Gift of Dr. and Mrs. P. Pal
M.79.151.1–2

These two deeply carved wooden plaques were once panels of a ritual diadem worn by a priest or monk during particular initiation ceremonies (*see* R3). Except for minor variations, both plaques are identical in design. The central figure seated on an elaborate throne is the transcendental Buddha. The one with both hands on his lap in the meditation gesture (*dhyanamudra*) is Amitabha; the other, with the right hand raised forming the gesture of reassurance (*abhayamudra*), is Amoghasiddhi. Both Buddhas are bejeweled and crowned. The five lobes of the crown are of the same shape as the two plaques. The thrones of both are of identical design, with lotus, overhanging carpet, personified *nagas* supporting the seat, lions trampling elephants (*gajasimha*), heralding *makaras*, roundels with symbols, two more *nagas*, and a *kyung* at the summit.

The differences between the two plaques are purely iconographic. Below Amitabha's seat are two peacocks—the peacock being his vehicle—while Amoghasiddhi is attended by two *garudas*. The two symbols above Amitabha's head are the conch shell and the lotus, while those above Amoghasiddhi are the bell and the wheel. A tree is placed at the apex of the Amitabha plaque and a *dorje* at the apex of the other.

These two plaques are not only extremely rare examples of wooden diadems, but also exemplify the best Tibetan woodcarving. The elaborate design of the throne is derived ultimately from Pala prototypes. Stylistically, they are related to the brass Manjusri (S9) and to the two early Kadampa thankas (P1, P2). The animals and *nagas* are particularly lively, and the empty, cut-away areas accentuate their forms with great clarity.

R3

Ritual Diadem
Northern Nepal, 19th century
Silver, gold, and paint
h. of each panel: 7½ in. (19 cm.)
Gift of Dr. Ronald M. Lawrence
M.74.139.15

Such crowns or diadems are used by priests and monks during religious ceremonies, such as *abhisheka* (initiation), and are usually embellished with images of the five transcendental Buddhas or their mystic syllables (*vijamantra*). While wearing it, the monk or priest himself becomes homologized with the divine essence and a fitting receptacle for cosmic forces. In Tibet, groups of monks, especially among the Kagyupas, may wear them during both solitary and collective initiations. (*See* Beyer, pp. 399ff for a detailed description of the various initiations in connection with the cult of Tara.)

Two Plaques from a Ritual Diadem

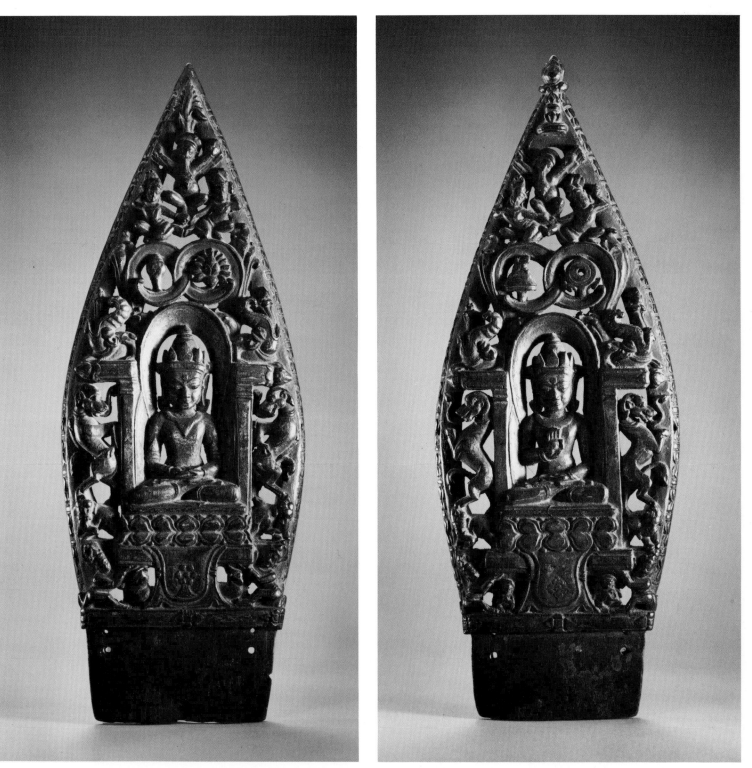

a

b

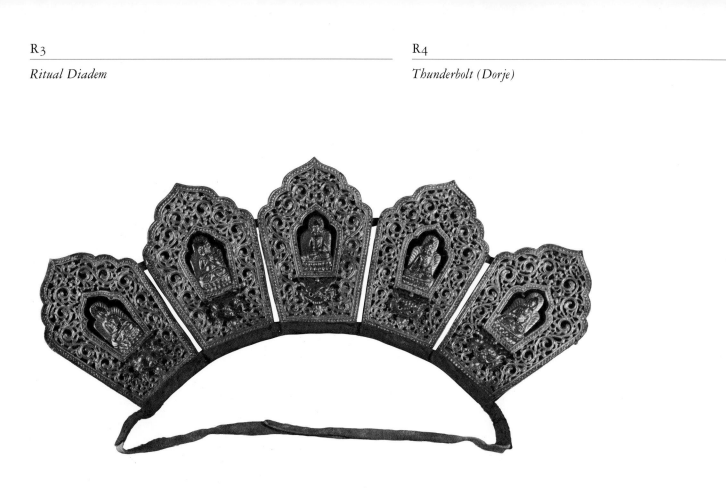

The five Buddhas, from the viewer's left, are Amitabha, Vairocana, Akshobhya, Ratnasambhava, and Amoghasiddhi, who are the five transcendental Buddhas of Vajrayana Buddhism. Below each is a polychromed *kirttimukha* (face of glory), acting as a guardian. The remaining space in each panel is filled with curling vines or tendrils whose meandering shapes form striking contrasts against the blue cloth.

This diadem was acquired in northern Nepal, where Lamaism is the principal religion. It may have been made locally or imported from Tibet.

R4

Thunderbolt (Dorje)
Eastern Tibet, 18th century
Gilt bronze, once inlaid with stones
l: 6 in. (15.2 cm.)
Indian Art Special Purposes Fund
M.81.4

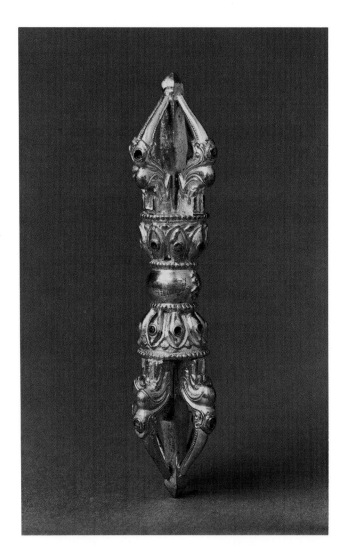

The thunderbolt is possibly the most important symbol of Vajrayana Buddhism. Not only is it responsible for the name of this form of Buddhism, but it is also the very symbol of *bodhicitta,* or enlightenment. Apart from symbolizing the faith, the thunderbolt is an important instrument in rituals, especially for exorcising evil spirits, and is a frequent attribute of gods and lamas.

The implement is designed with a central shaft that is pointed at each end. The middle section consists of two lotuses from which spring, at each end, the four prongs of the *dorje.* To-

gether with the projecting and pointed central shaft, each end becomes five-pronged. Each of the outside four prongs is designed as the head and snout of the mythical *makara*; thus the central shaft may represent the tongue of the animal as well as symbolizing tongues of flame, although the aquatic significance of the *makara* cannot be ignored. Like the *chöten,* the *dorje* is a cosmic symbol; its shaft may also represent the cosmic pillar.

R5

Skullcup with Lid
Eastern Tibet (Derge) or China,
18th century
Gilt silver
6½ x 8 in. (16.5 x 20.3 cm.)
Purchased with Funds Provided by
Anna Bing Arnold
M.79.243.4
Literature: "Skullcup with Lid," *Los
Angeles County Museum of Art Bulletin,*
vol. XXVI, 1980, p. 52.

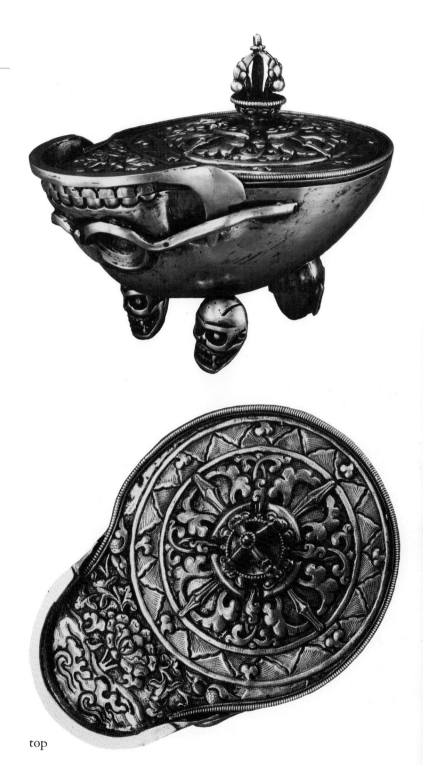

top

This cup is shaped like a human skull, with deep eye sockets and prominently displayed teeth made of silver. One row of teeth is attached to the cup and the other to the lid. The gilding and the silver contrast effectively to make the imagery both vivid and macabre. The three supports for the cup consist of two skulls in the front and a placid human or divine head at the back.

In contrast to the cup, the lid is sumptuously adorned with lively representations of natural and cosmic symbols. A peonylike lotus with foliage springs from stylized waters in the protruding area of the lid that extends over what would be the jaw of the skull. The principal portion of the lid is decorated with a mandala of two receding circles. The outer circle shows a conceptually rendered mountain; in the larger space of the inner circle there is a four-pronged *dorje* known as the *visva-vajra,* or cosmic thunderbolt. A fifth *dorje,* separately cast, is attached to the center of the *visva-vajra.* Functionally, it served as the handle for the lid, but symbolically, it represents the religion itself. It is given further cosmic significance by the addition of motifs representing water, the lotus, and Mt. Meru, the cosmic axis.

Skullcups, which serve as emblems of terrifying deities, are an essential element of tantric ritual. Lamas and mahasiddhas are often shown holding skullcups (S33, S37), from which they drink consecrated liquor or beer during the performance of esoteric rites. Actual blood may be imbibed on occasions; in such a ritual, a lama probably symbolizes one of the gods drinking the blood of his victim.

Though skullcups are frequently formed from an actual human cranium lined with metal, this example is made entirely of metal. It has been made particularly expressive by its depiction of the row of teeth and the deep eye sockets. Moreover, the elaborate and rich design of the lid, with its cosmic symbolism, makes this an unusual example. Its style, especially the use of natural motifs, is borrowed from the imperial Chinese robes and brocades often presented to important Tibetan monasteries by the emperors. It is extremely difficult to be certain whether this beautiful skullcup was made in China or in eastern Tibet.

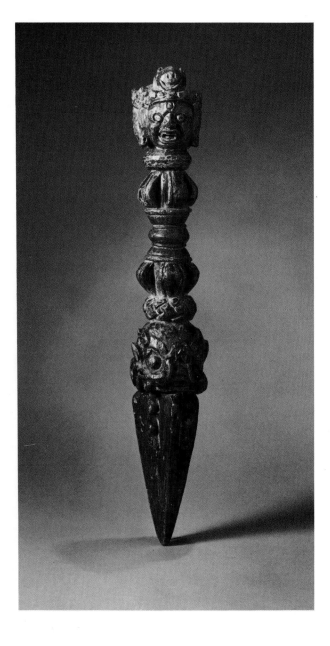

Ritual Dagger (Phurpa)
Western Tibet, 16th century
Wood with polychrome
l: 19 in. (48.3 cm.)
Indian Art Special Purposes Fund
M.78.45

The *phurpa*, or *phurbu*, is perhaps the most distinctive and enigmatic of all Tibetan ritual objects. The word is variously rendered in English as "magic dagger," "enchanting dagger," "peg," or "nail," and in French as *arme*. Though many articles and even a book have been devoted to this implement, its symbolism and origin remain elusive. It has been compared by one scholar with the divination arrow of the shamans (Meredith); another (Stein 1977, p. 62) sees in it diverse connotations of "*vajra, arme terrible, langue qui absorbe et goute, et phallus.*"

The component *phur* in the words *phurpa* and *phurbu* is a Tibetan rendering of the Sanskrit word *kila,* meaning peg or nail. As was recently shown, the *phurpa* is an implement that nails down as well as binds (Wayman 1981). It was thus by stabbing a *phurpa* into the earth, and thereby nailing and binding the evil spirits, that Padmasambhava, regarded as the inventor of the implement, consecrated the ground on which the Samye monastery was established in the eighth century. Whatever the original shape of an Indian *kila* may have been—none has survived—it seems very likely that in Tibet the form of the *phurpa*, with its three-sided blade, was suggested by the pegs that were driven into the earth to hold the rope stays of the tent. Padmasambhava may well have picked up one such peg from a tent of a nonbeliver and used it dramatically to exorcise the so-called "malevolent" spirits of pre-Buddhist religion in Tibet.

This unusually large and handsome *phurpa* is a fine example of those which were carved in wood and painted. Characteristically, a snake descends down each face of the three-sided blade. The long handle is carved with a *makara* at the hilt; underneath, the *dorje* is sandwiched between two knots of immutability; it is crowned with the three terrifying and grinning faces of Dorje Phurpa, the personified deity of the implement (S21). The knot of immutability may have been added because of the "binding" or "fastening" symbolism of the instrument. All this formal and symbolic enrichment of the *phurpa* must have been done in Tibet.

Neither the date nor the exact provenance of such *phurpas* is easy to establish. This work's condition suggests that it has some age; the style of the faces, which provides the only clue, is closely related to others which have been assigned to the sixteenth century (Huntington 1975, figs. 18, 48).

R7

Ritual Dagger (Phurpa)
Eastern Tibet (?), 17th century
Ivory, silver, and carnelian
l: 8½ in. (21.6 cm.)
Gift of Mrs. J. LeRoy Davidson
in Memory of Dr. J. Leroy Davidson
M.82.27
Literature: Huntington, 1975, pp. 34–35, figs. 42–44; Pal, *Elephants and Ivories in South Asia,* Los Angeles County Museum of Art, 1981, p. 100.
See plate 45

Entwined coils of snakes and the *makara* embellish the three-sided blade of the dagger. The lower section of the handle consists of two rows, each with grinning skulls, trefoil motif, and lotus petals. The wider upper section is carved with the three heads of Dorje Phurpa (S21). Each terrifying head has a grinning, fanged mouth, a third eye, a skull diadem, and flying hair. At the summit of the *phurpa* is a narrow cap of silver, surmounted by a circular piece of polished carnelian. According to Huntington, this thin sliver of stone is a substitute for the diamond *(vajra)* and is said to have the same symbolic value.

This is a particularly fine and relatively old example of an ivory *phurpa*. Articulately carved, the faces of the deity are more stylized and masklike than those in the wooden example in the collection (R6). This stylization, as well as the attempts at modeling the faces, may show some Chinese influence; hence, the

Ritual Dagger (Phurpa)
See plate 45

Chopper

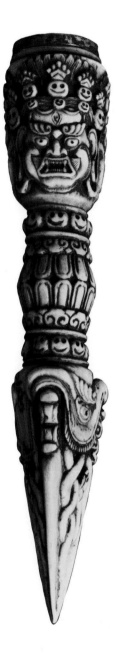

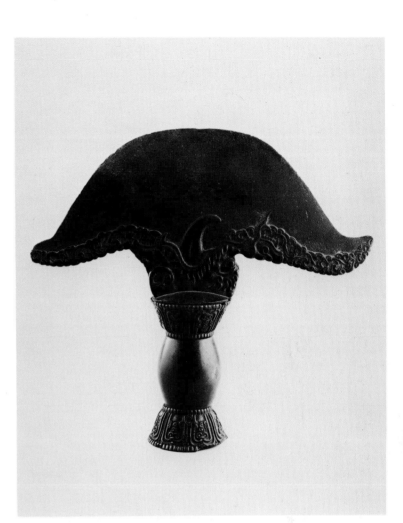

suggestion that the dagger may have been carved in an eastern Tibetan workshop. The skulls on this dagger are especially attractive and amusing. Hardly frightening, they are reminiscent of the smiling faces on Halloween pumpkins.

R8

Chopper
Eastern Tibet, 17th century (?)
Iron
l: 8½ in. (21.6 cm.)
Indian Art Special Purposes Fund
M.78.32

Both the shape and design of this chopper are visually arresting. Stylized lotuses showing Chinese influence decorate the base and neck of the handle. The lower edge of the blade, including the entire portion that is attached to the handle, is

adorned with the ornate and busy form of a *makara,* its jaws wide open and its tongue sticking out of its mouth.

The chopper is one of the most prominent weapons used by Buddhism's angry deities, both male and female. Continuously brandished by them or simply carried in their hands, its purpose is to chop up disbelievers. Just as the thunderbolt is typically paired with the bell, so do the chopper and skullcup generally accompany each other (S25, S26). The symbolism of the two may be the same. Since the chopper is the instrument for cutting through the fog of ignorance, it may signify the *upaya,* or means, while the blood in the cup symbolizes wisdom. In many ways, the chopper serves the same purpose as the *dorje* or the *phurpa* and is employed in rituals of exorcism by priests and shamans. This particularly handsome example may have been created in Kham in eastern Tibet, or possibly even in China.

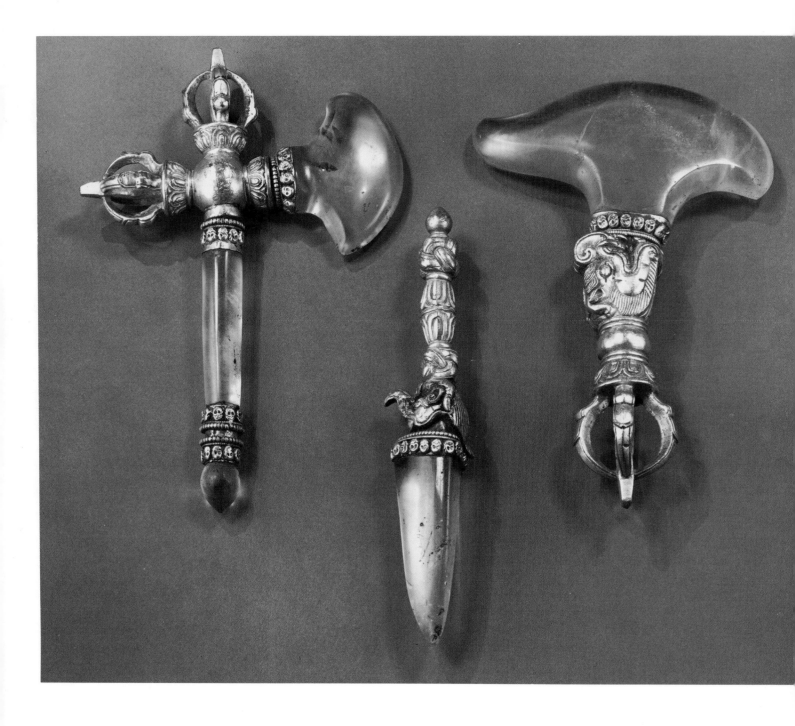

Set of Three Ritual Weapons
Eastern Tibet (Derge?), 17th century or
earlier
Gilt bronze and crystal
l. of chopper: 8½ in. (21.6 cm.)
l. of *phurpa*: 8 in. (20.3 cm.)
l. of axe: 8⅞ in. (22.5 cm.)
Purchased with Funds Provided by
Anna Bing Arnold
M.79.243.1–3.
Literature: "Chopper, Phur-bu, Axe,"
Los Angeles County Museum of Art Bulletin,
vol. XXVI, 1980, pp. 60–61.

One rarely comes across so completely or finely crafted a
set of ritual implements made of crystal as this one. The imple-
ments were very likely used in ritual ceremonies by a high lama
who may have received the set as a gift from a princely patron.

The crystal blade of the chopper is attached to the gilt-
bronze handle with a clasp decorated with grinning skulls. The
handle consists of a *makara*, a lotus, and half a *dorje* (R4). The
combination of the *makara* head and the row of skulls is re-
peated at the base of the hilt of the *phurpa*, which has a three-
sided crystal blade. Supported on the makara's head, the handle
of the *phurpa* is in the form of two lotuses sandwiched between
two knots of immutability. The crowning element is a knob
that may represent a closed lotus bud. A similar knob, but of
crystal, at the bottom of the axe handle *(parasu)* is separated
from the crystal handle by two clasps with rows of grinning
skulls. Another clasp with skulls joins the handle to the axe
head, which consists of a crystal blade and two halves of a *dorje*
joined at right angles to each other.

Both the crystals and the metal handles reflect the excel-
lent workmanship for which Derge was famous. The contrast
between the clarity of the translucent crystals and the richness
of the gilt handles makes these ritual weapons especially attrac-
tive. Because the forms of such implements changed so little
over the years, it is difficult to suggest an exact date for this set.
The quality of the craftsmanship suggests that they may have
been gifts sent to the Tibetan lamas by the Ming emperors
of China.

R10

Sword
Central Tibet, 18th century
Steel blade, jade handle; silver sheath
inlaid with coral and turquoise
l: 21½ in. (54.6 cm.)
The Michael J. Connell Fund Purchase
M.77.111.1
See plate 46

This sword was probably made in the same workshop as
the conch shell (R11), for the metalwork and inlay in both are
identical and of the same excellent quality. The jade handle of
the sword, carved with a beautiful floral design, is similar to the
handles seen in Mughal daggers of the seventeenth and eigh-
teenth centuries. Trade between India and Tibet during the

Sword
See plate 46

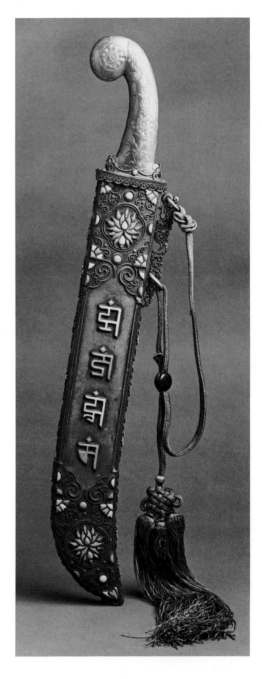

Conch Shell
See plate 47

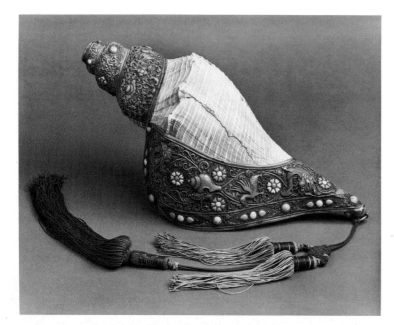

Mughal period continued unabated, and thus there is nothing surprising about a Mughal-style dagger handle finding its way to that country. (Apparently, exquisite Mughal carpets may still be seen in the Potala in Lhasa.) However, there is also reason to believe that some of the so-called Mughal jades were actually carved in China and exported to the Indian market. The handle of this sword may well be one such export jade.

The sheath of the sword is an excellent example of the sort of metalwork for which craftsmen of eastern Tibet were famous. The central panel of the sheath has four sacred syllables rendered in high-relief in a bold and clear Sanskrit script. The rest of the surface is decorated with exquisitely inlaid turquoise flowers and scroll designs formed with fine silver wires. As with **R11**, tassels are attached to the sword. The sacred syllables, as well as the sword's association with the conch shell, leave no doubt that it was used in religious rather than civil ceremonies. Like the *phurpa,* the sword is brandished by monks and priests during exorcism ceremonies.

R11

Conch Shell
Central Tibet, 18th century
Silver, coral, jade, and turquoise
l: 15½ in. (39.4 cm.)
The Michael J. Connell Fund Purchase
M.77.111.2
See plate 47

A conch shell is an essential implement in both Hindu and Buddhist ritual. Some shells in their natural condition are used as containers for consecrated water and often placed on top of a water pot on an altar. Others, such as this example, are used as trumpets. Hindus in India believe that the sound of a conch shell drives away evil spirits, and not only is it blown during ritual and all auspicious ceremonies, but, in many parts of the country, it is also blown three times daily as dusk descends. Presumably the Buddhists also adopted the same practice for their rituals, and hence the custom is prevalent in Tibet.

Often the natural conch shell is decorated with metal around the mouth and flanges. The inlay in this sumptuous example is particularly fine, showing the Tibetan craftsman at his best. Apart from meandering tendrils, rosettes, and dense foliage, the decorative patterns include a conch shell and a flying bird. Colorful tassels are attached to the end of the shell, which probably comes from the same worship as the sword (**R10**).

R12

Water Pot
Central Tibet (Gyantse?), 18th century
Silver, crystal, turquoise, and opal
h: 11½ in. (29.2 cm.)
Purchased with Funds Provided by The
Ahmanson Foundation
M.75.10

Water is perhaps the most important element in both Hindu and Buddhist ritual and is always present on the altar, either in a sumptuous pot such as this or in some other container. (A wide variety of water pots are used and are known by different names, depending upon their function.) During various ceremonies, the priest or monk sprinkles water as he mut-

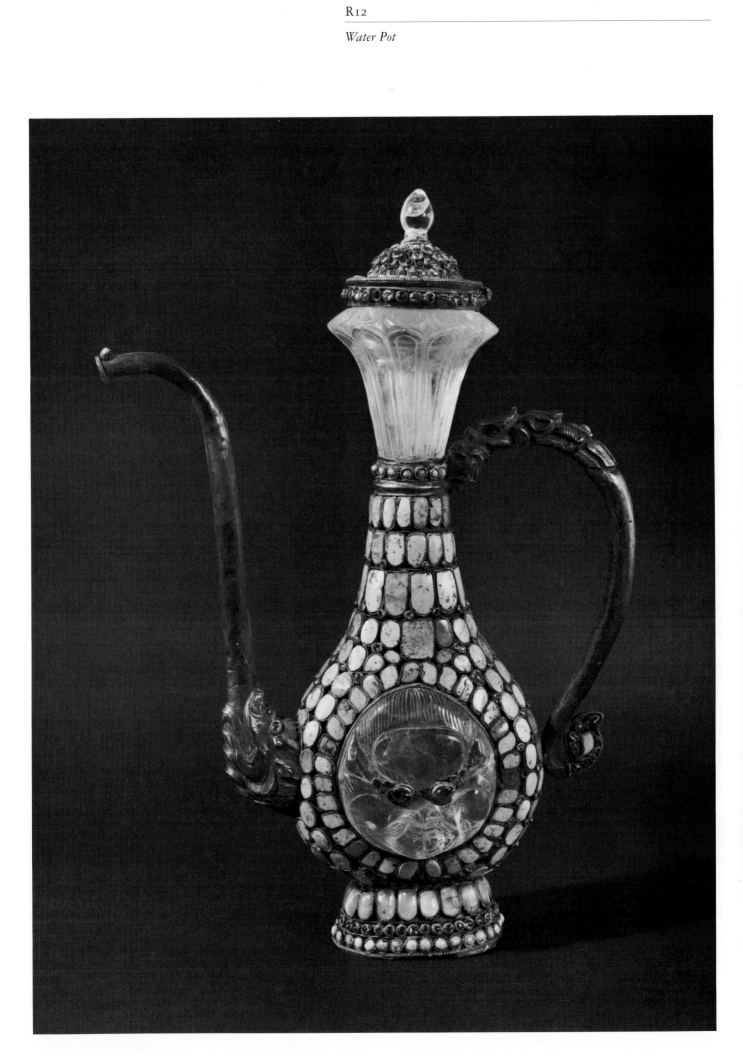

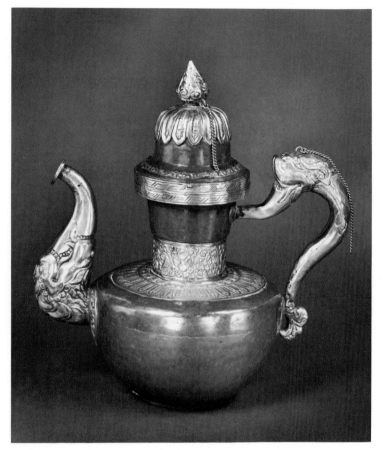

ters mantras on the deity, himself, and the congregation. This action symbolizes general cleansing and is essential in any ceremony or initiation rite. As a Tibetan tantric master has said: "By initiation with water, if one contemplates the path based thereon, one is able to wash away the defilements which block the way to Buddhahood" (Beyer, p. 410).

Each side of this piece is inlaid with turquoises and opals set in granulated silver and is decorated with an impressively carved crystal *kirttimukha,* or face of glory. An auspicious motif in Indo-Tibetan culture, the face of glory is a masklike, stylized lion's face similar to the *tao-tieh* mask of China. Here, the face is made more expressive by the use of opals for the eyes. The neck of the pot is a fluted and hollowed crystal that flares at the top. The lid is encrusted with small stones and there is a crystal knob in the shape of a lotus bud at the summit. The slender silver spout rises from the mouth of a *makara* while the serpentine handle is embellished with a dragon's head and an inlaid, foliated tail. The crystals, opals, and the diverse shapes and colors of the turquoise help create a richly variegated surface. Despite the sumptuousness of this decoration, the outline of the pot remains simple and elegant.

The form of such water pots may ultimately derive from Central Asia. This elaborate specimen is a superb example of the carving and inlay work for which Newari craftsmen from Nepal were especially admired. Possibly this pot was made by a Newar in the Gyantse region.

R13

Teapot
Northern Nepal, 18th–19th century
Copper and silver
h: 12 in. (30.5 cm.)
Gift of Dr. Ronald M. Lawrence
M.74.139.13

This teapot, unlike the sumptuous water pot for ritual use (R12), is of a type meant for daily use. The two pots differ in their decorative designs, as well as in their shapes. The features they share in common are a *makara* spout and a serpentine handle, but here a *makara* head also appears on the handle. This pot is broad and squat, and its decoration consists of silver work that contrasts effectively with its copper body. In addition to the mythical and auspicious creatures, plant motifs—especially the lotus—are used as decorative elements. All these animal and vegetable motifs are associated with water, and as ancient aquatic symbols of abundance and fertility, they are especially appropriate for a pot, whether it was made to dispense consecrated water or hot tea.

The pot was acquired by the donor in northern Nepal and may have been locally manufactured.

Pair of Butter Lamps
Eastern Tibet (Derge), 18th century
Silver, gilt, and inlaid stones
h. of each: 11 in. (28 cm.)
Purchased with Funds Provided by
Anna Bing Arnold
M.78.23a–b
Literature: *Los Angeles County Museum of
Art Bulletin,* vol. XXVI, 1980, p. 71.
See plate 48

Shaped like chalices, from which their forms may have
been derived, butter lamps such as these are typically Tibetan,
and are part of the essential equipment on altars in temples and
domestic shrines. Usually made of silver and enriched with
gilding, they are among the finest examples of Tibetan metal-
work. Although they were also manufactured in other places,
the most important center for this kind of work was Derge.

Each lamp is made in three separate sections that are
joined together. The base is decorated with a narrow band of
stylized vegetable design at the bottom; two rows of lotus petals
of different design are at the top. The lower row has longer pet-
als with fluted surfaces and flaring tips. The middle section is a
pot which takes the same form as the vase of immortality held
by Amitayus (**P1**). It is also adorned with lotus petals. The cup
holds yak's butter, which is used as the combustible substance,
and is beautifully enlivened with lotuses and sinuous plant
motifs. The flowers in the cartouches are rendered more natural-
istically than the forms used below.

R15

Portable Shrine (Gau)
Eastern Tibet (Derge), 18th century
Silver with partial gilding
8⅜ x 6¼ in. (21.2 x 15.9 cm.)
Indian Art Special Purposes Fund
M.80.48

Although portable shrines or amulet containers are famil-
iar in India (for example those of the Lingayat Saivas), nothing
quite like the Tibetan *gau* is known to have been used by Indian
Buddhists. It may be pointed out, however, that in Thailand a
devout Buddhist may hang a miniature shrine containing an
image of the Buddha around his neck.

At home the *gau* is kept on an altar, but when traveling,
a Tibetan fastens it to his crossbelt. Generally, the *gau* has a
trefoil-shaped top and a window in the middle through which
one can see an image of the owner's personal deity *(ishtadevata)*
wrapped in silks. It is made of two parts which fit together to
form a box. The back is usually left plain and the richly deco-
rated front is always visible through the opening in the cloth
case in which a *gau* is usually kept.

This *gau* is an especially fine example of ornamental
metalwork. The central portion around the opening, the nine
auspicious symbols, the flying *kinnaras,* and the bowl of offer-
ings at the bottom are all gilded to create an effective contrast
with the silver work. The background design consists of a
deeply carved and smoothly chased flowering vine that meanders

Portable Shrine (Gau)

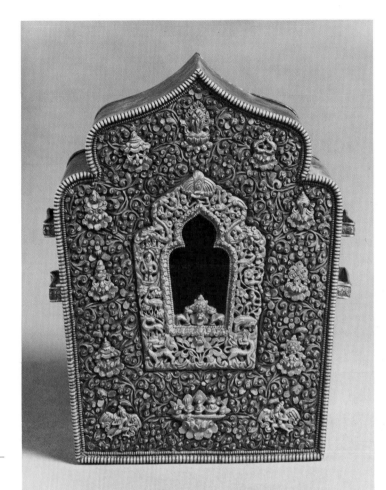

Portable Shrine (Gau)

Set of Votive Plaques (Tsha Tsha)
(above)

Mold for Dough Images (Zan Par)
(below)

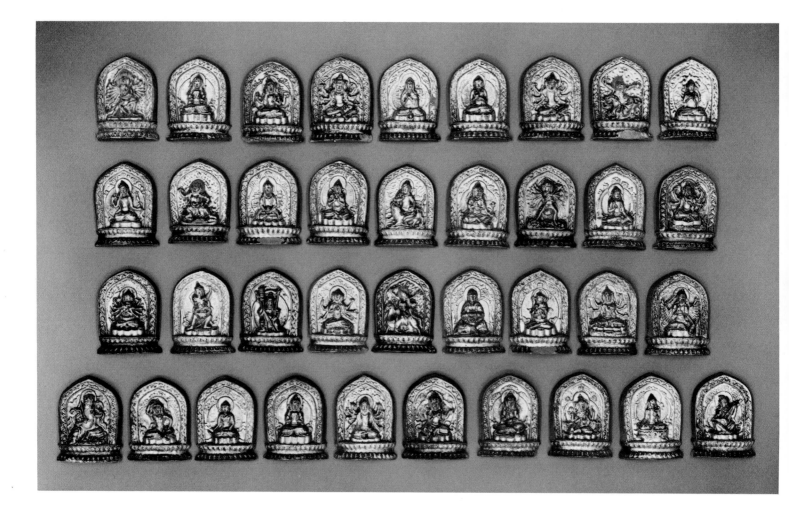

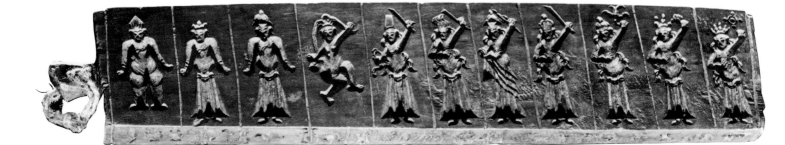

over the surface. The central panel weaves together animals, birds, a warrior, dragons, and a *khyung* with a reticulated flowering-vine motif. The windowsill has the combined motif of a wheel flanked by two animals. Usually, these are a pair of antelope, but here the artist appears to have depicted an antelope and a stylized lion. Although natural enemies, this pair symbolizes peace and harmony and is an ancient motif in India. The other fauna in the central panel include lions, an elephant, an antelope, a crane, a monkey, and a rabbit.

R16

Set of Votive Plaques (Tsha Tsha)
China, 18th century
Gilded and painted terracotta
h. of each: 3 in. (7.6 cm.)
Gift of Mr. and Mrs. J. J. Klejman of
New York
M.71.26.1–37

Small votive plaques such as these, generally made from molds, are known in Tibetan as *tsha tsha*. Large numbers of them have been found in ancient Buddhist sites in India as well as in Central Asia. They were made to serve as pilgrims' souvenirs, portable shrines, and to be inserted into large stupas and images to increase the containers' potency. Such plaques were evidently mass produced. Each plaque has on its back inscriptions identifying the deities in four languages—Chinese, Mongolian, Manchurian, and Tibetan. (For a transcription of the Tibetan names, *see* Appendix.)

Although incomplete, this set once belonged to Baron A. von Stael-Holstein, who acquired them in Beijing (Peking) in the last century. The baron also found a large number of the bronze molds from which these plaques were made, and clearly established that the molds originated during the reign of Emperor Qianlong (Chien-lung) (r. 1736–95). They may be compared with similar pantheons published by Walter Eugene Clark (1965, p. x and pls. 1–222, 225ff). Because each deity is identified on the back, these plaques are of considerable historical and iconographic interest. Both their good condition and the sharp delineation of the figures make them useful sources for the study of Vajrayana Buddhist iconography.

R17

Mold for Dough Images (Zan Par)
Provenance unknown, 19th century (?)
Wood
h: 3 in. (7.6 cm.); w: 16 in. (40.6 cm.);
d: 1 in. (2.5 cm.)
Gift of Mrs. Ann Rohrer
M.76.23

Since live sacrifice is forbidden in Buddhism, the Tibetans contrived different methods of offering substitutes. We have already seen the *rgyan tshogs* (**P30**, **P31**), which are painted substitutes. Another kind is known as *torma*; it is made from dough stamped into special carved wooden molds such as this one. A wide variety of figures, including humans, animals, birds, aquatic creatures, insects, and inanimate objects such as household goods, are portrayed in these substitute offerings. They are placed in rows on an altar and the evil spirits are coerced into accepting them instead of the real thing. (For a de-

R18

A Ritual Object with Unicorns

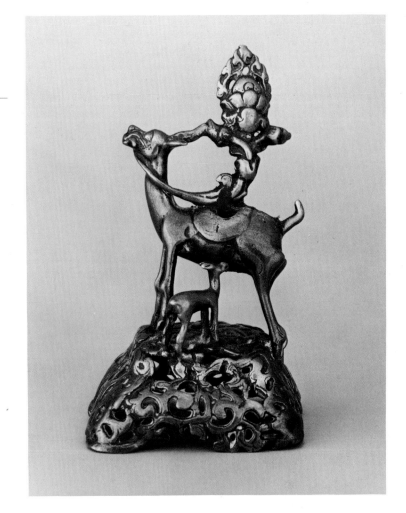

tailed description of this ritual in connection with the cult of Tara, *see* Beyer, pp. 324ff.)

Since the use of substitutes is widespread in Tibetan sacrifice rituals, it is difficult to determine the exact provenance of such molds. What is clear, however, is that the designs here and on other examples are freely rendered in an abstract, linear style which may reflect an ancient "animal style" that has not changed through the ages. Although abstract, the representations are typically lively and imaginative.

R18

A Ritual Object with Unicorns
Central or eastern Tibet, 16th century
or earlier
Brass
4½ x 2½ in. (11.4 x 6.4 cm.)
Indian Art Special Purposes Fund
M.82.74

A unicorn and its foal stand on an uneven base of pierced, stylized foliage. In its mouth the unicorn carries the stem of a flower, presumably a lotus, which supports a flaming jewel, symbolizing the Buddhist religion. Three holes on the body of the unicorn, one in front and two at the back, indicate

that the object may once have been used as an incense burner.

The unicorn is a familiar motif in Tibetan art; a pair of them often flanks the Wheel of Law on the roofs of Tibetan monasteries. Originally, the animal represented was a deer rather than a unicorn. The combined motif of the Wheel and a pair of deer symbolizes the first sermon of Buddha Sakyamuni in the Deer Park at Sarnath. Exactly when the deer was replaced by a unicorn is uncertain, although the latter animal appears in very early Indian mythology as a fertility symbol. This transformation, however, appears to have occurred in Tibet, where the motif of the unicorn alone or with its foal, as in this example, became a favorite; ritual objects employing it were frequently placed on altars.

Although we are uncertain exactly where and when this piece was made, it is a charming and lively animal sculpture.

R19

Pouch
Central or eastern Tibet, 19th century
Leather, gilt silver, turquoise, and
carnelian
h: 12¾ in. (32.4 cm.); w: 6½ in.
(16.5 cm.); d: 2 in. (5.1 cm.)
Gift of The Louis and Erma Zalk
Foundation
M.82.21

Pouches or purses such as this one, made for carrying flint, are worn suspended from belts or sashes, and are a common feature of Tibetan attire. This pouch, however, is uncommonly sumptuous and handsome. Most likely, it once belonged to a wealthy patron. The leather purse is encased in fine silver work, gilded and encrusted with semiprecious stones. The silver work is both engraved and cast so that the surface has an interesting and varied texture. The ornamental motifs used, lotus and other vegetal designs, are characteristic of this sort of pouch; they are rendered with finesse and precision.

R20

Brooch and Pair of Earrings
Central Tibet, 19th century
Turquoise and silver
l. of earrings: 4¾ in. (12.1 cm.)
diam. of brooch: 4⅛ in. (10.4 cm.)
Indian Art Special Purposes Fund
M.81.3.1a,b and 2

This lotus-form brooch and earrings, made with turquoise, the favorite stone of Tibetan women, are fine examples of Tibetan jewelry. These pieces are said to have been brought out of Tibet by Sir Francis Younghusband, who undertook a punitive expedition into that country on behalf of the British-Indian government in 1904.

Brooch and Pair of Earrings
(above)

Set of Chopsticks and Knife
(below)

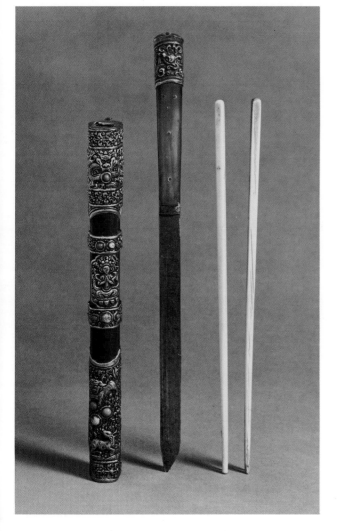

R21

Set of Chopsticks and Knife
Eastern Tibet, c. 1900
Wood, ivory, and silver inlaid with coral
and turquoise
l: 13 in. (33 cm.)
Indian Art Special Purposes Fund
M.80.125a–d

Richly encrusted with coral and turquoise, this hand-
some set of chopsticks and knife was probably intended for use
by a wealthy man. Such sets were carried as personal cutlery by
Tibetans while traveling. The use of chopsticks by Tibetans to
eat their food is a contribution of Chinese culture.

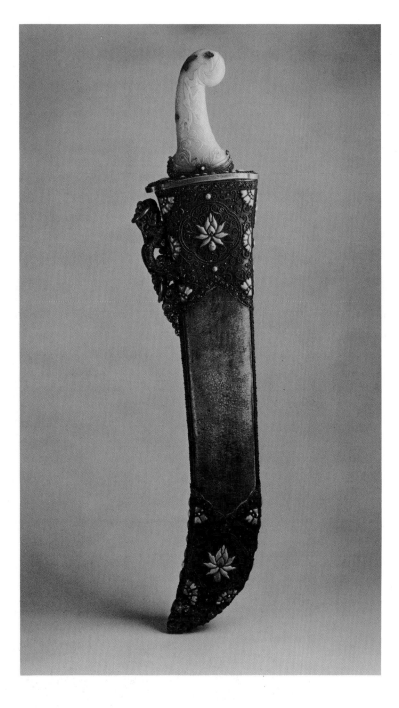

R22

Ceremonial Sword
Eastern Tibet, 18th century
Silver, steel, leather, jade, and coral
l: 20½ in. (52 cm.)
Herbert R. Cole Bequest
TR.6481.17a,b

Except for the differences in their sizes and shapes, this sword is so similar, both in quality and workmanship, to **R10** that it seems very likely they are from the same workshop. The principal difference in this piece may be noted in the absence of the letters on the sheath.

As is the case with the other sword, the lower and upper sections, as well as the narrow sides, of the sheath are decorated with raised floral designs made with silver wires. The flowers are filled in with turquoise and coral. The handle of the sheath is a finely executed dragon, while the handle of the dagger is carved jade. The floral design of the handle is less naturalistically rendered than that on **R10**, but three of the flowers are inlaid with jade and coral petals.

Plate 49
A Monk
illuminated folio from a *Kanjur* manuscript
(M8 a, detail)
See page 267

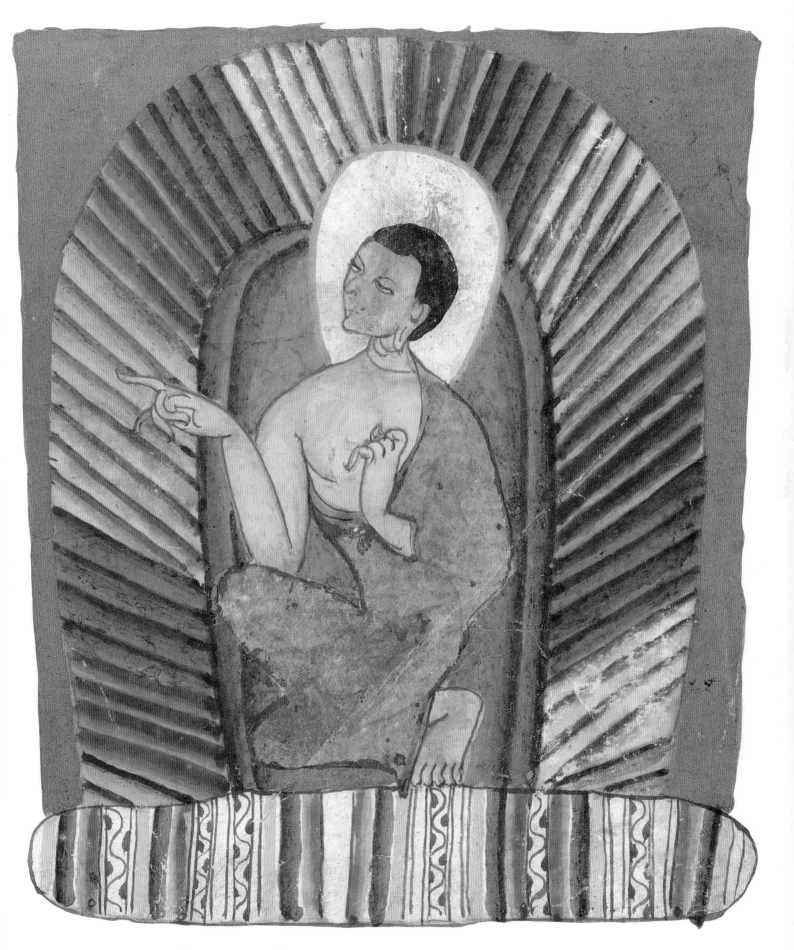

Plate 50
Previous Birth Stories of the Buddha
(P50)
See page 275

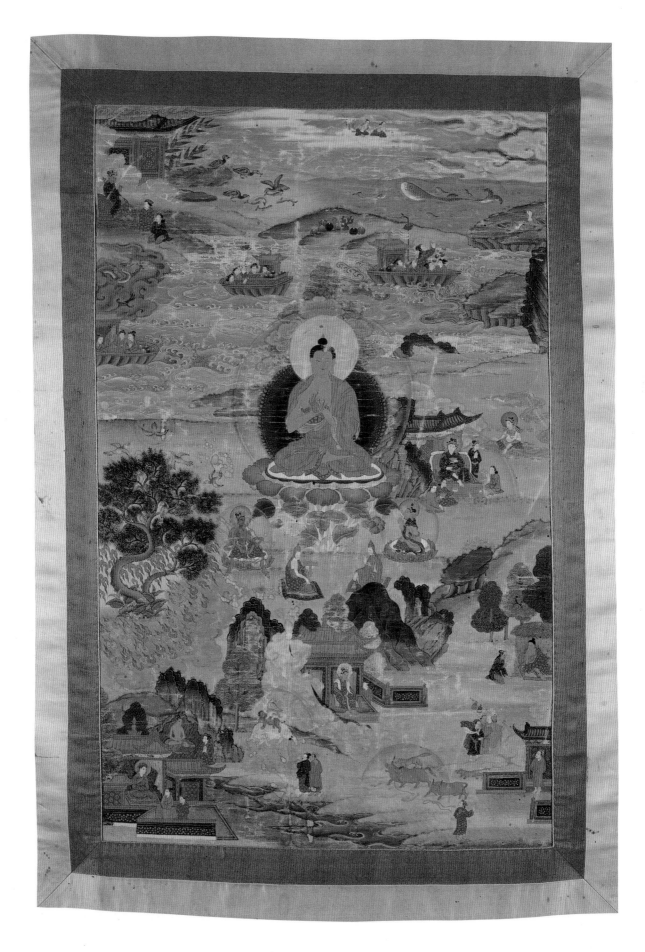

Plate 51
Myriad Samvaras
(P54, detail)
See page 278

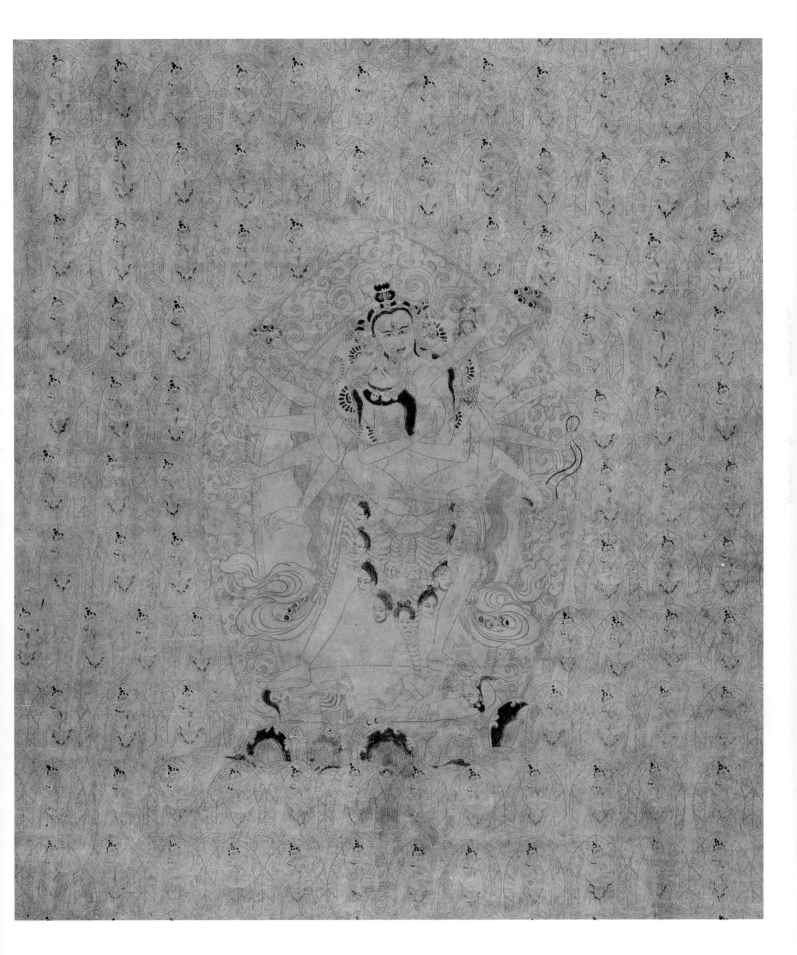

Plate 52
Mahakala and Companions
(P56)
See page 280

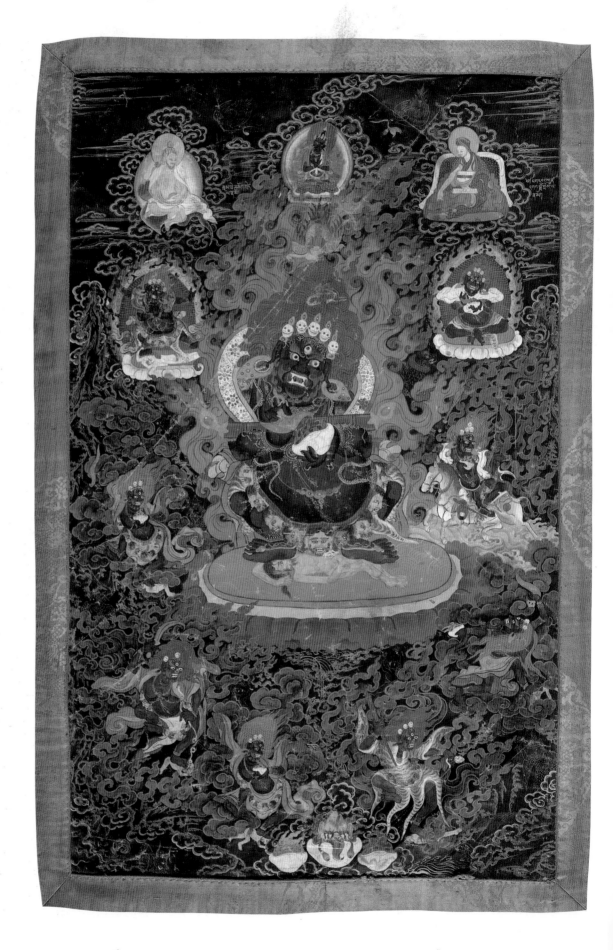

Plate 53
Eleven-Headed Avalokitesvara
(S45)
See page 286

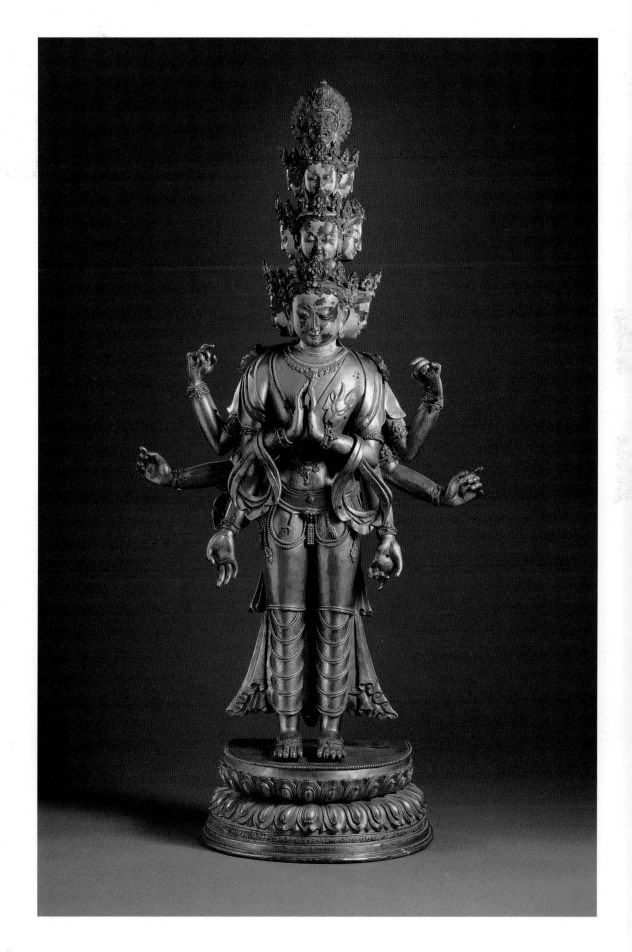

Plate 54
Padmasambhava
(S51 a)
See page 290

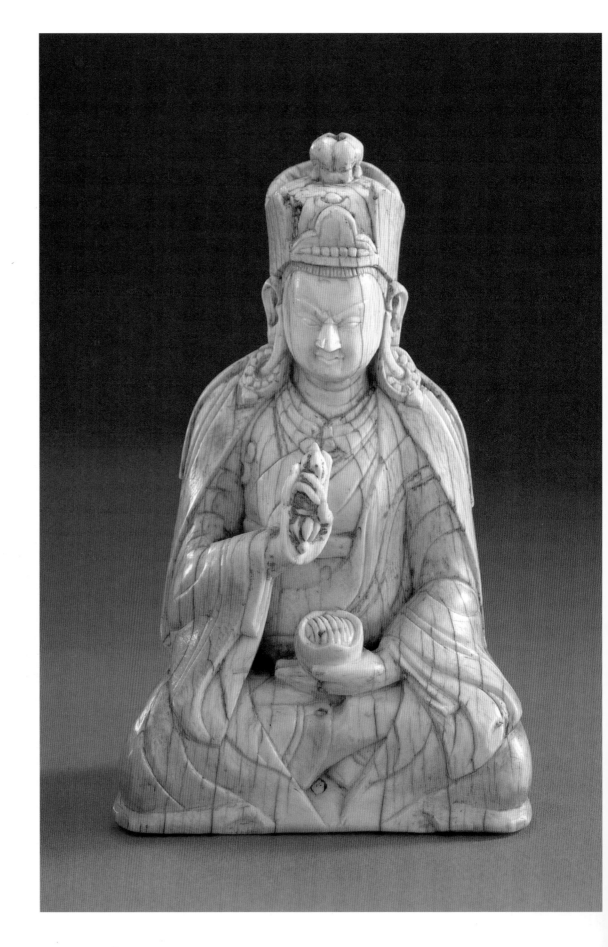

Plate 55
Ceremonial Ewer
(R25)
See page 297

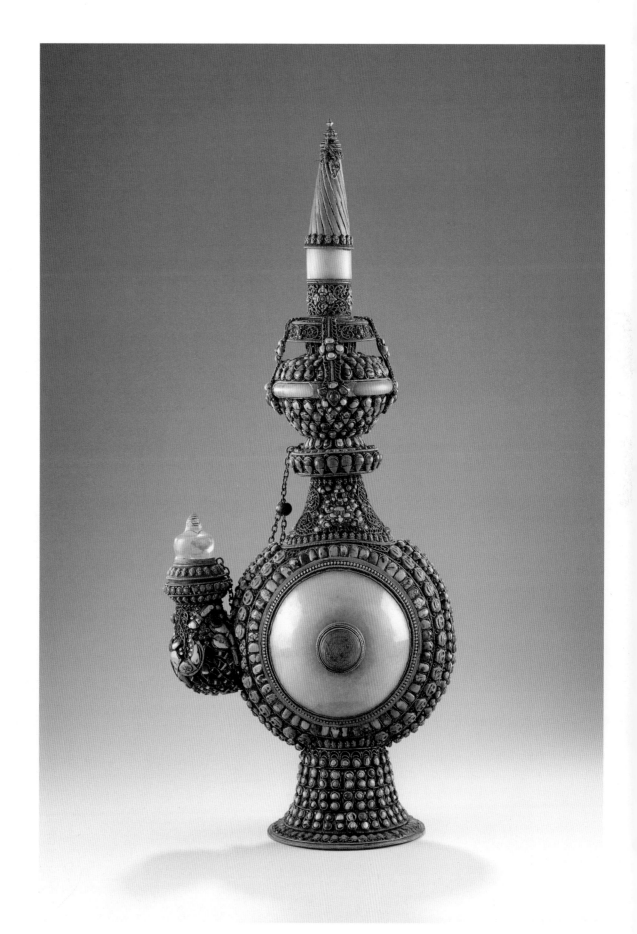

Plate 56
Vajrayogini
(T4)
See page 312

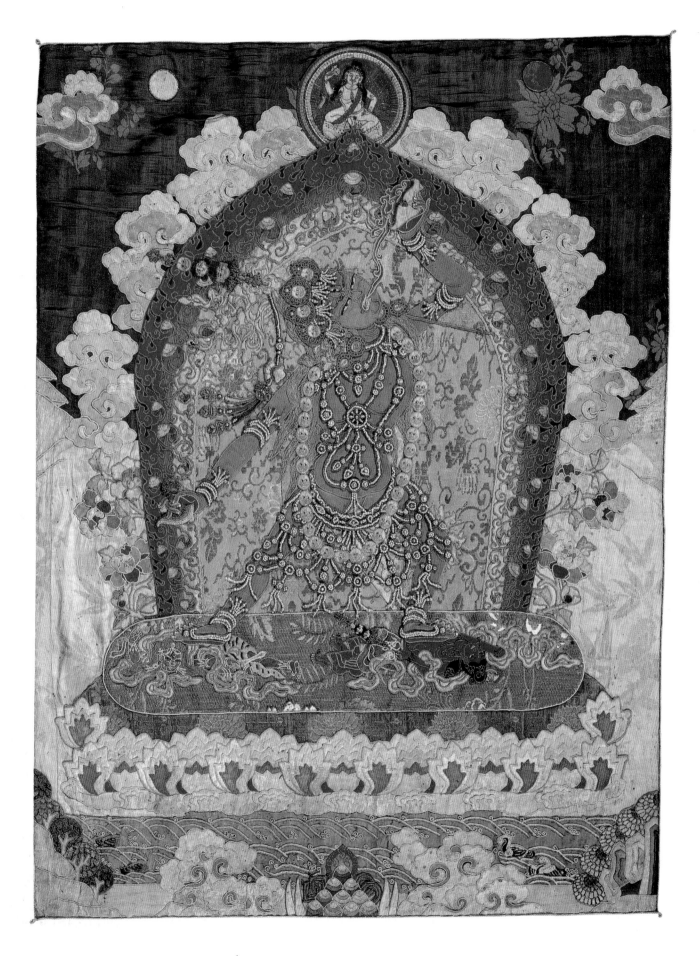

Addenda

This portion of the book consists of a color plate section and catalogue entries for the sixty-five works added to the collection since the first edition. The letter-and-number enumeration method of the original entries is continued here, with the addition of the letter *T* for textiles. Following the catalogue section are additional comments about works in the first edition, changes of accession numbers and credits, and corrections.

Painting

M8

Eight Illuminated Folios from a Kanjur *Manuscript*
Western Tibet (?), 12th–17th century (?)
Ink, watercolors, and gold on paper
Each page: approx. 8 x 26 in. (20.3 x 66 cm.)
Gift of David Salmon
M.86.343.1–.8
See plate 49

It is not possible to write exhaustively here about these intriguing illuminated folios, for a thorough study will require considerable time. The comments presented in this entry must therefore be regarded as tentative.

Each folio represents the title page of a *Kanjur* manuscript, with the text written in the formal *u chen* script. Some of the folios have faintly visible text written in a more cursive script on the reverse. Each page also has red, blue, or yellow cloth title flaps attached at one end. Two illustrations adorn the front of each folio; some are in better condition than others. On four of the folios, separate panels of blue-black-dyed paper with the text written in gold have been added, probably at a later date. At least one such panel has been glued over the earlier writing.

The illustrations depict usually a Buddha on the left of the page and an adoring monk on the right. Labels in the cursive script, several of which are illegible or damaged, identify the figures. At least three distinct styles of painting are discernible. In folio *a* the pictures seem to suggest the eleventh-century Kashmiri style in the coloring, drawing, and proportions of the figures. The rainbow effect of the aureoles behind the figures is a faint echo of the more brilliantly painted backgrounds of eleventh-century Kashmiri-style illuminations (M1). The second style, represented by *b*, clearly derives from the Nepali mode of several other examples in the collection (M2–M4, M6). Yet a third group of images, represented by *c*, are painted in the Kadampa style, which flourished particularly in central Tibet between the eleventh and fourteenth centuries (*see* P1–P3) but was also known in western Tibet (Pal and Fournier).

Because of vestigial traces of the Kashmiri style, one can assume that the folios probably were copied in a monastery somewhere in western Tibet. The problem, however, is with their date. Both because of the varied styles of the illuminations and their inconsistent placement and sizes, it would appear they were not planned or rendered at the time the manuscript was copied, if indeed all the folios belong to one manuscript. The Kadampa-style pictures are unlikely to have been done after the fourteenth century, while the Nepali-style illuminations relate generally to thirteenth- and fourteenth-century paintings. More difficult to date, however, are the so-called Kashmiri-style illuminations. Interestingly, the cushion on which the monk kneels in *a* shows a textile pattern similar to that on the garment worn by a goddess in a problematic illumination of another manuscript in the collection (M1 e). This picture may have been painted as late as the sixteenth century. Noteworthy also are minor similarities between two other illuminations in that manuscript (M1 j and k) and the two figures here, especially in the shape of the two Buddhas' hair and the somewhat awkward manner of the clenched fist of the Buddha in M1 j and the monk in this example.

It seems therefore that the pages may have belonged to a manuscript that was copied around the twelfth century somewhere in western Tibet. At least two different styles of handwriting can be recognized, and for some reason the title illuminations were not added at the time. Most of the illustrations were probably added in the fourteenth century, a few being done still later.

M9

Book Cover
Western Tibet (?), 14th century
Wood with colors and gold
10½ x 28⅛ in. (26.7 x 71.4 cm.)
Paul Walter Collection
M.86.345.12

Enshrined in the center of the rectangular band is the goddess Prajnaparamita, which indicates that the cover once belonged to a *Prajnaparamita* manuscript. The two figures on either side seated on lotuses within ogival aureoles are Buddhas. The crowned, bejeweled figure on the goddess's left holding a pot in his lap is Amitayus, the Buddha of infinite life. The other may represent either Buddha Sakyamuni at the moment of enlightenment or Akshobhya, one of the five transcendental Buddhas. The rest of the ground consists of deeply carved luxurious foliage and two leaping lion-griffins. Additional foliage, carved less deeply, adorns the area surrounding the central panel. The entire surface was once washed in gold, and some details were highlighted in red and black, only minute traces of which now remain.

M8 a

A Buddha and a Monk
Western Tibet (?), 12th–14th century
M.86.343.1
See plate 49 (detail)
(above)

M8 b

A Buddha and a Monk
Western Tibet (?), 14th century
M.86.343.2
(below)

A Buddha
Western Tibet (?), 14th century
M.86.343.3 (detail)

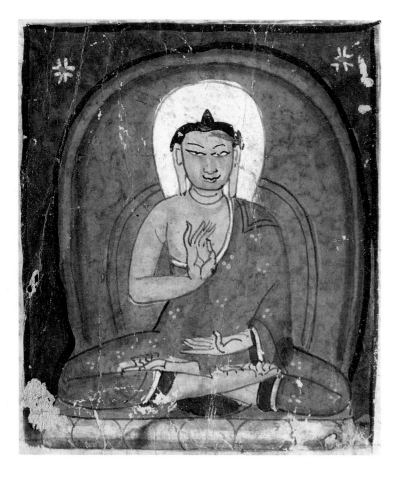

Compared with the three divine figures, the animals on the throne and the two leaping griffins are remarkably animated. It seems as if the artist deliberately wished to contrast the dynamic flux of the lively animals and swirling foliage with the calm serenity of the Buddhas and the goddess.

M10

Five Folios from a Gyalpo Kachem *Manuscript*
Central Tibet, c. 1500
Ink, colors, and gold on paper
Each page: 7 x 22 in. (17.8 x 55.9 cm.)
Each illustration: 3¼ x 3 in. (8.3 x 7.6 cm.)
Three folios: Gift of Mr. and Mrs. Jack Zimmerman
M.84.171.5–.7
Two folios: Given anonymously
M.87.272.3–.4

The five folios are from a manuscript that has been tentatively identified as *Gyalpo Kachem* (Will and testament of the king). Other folios are in the Newark Museum collection (Reynolds et al., pp. 148–50). The text was supposedly written by the seventh-century king Songtsen Gampo, hidden thereafter and rediscovered by Atisa in the eleventh century. Tibetans refer to such rediscovered treasures as *terma*.

Each folio is stained blue-black, which makes the gold script prominent. There are seven lines of text on each page and two illustrations. Below each illustration is a label identifying the figure, and above a mantra. Unfortunately, the labels are often indistinct. As in the Newark pages, the illustrations on three pages are of Buddhas. Except for their gestures the Buddhas are identical. In the Newark catalogue it has been suggested that the Buddhas may represent the Thirty-Five Buddhas of Confession of Sins (*see* M5, P8) or the Thousand Buddhas. The former seems unlikely since neither the decipherable names nor the attributes agree with known images of the Thirty-Five Buddhas.

The eight figures on the two remaining folios can be identified as mahasiddhas. Two of the labels can be clearly read as Bha ga na and Sgra mkhan zabs. The iconographic features of the mahasiddhas, however, are extremely simplified.

Characteristically, the figures of the Buddha are somber representations, though they have been somewhat enlivened by the slight inward turn of their bodies. Much more varied and animated are the depictions of the mahasiddhas engaged in various activities. Of the two mahasiddhas represented on the page illustrated here (*a*), the figure on the left is dressed as an Indian monk, while the other is depicted as an ascetic. The outlines of the figures as well as of the lotuses and clouds are freely drawn in bold strokes, and the coloring is remarkably rich and varied. While all the figures are represented in minimal landscape—the green ground behind them rising to a pointed peak indicating a hill with indigo blue sky—the cloud patterns differ considerably both in shape and color. The Buddhas are given green or blue aureoles with white or yellow flame borders. The aureoles of the mahasiddhas are uniformly red. The haloes of both groups are either green or blue. The lotuses on which they sit are painted in pink mauve or orange, while all hair is rendered in black. All the Buddhas have yellow complexions, but the mahasiddhas are given skins of pink or brown.

M9

Book Cover
(above)

M10 a

Two Mahasiddhas
M.87.272.4
(below)

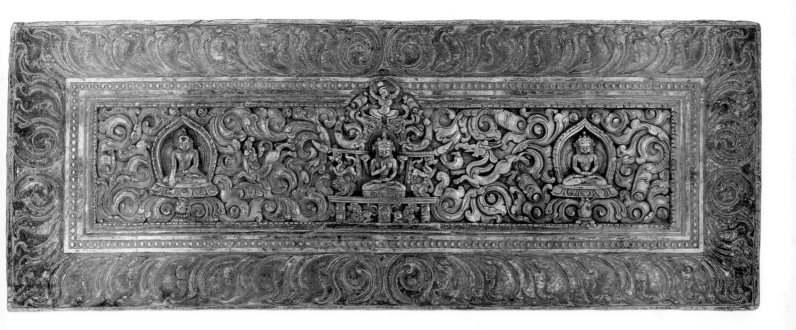

A Buddha (detail)
M.841716

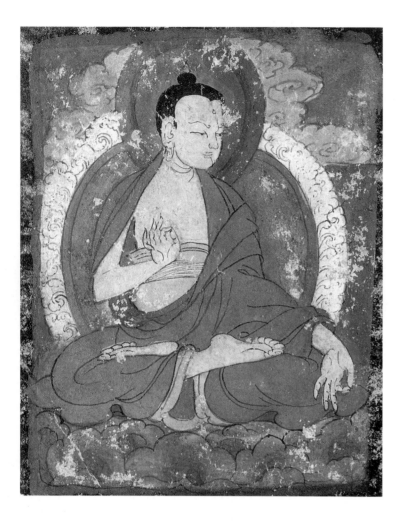

After making stylistic comparisons with existing murals in datable monuments in Tibet, the authors of the Newark catalogue suggest a fifteenth-century date for these illuminations. The end of the century is more likely than the early part.

M11

Manuscript of a Buddhist Tantra
Western Tibet, c. 1630
Gold and opaque watercolors on paper with wood covers
Each page: 3⅜ x 12⅜ in. (8.6 x 31.4 cm.)
Christian Humann Asian Art Fund
M.86.292
Literature: *Sotheby's Tibetan, Nepalese, Indian and South-east Asian Art,* London, March 10–11, 1986, p. 54, no. 171; Pal and Meech-Pekarik, p. 174, fig. 67.

This illustrated manuscript, composed of 183 leaves, is of a tantric text known as *Ngan song sbyong rgyud* (A tantra, the delivery from hell). Written in gold with four lines per page, the manuscript was copied for the benefit of the last king of Guge, Chos rgyal chen po Bkra shis brags pa lde (deposed 1630). The colophon is an extended explanation of the title and, as read and translated by H. E. Richardson, is as follows:

De bzhin gshegs pa dgra bcom pa yang dag par rdzogs pa'i sangs rgyas ngan song thams cad yongs su sbyong ba'i gzi brjid kyi rgyal po'i rtag pa zhes bya ba.

The glorious royal emblem of the perfectly fulfilled Buddha Tathagata who completely delivers all kings in hell. So it is called.

The king was overthrown around 1630 by disgruntled monks for supporting Christian missionaries. Earlier, in 1625, the Portuguese Jesuit Father Andrade, the first European to arrive in Guge, was welcomed by this liberal monarch. In one of the illuminations illustrated here the king is portrayed with members of his family. The figure on the other side of the page is Vaisravana, the regent of the north and the god of wealth. There are ten other illustrations in the book, seven of which show Buddhas and deities, and three lamas.

Art historically this is an important manuscript for several reasons. Not only is it a datable document associated with the last king of Guge, but the illuminations are unusual. Instead of being fully painted, they are line drawings in gold with touches of color, mostly blue and red. Moreover, as they are rendered against the blue-black paper they really relate to the *gser-thang* type of Tibetan painting (cf. P54, P55). Not only is this rare for manuscript illuminations, but they certainly demonstrate that the technique was well known by the early part of the seventeenth century. Both the writing and the illustrations are of fine quality.

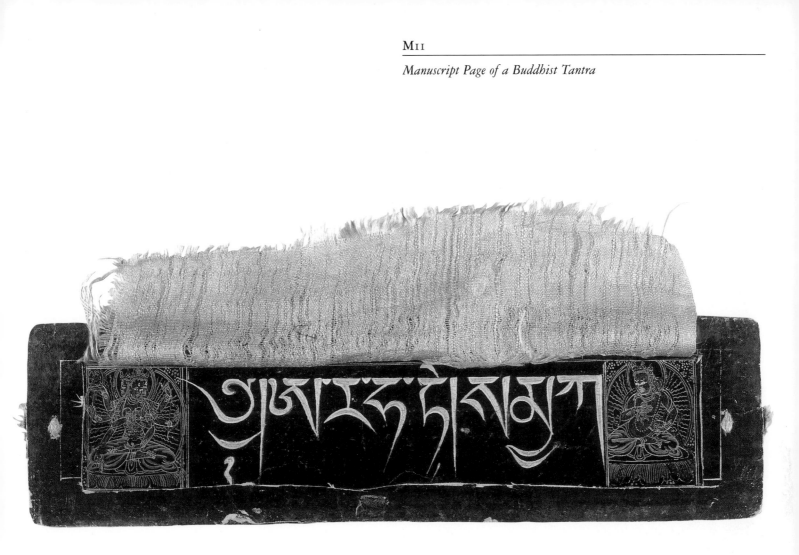

detail of a page

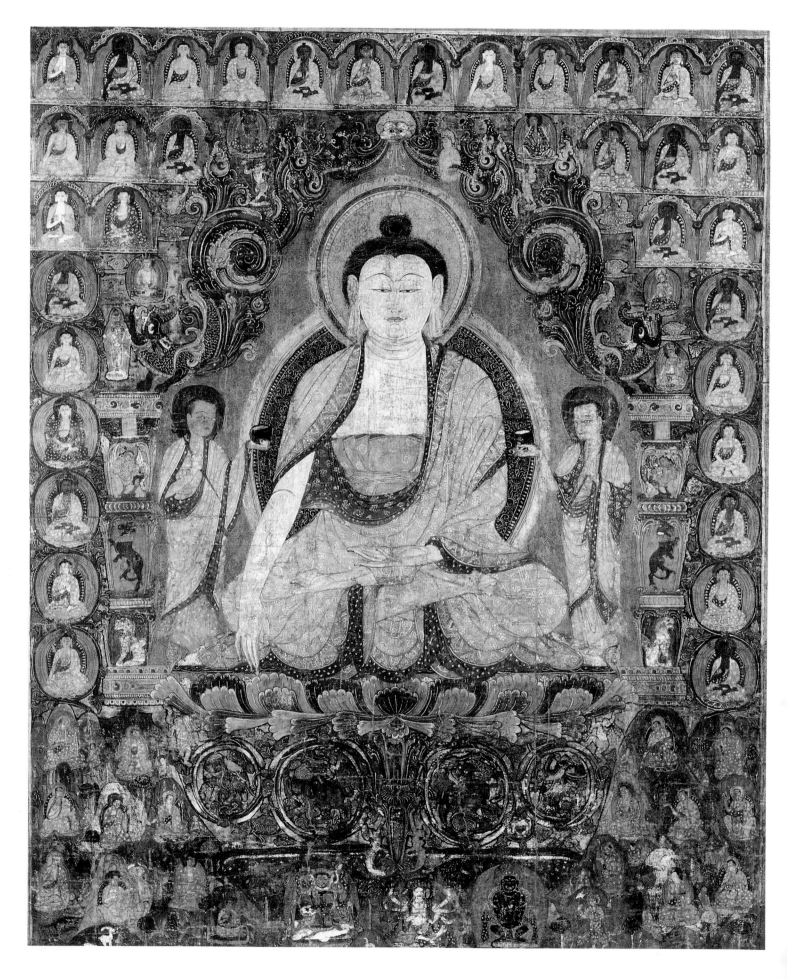

Buddhas and Arhats
Western Tibet (Guge), 15th century
33⅝ x 27⁹⁄₁₆ in. (85.4 x 70 cm.)
Gift of Mr. and Mrs. Michael Phillips
M.84.227.6
Literature: Fisher, 1985, pp. 104 and 107, fig. 64; Pal, 1987 B, pp. 62–63.

The golden Buddha in the center seated on a lotus within an elaborate shrine is Sakyamuni. He is flanked by his chief disciples, Sariputra and Mahamaudgalyayana, each offering him a begging bowl. Immediately around the richly detailed and ornamental arch of the shrine are several small representations of bodhisattvas and monks. On the top and along the sides of the thanka are thirty-five Buddhas portraying the Thirty-five Buddhas of Confession of Sins. On either side of the lotus below Sakyamuni are the figures of the eighteen arhats. Below the lotus the white goddess Ushnishavijaya is flanked by Vaisravana and Mahakala, who are protector gods.

While the Buddhas of Confession of Sins are depicted within shrines or on medallions both formed by lotus vines, the arhats are seated against miniature mountains with trees, foliage, and an occasional animal. The landscape elements are basically of the same form, though more abbreviated, as those enlivening the museum's well-known *Life of Milarepa* thanka (**P14**). The formula, however, is quite different from Chinese forms encountered in central Tibetan paintings and may well have derived from earlier Central Asian tradition.

Except for the landscape elements behind the arhats, the thanka is painted in the same style as three others in the collection (**P6**, **P7**, **P8**). Although the Milarepa thanka is not depicted in the Guge style, its similarities with this thanka help us to be more certain of its western Tibetan attribution.

Divine Figures and Auspicious Symbols
Central Tibet, 16th century
8⅝ x 58⅜ in. (21.9 x 148.3 cm.)
Gift of Mr. and Mrs. Herbert Kurit
M.85.213.4

This narrow, horizontal painting was probably part of a longer scroll, such as one in the Virginia Museum of Fine Arts, Richmond (Pal 1987 B, pp. 56–58). In special religious ceremonies such paintings were employed like a fence to demarcate a sacred area.

The surface of the scroll is divided into three horizontal registers, that in the middle being the widest. The narrower registers are decorated with a stylized floral design at the top and Sanskrit mantras in the formal Lantsa script along the bottom. The central section is filled with a row of dancing female deities, male divine guardians, and auspicious symbols. Altogether there are ten dancing females and three guardians in this segment. All the dancers strike the same pose with either the right or the left

hip thrust out. Six of them hold various objects, perhaps offerings, in their upraised hands, and four display various gestures of the dance. The guardians are all dressed in Tibetan attire. The auspicious symbols include the umbrella made with peacock feathers, vase, conch shells, mirror, gems, and altars with various offerings.

The figures and symbols are of various colors and are separated from each other by their aureoles of contrasting hues. Above them are stylized cloud designs in white and black. Freely drawn in black outline, the figures make a lively group. The rendering is not quite as sophisticated as in the Virginia scroll but is in the same Nepali tradition favored by Sakyapa monasteries. The style seems to be related to the fifteenth-century murals in the Gyantse *kumbum* and to several thankas of the sixteenth century (Pal and Tseng, pp. 37–38, fig. 12; Pal 1984, p. 103, pl. 49).

Previous Birth Stories of the Buddha
Eastern Tibet, 17th century
26 x 16½ in. (66 x 41.9 cm.)
Gift of Mr. and Mrs. John G. Ford
M.84.219
See plate 50

This is yet another fine example of the Karma-gadri style of painting in the collection (*see* **P26**, **P28**). As is usually the case with such narrative thankas, the various scenes unfold around the centrally placed figure of Buddha Sakyamuni, who is recounting the stories of his previous births. Because there are no identifying labels, it is not easy to determine whether the stories are from a compilation of *jatakas* or *avadanas*. What does seem certain is that they are not from the well-known *Avadana-kalpalata* of Kshemendra, which was popular among the Tibetans and of which several complete sets of paintings have been published.

Of the various stories depicted in this thanka at least two can be identified with some certainty. The scene at the lower-right corner probably represents the Mahisha Jataka, when the Lord was born as a buffalo and though constantly harassed by a monkey did not retaliate. The Tibetan artist seems to have replaced the monkey with a jackal. The second story is delineated in the middle left of the thanka in the form of a burning tree full of birds. This may be the Vattaka Jataka of the Pali version or the Vartakapota Jataka of a collection known as *Bodhisattva Avadana*. In the former story the Buddha was once born as a quail and abandoned by his parents when the forest was engulfed by fire. Lying in the nest, the chick remembered the Buddha of the past and saved himself and the other birds. In the second version the Buddha was a crippled and wingless bird and saved the forest from a conflagration by soliciting Agni, the god of fire. The story along the top seems to be concerned with fishes, a whale, geese, and seafaring merchants. It may represent the Dharmaruchi or Timingala Avadana of the *Avadana-kalpalata*, but this is uncertain.

How such Indian texts were Tibetanized is evident from the Buddha's congregation. His audience includes two bodhisattvas and two lamas. On the Buddha's left is a Tibetan monarch, or perhaps Padmasambhava, with a number of attendants.

detail

detail

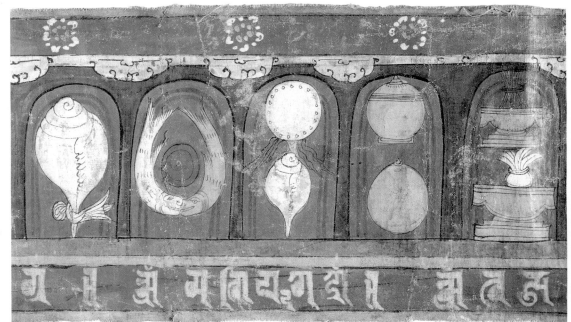

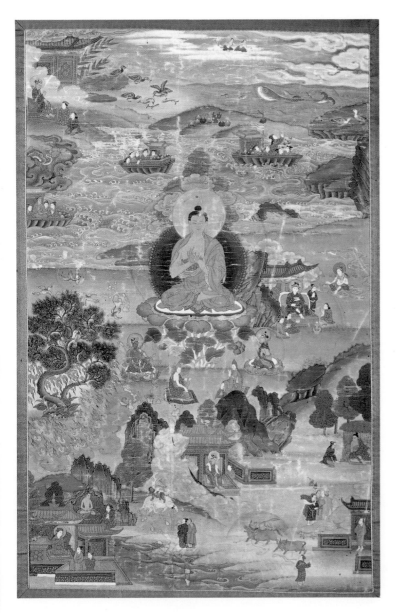

Both the enthroned figure and two of the attendants hold drinking cups.

Typical of Karma-gadri style, the thanka consists of several minicompositions of exquisitely rendered landscape vignettes with delicately drawn rocks and trees. The varied colors are subtly modulated. No matter how dramatic the incidents, the representation in this style of thanka is always characterized by an overall sense of serenity. For another example from the same series, *see* Pal 1988.

P51

Padmasambhava
Bhutan (?), 18th century
45 x 25½ in. (114.3 x 64.8 cm.)
Gift of Neil Kreitman
M.86.338.1

This thanka purportedly came out of Bhutan. Whether it was painted in that country or brought there from a Tibetan monastery cannot be ascertained. The style of the thanka is basically Tibetan, and no study has been done yet to establish a separate Bhutanese expression. The coloring in this thanka seems less strident than one usually encounters in Tibetan thankas of the eighteenth and nineteenth centuries. Otherwise the figurative forms, the landscape elements, and natural motifs all belong to the Tibetan repertoire.

The thanka depicts Padmasambhava, who is of course the patron saint of Bhutan, where the Kagyupas dominate. There is nothing unusual about his iconography. He is seated on a lotus rising from a lake, the water and the waves of which have been expressively rendered. On either side his two wives offer him libations in skullcups. In the clouds above is Buddha Sakyamuni flanked by Avalokitesvara and the green Tara. The bottom of the thanka is occupied by the altar, against which is a depiction of Hayagriva and his spouse. Below the altar are the eight auspicious symbols, while on top are various offerings consisting of an incense burner, a lamp, a bowl, a stringed instrument, a drum, and at least six skulls containing diverse items.

The condition of the thanka is not very good, and the colors have faded considerably. Nevertheless, the details have been finely rendered. Especially lively is the leafy arch around Padmasambhava inhabited by two animated dragons.

P52

Four Initiation Pictures
Central Tibet, 18th century
On paper
4¼ x 5½ in. (10.8 x 14 cm.)
Gift of Janet and Jeff Rockwell
M.88.59.1–.4

These four pictures belong to a large group mostly representing ferocious deities. They represent a type of picture known

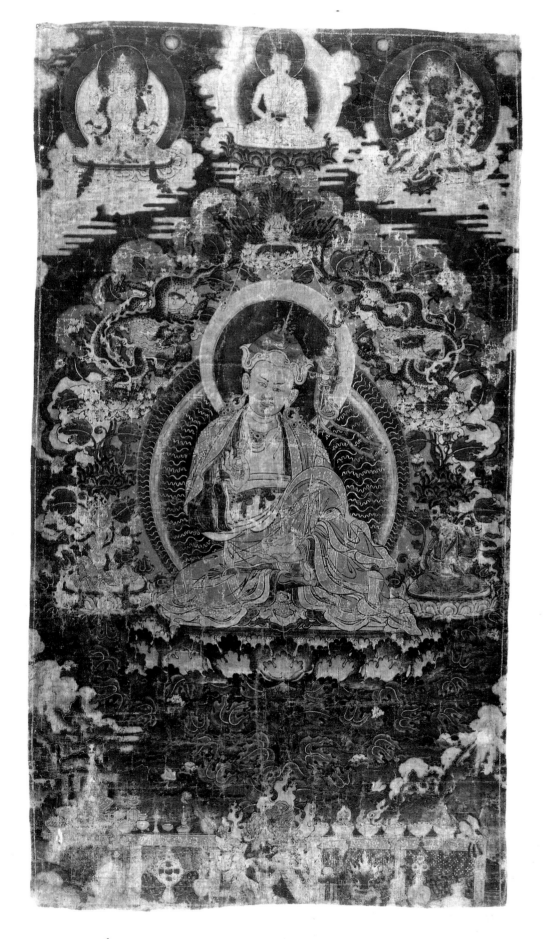

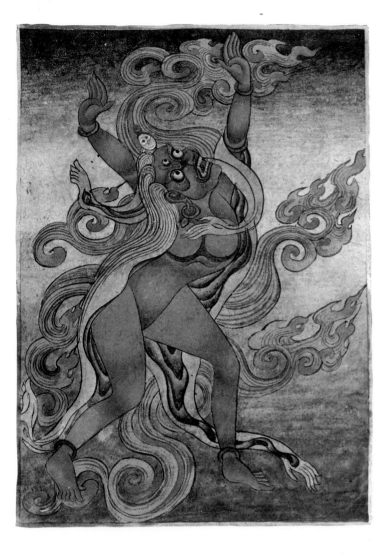

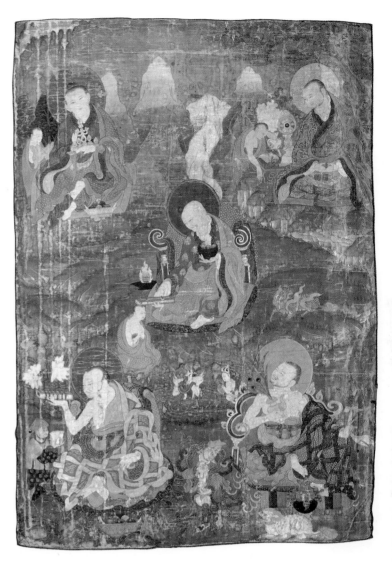

as a *tsa ka li,* used by lamas in the initiation ceremonies of adepts (Wayman 1973, pp. 56–57). The collection has another example that probably served the same purpose (P42). Each picture is identified at the back by a short inscription written in the cursive Tibetan script.

Boldly drawn and vividly painted in bright colors, the figures are extraordinarily lively and expressive. They include both male and female deities who are engaged in vigorous dances or are seated on animals. Invariably of demonic appearance, they frenetically prowl and prance with unmitigated fury and ferociousness. It is remarkable how varied their forms and posturings are, demonstrating the painter's inexhaustible powers of imagination. The females are frequently naked, but the males are covered with tiger skins and garlands of severed human heads. Female figures are also more richly ornamented than the males. Usually each deity is represented against billowing, stylized cloud formations, which together with the swirling scarves or leaping tongues of orange-red flames enhance the figure's frenetic activities. The background is painted green below, changing to a white highlighted area at the shoulder level and a blue sky at the top.

Each picture is framed by a wide red border all around. The predominant colors employed are red, green, blue, white, orange, and gray.

P53

Five Arhats
Eastern Tibet, 18th century
33 x 24 in. (83.8 x 61 cm.)
Gift of Susan Heinz
M.86.336

This is one of several thankas from a series depicting the eighteen arhats. The five arhats included here are identified by gold inscriptions. They are: upper left, Dgra gcan hdzin (Rahula); upper right, Lam phran bstan (Chudapanthaka); center, Bha ra dhva dza (Bharadvaja); lower left, Lamxbstan (Panthaka); and

lower right, Klu ye sde (Nagasena). Following each name is the expression *la na mo,* meaning salutation.

Each arhat can also be recognized by his attributes. Rahula holds a crown that was given to him by the children of the gods in the thirty-third heaven as a token of their gratitude for his fine sermon. Chudapanthaka simply sits in meditation with a wheel placed on a table at his side. Bharadvaja, also known as Pindola Bharadvaja, holds a bowl of gems in his left hand and blesses a devotee with a book. Panthaka upholds a book with his right hand while an attendant offers him a cup. Nagasena holds the vase of immortal life with his right hand and the beggar's staff (*khakkara*) with his left hand. His companion, attired like a divine guardian, seems to offer him a puppy. A spotted *phu* dog sits below the arhat's chair and snarls at the puppy. Two serpent deities rise from the river that meanders below Bharadvaja and offer him gems. Interestingly, while three of the attendants are monks, Panthaka's attendant wears a fur coat and a peculiar hat and that of Nagasena is regally attired.

The five arhats are seated in a highly imaginary landscape, with snowy mountain peaks in the distance. The style is characteristic of eighteenth-century paintings both in central and eastern Tibet. The distinctly Chinese rendering of the arhats' faces makes it likely that the series was painted in eastern Tibet. The iconographic features of the arhats reflect interesting variations from other known series and pantheons. Stylistically the painting is certainly earlier than another eastern Tibetan arhat thanka in the collection (P29).

P54

Myriad Samvaras
Central or eastern Tibet, c. 1800
32 x 24 in. (81.3 x 61 cm.)
Gift of Mr. and Mrs. Robert Mathey
M.84.224.1
See plate 51

The principal figure in the center of this thanka is the twelve-armed manifestation of Samvara embracing his spouse Nairatmya. All around them are multiple representations of identical two-armed manifestations of the same pair, also in *yab-yum.* In his twelve-armed manifestation Samvara is known as Chakrasamvara (T. Hkor lo bde bahi mchog). One of the *yidams* of Tibetan Buddhism, he is the presiding deity of the well-known Vajrayana text *Chakrasamvaratantra.* The initiation into the meditational practices and esoteric rites of this tantra is highly popular in Tibet, especially among the Sakyapas.

In his two-armed form Samvara holds the bell and the thunderbolt in hands crossed at the back of his spouse. This gesture is known as *vajrahunkara* or "thunderbolt sound." In the more cosmic manifestation the additional attributes are a trident, a chopper, a battle-ax, a drum, an outstretched elephant skin, heads of Brahma, a noose, a skullcup, and a cot's leg. Many of these emblems, as well as his third eye, clearly establish Samvara's close iconographic association with the Hindu god Siva.

This particular painting is a fine example of *gser thang* pictures. The figures are rendered in red and gray outline against a

P54

Myriad Samvaras
See plate 51 (detail)

gold background. While the effect is very subtle, it is not easy to discern the forms or details. The hair is painted in black, which stands out against the gold in stronger contrast.

P55

Myriad Amitayus
Central or eastern Tibet, c. 1800
32¼ x 22 in. (81.9 x 55.9 cm.)
Gift of Mr. and Mrs. Robert Mathey
M.83.253

This painting represents a type of thanka that is quite typical of Tibet, if not unique to that country. Known as *gser thang,* these thankas are rendered in a linear technique, the figures being drawn in gold against a red or black background. When and where exactly the technique originated is not known, but very likely gold on black painting derives from the mode of writing on black paper in gold ink. In this particular example the golden

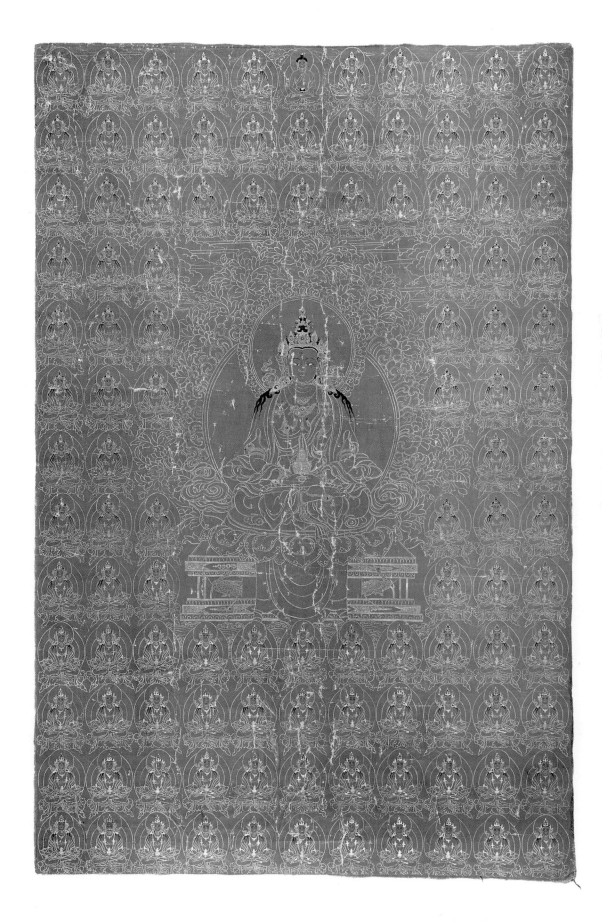

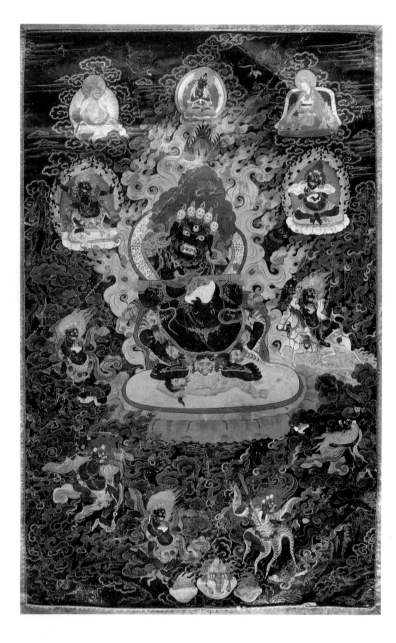

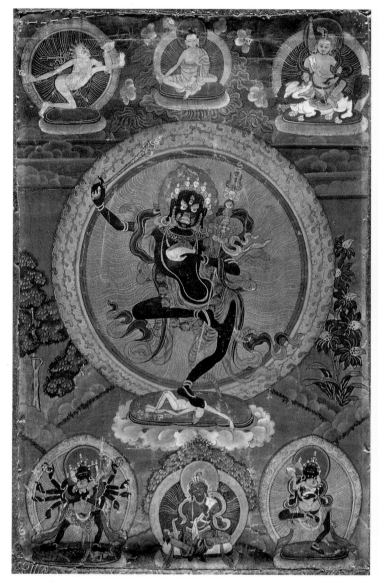

figures are drawn on a red background, probably because Amitayus's color is red.

The large enthroned figure in the center is Amitayus, the god of infinite life. He is represented in his *sambhogakaya* (resplendent body) form and can be identified by the vase of immortality in his hands and the two peacocks adorning his throne. His figure is repeated all around him with the exception of the representation of Buddha Sakyamuni in the middle of the top row. The reiterated figures symbolize infinity. By commissioning such a thanka, the donor believed he would be reborn in the Western Paradise. It was thought that the more images donated the greater the accumulated merit (*see* P35 for another thanka with myriad Buddhas).

P56

Mahakala and Companions
Central Tibet (Sakyapa monastery), 19th century
28 x 17¾ in. (71.1 x 45.1 cm.)
Given anonymously
M.85.293.2
See plate 52

Iconographically this expressive thanka may be compared with an earlier and more elaborate version in the collection (P24). It follows the same basic iconographic tradition except that there are fewer figures in this thanka. Only three of Mahakala's four companions are included here. Legden Nagpo, who usually is represented on Mahakala's right at the level of his waist, has been omitted. Instead, one of the five dancing Mother Goddesses, shown along the bottom of the other thanka, takes his place here.

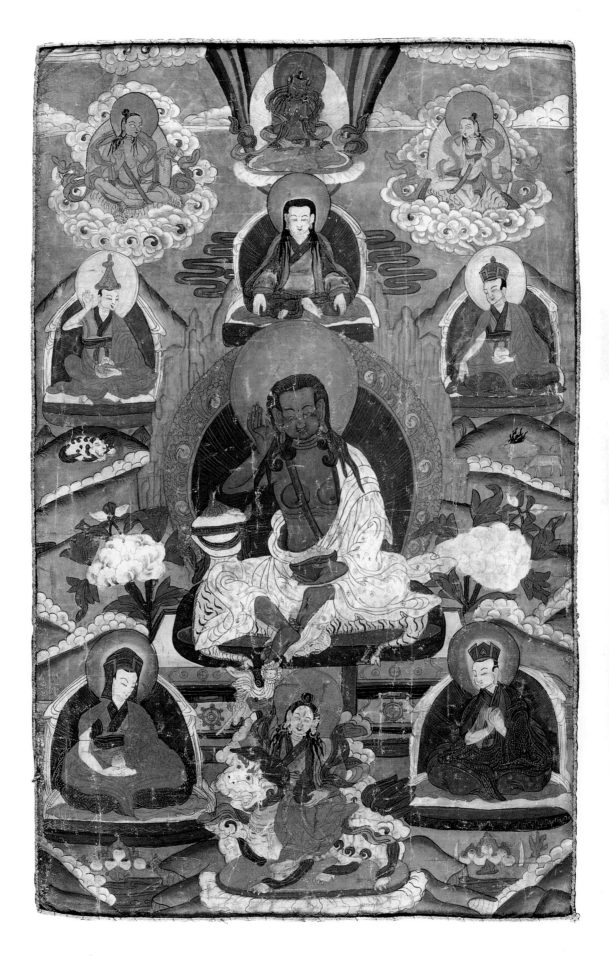

Only three other figures are depicted along the top. The central figure is that of Vajradhara, who is not the same figure as that seen in the other representation. He is flanked by two figures who are identified by inscriptions. The inscription beside the lama on his left reads, *Ngag dbang kun dga' blo gros la na mo.* That beside the bearded ascetic figure on the other side reads, *Bram ze chog srid la na mo.* Kun dga' blo gros may well be the Sakyapa monk (b. 1299) who was an imperial preceptor of the Mongol court in China. The other figure is a tantric deity whose exact identification is not known. Because of this inscription, however, we can now say that the similar figure seated beside the lotus base on the right of Mahakala in **P24** is also Bram ze chog srid. He is without question an Indian brahman ascetic and may well be the historical figure who became a manifestation of Mahakala as Gur kyeng rNyog lugs (*see* **S24**). The expression *bram ze* means brahman, and it should be noted that the Narthang pantheon of three hundred includes a form of Mahakala known in Tibetan as Mgon po bram zehi gzugs can, or Brahmana rupa dhara Mahakala. He too is shown as an angry ascetic figure but with different attributes (*see* Chandra, p. 765, no. 2444).

Mahakala's habitat is the cremation ground, which is suggested by fewer attributes in this thanka. Two ravens fly on either side of Vajrasattva carrying plucked eyes. At the bottom are three skulls filled with blood and human limbs. While the three figures at the summit float on clouds, the rest of the surface is filled with exuberantly rendered flames, behind which one can see jutting rock formations. Stylistically the thanka is more closely related to the Palden Remati in the collection (**P34**), though fewer colors are employed in this example. Rather the painting derives its dramatic effect from a more vibrant linear delineation where the gold outlines highlighted by reds, oranges, and whites make a striking contrast with the background. Especially noteworthy are the realistically modeled heads of Mahakala's garland and the corpse below his feet, which reflect European influence. Similarly "realistic" human representations may be seen also in another painting in the collection (**P33**).

P57

The Goddess Nairatmya (?)
Tibet or Nepal, 19th century
21¼ x 14 in. (54 x 35.6 cm.)
Given anonymously
M.85.293.1

The deities are represented against a mountainous background enlivened with trees and clouds. The central figure dances on a corpse brandishing a flaming sword with her right hand and holding a blood-filled skullcup in the left hand. A trident-cum-cot's leg rests in the crook of her left arm. Very likely she represents the Buddhist goddess Nairatmya (*see* **S25**), even though the usual chopper has been replaced here by the sword; however, she may represent a dakini. Below her are the goddess Tara in the center flanked by two forms of Samvara. Above, the central figure of a Buddha is flanked by an esoteric goddess Maitri-dakini and Jambhala seated on the lion.

It is not possible to suggest an exact provenance for this thanka. The style is usually regarded as provincial, and the painting may have been rendered at a place on either side of the Nepal-Tibet border or in eastern Tibet (cf. **P23**).

P58

Milarepa
Tibet or Nepal, 19th century
25½ x 16¼ in. (64.8 x 41.3 cm.)
Gift of Mr. and Mrs. Michael Phillips
M.82.165.2

The central figure seated on a tiger-skin is the poet-saint Milarepa (*see* **P19**, **S40**). As is customary, mountain peaks are drawn behind his aureole to indicate that he is seated before a cave. Immediately above him is his guru, Marpa, and higher up is Vajradhara, the primordial Buddha of Vajrayana. He is flanked by two other deities floating in the clouds. Thus, the placement of Vajradhara, Marpa, and Milarepa clearly denotes their direct spiritual lineage. The four monks surrounding Milarepa may represent his principal disciples or four eminent Kagyupa or Nyingmapa monks. Immediately below Milarepa is a protective deity riding a lion.

Stylistically the thanka appears to have been painted in a provincial monastery on the border of Tibet and Nepal or perhaps in northwestern Nepal rather than in a metropolitan center. This is evident both from the unimaginative stylization of the landscape and the unrefined, gaudy colors. While the patron of this thanka may not have had access to a talented artist, he certainly could afford to have it mounted in Chinese brocade.

P59

The Goddess Tara
Central Tibet (Gelukpa monastery), 19th century
32¾ x 21 in. (83.2 x 5.2 cm.)
Gift of Mrs. Anna C. Walter
M.82.233

The graceful central figure in this thanka is the White Tara, seated on a lotus against a brilliant circular aureole of blue, red, green, white, and gold. She holds a lotus in her left hand and displays the gesture of charity with the right. The third eye on her forehead and two additional eyes on the palms of her hands symbolize her omniscience. Stylized blue-green mountain forms have been added on either side of her, and the aureole is surrounded by a flowering plant.

Below the goddess are the protective deities Mahakala in the center, flanked by Kubera on his left and Yama on the right. Above them is a group of three monks in the center and two divinities in the corners. The monks represent Tsongkhapa and his two principal disciples; the presence of these monks makes it clear that the thanka was made for a follower of the Gelukpas. The red figure at the left corner is Amitayus, and the multiarmed goddess at the other end is Ushnishavijaya, both of whom are propitiated for long life.

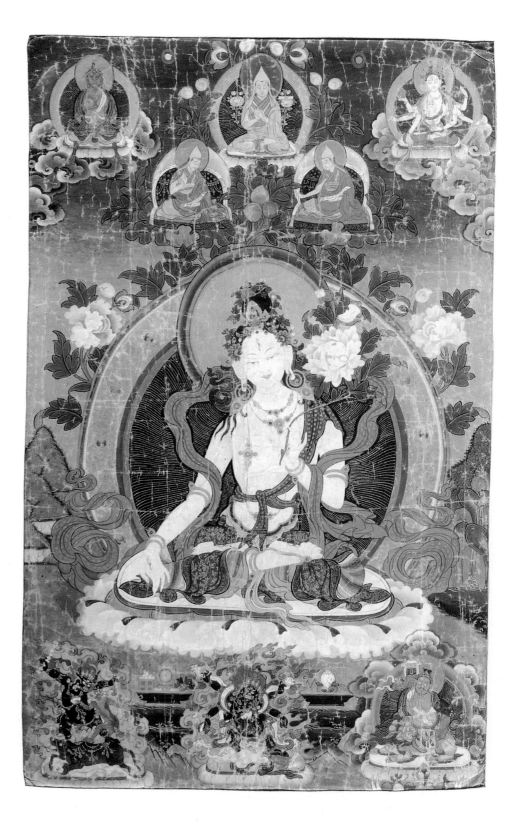

The thanka is mounted in elaborately embroidered imperial dragon brocades. Typically, two narrow strips of red and gold brocade serve as a frame immediately around the painting and are followed by the dragon mount. A gossamer yellow and red silk cover or curtain is still attached to the top of the mount. This cover is an essential part of a Tibetan thanka and is used to protect the painting. The practice seems to have derived from India (*see* Pal 1988, pp. 10–13).

Sculpture

S43

A Buddha
Western Tibet, 15th century
Brass
8¼ in. (21 cm.)
Gift of Mr. and Mrs. Michael Phillips
M.82.165.3a–e

Seated on a lotus base, the Buddha extends his right arm in the earth-touching gesture. In the context of Sakyamuni this gesture symbolizes his enlightenment at Bodhgaya; however, it is also the principal attribute of the transcendental Buddha Aksho-bhya. In the absence of any other cognizance it is difficult to identify the Buddha precisely.

On both technical grounds (*see* Reedy 1986 A, fig. 87.L40) and stylistic considerations the image can be given a western Tibetan provenance. Stylistically related sculptures in the collection are S9, S10, and S21. Noteworthy in this figure is the unusually prominent finial above the topknot and the whimsical treatment of the border of the upper garment below the right nipple.

What is perhaps more fascinating about this bronze is that it yielded a variety of objects when the plate at the bottom was removed. Most Tibetan bronzes are hollow and were originally filled with all sorts of consecrated material at the time of dedica-tion. Unfortunately, few have survived intact. Presumably the sealed plates at the bottom are removed by treasure seekers. This bronze, however, escaped such fate. The contents included several rolls of long, narrow paper with writing, a small metal stupa (*b*) without the crowning elements, human hair, and a considerable amount of soil and tiny rocks wrapped in pieces of cloth. The stupa has been metallurgically tested, and its metal content is the same as the image. The inclusion of hair indicates that the image very likely had funerary associations.

S44

The God Achala
Western Tibet, c. 1500
Copper alloy
4¹³⁄₁₆ in. (12.2 cm.)
Gift of Jack and Muriel Zimmerman
M.84.171.1

The god represented here is Achala (Steadfast), who is an angry manifestation of the Bodhisattva Manjusri. He stands in a militant posture and brandishes a sword with his right hand and holds the diamond noose with his left, which additionally forms the gesture of admonition. His disproportionate body consists of an elongated torso with an overhanging belly supported by rather stumpy legs. He wears a tiger skin, and a rich array of snakes forms his adornment. His awesome nature is also expressed by his ferocious face.

The distended proportions and the plastic concept of the form relate the figure to an earlier sculpture in the collection (S21) that almost certainly is of western Tibetan workmanship. The texture and the color of the metal also are similar in both.

S45

Eleven-Headed Avalokitesvara
Central Tibet, 16th century
Gilt copper alloy inlaid with turquoise and painted with gold
30¼ in. (76.8 cm.)
Gift of Margery and Harry Kahn
M.86.220.2
See plate 53

This impressive bronze represents the Bodhisattva Ava-lokitesvara in one of his major cosmic manifestations (*see* S3, P43 for other versions and discussions of iconography and concept). His ornaments and tiaras are richly encrusted with turquoise, and the faces were generously painted with gold, some of which has peeled off. The emblems from his hands have disappeared. Somewhat unusual is the disproportionately small head of his parental Buddha Amitabha sticking out of the flying hair of the angry head.

All the heads reflect strong Nepali influence, especially the angry head, which is modeled upon well-known Nepali represen-tations of Bhairava. The somewhat awkward posture of the figure as well as the treatment of the *dhoti,* the swirling scarf, and the lotus base, however, follow the Sino-Tibetan tradition. Its impos-ing size makes it likely that the bronze served as an important image in a central Tibetan monastery.

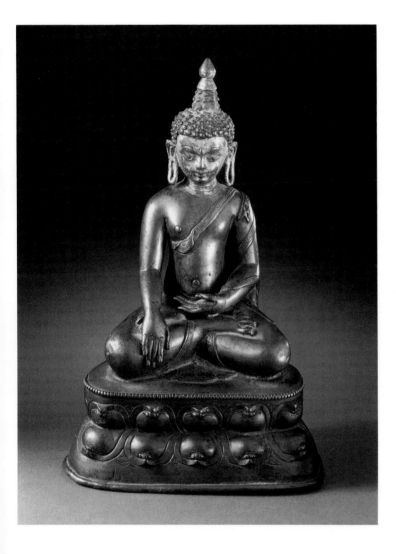

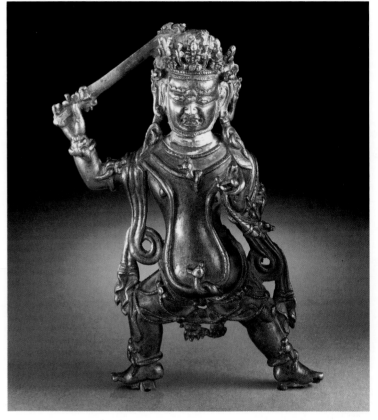

S46

Portrait of a Lama
Central Tibet, 16th century
Gilt copper with colors
9½ in. (24.1 cm.)
Gift of Anna C. Walter
M.86.344.1

The inscription on the back is a salutation to a lama about whom nothing is known, though it may be surmised that he was a Sakyapa. The face is painted in gold, and the hair still retains some of the original black paint. The eyes are painted white with black pupils, and the lips are red. The features are well defined, and the face has a calm and distinguished expression.

Dressed in a monk's robes, the figure sits on a lotus in an informal and relaxed manner. His right hand exhibits the gesture of teaching, and the left rests on his raised knee. Although the figure is idealized, the representation is on the whole naturalistic, especially due to the realistic treatment of the folds of his robes.

Eleven-Headed Avalokitesvara
See plate 53

Portrait of a Lama

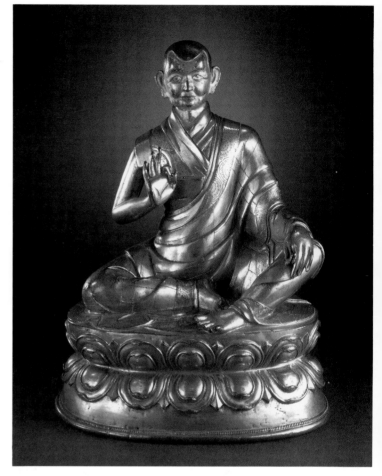

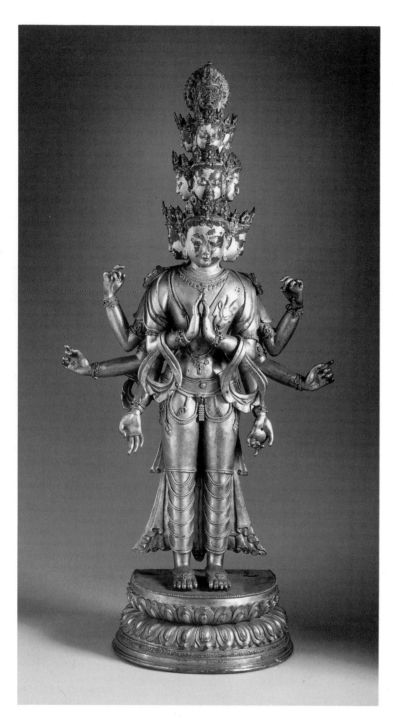

The floral designs of his vest and the border of his upper robes are finely incised. Even though his identity is not known, this is a fine example of a Tibetan religious portrait.

Removing the baseplate of the bronze revealed textile fragments, a lapis lazuli bead, a small pearl, bundles of broken clay pieces, wood, bark, scrolls, bone, a ceramic cylinder, a *tsha tsha* wrapped in colored silk, and several walnuts.

S47

Portrait of Karma Pakshi
Eastern Tibet, 16th century
Gilt copper alloy with traces of colors
7½ in. (19 cm.)
Gift of Anna C. Walter
M.85.296

The inscription on the back reads, *rje gnis pa karma pakshi la na ma.* It can be translated as, "Salutation to lord the second Karma Pakshi." The second Karmapa, Karma Pakshi (1206–83),

was a remarkable personality and led a fascinating life (*see* Thinley, pp. 47–52). Among his major architectural accomplishments was building a new monastery in the area of Sharchok Pungri in Kham and restoring the principal monastery of the order at Tsurphu. He traveled widely across the country and in China and spent much of his time in eastern Tibet.

In 1251 he visited the court of Kublai Khan while the latter was a prince. Subsequently Karma Pakshi became the preceptor of Emperor Mongka Khan. The great Mongols were then under the strong influence of the Sakyapas due largely to Sakya Pandita (1182–1251) and his nephew Phakpa. The Karmapa, however, was a gentle personality who refused to be drawn into religious rivalry and advised the Mongol princes to treat all sects equally. When Kublai became the emperor after Mongka, he remembered Karma Pakshi's earlier refusal to stay on at his camp and banished him to the coast of China, where the Karmapa was incarcerated and tortured for several years. Finally, however, Kublai Khan came around, and although he retained his Sakyapa association, he also venerated Karma Pakshi. For the remainder of his life the Karma Pakshi was renowned all over Tibet and Mongolia for his spiritual courage, wisdom, and learning and is remembered as one of the great Karmapas in the lineage.

This sixteenth-century gilt bronze from eastern Tibet, the main theater of his activity, depicts an idealized portrait of the Karmapa wearing the black ceremonial hat. He is seated in the classic meditation posture with his arms fully extended in front. It is not possible to determine how true to life the face is; in the paintings he is depicted without the goatee. It should be noted that this tradition of wearing the black hat did not begin until the early fifteenth century (*see* **P25** and p. 162). Thus, the bronze could not have been made before the fifteenth century.

The bottom of the bronze was sealed with a copper plate etched with a double *vajra*. Upon the plate's removal, the sculpture yielded a wide variety of material including rolls of cloth and paper with writing, soil, beads of semiprecious stones, seeds, what appear to be ashes, and an ivory roundel carved with the symbol of the interwoven knot of life. It is likely that the bronze was a memorial of a lama who may have been regarded as a reincarnation of the second Karmapa.

S48

The God Hayagriva
Central Tibet, 16th century
Copper alloy
7⁹⁄₁₆ in. (19.2 cm.)
Gift of Anna C. Walter
M.83.220.6

Hayagriva (Horse-headed) is an important deity in the Tibetan Buddhist pantheon and may serve as both a *dharmapala* (defender of the faith) and a *yidam* (tutelary deity). He has numerous forms in the Tibetan iconography, most of which depict him as an angry figure, as in this example. He may also be envisioned as a benign manifestation of the Bodhisattva Avalokitesvara. In either case he is distinguished by a horse's head emerging from the top of his crown. In India Hayagriva is an incarnation of the Hindu god Vishnu, but as is apparent from this image, the Buddhist god shares features with the Bhairava

Portrait of Karma Pakshi

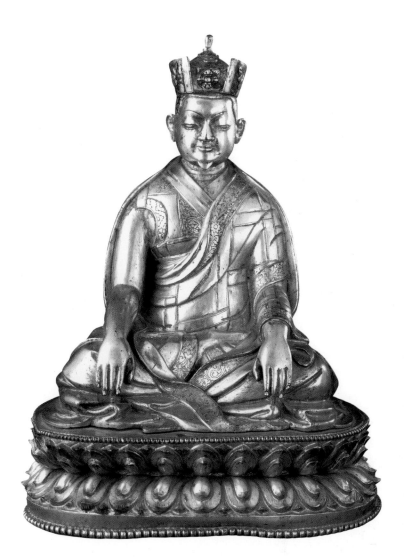

aspect of Siva, particularly in the angry faces with the third eye, the tiger skin, the elephant hide, and the garland of skulls. In Tibet Hayagriva is also the patron deity of horse traders.

In this particular representation the god is engaged in a sexual embrace (*yab-yum*) with his spouse, who also is given a horse's head. While he is six-armed, she has only two, which hold the blood-filled skullcup and a chopper. His principal hands cross each other behind her back in the *vajrahunkaramudra* ("thunderbolt-sound" gesture). The two uppermost hands stretch the elephant hide as they exhibit a staff on the right and a bow and arrow on the left. A staff is also held by the remaining right hand, while the third left hand holds a thunderbolt and a noose. As the two strike the militant posture, they trample two outstretched corpses.

Both figures are forcefully modeled, the back of Hayagriva being well finished. Particularly noteworthy is the realistic treatment of his tiger skin. A rectangular patch at the back indicates that the hollow body contains insertions.

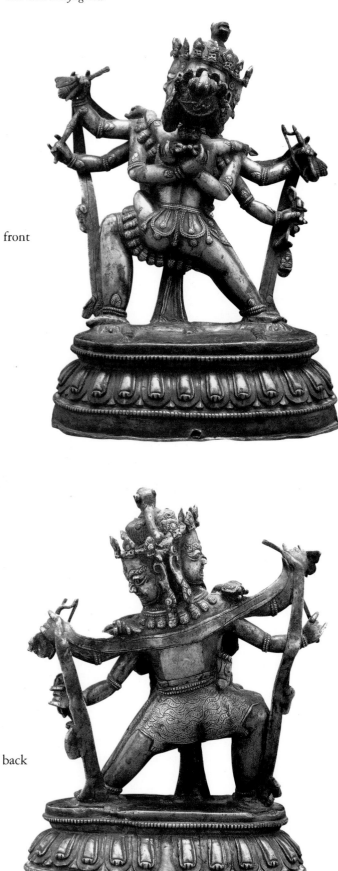

front

back

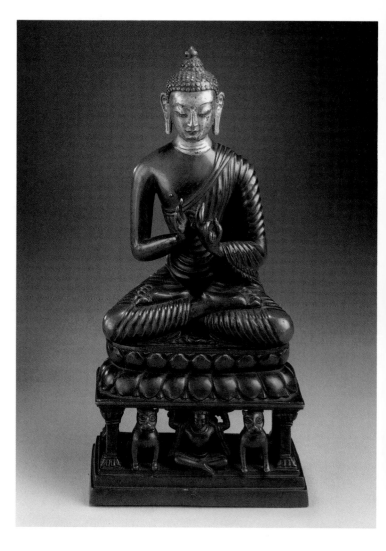

S49

A Preaching Buddha
Central Tibet, 16th–17th century
Copper alloy with gold paint
9 in. (22.9 cm.)
Gift of Michael Phillips
M.84.227.4
Literature: Klimburg-Salter, 1982, p. 193, pl. 113; Fisher, 1985,
pp. 110–11, fig. 71.

The figure has been identified as the transcendental Buddha Vairochana because of his gesture and the lion throne (Klimburg-Salter literature above). Neither, however, is sufficient for such a precise identification, for the figure may well represent the historical Buddha Sakyamuni. All that can be said is that the figure depicts a Buddha engaged in preaching.

Nevertheless, the bronze is an interesting art-historical document that demonstrates the continued fascination in Tibet

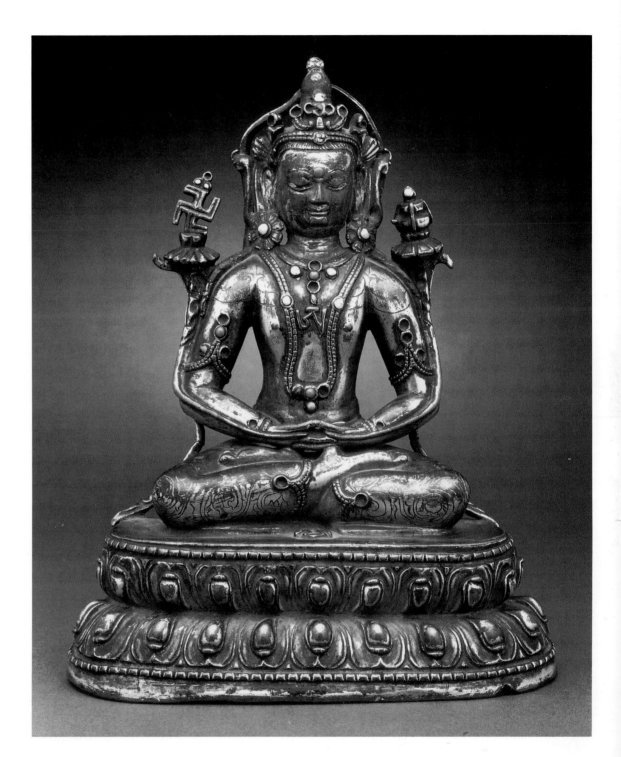

S50, detail of base

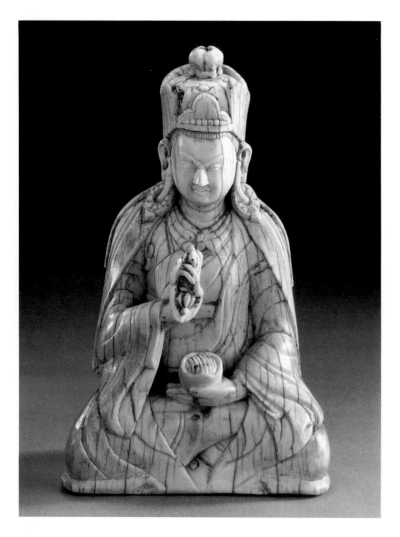

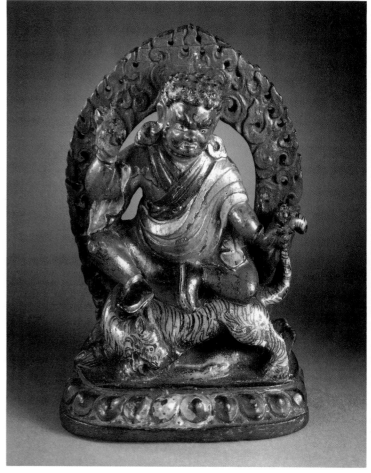

for a type of Kashmiri Buddha image that was repeatedly copied through the ages. In fact, the Museum's collection includes one such Kashmiri model of the eighth century that has been frequently published (Pal et al., p. 290, no. 156). The principal iconographic difference is the simplification of the throne in this example by the omission of the rampant griffins. That it continues to depict a well-known Kashmiri model suggests an origin of western Tibet, but the face is more closely related to those seen in Sino-Tibetan Buddha figures of the sixteenth and seventeenth centuries. The rich brown tonality of the surface is also seen more commonly in Sino-Tibetan bronzes than in those from western Tibet. A technical examination of the bronze further confirms an eastern Tibet provenance (*see* Reedy 1986 A). Historically, therefore, this is an important bronze, as it demonstrates the wide diffusion of the Kashmiri style in Tibet.

S50

A Bonpo Deity
Central Tibet, 17th century
Gilt copper with semiprecious stones
6⅛ in. (15.6 cm.)
Indian Art Special Purpose Fund
M.83.191

This is the first representation of a Bonpo deity to enter the collection, unless S8 is also a Bonpo image. Although Bonpo represents older, native Tibetan religious concepts, the forms and iconography of the deities were heavily influenced by Buddhistic ideas. That this is a Bonpo god can be determined by the syllable *am* on his chest and the swastika on the lotus held by his right hand. A swastika is an ancient Indian symbol of auspiciousness. Additionally, the plate at the bottom is incised with a mandala of the eight auspicious symbols (common to both Bon and Buddhism) around a swastika. Otherwise, however, the figure is no different from a bodhisattva.

Seated in meditation on a lotus, this richly ornamented deity holds two lotuses that support in addition to the swastika a pot containing elixir. In addition to his crown, he is distinguished by a lightly etched cape of cloud-collar pattern over his shoulders. The ornaments are inlaid with turquoise and coral. An exact identification of the figure is not possible as very little work has been done on the iconography of Bonpo deities. It has been suggested that the figure represents Chenrob-a, but I have been unable to find more information about this deity. Although the figure remains unidentified, it is a fine example of a Bonpo bronze.

While it is not possible to suggest an exact provenance, the style of the figure is distinctly Nepali. Very likely a Newari craftsman was responsible for this well-executed bronze. According to Reedy's technical analysis this bronze was made in central Tibet.

S51

Padmasambhava
a) Central Tibet, 17th century
 Ivory
 5½ in. (14 cm.)
 Gift of Corky and Don Whittaker
 M.83.218.3
 Literature: Pal, 1981, p. 99, fig. 101; Fisher, 1985, pp. 110–11, fig. 74.
b) Southern or central Tibet, 18th century
 Wood with colors
 6¾ in. (17.1 cm.)
 Gift of Marc Richards
 M.86.281

For Padmasambhava and his other representations in the collection, *see* S37 and P51. As in the others, in *a* Padmasambhava is portrayed in his conventional form. Only his magic staff is missing here.

Modeled in the round, this is not only a rare example of ivory sculpture from Tibet, but the carving is of fine quality. The unknown sculptor's mastery over the material is evident from the deft treatment of the garment's volume as well as the sensitive delineation of the hands, the attributes, and the hat. Especially expressive is the scowl on his face, which exhibits his anger in a restrained manner.

The richly polychromed wood sculpture of *b* depicts an esoteric form of Padmasambhava. He is shown here in a particularly menacing mood. He is dressed in his customary garb, but he has no hat and his feet are shod. His hair consists of short curls as with a Buddha, and he has a third eye. His right hand wields a thunderbolt, and the left holds a *phurpa* (R6), which he used to destroy the forces of evil and firmly establish the Buddhist religion in Tibet. He rides a tiger, which crushes a corpse, symbolizing the snares of the phenomenal world. A flaming nimbus serves as a background for the tableaux. In this form Padmasambhava is known in Tibetan as Gu ru rDo rje Gro lod.

S52

Yama and Yami

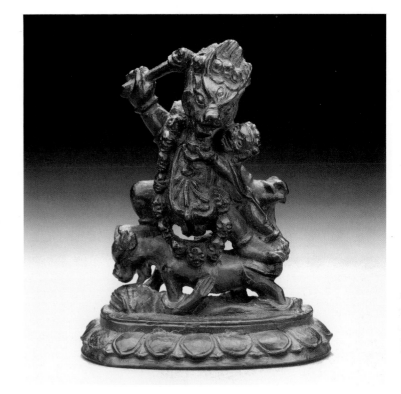

The aureole and the lotus have lost some of their pigments, but the tiger and the figure retain much of their original colors. With its black-striped orange body, the tiger is particularly animated. Padmasambhava's garments are painted in red, orange, and olive green and his boots in black. Black is also used for all hair on the head as well as the face. Although small, the sculpture is representative of the richly polychromed clay images that are so prominent in Tibetan monasteries.

S52

Yama and Yami
Western Tibet (?), 17th century
Wood
2½ in. (6.4 cm.)
Gift of Chino Franco Roncoroni
M.84.104

Carved in the round, this tiny sculpture representing Yama, god of death, and his sister Yami (*see* P33 for iconography) was very likely used in a traveling shrine, known as a *gau* (*see* R15). The god was the personal deity (or *yidam*) of the image's owner. The shape of the lotus petals is reminiscent of much-earlier Kashmiri bronzes, and hence the piece may have been made in western Tibet.

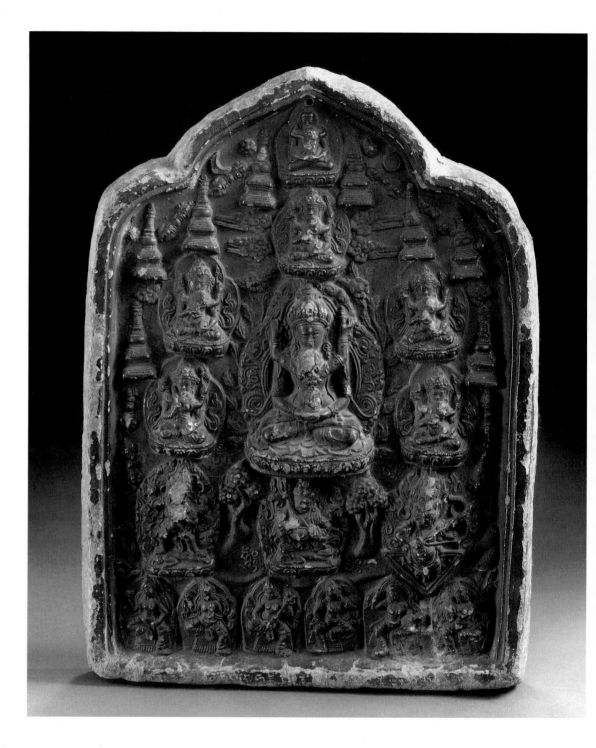

A Tantric Mandala
Central Tibet, 18th century or earlier
Terracotta with red pigment
11½ in. (29.2 cm.)
Gift of Marilyn Walter Grounds
M.84.220.2
Literature: Pal, 1987 A, p. 83, no. 47.

The central figure is Amitayus, the Buddha of infinite life, shown embracing (*yab-yum*) his spouse. He is surrounded by five other identical figures holding the same attributes and embracing their spouses. Their hand positions and emblems differ, however, from those of Amitayus, who holds a vase with both hands. While the emblems cannot be identified, the gestures are those seen in images of the Bodhisattva Vajrasattva. Surrounding this group of figures are eight stupas and eight thunderbolts, very likely representing the eight directions. The cosmic nature of the

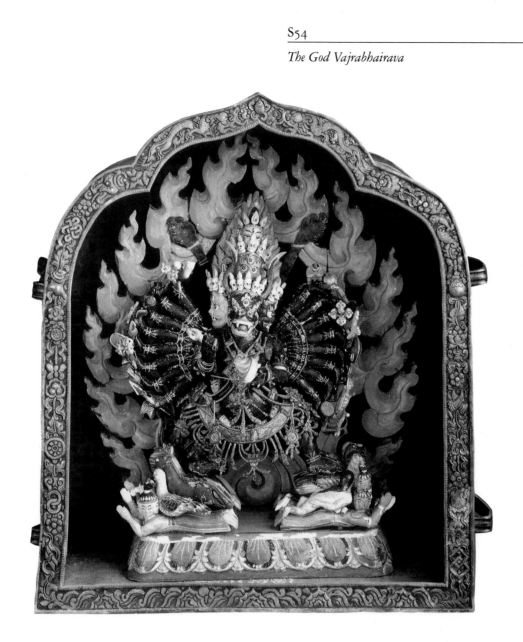

mandala is further emphasized by the sun and moon symbols at the top on either side of the primordial Buddha (*Adibuddha*) in *yab-yum* with the goddess Prajnaparamita. Below Amitayus are three guardian deities and lower still a group of six dancing goddesses, one of whom plays a stringed instrument. The exact identification of the mandala is difficult; perhaps it was used in rituals connected with the highly esoteric *Guhyasamajatantra* (Tantra of the secret society), popular with both Nyingmapas and the Gelukpas.

While most mandalas were painted, Tibetans also used terracotta mandalas, which seem generally to have been composed of separate *tsha tshas,* or miniature clay images (*see* R16). In this particular example, however, influence of a painted mandala is evident in the perfunctory attempts at landscaping, with two trees below Amitayus and stylized cloud patterns above. While the surface is now blackened by smoke, traces of the original red paint are still discernible.

S54

The God Vajrabhairava
Western Tibet, 18th–19th century

Image: Painted wood and silver
9½ in. (24.1 cm.)
Case: Metal and glass
10 in. (25.4 cm.)
Gift of Dr. Leslie Kalman and Frank C. Y. Wang
M.86.279a,b

The deity represented is Vajrabhairava, a ferocious manifestation of Bodhisattva Manjusri (*see* P12, S28). In Indian texts Vajrabhairava has a buffalo's head as the principal of his several heads, though in Tibet artists often seemed to have modeled the animal head after the more familiar yak, as has been suggested by Professor Stanley Olson of the University of Arizona, Tucson (personal communication). This is particularly true of the painted version in the collection (P12).

Although the iconography and composition do not differ from the metal example in the collection (S28), this well-carved wood is vividly painted with bright colors. It may have been used as a personal image in a domestic shrine and is said to have emerged from western Tibet. Stylistically, however, it conforms to countless other such images produced during the eighteenth and nineteenth centuries all over the country.

Ritual Objects

Ritual Daggers (Phurpas)
 a) Western or central Tibet, 15th century
 Iron and brass
 27 in. (68.6 cm.)
 Christian Humann Asian Art Fund
 M.86.190.2
 b) Central Tibet, 17th century
 Gilt copper, iron, and coral
 7 in. (17.8 cm.)
 Gift of Jerome L. Joss
 M.85.286.1

While two other *phurpas* in the collection (R6, **R7**) are made of wood and ivory, these two are made of metal, the more common medium for these ritual implements. In both, the blade is made of iron, as is usually the case, but in *a* the long stem or shaft is also of iron. Tibetans believe that the iron in *phurpas* derives from meteorites and that because of this the potency of these objects is increased. In general the smaller *phurpa, b,* has the same components as that made from wood (R6), with the addition of two small heads on the handle in the front. While in *b* the three faces on top have angry expressions, in *a* one of the faces has a benign expression, although with an open mouth. The thunderbolt in *a* emerges from a funnel that rises from a pot, and the top is surmounted by a small *chöten*. Furthermore, the band below the heads has a hole for the insertion of a piece now lost.

There are other features that make *a* an unusual *phurpa*. The size of the heads is in keeping with Nepali sculptures of the fifteenth century. The use of brass for the heads, the crowning elements, and the *makara* surmounting the blade may indicate a western Tibetan origin where the metal was more common. The style of the heads of the *b phurpa* suggests a date in the seventeenth century.

For information on the symbology and meaning of *phurpas*, *see* R6 and **R7**. For the use of *phurpas* in ritual, *see* Marcotty.

Ceremonial Urn
Eastern Tibet or China, 16th century (?)
Jade with silver, coral, turquoise, and lapis lazuli
13 in. (33 cm.)
Gift of Mr. and Mrs. Lionel Bell
M.83.247

This is one of the most spectacular ritual objects to have come out of Tibet. While its exact function is not known, its quality indicates its ceremonial use in an important monastery. Nor can one be certain of its origins. It could have been made in China and presented to a Tibetan monastery. Such ritual objects of great quality were often donated to important Tibetan lamas and monasteries by the Chinese emperors. The urn itself is an impressive piece of mutton jade and almost certainly was carved in China. The silver fittings and the lid may have been made in Tibet at such a well-known center as Derge in Kham, or the entire object may have been a product of an imperial workshop in China.

Both the filigree work and the inlaying are of excellent craftsmanship. The dominant decorative motif is the stylized lion's head, known in Chinese as a *tao-tieh* mask and in Sanskrit as *kirttimukha*. The second tier of the lid is decorated with the eight auspicious symbols of Buddhism.

Unfortunately, Sino-Tibetan metalwork on ritual objects is a neglected branch of art history, which makes it very difficult to suggest an exact date for such objects. Nevertheless, the superior workmanship of this piece makes it likely that it was made at a time when the tradition was still vigorous and creative.

Ceremonial Ewer
Central Tibet, 17th century or earlier
Silver, jade, and stones
21⅛ in. (53.7 cm.)
Gift of Mr. and Mrs. Michael Phillips
M.84.227.2
Literature: Fisher, 1985, pp. 112–13, fig. 77.
See plate 54

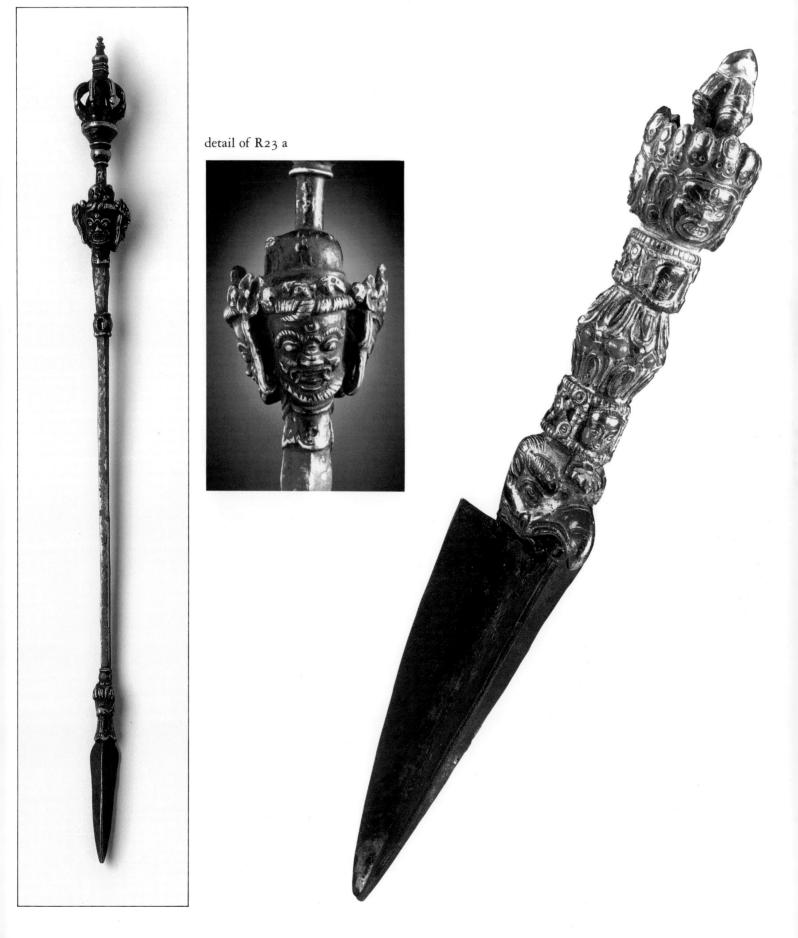

detail of R23 a

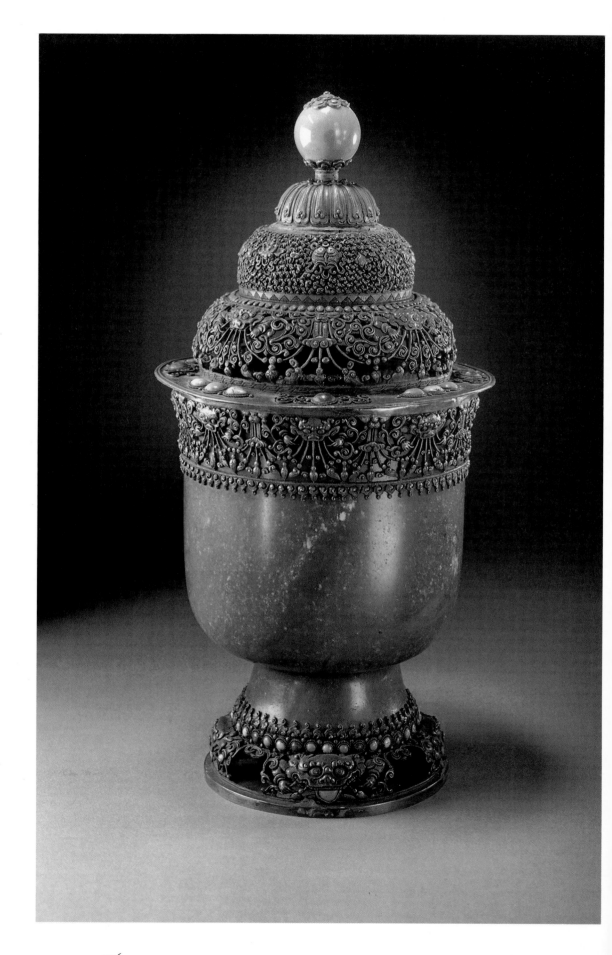

Ceremonial Ewer
See plate 55

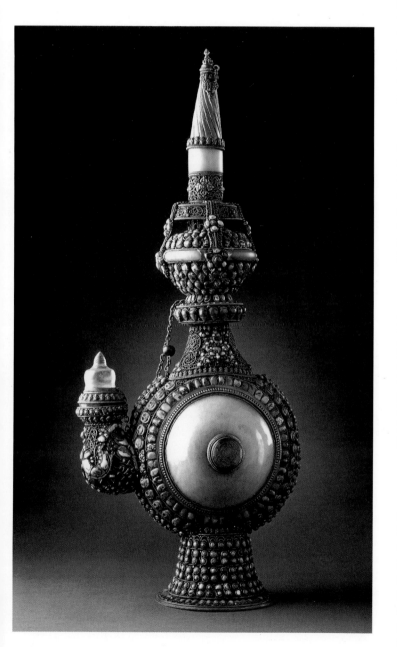

The water pot, or ewer, is an essential ritual object in a Buddhist monastery and is found in a wide variety of shapes and forms in Tibet (*see* R12 for another example in the collection). This particular pot is not only of impressive size but is one of the finest known. It is a *tour de force* in the art of inlaying and constructing a beautiful object with diverse materials.

While the shape of the ewer may ultimately derive from Central Asia, some of the components and the rich inlay are characteristically Tibetan. The silver stopper above the jade band is strongly reminiscent of certain Islamic minarets, especially in Anatolia (Ettinghausen and Grabar, figs. 342 and 349b). The middle of the neck has been shaped into an auspicious water pot with foliage, and the stopper above the mouth is a crystal *chöten*. A pale white jade ring encircles the water pot of the neck, while another piece forming the body of the ewer is carved so thin that the mantras underneath can be clearly read. The crystal knobs on this jade are engraved with *yantras* (mystical diagrams). The rest of the ewer is formed with exquisitely inlaid turquoise, opal, lapis lazuli, amber, and even rubies, all of which are held together with pure silver enmeshing that also creates an attractive and colorful design.

The deft incorporation of the auspicious water pot and the *chöten* into the design may indicate that the ewer was once used for rites connected with Amitayus (*see* P1), while its sumptuousness demonstrates the importance and affluence of the person who commissioned it. Unlike others in the collection, this vessel does not have a handle and may have been a symbolic rather than functional object. Its exact date, however, cannot be determined, and although tentatively assigned to the seventeenth century, it may have been made much earlier.

R26

Symbolic Conch
Eastern Tibet, 17th century
Silver and mother-of-pearl
3¾ in. (9.5 cm.)
Purchased with Funds Provided by The
Louis and Erma Zalk Foundation
M.83.2.3

This charming object was very likely used as a symbol on an altar, like the mirror in the collection (R33), rather than as a trumpet (*see* R11). Apart from playing a functional role, a conch shell is one of the eight auspicious symbols of Buddhism in particular and Indian religions in general. Among conch shells, those rare examples that have spirals turning to the right are considered especially auspicious. It should be recalled that the hair of a Buddha is also said to curl to the right as a sign of auspiciousness. When a conch is placed on an altar as an emblem, it signifies the Buddha's proclamation of his teachings. This particularly attractive piece is mother-of-pearl elegantly combined with exquisite silver work. The eight auspicious symbols decorate the silver stand and mouthpiece.

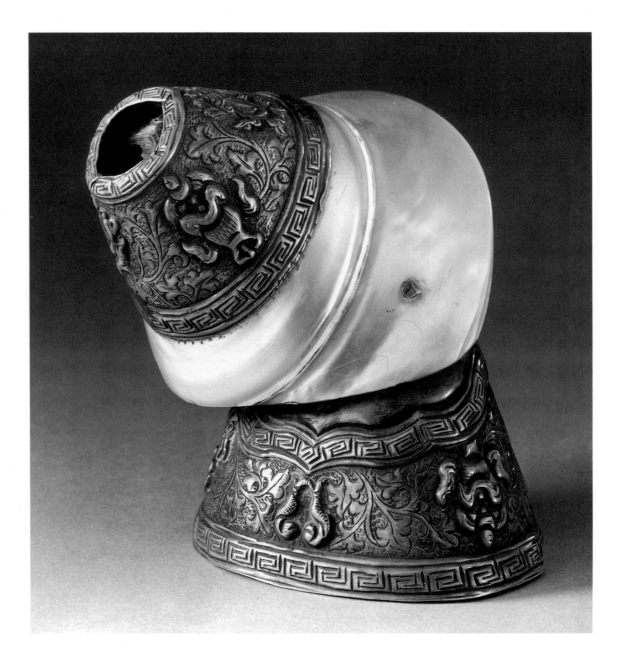

R27

Chöten with Relics
Central Tibet, 15th century
Brass and terracotta
Chöten: 9⁵⁄₁₆ in. (23.7 cm.)
Indian Art Special Purpose Fund
M.82.200.3

Like the much earlier Kadampa *chöten* in the collection
(R1), this example also once served as a reliquary. When the plate
at the bottom was removed, it yielded eight miniature terracotta
chötens made from a mold, two miniature images of Avalokitesvara
and Tara, two human skull fragments, a *yantra* (or mystical dia-
gram) consisting of a copper plate with double *dorje* wrapped in

cloth, and five packets of organic matter. Obviously, the *chöten*
was dedicated as a memorial to a deceased person, perhaps a
lama. This is also evident from the figure of Amitayus in the
niche; he is the Buddha of immortal life.

The form of this *chöten,* however, differs from the Kadampa
example. The drum is much smaller and is shaped like a pot
rather than a bell. The pedestal is more elaborate, adorned in the
recessed middle section with alternating thunderbolts and the
eight auspicious symbols. Above this pedestal rise three circular
tiers, each of which is adorned with floral and vegetal motifs. The
remaining sections conform to those encountered in the earlier
chöten but differ in their designs. For instance, the entablature
above the dome as well as the finial at the top differ. Here
an auspicious water pot rather than a closed lotus serves as the
crowning element.

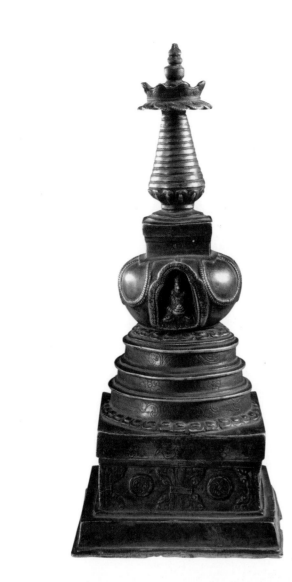

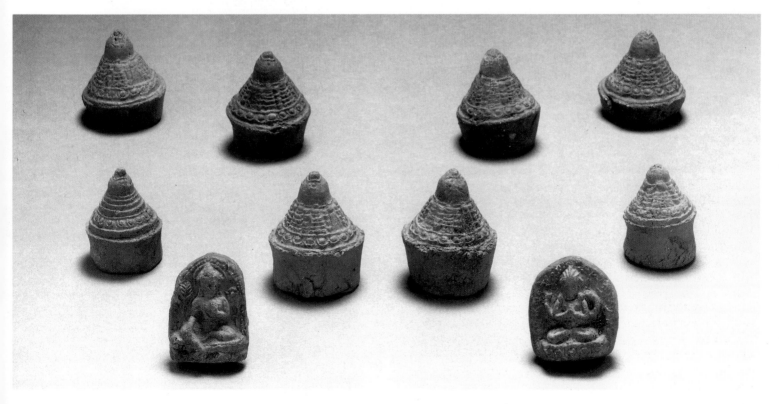

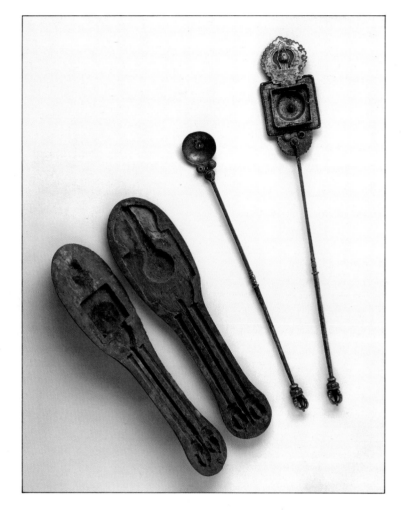

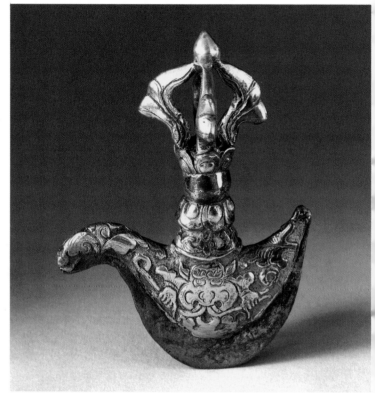

R28

Ritual Implements
Tibet or Nepal, 18th century or earlier
Wood, steel, gilt copper, silver, and semiprecious stones
20½ in. (52.1 cm.)
Christian Humann Asian Art Fund
M.86.190.1a–g

The two ritual implements consist of a ladle or spoon to pour the oblations and a receptacle to receive them. Each is made of two parts. The lower portions of the long handles terminate in thunderbolts, which also adorn the *yantra* in the receptacle. The objects were therefore used in Buddhist rather than Hindu rituals. One cannot be certain, however, whether they were used in Nepal or Tibet.

The receptacle is in the form of a square containing a circular bowl, etched with a *yantra* consisting of a triangle within a skullcup. At the center of the triangle is what appears to be a lotus from which rises perhaps a thunderbolt of abstract shape. The raised part of the cup inside the smaller square is adorned

with the thunderbolt motif. The border of the larger square is rendered as an open lotus. Thus, there is no doubt that the receptacle serves as a geometrical mandala. Serving as a finial to the receptacle is a flattened thunderbolt design that also looks like the prongs of a trident. Inside the spoon rests a clover-shaped piece of silver from which rises a silver object of the same design as that within the receptacle.

The design of the *yantra* is a abstract version of a skullcup containing a triangular form that is the focal point of the offering thankas dedicated to Mahakala (**P30**, **P31**). Thus, it is possible that these implements were used in the special shrine dedicated to this and other protective deities in a Tibetan monastery. Such a shrine is known as a *gonkhang*.

Chopper
Tibet, 18th century
Silver and copper
3¾ in. (9.5 cm.)
Gift of Jerome L. Joss
M.85.286.8

Surmounted by the ubiquitous thunderbolt motif, such choppers are known as thunderbolt choppers (*vajrakarttrika*). More characteristic of Tibetan choppers, it differs from the larger example (R8) in the collection. Apart from the thunderbolt handle, the blade here is adorned with foliage and a face of glory rather than a *makara.*

R30

Vase of Immortality (Tshe-bum)
Eastern Tibet, 18th century
Silver
7⅞ in. (20 cm.)
Purchased with Funds Provided by The
Louis and Erma Zalk Foundation
M.83.2.1

This type of water pot is known in Tibetan as the *tshe-bum* (vase of immortality) and is principally associated with Amitayus, the Buddha of immortal life. It can be held as an attribute or may be placed on an altar as an offering (*see* M11). Usually peacock feathers, signifying the destruction of spiritual poison, are placed in the vase as in the thanka. As a ritual object the vase is used by the guru to confer a blessing by touching the disciple's or devotee's head.

The foot of the vase and the top of the cap are each adorned with a lotus. The spout is the head of a *makara,* and the eight auspicious symbols are superimposed on the vegetal design decorating the side of the cap.

R31

Ritual Drums
Tibet, 18th century
 a) Skulls and wood with brass fillings and cloth tassels
 5½ in. (14 cm.)
 Gift of Corinne Whittaker
 M.85.298.2
 b) Opaque watercolors on wood and skin
 5 in. (12.7 cm.)
 Purchased with Harry and Yvonne Lenart Funds
 M.86.127a,b

Among the various musical instruments used by Tibetans, the drum is probably the second most essential object, after the bell. While the bell is more commonly used, the drum is particularly important for esoteric rituals such as the famous *chö* rites

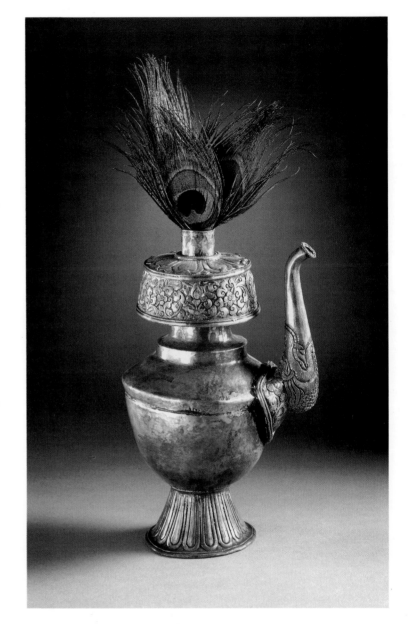

Vase of Immortality (Tshe-bum)

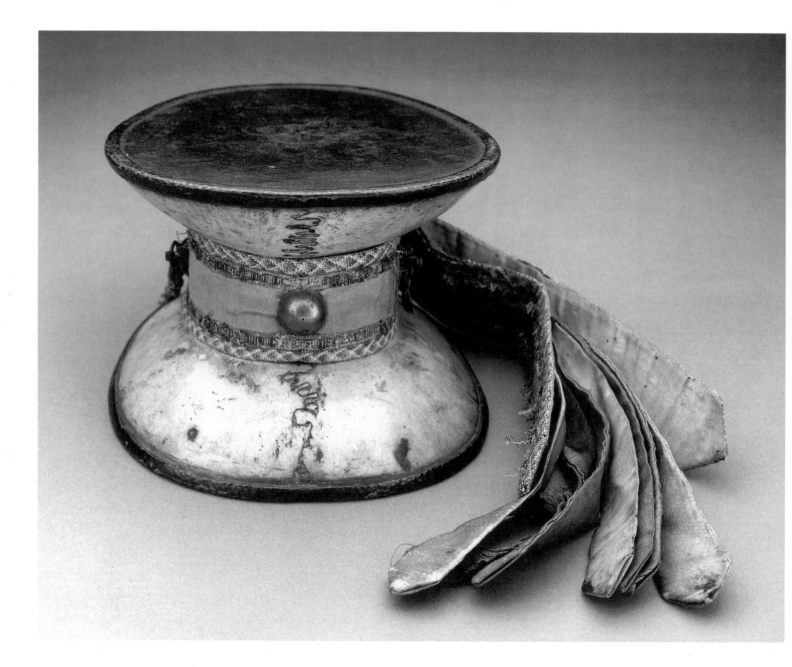

detail of base

and various other rites associated with oracles and exorcism. Where exactly the form originated is not known, but it is also a common attribute (known in Sanskrit as *damaru*) of the Hindu god Siva.

The skin of the skull drum (*a*) is tinted green and is decorated with gold symbolic offerings as are seen in offering thankas (**P30**, **P31**). On one side, the flaming, blood-filled skullcup with an overhanging tongue is very similar to the same configuration that is featured prominently in the symbolic-offering thankas intended particularly for the god Mahakala. Here, in addition, a head supports the skull while a leg and an arm emerge from the blood within the cup. On the other side, five different symbols (*hDod Yon sNa lnga*) that stimulate the senses are placed on an

Ritual Drum

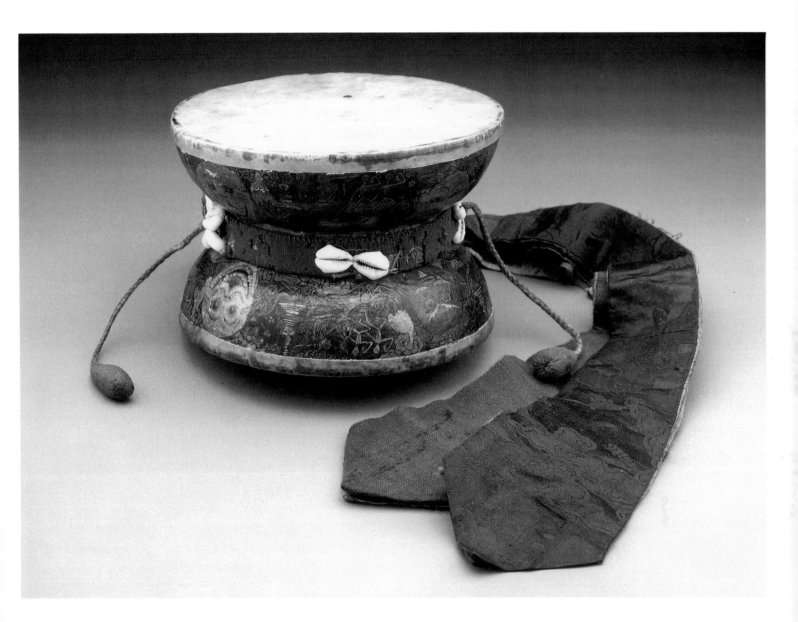

detail

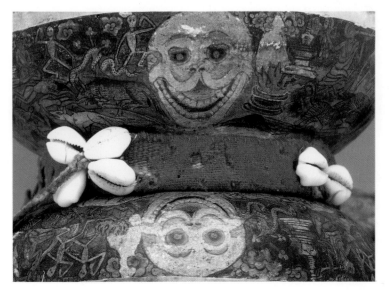

altar or table covered with a cloth of cloud-collar design. The large flaming mirror in the center symbolizes sight; the flanking cymbals, sound; and the liquid in the conch shell, which is hardly recognizable at the far left, signifies smell; the peaches at the other end symbolize taste; and the cloth covering is emblematic of touch.

Artistically, the second drum (*b*) is more elaborate. It is adorned with the scenes of the eight cremation grounds, which alternate with rather strikingly expressive human heads and grinning skulls. Each cremation ground is filled with stock motifs consisting of a fire, *chöten,* dancing skeleton, ascetic, animal, bird, hill, and river. It is of interest that each ascetic rattles a drum with his right hand as he blows a bone trumpet.

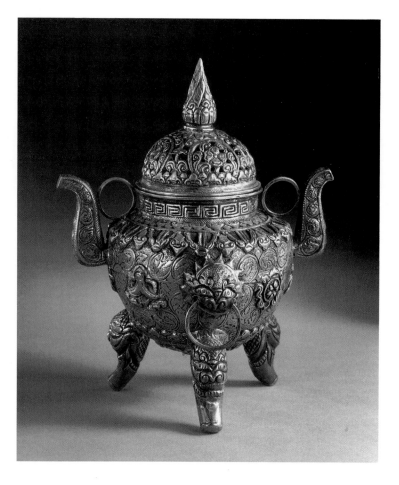

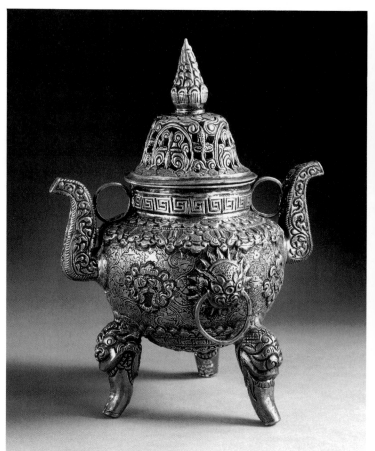

R32

Incense Burners
Eastern Tibet (Derge), 18th century
Silver
 a) 7⅛ in. (18.1 cm.)
 b) 6⅞ in. (17.5 cm.)
 Purchased with Funds Provided by
 The Louis and Erma Zalk Foundation
 a) M.83.26.2a,b
 b) M.83.26.3a,b

Although their sizes vary slightly, it is likely that the two incense burners form a pair, as they are of similar design. Incense burners are an essential part of an altar and were made in a variety of forms. These particular burners are essentially of Chinese design both in their form and decorative pattern. The principal motifs are stylized animal heads that in the Chinese context would represent *tao-tieh* masks but in a Buddhist context probably denote the evil/repellent face of glory, the eight auspicious symbols, and floral and vegetal scrolls. Compare the tall, conelike finial on the summit of the cover with the bowl of offering in the middle of a thanka dedicated to Mahakala (P31).

Mirror
Tibet, 18th century
Brass and copper
5¼ in. (13.3 cm.)
Gift of Anna Bing Arnold
M.87.211

A mirror is an auspicious object that is used in different ways in Buddhist art and ritual. It may be held by a deity as an attribute (*see* S8), or it may be included in a thanka or placed on an altar (as must have been the case with this well-crafted example) as one of the eight auspicious symbols. Generally it is regarded as a symbol of one's karma, either fate or accumulated deeds. In other words, one's karma is said to be reflected in the mirror. The mirror also symbolizes sight, one of the five senses. It is usually fringed with the flame motif symbolizing truth.

R34

Ceremonial Ewer
Eastern Tibet or Mongolia, c. 1800
Silver, jade, and semiprecious stones
10¾ in. (27.3 cm.)
Gift of Myrna and Peter Smoot
M.85.295.2a,b

The exact provenance of such ewers is difficult to determine. While eastern Tibet remains a strong possibility, some scholars have suggested that it may have originated in Mongolia. It may even have been made in China. Certainly Chinese workmanship as well as design is reflected by the jade pieces attached to the body, handle, and lid. These may indeed have been carved in China and the pieces assembled in eastern Tibet, perhaps in Derge, well known for its silver work. The make and design of the silver handle is also more Chinese than Tibetan, but the silverwork of the body and spout as well as the inlay with turquoise, lapis lazuli, and carnelian is Tibetan.

Among unusual features of this example are the design of the wheel with flying scarves and the white jade pieces on the body, the charming jade gander holding lotuses with its beak surmounting the silver lid, and the bird that looks like a partridge at the top of the handle. The position of the gander is most appropriate, for it symbolizes the propagation of Buddhist doctrine to all realms. Appositely also the bird holds a lotus, which is the symbol of the religion itself. The significance of the partridge, however, is a mystery. Such birds are often seen sitting on the handles of Islamic ewers made in West Asia, which may have been the source for this example.

Ceremonial Ewer

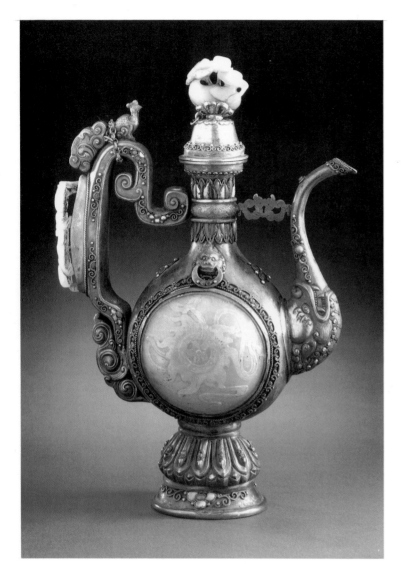

decorated with vegetal and floral designs and dragons. The stand is triangular in shape with a base that is adorned on top with stylized water motifs and on the sides with a conventional geometric border. From the ocean rises a lotus above which are gems and conch shells surrounded by scrolls or waves.

Very likely the object was made in an eastern Tibet workshop, perhaps in Derge.

R36

Woman's Headpiece
Ladakh, 19th century
Metals and gemstones on leather
28⅞ in. (73.3 cm.)
Christian Humann Asian Art Fund
M.86.191.3

Such spectacular headpieces are typically used by high-ranking Tibetan ladies. It is neither possible to be certain about the age of individual pieces, nor do we know how old the form is. Both men and women in Tibet love wearing elaborate jewelry, but very little is known about their forms or significance. Women's headpieces are especially varied, and this particular piece is unusually interesting both for its shape and design.

The Tibetan's inordinate affection for turquoise is clear from such headpieces. A wide variety of turquoise of natural shapes has been simply polished and attached to the leather backing. In addition, ornamental gold and silver plaques and natural pearls adorn the surface. The tassel is like a curtain of strung opals and silver beads with heart-shaped silver pendants at the bottom.

R35

Skullcup
Eastern Tibet, c. 1800
Silver, human skull, and turquoise
8¾ in. (22.2 cm.)
Purchased with Funds Provided by
Mr. and Mrs. Paul E. Manheim
M.82.201a–c

This skullcup differs from another in the collection (R5) in that it is more elaborate, has a stand, and is a genuine human skull lined with silver on the inside about half way down. At the bottom of the cup is attached a silver lotus inset with a turquoise in the center. The grinning heads decorating the rim of the cup are carved from bones and are set in silver. Unlike the other, this cup does not imitate a grinning skull. The lid in this example is

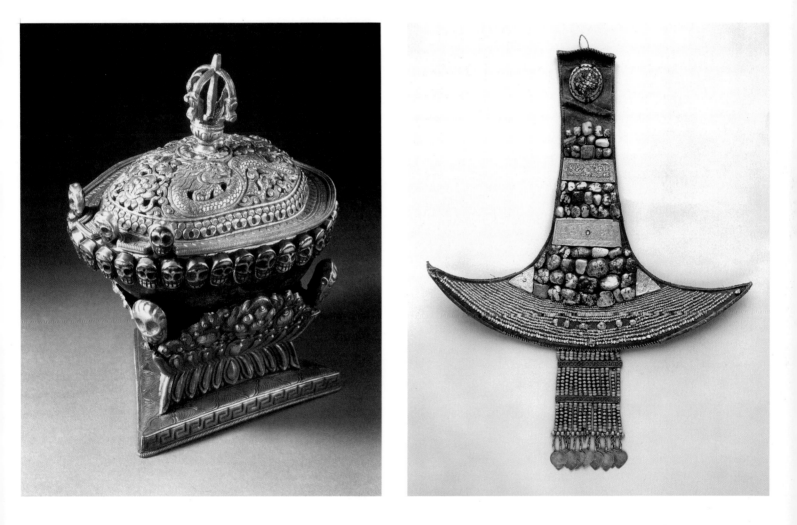

Textiles

Throne Cover
Tibet, 18th century
Polychrome silk and metallic thread; appliqué and embroidery on gauze weave (center) and supplementary weft on satin-weave ground (border)
54½ x 54½ in. (138.4 x 138.4 cm.)
Gift of Miss Bella Mabury
M.39.2.404

Textiles of all types played an important part in Tibetan Buddhist ritual. Images of deities were dressed or draped in costly silks, and chanting halls held a dazzling variety of banners, pillar coverings, ceiling cloths, thankas, valences, and altar cloths. Virtually every available surface was either covered with fabric or painted in patterns imitating decorative textiles.

This well-preserved square with a bright yellow silk double *vajra* appliquéd over four snarling dragons may once have graced the throne of a very high-ranking lama. Several early twentieth-century photographs taken in Tibet show textiles similar to the Museum's. In one such photograph the thirteenth Dalai Lama sits on a throne of large, stacked pillows with a textile hanging in front that features a double *vajra* (MacDonald, frontispiece).

The fabric under the *vajra* on the Museum's cover is from a Chinese ceremonial robe of the Ming dynasty. With dragon imagery closely related to that of the Wanli period (1573–1619), the textile probably dates to the fourth quarter of the sixteenth century. An unpublished pair of embroidered dragon roundels belonging to the Metropolitan Museum of Art and dating from the same period shows frontal cloud-grasping dragons almost identical in form and treatment to those on the Museum's cover. The border fabric, also from a length of dragon robe fabric, dates from the third quarter of the seventeenth century.

An excellent example of imperial-quality embroidery from the Ming period, the Museum's cover has long, running stitches that pick up a single thread of the ground fabric at regular intervals, creating the background and forming a delicate geometric pattern. A variation on this counted-thread technique is used to fill in the multicolored clouds. Clever use is made of the differences in light-reflecting properties of twisted and untwisted silk floss to create an illusion of depth: careful juxtaposition of twisted, matte-finish threads with glossy, untwisted floss gives an impression of bas-relief. Shifts in color tone and changes in stitch direction further add to the impression of depth. Thicker, couched gold threads for the dragon's scales and raised satin stitch for details such as the eyes provide textural variations.

DCG

Ceremonial Robe
Tibet, 18th century
Polychrome silk and metallic thread; supplementary weft on satin-weave ground
Center back: 59⅞ in. (152 cm.)
Costume Council Fund
M.71.53

This nobleman's ceremonial robe (*chu'ba*) was tailored in Tibet from two similar pieces of Chinese silk; the body of the garment from one, the sleeve extensions from the other. Because of the predominant pattern of animated dragons rampant on a stylized cloud-band ground, Chinese garments made of this type of fabric are called "dragon robes." Supplemental symbols figure in the decorative schema of this robe, including phoenixes at the neck and cuffs. In China the phoenix is a feminine symbol often meant to represent the empress; however, when paired with the five-clawed dragon, as here, it usually connotes matrimony. The addition of prominently placed double fish (emblematic of the joys of connubial bliss) and *shou* medallions (combining the characters for longevity and the number 10,000) suggest that the fabric of this robe was originally intended for a royal Chinese wedding garment (John Vollmer, oral communication, June 1988).

Because their long political and religious association with China centered on the exchange of goods, Tibetans had access to imported Chinese silk. The great noble families as well as the Dalai and Panchen Lamas participated regularly in so-called tribute missions to the Qing court, receiving ceremonial textiles and other silks along with tea and wrought silver items in exchange for Tibetan religious artifacts and woolen textiles. The first specific mention of the inclusion of dragon-patterned silks in these exchanges is in 1648, but the practice is undoubtedly older. Like the fabric of the Museum's robe, textiles made for the Chinese

Throne Cover

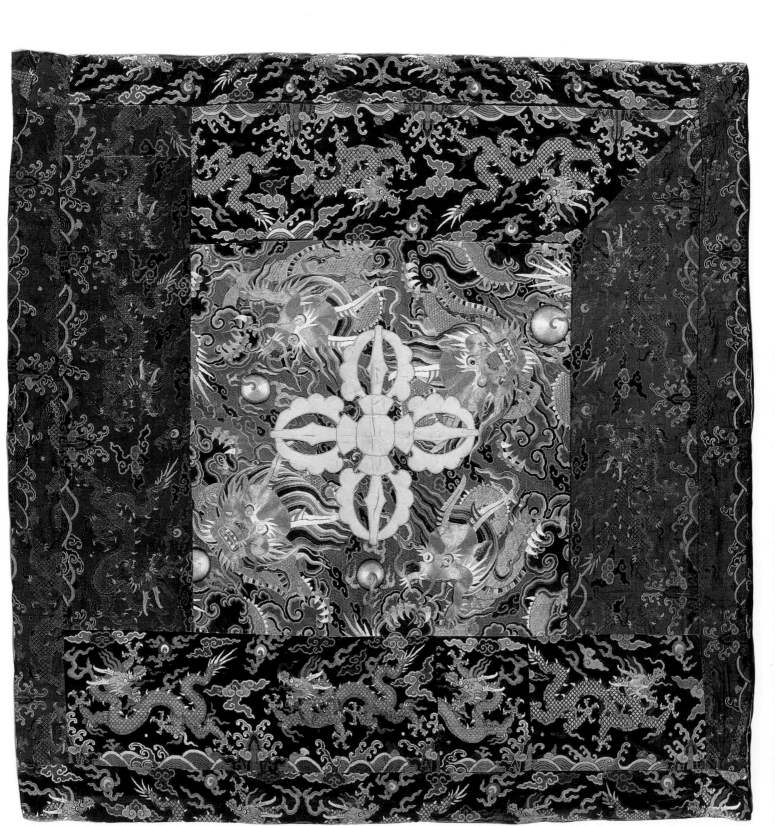

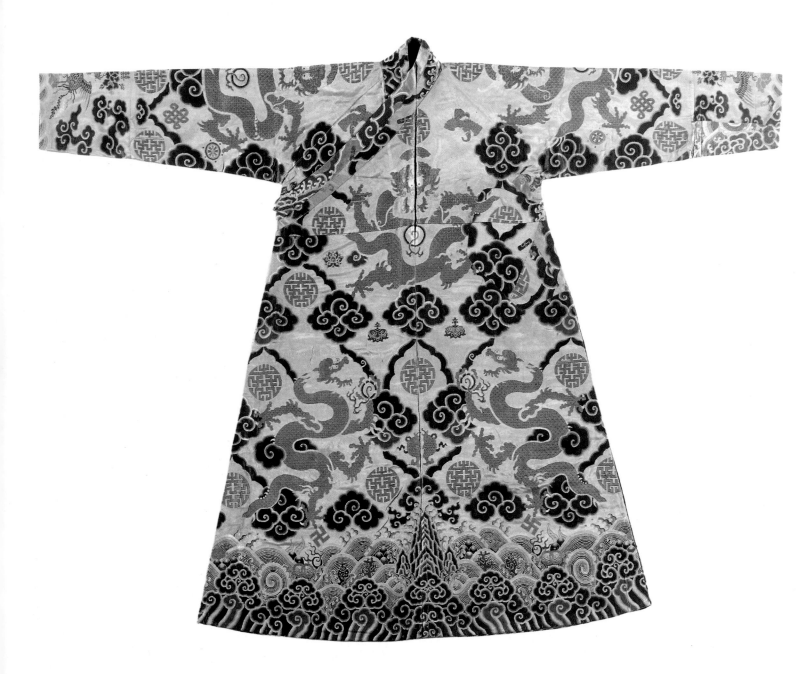

court but rejected by the imperial inspectors as unfit for royal use were often given as gifts to foreign emissaries.

The Tibetan nobleman who owned this *chu'ba* was most likely unaware of any feminine or matrimonial connotations of the robe's symbols; rather, he would have given them a purely Buddhist interpretation. The conch shell in the waves is one of the eight auspicious symbols of Buddhism, the rest of which (with the exception of the vase) are scattered above the water: double fish, royal canopy, state umbrella, lotus, wheel of the law, and endless knot. At the bottom of the garment, in a churning sea (the source of riches, according to Lamaist belief), are numerous symbols of wealth: flaming pearls, gold ornaments, wish-granting jewels, coral branches, rhinoceros horns, and swastikas (meaning "wishes multiplied by 10,000").

The combination of auspicious symbols and *li shi* (or vertical water, the wavy diagonal lines below the crests of the churning waves) was not well established until the end of the Kangxi period (1662–1722). But the eight large dragons of almost equal size—two at chest and center back, one on either upper arm, and two at knee level front and back—indicate a probable date of manufacture prior to an imperial edict of 1759 codifying every detail of dragon-robe design and requiring smaller dragons. Therefore, with a *terminus ad quem* of 1759, the fabric of the robe can be dated to the reign of the Yongzheng emperor (1723–36) or possibly the first two decades of the Qianlong reign (1736–96) (John Vollmer, oral communication, June 1988).

DCG

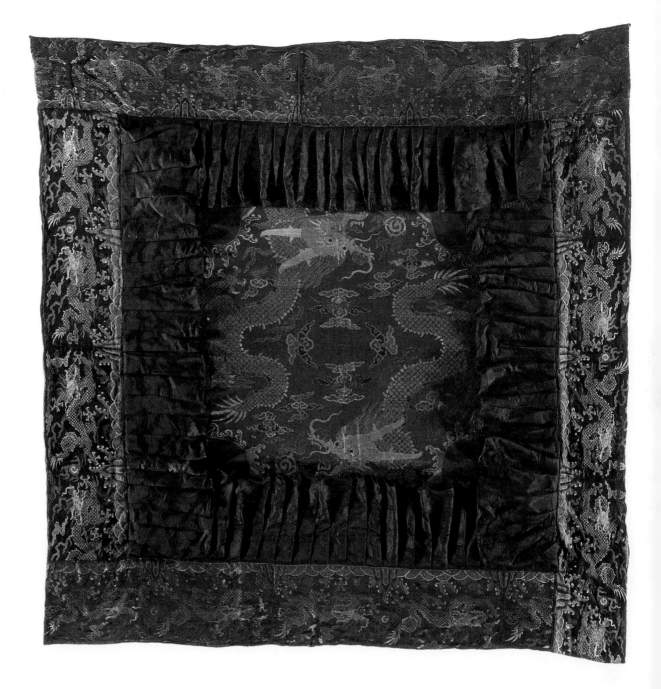

Canopy
Tibet, late 19th or early 20th century
Polychrome silk and metallic thread; supplementary weft on
satin-weave damask ground
70 x 70 in. (177.8 x 177.8 cm.)
Gift of Dr. and Mrs. David L. Rosenbaum and Dr. and Mrs.
Charles P. Rosenbaum
M.86.404

In the center of this dark blue silk canopy, two large and
vigorous four-clawed (*mang*) dragons, clasping the flaming pearl of
wisdom, swirl through a cloud-filled sky above a churning sea.
Assembled from an uncut Chinese robe, the Museum's canopy

may have sheltered a Lamaist image or a high-ranking personage.
Schuyler Cammann reported seeing in 1938 a portion of an
uncut, yellow silk dragon robe used as a canopy over one of the
principal Buddhas in the main shrine hall of a large Tibetan mon-
astery near Leh, Ladakh (Cammann 1952, p. 64, n. 20). That
these textiles functioned in other contexts is attested to by a pho-
tograph of the thirteenth Dalai Lama taken about 1920 at the
Jewel Park in Lhasa: an uncut length of dragon robe can be seen
hanging behind the throne (Bell 1924, facing p. 144).

It was common practice in the Buddhist world for laymen
to show their piety by donating expensive textiles to religious
leaders and establishments. George Bogle, who visited Tibet in
1774 as Warren Hasting's envoy, described the Panchen Lama's
chief temple at Tashilumpo as having a ceiling covered with Chi-

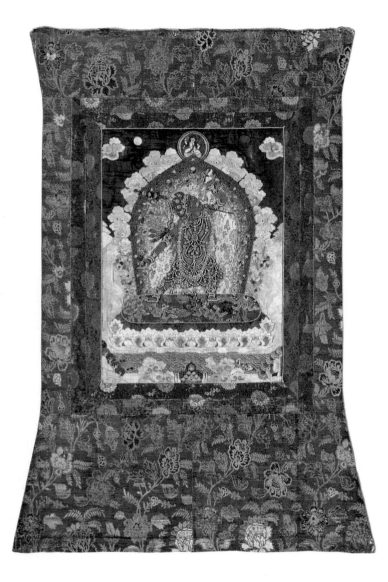

1988). The design, in soft shades of rust, off-white, blue, and green highlighted with metallic gold thread, would have created a dramatic "heaven" in the flickering light of oil lamps as it shimmered against the deep blue of the damask ground.

DCG

T4

Vajrayogini
Tibet, late 19th–early 20th century
Polychrome silk, metallic thread, and seed pearls; appliqué and embroidery
55¼ x 40 in. (140.3 x 101.6 cm.)
Purchased with Funds Provided by the Costume Council, Mr. and Mrs. H. Grant Theis, Mrs. Ronald Aubert, Peggy Parker, Joni Jensen Smith, and an anonymous donor
M.88.199

The esoteric *dakini,* Vajrayogini, steps triumphantly on the personifications of desire and jealousy in the center of this extraordinary appliquéd thanka. She drinks blood from a skullcup held in her left hand; in her right she wields a chopper. Her skull-topped magic staff (*khatvanga*) leans against her left shoulder, and a necklace of skulls loops down to her knees. Her human-bone breast ornaments, apron, and bangles are represented by tiny seed pearls. She is surrounded by a flaming aureole flanked by giant flowering plants. Above her sits a white figure (Heruka) holding a skull drum and a thighbone trumpet. Below her a delicately shaped, lotus-petal throne floats in a watery paradise where fish and pairs of ducks calmly glide, in rather startling contrast to the dramatic pose of the figure above.

Among the many representations of Vajrayogini in Western collections, this version in needlework is unique. She was an important deity, but rites pertaining to her were esoteric and practiced only by those properly initiated. Thus, this image of her may have been made for the occasion of the teaching of her secret doctrine by a skilled lama. The Museum's appliqué probably was executed by a lay specialist under the supervision of a high lama responsible for iconographic guidance.

If, indeed, in Tibet "the spiritual presence of a religious image is enhanced by the material out of which it is made" (Reynolds et al., p. 32), then this lavish use of expensive, imported silks and river pearls should make Vajrayogini's spiritual presence almost palpable. Only a large and wealthy monastery could have possessed the material and artistic resources to create this costly and skillfully executed work. Using fabrics as a painter does a palette, the artist chose textiles whose color and texture were appropriate to each element of the "painting." Silk-wrapped horsehair cord or metal-wire outlines around each cut-fabric shape, finely embroidered details, and, most notably, the use of seed pearls give a sculptural quality to the thanka and create a lively surface interest. The depth and animation thus achieved enhance the figure's expression of vital spiritual forces.

Tibetans used appliqué in both secular and religious contexts, but perhaps the most famous products in this technique are the enormous thankas (eighty to one hundred feet high) unrolled against hillsides or monasteries on certain festive occasions.

nese, Kalmuck, and European satins (Cammann 1951, pp. 100–101). Many were probably donations from wealthy patrons. It is also conceivable that the Chinese textiles he mentioned, like the Museum's canopy, were originally tribute silks presented by the Son of Heaven or his emissaries to official Tibetan visitors. For Tibetans, as for so many others, the ceremonial dragon robes of the imperial court were among the most highly prized of such gifts. During the Qing dynasty (1644–1912) these were always presented in the form of uncut lengths of woven-to-shape yardage, possibly in recognition of local variations in dress.

The Museum's canopy is made from the upper portion and decorative skirt bands of a man's semiformal court robe (*chaofu*) of the early Qing dynasty. The lobed design in the center represents a cloud collar that is mentioned on robes as early as the Jin dynasty (1122–1234). The seam for the front opening of the robe runs diagonally between the dragons on one side. The equally elongated jaws of the dragon and its aggressive profile support a date of 1650–75 (John Vollmer, oral communication, June

Smaller appliquéd thankas, such as this one, are far less common; only a handful exist in Western collections. A closely related piece, depicting Avalokitesvara, is in the Newark Museum's collection (Reynolds, cat. no. 186). Although Reynolds dates that thanka to the eighteenth century, the one belonging to the Museum must be assigned to the late nineteenth or early twentieth century because it incorporates Chinese textiles colored with coal-tar derivatives. These synthetic, aniline dyes did not reach China until the early 1870s.

Since at least two of the mounting brocades are used in the thanka itself, it is clear that the piece is in its original state. This unusual completeness provides insight into the unity of vision with which the thanka was conceived. Careful planning included not only the choice and placement of the fabrics of the central image but also of the mount.

DCG

T5

Ceremonial Hanging or Cover
Tibet, early 20th century
Polychrome silk, metallic and peacock feather filament-wrapped threads; embroidery and appliqué on satin-weave damask (center) and supplementary weft on satin-weave ground (border)
38½ x 38½ in. (97.8 x 97.8 cm.)
Gift of Miss Bella Mabury
M.39.2.63

This unusual textile consists of seventy-two embroidered, overlapping shapes that represent peacock feathers radiating from a central, oval "feather." The barbs of each "feather" are formed by delicate threads of green and gold peacock plume barbs (wrapped around a white silk core) couched to a bright yellow silk fabric. Stem stitches of magenta silk floss create the central shafts; the eyes are of white, yellow, magenta, brown, and light and dark blue silk floss in satin stitch, accented with couched, foil-wrapped thread.

Each "feather" is backed with yellow Chinese silk. The entire configuration is stitched to a pale orange silk damask, self-patterned with stylized clouds and enclosed by a narrow border of black silk satin with a design of dragon roundels and auspicious symbols in gold.

An umbrella or canopy made of three hundred "feathers" in the collection of the Newark Museum may have been embroidered in China and later assembled in Tibet (Newark, pp. 17–18). That the source of these feathers is China is supported by a fifty-seven-foot-long scroll in the Provincial Museum of Liaoning depicting an official appearance of the emperor Qianlong and his 3,766-person retinue (Montreal, pp. 160–61): among the dozens of silk umbrellas carried before the emperor, one is made of overlapping peacock feathers apparently embroidered individually like those on the pieces belonging to Newark and the Museum. These feathers could initially have found their way to Tibet as part of Sino-Tibetan gift exchanges. By the early twentieth century—from whence the Museum's cover dates—these embroidered feathers may have been made in China as a trade item for Tibet.

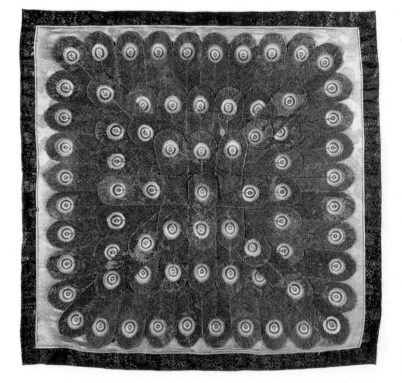

In Tibet, canopies of peacock feathers (whether real or embroidered is not known) were used during the important twenty-four-day Monlam festival celebrating the Buddhist New Year. On the penultimate day of the festival an image of Champa (Maitreya), the Buddha of the future, was carried in procession shaded by an umbrella of peacock feathers (MacDonald, p. 207). Unfortunately, the Museum's piece gives no clear indication of its function: it has no central holes nor any attachments, as would a canopy. Thus, it might have been draped before a seated image, hung behind the image of an important personage, or used as a throne cover.

DCG

Additional Comments

Since this catalogue was first published, some reviewers have made helpful comments and pointed out a few errors, which are addressed below. Before doing so, however, some observations should be made regarding relevant literature and research that have been published or undertaken in the meantime.

While the revised bibliography includes most literature on Tibetan art and culture published since 1983, a few words should be said about the Chinese publications. Generally, they are useful for their illustrations of temples and monasteries (including their contents) that escaped destruction during the Cultural Revolution, but the accompanying texts are less reliable. For instance, in a recent publication of a series of thankas depicting the life of the famous Sakya teacher Phakpa (1235–80), it has been suggested that the series was painted before 1478 (Shuwen et al.). From our present knowledge of the styles and dates of Tibetan paintings, such an attribution seems impossible. If one were to accept the dating of this biographical series, then one would have to radically alter established ideas regarding the chronological framework of Tibetan painting. Also confusing is the sinicization of Tibetan words, which often makes it difficult to identify monuments and monasteries. Nevertheless, the illustrations do serve as comparative material to establish the styles and dates of the thankas and bronzes that are now outside Tibet. Helpful also are the numerous Chinese textiles that have recently come out of Tibetan monasteries. Some of them date from the Song dynasty. They are of great interest not only for the history of Chinese textiles but also for the study of the interrelationship between Chinese and Tibetan paintings. Rich in landscape elements, some of these textiles may have been the source for natural forms encountered in Tibetan thankas.

Those interested in learning more about the techniques and methods of painting thankas as well as the materials used will profit enormously from the detailed studies by Jackson and Jackson and Gega Lama (*see* bibliography). Similarly, for the techniques and materials of metal sculptures, readers are referred to Reedy's thesis (*see* bibliography), which will be published probably in 1990. Over the last few years Dr. Reedy has been engaged in a technical and metallurgical examination of Himalayan bronzes. Her study helps us to determine more precisely the region where the metal sculptures were manufactured. Reedy's conclusions regarding the provenance of the bronzes included in this volume are incorporated into the following pages.

Reedy's examination was not limited to metal analysis only. She also removed the baseplates from those bronzes that had them, thus revealing the consecrated objects that were frequently stuffed into Tibetan metal images. This practice of filling the hollow body of an image or other votive objects with all sorts of relics seems to have been particularly popular with Tibetan Buddhists and is also encountered in both China and Japan. Apparently, these consecrated objects act as charms to protect the

image as well as enhance its spiritual potency. The custom is certainly a continuation of the more ancient practice of enshrining a relic inside a stupa. This was common in both India and Sri Lanka. The practice was continued with images, especially those made of metal. It is much more convenient to fill a metal image than one made of stone. Nevertheless, it should be noted that metal images recovered in large quantities in India, Sri Lanka, Nepal, or Southeast Asia seldom contain such relics. Even those that have been buried in the ground for centuries and have escaped vandalism from treasure hunters do not always contain any consecrated objects. However, *in situ* stone or brick stupas do enshrine relics of various kinds.

The objects whose contents have been examined are S20, S25, S37, S46, S47, and S50. Of these, S50 represents a Bonpo bronze, while the others are Buddhist. S20 and S25 depict deities, while S37, S46, and S47 portray historical personages. The contents of the images vary considerably from one another, although certain items such as seeds or grains and rolls of paper filled with writing seem to be fairly common. Pieces of textiles too are included in some examples. The Bonpo bronze (S50) contained among other things human hair, pieces of human skull and bones, and a human tooth, thereby clearly indicating its funerary character. Two images (S25, S46) enshrined a number of small, votive, terracotta plaques known as *tsha tsha*. Especially elaborate are the contents of the Nairatmya (S25). They include several *tsha tshas* (representing various deities) as well as miniature stupas, pieces of coral, turquoise, bark and wood, and a piece of bone.

The contents of such images can be of both religious and art-historical significance (*see* Hatt; Reedy 1986 B). For instance, the terracotta figures and miniature stupas in S25 reflect a figural style prevalent in fifteenth-century sculptures, especially in Gyantse, which seems to confirm the date suggested for the bronze in the catalogue.

Jackson and Jackson's book provides a detailed description of the techniques involved in painting thankas, which they learned from three Tibetan artists; however, Gega Lama's book on the principles of Tibetan art is based on his own experiences. Being himself a painter in the Karma-gadri manner (*see* p. 51 of this catalogue), he is naturally partial to this style, which he considers the finest of all the painting methods prevalent in Tibet. Gega Lama's observations regarding the origin of the Karma-gadri style (*see* P26, P28, P29, P50) are interesting. He believes it was created by Namkha Tashi, an emanation artist born in Upper Yarlung district in 1500. According to Gega Lama, Tashi incorporated elements from three countries: forms in accordance with Indian standards, coloring and texture of the Chinese method, and composition in the Tibetan manner. Gega Lama further explains that the style was developed principally in the camps during the constant travels of the Karmapa hierarchs. "The custom and traditions which developed from this became the so-called 'camp culture,' and in particular the painting was known as the 'camp style'" (Lama, p. 37).

Whatever elements Namkha Tashi borrowed, he integrated them into the new style so skillfully that it is impossible to tell the components apart. Also, since the style came into being in the sixteenth century, it is difficult to know what Indian works Namkha Tashi consulted for the figural forms. Gega Lama is more precise, however, about the Chinese sources and mentions specifically some Chinese works that Namkha Tashi used as models. One of these was a scroll given by the Chinese emperor Yung Lo to Dezin Shegpa (P25), which was last seen in the Tshurphu monastery in 1949.

Since this catalogue was first published, an entire book has been devoted to the study of Tibetan painting styles (Pal 1984). Many observations and attributions made here have been further elaborated in that book. It includes substantial discussions about the Kadampa style, the Sakyapa style, and Sino-Tibetan styles of painting. Mention should also be made of a publication on Buddhist book illuminations in which most of the Museum's illuminated books and book covers are discussed further (Pal and Meech-Pekarik). In that book an entire chapter is devoted to Tibetan book illustrations, a subject about which very little literature is available otherwise.

Corrections

pp. 150–51 P15
By an oversight, the inscriptions identifying the figures in this thanka were not included in the first edition of the catalogue. While some of the inscriptions are not always clear, the names of the four prominently represented monks are as follows: (beginning at upper left) rJe btsun Kun rig pa; mNga' brnyes chos 'bar; Kun dga' snying po; and bSod nams rtse mo. Of the four, Kunga Nyingpo and Sonam Tsemo are well-known Sakyapa teachers. The collection, in fact, contains two other representations of Sonam Tsemo (P18, S38). A comparison of the three shows how each portrait differs from the other, and without the inscriptions one would hardly have recognized them as depictions of the same person. Kunga Nyingpo (1092–1158), also known as Sachen, was the founder of the doctrine that distinguishes the Sakyapa school of Tibetan Buddhism. Although no information is available about the other two teachers, they are said to have lived in the twelfth century (personal communication from the Sakyapa Center in New York).

p. 184 P46
As Dale Carolyn Gluckman has pointed out, there are actually ten flying bats represented in the embroidered thanka, thereby doubling the number of blessings. With regard to the so-called "forbidden" stitch, the following comments by Schuyler Cammann (1962, p. 30) should be noted:

> In Chinese, this process is known as "making seeds" (*ta tzu*), while the Western world knows it as the "French knot." But the foreigners residing in China called it "Peking knot" or "the Peking stick" and some "Old China Hands" even referred to it as "the forbidden stitch," citing a baseless legend that its use was officially banned because it was so ruinous to the eyesight of the embroiderers. There does not seem to be any factual basis for this belief.

Cammann points out further that while the idea of these seed-knots or ring-knots may have originated in Beijing (Peking), during the nineteenth and early twentieth centuries the technique was popular in central China, especially in Hangchow and Joochow. It seems almost certain therefore that this particular example was made in China for a lamaist monastery.

p. 187 para. 1
While lapis lazuli was imported from Central Asia, turquoise was mined locally. However, because of the great demand for turquoise among the Tibetans, the stone had to be imported as well from Iran and Central Asia.

p. 193 S2
Reedy's study confirms a western Tibetan attribution.

p. 193 S3
Reedy's study places this bronze in western Tibet, which includes Ladakh. As there is little evidence of bronze manufacture in Ladakh, this object may have been made in the western Tibetan kingdom of Guge.

p. 195 S4, S5, S6
According to Reedy, all three bronzes were made in Kashmir. The workmanship of S5 and S6 probably indicates a provincial center.

p. 197 S7
According to Reedy, this rather crude figure was fashioned in Himachal Pradesh.

p. 199 S8, S9
S8 was manufactured in western Tibet, while the more impressive S9 is given a confirmed central Tibetan provenance. This figure is, in fact, a fine example of the central Tibetan style of bronzes under the influence of Pala aesthetic.

p. 201 S11
Reedy was unable to establish an exact provenance for this bronze.

pp. 201–2 S12
I was uncertain of this figure's provenance, but Reedy's study places it in western Tibet.

p. 202 S13
According to Reedy, this bronze was made in Nepal. The date of the figure must also be revised, for it does show close stylistic affinity to other Nepali bronzes of the ninth and tenth centuries. In fact, stylistically it is a mate to another bodhisattva figure now in the Musée Guimet in Paris (von Schroeder, pp. 316–17, no. 80E). That figure retains its lotus base and elaborate throne back. So close are the two figures in every detail that they must have been made by the same sculptor. A third bronze in a private collection (von Schroe-

der, pp. 422–23, 109F) must also have been made by the same hands. Interestingly, while attributing the Musée Guimet bronze to Nepal, von Schroeder catalogued the other two as central Tibetan.

pp. 202–4 S14

In a recent article (Alsop) it was clearly demonstrated that the figure represents Avalokitesvara and the image is a copy of a sacrosanct model called Phakpa (meaning noble) Lokesvara preserved in the Potala palace in Lhasa.

p. 204 S15

Reedy was unable to suggest a certain provenance.

p. 216 S27

Reedy was unable to suggest a certain provenance.

p. 220 S32

The region of manufacture, according to Reedy, is central Tibet.

p. 222 S33

According to Reedy, the provenance of this bronze is eastern Tibet.

pp. 223, 225 S34

Reedy was unable to suggest a certain provenance.

p. 225 S35

According to Reedy, provenance is eastern Tibet.

pp. 225–26 S36

Reedy confirms eastern Tibetan attribution.

pp. 226, 228 S37

Reedy confirms eastern Tibetan attribution. Also, in second column, second paragraph read "in the crook of his *left* arm."

p. 228 S38

According to Reedy, provenance is eastern Tibet.

pp. 228, 230 S39

According to Reedy, provenance is eastern Tibet.

p. 230 S40

According to Reedy, provenance is eastern Tibet.

pp. 253–54 R18

According to Reedy, provenance is western Tibet.

P1	From the Nasli and Alice Heeramaneck Collection, Museum Associates Purchase M.84.32.5
P9	From the Nasli and Alice Heeramaneck Collection, Museum Associates Purchase M.83.105.19
P10	From the Nasli and Alice Heeramaneck Collection, Museum Associates Purchase M82.6.4
P20	From the Nasli and Alice Heeramaneck Collection, Museum Associates Purchase M.83.105.16
P23	From the Nasli and Alice Heeramaneck Collection, Museum Associates Purchase M.84.32.6
P24	From the Nasli and Alice Heeramaneck Collection, Museum Associates Purchase M.83.105.18
P34	From the Nasli and Alice Heeramaneck Collection, Museum Associates Purchase M83.105.17
R10	Gift of the Michael J. Connell Foundation
R11	Gift of the Michael J. Connell Foundation
R12	Gift of the Ahmanson Foundation
R22	M.84.31.513a,b

Errata

p. 25, line 13
"*Tanjur* (original treatises)" should read "*Kanjur* (original treatises)."

p. 25, line 14
"*Kanjur* (commentaries)" should read "*Tanjur* (commentaries)."

p. 36, last line
"a false notion, to obliterate which yoga" should read "a false notion to obliterate, for which yoga."

p. 55, line 23
"well-proportioned" should read "well proportioned."

p. 58, line 34
"electicism" should read "eclecticism."

p. 76
"Amithabha" should read "Amitabha."

p. 128, col. 1, last line
"Lewis" should read "Louis."

p. 144, col. 1, line 5
"(Bihbar)" should read "(Bihar)."

p. 172, P35 accession number
"M.80.221.2" should read "M.80.221.1."

p. 225, S35 accession number
"M.76.67" should read "M.79.67."

p. 225, col. 2, line 6
"p. 596" should read "p. 546."

p. 230, S41 credit line
"Werner Scharff" should read "Werner G. Sharff."

p. 237, line 15
"Once such vase" should read "One such vase."

p. 244, col. 2, line 38
"Leroy" should read "LeRoy."

p. 248, line 37
"wth" should read "with."

p. 248, line 43
"worship" should read "workshop."

p. 251, R14 accession number
"M.78.23a-b" should read "M.78.23a,b."

p. 254, R20
Medium line should read "Turquoise, garnets, pearls, and silver."

p. 256, R22
Medium line should read "Silver, steel, leather, jade, coral, turquoise, and rubies."

p. 270
"Kanjur" should read "Tanjur."

p. 271
"Tanjur" should read "Kanjur."

Appendix

Text and Translation of Selected Inscriptions
on Tibetan Works in the Museum's Collection

H. E. Richardson

[*This appendix is by no means exhaustive; it only includes reasonably legible inscriptions. In the bronzes the inscriptions generally occur along the base, but occasionally on the back as well. Dedicatory inscriptions on thankas are usually added at the bottom. The reader may assume that when the translations are not given for a particular object, the inscription is either a mantra or the name of a deity. Letters or words in parentheses denote possible reconstructions, and an 'x' signifies an illegible letter. Notes have been added only where it was felt they were necessary to elucidate a particular point in the inscription.*
P.P.]

The majority of inscriptions on the thankas in the Museum's collection simply identify the deities or other personages depicted. Some describe scenes from the life of the subject. In a few instances, an inscription at the bottom of the painting names the donor and sometimes the painter. Some high lamas were famous artists, but their work is rare; most thankas were painted by professional artists (*lha bris pa*), whose standards of literacy were not particularly high; thus, even well-known names may be wrongly written. The orthography, therefore, is generally variable.

Inscriptions on the backs of thankas are for the most part mantras, religious sayings such as the *Ye dharma hetu prabhava* dictum (either in Sanskrit or in its Tibetan translation), invocations of the deity represented on the front, and so on. There is considerable unevenness in the calligraphy as well as in the orthography of these, even though they quite often appear to have been written by educated monks —the donor or someone writing on his behalf—rather than by the painter. Some are in fine classical Tibetan *dbu med* or *dbu can* script, others in cursive writing. Other inscriptions include prayers by the donor for the welfare of a teacher or parents as well as for all sentient beings. It is rare that persons named in such dedications can be identified.

Inscriptions on bronzes, where space is usually restricted, name the figure represented and sometimes include a brief invocation. Occasionally, a donor or person for whose spiritual benefit the image is dedicated may be named; but here, too, identification is elusive.

Thankas in the collection in which inscriptions provide valuable art historical information are: **P5,** in which the artist is named; **P13,** a portrait of two Sakyapa lamas known to have been active in the mid-fifteenth century; and **P20,** a portrait with scenes from the life of Kunga Tashi (Kun dga' bKra shis), the thirty-second abbot of Sakya (1349–1425). In several other thankas the donor is named but is not identifiable. The most interesting of these is **P1,** the magnificent painting that is, without question, the oldest in the collection. The donor is not known, and the orthography is so bad that its origin is open to wide conjecture; however, the orthography may mean the painting came from Tsang. The donor, incidentally, draws attention to the remarkable size of the painting, which measures a full 102 inches long.

Items of iconographic interest, other than thankas, are illuminated pages from an early *Prajnaparamita* manuscript (**M1**) and a set of gilded clay *tsha tsha* (R16) with the names of the deities and other personages given in four languages. Among the inscribed bronzes, an interesting figure (S31) of Dampa Sangye (Dam pa Sangs rgyas) was dedicated in memory of Lama Palden Sengge (dPal ldan Seng ge), who may be identified as having died in 1342. The inscription on S32, the exceptionally fine image of a lama named Karma Dudtsi (bDud rtsi), is obscure, and the lama is not yet identified. There is an even more obscure inscription on an image of an eleven-headed deity (S3).

M1 *Twelve Illuminated Folios from a* Prajnaparamita *Manuscript*

M1 b) *Stong pa nyid stong pa nyid*
M1 c) *Shes rab kyi pha rold tu phyind pa*
M1 d) *Dad pa'i stabs*
M1 e) *Shyin ba'i pha rold tu phyind pa stong phrag brgya pa las*
M1 f) *'Dus ma byas stong pa nyid*
M1 h) *Don dam pa stong pa nyid*
M1 i) *Sangs rgyas rin cen 'byung ldan*

Notes:
The inscriptions on seven of the twelve folios of this manuscript are labels which appear at the bottom of the illustrations on folios b–f and h–i. Evidently, they are the titles of the deities represented.

M4 *Two Illuminated Pages from a* Dharani *Manuscript*

M4 a) This is the second page of a tantric work beginning with invocations to Narasimha, Mahesvara, and others. There are small letter notes mentioning "Ra lugs" (the tradition of Ra Lotsawa) and the tantra of *sbyor drug* (six preliminary practices).

The figures are identified as: (on the left) 'Phags pa Klu grub (Nagarjuna); and (on the right) Bu ston Rinpoche (Butön rinpoche) (1290–1364).

M4 b) This is the second page of a text beginning with invocations to Buddhas, bodhisattvas, and goddesses. It appears to be a *dharani* (charms) manuscript.

The figures are: (on the left) dPal gsang ba 'dus pa (Guhyasamaja); and (on the right) gShin rje gshed (Raktayamari).

P1 *Tathagata Amitayus and Acolytes*

Apart from the dedicatory inscription, which is camouflaged in the lotus petals below the central figure, various other shorter inscriptions, in curious orthography, identify the other figures. The six figures at the top of the painting have their names written in their halos. Of the five figures along the bottom only four bear inscriptions below each figure; the figure in the middle has no label. The calligraphy of the dedicatory inscription is bad, so it is not always certain whether *d,* or an *ng,* or even an *r* is intended in some words.

Figures along the top row only (from left to right): 'Ga ba; Men grung (?) pa; Sem pa; Gyang can ma; Rna ra (ru?) ba tha yas; Shas (Shes) rig bu (?)

Figures along the bottom (from left to right): Bstam 'grin; Bcas ras zig; no inscription; Phyag bdor; Mi gyo ba.

Inscription:
Om bsva sti Ba yul gcang rag nag ga du bkyang 'gon blo bzang mchos dgyan gyis mtshes 'grub mdzad pa sya[1] bkobs mthug bstam rten[2] la gnang nyan 'di msyan (?) gyis mdzad nas mdom 'dzal che ba yin bkra shis.[3]

1. *pa sya* is perhaps *pa yi.*
2. *rten* must be intended, though the letter is *hen.*
3. The Tibetan letter in the word *shis* at the end of the text (*bkra shis*) is much more like the Sanskrit *s* than Tibetan.

Translation:
Om Swasti...On the occasion of the life-attainment ceremony by the Lama Chos kyi rgyal mtshan at Gcang rag nag ga in Ba yul this picture made in fulfillment of his vow by Chos rgyan measures a full fathom in size. Good Fortune!

Notes:
This translation assumes many errors in orthography: *bkyang 'gon* for *skyabs mgon; mtshes 'grub* for *tshe 'grub; mthug bstam* for *thugs dam; gnang nyan* for *snang brnyan; 'dzal* for *'jal.* These, and the spellings of some of the names of the figures, are so gross that it can hardly be believed that the painter had before him an example written by a lama. They also make the identification of the place names conjectural; but *Ba yul,* which occurs twice in the *The Blue Annals,* appears to have been a high region south or west of *Lha rgya ri* in *E (gYe) yul. gCang rag nag ga* is not identified as yet. If *bkyang 'gon* is a name and not merely an error for *skyabs mgon,* it could refer to a monastery.

P5 *Mandalas of Hevajra and Other Deities*

Dedicatory incription at the bottom of the painting:
bla ma kun mkhyen 'jam dbyangs kyi | | thugs dam bzhengs' phro 'di dang ni | | brgyud ris bde dgyes dus 'khor dang | | 'jigs byed rdo rje phyag dang x x un | | bla ma nyi kyi nang rten du | | btsun pa (rgyal) mtshan x gyis bzhengs | | lha bzo gzhan las byas | phas (?) rgyal po dpal seng yin | de ltas nas | bla dgong su yongs rdzogs nas | | kun gyis byang chub thob par shog | | dge'o | |

Translation:
This [thanka] which proceeds from the vow of the all-knowing Lama 'Jam dbyangs and the circle of the tantra of *bde dgyes* and 'Jigs byed rdo rje, [was] set up as an inner spiritual support for the lama himself by the monk rGyal-mtshan. Of the other craftsmen who did the work [the head] was rGyal po dpal seng. By seeing this...when the lama attains complete fulfillment, may all creatures [also] win enlightenment. May it be for merit.

Notes:

Because the dedicatory inscription is badly effaced the transcription may not be wholly accurate. The person who commissioned the painting was a monk (*btsun pa*) whose name was rGyal mTshan.

The painting, however, was dedicated in honor of the lama Jamyang ('Jam dbyangs). The importance of the inscription lies in the fact that the painter (*lha bzo*) is also named. His name is given as Gyalpo Palseng (rGyal po dPal seng).

P13 *Sakyapa Lineage*

The figures in this thanka are shown in the order indicated by the arrangement of numbers below.

I	2	3	4	5	6	7	8	9	10
11	12	13	14	15	16	17	18	19	
20								26	
21								27	
22		32			33			28	
23								29	
24								30	
25								31	

Listed below are the transcriptions of the names of the figures, given in faint inscriptions, as they correspond to the numbers as arranged above.

1. rDo rje 'chang
2. bDag med ma
3. Bir wa pa
4. Nag po pa
5. Na ro pa
6. A wa du ti pa
7. Ga ya da ra
8. bLa chen (mchog?)
9. Se ston (?)
10. Zhung b'en (?)
11. Sa pan
12. bSod nams rtse mo
13. Mus chen la na mo
14. Illegible
15. No inscription
16. Chos kyi kun dga' bzang po la na mo
17. Chos rje mu sa pha chen po la na mo
18. rJe btsun la na mo
19. Tsho bsgom
20. 'Phags pa
21. Zhang dkon dpal
22. Brag phug pa
23. bLa ma Dam pa
24. dPal ldan tshul khrim
25. dPal ldan rdo rje pa
26. (?) chen pa
27. dKar po brag pa
28. Ri khrod pa
29. Buddha sri
30. 'Jam dbyangs shes rab rgya mtsho
31. bLa ma bSod nams dbang phyug
32. rJe btsun dam pa Kun dga' dbang phyug
33. rJe btsun dam pa bSod nams seng ge

Notes:

Of the central figures, Kun dga' dBang phyug (Kunga Wangchuk) (1418–1462) may be identified with sLob dpon Kun dga' dBang phyug of the bZhi thog branch of the Sakya. bSod nams Seng ge (Sonam Senge) was a teacher of the Rin spungs prince Kun bzang po, who, with the teacher Sangs rgyas 'phel, founded the monastery 'Bras yul. The thanka might, therefore, date from the fifteenth century.

P14 *The Life of Milarepa*

Inscriptions:

Small seated figure on the right of Milarepa's head:
　　bSod nams lha'i dbang po

Similar figure on the left of his head:
　　Dus zhab pa blo gros (Dus zhabs?)

The row of twelve seated figures above Milarepa (from left to right) are identified as follows:
　　Rin chen (?chos rgyal) dpal bzang po
　　(dBon?) dPon rin bSod nam(s) grags
　　Phag mo gru pa
　　Mar pa
　　Te lo pa
　　rDo rje 'chang
　　Stod pa sangs rgyas
　　Na ro pa
　　sGam po pa
　　'Jig rten mgon po
　　Cung Rin po che
　　dBon Rin po che

Notes:

The panels all around the central figure depict scenes from the life of Milarepa. Most of the text is badly damaged, as are the names of many of the figures. Some of the scenes can be identified from the inscriptions, but some of the writing is effaced. At the bottom is a damaged inscription in cursive Tibetan script which is illegible.

P16 *Three Mandalas*

The inscription below this painting is considerably effaced. Possible reconstructions are shown in parenthesis:

Inscription:

| | dkyil x x bcuis[1] dge bai (lugs) chos kyi rje lnga rig par chen tshul (gyi) 'od zer gyi thug gi dgong pa khye pa x x x (don du) yongs su rdzogs par gyur cig de gi thug rje dang byin rlab la rtens[2] bdag rgyan 'ore[3] kyi pha ma'i gtso byas sems can kyi sdig sgrib dag nas sangs rgyas tho par gyur cig | | mangalam | |

1. Abbreviation for *bcu gnyis*
2. Abbreviation for *rten nas*
3. This is written in abbreviated form; it should be *'od zer.*

Translation:

This mandala, one of a series, was dedicated by rGyal mtshan Ore' [i.e. 'Od zer] for the cleansing of his sins, those of his father and mother, and all creatures.

It prays that the learned Lama Tshul gyi 'Od zer [Tshulgyi Özer] may attain fulfillment of his wishes.

Note:

For another reading and translation of this inscription, *see* Tucci 1949, p. 600.

P18 *Sonam Tsemo and His Lineage*

Inscription at the back on the top mount:
　　g-h yas drug pa bsod nams rtse mo

Translation:
　　bSod nams rTse mo, 6th on right.

Dedicatory inscription at bottom on the red border:

bsod nams dpag med las grub cing mkhyen pa'i ye shes rab rgyas pa | | gro ba'i rtsa lag mchog gyur pa bsod nams rtse mo la phyag 'tshal | | smon lam mtsho skyes lugs kyi skye rdo rje | bla ma brgyud pa la sogs pa'i lha tshogs rnams la phyag ' tshal zhing | | skyab su mchi'o | dus tham du rjes su gzung du gsol | |

Translation:

Reverence to bSod nams rTse mo who achieves immeasurable virtue, extends knowledge and wisdom, and is an excellent friend to all creatures. Doing reverence to the assembly of deities of the Lama Brgyud pa's of the (tradition of) mTsho skyes rdo rje (?), I take refuge in them and pray at all times to follow their teaching[.]

The figures surrounding Sonam Tsemo are shown in the order indicated by the arrangement of numbers below.

I	2	3	4	5	6	7	8	9
10	11	12				13	14	15
16	17	18			19	20	21	
22						28		
23						29		
24						30		
25						31		
26						32		
27						33		
34	35	36	37	38	39	40	41	42

Listed below are the transcriptions of the names of the figures as they correspond to the numbers as arranged above.

1. No inscription
2. xx dpal 'dzin lha lcam
3. mTsho skyes rdo rje
4. Bi la sya va jra

323

5. No inscription but figure represents Vajradhara
6. Yan lag med pa'i rdo rje
7. Indra Bhu di
8. Nag po spyod pa
9. Ga ya dha ra
10. 'Brog mi
11. gSer bzad dri med
12. No inscription
13. No inscription
14. Mya ngan med mchog dpal
15. Se ston
16. Zar ston
17. No inscription
18. No inscription
19. No inscription
20. No inscription
21. Sa chen
22. Rin chen don grub
23. Chu bo'i pa na
24. Brag phug pa
25. xx Tshul khrims
26. Mus chen
27. Sangs rgyas bstan pa rin chen phyogs bcur spel
28. Chos rje rgyal grags
29. dKon mchog dpal
30. Blo gros brtan pa
31. Kun dga' bzang po
32. bSod nams seng ge
33. dKon mchog lhun grub rgyal ba'i 'phrin les pa
34. x x stods pa chen
35. Mus chen
36. rDo rje gnags ri
37. rGyal mtshan rtse mo'i dbur brgyan
38. Phag mo x x gcig ma
39. Gur mgon
40. 'Phags ma gzhan gyis mi thub
41. 'Phags ma lcags sgrogs ma
42. gDugs dkar mo can

Notes:
The central figure in the thanka, Sonam Tsemo (bSod nams rTse mo) was the famous Sakyapa teacher who lived from 1142 to 1182. He is surrounded by other members of the Sakyapa lineage, both human and divine.

Most of the names end with the expression *la na mo* which is an expression of salutation. On the back of the thanka are copious mantras and religious apothegms.

P19 *Mahasiddas in Landscape*
The single figure shown on side *a* is inscribed Seng ge pa (Sengepa) on the lower left-hand side of the picture. The writing on the right appears to be the number *don drug*, or 76. In the drawing of two figures (side *b*), that on the left is Bainapa (Vinapa) and is numbered 43. That on

the right, numbered 44, is Su na lo ki. The drawings are presumably from an artist's book of models. The words which begin the inscription apparently say something about his activities but are indistinct; perhaps *bsten gzugs* for *bzhugs* meaning "firmly established." The other is not clear and there are not enough examples of the artist's writing to make conjecture easy.

P20 *Kunga Tashi and Incidents from His Life*

Listed below are the transcriptions of the names of the figures as they correspond to the numbers as arranged above.

1. Drin can rtsa bai bla ma kun dga' bkra shis la na mo
2. unnamed
3. unnamed
4. gSer or gSeng Chos 'jam nag la na mo
5. rJe-btsun sgrol-ma la na mo
6. sByin pa'i bdag po tshe bsam rjes su bzung tu gsol
7. bDag shes rab rjes su bzung gsol
8. 'Dod khams ma la na mo
9. Gur gyi mgon po la na mo
10. dMag zor ma la na mo
11. sByin bdag po tshe ring bsam 'grub la na mo
12. Shes rab gal
13. Gnyer bstan phun la na mo
14. Kun bkras nas lha chen pa drug la nyams gso mdzad
15. Phun tshogs yang rtse
16. Kun bkras nas bsam brling dgon pa nyams gso mdzad tshul
17. Kun bkras zhabs dring pa dang bcas pa lha mchod yang rtser phebs tshul
18. Chos khrir kun bkras rab byams pa mang po la sgrogs gleng mdzad tshul
19. Kun bkras mdzod pa spel skya bar gser sku bzhengs dgos bka' bsgyur ba

20. Mdzod pa spel skya bas gzigs rtog phul tshul
21. Mdzod pa nas bzo par bka' khyab par tshul
22. Kun bkras kyi zhabs lha zhangs pa mdzad tshul

Notes:
The first thirteen inscriptions identify the various Sakyapa lamas, deities, and donors. Nos. 14 through 22 identify scenes from the life of Kun dga' bKra shis (Kunga Tashi). Some of these inscriptions are on cartouches, as indicated in the key given above; others are written on the surface in the usual fashion.

No. 14 shows him repairing a temple, apparently the Lhakhang Chenmo of Sakya.

No. 15 shows the temple of Phun Tshogs yang-rtse.

No. 16 shows the lama repairing Bsam brling dgon pa, another temple.

No. 17 pictures him attended by servants, on his way to perform ceremonies at Yang rtse.

No. 18 shows him on his throne, preaching to monks.

No. 19 pictures him ordering his treasurer to make a golden image.

No. 20 has the treasurer presenting the image for inspection.

No. 21 shows the treasurer giving instructions to workmen.

No. 22 Kun dga' bKra shis makes images of the gods (or performs ceremonies to the gods?).

Tucci (1949, pp. 372–89) read the inscriptions on the painting, but he did not name the person depicted. The person can now be identified as Kun dga' bKra shis rgyal mtshan, the thirty-second abbot of Sakya, who lived from 1349 to 1425; cf. Karmay 1975, pp. 55, 67, 79–80, 101 (n. 73), where he is known by the abbreviation Kun bKras pa. The figure above his head may be his father, Chos kyi rGyal mtshan (Chökyi Gyaltsen) (Roerich 1979, p. 215). The principal donor is Tshe bsam (Tshe dbang bsam bstan?) (no. 6). Another monk donor, Shes rab (no. 7), prays to follow as a disciple of the lama. The principal lay donor is Tshe ring bsam' grub, shown in the dress of a high official (no. 11).

There is no suggestion in the thanka that Kunga Tashi was dead when it was

painted; and it is unlikely that this sort of painting would have been undertaken very long after the death of the person depicted. The thanka may, therefore, date from as early as the fifteenth century.

P21 *Mahakala and Companions*

Inscriptions identify the figures seated in the clouds in the order indicated by the arrangement of numbers below.

```
 I    2    3  4  5   6   7  8  9  10  11
         12        13 14       15  16 17 18
19                                    22 23
    20                                   24
21
```

Inscriptions:
1. rTse mo
2. illegible
3. Lo chen Rin bzang
4. bDe ba'i rdo rje
5. mKha' 'gro ma
6. rDo rje 'chang
7. Bram ze mchog srid
8. Dad byed go cha
9. Brag stengs pa
10. Sa (or Pa) chen pa
11. Grags pa
12. dPal ldan bla ma
13. dKon mchog dpal
14. Sa pan
15. 'Phags pa
16. Brag phug pa
19. Sher chen
20. Sa Skya chen po (?)
21. bDag chen blo gros pa
22. dKon mchog tshul khrims
23. dGe legs shes
24. Shar bdagi

Dedicatory inscription at the bottom:
| | Thub dbang rdo rje 'chang svogs chos skyongs bcas | bris sku di mdo khams ga zi ba | | mang thos tshul gnas on po mkhyen rab gyi pha mes gtso byas mkha' mnyam sems can gyi sgrib gnyis sbyang zhing tshog gnyis rdzogs phyir bzhengs dge des rnam mkhyen myur du thob par shog | zhal bkod rab gnas ewam chos rjes mdzad x x 'dzin bkra shis rdzong khas bkra shis rtsal | sarba mangalam | |

Translation:
With the aid of Thub dbang rdo rje 'chang and other protectors of religion, mDo khams Ga zi ba, as one who listens to teaching, has set up this picture so that all creatures under the sky, headed by the father and grandfather of On po mkhyen rab, may be purged of the two sins and attain fulfillment in the two spheres. By its merit may they soon win complete knowledge.

Ewam chos-rje performed the consecration of the image. The rdzong of xx 'dzin bkra shis wishes good fortune. Blessing for all.

P25 *Portrait of the Fifth Karmapa*

The inscriptions identify the figures shown as follows:

Upper row
Left: rNam grol sde
Center: Kye rdo rje
Right: Grol sde

Center of thanka
Sa skyong gtsug rgyan chos rje De bzhin gshegs pa

Lower row
Left: Chos 'phel ye shes [wearing red hat]
Right: on higher level: Bya yul pa
 on lower level: gTsug rum pa

Inscription on back
gyon bdun bDe bzhin gshegs pa

Notes:
The central figure, wearing the black hat, is De bzhin gshegs pa (Dezhin Shegpa) the fifth Karmapa (1384–1415). The figure wearing the red hat is Chos dpal Yeshe (Chospal Yeshe, 1406–1452), the third member of the Shamar lineage. The Shamarpas are a subsect of the Karmapas.

P31 *A Symbolic Banquet*

Inscription:
shing mo sbrul lo gung ru byang 'dren zur pa blo bzang bsam bstan nas dad pas phul | |

Translation:
Given as an act of faith by Blo bzang bSam gtan (Lobsang Samten), the retired Byang dren of Gung ru in the female wood-snake year.

Notes:
Byang 'dren is another name for the *dbu mdzad*, the monk who leads the prayers in the assembly. The name of the monastery or college is unfortunately indistinct. It could be Mung ru, Gung ru, or Phung ru. The first is not traceable; but there are places called Gung thang and Phung mkhar. The date referred to may be either 1725 or 1785.

P45 *Temple Hanging*

Inscription:
Svasti Byang grol zhi ba lung rtogs rol mtsho'i rlabs srid pa'i rtse mor 'grims

pa'i nor bu'i gling mdzes byed bzang gos dra ba dra phyed 'di gra tshang 'bul bla p'a ra dge bshes ni | blo bzang dbang phyug ngo g-yog nas phul ba'i | 'brel thogs 'das gson bshes gnyen ded dpon la | brten nas 'khor ba'i rgya mtsho las brgal te sku gsum rin chen gling du son gyur cig | | skal bzang

2. *na mo gu ru bhya rab byung bcu drug pa'i lcags 'brug lo dra phed gsar bskrun skabs rje rin po che'i sku dar rje btsun chos rgyan gyi sku bcas bzhengs rgyu 'dul ba 'dzin gra nas bsdus chud yan slob gnyer ba rnams nas zhal 'debs phul ba sdom dngul srang bzhi brgya srang gang zho gang tam dkar bcu bzhi gzhan yang g-yu byur bcas byung ba'i dge ba rnams rgyal bstan dar dang 'gro rnams rdzogs byung thob pa'i rgyur gyur cig | |*

Translation:
1. Svasti This wave of the liberating peaceful ocean, the Jewel Park that reaches the peak of existence, this beautifully made network hanging of fine silk, an excellent gift to the monastery is offered by Pha ra Dge bshes Blo bzang dbang phyug [geshe Lobsang Bangphyug], the master, and his pupils. May they, relying on the guidance of a succession of religious teachers past and present, cross over the ocean of worldly existence and enter the sphere of the three precious lives.

 [written by?] Skal bzang

2. Reverence to the Guru. At the time of making this new network hanging in the Iron dragon year of the 16th *rab byung* [1940] in order to set up a picture of the Rje Rinpoche in silk and a picture of Rje btsun Chos rgyan, having made a collection from the whole vinaya college, contributions from the students amounted to four hundred *srangs* of silver, one *zho* and fourteen white [silver] *tam ka* together with turquoises and coral. May this cause the doctrine of the Buddha to spread and all creatures to attain enlightenment.

Notes:
The name of the monastery is Byang rtse Norbu'i gling (Norbulinga). The figures of the rJe Rin po che (Tsongkhapa) and Chos rgyan (Chos kyi rGyal mtshan, or Chökyi Gyaltsen, the First Panchen Lama) are in the center of the hanging.

S3 *Eleven-Headed Avalokitesvara*
Inscription:
Hrogs nri nya'a chang lha rog gi g-yar dam tu (du?) bzhengs su gsol ba

Provisional translation:
Pleased to set this up at Hrogs tri as a vow (in return for) help from Nya'a (Nyag) Chang Lha.

Notes:
Line 1 is in a strange "mystic" lettering, and the transcription may be inaccurate. Lines 2 and 3 are scantily punctuated. The *s* of *bzhengs* is written at the beginning of line 3.

S31 *Dampa Sangye*

Inscription:

| | dPal dan bla ma'i thugs dgongs rdzogs phyir du | dam pa'i sku 'dra dad ldan gsol 'debs sten | a nes tso byas bu slob rnams kyi zhengs | dge bas ' gro kun sangs rgyas thob par shog | bkra shis | dge 'o | |

| | Om sidha | tshogs gnyis rab rdzogs sku gnyis lhun grub pa'i | 'jam bu gling du stan pa'i sgron me sbar | khyad par kha ba can du smin sgrol 'dzad | dam pa'i sangs rgyas zhabs la phyag ' tshalo | ska cad thar phyin 'od gsal {mngon} du gyur, thabs la snga snyes 'kha' gro dbang du 'dus | 'gros ba'i don la sgrub pa'i rgyal 'tshan rtsugs | | dpal ldan seng ge'i zhabs la phyag 'tshalo |

Translation:
Headed by his aunt (or "the nun") the disciples have set up this holy image as a support for faithful prayers for the memorial service of the glorious lama (or dPal ldan Bla ma). By its merit may all creatures attain Buddhahood. Good luck good fortune.

Om sidha, Homage to the feet of Dampa'i Sangs rgyas! Fully accomplished in the two spheres, miraculously perfected in two bodies, who lights the lamp of faith in the world and especially in the land of snow has brought about salvation, who has become a master of the scriptures and has attained liberation and become clear light. Relying on his mastery of means he brings under his power all that go in the sky and has planted the banner of victory for the accomplishment of the purpose of living beings. Homage to the feet of dPal ldan seng ge.

Notes:
The image is of Dam pa Sangs rgyas (Dampa Sangye), the eleventh-century Indian mystic who was the subject of many legendary stories. He was the initiator of the Zhi byed (Shiche) school in the eleventh century. The image is dedicated

in memory of the lama dPal ldan Seng ge (Palden Sengge). A person of that name, who died in 1342, is mentioned several times in *The Blue Annals,* whose author, 'Gos Lotsawa, belonged to the same lineage of teachers as Palden Sengge (Roerich 1979, pp. 330, 374, 384, 785, 1052). The image may therefore date from the fourteenth century.

S32 *Portrait of Karma Dudtsi*

bde bar gshegs pa bla ma rin por che karma bdud rtsi; bzims mal sku 'dra sku rgyu ljon la grub pa'i bzud bzhugs la yabs sras kyi byin rlabs yongs sja sjags dang gzhan yang ri | por che la sogs pa'i khyadu 'pags pa bzhugs.

Translation:
A portrait image for the bedroom of the late Lama Rinpoche Karma bdud rtsi. May the image and the relics, made of wood and placed inside, be a blessing and a way of perfection for father and son, and may it be a holy object especially for other rinpoches and so on.

Notes:
A Karmapa lama named Karma bDud rtsi (Karma Dudtsi) is recorded as having lived in the sixteenth century. The "father and son" referred to in the inscription may be the donors, or may be the late lama and his disciple.

Several orthographical irregularities occur here. *Sja sjags* must be in error for *Su rdzogs. Khyadu* in last line is not quite clear.

S34 *Mahasiddha Virupa*

Inscription:

Om svasti | sku gsung thugs yon tan 'phrin las cig tu sdus pa'i ngo bo nyid | bla ma rnams dang dpaldan wir wa pa gnyisu med la dag no skyabsu mchi | dge slong namkha' gshes gnyen khu mtshan gnyis kyis | tshe 'das gyi don du gzhengs pa'i bsod nams kyis 'gro kun sangs rgyas myur thob shog | |

Translation:
Om swasti! I take refuge in the lamas and the glorious Virvapa, who are as one, and whose nature combines together body, speech, thought, wisdom, and action. Through the merit of setting up [this image] by the monk Nam kha' gShes gnyen (bShes gNyen) and his uncle, for the sake of the dead may the two [donors] and all beings swiftly attain Buddhahood.

S38 *Sonam Tsemo*

Inscription:

rJe btsun bSod nams rtse mo la na mo: mangalam |

Translation:
Veneration to the reverend bSod nams rTse mo [Sonam Tsemo]. Good fortune!

R16 *Set of Votive Plaques (Tsha Tsha)*

The back of each *tsha tsha* is inscribed in Chinese, Mongolian, Manchurian, and Tibetan. The inscriptions identify the figures and the Tibetan names are as follows:

1. Spyan ras gzigs rdo rje chos
2. 'Jig rten dbang phyug ha la ha la
3. rDo-rje rgyu
4. Kshe tra pa'la
5. 'Od zer can phyag gnyis ma
6. Sher byin phyag gnyis ma
7. gTsug tor rnam rgyal ma
8. kLu dbang gi rgyal po
9. Lha mo ral gcig ma phyag nyi shu rtsa bzhi ma
10. Dus kyi 'khor lo
11. gSang 'dus mi bskyod rdo rje
12. Sangs rgyas rjes su skyong ba
13. rNal 'byor nam mkhar
14. rDo rje rin chen
15. Pi lwang dbyangs can ma
16. dGon gyi Lha mo
17. rGyal chen 'dugs skya ser
18. sGrol ma nor sbyin ma
19. Lo ma gyon ma phyag drug ma
20. bTsong kha pa chen po
21. sRid med kyi bu
22. sNying po kye rdo rje
23. Lha mo tsunda phyag bzhi ma
24. rDo rje bsrung ba
25. Dombi pa
26. gSang sngags rjes 'dzin
27. Lo ma gyon ma phyag drug ma (duplicate of no. 19)
28. Phyag rdor gtum chung (?chud)
29. bDug nag sel ba'l sgrol ma
30. sBed byed
31. 'Thags ma gdugs dkar po can
32. 'Jam dbyangs gsang sgrub
33. brTsad dmar can (?)
34. Sher phyin phyag gnyis ma (duplicate of no. 6)
35. sGrol ma gser mdog ma
36. rDo rje rgyal po

Tibetan Pronunciation Key

The Tibetan words in this catalogue are spelled phonetically. What follows is a concordance of the phonetic renderings of those words which appear frequently in the text with their correct Tibetan transliterations. Words whose phonetic renderings and transliterations are equivalent have been omitted from this list.

Butön	Bu ston	lu	klu
Chamdo	Chab mdo	Milarepa	Mi la Ras pa
chö	gcod	Mikyö Dorje	Mi 'gyo rDo rje
Chödrag Gyatsho	Chos grags rGya mtso	Narthang	sNar thang
Chögyal	Chos rgyal	Ngok	rNgog
Chökyi Gyaltsen	Chos kyi rGyal mtshan	Ngoktön	rNgog ston
chökyong	chos skyong	Nyingmapa	rNying ma pa
Chospal Yeshe	Chos dpal Yeshe	Phagmotrupa	Phag mo gru pa
chöten	mchod rten	Phakpa	'Phags pa
Dampa Sangye	Dam pa Sangs rgyas	Reting	Rva sgreng
Dezhin Shegpa	De bzin gshegs pa	Rinchen Sangpo	Rin chen bZang po
Dölma	sGrol ma	Rölpe Dorje	Rol pa'i rDo rje
Drepung	'Bras spungs	Sakyapa	Sa skya pa
Drigungpa	'Bri gung pa	Samye	Bsam yas
Dromtön	'Brom ston	Senge Namgyal	Seng ge rNam rgyal
Drukpa	'Brug pa	Shalu	Zhva lu
Ganden	dGa' ldan	Shamarpa	Zhva mar pa
Gelukpa	dGe lugs pa	Shiche	Zhi byed
Gyalpo Palseng	rGyal po dPal seng	Shinje	gShin rje
Gyeltsabje	rGyal tshab rje	Sonam Gyatso	bSod nams rGya mtsho
Gyeltsen Özer	rGyal mtshan 'Od zer	Sonam Senge	bSod nams Seng ge
Jamyang	'Jam dbyangs	Sonam Tsemo	bSod nams rTse mo
Kadampa	bka' gdams pa	Songtsen Gampo	Srong brtsan sGam po
Kagyupa	bka' brgyud pa	Talungpa	sTag lung pa
Kanjur	bka' 'gyur	Tanjur	bsTan 'gyur
Karma Dudtsi	Karma bDud rtsi	Tashilumpo	bKra shis lhum po
Karma Pakshi	Ka rma Pak shi	Tashipal	bkra shis dpal
Kham	Khams	Thisong Detsen	Khri srong lDe brtsan
Khedubje	mKhas grub rje	Thubten Namgyal	Thub bstan rNam rgyal
Khutön	Khu ston	Trophu	Khro phu
kumbum	sku 'bum	Tsang	gTsang
Kunga Dorje	Kun dga' rDo rje	Tshelpa	'Tshal pa
Kunga Wangchuk	Kun dga' dBang phyug	Tshewang Namgyal	Tshe dbang rNam rgyal
Kunga Sangpo	Kun dga' bZang po	Tshulgyi Özer	Tshul gyi 'Od zer
Kunga Tashi	Kun dga' bKra shis	Tshurphu	mTshur phu
Künlek	Kun legs	tulku	sprul sku
Langdarma	Glang dar ma	Yeshe Ö	Yeshes 'Od
Legden Nagpo	Legs ldan Nag po	Yuthok Yönten Gonpo	Yu thog Yon tan mGon po
Lobsang Samten	Blo bzang bSam gtan		

Included here are significant Sanskrit and Tibetan terms used in this catalogue. Definitions have been limited to those meanings most relevant to Tibetan art and thought. Spellings of words in the Sanskrit glossary contain all appropriate diacritical marks, which have been omitted in the rest of the catalogue to facilitate reading.

Sanskrit Terms

abhayamudrā	gesture of reassurance
abhicāra	tantric rite performed to destroy the enemy
Abhirati	heaven of Akshobhya
abhisheka	religious initiation ceremony
Ādibuddha	primordial Buddha in Vajrayāna Buddhism
Akshobhya	"imperturbable"; one of the five transcendental Buddhas of the Vajrayāna pantheon
āmalaka	myrobalan, a medicinal fruit; symbol of Bhaishajyaguru, the Healing Buddha
Amitābha	Buddha of endless life; one of the five transcendental Buddhas of the Vajrayāna pantheon
Amitāyus	Buddha of endless life; a form of Amitābha
Amoghasiddhi	"unfailing perfection"; one of the five transcendental Buddhas of the Vajrayāna pantheon
Ānanda	one of Buddha Śākyamuni's principal disciples
anātmā	no-soul; a technical term in Buddhist philosophy
Āryamañjuśrīnāmasaṅgīti	litany of epithets extolling Mañjuśrī
Ashṭamaṇḍalaksūtra	a Mahāyāna scripture
Ashṭasāhasrika Prajñāpāramitā	the most fundamental work on Mahāyāna philosophy; perhaps composed by Nāgārjuna
Atīśa Dipaṅkara Śrījñāna	Indian Buddhist teacher who visited Tibet in 1042 and reestablished Buddhism there
ātma	the self
avadāna	birth stories of Buddha Śākyamuni's previous lives
Avalokiteśvara	the principal bodhisattva of the Vajrayāna/Mahāyāna pantheon
Bhagavadgītā	Hindu scripture and philosophical work; perhaps the most sacred book of the Hindus
Bhaishajyagurusūtra	a Mahāyāna text about Bhaishajyaguru, the Healing Buddha
Bhaishajyarāja	a Mahāyāna bodhisattva
Bhīmaratha	rite of longevity and senility performed in Nepal by the Newars
bhūmi	a stage of enlightenment; a term in Mahāyāna philosophy
bhūmisparśamudrā	touching-the-earth gesture made by Buddha Śākyamuni at the moment of his enlightenment
bodhi	enlightenment; from which comes the word Buddha, meaning the Enlightened One
bodhicitta	mind of enlightenment

bodhisattva	a being who compassionately refrains from entering Nirvana in order to save others; worshiped as a deity in Mahāyāna and Vajrayāna Buddhism	gajasiṃha	combined motif of a lion and an elephant depicted on thrones
Brahmā	a Hindu god, also venerated by the Buddhists	Gaṇeśa	elephant-headed Hindu god; also worshiped by Buddhists
cāmara	fly whisk made from yak's tail hair	garuḍa	Indian mythical bird identified with the Tibetan khyung; avian mount of Vishṇu
Cāmuṇḍā	Hindu goddess of dread; identified with the Tibetan goddess Lhamo	Gaurī	a Vajrayāna goddess; also a name for the Hindu goddess Durgā
Caṇḍālī	a Vajrayāna goddess	Gayādhara	an Indian Buddhist teacher who went to Tibet in the eleventh century
caryā	second class of tantra (praxis)		
Caurī	a Vajrayāna goddess	Ghasmarī	a Vajrayāna goddess
Citralakshaṇa	a book on iconometry	Gūhyasamājatantra	one of the oldest and most basic Vajrayāna texts
ḍāka	a class of demigods, especially associated with the mahāsiddhas	guruparamparā	lineage of gurus
ḍākinī	a class of demigoddesses; female of ḍāka	harmikā	rectangular entablature above the dome of a stūpa
Dāna Pāramitā	perfection of charity; a Buddhist goddess	Hayagrīva	a Vajrayāna god; the horse-headed one
Devanāgarī	script in which Sanskrit is written	ishṭadevatā	a god who protects and guides the individual, family, or monastery
dhāraṇī	that which supports; collection of mantras	Jambudvīpa	a name of the Indian subcontinent in Indian cosmography
dharmadhātu	synonym for stūpa; literally, "essence of religion"	jaṭā	hairstyle of ascetics who allow their hair to grow; a tall hairdress is thus called a jaṭāmukuṭa, or crown of jaṭā.
dharmapāla	protector of religion		
Dharmarāja	synonym for Yama, the Hindu god of death	jātaka	a story about Śākyamuni's previous births
dharmatā	religiosity	Jivarāma	a Newari artist who visited Tibet in the fifteenth century
Dharmatāla	an arhat		
dhoti	loincloth worn by Indian men	jñāna	wisdom or knowledge
Dhritarāshṭra	regent of the east	jñānakhaḍga	sword of knowledge
dhyāna	invocation of a deity including his or her personal description; used by priests to invoke a deity and by artists to represent him or her; meditation	kāla	time
		Kālacakra	a Vajrayāna text and god; literally, "wheel of time"
		kalaśa	water pot
dhyānamudrā	gesture of meditation	Kālī or Kālikā	a Hindu goddess of dread; also worshiped by Buddhists
Divyavadāna	collection of stories about the lives of Buddha Śākyamuni		
		Kālika	an arhat
Ḍombinī	a Vajrayāna Buddhist goddess	Kāmadhātu	realm of desire; one of the spheres in the Buddhist cosmology
Ekajaṭī	a manifestation of Tārā		

Kamalaśīla	an Indian Buddhist teacher who went to Tibet in the eighth century; a disciple of Śāntarakshita	Maitreya	the future Buddha, whose appearance is still awaited by the Buddhists
Kaṅkālī	a Vajrayāna goddess; a manifestation of Kālī	makara	an Indian mythical creature; an auspicious symbol
Karālī	a Vayrayāna goddess; a manifestation of Kālī	maṇḍa	essence; from which the word mandala is derived by some lexicographers
karuṇa	compassion	maṇi	jewel; an important Buddhist symbol
khakhara	mendicant's staff	Mañjuśrī	one of the most important Buddhist deities
khaṭvāṅga	a cot's leg which is wielded as a skull-crowned magic staff by angry Vajrayāna deities	mantra	mystical formula of invocation or incantation essential in tantric religious practice
kīla	peg or nail used in tantric ritual	Māra	the Buddhist god of desire
kinnara	an Indian mythical creature; half-bird, half-human in form	meru-daṇḍa	spinal column or the vertebrae
kīrttimukha	face of glory; stylized lion's face; an auspicious Indian symbol	mudrā	gestures made with the hands by both priests and deities; symbolize various abstract concepts
kritāñjalimudrā	gesture of adoration; synonym of namaskāramudrā	nāga	serpent; mythical creatures that play an important role in Buddhist legends and art
kriyā	a class of tantra (liturgical performance)	Nāgārjuna	an Indian Buddhist philosopher who lived in the second century A.D.; traditionally credited as the author of *Prajñāpāramitā* literature
kuṇḍikā	small water pot carried by ascetics		
Kushāṇa	an Indian dynasty that ruled in northwest India from the first century B.C. until third century A.D.	Nairātmā or Nairātmyā	a Vajrayāna goddess; literally, "No-Soul"
Mahābhairava	an epithet of Mañjuśrī; also of the Hindu Śiva	namaskāramudrā	gesture of adoration or greeting
		Narasiṃha	an avatar of the Hindu god Vishṇu
Mahākāla	a Vajrayāna god; also the Hindu Śiva; in Tibet, the preeminent dharmapāla, and protector of the tent	nyāgrodhaparimaṇḍala	circular like the fig tree; a metaphor for the Buddha image
Mahākālī	*see* Kālī	Odantapurī	a famous Indian Buddhist monastery
Mahāmaudgalyāyana	one of Śākyamuni's principal disciples	Pāla	an Indian dynasty; ruled in Bihar and Bengal from the eighth through the twelfth century
Mahāmāyūrī	a Vajrayāna goddess; also a dhāraṇī who heals snakebite	pañcaśikha	one with five tufts or "crests" of hair
mahāsiddha	a perfected being; venerated by both Buddhists and Śaivas	paramārtha śunyatā	ultimate nothingness; a term used in Mahāyāna philosophy
Mahāsthāmaprāpta	name of a bodhisattva	pāramitā	perfection; a term used in Mahāyāna philosophy
mahāsukha	great bliss		
Mahāyāna	a form of Buddhism; the Great Path	paraśu	battle-axe used as an attribute by deities
Maheśvara	a synonym of Śiva; literally, "the great god"	paryaṅkāsana	a posture of meditation in which both feet are placed on the thighs

paṭa — painting on cloth

paubhā — Newari word for paṭa

prajñā — insight or wisdom; partner

Prajñāpāramitā — one of the most important Buddhist goddesses

pratyālīḍha — a militant posture struck by angry deities

pūjā — worship

Pukkasī — a Vajrayāna goddess

Raktayamāri — a Vajrayāna god; an angry form of Mañjuśrī

Ratnasambhava — jewel-born; one of the five transcendental Buddhas of the Vajrayāna pantheon

Saddharmapuṇḍarikā — a Mahāyāna scripture; literally, "Lotus of the True Law"

sādhana — a meditation formula; same as dhyāna

Sādhanamālā — a Vajrayāna text containing descriptions and mantras of deities

sahaja — co-emergence of the twin principles of insight and compassion; technical term in tantric Buddhism; literally, "natural" or "spontaneous"

sahasrāksha — an epithet meaning thousand-eyed

Śaiva — a follower of Śiva

Śākyamuni — an epithet of the Buddha; sage of the Śākya tribe

Śākya Paṇḍita — a Tibetan teacher (1182–1251)

Śākyaśrī — an Indian Buddhist teacher who went to Tibet in 1204

Sampuṭatantra — a Vajrayāna text

samsāra — phenomenal world; the indefinitely repeated cycle of transmigration, birth, death, and rebirth

Śāntarakshita — an Indian Buddhist teacher who went to Tibet in the eighth century

Sarasvatī — the popular goddess of learning, wisdom, and music; worshiped by both Hindus and Buddhists; called Changehanma in Tibet

Śavarī — a Vajrayāna goddess

Shadaksharī Lokeśvara — a form of Avalokiteśvara; deification of the six-syllable mantra: *om maṇi padme hum*

siddhi — enlightenment; miraculous powers; perfection

Śilpaśāstra — treatise on the theory and practice of the visual arts

Śiva — one of the two principal Hindu gods, also venerated by Buddhists; the other is Vishṇu

Somapurī — an Indian Buddhist monastery

Sraddhākaravarman — an Indian Buddhist teacher who lived in the eleventh century; the guru of Rinchen Sangpo

Śrāvakayāna — an early form of Buddhism; the path of the śrāvaka, or the listeners

stūpa — a hemispherical or cylindrical mound or tower serving as a Buddhist shrine

Sukhāvatī — Amitābha's paradise; commonly known as the Western Paradise

Sukhāvatīvyūha — a Mahāyāna text about the Western Paradise of Amitābha

śūnyatā — nothingness or voidness; a term in Mahāyāna philosophy

Sūryavaivrocana — a bodhisattva; acolyte of Bhaishajyaguru

sūtra — a scripture or book containing doctrines and aphorisms

Tārā — one of the most important Vajrayāna goddesses; consort of Avalokiteśvara

Tārānāth — Tibetan polymath and famous lama; born in 1575

tarjanīmudrā — gesture of admonition

tathāgata — synonym for a Buddha; literally, "he who comes and goes in the same way"

Trayastrimśa — name of a heaven; literally, "thirty-third"

Triratna — Three Jewels of Buddhism—the Buddha, the religion (dharma), and the monastic order (saṁgha)

Uḍḍiyāna — a sacred region in tantric mythology; identified with the Swat Valley in Pakistan

upāya	means or fitness of action; a concept in Vajrayāna philosophy	Vasudhārā	the Buddhist goddess of wealth
		Varālī	a Vajrayāna goddess
urṇa	an auspicious tuft of hair between the eyebrows of a Buddha signifying superhuman quality	Varuna	a Hindu god; lord of the west and the waters; venerated by both Hindus and Buddhists
ushṇīsha	cranial bump on the head of a Buddha symbolizing wisdom	Vetālī	a Vajrayāna goddess
Ushṇīshavijayā	a Vajrayāna goddess of long life	vidyā	knowledge; incantation; charm
Vairocana	belonging to the sun; one of the five transcendental Buddhas of the Vajrayāna pantheon	vīja	literally, "seed"; elemental and essential syllables in a mantra
		Vikramaśīla	a Buddhist monastery in India
Vaiśravaṇa	the god of wealth and guardian of the north; venerated by both Hindus and Buddhists; identified with Kubera, the Indian god of wealth	Vimalakīrti	a Buddhist adept; human hero of *Vimalakīrtinirdeśa*
		Vimalakīrtinirdeśa	an important text on Mahāyāna philosophy
vajrācārya	generally applied to a Vajrayāna teacher; in Nepal signifies a Buddhist priest	Vinapā	one of the eighty-four mahāsiddhas
Vajradhara	a Vajrayāna Buddhist deity; regarded as the supreme Buddha in some texts	Viruḍhaka	regent of the south
vajrahumkāramudrā	a particular gesture of the hands used by Vajrayāna deities and priests	Vishṇu	one of the two most important Hindu gods; the other is Śiva
vajrakīla	literally, "diamond peg"—a weapon or ritual implement used by Vajrayāna priests	viśvavajra	a ritual implement known as the double-thunderbolt
		yaksha	an ancient Indian nature deity; often portrayed as a gnome
Vajrakumāra	Sanskrit name for Dorje Phurpa; literally, "diamond-youth"	Yama	Hindu god of death; in Tibet, Lord of the Dead and King of Religion
vajrapañjara	literally, "diamond cage"; an attribute of a deity	Yamāntaka	name of an angry form of Mañjuśrī; literally, "Destroyer of Yama"
Vajrapāṇi	one of the oldest and most significant bodhisattvas; literally, "thunderbolt-bearer"	yāna	path; way; vehicle
vajrāsana	literally, "diamond seat"; specifically refers to Bodhgaya, where the Buddha was enlightened	yoga	spiritual system, common to both Buddhism and Hinduism, which emphasizes rigorous physical and mental discipline in order to attain knowledge of the self, and to achieve union with the Universal Consciousness; literally, "union"
Vajrasattva	name of an important Vajrayāna Buddhist deity; literally, "thunderbolt-being"		
Vajravārāhī	name of an important Vajrayāna goddess; literally, "Adamantine Sow"	yogi	a practitioner of yoga
Vajravidāraṇa-nāma-dhāraṇī	a Vajrayāna text of protective spells	Tibetan Terms	
Vajrayāna	a form of Buddhism; the diamond path or vehicle	Alchi	a monastery in Ladakh; founded in the eleventh century
Vajrīputra	an arhat	Bod	Tibetan name for Tibet

Bodpas	Tibetan name for Tibetan people; derived from Bod	khyung	mythical bird; identified with the Indian garuḍa
Chamdo	a Gelukpa monastery in Kham; founded 1436–44	kumbum	a chöten with chapels
chö	a meditative technique that leads to detachment from the ego	Langdarma	known as "apostate king"; anti-Buddhist; assassinated around 842; this assassination ended Yarlung dynasty
chökyong	a god who protects the religion	Lhamo	most eminent goddess of Tibetan pantheon; protectress of Gelukpa order and of Lhasa, Tibet's capital
Drepung	a monastery in central Tibet; founded by Gelukpas in 1416	li	general term for metal alloy used in sculptures
Drigung	a Kagyupa monastery; founded in 1167	lotsawa	translator
Drigungpa	a Kagyupa suborder; an adherent of Drigung monastery	Marpa	founder of the Kagyupa order; remembered for introducing Tibetan poetry which was expressive of personal feelings and observations as well as religious ones; teacher of Milarepa; lived 1012–1096
Drukpa	a subsect of the Kagyupa order, founded by Padmo Dorje (1128–1188); principal order in Bhutan		
Ganden	monastery where Gelukpa order originated; founded in 1409 by Tsongkhapa	Ngor	monastery founded in 1429 by Kunga Sangpo; branch of the Sakyapa order; followers called Ngorpas
Gelukpa	religious order founded by main disciples of Tsongkhapa; became the country's most important order beginning in the seventeenth century; adherents distinguished by their yellow hats	Nyingmapa	"ancient order"; a religious order founded around the tenth–eleventh centuries by combining various older sects and traditions
geshe	a doctor of divinity	Panchen Lama	title of the abbot of the Tashilumpo monastery; most important religious figure in Tibet after the Dalai Lama
Guge	kingdom founded in western Tibet in the ninth century by one of Langdarma's sons	Phagmotrupa	a Kagyupa suborder; founded in 1158 by Phagmotrupa, member of a royal dynasty
Gyantse	important commercial, artistic, and religious center in central Tibet	Reting	a Kadampa monastery established by Dromton in 1056–57
hoshang	Chinese monk; literally, "teacher"	Rinchen Sangpo	great translator who revived Buddhism in the country; lived 958–1055 in western Tibet; friend of King Yeshe Ö
Iwang	an early Kadampa monastery in south-central Tibet; founded in the eleventh century		
Kagyupa	religious order founded by Marpa; more mystically oriented than other orders	Sakya	monastery founded in 1073 by Khön family; adherents called Sakyapas
Kanjur	Tibetan Buddhist canonical literature; the commentaries on original texts	Samye	monastery established c. 779 by King Thisong Detsen, Śāntarakshita, and Padmasambhava
Karmapa	a Kagyupa suborder; the abbots distinguished by their black hats	Sera	a monastery in central Tibet; established by Gelukpas in 1419
Khedubje	one of Tsongkhapa's chief disciples; an authority on tantras; author of *Fundamentals of the Buddhist Tantras*; lived 1385–1438	Shalu	monastery founded by Che family in 1040; belongs to Sakyapa order; seat of Butön rinpoche (1290–1364); adherents called Shalupas

Songtsen Gampo	king of Tibet (r.c. 609–49); founded Yarlung dynasty; Buddhism introduced to Tibet during his reign	Yeshe Ö	a member of Guge royal family who abdicated the throne to spread Buddhism in Tibet; lived c. 1000
Sumda	a monastery in western Tibet; founded in the eleventh century by Rinchen Sangpo	yidam	a god who protects and guides the individual, family, or monastery
Tabo	a monastery in western Tibet; founded in the tenth century by Rinchen Sangpo	Zanskar	region in India adjoining Ladakh; culturally Tibetan
Tanjur	Tibetan Buddhist canonical literature; original treatises		
Talungpa	a branch of the Kagyupa order; monastery of Talung founded by Talung Tashipal (1142–1210)		
Tashilumpo	monastery established in 1447 by Gelukpas in Tsang; seat of the Panchen Lamas		
Thel	monastery founded 1158; principal seat of the Phagmotrupas		
Thisong Detsen	king of Tibet (b. 742); fervent adherent of Buddhism; established first great monastery at Samye		
Thubten Namgyal	monastery established in 1478 by Sonam Senge; belonged to Sakyapa order		
Toling	monastery founded by Yeshe Ö and Rinchen Sangpo in the tenth century in the kingdom of Guge		
torma	an effigy of flour and/or yak's butter; offered as a substitute for real objects		
Tsang	region in central Tibet		
tshe bum	water container used on altars and in life-prolonging ceremonies		
Tshel	monastery founded 1175; a Kagyupa suborder		
Tshurphu	monastery founded 1189; principal seat of the Karmapas		
Tsongkhapa	great reformer of Tibetan Buddhism; founder of the Gelukpa order; lived 1357–1419		
tulku	a living Buddha; an emanation of an earlier lama; Dalai Lama is an example		
yab-yum	literally, "father-mother"; position of sexual union; means union of compassion and insight		
Yarlung dynasty	mid-seventh to mid-ninth century; founded by Songtsen Gampo		

Bibliography

Alsop, I. 1990. "Phagpa Lokeśvara of the Potala." *Orientations* 21, no. 4, pp. 51–61.

Anyetsang, M. C. 1980. "The Thanka Paintings of Tibet." *The Tibet Society Bulletin* 15, pp. 5–9.

Aris, M., and A. S. S. Kyi, eds. 1981. *Tibetan Studies in Honour of Hugh Richardson.* Warminster, England: Aris and Phillips.

Austen, H. H. G. 1865. "On the System Employed in Outlining the Figures of Deities and Other Religious Drawings, as Practiced in Ladak, Zaskar, etc." *Journal of the Asiatic Society of Bengal* 33, pp. 151–54.

Aziz, B. N. 1979. "Indian Philosopher as Tibetan Folk Hero." *Central Asiatic Journal* 23, nos. 1–2, pp. 19–37.

Bartholomew, T. T. 1980. "Guardians of Tibetan Buddhism." *Apollo* 112, no. 222, pp. 94–100.

Beguin, G. 1974. "Bronzes himalayens," *La Revue du Louvre* 4–5, pp. 333–44.

———. 1980. *Forty-one Thangkas from the Collection of His Holiness the Dalai Lama.* Paris: Editions Sciaky.

———. 1981. *Les mandalas himalayens du Musée Guimet.* Exh. cat. Réunion des musées nationaux, Paris.

———. 1987. *Les Arts du Nepal et du Tibet.* Paris: Desclee de Brouwer.

———. 1989. *Tibet Terreur et magie dieux farouches du Musée Guimet.* Brussels: Musées Royaux d'Art et d'Histoire.

Beguin, G., et al. 1977. *Dieux et démons de l'Himalaya.* Exh. cat. Réunion des musées nationaux, Paris.

Beguin, G., and J. Liszak-Hours. 1982. "Objets himalayens en metal du Musée Guimet." *Annales du laboratoire de recherche des Musées de France,* pp. 28–82.

Beguin, G., and P. Mortari Vergara. 1987. *Demeures des hommes, sanctuaires des dieux. Sources, développement et rayonnement de l'architecture Tibétaine.* Rome: Il Bagatto.

Bell, C. 1924. *Tibet Past and Present.* Oxford: Clarendon Press.

———. 1968. *The Religion of Tibet.* London: Oxford University Press.

Beyer, S. 1978. *The Cult of Tara.* Berkeley and Los Angeles: University of California Press.

Bhattacharyya, B. 1958. *The Indian Buddhist Iconography.* 2d ed. Calcutta: Firma K. L. Mukhopadhyay.

Birnbaum, R. 1979. *The Healing Buddha.* Boulder, Colo.: Shambhala.

Blofeld, J. 1978. *Bodhisattva of Wisdom.* Boulder, Colo.: Shambhala.

Brauen, M., and P. Kvaerne. 1978. *Tibetan Studies.* Zurich: Völkerkundemuseum der Universität Zürich.

Brzostoski, J. 1963. *Collection of Tibetan Art.* Riverside Museum, New York.

Cammann, S. 1951. *Trade through the Himalayas.* Westport, Conn.: Greenwood Press.

———. 1952. *China's Dragon Robes.* New York: Ronald Press.

———. 1962. "Embroidery Techniques in Old China." *Archives of the Chinese Art Society of America* 16, pp. 16–40.

Chandra, L. 1986. *Buddhist Iconography of Tibet.* 2 vols. Kyoto: Rinsen.

Chang, G. C. C. 1977. *The Hundred Thousand Songs of Milarepa.* 2 vols. Boulder, Colo.: Shambhala.

Chapin, H. B., and A. C. Soper. 1972. *A Long Roll of Buddhist Images.* Ascona, Switzerland: Artibus Asiae.

Chattopadhyay, A. 1972. *Catalogue of Kanjur and Tanjur,* vol. 1. Calcutta: Indo-Tibetan Studies.

———. 1981. *Atisa and Tibet.* Delhi: Motilal Banarasidass.

Chibetto-no-Hiboten [Exhibition of secret treasures from Tibet]. 1967. Exh. cat. Yomiuri Shimbun, Tokyo.

Chibetto-no-Kaiwa [Tibetan painting]. 1980. Exh. cat. Itabashi Ward Museum of Art, Tokyo.

Chow, F. 1971. "Arts from the Rooftop of Asia—Tibet, Nepal, Kashmir." *Metropolitan Museum of Art Bulletin,* May, pp. 380–93.

———. 1979. *Arts from the Rooftop of Asia.* Exh. cat. Metropolitan Museum of Art, New York.

Clark, W. E. 1965. *Two Lamaistic Pantheons.* Cambridge, Mass.: Harvard University Press.

Conze, E., et al. 1964. *Buddhist Texts through the Ages.* New York: Harper and Row.

Copeland, C. 1980. *Tankas from the Koelz Collection.* Exh. cat. Museum of Anthropology, University of Michigan, Ann Arbor.

Dargay, E. M. 1977. *The Rise of Esoteric Buddhism in Tibet.* Delhi: Motilal Banarasidass.

Das, S. C. 1965. *Indian Pandits in the Land of Snow.* Calcutta: Firma K. L. Mukhopadhyay.

David-Neel, A. 1971. *Magic and Mystery in Tibet.* New York: Dover.

Denwood, P. 1971. "The Tibetan Temple—Art in Its Architectural Setting." In *Mahayanist Art after A.D. 900.* Ed. W. Watson. London: University of London.

Doris Wiener Gallery, New York. 1974. *Thangka Art.* Exh. cat.

Douglas, N., and M. White. 1976. *Karmapa: The Black Hat Lama of Tibet.* London: Luzac.

Dutt, N., ed. 1939. *Gilgit Manuscripts,* vol. 1. Srinagar: Government of Kashmir.

Ekvall, R. B. 1964. *Religious Observances in Tibet: Patterns and Functions.* Chicago: University of Chicago Press.

Eliade, M. 1964. *Shamanism.* London: Routledge and Kegan Paul.

Ellingson-Waugh, T. 1974. "Algebraic and Geometric Logic," *Philosophy East and West* 24, no. 1, pp. 23–40.

Ettinghausen, R., and O. Grabar. 1987. *The Art and Architecture in Islam 650–1250.* Harmondsworth: Penguin Books.

Evans-Wentz, W. Y., ed. 1954. *The Tibetan Book of the Great Liberation.* London: Oxford University Press. *See also* Lama Kazi Dawa-Samdup.

Ferrari, A. 1958. *mK'yen-brtse's Guide to the Holy Places of Central Tibet.* Rome: Istituto Italiano per il medio ed estreme oriente.

Fisher, R. 1974. *Mystics and Mandalas.* Exh. cat. Tom and Ann Peppers Art Gallery, University of Redlands, California.

————. 1985. "The Art of Tibet." *Arts of Asia* 15, no. 6, pp. 102–13.

————. 1988. "Art from the Himalayas." *Orientations* 19, no. 7, pp. 72–83.

Francke, A. H. 1978. *Ladakh.* New Delhi: Cosmo Publications.

Getty, A. 1962. *The Gods of Northern Buddhism.* Tokyo: Tuttle.

Giles, H. A. 1918. *An Introduction to the History of Chinese Pictorial Art.* 2d ed. Shanghai: Kelly and Walsh.

Gordon, A. K. 1959. *The Iconography of Tibetan Lamaism.* Rutland, Vt.: Tuttle.

Goswamy, B. N., and A. L. Dahmen-Dallapiccola. 1976. *An Early Document of Indian Art.* New Delhi: Manohar.

Granoff, P. 1968–69. "A Portable Buddhist Shrine from Central Asia." *Archives of Asian Art* 22, pp. 80–95.

Guenther, H. V. 1963. *The Life and Teaching of Naropa.* London: Oxford University Press.

————. 1966. *Tibetan Buddhism without Mystification.* Leiden: Brill.

————. 1969 *The Royal Song of Saraha.* Seattle: University of Washington Press.

Guenther, H. V., and C. Thungpa. 1975. *The Dawn of Tantra.* Berkeley, Calif.: Shambhala.

Guy, J. 1982. *Palm-leaf and Paper.* Exh. cat. National Gallery of Victoria, Melbourne, Australia.

Hambis, L., ed. 1977. *L'Asie centrale.* Paris: Collection orientale de l'impirimerie nationale.

Hatt, R. T. 1980. "A Thirteenth-Century Tibetan Reliquary." *Artibus Asiae* 42, nos. 2–3, pp. 175–220.

Heissig, W. 1980. *The Religions of Mongolia.* Trans. G. Samuel. Berkeley and Los Angeles: University of California Press.

Heller, A., and T. Marcotty. 1987. "Phur-pa Tibetan Ritual Daggers." *Arts of Asia* 17, no. 4, pp. 69–77.

Henss, M. 1981. *Tibet, Die Kulturdenkmäler.* Zurich: Atlantis.

Ho, Wai-kam, et al. 1981. *Eight Dynasties of Chinese Paintings.* Exh. cat. Cleveland Museum of Art in association with Indiana University Press.

Hoffman, H. 1961. *The Religions of Tibet.* Trans. E. Fitzgerald. London: Allen and Unwin.

Hunter, A. 1985. "Tibetan Prayer Wheels." *Arts of Asia* 15, no. 1, pp. 74–81.

Huntington, J. C. 1968. "The Styles and Stylistic Sources of Tibetan Paintings." Ph.D. diss., University of California, Los Angeles.

————. 1970 A. "The Technique of Tibetan Paintings." *Studies in Conservation* 15, no. 2, pp. 122–23.

————. 1970 B. "The Iconography and Structure of the Mountings of Tibetan Paintings." *Studies in Conservation* 15, no. 3, pp. 190–205.

————. 1972. "Gu-gre bris: A Stylistic Amalgam." In *Aspects of Indian Art.* Ed. P. Pal. Leiden: Brill, pp. 105–17.

————. 1975. *The Phur-pa, Tibetan Ritual Daggers.* Ascona, Switzerland: Artibus Asiae.

————. 1983 A. "A Rocky Road for the 'Silk Route and the Diamond Path' Exhibition." *Art Journal* 43, no. 3, pp. 262–67.

————. 1983 B. "Three Essays on Himalayan Metal Images." *Apollo* 261, no. 118, pp. 416–28.

Inoue, T., et al. 1978. *Chibetto Mikkyo Nekiga* [Tibetan esoteric murals]. Kyoto: Shinshindo.

Jackson, D. P., and J. A. Jackson. 1984. *Tibetan Thangka Painting: Methods and Materials.* London: Serindia Publications.

Jisl, L. n.d. *Tibetan Art.* London: Spring Books.

Jung, C. G. 1973. *Mandala Symbolism.* Trans. R. F. C. Hull. Princeton, N.J.: Princeton University Press.

Kak, R. C. 1923. *Handbook of the Archaeological and Numismatic Section of the Sri Pratap Museum, Srinagar.* Calcutta and Simla: Thacker, Spink.

Karmay, H. 1975. *Early Sino-Tibetan Art.* Warminster, England: Aris and Phillips.

————. 1977. "Tibetan Costume, Seventh to Eleventh Centuries." In Macdonald and Imaeda, pp. 64–81.

Karmay, S. 1988. *Secret Visions of the Fifth Dalai Lama.* London: Serindia Publications.

Khosla, R. 1979. *Buddhist Monasteries in the Western Himalaya.* Kathmandu: Ratna Pustak Bhandar.

Kidd, D. 1975. "Tibetan Painting in China," *Oriental Art,* n.s. 21, no. 1, pp. 56–60.

Klimburg-Salter, D., ed. 1982. *The Silk Route and the Diamond Path.* Exh. cat. UCLA Art Council, Los Angeles.

Kobayashi, Y., and T. Harudan. 1980. *Mandala: Now You See It, Now You Don't.* Exh. cat. Seibu Museum of Art, Japan.

Kramrisch, S. 1964. *The Art of Nepal.* Exh. cat. Asia Society, New York.

Kreijger, H. 1989. *Godenbeelden uit Tibet.* Amsterdam: SDU Uitgeverij, Openbaar Kunstbezit.

Kunstamt Berlin-Tempelhof. 1981. *Tantrische Kunst des Buddhismus.* Exh. cat.

Kvaerne, P. 1985. *Tibet: Bon Religion.* Leiden: Brill.

Lalou, M. 1957. *Les Religions du Tibet.* Paris: Presses Universitaires de France.

Lama Anagarika Govinda. 1962. *Foundations of Tibetan Mysticism.* London: Rider.

Lama, G. 1985. *Principles of Tibetan Art.* 2d ed. Antwerp: Karma Sonam Gyantso Ling.

Lama Kazi Dawa-Samdup, trans., and W. Y. Evans-Wentz, ed. 1960. *Tibetan Yoga and Secret Doctrines.* London: Oxford University Press.

————. 1969. *Tibet's Great Yogi Milarepa.* London: Oxford University Press.

Lamotte, E. 1961. "Mañjuśrī," *T'oung Pao* 49, nos. 1–2, pp. 1–96.

Lauf, D. I. 1976. A. *Secret Revelation of Tibetan Thangkas.* Freiburg, Switzerland: Aurum Verlag.

————. 1976 B. *Tibetan Sacred Art.* Berkeley, Calif.: Shambhala.

————. 1977. *Secret Doctrines of the Tibetan Book of the Dead.* Boulder, Colo.: Shambhala.

Lauf, D. I., et al. 1969. *Tibetische Kunst.* Exh. cat. Helmhaus, Zurich.

Laufer, B. 1913. *Dokumente der Indischen Kunst.* Leipzig: Otto Harrassowitz. *See also* Goswamy.

Lee, S. E., and Wai-kam Ho. 1968. *Chinese Art under the Mongols: The Yüan Dynasty (1279–1368).* Exh. cat. Cleveland Museum of Art, Ohio.

Lessing, F. D. 1942. *Yung-Ho-Kung.* Stockholm: Elanders Boktryckeri Aktiegolag.

Lessing, F. D., and A. Wayman. 1968. *Mkhas grub rje's Fundamentals of the Buddhist Tantras.* The Hague: Mouton.

Liu, I-se, ed. 1957. *Hsi-tsang Fo-Chiao I-shu* [Tibetan Buddhist art]. Peking.

Lo Bue, R. 1985. "The Newar Artists of the Nepal Valley: An Historical Account of Their Activities in Neighbouring Areas with Particular Reference to Tibet—1." *Oriental Art,* n.s. 31, no. 3, pp. 262–73.

————. 1985–86. "The Artists of the Nepal Valley—2." *Oriental Art,* n.s. 31, no. 4, pp. 409–20.

Lokeshchandra, ed. 1968. *The Autobiography and Diaries of Si-tu Pan chen.* Sata-Pitaka Series, vol. 77. New Delhi: Indian Academy for International Culture.

Los Angeles County Museum of Art. 1975. *A Decade of Collecting.* Exh. cat.

Lowry, J. 1973 A. *Tibetan Art.* London: Her Majesty's Stationery Office.

————. 1973 B. "Tibet, Nepal or China?" *Oriental Art,* n.s. 19, no. 3, pp. 306–15.

————. 1977. "A Fifteenth-Century Sketchbook (Preliminary Study)." In Macdonald and Imaeda, pp. 83–118.

Macdonald, A., et al. 1977. "Un portrait du Cinquième Dalai-Lama." In Macdonald and Imaeda, pp. 119–56.

Macdonald, A., and Y. Imaeda, eds. 1977. *Essais sur l'art du Tibet.* Paris: Librairie d'Amérique et d'Orient.

Macdonald, A., and A. V. Stahl. 1979. *Newar Art.* Warminster, England: Aris and Phillips.

MacDonald, David. n.d. (c. 1978). *Cultural Heritage of Tibet.* Rev. ed. New Delhi: Light & Life Publishers.

Mallmann, M. T. de. 1964. *Etude iconographique sur Mañjuśrī.* Paris: Ecole Française d'Extrême-Orient.

――――. 1967. *Introduction à l'étude d'Avalokiteśvara.* Paris: Presses universitaires de France.

――――. 1975. *Introduction à l'iconographie du tântrisme bouddhique.* Paris: Andrien-Maissoneuve.

Marcotty, T. 1987. *Dagger Blessings—The Tibetan Phurpa Cult: Reflections and Materials.* Delhi: D. K. Fine Art Press.

Martin du-Gard, I. 1985. "Peinture d'offrandes à dPal-ldan dmag-zor rgyal-ma." *Arts Asiatiques,* no. 40, pp. 68–82.

Meredith, G. 1967. "The Phurbu: The Use and Symbolism of the Tibetan Magic Dagger." *History of Religions* 6, no. 3, pp. 239–41.

Monod-Bruhl, O. 1954–55. *Peintures tibetaines.* Paris: A. Guillot.

Montreal Palais de la Civilisation. 1986. *China: Treasures and Splendors.* Exh. cat. Arthaud, Paris.

Mukherji, D., ed. 1964. *Āryamañjuśrīnāma-sangīti.* Calcutta: University of Calcutta.

Müller, M., ed. 1965. *Buddhist Mahayana Texts.* Delhi: Motilal Banarasidass.

Museum für Ostasiatische Kunst, Cologne. 1974. *Buddhistische Kunst aus dem Himalaya.* Exh. cat.

Nebesky-Wojkowitz, R. de. 1956. *Oracles and Demons of Tibet.* The Hague: Mouton.

Neven, A. 1980. *New Studies into Indian and Himalayan Sculpture.* Exh. cat. Gallery "De ruimte," Ersel, The Netherlands.

Oddy, W. A., and W. Zwalf, eds. 1981. *Aspects of Tibetan Metallurgy.* British Museum Occasional Papers, no. 15. London: British Museum.

d'Oldenburg, S. 1914. "Matériaux pour l'iconographic bouddhique de Kharakhoto 1." In *Matériaux pour l'ethnographie de la Russie,* vol. 2, pp. 79–157. St. Petersburg, Russia.

Olschak, R. C., and G. T. Wangyal. 1973. *Mystic Art of Tibet.* New York: McGraw-Hill.

Olson, E. 1950–71 and reprints. *Catalogue of the Tibetan Collection and Other Lamaist Articles.* 5 vols. Newark Museum, New Jersey.

――――. 1964. "A Tibetan Buddhist Altar." *The Museum,* n.s. 16, nos. 1–2, pp. 1–40. Newark, N.J.: Newark Museum. *See also* reprint in vol. 24 (1972).

――――. 1974. *Tantric Buddhist Art.* Exh. cat. China Institute in America, New York.

Pachow, W. 1979. *A Study of the Twenty-two Dialogues on Mahayana Buddhism.* Taipei: Chinese Culture.

Pal, P. 1966. "Tibet and Nepal." In J. Rosenfield, et al., pp. 105–120.

――――. 1969 A. *The Art of Tibet.* Exh. cat. Asia House, New York.

――――. 1969 B. "The Art of Tibet." *The Connoisseur* 171, no. 687, pp. 43–50.

――――. 1971. *Indo-Asian Art from The John Gilmore Ford Collection.* Exh. cat. Baltimore, Md.: Walters Art Gallery.

――――. 1972–73. "A Note on the Mandala of the Eight Bodhisattvas." *Archives of Asian Art* 26, pp. 17–73.

――――. 1974 (vol. 1) and 1978 (vol. 2). *The Arts of Nepal.* Leiden: Brill.

――――. 1975. *Bronzes of Kashmir.* Graz, Austria: Akademische Druk.

――――. 1976. *Nepal: Where the Gods Are Young.* Exh. cat. Asia House, New York.

――――. 1977 A. *The Sensuous Immortals.* Exh. cat. Los Angeles County Museum of Art.

――――. 1977 B. "The Lord of the Tent in Tibetan Paintings." *Pantheon* 35, no. 2, pp. 97–102.

――――. 1979. "Kashmiri-Style Bronzes and Tantric Buddhism." *Annali dell'Istituto Orientale di Napoli* 39 (n.s. 29), pp. 253–73.

――――. 1980. "In Her Image: Indic Culture." In *In Her Image.* G. Larson, et al. Exh. cat. University of California, Santa Barbara, pp. 29–94.

――――. 1981. *Elephants and Ivories.* Exh. cat. Los Angeles County Museum of Art.

――――. 1982 A. "Cosmic Vision and Buddhist Images." *Art International* 25, nos. 1–2, pp. 8–40.

――――. 1982 B. *A Buddhist Paradise: The Murals of Alchi.* Basel: Ravi Kumar for Visual Dharma Publications.

――――. 1984. *Tibetan Paintings.* Basel: Ravi Kumar.

――――. 1987 A. *Icons of Piety, Images of Whimsy.* Exh. cat. Los Angeles County Museum of Art.

――――. 1987 B. "Tibetan Religious Paintings, 1." *Arts in Virginia* 27, nos. 1–3, pp. 44–65.

――――. 1988. "Tibetan Religious Paintings, 2." *Arts in Virginia* 28, nos. 2–3, pp. 6-33.

Pal, P., et al. 1984. *Light of Asia: Buddha Sakyamuni in Asian Art.* Exh. cat. Los Angeles County Museum of Art.

Pal, P., and L. Fournier. 1982. *A Buddhist Paradise: The Murals of Alchi Western Himalayas.* Vaduz, Liechtenstein: Ravi Kumar.

Pal, P., and J. Meech-Pekarik. 1988. *Buddhist Book Illuminations.* New York: Ravi Kumar.

Pal P., and H. C. Tseng. 1969. *Lamaist Art.* Exh. cat. Museum of Fine Arts, Boston.

Pallis, M. 1949. *Peaks and Lamas.* New York: Alfred A. Knopf.

――――. 1960. *The Way and the Mountain.* London: Peter Owen.

Pelliot, P. 1924. *Les Grottes de Touen-Houang,* vol. 11. Paris: Librairie Paul Geuthner.

The People's Fine Art Publishing House, China. 1982. *Selected Tibetan Jataka Murals.* Kyoto: Binobi.

Petech, L. 1979. *The History of Ladakh.* Rome: Istituto Italiano per il medio ed estremo oriente.

Pott, P. H. 1951. *Introduction to the Tibetan Collection of the National Museum of Ethnology, Leiden.* Leiden: Brill.

――――. 1964. "Tibet." In *Burma, Korea and Tibet.* A. B. Griswold, et al. London: Methuen.

Pritzker, T. 1989. "The Wall Paintings of Tabo." *Orientations,* 20, no. 2, pp. 38–47.

Raghuvira and Lokeshchandra. 1961–72. *A New Tibeto-Mongol Pantheon.* 20 vols. New Delhi: Indian Academy for International Culture.

Reedy, C. L. 1986 A. "Technical Analysis of Medieval Himalayan Copper Alloy Statues for Provenance Determination." Ph.D. diss., University of California, Los Angeles.

――――. 1986 B. "A Buddha within a Buddha: Two Medieval Himalayan Metal Statues." *Arts of Asia* 16, no. 2, pp. 94–103.

――――. 1987. "Tibetan Art as an Expression of North Indian Tantric Buddhism." In *Himalayas at a Crossroads: Portrait of a Changing World.* Ed. D. Shimkhada. Pasadena: Pacific Asia Museum.

Reynolds, V. 1978. *Tibet: A Lost World.* Exh. cat. American Federation of Arts, New York.

Reynolds, V., et al. 1986. *Sculpture and Painting,* revised vol. 3 of Olson 1950–71.

Rhie, M. M. 1985. "The Buddhist Art of Tibet." *Arts of Asia* 15, no. 1, pp. 82–103.

Richardson, H. E. 1958–59. "The Karmapa Sect, a Historical Note." *Journal of the Royal Asiatic Society,* 1958, pts. 3 and 4, pp. 139–64, and 1959, pts. 1 and 2, pp. 1–18.

――――. 1962. *Tibet and Its History.* London: Oxford University Press.

――――. 1977. "The Jo-khang, 'Cathedral' of Lhasa." In Macdonald and Imaeda, pp. 157–88.

Robinson, J. B. trans. 1979. *Buddha's Lions.* Berkeley, Calif.: Dharma.

Roerich, G. 1925. *Tibetan Painting.* Paris: Paul Geuthner.

――――. 1979. *The Blue Annals.* Delhi: Motilal Banarasidass.

Rosenfield, J., et al. 1966. *The Arts of India and Nepal: The Nasli and Alice Heeramaneck Collection.* Exh. cat. Museum of Fine Arts, Boston.

Ruegg, D. S. 1966. *The Life of Bu Ston Rin Po Che*. Rome: Istituto Italiano per il medio ed estreme oriente.

Sagaster, K., ed. 1983. *Ikonographie und Symbolik des Tibetischen Buddhismus*. Part A/B, Asian Research vol. 77–78. Wiesbaden: Harrassowitz.

Schafer, E. H. 1963. *The Golden Peaches of Samarkand*. Berkeley and Los Angeles: University of California Press.

Schiefner, A. 1869. *Taranath's Geschicte des Buddhismus*. St. Petersburg, Russia: Commissionhare der Kaiserlichen Akademie der Wissenschaften.

Schmid, T. 1952. *The Cotton-Clad Mila*. Stockholm: Statens Etnografiska Museum.

——. 1958. *The Eighty-five Siddhas*. Stockholm: Statens Etnografiska Museum.

Schroeder, U. von. 1981. *Indo-Tibetan Bronzes*. Hong Kong: Visual Dharma Publications.

Shunsho, M. 1981. Chibetto Bijutsu no tabi [Survey of Tibetan art]. Tokyo: Rokko Shuppan.

Shuwen, Yang, et al. 1987. *The Biographical Paintings of 'Phags-pa*. Beijing: New World Press.

Sierksma, F. 1966. *Tibet's Terrifying Deities*. Tokyo: Tuttle.

Singh, M. 1968. *Himalayan Art*. Greenwich, Conn.: New York Graphic Society.

Smith, G. 1969. "Introduction." In *The Autobiography of the First Panchen Lama, Blobzang chos kyi rhyalmtshan*. Ed. Ngawang Gelek Demo. New Delhi: Caxton Press Extension.

Snellgrove, D. L. 1957. *Buddhist Himalaya*. Oxford: Cassirer.

——. 1959. *The Hevajra Tantra*. 2 pts. London: Oxford University Press.

——. 1967. *The Nine Ways of Bon*. London: Oxford University Press.

——. 1971. "Indo-Tibetan Liturgy in Its Relationship to Iconography." In *Mahayanist Art after A.D. 900*. Ed. W. Watson. London: University of London.

——, ed. 1978. *The Image of the Buddha*. Tokyo: UNESCO/Kodansha.

Snellgrove, D. L., and H. E. Richardson. 1968. *A Cultural History of Tibet*. New York: Praeger.

Snellgrove, D. L., and T. Skorupski 1977 (vol. 1) and 1980 (vol. 2). *The Cultural Heritage of Ladakh*. Warminster, England: Aris and Phillips.

Spink and Son, London. 1979. *The Art of Nepal and Tibet*. Exh. cat.

Stein, M. A. 1921. *Serindia*. 5 vols. London: Oxford University Press.

——. 1975. *Ancient Khotan*, vol. 1. New York: Hacker.

Stein, R. A. 1958. "Peintures Tibetaines de la vie de Gesar." *Arts Asiatique* 5, no. 4, pp. 243–71.

——. 1972. *Tibetan Civilization*. Palo Alto, Calif.: Stanford University Press.

——. 1977. "La Gueule du makara: Un trait inexpliqué de certains objets rituels." In Macdonald and Imaeda, pp. 52–62.

——. 1978. "A propos des documents anciens relatifs au *phur-bu* (kila)." *Proceedings of the Csoma de Koros Memorial Symposium*. Ed. Louis Ligeti. Budapest: Akademiai Kiado, pp. 427–44.

Stoddard, H. 1985. "A Stone Sculpture of mGur mGon-po, Mahakala of the Tent, Dated 1292." *Oriental Arts*, n.s. 31, no. 3, pp. 278–82.

Stooke, H. J. 1961. "Some Tibetan T'ankas at Oxford." *Ars Orientalis* 4, pp. 207–18.

Thinley, K. 1980. *The History of the Sixteen Karmapas of Tibet*. Boulder, Colo.: Prajna Press.

Thomas, F. W. 1935–55. *Tibetan Literary Texts and Documents Concerning Chinese Turkestan*. 4 vols. London: Royal Asiatic Society.

Tibet House, New Delhi. 1965. *Tibet House Museum*. Exh. cat.

Topsfield, A. 1982. *The Art of Central Asia*. The Stein Collection in the British Museum, vol. 1. Tokyo: Kodansha International.

Trungpa, C., et al. 1980. *The Rain of Wisdom*. Boulder, Colo.: Shambhala.

Tsong-ka-pa. 1977. *Tantra in Tibet*. Trans. and ed. J. Hopkins. London: Allen and Unwin.

Tucci, G. 1932–41. *Indo-Tibetica*. 4 vols. Rome: Reale Accademia d'Italia.

——. 1935. "On Some Bronze Objects Discovered in Western Tibet." *Artibus Asiae* 5, pp. 105–16.

——. 1937. "Indian Paintings in Western Tibetan Temples." *Artibus Asiae* 7, pp. 191–204.

——. 1947. "Tibetan Book Covers." In *Art and Thought*. Ed. K. Bharata Iyer. London: Luzac.

——. 1949. *Tibetan Painted Scrolls*. 3 vols. Rome: La Libreria dello Stato.

——. 1956. *To Lhasa and Beyond*. Rome: Istituto Poligratico dello Stato.

——. 1959. "A Tibetan Classification of Buddhist Images according to Their Style." *Artibus Asiae* 22, pp. 179ff.

——. 1961. *The Theory and Practice of the Mandala*. London: Rider.

——. 1967. *Tibet: Land of Snows*. Trans. J. E. S. Driver. New York: Stein and Day.

——. 1973. *Transhimalaya*. Geneva: Nagel.

——. 1980. *The Religions of Tibet*. Trans. G. Samuel. Bombay: Allied.

Tulku, T. 1972. *Sacred Art of Tibet*. Berkeley, Calif.: Dharma.

University of Rochester, New York. 1961. *The Art of India*. Exh. cat.

de Visser, M. W. 1920. *The Arhats in China and Japan*. Berlin: Oesterheld.

Waddell, L. A. 1958. *The Buddhism of Tibet or Lamaism*. 2d ed. Cambridge: Heffer.

Waley, A. 1931. *A Catalogue of Paintings Recovered from Tunhuang by Sir Aurel Stein, K.C.I.E.* London: British Museum and the Government of India.

Wayman, A. 1973. *The Buddhist Tantras*. New York: Samuel Wieser.

——. 1977. "The Goddess Sarasvatī—From India to Tibet." *Kailash* 5, no. 3, pp. 246–51.

——. 1982. "Notes on the *phur-bu*." *Journal of the Tibet Society* 1, pp. 79–85.

Williams, C. A. S. 1976. *Outlines of Chinese Symbolism and Art Motives*. New York: Dover.

Wylie, T. V. 1962. *The Geography of Tibet according to the 'Dzam-gling rgyas-bshad*. Rome: Istituto Italiano per il medio ed estremo oriente.

——. 1964. "Ro-langs: The Tibetan Zombie." *History of Religions* 4, no. 1, pp. 69–80.

Zwalf, W. 1981. *Heritage of Tibet*. London: British Museum.

Index

Numerals in **bold** type indicate illustrations.